1000 MASTERPIECES
OF EUROPEAN PAINTING
FROM 1300 TO 1850

Front cover
Agnolo Bronzino: Portrait of Lucrezia Panciatichi
(Detail from illustration on p. 132)
Galleria degli Uffizi, Florence

Back cover
Michelangelo Buonarroti: The Holy Family with St. John (Tondo Doni)
(Detail from illustration on p. 634)
Galleria degli Uffizi, Florence

Illustration pages 8/9
Hieronymus Bosch: The Garden of Earthly Delights
(Detail from illustration on p. 100/101)
Museo del Prado, Madrid

© 2005 Tandem Verlag GmbH
KÖNEMANN is a trademark and an imprint of Tandem Verlag GmbH

Art Director: Peter Feierabend
Project Manager: Ute Edda Hammer
Project Coordinator and Picture Research: Petra Ahke
Layout: Sabine Vonderstein
Cover Design: Peter Feierabend, Claudio Martinez

Original title: *1000 Meisterwerke der europäischen Malerei von 1300 bis 1850*
ISBN for the German edition: 3-8331-1310-3

© 2005 for this English edition:
Tandem Verlag GmbH
KÖNEMANN is a trademark and an imprint of Tandem Verlag GmbH

Translation from German: Angela E. Anderson, Timothy Jones
Marion Kleinschmidt and Sally Schreiber
Editor of the English-language edition: Julia Muney Moore
Project Manager: Tammi Reichel
Project Coordinator: Kristin Zeier

Printed in China

ISBN 3-8331-1493-2

10 9 8 7 6 5 4 3 2
X IX VIII VII VI V IV III II I

1000 Masterpieces of European Painting

from 1300 to 1850

Christiane Stukenbrock
Barbara Töpper

In cooperation with
SCALA group S.p.A., Florence

KÖNEMANN

Abbate, Niccolò dell' • Aelst, Willem van • Aertsen, Pieter • Albani, Francesco • A
del Castagno • Andrea del Sarto • Anguisciola, Sofonisba • Anthonisz., Cornelis • An
Baciccio, Giovanni Battista • Bakhuyzen, Ludolf • Baldovinetti, Alesso • Baldung
Evaristo • Bassano, Jacopo • Batoni, Pompeo Girolamo • Baugin, Lubin • Beccaf
Guilhelmine • Berlinghieri, Bonaventura • Bermejo, Bartolomé • Berrugue
Ferdinand • Boilly, Louis-Léopold • Bonifazio Veronese • Bonington, Richard Parkes
• Bramante, Donato • Bramantino • Breu, Jörg, the Elder • Bril, Paul • Broederlam, Me
• Burgkmair, Hans, the Elder • Campin, Robert • Canaletto • Caravaggio • Caron, Anto
• Carracci, Ludovico • Carriera, Rosalba • Ceruti, Giacomo • Champaigne, Philippe de
Pieter • Cleve, Joos van, the Elder • Clouet, François • Clouet, Jean • Constable, Joh
Courbet, Gustave • Cranach, Lucas, the Elder • Crespi, Giuseppe Maria • Crivelli, C
Veneziano • Dossi, Dosso • Dou, Gerrit • Duccio di Buoninsegna • Dürer, Albrecht • D
Georg • Fontainebleau, School of • Foppa, Vincenzo • Fouquet, Jean • Fra Angelico
Fusseli, John Henry • Gaddi, Taddeo • Gainsborough, Thomas • Gentile da Fabriano
• Giordano, Luca • Giorgione • Giotto di Bondone • Giovanni da Maiano • Goes, Hug
Jean-Baptiste • Gros, Antoine-Jean • Grünewald, Mathis • Guardi, Francesco • Guerc
Heemskerck, Maerten van • Hemessen, Jan Sanders van • Hey, Jean • Heyden, Jan van
Younger • Honthorst, Gerard (Gerrit) van • Hooch, Pieter de • Hoogstraten, Samuel v
Willem • Kauffmann, Angelika • Kersting, Georg Friedrich • Koch, Josef Anton • Kul
Brun, Charles • Le Nain, Louis • Leonardo da Vinci • Leyden, Lucas van • Limburg,
Johann • Lochner, Stephan • Longhi, Pietro • Lorenzetti, Ambrogio • Lorenzetti, Pietro •
• Mantegna, Andrea • Maratta, Carlo • Martini, Simone • Masaccio • Masolino da Pa
Aix Annunciation • Master of the Bartholomew Altar • Meléndez, Luis • Melozzo da Forlì
Buonarroti • Mieris, Frans van • Mignard, Pierre • Momper, Joos de • Mor, Anthonis •
Nattier, Jean Marc • Oberrheinischer Meister/Master of the Upper Rhine • Orcagna,
Michael • Palma Vecchio • Pantoja de la Cruz, Juan • Parmigianino • Patenier, Joach
Piero di Cosimo • Pietro da Cortona • Pinturicchio • Piombo, Sebastiano del • Pisan
Francesco • Quarton, Enguerrand • Raphael • Rembrandt • Reni, Guido • Reynolds, Si
• Robert, Hubert • Romano, Giulio • Rosa, Salvator • Rosso, Giovanni Battista • Rube
Francesco • Sánchez Coello, Alonso • Sassetta • Savery, Roelandt • Schönfeld,
Hercules Pietersz. • Signorelli, Luca • Sittow, Michel • Snyders, Frans • Sodoma, Il • S
• Strozzi, Bernardo • Subleyras, Pierre • Teniers, David, the Younger • Terborch, Gerard
Wilhelm • Titian • Tura, Cosmè • Turner, Joseph Mallord William • Uccello, Paolo • Vas
Paolo • Verrocchio, Andrea del • Vigée-Lebrun, Élisabeth • Vignon, Claude • Vitale d
• Weyden, Rogier van der • Witz, Konrad • Wouwerman, Philips • Wright, Joseph • Z

Alessandro • Allori, Cristofano • Altdorfer, Albrecht • Amberger, Christoph • Andrea da Messina • Arcimboldo, Giuseppe • Averkamp, Hendrick van • Baburen, Dirck van • Hans • Barbari, Jacopo de' • Barnaba da Modena • Barocci, Federico • Baschenis, omenico • Bellini, Gentile • Bellini, Giovanni • Bellotto, Bernardo • Benoist, Marie-dro • Beyeren, Abraham van • Blanchard, Jacques • Blechen, Karl Eduard one, Paris • Bosch, Hieronymus • Botticelli, Sandro • Boucher, François • Bouts, Dierick • Bronzino, Agnolo • Brouwer, Adriaen • Brueghel, Jan • Bruegel, Pieter • Bruyn, Barthel aroto, Giovanni Francesco • Carpaccio, Vittore • Carracci, Agostino • Carracci, Annibale rdin, Jean-Baptiste Siméon • Christus, Petrus • Cima da Conegliano • Cimabue • Claesz., rnelis van Haarlem • Corot, Jean-Baptiste Camille • Correggio • Cossa, Francesco del • David, Gerard • David, Jacques-Louis • Delacroix, Eugène • Domenichino • Domenico ir Anthony van • El Greco • Elsheimer, Adam • Eyck, Jan van • Feti, Domencio • Flegel, Bartolommeo • Fragonard, Jean-Honoré • Friedrich, Caspar David • Froment, Nicolas • tileschi, Artemisia • Gentileschi, Orazio • Géricault, Théodore • Ghirlandaio, Domenico der • Gossaert, Jan • Goya, Francisco de • Goyen, Jan van • Gozzoli, Benozzo • Greuze, • Haecht, Willem van • Hals, Frans • Heda, Willem Claesz. • Heem, Jan Davidsz. de • Hobbema, Meindert • Hogarth, William • Holbein, Hans, the Elder • Holbein, Hans, the Huber, Wolf • Huguet, Jaime • Ingres, Jean-Auguste-Dominique • Jordaens, Jacob • Kalf, , Hans Suess von • Lancret, Nicolas • Largillière, Nicolas de • La Tour, Georges de • Le Jan, Hermann von • Liotard, Jean-Étienne • Lippi, Fra Filippo • Lippi, Filippino • Liss, zo di Credi • Lorenzo Monaco • Lorrain, Claude • Lotto, Lorenzo • Magnasco, Alessandro • Massys, Quentin • Master of the Darmstadt Passion • Master of St. Veronika • Master mling, Hans • Mengs, Anton Raphael • Menzel, Adolf von • Metsu, Gabriel • Michelangelo oni, Giovanni Battista • Moser, Lukas • Multscher, Hans • Murillo, Bartolomé Estéban rea • Orley, Bernard van • Ostade, Adriaen van • Overbeck, Johann Friedrich • Pacher, Perugino, Pietro • Pesne, Antoine • Piazzetta, Giovanni Battista • Piero della Francesca • Pollaiuolo, Antonio del • Pontormo • Poussin, Nicolas • Pozzo, Andrea • Primaticcio, hua • Ribera, Jusepe de • Ricci, Sebastiano • Richter, Adrian Ludwig • Rigaud, Hyacinthe eter Paul • Ruisdael, Jacob van • Runge, Philipp Otto • Ruysdael, Salomon van • Salviati, nn Heinrich • Schongauer, Martin • Scorel, Jan van • Seghers, Daniel • Seghers, na, Francesco • Spitzweg, Carl • Spranger, Bartholomeus • Steen, Jan • Strigel, Bernhard brugghen, Hendrick • Tiepolo, Giovanni Battista • Tintoretto • Tischbein, Johann Heinrich iorgio • Veen, Otto van • Velázquez, Diego Rodriguez de Silva y • Vermeer, Jan • Veronese logna • Vivarini, Alvise • Vivarini, Bartolomeo • Vouet, Simon • Watteau, Jean-Antoine y, Johann Joseph Edler von • Zoppo, Marco • Zucchi, Jacopo • Zurburán, Francisco de

Contents

Artists in alphabetical order

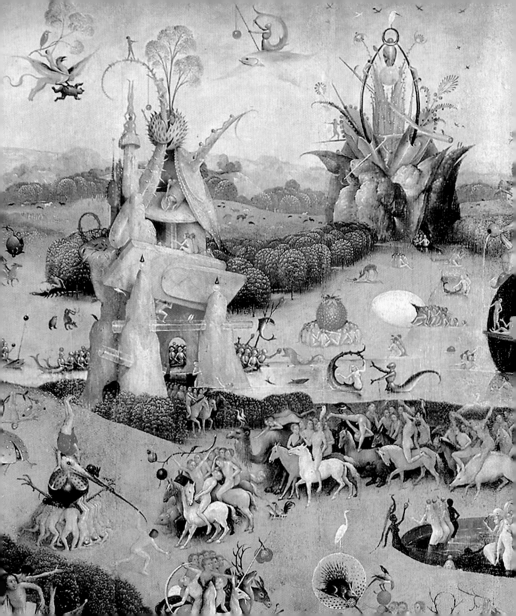

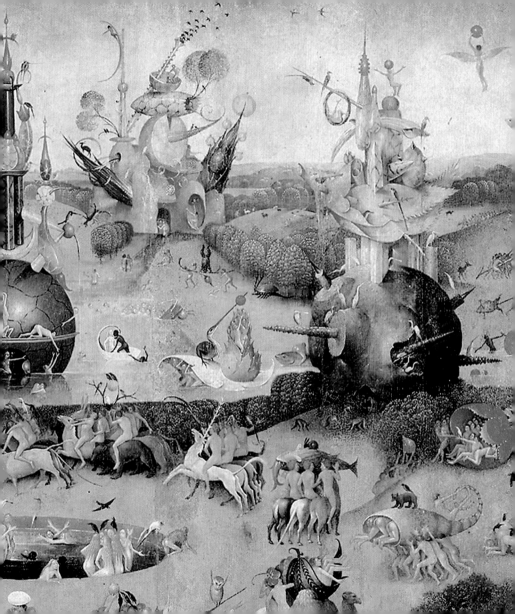

Abbate, Niccolò dell'

Niccolò dell'Abbate (1509 or 1512 Modena–1571 Fontainebleau) was one of the leading masters of the first School of Fontainebleau. He at first studied sculpture under the tutelage of Antonio Begarelli (c. 1499–1565), and was then influenced by the paintings of Dosso Dossi, Parmigianino and probably also Correggio. In 1552 he came to Fontainebleau, where he painted the *Galerie d'Ulysse* and the so-called *Gallery of Henry the 2nd*. He also painted portraits and mythological subjects in addition to creating designs for buildings, fine goldwork and tapestries for the royal factory. His paintings contributed to the spread of Italian Mannerism in France. They include *Young Man with Parrot*, after 1552, Kunsthistorisches Museum, Vienna; *The Rescue of Moses*, Musée de Louvre, Paris; and *Artistaeus and Eurydice*, 1560–1570, The National Gallery, London.

Portrait of a Lady, c. 1549
Oil on parchment mounted on canvas, 45 x 30 cm
Galleria Borghese, Rome
This picture, which was certainly painted before the artist moved to Fontainebleau, shows many characteristics typical of his work. The elegant figure of the young woman is compact and delicately contoured. The rigid and somewhat affected pose, seen in the way the woman is holding her hand, was in fashion at the time.

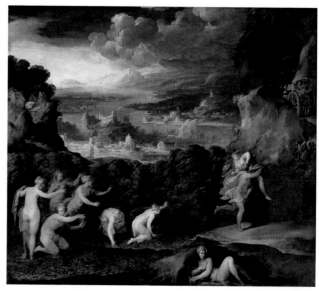

The Rape of Persephone, c. 1552–1570
Oil on canvas, 196 x 216 cm
Musée du Louvre, Paris
Under the influence of Dutch art, Abbate's later landscapes became increasingly realistic. This picture shows an episode from Greek mythology. While playing with sea nymphs, Persephone, the daughter of the fertility goddess Demeter, is abducted by Hades, the god of the underworld, to become his bride in the realm of the dead.

Aelst, Willem van

Willem van Aelst (1625 Delft–after 1683 Amsterdam) came from a family of lawyers. He learned to paint at an early age from his uncle, Evert van Aelst, and was accepted into the painters' guild in Delft in 1643. In 1645 he travelled to France, then later to Italy, where in 1649 he worked at the grand ducal court in Florence. It was there that he developed his characteristically elegant style under the influence of the insect painter Otto Marseus van Schrieck. In 1657 he settled in Amsterdam and concentrated on painting hunting still lifes. Willem van Aelst was one of the most outstanding and influential still life painters of his time, and had a great effect on the development of the genre. His works include *Still Life with Flowers*, 1663, Mauritshuis, The Hague; *Hunting Trophies*, 1668, Kunsthalle, Karlsruhe; and *Still Life with Game*, 1671, Mauritshuis, The Hague.

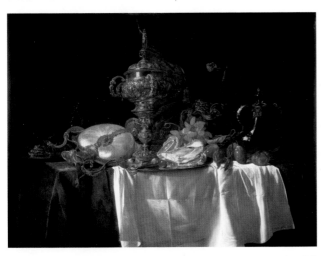

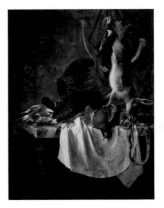

Still Life with Game and Hunting Weapons, 1652
Oil on panel, 125 x 99 cm
Galleria Palatina,
Palazzo Pitti, Florence
In his still lifes of hunting trophies, Aelst concentrated on the rendering of the fabrics, the birds' feathers and the hunting equipment. Such paintings were popular in aristocratic and courtly society, and were most often used to decorate hunting rooms or trophy cabinets. The genre reached its zenith in the works of 17th-century Dutch painters.

Still Life with Fruit and Vessels, 1653
Oil on canvas, 77 x 120 cm
Galleria Palatina,
Palazzo Pitti, Florence
This splendid still life was painted while van Aelst was in Italy. Until 1675 it was in the possession of the Cardinal Leopold de'Medici, together with its counterpart, a similarly opulent still life also depicting fruit.

The execution shows both Aelst's skill as a painter and his feel for composition. The luscious food and costly objects are harmoniously arranged, and Aelst has emphasized their luxury and the differences among their textures through his ingenious use of color.

Aertsen, Pieter

Pieter Aertsen (c. 1508 Amsterdam–1575 Amsterdam), nicknamed Lange Pier or Pietro Lungo, was an important pioneer of still life and genre painting in Flanders and Holland in the 16th century. After studying under Allaert Claesz. in Amsterdam, he went to Antwerp, where he worked until 1555. He is listed as a member of the St. Luke's Guild from 1535. Kitchen scenes, usually with Biblical or rustic backgrounds and elements drawn from his everyday surroundings, are common in his work. These subjects played a special role in European still-life painting. The way in which Aertsen incorporated elements of Venetian art and harmoniously combined them with his own northern style was of great importance. Many of his altar paintings were lost in 1566 when countless religious works were destroyed as part of the Reformation. Major works by the artist include *Triptych of the Crucifixion*, 1546, Koninklijk Museum voor Schone Kunsten, Antwerp; *Christ at the House of Mary and Martha*, 1552, Kunsthistorisches Museum, Vienna; and *Peasant Scene*, 1556, Museum Mayer van den Bergh, Antwerp.

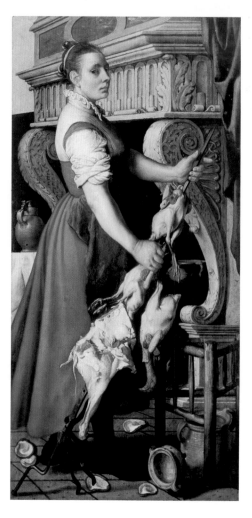

The Cook, 1559
Oil on panel, 161 x 79 cm
Galleria di Palazzo Bianco, Genoa
Aertsen also painted monumental compositions in addition to his small-scale works. The maid in this painting almost fills the entire panel. She stands self-confidently before a magnificent fireplace, preparing a meal. The proud posture, which is also to be found in other pictures with similar subjects, can be compared with the elegance of middle-class portraits painted around the same time.

Albani, Francesco

In spite of his many religious paintings, Francesco Albani (1578 Bologna–1660 Bologna) is considered to be the foremost Bolognese painter of mythological subjects. Albani first studied with the Flemish painter Denis Calvaert, and in 1595 he became a pupil of Annibale Carracci in Rome. He received important commissions there in the early 1600s, but nonetheless returned to his native city in 1625, where he concentrated primarily on landscapes with a few added figures. His classical compositions were widely praised by his contemporaries. They feature luminous, light colors; a transparent depiction of flesh; sensuous, soft lines and imply grace of movement. Albani's works are important precursors of modern landscape painting. His major works include *Mercury and Apollo*, c. 1624, Galleria Nazionale d'Arte Antica, Rome; *Annunciation*, 1632, San Bartolomeo, Bologna; and *Dancing Cherubs*, c. 1630–1640, Pinacoteca di Brera, Milan.

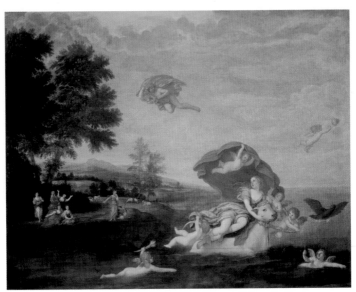

The Rape of Europa, 1639
Oil on canvas, 76.3 x 97 cm
Galleria degli Uffizi, Florence
In the early Renaissance , the story of Europa's abduction by Zeus as told in Ovid's *Metamorphoses* was one of the most popular subjects of Italian artists. According to Ovid, Zeus turned himself into a white bull so that he could approach Europa, the princess he loved. Europa climbed on the animal's back and was carried over the sea to Crete. In this painting, Europa and the bull are accompanied by putti and by Hermes, the messenger of the gods. Europa's horrified companions remain on shore.

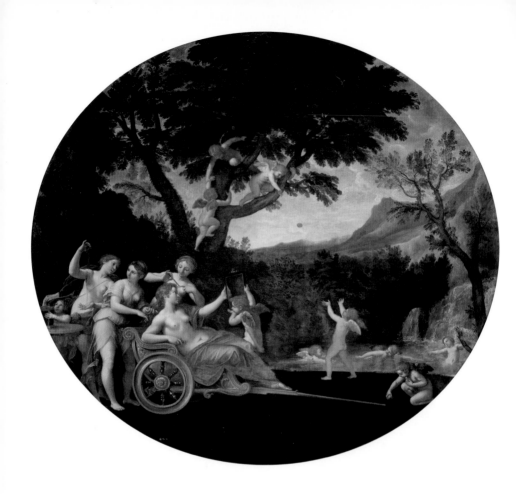

The Toilet of Venus, c. 1620
Oil on canvas, diam. 154 cm
Galleria Borghese, Rome
This painting forms part of a cycle
of four tondos, or circular pictures,
depicting stories of Venus that
Albani painted for Prince Scipione
Borghese (1576–1633). Inspired by
his mythological subject, Albani
created a pleasant, idyllic scene in
an idealized, light-filled landscape.
The gracefully childlike putti sym-
bolize the pleasures of life.

Allori, Alessandro

Alessandro Allori (1535 Florence–1607 Florence), whose real name was Alessandro di Cristoforo de Lorenzo Allori, also called himself Il Bronzino after his uncle and teacher Agnolo Bronzino, who had a strong influence on his work. Another major artistic influence was Michelangelo, whose works he studied during a sojourn in Rome from 1554 to 1559. The painters of the Antwerp School were an additional source of inspiration for him. In the 1560s Allori adjusted his painting style to fit the ideals of the Counter-Reformation. His skillful nudes, painted after 1570, show him to be a typical Mannerist and brought him many commissions in Florence and elsewhere. Important works by the artist include *Hercules and the Muses*, 1568, Galleria degli Uffizi, Florence; *Venus and Cupid*, c. 1570, Galleria degli Uffizi, Florence; and *St. Fiacrius*, c. 1602, San Spiritu, Florence.

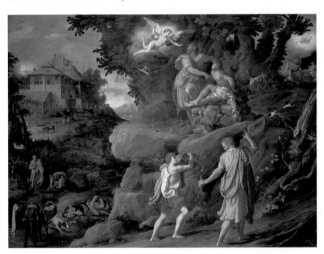

The Sacrifice of Isaac, c. 1602
Oil on panel, 94 x 131 cm
Galleria degli Uffizi, Florence
This painting portrays the Old Testament story in several scenes. Represented are, from left to right: Abraham and Isaac's departure, Isaac collecting and carrying wood, the servants being left behind, Abraham's willingness to make the sacrifice, the angel's command to sacrifice the ram instead of Isaac, and finally, God's blessing. The tranquil and well-thought-out composition displays Allori's new style, which he developed by the beginning of the 17th century.

The Annunciation, 1579
Oil on panel, 162 x 103 cm
Galleria dell'Accademia, Florence
In this daring work, the angel brings God's message to Mary with sweeping gestures and an air of urgency, while the Virgin receives the news humbly. The dramatic use of light adds to the dynamism of the vividly-drawn figures.

Allori, Cristofano

Cristofano Allori (1577 Florence–1621 Florence) was the son of the painter Alessandro Allori. He became familiar with the art of his great-uncle, Agnolo Bronzino, through painting lessons with his father. The influence of Gregorio Pagani was also important for the artist's development: It was Pagani who brought Allori into contact with the Bolognese School and helped him overcome the cool rigidity of late Mannerism. Allori combined stylistic elements of Ludovico Cardi Cigoli, Santi di Tito and especially Correggio with intensive study of live models and nature. He achieved great renown both with his portraits and his dramatic works on biblical and mythological subjects.

Among his works are *John the Baptist*, c. 1612, Galleria Palatina, Palazzo Pitti, Florence; *Isabella of Aragon Kneeling before Charles VIII*, Musée du Louvre, Paris; and *Christ in the House of Emmaus*, c. 1610, Galleria Palatina, Palazzo Pitti, Florence.

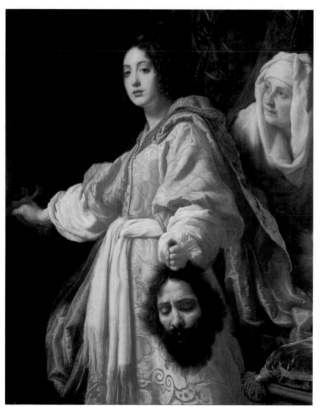

Judith with the Head of Holofernes, c. 1613
Oil on canvas, 139 x 116 cm
Galleria Palatina,
Palazzo Pitti, Florence
In this painting Allori dramatically emphasizes contrasts: The contrast between the grim face of the Assyrian general and the angelic features of the heroine, and the contrast between Judith's sensual appearance and the horrific nature of her recent actions. The artist is said to have portrayed his mistress, Mazzafirra, in the figure of Judith, while the maid supposedly has the features of Mazzafirra's mother.

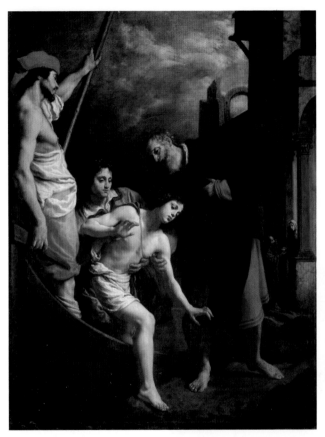

Tobias and the Angel, c. 1621
Oil on copper, 45 x 36 cm
Galleria Palatina,
Palazzo Pitti, Florence
The travels of Tobias were a popular subject for Italian painters from the 15th to the 17th centuries, and were probably first used as propitiatory offerings by sons from patrician families before setting off on a journey. Allori remains true to the usual representation here: The young man, elegantly dressed, is escorted through a wide landscape with the archangel Raphael as his guardian. The fish is a reference to the miracles Tobias wrought using its gallbladder, liver and heart.

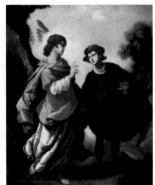

The Hospitality of St. Julian, c. 1612–1618
Oil on panel, 259 x 202 cm
Galleria Palatina,
Palazzo Pitti, Florence
This painting, one of Allori's most beautiful works, shows a seldom-represented episode from the legend of St. Julian the Hosteler. Having mistakenly killed his parents, St. Julian decided to dedicate his life to helping pilgrims and built a hostel for them. One stormy night he helped a sick man cross over the river: The man revealed himself to be Christ and instructed Julian to end his self-imposed atonement.

Altdorfer, Albrecht

Albrecht Altdorfer (c. 1480 Regensburg?–1538 Regensburg), who was in all probability the son of the painter Ulrich Altdorfer, was named a citizen of Regensburg in 1505 under the designation "The Painter of Amberg." He became a member of the city council in 1519 and the city's master builder in 1526. He made several trips to Vienna in his lifetime, and became a leading master of the Danube School through the development of ideas adopted from Austrian and Italian art as well as from Albrecht Dürer. Altdorfer's main interest lay in landscape painting. At first he tried to combine the natural world with human figures to form a harmonious whole, but this became far less important to him in his later years, and he began to create the first pure landscapes in European art. Despite their wealth of detail, his works tend to be imaginary scenes in front of a backdrop of indefinable depth. Among the artist's works are *The Witches' Sabbath*, 1506, Musée du Louvre, Paris; *Forest with St. George*, 1510, Alte Pinakothek, Munich; and *The Passion Altar*, c. 1515, Augustiner-Chorherrenstift, St. Florian-near-Linz.

The Martyrdom of St. Florian, c. 1518
Oil on panel, 76.4 x 67.2 cm
Galleria degli Uffizi, Florence
This impressive panel is one of a series of seven or eight paintings depicting scenes from the life of St. Florian. According to the legend, this Austrian-born Roman legionnaire was thrown into prison for coming to the aid of persecuted Christians. After being subjected to various kinds of torture, he was ultimately drowned in the River Enns with a millstone around his neck as illustrated here. This daring work is one of Altdorfer's most splendid large-scale compositions.

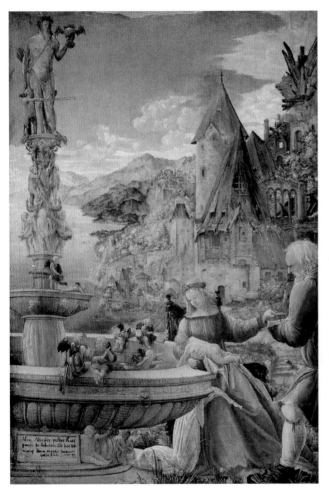

The Rest on the Flight into Egypt, 1510

Oil on panel, 57 x 38 cm
Gemäldegalerie, SMPK, Berlin
Altdorfer piously dedicated this unusual work to the Virgin Mary, and it contains a number of hidden allusions. For example, the Romanesque ruin is a reference to the fall of the temple when the Virgin and Child entered the city of Sotinen. The peaceful scene contrasts with the precipitous landscape, which makes it clear what a hard journey the Holy Family has undertaken.

View of the Danube Valley near Regensburg, after 1520

Parchment mounted on wood,
30.5 x 22.2 cm
Alte Pinakothek, Munich
With this image, Altdorfer painted one of the first topographically exact landscape pictures, one that is no longer merely a background for figures. In this well-balanced composition he sensitively captures the mood of nature.

Opposite
**Susanna at her Bath and
The Stoning of the Elders, 1526**
*Oil on panel, 74.8 x 61.2 cm
Alte Pinakothek, Munich*
Two scenes from the Old Testament story of Susanna and the Elders are depicted in this painting. She is represented in the traditional manner, at her bath and on the stair with a lily. This flower and the enclosed garden are symbols of her innocence, and the dog in her lap represents her faithfulness to her husband. Susanna's bath is limited to having her feet washed by two maids, as seen in the detail on the right. Two elders who have been observing her begin to make improper suggestions; when she does not give in to them, they both accuse her of adultery. Nevertheless, the prophet Daniel discerns the truth and has the old men convicted.

**Beggars Sitting on the
Train of Haughtiness, 1531**
*Oil on panel, 28.7 x 41 cm
Gemäldegalerie, SMPK, Berlin*
The subject of this small picture is the contrast between wealth and poverty. The beggars sitting on the train of the wealthy is an allusion to the neediness seen in front of each castle's very door. The seriousness of the message is softened, however, by the cheerfulness of this mysterious and fantastic scene. In the expansive, light-filled landscape, the luminous figures become one with their surroundings.

The Battle of Alexander, 1529
Oil on panel, 158.4 x 120.3 cm
Alte Pinakothek, Munich

This extraordinary painting is part of a history cycle completed by various artists at the behest of Duke William IV of Bavaria (1493–1556) and his wife, Jacobea. Alexander the Great (356–323 B.C.) is depicted conquering the Persian King Darius in the Battle of Issus in 333 B.C. He stands before an immense universal eastern Mediterranean landscape that includes the island of Cypress and, in the distance, the Egyptian coast. Mounted on his armored battle horse, Alexander pursues the defeated Persian king, who has fled in his battle wagon. The victorious Alexander is located precisely at the center of the composition, in the midst of an overwhelming mass of warriors and directly beneath the cord hanging down from the framed inscription. The movement of the clouds picks up the confusion of the battle, thus increasing the drama of the event. By dispensing with precise contours of the mountains and clouds, Altdorfer has created the impression of a natural event abstracted from reality.

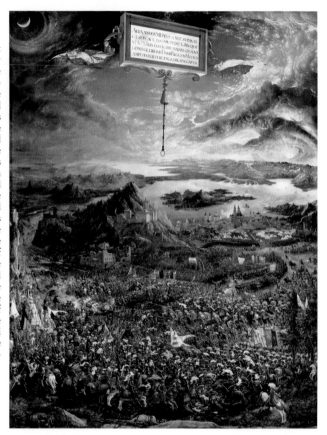

Amberger, Christoph

Christoph Amberger (c. 1505 Augsburg?–1562 Augsburg) was an outstanding portrait painter of the German Renaissance and a leading representative of the Augsburg School. He studied with Leonhard Beck, but was additionally inspired by the portraits of Hans Holbein the Younger. The use of color and the decorative style of Venetian paintings, which he found in the works of Hans Burgkmair the Elder, also had a great influence on him. Amberger typically displays a vivid characterization of the people he depicts, at times carrying it to the point of monumentality and overbearing significance. His works also display typical Mannerist severity and reserve. In later years, Amberger painted portraits and altarpieces based on Italian models. His works include *The Emperor Charles V*, 1532, Gemäldegalerie, SMPK, Berlin; *Christoph Baumgartner*, 1543, Kunsthistorisches Museum, Vienna; and *Virgin and Child with St. Ulrich and St. Afra*, 1554, Augsburg Cathedral, Augsburg.

Christoph Fugger, 1541
Oil on panel, 97.5 x 80 cm
Alte Pinakothek, Munich
Amberger portrays the sitter, son of the powerful Augsburg merchant Raymond Fugger (1489–1535), in a self-confident, elegant pose. The size of the figure in relation to the rest of the picture, the courtly pose, and the buildings in the background all indicate this family's status and influence. In this work Amberger incorporates elements of Italian art and combines them with the traditional severity of German portraits.

The Cosmographer
Sebastian Münster, c. 1552
Oil on panel, 54 x 42 cm
Gemäldegalerie, SMPK, Berlin
Amberger painted this great German academic, who was rector of the Basel University from 1488 to 1552, shortly before Münster's death. A sense of space is suggested only by the use of shadow. The frontal lighting is unusual, and serves to emphasize the pensive expression of the sitter. This use of light, together with the luminous coloring, is typical of Amberger's late style.

Andrea del Castagno

Andrea del Castagno (c. 1422 Castagno near Florence–1457 Florence), whose actual name was Andrea di Bartolo, was probably a pupil of the provincial painter Paolo Schiavo. Sources seem to indicate that in the late 1430s he was introduced into Florentine artistic circles as the protégé of Bernadetto de'Medici. Inspired by Masaccio and in particular by the sculptor Donatello (1386–1466), he developed a markedly individual style that would have a great influence on Florentine painters. Andrea's works are characterized by sharply-drawn, muscular, dynamic figures whose physicality is heightened by a clear use of perspective and a reduction of spatial elements. In some paintings, however, the figures' massiveness is moderated by the artist's use of lighting, a broad application of color, or the individual characteristics of the figures. Among his major works are *God the Father with Saints*, c. 1442, San Zaccharia, Florence; *The Assumption of Christ*, 1449/50, Gemäldegalerie, SMPK, Berlin; and *The Crucifixion*, c. 1456, Santa Maria degli Angeli, Florence.

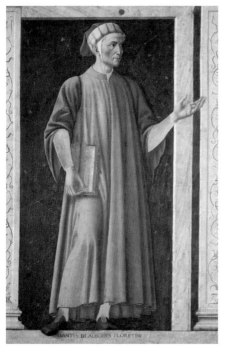

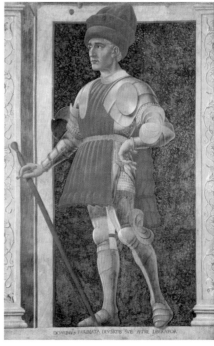

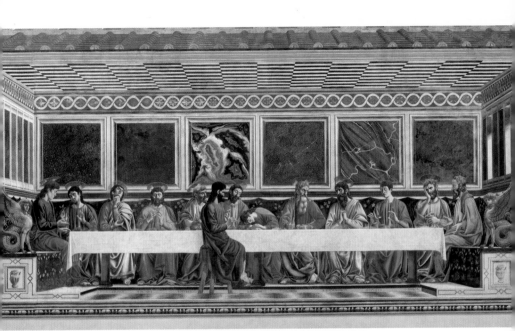

Opposite left
Dante Alighieri, c. 1450
Fresco removed from wall,
247 x 153 cm
Galleria degli Uffizi, Florence
This fresco portrait is part of the
nine-part cycle of *Uomini Famosi*
("Famous People") originally in the
Villa Carducci in Legnaia, near
Florence. The cycle contains depic-
tions of soldiers and poets who
had added to Florence's fame, as
well as of famous women of anti-
quity. This painting shows the most
important Italian writer and author
of *The Divine Comedy*, Dante
Alighieri (1265–1321).

Opposite right
Farinata degli Uberti, c. 1450
Fresco removed from wall,
250 x 154 cm
Galleria degli Uffizi, Florence
The larger-than-life, idealized por-
traits in Villa Carducci are like
sculptures that protrude from the
painted architecture. Viewing them,
one has the impression, especially in
the portrait of this mercenary com-
mander (died 1426), that the figures
are about to cross the invisible
barrier dividing the picture from the
viewer. In this case, the massiveness
of the figure is emphasized by the
depth of the niche behind it.

The Last Supper, c. 1450
Fresco, 470 x 975 cm
S. Appollonia, Florence
This fresco is situated in the
refectory, the monastery's dining
hall, and thus directly relates the
Last Supper to the meals being
taken by the monks. The painted
room seems to be an extension of
the real dining room, emphasizing
this connection even more: It is as if
Christ and his disciples were actu-
ally present. Christ is sitting behind
the table with all the disciples except
Judas, who remains isolated in his
position nearest the viewer.

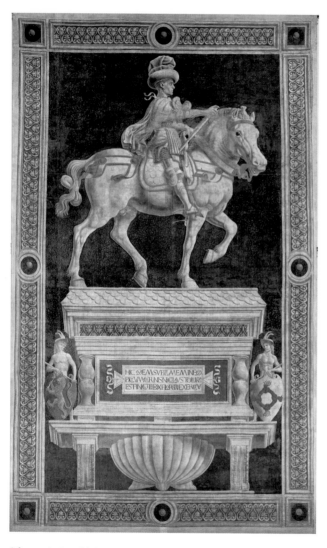

**Niccolo da Tolentino
on Horseback, 1456**
*Fresco removed from wall,
833 x 512 cm*
S. Maria del Fiore, Florence
This memorial to the Florentine
commander Niccolo da Tolentino
(died 1435), which originally stood
more than 25 feet above the floor, is
one of Castagno's last works. It is
the counterpart to Paolo Uccello's
Giovanni Acuto, who is also depic-
ted on a horse. Despite the similarity
to Uccello's portrait, attributable to
the nature of the commission, the
composition still bears charac-
teristics typical of Castagno's works;
for example, the way the sarco-
phagus and the noble youths on
either side of it have been painted
without any use of perspective.

Opposite
**Holy Trinity with St. Jerome,
c. 1455**
Fresco, 300 x 179 cm
SS. Annunziata, Florence
In this painting Andrea del Cas-
tagno depicts the saint as a penitent
in the desert with his attributes, a
lion and a cardinal's hat. The figures
standing next to him are probably
St. Paula and St. Eustachius, who
accompany the Church Father to
Bethlehem to hear him preach. They
regard the appearance of the Trinity
with awe: Shown are God the
Father, holding His crucified Son in
His arms, and the Holy Ghost in the
guise of a dove.

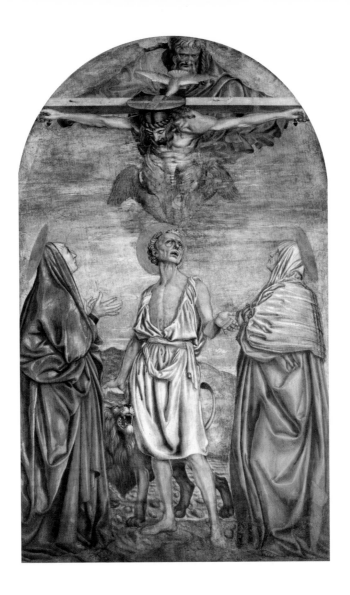

Andrea del Sarto

Andrea del Sarto (1486 Florence–1531 Florence), whose real name was Andrea d'Angiolo di Francesco, was given his nickname because he was the son of a tailor (Ital. *sarto*). According to Vasari, Andrea first had lessons with a goldsmith before continuing his training, probably with Piero di Cosimo. In 1508 he was accepted as a member of the guild of Medici e Speziali, to which painters also belonged. From 1511 he shared a studio with Jacopo Sansovino and probably also Franciabigio. In 1518 he was invited to Fontainebleau Castle by Francis I (1494–1547), but returned to his native city just a year later and made a career for himself carrying out important commissions for frescoes and painted altarpieces. Together with Fra Bartolommeo, Andrea del Sarto is considered the greatest master of the Florentine High Renaissance as well as one of the pioneers of Mannerism. His works include *The Birth of the Virgin*, 1513/14, Chiostrino dei Voti, SS. Annunziata, Florence; *Joseph in Egypt*, c. 1516, Galleria Palatina, Palazzo Pitti, Florence; and *Caritas*, 1518, Musée du Louvre, Paris.

Madonna of the Harpies, 1517
Oil on panel, 207 x 178 cm
Galleria Palatina,
Palazzo Pitti, Florence
This painting originally decorated the main altar of San Francesco de' Macci in Florence. Standing on a pedestal, the Madonna is flanked by St. Francis and John the Evangelist. The pedestal is decorated with imaginary winged beings, which Vasari falsely saw as representing harpies (Italian *arpie*), evil female demons in the shape of birds.

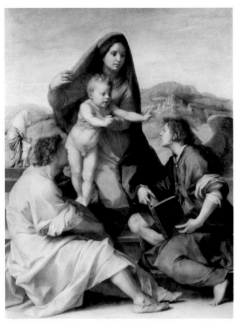

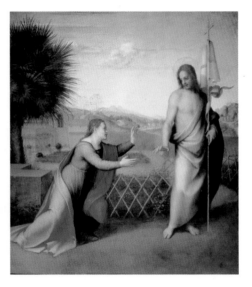

**The Virgin and Child with a Saint and an Angel
(Madonna of the Stair), c. 1522**
Oil on panel, 177 x 135 cm
Museo del Prado, Madrid
The monumental representation of powerful figures in
a traditional triangular composition make this painting
a characteristic work of Andrea del Sarto. On the left
in the background, St. Elizabeth and John the Baptist
are seen fleeing from the slaughter of infants ordered by
Herod, while in the foreground a figure, probably
representing John the Evangelist, and an angel sit at the
Madonna's feet.

Noli me tangere, c. 1510
Oil on panel, 176 x 155 cm
Museo del Cenacolo di S. Salvi, Florence
Andrea painted this fine early work before he went to
Rome in 1511. It was a commission from the Morelli
family, who had made their substantial fortune in the
silk trade. It originally hung in the Augustine church of
San Gallo, which was destroyed in 1529. It was then
hung in San Jacopo tra'Fossi until it was installed in the
Galleria degli Uffizi in 1875. Since 1982 it has been part
of the collection of the new San Salvi Museum, also
located in Florence.

The Last Supper, 1526/1527
Fresco, 462 x 872 cm
Museo del Cenacolo
di San Salvi, Florence
Andrea del Sarto took depictions of the Last Supper by Leonardo da Vinci, Raphael and Dürer as his inspiration for this fresco, which is no less highly esteemed than the works on which it is modeled. Outstanding features of the painting are its vivid representation of the 12 apostles sitting at the table with Christ as well as its glowing colors, which can again be seen in their full glory after a thorough restoration.

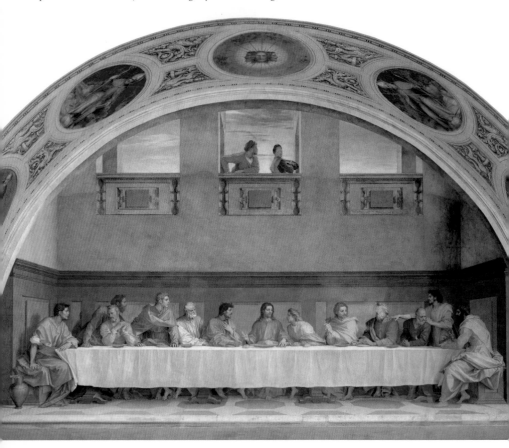

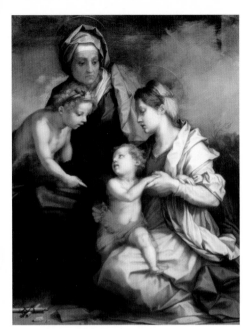

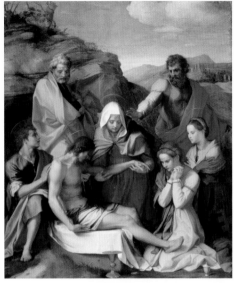

Sacra Famiglia Medici (Virgin and Child with St. Elizabeth and John the Baptist), c. 1529
Oil on panel, 140 x 104 cm
Galleria Palatina, Palazzo Pitti, Florence
Andrea del Sarto, who painted many different versions of the *sacra conversazione*, created this work shortly before his death specifically for Ottaviano de' Medici (1482–1546). Giorgio Vasari tells us that this powerful merchant and patron of the arts did not want to accept the painting at first, but then bought it later—at double the original price.

Lamentation (La Desposizione), c. 1525
Oil on panel, 238 x 198 cm
Galleria Palatina, Palazzo Pitti, Florence
Antonio Brancacci commissioned this large *Lamentation* in 1523 for the high altar of San Pietro a Luco in Mugello, where the original frame is still to be found today. The composition shows the Virgin Mary with the saints Mary Magdalene, Catherine, John, Peter and Paul. This picture is outstanding for its luminous colors and the skillful depiction of grief and emotion in the expressions and gestures of the saints.

Anguisciola, Sofonisba

Sofonisba Anguisciola (c. 1530 Cremona–after 1623 Palermo) came from a noble family. She was one of four sisters, all of whom painted. Between 1545 and 1549 she studied with Bernardino Campi and Bernardino Gatti. Anguisciola was particularly influenced by Correggio, especially his portraits, and went on to became one of the most famous female painters in Italy in the 1550s. In 1560 she went to Madrid, where she worked for Philip II (1527–1598). At some point before 1584 she moved to Genoa and then ultimately settled in Palermo, where she met Anthony van Dyck. Her works are characterized by restrained but penetrating observation, and tranquil compositions employing muted colors. Among her works are *Bernardino Campi Painting Sofonisba Anguisciola*, c. 1550, Pinacoteca Nazionale, Siena; *Self-Portrait*, 1554, Kunsthistorisches Museum, Vienna; and *Chess Game*, 1555, Muzeum Narodowe, Poznan.

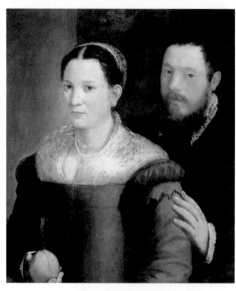

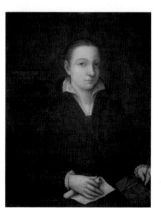

Self-Portrait, c. 1550
Oil on canvas, 88.5 x 69 cm
Galleria degli Uffizi, Florence
Anguisciola painted a great number of self-portraits during her painting career. According to the inscription, she painted this one at the age of 20. In the 1550s she often portrayed herself as she is seen in this picture, in a simple pose in front of a neutral background, and wearing severe clothes without any frills. She is holding a piece of paper in her right hand, and in the left a brush and palette. She presents herself to viewers as a self-confident artist, and looks out at them with a steady, wide-eyed gaze.

Portrait of a Couple, c. 1570
Oil on canvas, 72 x 65 cm
Galleria Doria Pamphili, Rome
Anguisciola painted many portraits of members of the royal household after her arrival in Spain, including one of Philip II's wife, Anne of Austria (1549–1580), whom he married in 1570. In this portrait the artist has created a very intimate, affectionate picture of an unknown couple. The painting radiates a complex and intense mood despite the simplicity of its composition. The elegantly dressed woman holds a piece of fruit in her hand, possibly as a reference to the fruitfulness and fulfillment of the marriage.

Anthonisz., Cornelis

Cornelis Anthonisz. (c. 1505 Amsterdam–1553 Amsterdam) was a painter, printmaker and cartographer. He served Charles V (1500–1558) in this last capacity, travelling to Algeria with Charles' army and taking part in the siege of Thérouanne near St. Omer in 1553. His paintings of cities from a bird's-eye perspective are of particular importance. Anthonisz. is best known for his group portrait of the civic guard of Amsterdam, one of the first of this genre.

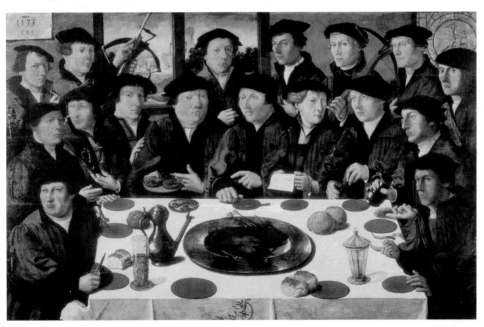

Banquet of the Amsterdam Civic Guard (The Brass Penny Banquet), 1533
Oil on panel, 130 x 206.5 cm
Amsterdams Historisch Museum, Amsterdam
The group shown here in all probability used the name day of their patron saint, St. George, as an opportunity to have their portrait painted. The civic guards, originally formed to defend the city in times of war, were also an expression of its democratic constitution and citizen self-confidence; therefore group portraits of this type are not as hierarchically composed as more traditional group portraits.

Antonello da Messina

Antonello da Messina (c. 1430 Messina–1479 Messina) lived and worked mainly in Sicily. He studied painting both there and in Naples, where he was living around 1450. A second journey from 1474 to about 1476 took him to Venice and Milan. Antonello's works are influenced primarily by Dutch art and the works of Piero della Francesca. Even in his early work, he had the ability to combine a realistic depiction of the smallest detail with a pronounced sense of space. Through this vivid style he constructed an artistic language increasingly based on geometric forms and strict perspective. His greatest achievement was introducing the new technique of painting with oils from the north into Italian art. Works by the artist include *St. Jerome in his Studio*, c. 1474, The National Gallery, London; *Polyptych of St. Gregory*, 1473, Museo Regionale, Messina; and *Virgin and Child and Saints* (Pala di San Cassiano), 1475/76, Kunsthistorisches Museum, Vienna.

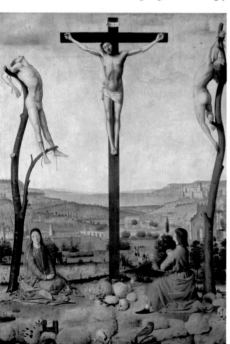

Crucifixion, 1475
Tempera on panel, 52.5 x 42 cm
Koninklijk Museum voor Schone
Kunsten, Antwerp
Of all the different versions that Antonello painted of this subject, this one is the most dramatic. The crucified men stand out against the sky like monuments. While the thieves writhe in the agony of death, Christ alone appears to be composed. His mild features reflect his forgiveness and love. Beneath him, John is praying fervently, while Mary has sunk down in deep grief. The skull and bones, both symbols of Golgotha as well as the owl, allude to death.

Opposite below
St. Sebastian, 1479
Oil on panel, 35 x 26 cm
Accademia Carrara, Bergamo
St. Sebastian was one of the most important patron saints thought to protect people from the frequent plague epidemics. The representation of him as a scantily-clad youth shot through with arrows was very common in the 15th century. This is not only because he was widely worshipped as a helper in times of distress and need, but also because of the artistic possibilities offered by the nude figure. In this painting, Antonello unifies the elements making up the picture through his use of line and color.

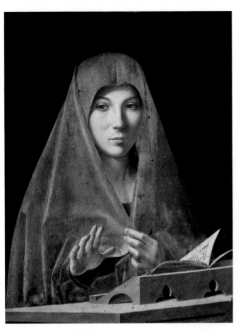

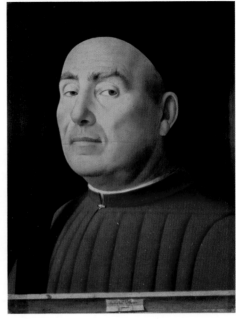

The Virgin Annunciated, c. 1475
Oil on panel, 45 x 34.5 cm
Galleria Regionale della
Sicilia, Palermo
In this painting, probably the most
famous in Sicily, the artist has
succeeded in expressing great
emotional involvement by means of
a reduced palette, simple forms and
restrained gestures. The geometric
strictness shows the influence of
Piero della Francesca, whose works
he had studied.

Portrait of Trivulzio
(Portrait of a Man), 1476
Oil on panel, 36 x 28 cm
Museo Civico, Turin
Antonello da Messina was one of
the most important Italian portrait
painters of his time. In his portraits,
he moved away from using the
traditional profile view, adopting in
its stead a three-quarter view of his
subject. His use of the interplay be-
tween light and shadow makes vivid
the rendering of facial expressions.

Arcimboldo, Giuseppe

Giuseppe Arcimboldo (c. 1527 Milan–1593 Milan) was trained as an artist in his father's workshop, where he made stained-glass windows, tapestries and frescoes for churches. From 1562 to 1587 he worked as a court painter in Prague, where his tasks included portrait painting as well as the design of costumes and decorations. Arcimboldo developed an original naturalistic-Mannerist style in his imaginative portraits and allegories. He created supernatural heads and figures as if they were still lifes, making collages out of fruit, plants, animals and even man-made objects combined in fanciful ways. His art can be understood as a reaction to the end of the Renaissance and its new, scientific understanding of nature. The artist's works include *The Librarian*, c. 1565, Castle, Skokloster (Uppsala); *The Fire*, 1566, Kunsthistorisches Museum, Vienna; and *King Herod*, Collezione Conte Cardazzo, Venice.

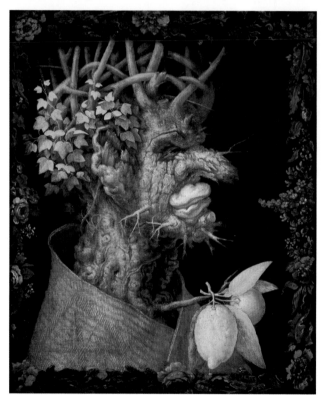

Winter, 1573
Oil on canvas, 76.5 x 64 cm
Musée du Louvre, Paris
This picture belongs to the cycle of "The Four Seasons," which has often been copied. In *Winter*, the figure is not formed by bringing together several disparate elements, but is composed of a single tree trunk whose shape has similarities to the human form.

Opposite
Spring, 1573
Oil on canvas, 76.5 x 64 cm
Musée du Louvre, Paris
Arcimboldo uses flower and leaf forms to create this allegory of Spring from the "The Four Seasons" cycle. The shapes of the plants form the body, while color is used for nuance and emphasis.

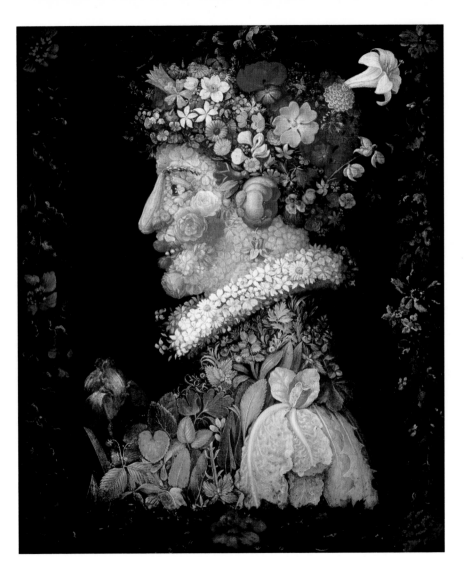

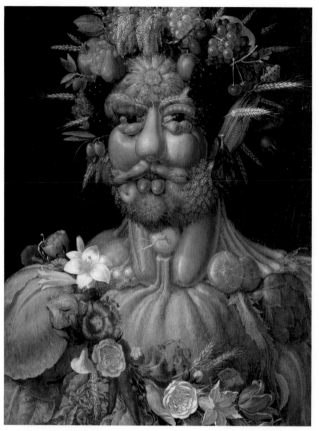

Below
The Gardener (A Joke with Vegetables), c. 1590
Oil on panel, 35 x 24 cm
Museo Civico, Cremona
This picture is part of a series known as "The Jokes." Arcimboldo painted these works in such a way that they show an entirely different picture when viewed upside-down. In this case, for example, the erstwhile portrait of a gardener becomes a bowl of vegetables.

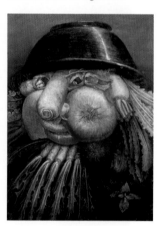

Rudolf II as Vertumnus, c. 1590
Oil on panel, 70.5 x 57.5 cm
Castle, Skokloster (Uppsala)
In this painting Arcimboldo has combined a portrait of Emperor Rudolf II with that of Vertumnus, the Roman god of the new year and of prosperous trade. In classical mythology, Vertumnus is also credited with an unlimited ability to transform himself. The painter here attempts—possibly not without some irony—to allude to the characteristics of the monarch in the guise of depicting the Roman deity.

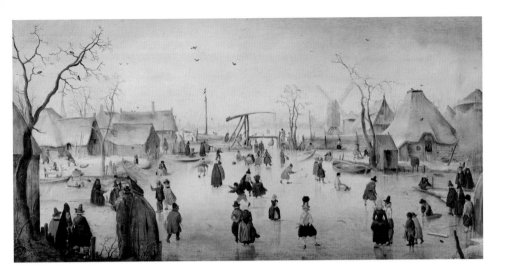

Avercamp, Hendrick van

Hendrick van Avercamp (1585 Amsterdam–1634 Kampen) was also called *De Stomme van Kampen* ("the mute of Kampen") because he was a deafmute. He was probably trained as a painter by Gillis van Conixloo, and was also inspired by the works of Pieter Bruegel the Elder and Arent Arentsz. Sometime after 1610 he moved to Kampen. Avercamp painted mostly winter landscapes containing multiple figures, but he was also known to paint seascapes. His realistic painting style is distinguished by its fine use of perspective and its vivid colors, both of which distinguish his work from that done in the Flemish tradition; instead, he creates a connection to Dutch art. One of the most important artists of his time, Avercamp had a great influence on the later development of landscape painting. The artist's works include

Winter Landscape with Skaters, 1605, Wallraf-Richartz-Museum, Cologne; *Winter Pleasures in Yselmuiden*, c. 1613, Musée d'Art et d'Histoire, Geneva; and *Winter Landscape with Skaters*, 1620, Museum Boijmans van Beuningen, Rotterdam.

The Delights of the Winter, c. 1610
Oil on panel, 36 x 71 cm
Mauritshuis, The Hague
In contrast to the works of Pieter Bruegel the Elder, Avercamp's landscapes remain very much within the bounds of the genre. Without trying to convey any moral or proverbial message, he shows the pleasures of simple villagers and elegant citizens taking their stroll. His winter pictures are characterized by their suggestion of atmosphere and the coolness of the air and the light, as well as by a restrained use of color that serves to create unity among the elements of the picture.

The First "Uomo Universale" of the Italian Renaissance

The importance of Leon Battista Alberti (1404–1472) in each of his various endeavors as a humanist, poet, art theoretician and architect is equally great and impossible to overestimate. This universal scholar was intimately acquainted with the most important humanists, artists, popes and regents of his time period. Just how varied his interests and skills were is demonstrated by the commission that Cardinal Prospero Colonna awarded him in 1443: to salvage a ship that had been sunk in Lake Nemi. Although the attempt ultimately failed, in the process Alberti developed a new method for measuring the depth of water. His versatility can only be compared to that of Leonardo da Vinci (1452–1519) and Michelangelo (1475–1564); however, these two lived in a later time and were able to build on Alberti's basic ideas.

Alberti's treatises on painting and sculpture, the *Elementi di Pittura* ("Elements of Painting"), *La Statua* ("Sculpture") and *Della Pittura Libri III* ("About Painting, Book III"), which appeared in 1434/35 first in Latin and somewhat later in an

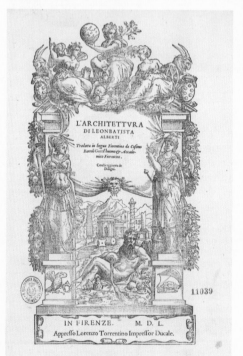

Leon Battista Alberti:
De re aedificatoria, Torrentino, frontispiece, 1450
Biblioteca Ricciardiana, Florence
This encyclopedic study of architecture is considered Alberti's most important theoretical work.

Opposite
Unknown Florentine Painter:
Leon Battista Alberti, early 17th century
Oil on canvas, 63 x 45 cm
Galleria degli Uffizi, Florence
This painting shows the humanist Alberti—who had mastered Greek, Latin and Italian, among other languages—in a peaceful, self-confident pose.

LEON BATT.ᴬ ALBERTI

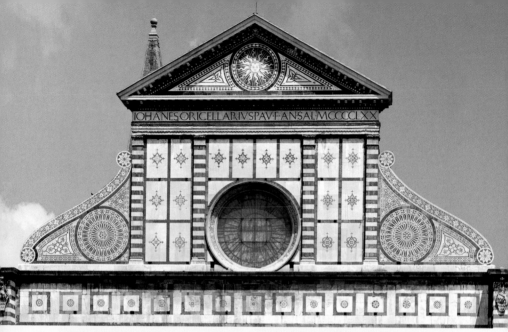

Leon Battista Alberti
Santa Maria Novella, c. 1458
Facade (detail),
Florence
The geometric design of the facade of the Santa Maria
Novella is one of the best examples of Alberti's theories
of architecture in application.

Italian translation, provided the Renaissance with
its first scientifically-based theoretical foundation
of art and art history.

In the first book, Alberti gives an explanation of
perspective based on his own extensive obser-
vations in the fields of geometry and optics. He
defines painting as a "projection of lines and colors
onto a surface," and insists that artists have a
knowledge of poetry and rhetoric as well as a
certain amount of general knowledge so as to be
able to render their subjects appropriately. This
methodical approach was very innovative, as older
treatises, such as that written in about 1390 by
Cennino Cennini (active c. 1398), tended to con-
centrate on more practical instructions for the artist.

In contrast, Alberti (in imitation of the ancient *artes
liberales*) elevates art beyond a mere craft to the
level of a science. This reflects the newly develop-
ing humanistic approach to art, which Alberti
himself embodied as the ideal *uomo universale*
("Renaissance man").

Leon Battista Alberti was born an illegitimate, but
nonetheless recognized, son of one of the most

high-ranking and wealthiest Florentine families. He received a comprehensive education, and obtained his doctorate in law at the age of just 24 in Bologna, which at the time had one of the most famous universities in Italy. By the age of 20 he had already written the comedy *Philodoxeos*; later, he took up the study of mathematics and the natural sciences. Although Alberti also tried his hand at painting and sculpture, he ultimately remained a theoretician. Even in his later work as an architect he contented himself with producing designs and models of various projects, preferring to leave the practical execution of the buildings to others with greater aptitude.

Besides his theoretical writings on how to paint and his exhaustive explanation of perspective, Alberti also describes in his treatises the appropriate criteria for evaluating a painting or other work of art. His fundamental ideas concern drawing contours, structuring a composition, and using color. In his opinion, only the harmonious combination of all these factors could lead to a satisfactory result. To achieve this, he advises painters to be diligent in drawing studies from nature. The various parts of the body should correspond to one another in size, character, purpose and other qualities; for "if in a picture the head is very large, the chest small, the hands broad, the feet swollen and the body bloated, the composition would be sure to be ugly." Finally, he singles out for praise his contemporaries Donatello, Ghiberti, Luca della Robbia and Masaccio, who, according to Alberti, were in a position to create great works of art again using the new methods of the Renaissance after their long period of decline.

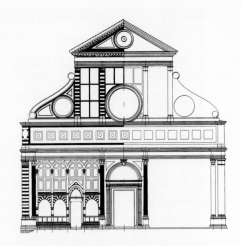

Leon Battista Alberti:
Santa Maria Novella, c. 1458
Geometric arrangement of the facade
Florence
The revolutionary element in this design is Alberti's idea of connecting the narrower upper floor with the broader lower part of this church, completed in the mid-14th century, by means of two huge volutes.

Around 1450, Alberti's treatise on architecture, *De re aedificatoria,* was published. In it, he again turns to the theme of harmonious proportions, but applied to buildings rather than paintings. The treatise takes as its premise that beauty is the result of the harmonizing of all parts into a unified whole. According to Alberti, this is achieved by adhering to specific ratios, purposes and orders, according to the principle of proportion—which he claims is the most perfect and highest law of nature. Each part should be unified and independent, and at the same time echo the harmony of the whole.

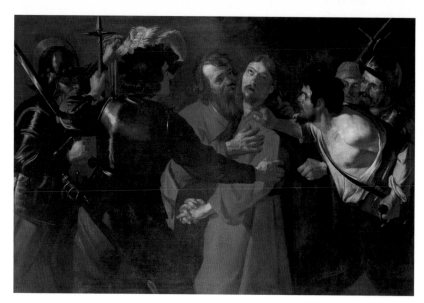

Baburen, Dirck van

In 1611, Dirck van Baburen (c. 1590 Utrecht–1624 Utrecht), also known as Teodore van Baburen, was a pupil of the Mannerist painter Paulus Moreelse in his native city. From 1617 to 1622 he worked with David de Haen in Rome, where he was influenced by Carlo Sarceni and Sarceni's teacher, Caravaggio. Upon his return to Utrecht he became a member of the painters' Guild of St. Luke. Baburen was one of the leading masters of the Utrecht Caravaggists, a group that strongly influenced later artists such as Frans Hals, Rembrandt and Jan Vermeer. A characteristic of his painting style is his focus on particular character types. He also brings the human body into the foreground, using light and shadow to emphasize its physicality.

Baburen painted mostly biblical and mythological subjects, and was especially famous for his genre scenes. His works include *The Burial*, 1617, S. Pietro in Montoria, Rome; *Young Boy with Jew's Harp*, 1621, Centraal Museum, Utrecht; and *Prometheus Bound*, 1623, Rijksmuseum, Amsterdam.

The Arrest of Christ, c. 1619
Oil on canvas, 139 x 202 cm
Galleria Borghese, Rome
This picture portrays Christ's hopeless situation with great drama: As one soldier seizes his arm, another grasps his robe at the collar, drawing his sword at the same time. Judas also puts his hand on Christ's chest. In contrast to all this activity, Christ's hands, clasped tightly together, are depicted in defenseless isolation. This contrast, as well as the interplay of all of the hands in the composition, increase the drama of the situation.

➞ *Baccio della Porta, see Fra Bartolommeo*

Baciccio, Giovanni Battista

Giovanni Battista Baciccio (1639 Genoa–1709 Rome), whose actual name was Giovanni Battista Gaulli, is also called Baciccia. After an apprenticeship in Genoa he moved to Rome in 1653 or 1656, where he studied the works of Raphael and Pietro da Cortona. He soon became the protégé of the sculptor and architect Giovanni Lorenzo Bernini (1598–1680). He became a member of the Accademia di San Luca in 1662, and became its leader in 1674. Baciccio was known for his frescoes and portraits. His use of warm colors, his treatment of light, and his utilization of extreme foreshortening resulted in a personal, dynamic style, which in turn influenced the frescoes of the Roman Baroque and his successors. Works by the artist include *Pope Clement IX*, c. 1668, Galleria dell'Accademia Nazionale di San Luca, Rome; *Dome Fresco*, c. 1670, Santa Agnese in Agone, Rome; and *Triumph of the Name of Christ*, c. 1677, Il Gesù, Rome.

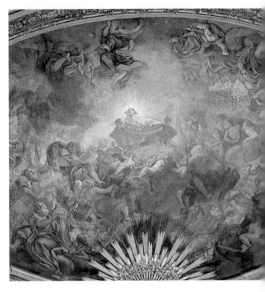

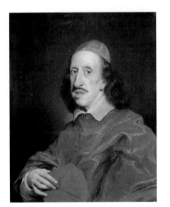

Cardinal Leopold de'Medici, c. 1667
Oil on canvas, 73 x 60 cm
Galleria degli Uffizi , Florence
Baciccio's outstanding portraits show the influence of Anthony van Dyck. Baciccio took elements of van Dyck's painting and further developed them to create his own vivid narrative style and innovative use of lighting. He often painted portraits of church dignitaries, as seen in the case of Leopold de'Medici (1617–1675). The son of Cosimo II de' Medici and Maria Magdalena of Austria, Leopold was a passionate art connoisseur and collector; he was elected cardinal at age 50.

Glory of the Mystic Lamb (detail), c. 1682
Fresco, diam. 16 m
Il Gesù, Rome
Baciccio began working on the imposing ceiling paintings for this Jesuit church in 1672, and finished them, his most important compositions, in the space of five years. One is this fresco located in the church's apse, executed in the High Baroque style. It is traditional to find the depiction of Christ as the lamb of God in this part of the church. Here, the lamb is resting on a throne surrounded by a golden halo, being adored by a throng of angels and saints.

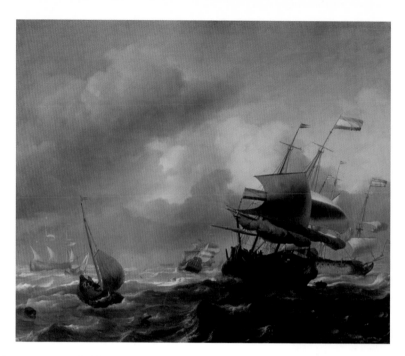

Backhuyzen, Ludolf

Ludolf Backhuyzen (also spelled Bakhuysen; 1631 Emden–1708 Amsterdam) was one of the most important marine painters of his time. He came to Amsterdam as a clerk, and studied painting with Allaert van Everdingen and Hendrick Dubbel. Unlike his contemporaries, topographic exactitude, precise rendering of detail, or the dichotomy between human works and the forces of nature did not interest him. He was more concerned with bizarre elements and independent forms of expression. Along with the use of strong light and dark zones, this allowed him to achieve a feeling of alienation that anticipates tendencies in Romantic painting. His works include *The Roads of Amsterdam*, 1668, Musée du Louvre, Paris; and *The Mussel Pier near Amsterdam*, 1673, Rijksmuseum, Amsterdam.

Seascape with Ships, 1669
Oil on canvas, 65 x 79 cm
Galleria Palatina, Palazzo Pitti, Florence
Backhuyzen was highly esteemed at European courts particularly for the somber renderings of storms at sea, which he painted along with tranquil harbor scenes. The mysterious, almost demonic effect here is achieved not only through the depiction of the raging elements, but also because of the abstract pattern of light and shadow that determines the composition.

Baldovinetti, Alesso

Alesso Baldovinetti (c. 1425 Florence–1499 Florence) was one of the most important representatives of the early Renaissance in his native city. His models were his teacher, Domenico Veneziano, as well as Fra Angelico, Andrea del Castagno and Piero della Francesca, and he combined various elements of their artwork with great skill. In addition to designing glasswork, mosaics and inlaid work, he received commissions for altarpieces and wall decorations in churches. In later years, he took over supervision of the restoration work on the 13th-century mosaics in the Baptistery in Florence. Artists of succeeding generations such as Domenico Ghirlandaio, Antonio del Pollaiuolo and Andrea del Verrochio were inspired by his art. Baldovinetti's works include *The Adoration of the Shepherds*, c. 1461, SS. Annunziata, Florence; *Virgin and Child*, Musée du Louvre, Paris; and *The Trinity with Two Saints*, 1470/71, Galleria dell'Accademia, Florence.

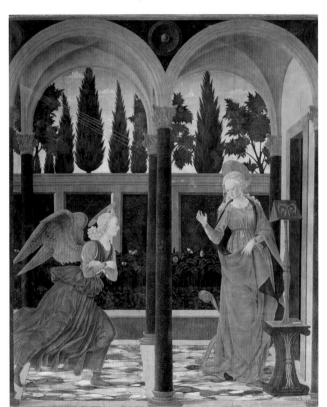

Annunciation, 1457
Tempera on panel, 167 x 137 cm
Galleria degli Uffizi, Florence
This work is an impressive example of Baldovinetti's compositional method. A linear conception and a taut structure combine to provide strong contours and closure; nevertheless, the picture as a whole remains light and cheerful.

Baldung Grien, Hans

Hans Baldung Grien (c. 1484 Schwäbisch-Gmünd?–1545 Strasbourg) was probably trained around 1500 by a Strasbourg master to follow in the tradition of Schongauer. From 1503 to 1507 he worked in Dürer's workshop in Nuremberg. In 1509 he returned to Strasbourg via Halle, received his citizenship, and was accepted into the painters' Guild of St. Luke as a master in 1510. From 1512 to 1516 he lived in Freiburg. Many of the different sensibilities of the time are reflected in Baldung Grien's works. Although a relationship to the art of the Middle Ages is still discernible in his idyllic and romantic paintings, as well as in his serious religious works, it is his mythological and allegorical paintings with their sensuous nudes that display a humanistic manner of thought, and finally supersede the artist's religious works in quality. Major works by the artist include *Altar of the Virgin Mary*, c. 1514, Münster, Freiburg; *The Martyrdom of St. Dorothea*, 1516, Národní Galerie, Prague; and *Two Witches*, 1523, Städelsches Kunstinstitut, Frankfurt.

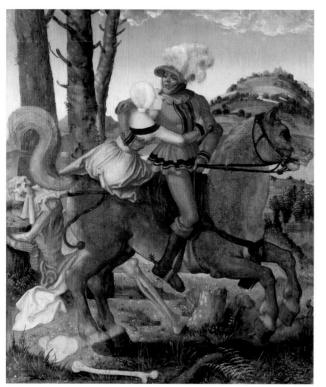

Horseman with Woman and Death, c. 1501
Oil on panel, 35.4 x 29.6 cm
Musée du Louvre, Paris
Baldung Grien returned to the theme of the beauty of the female body again and again, although he always treated it in accordance with humanistic ideals. Youth and maturity threatened by ephemerality are symbols for nature and even for life itself. This early work of Baldung Grien's already contains this allegory. Death lies in wait at the side of the road and grasps the girl's hem, but the daring rider in red tears her from Death's grasp and dashes off with her on his horse.

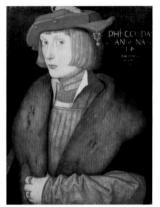

**Count Palatine
Philip the Warlike, 1517**
*Oil on panel, 41.5 x 30.8 cm
Alte Pinakothek, Munich*
As the inscription on this picture
tells us, Baldung Grien has por-
trayed the 14-year-old Count Pala-
tine of Pfalz-Neuburg (1503–1548).
With great skill, he captures the
bold character of this young man,
who had become the rector of
Freiburg University the year before.

Left
The Nativity, 1520
*Oil on panel, 105.5 x 70.4 cm
Alte Pinakothek, Munich*
In this picture the traditional,
solemn representation of the event
is pushed far to the right side of the
picture. The painter has created a
Nativity scene full of deep emotion
through the use of unrealistic light-
ing that emanates solely from the
Child Jesus.

**The Three Ages of Man,
with Death, c. 1540**
*Oil on panel, 151 x 61 cm
Museo del Prado, Madrid*
In this painting the transitoriness of
nature as well as of humankind and
its works—as symbolized by the
ruined city—are conveyed to the
viewer in an extreme fashion. The
baby, the young woman and the old
woman stand for the different stages
of life (youth, maturity and old age),
while the hourglass held by Death
reminds us how limited our time on
earth is. The owl could be a symbol
of sin, while the redemption of sin
is suggested by the small crucifix
suspended in the cloudy sky.

Opposite right
**The Three Graces
(The Harmonious Elysium
of Youth), c. 1541**
*Oil on panel, 151 x 61 cm
Museo del Prado, Madrid*
Female nudes are one of the major
motifs in Baldung Grien's works,
probably because of his intensive
study of models from life. They
appear again and again in biblical,
mythological and allegorical con-
texts. Here he has painted the Three
Graces of classical antiquity, who
bring grace, beauty and the joys of
celebration to both gods and hu-
mans. They often form part of
Venus' entourage, as is suggested by
the swan, one of Venus' attributes.

**Virgin and Child with
Two Parrots, c. 1527**
*Oil on panel, 91 x 63.2 cm
Germanisches Nationalmuseum,
Nuremberg*
Due to a lack of commissions from
the Church, Baldung Grien turned
to the secular world, with its classi-
cal and profane subjects, for inspira-
tion. He also included some of
these in his religious paintings, as
can be seen here. This is a depiction
of *Maria lactans*, i.e. of Mary
breastfeeding her Child. This was a
very popular motif in the late
Middle Ages, and has its origin in
Egyptian representations of the
goddess Isis with the infant Horus.

Barbari, Jacopo de'

Jacopo de'Barbari (c. 1445 Venice–before 1516 Brussels or Mechlin), painter and graphic designer, was also called Jakob Walch or "The Master of the Caduceus" in the north; the latter name was given to him because of his engraving mark. In Venice he was influenced by the artistic circles of Alvise Vivarini, Antonello da Messina and Bellini. Dürer, whom he met for the first time in 1494, also helped shape his style. In 1500 he moved to Nuremberg and worked for Emperor Maximilian I (1459–1519), and from 1503 he was employed at various German courts. Around 1508 he entered the service of Philip of Burgundy and in 1510, that of Margaret of Austria. Barbari was one of the artists who brought the Italian Renaissance to northern Europe, while at the same time adopting elements of northern European art into his own work. He inspired Albrecht Dürer to study ancient art. Among the artist's works are *St. Oswald*, 1500, private collection, Hungary; *Christ Giving a Blessing*, 1503, Gemäldegalerie Alte Meister, Dresden; and *The Old Man and the Girl*, 1503, Philadelphia Museum of Art, Philadelphia.

Still Life with Partridge and Iron Gauntlets, 1504
Oil on panel, 51.6 x 42.4 cm
Alte Pinakothek, Munich
This small panel is considered to be the oldest pure still life in existence, and played a very special role in the development of the genre. It is related to Italian inlay work and greatly influenced the work of Albrecht Dürer. It is possible that the piece formed part of the paneling of a room or was part of a piece of furniture, for example, the door of a cupboard used to store hunting equipment.

Barnaba da Modena

Barnaba da Modena is known to have lived in Genoa between 1361 and 1383. Although this painter's works are extant, his history and artistic development is a matter for conjecture. What is certain is that he was influenced by Sienese art and was familiar with the Venetian-Byzantine style of painting. In his colorful devotional pictures enhanced with gold leaf, he seems to have taken up elements of art from the first half of the century despite his more modern style. This pictorial style fit very well with the new, stricter form of religious fervor common after the years of the plague in 1347/48. Other painters of the time also painted such works in a "pious style." Barnaba's highly original style was very successful and he received commissions from Spain, Piedmont and probably also Pisa. Works by the artist include *The Miracle of the Pentecost*, 1374, National Gallery, London; *The Madonna of the Forests (The Compassionate Madonna)*, Santa Maria dei Servi, Genoa; and *Judgement Day*, San Agostino, Genoa.

Virgin and Child, 1370
Tempera on panel, 101 x 69 cm
Galleria Sabauda, Turin
The influence of Byzantine models on Barnaba's work is apparent in the spacious background decorated with ornamentation in gold as well as in the dark color of Mary's robe. However, the rounded lines of the herringbone pattern allow him to achieve a much more modern effect in keeping with his time. The Virgin's expression and pose are also typical of Barnaba's works: She is not looking at the child, but has turned toward the viewer. This also shows Barnaba's more modern style and attitude toward this genre of painting.

Barocci, Federico

Federico Barocci (c. 1535 Urbino–1612 Urbino), also called Baroccio Friori da Urbino, worked as a painter, draftsman and printmaker. He studied in Urbino with his father, the sculptor Ambrogio di Federico Barocci, as well as with the painter Battista Franco and the architect Girolamo Genga (c. 1472–1552) at the court of Pesaro. In the mid-1550s, as well as from about 1560 to 1563, he worked in Rome, and from 1567 on he again resided in his native city. Barocci chiefly painted religious panels, but also some portraits. His art, stylistically placed between Mannerism and Baroque, was influenced by both Raphael and Caravaggio. Many of his motifs, known through etchings, were widely imitated. His works include *The Martyrdom of St. Sebastian*, 1557, Duomo, Urbino; *The Deposition from the Cross*, 1569, Duomo, Perugia; and *Portrait of Giuliano della Rovere*, c. 1595, Kunsthistorisches Museum, Vienna.

**Rest on the Flight
into Egypt, c. 1573**
*Oil on canvas, 190 x 125 cm
Pinacoteca Apostolica Vaticana,
Vatican*
In this painting Barocci dispenses with the graphic methods of Mannerism. He blends the figures into the landscape using gentle colors. The gestures and poses create a sense of flowing motion that betrays his intensive study of composition.

Opposite
**Madonna del Popolo
(Madonna of the People), c. 1577**
*Oil on canvas, 359 x 252 cm
Galleria degli Uffizi, Florence*
The wealth of figures and movement, as well as its complex structure, make this painting for the altar of the lay brotherhood of S. Maria della Misericordia in Arezzo the earliest forerunner of Italian Baroque style. The Virgin, kneeling before Christ, commends to him the lay brothers, gathered on the Piazza of Arezzo. The mother figure, below left, represents the allegory of love.

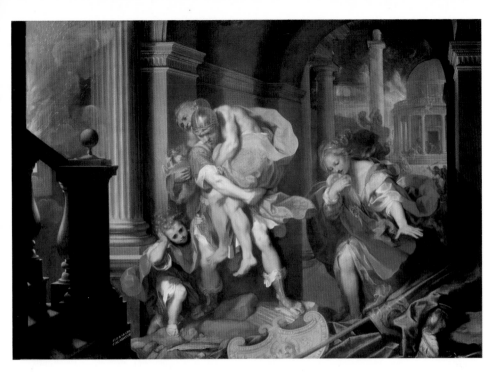

Opposite
The Nativity, c. 1597
Oil on canvas, 134 x 105 cm
Museo del Prado, Madrid
This painting, originally executed for the Duke of
Urbino, Francesco Maria II delle Rovere, is a charac-
teristic example of Barocci's later work. In contrast to
the fashion of his time, he is more interested in the idyllic
than the dramatic aspects of the subject. The contrast
of light and dark along with the intimacy of the scene
already hint at the Baroque manner, but the elegance,
artificiality and sentimentality of the picture, as well as
the unnatural colors used, are still very much in the
Mannerist style.

**Aeneas Fleeing from
the Burning of Troy, 1598**
Oil on canvas, 179 x 253 cm
Galleria Borghese, Rome
This painting shows a poignant episode from the tales
of the Trojan War. After Troy is taken, the Trojan hero
Aeneas is able to flee the city with his elderly father,
Anchises. Although he also manages to save his son, he
loses his wife. The drama of the family's flight is
suggested not only by the falling buildings and the
narrow stairwell, but also by the visual distance
between the man and his wife, which foreshadows their
coming separation.

Baschenis, Evaristo

Evaristo Baschenis (1617 Bergamo–1677 Bergamo) is considered an important representative of neo-Caravaggism. This artist, who was born into a family of painters, first became a priest but soon turned to painting. He concentrated almost exclusively on still lifes. At the beginning of his career he also did kitchen and hunting pieces, but his later works are solely still lifes of musical instruments, sometimes including people in them. His style lies between that of Jan Vermeer and Caravaggio. He continued Caravaggio's fine manner of still-life painting in his elegant *trompe-l'œil* paintings. Baschenis's paintings are among the most fascinating and concentrated works of the 17th century in this specialized area, and they had many imitators. Works by the artist include *Self-Portrait at the Spinet Accompanied by Alessandro Agliardi on the Lute*, 1670, Collezione Conte P. Agliardi, Bergamo; and *Still Life with Musical Instruments*, Musées Royaux des Beaux-Arts, Brussels.

Still Life with Musical Instruments and Statuette, c. 1650
Oil on canvas, 60 x 88 cm
Accademia Carrara, Bergamo
In contrast to Dutch painters, Baschenis does not assign his works any didactic or allegorical meaning. Although in Dutch art musical instruments often symbolize the sense of hearing and suggest the ephemeral nature of life because of the way music dies away, Baschenis is solely concerned with their aesthetic charm. Even so, their almost monochromatic coloring is enlivened by only a few highlights, as in this splendid still life.

Still Life with Stringed Instruments, c. 1650
Oil on canvas, 115 x 160 cm
Accademia Carrara, Bergamo
The virtuosity of the painter can be seen not only in the arrangement of the objects in this painting, but also in the way the composition conveys a contemplative atmosphere. This particularly harmonious version of the subject is made outstanding both by the masterly use of perspective in depicting the instruments, which makes them seem almost tangible, and by the exquisite coloring and extraordinary technical skill—notice the dust on the instruments in the detail opposite.

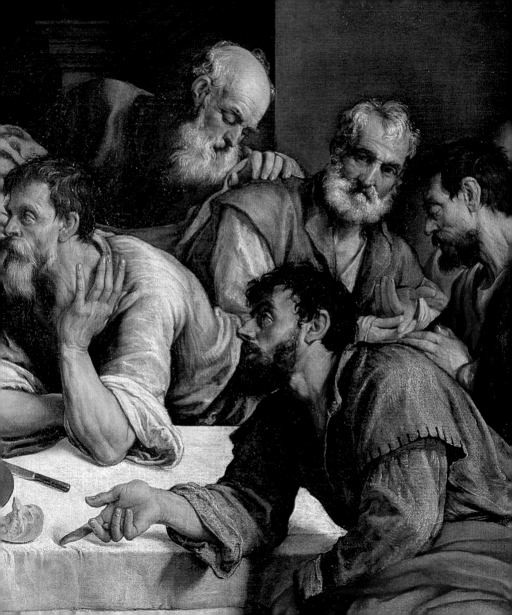

Bassano, Jacopo

Jacopo Bassano (c. 1517 Bassano–1592 Bassano), whose actual name was Giacomo da Ponte, was one of the outstanding artists of the late Renaissance. Bassano was born into a family of painters. At first he studied with his father, Francesco Bassano the Elder, and then with Bonifazio Veronese in Venice. From 1535 he is known to have worked there independently as a painter. In 1540 he settled in his native city, where he operated his own workshop. He was elected as a councillor and consul in 1549. Bassano was influenced by Titian, Lorenzo Lotto, Tintoretto and Mannerist painters among others. He developed a popular manner of painting, but at the same time, borrowed artistic methods used in more serious art. His paintings display extraordinary luminosity, great exactness of detail and simple narrative elements. Works by the artist include *The Beheading of John the Baptist*, c. 1550, Statens Museum for Kunst, Copenhagen; *Landscape with the Parable of the Sower*, 1560–1570, Museo Thyssen-Bornemisza, Madrid; and *The Earthly Paradise*, c. 1573, Galleria Doria Pamphilj, Rome.

The Last Supper, c. 1547
Oil on canvas, 168 x 270 cm
Galleria Borghese, Rome
In this painting of the Last Supper Bassano shows the apostles crowded together and gesticulating vehemently; some are also depicted in a dramatically foreshortened perspective. In so doing, he introduced aspects of genre painting into a traditional religious subject. This need not be seen as a secularization of the theme, but rather as an accessible style that foreshadows future artistic developments. The detail opposite clearly shows the disciples' varied reactions to Christ's announcement that one of the group will betray him. There is a reference to future salvation in the way the apostle at the front edge of the picture points to the broken bread while looking unwaveringly at the Redeemer.

The Adoration of the Shepherds, c. 1562
Oil on canvas, 105.5 x 156 cm
Galleria Nazionale d'Arte Antica, Rome
This painting exemplifies the work that Bassano executed independently after 1550. The popular style of the painting demonstrates his close relationship with nature and rural life, while the religious subject matter serves as a pretext for depicting the idyllic scenery. Bassano's contemporaries praised his pictures in particular for the way in which they bring intelligence and true-to-life representation into harmony with one another. In comparison with the artist's earlier works, this painting is far more restrained in its coloring.

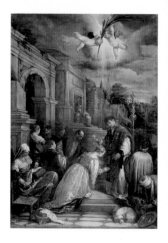

Above
St. Valentine and St. Lucy, c. 1575
Oil on canvas, 184 x 130 cm
Museo Civico,
Bassano del Grappa
This intensively colored later work
of Bossano's clearly shows his
increased expression of light. The
atmosphere, created in a palette of
cool, reflective tones, is interwoven
with light.

Left
Crucifixion, 1562
Oil on canvas, 315 x 177 cm
Museo Civico, Treviso
Bassano impressively managed to
capture the oppressive mood of
this scene. Before the darkly shim-
mering and vibrating light of the
cloudy sky rises the crucified Christ,
clear and silver. The intensive colors
and the bearing of the figures at his
feet increase the dramatic tension of
this picture.

Batoni, Pompeo Girolamo

Pompeo Girolamo Batoni (1708 Lucca–1787 Rome) was an important representative of the late Baroque in Rome, as well as a forerunner of neo-classicism in Italy. He began his training in his father's goldsmith shop, then settled in Rome in 1728, where he studied in particular ancient sculpture and the works of Raphael. Batoni's reputation is based on his dramatic mythological and religious paintings full of theatrical pathos and emotion. The influence of Correggio and of 17th century Bolognese painting can be discerned in these works. He achieved international fame through his portraits, some of which he painted during his journey through Europe in 1748. Along with Anton Raphael Meng, Batoni was the most popular portraitist in Rome. His works include *Sacra Conversazione*, 1732, San Gregorio al Celio, Rome; *The Five Allegories of the Arts*, 1740, Städelsches Kunstinstitut, Frankfurt; and *Diana and Cupid*, 1761, The Metropolitan Museum of Art, New York.

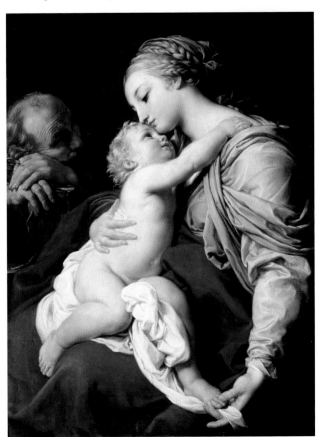

The Holy Family, c. 1760
Oil on canvas, 98.5 x 73.5 cm
Musei Capitolini, Rome
This intimate scene is depicted with clarity and simplicity. The restrained use of color and the intertwined contours lead to an extraordinarily dense composition in which each figure takes its place with dignity. Batoni took the great works of the *Cinquecento* as his models for this painting. He did not simply imitate them, however; rather, it was a sign of his search for a new ideal of beauty, one that influenced the religious paintings of his successors.

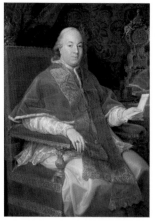

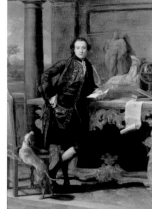

Portrait of Charles Crowbe, 1761/62
Oil on canvas, 254 x 169 cm
Musée du Louvre, Paris
Many wealthy English people had their portraits painted while on their "grand tour," a then obligatory educational journey through Italy. This was also the case with the jurist and historian depicted here in life size. The objects arranged on the table all suggest his classical education. Batoni gave the genre of portraiture new meaning by including informative details of this nature, which are to be found in many of his other portraits.

Portrait of Pius VI, 1775/76
Oil on canvas, 138 x 99 cm
Galleria Sabauda, Turin
Many distinguished personages sat for Batoni: This is Batoni's portrait of Giovanni Angelo Braschi (1717–1799), who was elected pope in 1775. It is the first portrait to depict the pope with his white pileolus head covering instead of a red velvet cap; the latter is visible lying on the books behind him.

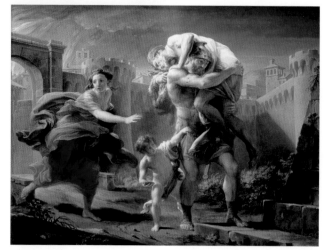

Right
Aeneas' Fleeing from Troy, c. 1750
Oil on canvas, 76.7 x 97 cm
Galleria Sabauda, Turin
In this painting, Batoni impressively portrays an event from the story of the fall of Troy whose outcome is already suggested in the way the figures are represented. Aeneas is able to escape from the burning city with his father and son, but is unable to rescue his wife. She can be seen desperately trying to catch up with them as they hurry toward safety. The artist has chosen to depict the scene taking place outside the walls of the city, and allows the interaction between the figures to tell the story.

Baugin, Lubin

Lubin Baugin (c. 1611 Pithiviers, Loiret–1663 Paris) was nicknamed *Le Petit Guide* ("Little Guido") because of the strong influence Guido Reni had on his work. He is known to have worked in Paris from 1630, and it is likely that he lived in Rome before this. His teacher, Simon Vouet, introduced him to Italian painting. In 1645 he became a member of the Académie de St. Luc, although he was expelled from it several times. In 1651 he became a court painter. Baudin's surviving works are religious paintings executed in a gentle manner with large figures and clear, broad use of color. Those still lifes signed "A. Boudin," on the other hand, are heavily influenced by the late Mannerism of the School of Fontainebleau; it is not completely certain that these are by the same painter. Works by the artist include *Virgin and Child with St. John*, Musée des Beaux-Arts, Nancy; *The Birth of the Virgin*, Musée Granet, Aix-en-Provence; and *Still Life with Candlestick*, Galleria Spada, Rome.

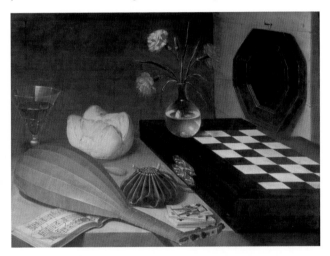

Still Life with Waffles, c. 1633
Oil on panel, 41 x 52 cm
Musée du Louvre, Paris
In the choice of everyday objects as well as in their arrangement, Baudin's still lifes display both a strange austerity and a mysterious physicality. The restrained charm exercised upon the viewer by the cool, shimmering colors in this picture already anticipates the works of Jean-Baptiste Siméon Chardin in the next century.

Still Life with Chessboard, before 1630
Oil on panel, 55 x 73 cm
Musée du Louvre, Paris
The objects shown here represent not only the pleasures of playing games; they are also didactic symbols. The chessboard, pack of cards, lute, wine, flowers and bread stand for the five senses. In addition, there are references to Christian iconography: The carnations symbolize Christ's Passion and Incarnation, while the wine and bread are reminders of the Last Supper. They stand in symbolic contrast to the ephemeral pleasures suggested by the other objects.

Beccafumi, Domenico

Domenico Beccafumi (c. 1486 Montaperti near Siena–1551 Siena), whose real name was Domenico di Giacomo di Pace, was also called Meccarino or Mecuccio. From 1510 to 1512 he lived in Rome. Afterward he worked primarily in Siena and the surrounding area, interrupted by trips to Rome, Genoa and Pisa. Beccafumi was ablt to unite the influences of various models in his work, such as those provided by Raphael, Michelangelo and Leonardo da Vinci, arriving finally at an individual manner of expression in which complex lighting and coloring play a large role. His œuvre includes frescoes, panels, woodcuts and sculpture, as well as the spectacular mosaic floor in the Siena Cathedral. He is considered the leading master of Sienese Mannerism and, along with Jacopo Pontormo and Rosso Fiorentino, formed part of the first generation of Tuscan painters working in this style. Works by the artist include *The Nativity*, 1523, San Martino, Siena; *Christ in Purgatory*, c. 1533, Pinacoteca Nazionale, Siena; and *The Ascension*, c. 1545, Duomo, Siena.

Above
**St. Catherine Receiving
the Stigmata, c. 1513**
*Oil on panel, 28.6 x 41.3 cm
Collection Stanley Moss,
New York*
This predella panel, which formed part of an unknown altarpiece, shows the saint kneeling before the crucifix while receiving replicas of Christ's wounds (stigmata) from rays of light. The improvised use of lighting—the light appears to be coming through the church windows high above—effectively divides the scene into contrasting areas of light and dark, as well as making the room seem deeper.

Opposite right
The Annunciation, c. 1545
Oil on panel, 237 x 222 cm
SS. Martino e Vittoria,
Sarteana near Siena
In his late phase Beccafumi concentrated mostly on sculpture, but he did paint several panels in which he returned to tranquil, simplified compositions. In these works, the colors flow into one another without distinct contours, despite the artist's continued use of a rich palette of colors and strong contrasts between light and dark.

Archangel Michael Directing the Fall of the Rebel Angels, c. 1525
Oil on panel, 348 x 228 cm
Pinacoteca Nazionale, Siena
In this spectacular composition, Beccafumi depicts the incident of the fall of the rebel angels. With the Archangel Michael leading the way, the heavenly host drives the rebellious angels from heaven into the tenebrous depths below. The division between good and evil is effectively suggested by the artist's use of lighting.

The Mystic Marriage of St. Catherine, c. 1528
Oil on panel, 345.5 x 255.5 cm
Collezione Chigi Saracini, Siena
Catherine of Siena (1347–1380), a Dominican nun, is highly esteemed for her good works on behalf of the sick and the poor. According to legend, Christ presented her with a crown of thorns, the stigmata and a wedding ring. In the background of this contrast-filled composition, we see this ring being symbolically placed on her finger.

Bellini, Gentile

Gentile Bellini (c. 1426 Venice–1507 Venice) was trained by his father, the painter Jacopo Bellini, and later took over the leadership of his workshop. Beginning in 1466 he received official commissions from the city of Venice, and was granted the title of Count-Palatine (*conte palatino*) three years later. From 1479 to 1481 he was sent to Constantinople on diplomatic missions as a Venetian ambassador. Bellini's paintings are characterized by a schooled use of perspective in their construction, as well as by their calm contours surrounding areas of restrained color. His fresh, realistic narrative style and eye for detail enabled him to depict life in Venice very vividly. It is this aspect of his art that

Procession in St. Mark's Square, 1496
Tempera on canvas, 367 x 745 cm
Galleria dell'Accademia, Venice
This picture is the largest in Bellini's series treating the legend of the relic of the Holy Cross in Venice, and depicts the major action of this popular story. In the foreground, members of the Scuola di San Giovanni Evangelista are seen with the crucifix containing the relic. The man kneeling behind the baldachin is a certain Jacopo de Salis, who is praying for his son to be healed.

made him so important in the development of Venetian *vedute* (Italian for "views") and panoramas. Some of the artist's works include *The Virgin Mary with Donors*, c. 1450, Gemäldegalerie, SMPK, Berlin; *San Lorenzo Giustiniani*, 1465, Galleria dell'Accademia, Venice; and *Mohammed II*, 1480, The National Gallery, London.

Recovery of the Holy Cross, c. 1498
Oil on canvas, 323 x 430 cm
Galleria dell'Accademia, Venice
Bellini painted a series of three pictures depicting miracles and the reverence accorded to a relic of the Cross on commission for the Scuola di San Giovanni Evangelista. This painting depicts the moment in which the sacred relic is rediscovered at the bridge of San Lorenzo.

**St. Mark Preaching
in Alexandria, c. 1505**
*Oil on canvas,
347 x 770 cm
Pinacoteca di Brera, Milan*

In his will, Gentile left the sketchbooks of their father to his younger brother Giovanni, under the condition that Giovanni complete this unfinished painting depicting the sermon of St. Mark in Alexandria. The work was originally intended for the Scuola di San Marco. This incident from the life of the patron saint is unusual, and has

not been transmitted to us in this form. The sermon delivered by St. Mark before a group of Venetians and Orientals gave the painter a marvelous opportunity to convey a colorful Oriental atmosphere. Interestingly, the artist chose to portray the scene as taking place during the painter's lifetime, rather than in a historical setting.

Bellini, Giovanni

Giovanni Bellini (c. 1430 Venice–1516 Venice), also called Giambellino, was the younger brother of Gentile Bellini and is counted among the best-known Venetian painters. He trained at first with his father and then with his brother-in-law, Andrea Mantegna, in Padua. He worked chiefly in his native city, where he had his own workshop. In 1479 he took over his brother's work on the Doge's Palace. In 1483, he was named the city's official painter. Taking as his point of departure the works of Mantegna and the elements of Dutch art that were introduced into Venetian art by Antonello da Messina, Bellini developed an individualized use of lighting and the natural atmosphere. His pictures are composed of glowing, warm colors, and he uses stylistic devices in such a way that shapes, figures and space combine to create a distinctive mood. His best-known students include Titian and Lorenzo Lotto. Major works by the artist include *The Transfiguration of Christ*, c. 1460, Museo Correr, Venice; *Portrait of Jörg Fugger*, 1474, Galleria Palatina, Palazzo Pitti, Florence; and *St. Christopher, St. Jerome and St. Augustine*, 1513, San Giovanni Crisostomo, Venice.

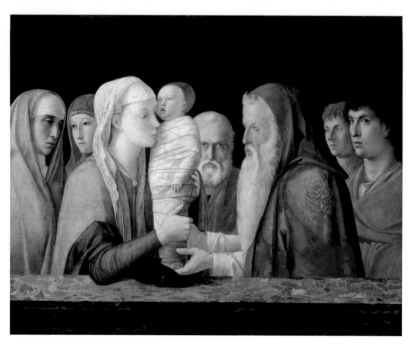

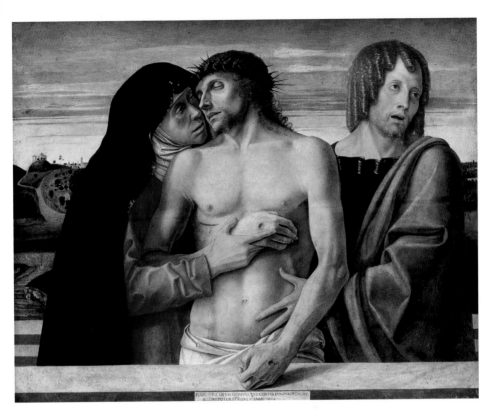

Opposite
The Presentation in the Temple, c. 1462
Tempera on panel, 80 x 105 cm
Fondazione Querini Stampalia, Venice
The model for this picture is Mantegna's *Presentation in the Temple*. The paintings are similar both in structure and in the figures depicted. Behind the Virgin Mary, who hands the swaddled Child to the high priest, other people are represented: Bellini's sister Nicolosia and her husband Mantegna (both looking to the left), with Jacopo Bellini in the middle. The figures at either side are probably Bellini's mother and Bellini himself.

Pietà, c. 1465–1470
Tempera on panel, 86 x 107 cm
Pinacoteca di Brera, Milan
This picture is the first version Bellini did of this subject; even so, the transition to Bellini's later, individual style is clearly manifested. Grieving bitterly, the Virgin and St. John hold Christ's lifeless body in the foreground, close to the viewer. The inscription suggests the purpose of such religious pictures: "If these grieving eyes wring a sound of lament from you, then the work of Giovanni Bellini can also weep."

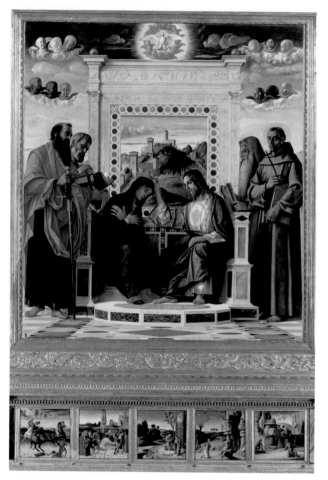

**The Coronation of the Virgin
(The Pesaro Altarpiece), c. 1473**
Oil on panel, 262 x 240 cm
Museo Civico, Pesaro
This solemn *sacra conversazione* is notable for the fact that Bellini did not place the saints in ranks next to one another, as in earlier works of this type, but grouped them to form a narrative scene. He has conceived a magnificent geometric structure, as well, which is emphasized by the way the architectural elements are portrayed. Bellini has also effectively integrated a realistic depiction of the landscape of Gradara into this important picture.

Opposite below
**The Sacred Allegory,
c. 1490–1500**
Oil on panel, 73 x 119 cm
Galleria degli Uffizi, Florence
This work is still shrouded in mystery: Neither its date nor its meaning have been ascertained. Although some figures are readily identifiable—for example, the Virgin on her throne to the left, St. Paul with a sword, and St. Sebastian with his pale skin—there is no compelling connection between them. There is scarcely any other painting of this era that refers so unambiguously to the art of Giorgione in its emotional atmosphere, created by a complex gradation of lighting.

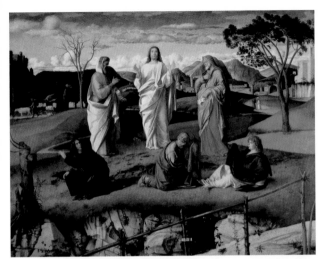

Transfiguration, 1478/79
Oil on panel, 115 x 151.5 cm
Museo Nazionale
di Capodimonte, Naples
Bellini depicts this event taking place in front of an expansive landscape. During prayers, Christ begins to glow supernaturally. At the same time, the prophets Elijah and Moses appear. The tranquil sublimity of this group contrasts with the way in which the disciples Peter, John and Jacob the Elder back away in wonderment. The depiction of the figures and the artistic manipulation of space make this picture one of the high points in Giovanni Bellini's career.

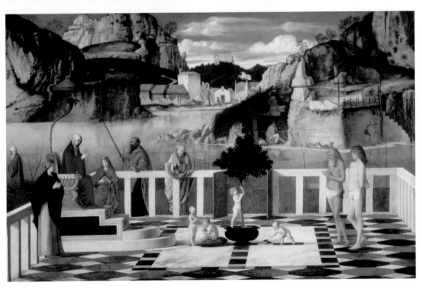

**Virgin and Child with Pear
(Morelli Madonna), c. 1488**
*Oil on panel, 84.3 x 65.5 cm
Accademia Carrara, Bergamo*
This religious painting, originally
from a private collection, achieves
its effect through the masterly,
elegant manner in which the land-
scape in the background has been
realized. It has been brought to life
through small figures that give it a
cheerful, bucolic atmosphere. Bellini
borrowed this Arcadian mood from
the pastoral poetry popular in his
day and here, as in later works,
brought it to canvas.

Above right
**The Doge Leonardo Loredan,
c. 1503**
*Tempera on panel, 62 x 45.1 cm
The National Gallery, London*
Not until the end of the 15th cen-
tury did Venetian painters begin to
depict the individual characteristics
and the mood of their sitters in their
portraits. Bellini's portrait of the city
father can be considered the high
point of this development. Placed
behind a balustrade in an undefined
space, this portrait of the doge
clearly resembles a bust, and thus
takes on the additional grace of an
immortal dignity.

Opposite
**Virgin and Child with Saints (The
S. Zaccharia Altarpiece), 1505**
*Oil on panel, 523 x 235 cm
San Zaccaria, Venice*
Here Bellini has created another
version of the *sacra conversazione*.
The figures of the Vrigin and the
saints—Peter, Catherine, Lucy and
Jerome—are vividly drawn, al-
though their dignity and individual
characteristics are preserved along
with a simple symmetry. To make
the light enter the picture appear
more like natural daylight, Bellini
has positioned the figures in an apse
that is open on the sides.

Bellotto, Bernardo

Bernardo Bellotto (1721 Venice–1780 Warsaw) stands as one of the most important Venetian painters of the 18th century. He is also called Canaletto, as is his uncle and teacher, Antonio Canal, who greatly influenced his early work. From 1742 to 1745 he travelled through Italy, then worked at the Saxon court in Dresden from 1747. He remained there, with brief interruptions, until 1767, having become a teacher at the Academy in 1764. In 1768 he became the court painter of King Stanislaus II (1732–1798) of Poland and settled in Warsaw for the rest of his life. By the 1740s Bellotto had developed his own style, characterised by great topological exactness, precise architectural perspective and cool, pale coloring. As well as *vedute* (detailed views of a city or landscape) and *capricci* (imagined combinations of buildings and landscapes) , he also painted historical and genre scenes. Among the artist's works are *The Sun Stone above Pirma*, c. 1755, Gemäldegalerie Alte Meister, Dresden; *Panorama of Warsaw with the Vistula River*, 1770, Nationalmuseum, Warsaw; and *The Dominican Church in Vienna*, 1772, Kunsthistorisches Museum, Vienna.

Capriccio with the Colosseum, c. 1745
Oil on canvas, 134 x 118 cm
Galleria Nazionale, Parma
This early work forms part of a four-part cycle, painted during Bellotto's sojourn in Rome, that depicts various views of the city. Bellotto has not shown the ancient amphitheater in its true context despite his precise depiction of it, but has instead added towering ruins from his imagination. In this way, he creates a fascinating montage that is enlivened by the figures populating it.

Turin with the Palazzo Reale, 1745
Oil on canvas, 127 x 164 cm
Galleria Sabauda, Turin
This view shows renovation work being done on the wall of the *bastion verde* in the city of Turin. Behind the wall, the main and west wings of the fortress can be seen along with the garden between them. The dome of San Sindone and the campanile of the cathedral rise above the roofs. In the background, the northern part of the city, surrounded by a fortifying wall, is visually joined to the group of buildings that make up the palace. In the distance, one can see the peaks of the Savoy Alps on the horizon.

Following page above
The Old Bridge over the Po in Turin, 1745
Oil on canvas, 127 x 174 cm
Galleria Sabauda, Turin
This painting shows the view from the outer bridges of Turin toward the Alps. To the left one sees the houses of the suburb Borgo di Po, which extends along the riverbank. Behind this, the Monte dei Cappuccini with its landmark, the church of S. Maria del Monte, can be recognized. On the opposite side of the river, in the middle of the picture, the Castello di Valentino rises in front of the silhouettes of the mountains. The painter has portrayed himself in the foreground, sketching the bridge in the company of two gentlemen.

Below
**The Old Marketplace in Dresden
in a View from Schlossstrasse,
c. 1750**
*Oil on canvas, 144 x 241 cm
Pushkin Museum of Art, Moscow*
During his first Dresden period
between 1747 and 1758, Bellotto
painted a 14-part cycle with various
views of Dresden for August II
(1696–1763). This painting is his
second rendering of the market-
place, and differs from the first
only in that fewer figures are rep-
resented in it. The view is facing
toward the south, where the
Kreuzkirche can be seen rising up
behind the row of houses.

Benoist, Marie-Guilhelmine

Marie-Guilhelmine Benoist (1768 Paris–1826 Paris) was one of the most successful French woman artists of her generation. In 1780 she became a pupil of Elisabeth-Louise Vigée-Lebrun, and later of Jacques-Louis David. Her works, which were first exhibited in 1784, soon met with public recognition. In 1804 she won a gold medal and founded a studio for women artists. She also received the monopoly on portrait commissions for the Départment under Napoleon (1769–1821). In the beginning of her career Benoist painted classical subjects as well, but gave them up after 1795 in favor of genre subjects. About this time she also turned away from David's classicizing style. Her powerful pictures anticipate the painting style of Jean-Auguste-Dominique Ingres. Works by the artist include *Princess Pauline Borghese*, 1808, Musée National du Château de Versailles et de Trianon, Versailles; and *Reading the Bible*, 1810, Musée Municipal, Louviers.

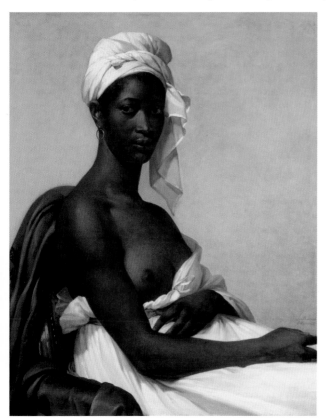

Portrait of a Black Woman, 1800
Oil on canvas, 81 x 65 cm
Musée du Louvre, Paris
Every detail of this painting serves to emphasise its central theme: the dignity of this foreign woman. She looks down at the viewer proudly with an enigmatic expression. The whiteness of the robe she is wearing brings out her dark skin color without adding any exotic or erotic element. Louis XVIII (1755–1824) found the painting so impressive that he bought it for the collection at the Louvre.

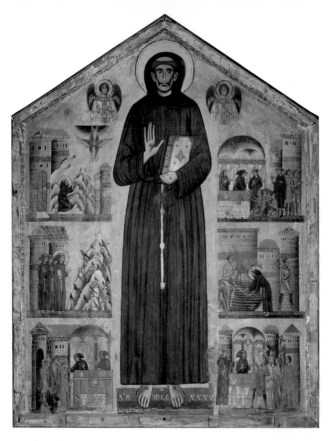

**St. Francis with
Scenes from His Life, 1235**
Tempera on panel, 160 x 123 cm
S. Francesco, Pescia
Saint Francis of Assisi (1183–1226)
appears here as a divine authority.
This is emphasized by the scenes
that surround him. At the upper left
one can see his stigmatization,
below this the famous Sermon to
the Birds, followed by his miracles
of healing—performed on a de-
formed child, a cripple and a lame
man—and finally the exorcism of
demons. The influence of Byzantine
art is seen clearly in the simple
narrative elements of this picture,
one of the most beautiful examples
of 13th-century Italian painting.

Berlinghieri, Bonaventura

Bonaventura Berlinghieri (c. 1207–after 1274) is known to have lived in Lucca in 1228, where he ran a successful workshop along with his father, the Milanese painter Berlinghiero Berlinghieri, and his brothers. Two of these brothers are also known: the painter Barone Berlinghieri and the miniature painter Marco Berlinghieri. The fine works they produced made this family famous well beyond the borders of their native city. It is scarcely possible to distinguish differences in style between the various artists in the family, but the altarpiece for the church of San Francesco in Pescia shown here can be safely attributed to Bonaventura because of the signature that appears on it.

Bermejo, Bartolomé

Bartolomé Bermejo (c. 1430–1440 Cordoba–after 1495 Catalonia), whose actual name was Bartolomé de Cardenas, probably came from Andalusia. He is known to have lived in Daroca, Aragon, from 1474 to 1476, and in Saragossa from 1477 to 1481. Later he worked in Catalonia, living in Barcelona from 1486 to 1494. He may have undertaken journeys to the Netherlands and Italy, as his pictures clearly show the influence of Dierick Bouts, Petrus Christus, Hugo van der Goes and Antonello da Messina. Bermejo's drawings are almost Mannerist in their fluidity, and his depictions of figures and nature achieve a degree of dramatic expression that is otherwise not found in Spanish art of his century. He is also a great master of oil painting, as can be seen in the examples depicted here. Works by the artist include *St. Domingo of Silos*, c. 1475, Museo del Prado, Madrid; *St. Michael with Kneeling Donor*, c. 1480, Wernher Collection, Luton; and *Pietà of Canon Luis Desplá*, 1490, Cathedral, Barcelona.

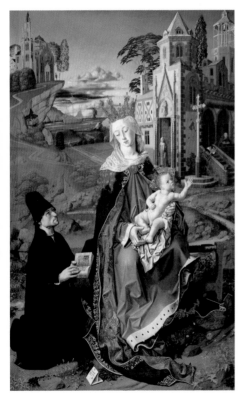

Madonna and Child in a Landscape (Madonna of Montserrat), c. 1482
Oil on panel, 147 x 91 cm
Duomo, Acqui Terme in Piedmont
This central panel from a triptych, the wings of which were painted by Rodrigo de Osona, was placed in the sacristy of the cathedral at the end of the 19th century. Bermejo's composition clearly shows his increasing adoption of elements of Italian art; it thus marks a stylistic transition in his work. The saw upon which the Virgin is enthroned could be a reference to the jagged contours of Montserrat Mountain in Catalonia.

Berruguete, Pedro

Pedro Berruguete (c. 1453 Paredes de Nava, Valadolid–1504 Ávila) is an important link between Spanish, northern Alpine and Italian art at the start of the Spanish Renaissance. He is first mentioned as living in Italy, where he worked from about 1477 along with Justus van Ghent at the court of Federigo da Montefeltro (died 1482) in Urbino. In 1483 he is known to have been in Toledo, where he executed frescoes in the cathedral from 1485 to1488 and in 1495, and around 1500 he was working in Avilá. Berruguete was in all likelihood trained by a master influenced by the Dutch style who worked at the Castilian court. Berruguete thus combined the skills he personally obtained in Italy with Flemish painting techniques. After Berruguete returned to Spain toward the end of his life, the influence of Spanish traditions in his works visibly increased, as well. He was the father of the famous sculptor Alonso Berruguete. Works by the artist include *Angel's Pietà*, c. 1482, Pinacoteca di Brera, Milan; and *Adoration of the Magi*, Museo del Prado, Madrid.

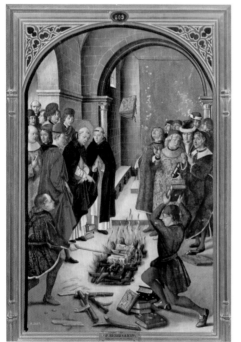

St. Dominic and the Albigenses, c. 1499
Oil on panel, 169 x 74 cm
Museo del Prado, Madrid
In his late works, Berruguete's style of painting became harsher and he used opaque, enamel-like paint. There is no other Spanish painter who used foreshortening to such great effect, or produced light-filled interiors with such an effective sense of space. In this panel of the Dominic Altar, we see St. Dominic, who founded his order to combat the heretical Albigensian movement from the south of France, surrounded by members of the sect at a book-burning.

Opposite left
St. Dominic Presiding at the Court of the Inquisition (The Burning of the Heretics), c. 1495
Tempera on panel, 154 x 92 cm
Museo del Prado, Madrid
This altarpiece depicts the public carrying out of a sentence imposed by the court of the Inquisition in Albí, which the saint used as the basis of his struggle against the Albigensians. He is sitting on a tribunal surrounded by founders of his order. One of them is holding a flag with the Cross of Florence on it. Below him are two almost naked men who have been sentenced to death by burning. Two others, wearing crowns and dressed in penitential robes, are being brought forward.

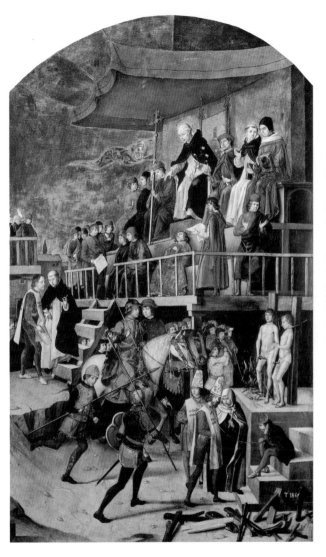

Prince Federigo da Montefeltro and his Son Guidobaldo, c. 1477
Oil on panel, 138 x 80 cm
Palazzo Ducale, Urbino
This double portrait of the duke with his son originally adorned the study of the palace in Urbino, and depicts two sides of this powerful man. On the one hand the duke is shown with his insignia of power: armor, ermine cloak and sword. On his knee he wears the Order of the Garter, awarded to him in 1474. On the other hand, he is engrossed in the book he is reading, signifying that he is not only a ruler, but also as an educated humanist.

Beyeren, Abraham van

Abraham van Beyeren (c. 1620 The Hague–1690 Overschie, near Rotterdam) was one of the most important Dutch still-life painters. He lived in Leiden in 1639 before becoming a member of the painters' Guild of St. Luke in The Hague in 1640, where he was one of the founders of the Confreria Pictura. The following year he left for Delft, return-ing to The Hague in 1663. In 1672 he lived in Amsterdam and in 1674 in Alkmaar. Beyeren's extensive body of work includes various types of still lifes as well as seascapes. His paintings of sea creatures were influenced by the fish artist Pieter de Putter, who may have been his teacher. His splendid still lifes also display the influence of Jan Davidsz. de Heem, from whom he borrowed several motifs. Major works by the artist include *Breakfast Table*, Collection Cook, Richmond; *Fish Still Life*, Mauritshuis, The Hague; and *Rough Sea*, Magyar Nemzeti Múzeum, Budapest.

Still Life with Bouquet of Flowers
Oil on canvas, 80 x 69 cm
Mauritshuis, The Hague
This painting is captivating not only because of the way in which the luxurious bouquet is depicted, but also because the flowers are shown past full bloom. This particular theme suggests the ephemeral existence of nature. Similarly, the opened pocketwatch also indicates the transitoriness of human life. These two motifs are commonly found in combination in 17th-century Dutch art.

Still Life with Lobster and Large Jug
Oil on canvas, 105 x 130 cm
Kunsthaus, Zurich
Large still-life paintings with compositions depicting luxurious fabrics, precious glasses, goldsmith's tools and expensive fish and fruits appeared in Flemish paintings well before Dutch artists began to recreate them in the middle of the century. Beyeren's paintings are char-acterized by warm shades of color with little high-lighting, as well as by a brilliant rendering of the objects gleaming in the light.

Blanchard, Jacques

Jacques Blanchard (1600 Paris–1638 Paris) received his artistic training from his uncle, Nicolas Bollery, among others. Around 1625 he took a trip to Italy and was greatly influenced by the artworks he saw there. Unfortunately, none of the large number of decorative works that he produced upon his return have been preserved. Blanchard's extant paintings combine Flemish clarity and elements of French Mannerism with the Venetian manner of coloring. Because of his artistic debt to Titian, he is frequently called the "French Titian." Works by the artist include *Venus and Adonis*, c. 1629, The Metropolitan Museum of Art, New York; *The Penance*

of *St. Jerome*, 1632, Magyar Nemzeti Múzeum, Budapest; and *Bacchanalia*, 1636, Musée des Beaux-Arts, Nancy.

Venus and the Graces
Surprised by a Mortal, c. 1632
Oil on canvas, 170 x 218 cm
Musée du Louvre, Paris
In this painting, with its unusual combination of elements, a man regards the goddess and her companions without embarrassment, and none of the women shrinks back before the intruder in modesty. Their casual attitudes and naked beauty make sensual, physical love the subject of this picture. Blanchard's works were and remain widely popular primarily because of his expert handling of the female nude and his pleasing use of color.

Blechen, Karl Eduard Ferdinand

Karl Eduard Ferdinand Blechen (1798 Cottbus–1840 Berlin) was one of the most important late Romantic landscape painters in Germany as well as a pioneer of Realism. In 1822 he studied at the Berlin Academy, receiving inspiration from the Romanticism of Caspar David Friedrich and the Realism of Johann Christian Clausen Dahl. In 1825 he was employed as a set designer in Berlin. A journey through Italy in 1828/29 had a decisive influence on him. Through his confrontation with nature, Blechen discovered a natural, glowing style of coloring that became his most powerful method of expression. In 1831 he accepted a chair at the Berlin Academy. Among his works are *Grotto near the Bay of Naples*, c. 1829, Wallraf-Richartz Museum, Cologne; and *The Battle of Amalfi*, 1831, and *The Palm House on the Island of Peacocks*, c. 1833, both in the Gemaldegalerie, SMPK, Berlin.

In the Park of the Villa d'Este, 1831/32
Oil on canvas, 127.5 x 94 cm
Nationalgalerie, SMPK, Berlin
This imaginary scene in front of the famous villa near Rome approaches the nature of a genre picture based on the elegantly dressed courtly figures from the late Renaissance. The picture shows Blechen's view of the past. The statues and the well, both invented by the artist, give the picture a certain dignity, an effect that is intensified by the extreme contrast between light and shadows.

Opposite
Rolling Mill near Eberswalde, c. 1834
Oil on panel, 25.5 x 33 cm
Nationalgalerie, SMPK, Berlin
This work is one of the earliest German paintings of industry and depicts the drastic change in the landscape caused by the new means · of production. Without any exaggeration, the picture brings the lifestyle of the fishermen, who are dependent on nature for their livelihood, into contrast with the factory, which harnesses the power of nature. The loss of the closeness of man to nature is expressed by the melancholy mood of the painting.

Boilly, Louis-Léopold

Louis-Léopold Boilly (1761 La Bassée–1845 Paris) was given the nickname "Little Master of the Revolution" because of his penchant for small-format, penetrating and witty paintings portraying the consequences of the French Revolution. From 1779 he worked in Arras, moving to Paris in 1784. Boilly had considerable success with his portraits, as well as with Rococo scenes and genre pictures. In the latter, he brings the wit and irony of the courtly Rococo style to bear on the bourgeois world of his time. In his later pictures, which can be seen as documents of cultural history, he offers an amusing look at everyday life in Paris. Works by the artist include *Robespierre*, 1789, Musée des Beaux-Arts, Lille; *Arrival of the Mail Coach in Paris*, 1803, Musée du Louvre, Paris; and *Visitors in the Salon of the Louvre*, c. 1808, Private Collection, New York.

**Artists' Gathering
in Isabey's Studio, 1798**
Oil on canvas, 72 x 111 cm
Musée du Louvre, Paris
Boilly created a new type of picture
in French art with this solemn
representation of living painters of
all genres. In it, he combines the
concept of a conversation piece
with that of a pantheon of artists.
The paintings hanging on the walls
surrounding them include portraits
of the old masters as well as one of
the goddess Minerva with allegories
of the arts.

**Politicians in the
Jardin des Tuileries, 1832**
Oil on canvas, 50 x 60.5 cm
Hermitage, St. Petersburg
This Parisian park has been a center
of society life since its construction
in the 16th century. A group of
elderly men are seen attentively
listening to a man who is reading
the newspaper aloud. Their some-
what exaggerated expressions give
the painting some of the qualities of
a caricature.

Opposite
A Game of Billiards, 1807
Oil on canvas, 56 x 81 cm
Hermitage, St. Petersburg
Boilly often painted intimate scenes
like this close gathering of indi-
vidual groups of figures. The silvery
finish is also typical of Boilly's
paintings. Particularly remarkable in
this picture is the accurate and
detailed rendering of the Empire
fashion current at the time.

Bonifazio Veronese

Bonifazio Veronese (1487 Verona–1553 Venice), who was actually named Bonifacio de'Pitati, was also called Bonifazio Veneziano. He was trained in the workshop of Palma il Vecchio, but was also deeply inspired by Giorgione and Titian. Bonifazio's works are situated at the transitional point between the Renaissance and Mannerism. While warm colors and natural forms dominate his early works, his figures later took on increasingly Mannerist tendencies. Veronese was granted the significant assignment of artistic supervisor for the group paintings in the offices of the Palazzo dei Camerlenghi, to which each member of the ten-man council donated a picture upon retirement. Trained in his workshop were, among others, Jacopo Bassano and possibly Tintoretto. Works by the artist include *The Discovery of Moses*, Pinacoteca di Brera, Milan; *Four Virtues*, Galleria Estense, Modena; and *Christ on His Throne*, 1531, Galleria dell'Accademia, Venice.

Christ and the Woman Taken in Adultery
Oil on canvas, 175 x 340 cm
Pinacoteca di Brera, Mailand
This densely-populated scene shows an episode from Christ's life in the temple and depicts Christ's generous and merciful interpretation of Jewish law. A group of Pharisees has brought before him a woman accused of adultery who, according to the ancient law, should be stoned to death. But Christ, who forms the dramatic central point of this picture, writes on the ground—here he can be seen pointing at what he has written—and answers that whoever is himself without sin should be the one to throw the first stone. He sends the woman away after telling her to sin no more.

Bonington, Richard Parkes

Richard Parkes Bonington (1802 Arnold, near Nottingham–1828 London) is considered a pioneer of realistic landscape painting and Impressionism. He received his early training in Calais from the watercolorist Louis Francia. In 1818 he went to Paris, where he began copying the works of Dutch masters, then studied at the École des Beaux-Arts with Antoine-Jean Gros. A meeting with the artists Théodore Géricault and Eugène Delacroix was important for him, and he was particularly inspired by the paintings of J.M.W. Turner, Veronese and Canaletto on his trips to England in 1825 and to Italy in 1826. In France, where he was soon successful, Bonington was one of the first artists to paint from nature with watercolors. His view of nature and fresh, spontaneous manner of painting influenced not only John Constable, but also the school of Barbizon. Among the artist's works are *View of Venice*, c. 1826, Musée du Louvre, Paris; *Das Parterre d'Eau in Versailles*, c. 1826, Musée du Louvre, Paris; and *The Promontory near Saint Valery-sur-Somme*, c. 1826, City Museum and Art Galleries, Hull.

Boats off the Coast of Normandy, 1823/24
Oil on canvas, 33.5 x 46 cm
The Hermitage, St. Petersburg
Bonington painted this coastal scene, bathed in the light of the midday sun, using delicate nuances and fine gradations of color. The contrast between the warm, shaded foreground and the brighter, cooler background is typical of his works. His depiction of atmosphere and lighting through the use of color clearly shows the influence not only of English, but also of French watercolor painting, on the artist.

Bordone, Paris

Paris Bordone (1500 Treviso–1571 Venice) is a typical representative of the late Renaissance in Venice. He is known to have lived in the city from 1518. He was probably trained by Titian, who remained a great influence on him throughout his creative life. Giorgione and Lorenzo Lotto were also sources of inspiration for him. Bordone soon became known as a portrait painter and received many commissions at home and from abroad. He was employed by the wealthy Fugger family in Augsburg in 1540, and worked for the French court in 1559. In addition to portraits, he also painted religious and mythological paintings, altarpieces and frescoes. His works include *Portrait of Nikolaus Korbler*, 1532, Sammlung Fürst von Liechtenstein, Vaduz; *Portrait of Hieronymus Krofft*, 1540, Musée du Louvre, Paris; and *Bathsheba at Her Bath*, c. 1544, Wallraf-Richartz Museum, Cologne.

Portrait of a Woman, c. 1530
Oil on canvas, 106 x 82 cm
Galleria degli Uffizi, Florence
This portrait from the collection of Cardinal Leopold de'Medici is said to depict the family's wet nurse. As in other Bordone portraits, the influence of Titian can be felt especially in the modeling of the facial features and the treatment of color in the woman's dress. The architectural feature in the background is a reference to Lombard painting.

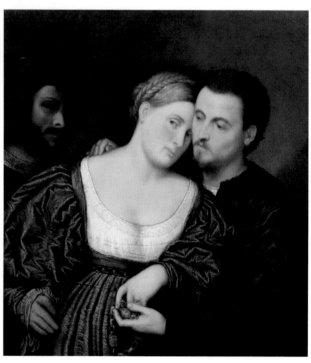

St. George Fighting the Dragon
Oil on panel, 290 x 189 cm
Pinacoteca Apostolica Vaticana,
Vatican

This altar panel, originally intended for the Franciscan church of San Giorgio in Noale (Treviso), is one of Bordone's greatest works. As in most of the contemporary depictions of this subject, the Christian soldier and martyr is shown in his mythological role as the slayer of the dragon. According to legend, St. George rescued a beautiful princess from this monster.

Opposite right
Venetian Lovers
c. 1520–1530
Oil on canvas, 95 x 80 cm
Pinacoteca di Brera, Milan

This is one of Bordone's most well-known paintings. The affectionate relationship between this couple gives the picture a restrained sensuality that calls to mind certain works by Giorgione. Any element of effusiveness, however, is replaced by the style of a bourgeois idyll. The refined sensitivity is also typical for this phase in Bordone's career.

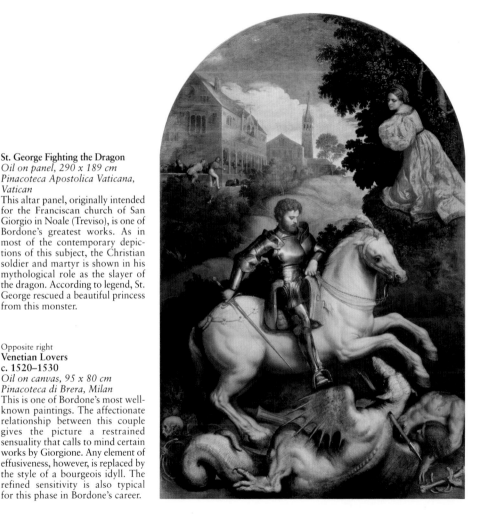

Bosch, Hieronymus

Hieronymus Bosch (c. 1450 Hertogenbosch–1516 Hertogenbosch), born Hieronymus van Aken, came from a family of painters and probably studied with his father. In 1474 he became a member of the Marien-Bruderschaft, and in 1488 joined the Liebfrauen-Bruderschaft. He was widely known as a painter even during his lifetime, and received important commissions for paintings, stained-glass windows and other decorative work. His works belong to the old Dutch artistic tradition in style, but his choice of subjects is highly individual. Bosch painted works dealing with many subjects from Christian iconography, and filled them with a unique and sometimes visionary artistic language. Moral themes such as mortal sin are treated in a dramatic and memorable manner; fantastic and often cruel images dominate in his depictions of Hell and the temptations of the saints. His pictures dealing with the world and its contemporary situation often contain a moral and betray a pessimistic, even cynical view of life. Bosch developed a highly individual style in his works, one characterized by a strong attachment to nature, a strict adherence to certain forms, and a system of symbolism that can no longer be fully understood. His depiction of landscapes also achieved some importance. Among the artist's works are *The Wedding at Cana*, Museum Boijmans van Beuningen, Rotterdam; *St. John on Patmos*, 1490–1500, Gemäldegalerie, SMPK, Berlin; and *The Vagrant (The Prodigal Son)*, c. 1510, Museum Boijmans van Beuningen, Rotterdam.

The Conjurer, c. 1477
Oil on panel, 53 x 65 cm
Musée Municipal,
St-Germain-en-Laye
Bosch's inspiration for this scene was one of the astrological pictures popular at the time, showing the purported influence of the planets on the activities and social order of humankind. While the magician performs his trick with the tumblers, his associate steals from the purse of an onlooker. Five versions of this subject exist; it is not completely certain whether any of them is by Bosch.

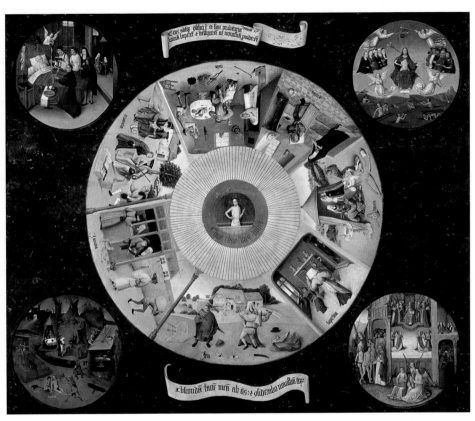

**The Seven Deadly Sins
and the Four Final Events,
c. 1480**
*Oil on panel, 120 x 150 cm
Museo del Prado, Madrid*
This panel, which was originally
conceived as a tabletop, is charac-
terized by a peculiar typology and
composition. In the central circle the
seven deadly sins are depicted,
illustrated by small genre scenes full
of melodramatic situations. They
have Latin titles and symbolize
(clockwise from the top) Gluttony,
Sloth, Lust, Pride, Anger, Envy and
Greed. In the center appears the
risen Christ in the center of what
appears to be an eye. The represen-
tation of an eye, as well as the in-
scription, remind us that God's eye
sees everything. The four medallions
in the corners describe the last path
mankind must take: Death, the Day
of Judgement, Hell, and finally the
Kingdom of Heaven.

Above
The Hay-Wain Triptych, c. 1500
Oil on panel
Central panel: 135 x 100 cm
Side panels: 135 x 45 cm each
Museo del Prado, Madrid
The theme of this altarpiece is humanity's foolish actions, from Heaven (the left wing) into Hell (the right wing). The central panel is devoted to the present, and shows every sort of vanity at all levels of society, both secular and ecclesiastical. In the center is a haywain (wagon), a symbol of worldly goods. It is being drawn by animal-like figures to the right, where punishment awaits those of little faith.

Opposite left
The Ship of Fools, c. 1500
Oil on panel, 57.8 x 32.5 cm
Musée du Louvre, Paris
Bosch's moralizing tendency is obvious in this late work, a fable about the secularization of the church and the immoral urges and greed of humankind. The world is symbolized by a drifting ship manned by a crew consisting of representatives of the clergy and secular society, all abandoning themselves completely to worldly pleasures. The message is particularly emphasized by the fool sitting on a rotten branch and the owl in the treetop, symbolizing humanity's blindness.

Opposite right
The Penitent St. Jerome, c. 1500
Oil on panel, 77 x 59 cm
Museum voor Schone
Kunsten, Ghent
In his painting of the Church Father Bosch did not adhere to the representation common in the 15th century: that of a thoughtful writer sitting at his desk. Instead, St. Jerome is lying prone on the ground in penance, lost in prayer. While praying, he is helplessly at the mercy of the nightmarish creatures and elements of hell. St. Jerome's identity is confirmed by his attributes, the lion on the left and the cardinal's robe and hat on the right.

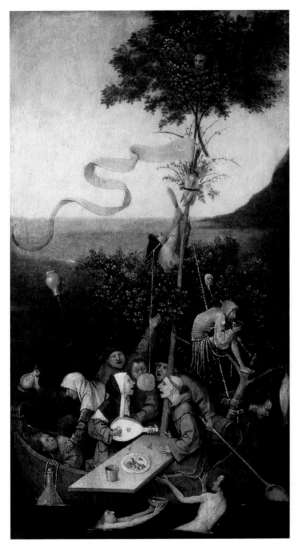

**The Garden of
Earthly Delights, c. 1510**
*Oil on panel
Central panel: 220 x 195 cm
Side panels: 220 x 97 cm each
Museo del Prado, Madrid*

This unique triptych is one of the most famous, and one of the most mysterious, of Bosch's works. While the earthly paradise depicted on the left wing still displays the familiar Christian manner of representation, the central panel breaks with this tradition. Bosch has with great imagination portrayed the sensual desires of mankind as vices, adopting a moralizing and satirical approach. The desires depicted are almost solely the carnal ones, and are illustrated in numerous scenes. The tree of life towers over the center of the painting, rising up behind the triumphal procession around the Fountain of Youth. Even Hell, shown on the right wing, does not correspond to the usual concept: There is no possibility of redemption to be found in this nightmarish, demonic world.

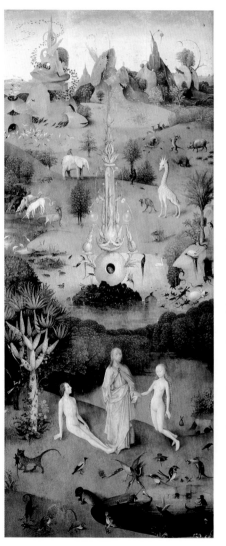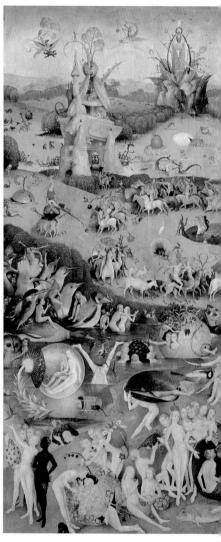

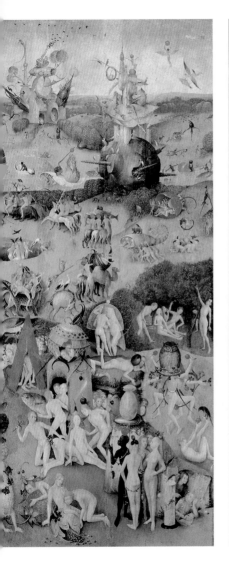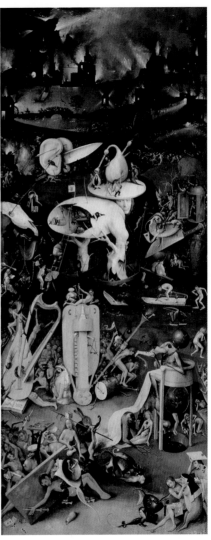

The Adoration of the Magi, c. 1510
Oil on panel
Central panel: 138 x 72 cm
Side panels: 138 x 33 cm each
Museo del Prado, Madrid
This triptych contrasts the dilapidated hut in which Jesus was born with the exotic splendor of the wise men from the east. The three worldly rulers are kneeling down before the newborn Child holding their precious presents while the shepherds watch surreptitiously. The wings show the donors of the altar, Pieter Bronchorts and Agnes Bosschuyse, with their patron saints. The rest of the world can be seen in the background, where humanity goes about its vain pursuits without noticing the event that has taken place. The panels are impressively linked by the continuity of the painting over the entire altarpiece.

Ecce Homo, 1515/16
Oil on panel, 74.1 x 81 cm
Museum voor Schone
Kunsten, Ghent
The theme of the public humiliation of Christ is traditionally meant to arouse the viewer's sympathy and identification with His suffering, while the deformed grimaces of his torturers express their cruelty and ignorance. Here, the belief that ugliness and devilishness are identical is conveyed by means of a completely new representation of this traditional subject matter. Bosch's original manner of looking at human physiognomy has had a lasting effect on the development of caricature drawing.

Botticelli, Sandro

Sandro Botticelli (1445 Florence–1510 Florence), born Alessandro di Mariano Filipepi, worked mainly in his native city. He first learned the craft of goldsmithing before becoming a pupil of Fra Filippo Lippi. Antonio del Pollaiuolo, Andrea del Verrochio, and later Ghirlandaio and Perugino, all had a stimulating influence on his art. The humanist circle of Lorenzo de'Medici (1449–1492) also provided him with important inspiration. Botticelli painted idealized pictures of classical mythology that are full of atmosphere and peopled with powerfully imaginative figures. These poetic and sensuous works are not only an expression of the Renaissance mindset, but also symbols of worldly power and the contemporary political situation. As the leading Florentine painter, Boticelli received the commission for three large frescoes in the Sistine Chapel in the Vatican around 1482. Major works by the artist include *Pietà*, c. 1490, Alte Pinakothek, Munich; *Portrait of Michele Marullo*, c. 1490, Colección Guardans-Cambó, Barcelona; and *The Nativity*, c. 1500, The National Gallery, London.

Opposite
Madonna del Magnificat,
c. 1480/81
Tempera on panel, diam. 118 cm
Galleria degli Uffizi, Florence
Boticelli directs the viewer's perception of the group of figures in this typically Florentine tondo painting with a consummate ease that had previously not been seen. By using foreshortened perspective and arranging the figures within the composition, he makes it seem as if one is looking into a hemisphere that holds the gaze captive.

Portrait of a Man Holding a
Medallion of Cosimo de'Medici,
c. 1474/75
Tempera on panel, 57.5 x 44 cm
Galleria degli Uffizi, Florence
Botticelli has here painted one of the most unusual portraits of the early Renaissance. The young man standing before a river landscape is looking directly at the viewer and presenting a medallion, on which a profile of Cosimo de'Medici (1389–1464) can be seen. The medallion is set into the painting as a gilded plaster cast.

Portrait of a Man, c. 1471
Tempera on panel, 51 x 33.7 cm
Galleria Palatina,
Palazzo Pitti, Florence
Botticelli experimented with new modes of expression in his early portraits. This half-length portrait, for example, shows three quarters of the young man's face. The bright colors of his jerkin and his hat stand out against the pale sky. The way the portrait is painted from a position slightly below the sitter makes him appear proud and perhaps somewhat condescending.

Primavera (The Allegory of Spring), c. 1482
Tempera on panel, 203 x 314 cm
Galleria degli Uffizi, Florence
The central point of this mythological representation, which is one of the best-known and loveliest works of the Italian Renaissance, is formed by Amor and Venus as *humanitas*: love as the source of all things. To their left appear the three Graces performing a circle dance, and Mercury, with his winged sandals and caduceus. He is there to guard the goddess' blossoming garden, dominated by a towering myrtle tree. On the other side of the painting is the key scene of the picture, taken from the *Fasti* ("calendar") of the Roman poet Ovid (43 B.C.–18 A.D.): The nymph Chloris is being transformed into Flora, the flower goddess of spring, by the wind-deity Zephyr, who is in love with her.

Opposite left
St. Augustine, 1480
Fresco, 185 x 123 cm
Ognissanti, Florence
This fresco portrays the influential Church Father Augustine (354–430) in his study surrounded by astronomical instruments, books, and the bishop's mitre that symbolizes his status as the Bishop of Hippo in Africa. The contents of the portrayal refers to a fresco of St. Jerome located exactly opposite this one. The clock in the background stands at the hour before sunrise, the time of St. Jerome's death in a far-away monastery in Bethlehem. Moved by a vision of this death, the Church Father pauses, lays a hand on his chest, and bows his head. The pathetic gesture is effectively heightened by foreshortening, a favorite stylistic tool in Boticelli's works.

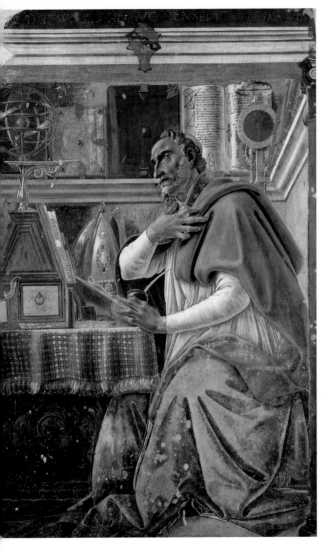

Pallas and the Centaur, c. 1482
Tempera on canvas,
207 x 148 cm
Galleria degli Uffizi, Florence

This work portrays the victory of virtue over lust. A mountain-dwelling centaur, a combination of horse and man, is being apprehended by the Greek goddess of weaving, artistry and wisdom, Pallas Athena, who was adopted by the Romans as Minerva, also the goddess of war and a symbol of virtue. This figure has also sometimes been identified as the Amazon Camilla. Her robes are embroidered with olive branches (one of Athena's attributes) and diamond rings, both insignia of the Medici.

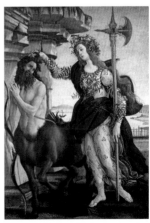

**Revolt Against
the Law of Moses, 1481/82**
Fresco, 348.5 x 570 cm
Sistine Chapel, Vatican

In this picture, the most important painting from Botticelli's cycle depicting the life of Moses on the side wall of the Sistine Chapel, there are three scenes showing the Hebrews' disobedience of the Law of God as represented by Moses and Aaron, as well as one showing the punishment of the disloyal Levites. On the right, Joshua is defending Moses, whom the people want to stone to death. In the middle of the picture, the sons of Aaron and the Levites are disputing Moses' right to the priesthood. On the left, the ground opens up and swallows the rabble-rousers entirely.

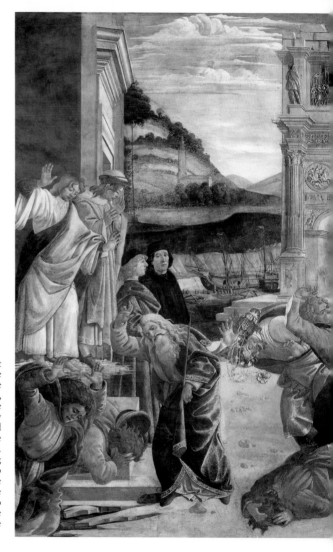

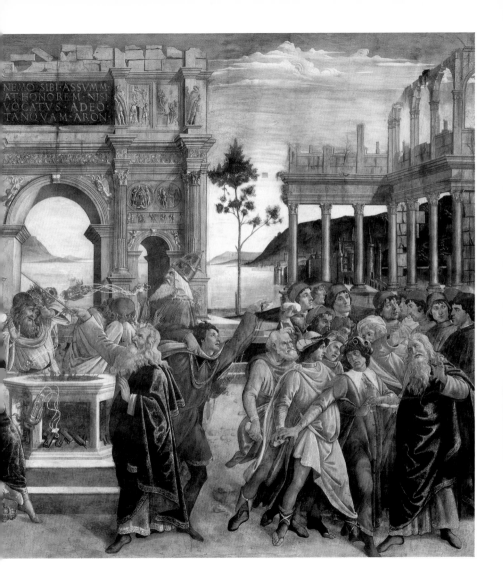

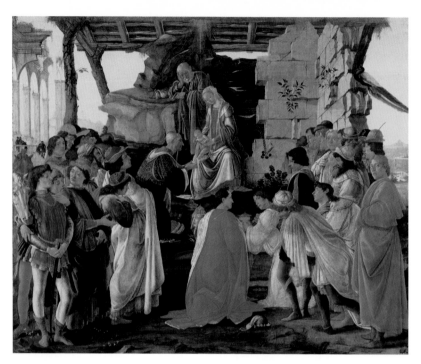

The Adoration of the Magi, c. 1475
Tempera on panel, 111 x 134 cm
Galleria degli Uffizi, Florence
Inspired by the work of Ghirlandaio, Botticelli included portraits of real people in his compositions. The early art historian Giorgio Vasari identified the three wise men in this picture, for example, as members of the Medici family. According to him, the wise man turning to the Christ Child is Cosimo. Kneeling in the middle and bowing down to his left are Cosimo's sons, Piero and Giovanni, while the liegeman dressed in a white robe could be Lorenzo.

Opposite below
The Birth of Venus, c. 1485
Tempera on canvas, 172.5 x 278.5 cm
Galleria degli Uffizi, Florence
Botticelli adheres closely to the account of the poet Angelo Poliziano (1454–1494) in his rendering of this mythological subject. Zephyr, the god of the wind, and Aura, the breeze (shown in detail on the following pages) drive Venus from the sea onto land. There she is met by one of the Horae, the goddesses of the seasons, who has been sent to dress her. The roses floating down from the sky are a reference to their having first blossomed at the birth of this goddess of spring and love.

**"The Calumny" by Apelles,
c. 1495**
*Tempera on wood, 62 x 91 cm
Galleria degli Uffizi, Florence*
Botticelli took descriptions of a picture by the Greek painter Apelles (c. 300 B.C.) as a model for this allegory, which was painted for the financier Antonio Segni. Led by "Envy," "Calumny," "Treachery" and "Deceit" bring an innocent man before the "unjust judge." "Ignorance" and "Superstition" are whispering lies to the judge, who has the ears of a donkey. "Contrition" and "Naked Truth" stand slightly apart, and the latter's outstretched arm symbolizes a higher standard of justice.

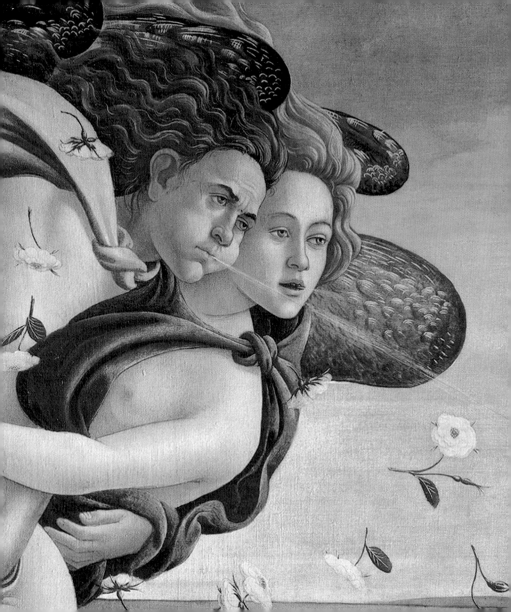

Boucher, François

François Boucher (1703 Paris–1770 Paris) was one of the major representatives of the Rococo style in France. Decisive influences on his painting included, among others, his teacher François Lemoyne, with whom he studied around 1720, and Antoine Watteau. After a trip to Italy from 1727 to 1731, his successful career began with his acceptance at the Academy, of which he later became director. He also became the artistic director of the royal Gobelins factory, and in 1765 was chosen by the king as his primary painter. Paintings dealing with society or mythological subjects are central among Boucher's decorative works. His paintings are full of grace and *joie de vivre*, and Boucher increases their sensual impact through a clever use of alienation. His often highly erotic pictures corresponded to the taste at the French court, but at the same time were heavily criticized by the progressive bourgeoisie. Significant works by the artist include *The Triumph of Venus*, 1740, Nationalmuseum, Stockholm; *The Toilet of Venus*, 1751, The Metropolitan Museum of Art, New York; and *Madame de Pompadour*, 1759, Wallace Collection, London.

Morning Coffee, 1739
Oil on canvas, 81.5 x 65.5 cm
Musée du Louvre, Paris
The mood of this morning interlude is conveyed by a cheerful brightness. The light coming through the window bathes the elegant room in a golden color that emphasizes the youth, beauty and insouciance of the figures depicted. However, this impression of harmony may be deceptive: The fact that each person is looking in a different direction, their gestures and their actions all suggest considerable detachment from each other.

Diana Leaving Her Bath, 1742
Oil on canvas, 57 x 73 cm
Musée du Louvre, Paris
Boucher's mythological themes are treated very much in the Rococo style: The amorous aspect is more important than the heroic one. In this intimate scene, the seductive charms of this strict and virginal goddess of the hunt are displayed in a voyeuristic manner, and the nymph's pose only serves to heighten them. As in other of Boucher's pictures, the sensuality of innocence provides the erotic element.

Nude on a Sofa (Louise O'Murphy), 1752
Oil on canvas, 59 x 73 cm
Alte Pinakothek, Munich
Boucher painted reclining nudes on several occasions. The model for this painting was a young Irish girl who for a short time was a favorite of King Ludwig XV (1721–1774). Boucher portrays not a classical beauty, but a pretty little flirt in an erotic, provocative pose. However, the artificiality of the surface and the artist's delicate use of color transport both the nude body and the pictorial space into a world that remains inaccessible to the viewer.

Right
The Visit of Venus to Vulcan, 1757
Oil on canvas, 210 x 200 cm
Musée du Louvre, Paris
Boucher is not depicting an erotic adventure in this painting; rather, Venus descends into Vulcan's smithy to accept weapons on behalf of the Trojan hero Aeneas. The vivid effect is a result of the rhythm created by the clouds and figures as well as the contrast between bright and gentle colors, which denote the different spheres of the fire god and his wife.

Bouts, Dierick

Dierick Bouts (c. 1410–1420 Haarlem–1475 Louvain) was one of the leading Dutch masters of the 15th century. He is first documented in Louvain in 1448. He worked there from 1457, and was named the city painter in 1468. The similarities between his style and that of Petrus Christus suggests that Christus may have been his teacher. Bouts was also heavily influenced by Rogier van der Weyden, but his narrative canvases are more peaceful and restrained, without a strong dramatic or symbolic element. His use of perspective is very skillful, and he successfully captures the varying moods of nature and different times of day. Important works by the artist include *Portrait of a Young Man*, 1462, The National Gallery,

London; *Virgin and Child*, The National Gallery, London; and *The Way to Paradise*, c. 1470, Musée des Beaux-Arts, Lille.

Last Supper Altarpiece, 1467
Oil on panel
Central panel: 180 x 150 cm;
Side panels: 88.5 x 71.5 cm each
Sint-Pieterskerk, Louvain
This famous altarpiece was commissioned by the Confraternity of the Holy Sacrament. In contrast to traditional representations, Bouts chose to portray the moment when the host is consecrated. The strongly symmetrical structure of the painting gives the composition an atmosphere of reverential peace. On the wing panels, the theme of the Last Supper is widened to include scenes from the Old Testament: the meeting of Abraham and Melchisedek, the feast of the Passover, the gathering of manna, and Elijah in the desert.

Left
Christ in the House of Simon the Pharisee, c. 1460
Oil on panel, 40.5 x 61 cm
Gemäldegalerie, SMPK, Berlin
This painting relates the familiar New Testament story involving Mary Magdalene. Christ, who has been invited to a meal, is sitting at the table with Simon, Peter and John. Mary kneels in front of him, wiping her tears from his feet with her hair and anointing them with oil. In the doorway to the right appears the patron of the picture, a Carthusian monk. Some art historians have attributed this picture to Dierick Bouts the Younger, son of the painter.

Previous page below
**The Martyrdom of
St. Erasmus, c. 1468**
Oil on panel
Central panel: 82 x 81 cm
Side panels: 82 x 34 cm each
Sint-Pieterskerk, Louvain
This altarpiece, one of the most
significant works stemming from
the artist's mature period, is an im-
pressive example of Bout's typical
and most individual style. The
central panel shows St. Erasmus, the
Bishop of Antioch, being tormented:
Two torturers are stretching his
entrails using a pulley. The panels
on each side of this gruesome scene
depict St. Jerome with the lion on
the left, and on the right, St. Bernard
after taming the Devil.

The Altarpiece of the Virgin, c. 1445

Oil on panel
Central panel: 80 x 105 cm
Side panels: 80 x 56 cm each
Museo del Prado, Madrid

In this altarpiece, which is generally accepted as being the earliest work of the master, Bouts combines four scenes from the life of the Virgin Mary in an unusual fashion to form a triptych. The central panel shows the Visitation of the Virgin and the Nativity, while the outer panels depict the Annunciation and the Adoration of the Magi. The portals serve as connecting elements, containing figures and scenes from the Old Testament that complement the theme of the altarpiece. The Virgin and Jesus thus form the link between the old and new covenants. The vividly depicted figures radiate deep piety and inner spirituality. Works by Rogier van der Weyden and Petrus Christus, which themselves may share a common source of inspiration, are thought to have served as models for these compositions.

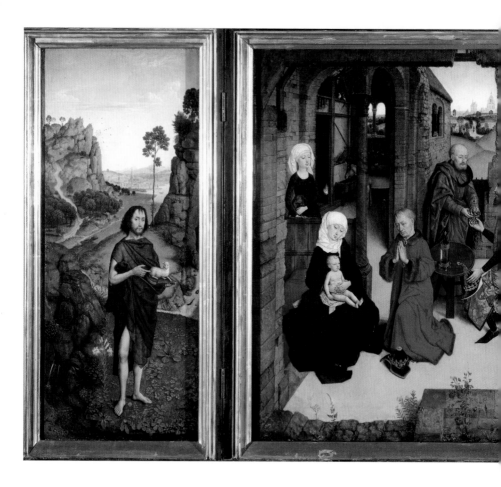

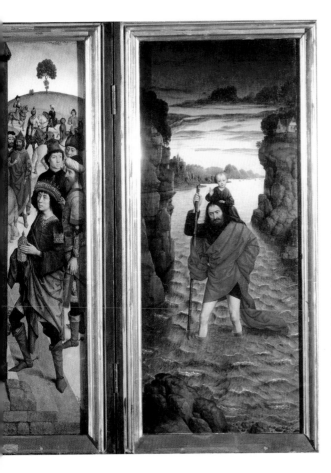

The Pearl of Brabant, 1467/68
Oil on panel
Central panel: 62.6 x 62.6 cm
Side panels: 62.6 x 27.5 cm each
Alte Pinakothek, Munich
This unique example of old Dutch painting is characterized by its graceful style, precision of detail and glowing colors. The Adoration of the Magi on the central panel is flanked on the left by John the Baptist. He is pointing to the lamb, a reference to Christ's coming, which is also suggested by the light of the rising sun. On the opposite side, St. Christopher is seen carrying the Christ Child over a river. The Christ Child itself symbolizes light and comfort in the approaching darkness, and thus also victory over death.

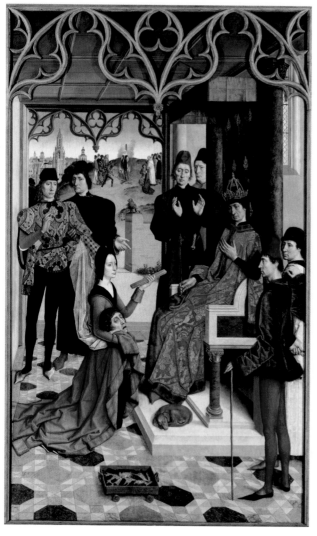

The Countess' Ordeal by Fire Before Emperor Otto III
c. 1473
Tempera on panel, 324 x 182 cm
Musées Royaux des
Beaux-Arts, Brussels

Bouts was commissioned by the city of Louvain to paint five panels for the city hall depicting historical scenes of impartial justice to act as inspirational examples to the city's judges. The painter completed four of the pictures, of which only two, those showing the justice of Emperor Otto (983–1002), are extant. According to legend, the empress maligned a count who had resisted her attempts at seducing him. Because the empress accused him of having made overtures to her, however, the count was sentenced to death and beheaded. During an ordeal by fire the countess then proved the innocence of her husband: Holding her husband's head, she was able to grasp a red-hot piece of iron without burning herself. This divine judgement convinced the emperor, who had the empress burned; Bouts shows this in a second scene in the background.

Bramante, Donato

Donato Bramante (c. 1444 Fermignano, near Urbino–1514 Rome), also called Donato d'Angelo or Donato da Urbino, is known primarily as the founder of the Italian High Renaissance style of architecture, but he is also famous as a painter. Indeed, his first training was as a painter, possibly under the tutelage of masters from northern Italy. In the 1460s he worked at the court of Urbino, where he may have met Piero della Francesca. It was also here that Luciano Laurana introduced him to architecture. In addition, Bramante was influenced by the works of Andrea Mantegna, the sculptor Donatello (1386–1466) and the architect and art theoretician Leon Battista Alberti (1404–1472). After the turn of the century he moved to Lombardy, then to Milan. At first he worked as a painter, then as an architect for Duke Sforza. In 1499 he went to Rome, entering the service of Pope Julius I (1443–1513) in 1503. Here, the construction of St. Peter's Basilica began according to his designs. He succeeded in developing a completely new interpretation of antiquity in which harmony and clarity find an ideal expression. Bramante left important theoretical writings in addition to his artworks, which include *The Armed Men*, Pinacoteca di Brera, Milan; and *Heraclitus and Democritus*, 1477, Pinacoteca di Brera, Milan.

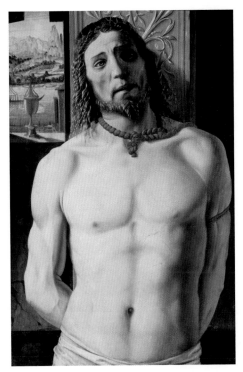

Christ at the Column, c. 1480/81
Tempera on panel, 93 x 62 cm
Pinacoteca di Brera, Milan
Bramante painted this panel for the Chiaraville Abbey near Milan. His depiction of Christ's body has a certain monumental geometry; it seems to be carved from a block of marble. Bramante's use of light and shadow for aesthetic effect is also remarkable. The dominating effect of his figures and his manner of landscape painting greatly influenced Lombard painting.

Bramantino

Bramantino (1465 Milan–1530 Milan), whose given name was Bartolomeo Suardi, was highly respected in his native city as an important painter and architect. He may have received his training as a painter under the Renaissance artist Bernadino Butinone. In 1508 he travelled to Rome, where he assisted Bramante in his work on various buildings until 1512. At the same time, around 1509, he designed 12 allegories of the months for a series of tapestries which are now considered masterpieces of the Italian art of tapestry-making. In 1525 he became court painter to Duke Francesco II Sforza. Bramantino was influenced by the Lombard school and Leonardo da Vinci's *sfumato* (the blurring of contour through subtle gradation of color). His pioneering workshop produced artists that include Gaudenzio Ferrari and Bernardino Luini. Works by the artist include *Adoration of the Child*, c. 1490, Biblioteca-Pinacoteca Ambrosiana, Milan; and *Adoration of the Magi*, c. 1502, The National Gallery, London.

Crucifixion, c. 1520
Tempera on canvas,
372 x 270 cm
Pinacoteca di Brera, Milan
The influence of Mannerism on Bramantino in his later years is visible in this monumental painting. Despite this, the work is characterized by the rigid, strict means of expression used in it. The austere arrangement of the figures in front of a backdrop of invented architecture is also typical of the artist's striking style.

Breu, Jörg, the Elder

Jörg Breu the Elder (c. 1475 Augsburg?–1537 Augsburg) was an important German painter and draftsman of the late Gothic period. From 1493 he studied under Ulrich Apt the Elder. After completing his training, he travelled through Bavaria, visiting Austria in 1501. In the following year he settled in his native city and established his own workshop there. He received commissions from Emperor Maximilian I (1459–1519) and Duke Wilhelm IV (1493–1550), among others. It is possible that he lived in Italy between 1508 and 1514. Shortly before his death he wrote a chronicle in which he supported the destruction of paintings by the Reformation. Breu was one of the most remarkable painters of Dürer's time, and can be seen as a forerunner of the Danube School. His early works display a dynamic power of expression and a dramatic use of forms that became more moderate under the influence of the Italian Renaissance. Among the artist's works are the side panels of the *St. Bernard Altarpiece*, 1500, Stiftskirche, Zwettl; and *Lucretia*, 1528, Alte Pinakothek, Munich.

The Flight into Egypt, 1501
Oil on panel, 92.5 x 128 cm
Germanisches Nationalmuseum, Nuremberg
This altarpiece shows how Breu had turned away from the late Gothic tradition. The landscape has become important in its own right and is no longer purely subordinate to the main action. It is actually used as an integral part of the scene, there being some interplay between its elements and the figures depicted. In addition, the figures are not just an extension of their clothing, but are conceived of as a whole.

Bril, Paul

Paul Bril (1554 Antwerp–1626 Rome), the Flemish painter and copperplate engraver, worked mainly in Rome. He received his first training from his father, the painter Mattheus Bril the Elder. In 1574 he travelled via Lyon to Rome, where he founded a workshop based on the model of that of the Caraccis; Agostino Tassi, the teacher of Claude Lorrain, was among the painters later trained there. Bril's works span multiple genres, ranging from landscapes and large mythological and religious works to important miniatures and etchings. Significant works by the artist include *Forest Landscape*, 1591, Galleria degli Uffizi, Florence; *Venus and Adonis*, Musée des Augustins, Toulouse; and *The Conversion of Saint Jerome*, c. 1606, Museum Boijmans van Beuningen, Rotterdam.

Stag Hunt, c. 1593
Oil on canvas, 105 x 137 cm
Musée du Louvre, Paris
Inspired by the Caraccis, Bril devoted himself to classical landscapes with figures, a genre he helped to establish. In his clear, harmonious and light-filled landscapes he combined the robust forms of his native country with the gentler Italian use of color. Through the influence of Adam Elsheimer, whom he met around 1600, he developed the use of strong contrasts between light and shadow, as well as a generous and poetic manner of painting.

Landscape with Temple of the Sibyl, 1595
Oil on copper, 11 x 17 cm
Galleria Borghese, Rome
The limited horizon and the narrative detail in this small picture are derived from the Dutch tradition of landscape painting, although the openness and directionless joining of the picture segments is lacking. Rather, the segments are tightly structured and subordinated to the rhythm of the dominating contrast of light and shadow. However, the turbulent density of the composition suggests the true magnitude of the landscape.

View of a Seaport, c. 1610
Oil on canvas, 107 x 151 cm
Galleria Borghese, Rome
In his late phase after 1610, during which he reached his artistic zenith, Paul Bril gradually freed himself from the influence of Adam Elsheimer and began to emphasize the orthogonal division of his compositions. He now preferred large canvases to small, easily transportable copperplates and began adding large galleys and trading ships to his harbour views, which nonetheless continue to display the bizarre rock and cloud formations typical of his works in this genre. These mature paintings are characterized by tranquil compositions that emphasize the horizontal plane and make effective use of gentle, balanced coloring.

Broederlam, Melchior

Little is known about the life or work of Melchior Broederlam. He is documented as having lived in Ypres in West Flanders between 1381 and 1409. He was court painter to the Count of Flanders and entered the service of Philip the Bold, the duke of Burgundy (1342–1404), in 1384. His primary assignment was the decoration of Hesdin Castle, which he accomplished between 1386 and 1392; and in 1392 he returned to Ypres. In addition to painting religious pictures and portraits, this multi-talented artist also designed stained-glass windows, gold work, official robes and costumes for festivities. The only works conclusively proven to be by Broederlam are the two altar wings commissioned by Philip the Bold for the Carthusian monastery in Champmol, near Dijon. They decorate the outer sides of a carved altar made by the Dutch sculptor Jacques de Baerze. The inner sides depict saints as well as scenes from Christ's Passion. Broederlam is one of the pioneers of early Flemish painting, which the Van Eyck brothers would develop to its highest point a generation later.

Opposite left

Diptych with the Annunciation and Visitation of Mary (Altarpiece of Jacques de Baerze), c. 1396

Tempera on panel, 167 x 125 cm
Musée des Beaux-Arts, Dijon

In these altar panels—the left one is shown here—the painter disregards the strict, solemn style usually used to depict these scenes, choosing instead a colorful approach with a great amount of detail. Inspired by Italian art, Broederlam attempts to render architectural detail realistically, the first time this was done in Flemish art. This detail is delicately painted using several points of view, and does not adhere to one system of perspective. The figures also herald an innovation in art: The angel of the Annunciation in the detail opposite displays a physicality and presence never seen before. He holds a banner with words of greeting to Mary. The jug with a white lily dominating the foreground symbolizes her virginity.

Opposite right

The Presentation in the Temple And Flight into Egypt (Altarpiece of Jacques de Baerze), c. 1396

Tempera on panel, 167 x 125 cm
Musée des Beaux-Arts, Dijon

Broederlam's works also show characteristics of book illustrations of his time. Such an opulent landscape with a genre-like scene—for example, Joseph is seen drinking from a bottle—is unusual for altarpieces. The realistic depiction and delicate nuances of color surpass any illustration found in books, however. The continuous extension of the landscape from the foreground into the background is also an innovation in painting.

Bronzino, Agnolo

Agnolo Bronzino (1503 Monticelli, near Florence–1572 Florence), also called Agnolo di Cosimo di Maiano or Agnolo Tori, was one of the most famous representatives of Florentine Mannerism. He was a student of Raffellino del Garbo and Jacopo Pontormo. Later he was also inspired by Michelangelo, whose works he became familiar with during a trip to Rome in 1546/47. From 1530 to 1533 he was employed as a painter by the duke of Umbria, Guidobaldo da Urbino, in Pesaro. Upon his return to Florence he soon became a popular artist, and was appointed court painter of the Medici in 1540. At first Bronzino was very much influenced by the works of Pontormo, but later turned to strict, objective methods of composition. By employing the paint as an autonomous element, he achieved the cool character of his pictures, which nonetheless remain vivid and realistic. Besides religious and allegorical subjects, he also painted many portraits. Other works by Bronzino include *The Martyrdom of St. Laurence*, 1529, San Lorenzo, Florence; *Pygmalion and Galatea*, 1529, Galleria Nazionale d'Arte Antica, Rome; and *Frescoes in the Chapel of Eleonora of Toledo*, 1545–1564, Palazzo Vecchio, Florence.

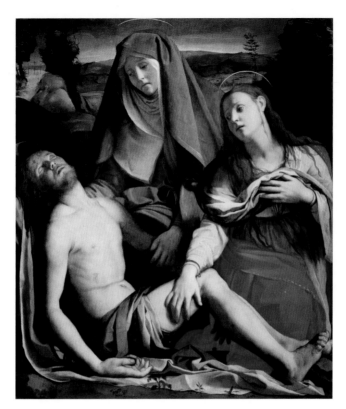

Opposite

The Panciatichi Holy Family, 1530–1548
Oil on panel, 117 x 93 cm
Galleria degli Uffizi, Florence
This work displays not only Bronzino's technical skill, but also the complex extremes of his compositions and the portrayal of bodily motion that are characteristic of his art. The Holy Family with the young St. John, who is shown embracing the Christ Child, is placed in front of a rocky landscape with a fortress under a gloomy sky. The battlements of the fortress carry a flag with the coat of arms of the donors, the Panciatichi family.

Lamentation, c. 1530
Oil on panel, 105 x 100 cm
Galleria degli Uffizi, Florence
This early painting shows the strong influence of both Michelangelo and Pontormo on Bronzino. The monumental forms of the composition and the lifelike figures express true piety. The closeness of the figures to the viewer intensifies the inner emotions of the Virgin and Mary Magdalene.

Portrait of Bartolomeo Panciatichi, c. 1540
Oil on panel, 104 x 84 cm
Galleria degli Uffizi, Florence
In his portraits, Bronzino had the ability to depict the individual personalities of his sitters with great precision. He typically used clear, almost geometric forms, which in this case are emphasized by the strongly vertical architectural details in the background. The refined facial features of this aristocrat (1507–1583) seem mask-like, making him appear cool and reserved despite the intensity of his gaze.

Portrait of Lucrezia Panciatichi, c. 1540
Oil on panel, 102 x 85 cm
Galleria degli Uffizi, Florence
This portrait of the wife of Bartolomeo Panciatichi gives her an air of strict unimpeachability. In 1528, Bartolomeo married Lucrezia di Gismondo Pucci (1507–1572), who was the same age as himself. Both portraits were painted about the same time, but they were probably not conceived of as a matched pair. The sitter has laid her hand on an open book, giving the portrait a personal touch.

Opposite
Allegory of Love (Venus, Cupid, Folly and Time), c. 1543
Oil on panel, 146 x 116 cm
The National Gallery, London
Bronzino has represented the various "faces" of love in this allegorical painting. For example, the bow and apple held by Venus symbolize both the sweet and the dangerous aspects of love, while the putto strewing roses stands for the promised pleasures of love, which the masks reveal to be illusory. Other figures represent "Malice," "Jealousy," "Truth" and "Time" as hindrances to pleasure.

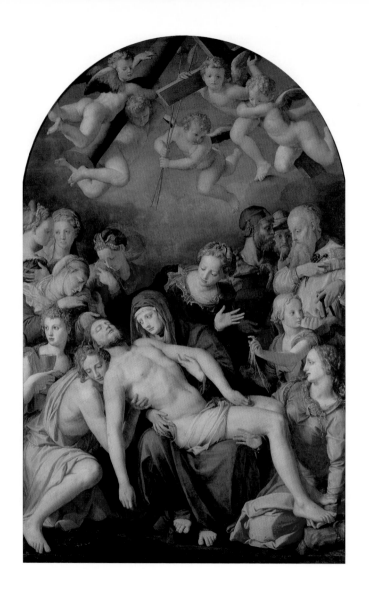

Deposition of Christ, 1549
Tempera on panel, 268 x 173 cm
Musée des Beaux-Arts, Besançon
Bronzino adhered to the grand,
courtly Florentine Mannerist style
even in his religious works. He
originally painted this altarpiece
for the oratory of Eleonora of
Toledo (1522–1562) in the Palazzo
Vecchio. However, it was presented
to Nicholas de Gravalle as a gift
shortly after its completion, and
remained in the chapel containing
his grave in the Carmelite church in
Besançon until it was removed
during the French Revolution.

**Portrait of Eleonora of Toledo
and her Son Giovanni de'Medici,
c. 1545**
Oil on panel, 115 x 96 cm
Galleria degli Uffizi, Florence
Bronzino achieves the element of
distance in his portraits both by
rigid poses and by the glazed effect
produced by his paint application.
This is evident in this portrait as
well, where Eleonora of Toledo,
wife of Cosimo de'Medici, and
their son pose for us in solemn and
timeless introspection. The careful
and detailed rendering of fabrics is
also characteristic of Bronzino.

**Portrait of Laura Battiferri,
c. 1555–1560**
Oil on canvas, 83 x 60 cm
Palazzo Vecchio, Florence
Bronzino portrays this poet, also the
wife of the sculptor Bartolomeo
Ammannati, with her head raised
proudly. He has not painted simply
an official portrait of her with a
book, but has also managed to
convey something of the character
of the sitter. The religious severity of
this austere figure reflects the spirit
of the Counter-Reformation, which
had a strong influence on art during
this time period.

Brouwer, Adriaen

Adriaen Brouwer (c. 1606 Oudenaarde–1638 Antwerp) went to Holland in 1622 and possibly studied with a Flemish master in Amsterdam. Frans Hals, with whom Brouwer worked for a considerable length of time in Haarlem, also had a great influence on him. In Haarlem he became a member of the Rhetoricians' Society in 1626. About 1631 Brouwer moved to Antwerp and became a member of the Guild of St. Luke. Here he had contact with Peter Paul Rubens and perhaps Pieter Brueghel the Younger and his circle. Brouwer's genre paintings combine the Flemish and the Dutch traditions, as is seen in the way the artist makes his peasant figures more vivid by portraying the range of their emotions. Brouwer concentrated mainly on an anecdotal style, frequently with an element of allegory or caricature, and is considered one of the greatest painters of rustic scenes after Pieter Bruegel the Elder. His works include *Village Bath*, c. 1620–1630, Alte Pinakothek, Munich; *The Five Senses*, Alte Pinakothek, Munich; and *Landscape in Moonlight*, c. 1633, Gemäldegalerie, SMPK, Berlin.

The Ball Players
(Drinkers at Table Outdoors)
Oil on panel, 25.5 x 21 cm
Musée Royaux des
Beaux-Arts, Brussels
In this painting Brouwer depicts an idyllic scene in the courtyard of an inn with little detail. The men have interrupted their game of throwing balls through an iron ring. Five of them are deep in conversation, while two others answer the call of nature. The painting is effectively and carefully constructed: For example, the equipment for the game is depicted as a vivid still life.

Brawling Peasants
Oil on panel, 25.5 x 34 cm
Mauritshuis, The Hague
Brouwer's generally small pictures often depict the everyday life of common people on the street, in the countryside or in inns. He frequently included singing, laughing, smoking or quarreling peasants in his paintings. His use of brown tones and precise depiction of mood are

evidence of the fact that he was influenced by Dutch art. In this picture, a violent argument has just broken out. In the 17th century, card games and drunkenness were considered vices that left people at the mercy of their primitive urges. The pigs in the right hand corner of the picture can be considered a commentary on and judgement of the behavior of the quarrelers.

Brueghel, Jan

Jan Brueghel (1568 Brussels–1625 Antwerp), the second son of Pieter Bruegel (the Elder), was nicknamed "Velvet" or "Flowers" because of the subjects he painted and the bright enamel paints he used. His first painting lessons were with his grandmother, Marie Bessemers, a talented miniaturist. He then went to study with Pieter Goetkint, and finally with Gillis van Coninxloo in Antwerp. From 1589 to 1596 he was in Italy, living in Naples, Rome and Milan. Upon his return to Antwerp he was accepted into the Guild of St. Luke. In 1609, Archduke Albrecht of Austria, the governor of the Netherlands, appointed him as court painter. Brueghel was famous above all for his landscapes and his still lifes of flowers. After 1615 he worked with Peter Paul Rubens, who was a friend of the family. Among the artist's major works are *The Battle of Arbela*, 1602, Musée du Louvre, Paris; *Still Life with Bouquet of Flowers*, 1610, Alte Pinakothek, Munich; and *The Holy Family*, Alte Pinakothek, Munich.

Landscape with Windmills, c. 1607
Oil on panel, 34 x 50 cm
Museo del Prado, Madrid

Brueghel's landscapes were influenced by his father, as well as by Joos de Momper and Paul Bril. Until 1600 he painted mostly mannered fantasy landscapes, but then turned to the early Baroque for inspiration in pictorial structure, observation of nature, and coloring. Thus he painted flat landscapes containing few motifs and figures in varying light conditions rather than large-scale landscapes filled with various separate subjects.

**Still Life with Bowl,
Wreath and Jewelry Box, 1618**
*Oil on panel, 47.5 x 52.2 cm
Musées Royaux des
Beaux-Arts, Brussels*
Brueghel's pictures depicting flowers
and wreaths also display a wealth of
detail and careful execution. Particularly in his later works, he
achieved an exquisite clarity. This
masterly skill, probably influenced
by his initial training in miniature
painting, is also greatly admired in
Rubens' works.

**Allegory of Sight
and Smell, 1617/18**
Oilon canvas, 175 x 263 cm
Museo del Prado, Madrid
The canvas pictured above is part of a series about the five senses, a subject that was very popular and often depicted in the Netherlands at the time. Brueghel has painted a very complex composition that contains several references to seeing and smelling. The elegant figures of two women, which, like the putti, were painted by Peter Paul Rubens, are busy at a round table. One of the women abandons herself to the heady perfume of the abundant flowers, while the other is absorbed with looking at herself in the mirror. All the objects depicted—jewels, telescope, globe, the works of art—refer to that which humans can perceive. The room is decorated with pictures as if it were a collector's gallery, each of them in some way connected with the main theme of the painting.

**Allegory of Taste,
Hearing and Touch, 1617/18**
*Oil on canvas, 176 x 264 cm
Museo del Prado, Madrid*
In this depiction of three of the five
senses, painted with the help of
Peter Paul Rubens and Frans
Snyders, the artist shows us lux-
urious surroundings. Allegories of
taste, hearing and touch are the
main theme of the picture. The
various comestibles, the opulent
meal and the costly silver symbolize
taste. The musical instruments, the
birds, the clocks and the lute player
all refer to hearing. The stag was
also considered a symbol for
hearing because of its fine ears. At
the same time, the stroking of the
animal refers to the sense of touch.
Brueghel again employs the device
of pictures hanging on the wall in
the background that relate to the
theme of his painting.

Bruegel, Pieter

Pieter Bruegel (c. 1527 Breda–1569 Brussels), nicknamed "Peasant" Bruegel, was the first in a long series of artists in his family. He became a member of the Painters' Guild in Antwerp in 1551. The following year he travelled to Italy, probably returning in 1555. In 1563 he settled in Brussels, where he, a respected humanist, formed part of the circle surrounding the poet and academic Dirk Volckertsen (1522–1590). In his paintings, Bruegel applies the idealized Renaissance concept of man to the peasant class, which he portrays both at work and at play. Following Hieronymus Bosch's example, these pictures depict traditional adages using grotesque and tragicomic elements in their humorous, sometimes biting allusions. Bruegel was the most original and influential painter of his time, and his simultaneously poetic and realistic landscapes had a lasting influence on Flemish art and that of the northern Netherlands. Among the artist's major works are *The Tower of Babel*, 1563, Kunsthistorisches Museum, Vienna; *Return of the Hunters (January)*, 1565, Kunsthistorisches Museum, Vienna; and *Peasant Dance*, c. 1568, Kunsthistorisches Museum, Vienna.

Opposite
Landscape with the Fall of Icarus, c. 1558
Oil on panel, transferred to canvas, 74 x 112 cm
Musées Royaux des Beaux-Arts, Brussels
Bruegel here treats a mythological subject that was very popular at the time. Icarus, fleeing from Crete on wings made of feathers and wax, comes too close to the sun and falls into the sea. The figure of Icarus can scarcely be seen, while in the foreground a farmer plows the soil. Bruegel's unusually realistic depictions of nature, into which scenes from everyday life are woven, had a decisive effect on the development of landscape painting.

Netherlandish Proverbs, 1559
Oil on panel, 117 x 163 cm
Gemäldegalerie, SMPK, Berlin
Even early on in his career, Bruegel took up the contemporary theme of a topsy-turvy world. In this painting he depicts the foolishness and excesses of humankind by means of images illustrating 100 Netherlandish proverbs, many of which are still in use today. Particularly admirable is the way Bruegel managed to combine the myriad small and quite complex scenes to create a single, almost everyday street scene.

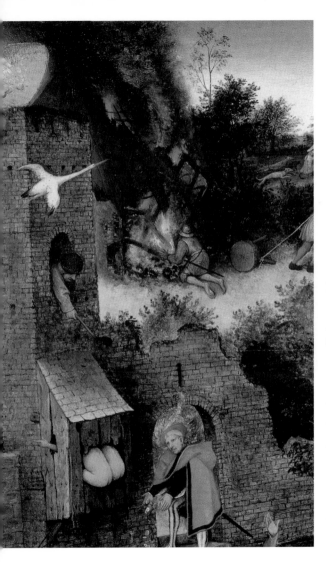

Netherlandish Proverbs (detail)
Bruegel has "hidden" the proverbs in both buildings and the landscape in ways that are sometimes grotesque, but always highly imaginative. The man on the battlements of the tower holding his coat in the breeze symbolizes the proverb "to know where the wind is coming from," and the figure next to him "shakes feathers out in the wind," which means that all his efforts have been in vain. The woman is wasting time and "watches the storks," while the man falling "from an ox onto a donkey" is experiencing business setbacks. The man in the box on top of a column, the pillory, also represents a little-known proverb: He is "playing on the pillory," i.e. attracting attention to himself. In the latrine on the right-hand side of the tower, two men are "shitting into the same hole," an allusion to inseparable companions.

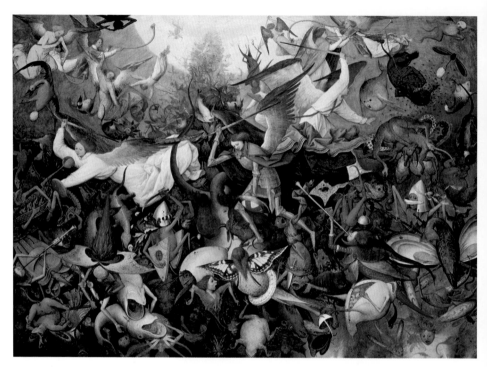

The Fall of the Rebel Angels, 1562
Oil on canvas, 117 x 162 cm
Musée Royaux des Beaux-Arts, Brussels
Bruegel has used this biblical episode to depict the way that demons and devils, entities that were very much real to his contemporaries, came into being. Together with his loyal followers, the Archangel Michael—seen in the middle of the picture, holding a shield—drives off the angels who are rebelling against God, whereupon they are transformed into the fantastic creatures that populate Hell. They are shown with the bodies of animals, naked, and with their mouths and bellies wide open.

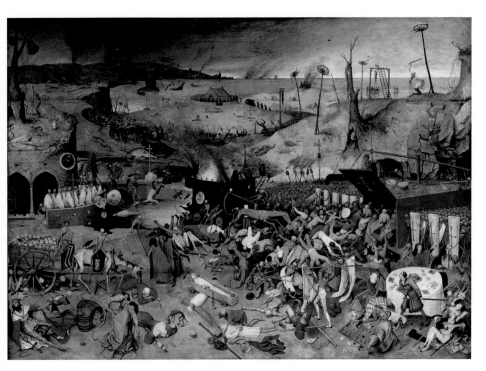

The Triumph of Death, c. 1562
Oil on panel, 117 x 162
Museo del Prado, Madrid
This picture belongs to a group of works by Bruegel that depict subjects at the very outer limits of human existence and human activity in a drastic manner. Madness, vice, murder and fear seem to be the primary motivations in the world of horrors depicted here, which seems more like a preliminary form of Hell. At the end, the world is destroyed and Death triumphs: He is seen riding with his sickle in the guise of the Rider of the Apocalypse. These paintings are closely related to the art of Hieronymous Bosch.

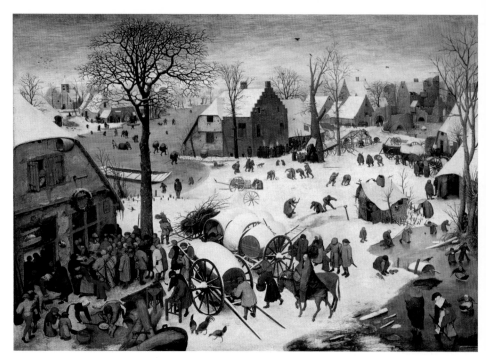

The Census of Bethlehem, 1566
Tempera on panel, 116 x 164.5 cm
Musées Royaux des
Beaux-Arts, Brussels
Bruegel depicts this episode from
the New Testament as taking place
in the landscape of his native
Flanders. Vignettes show typical
aspects of village life in winter,
while Joseph with Mary on the
donkey hurries to the place of
registration. This event is given the
dignity it deserves through the
traditional cosmic overview, and
gains in reality through the depic-
tion of everyday life.

Opposite above
The Land of Cockayne, 1567
Oil on panel, 52 x 78 cm
Alte Pinakothek, Munich
In this allegory Bruegel condemns
gluttony, using the concept of an
earthly paradise as his point of
departure. Fat and exhausted, a
knight, a peasant and a cleric or
scholar lie under a table. Its round
shape and the arrangement of the
men like spokes of a wheel sym-
bolize an endless cycle. The steep
descent to the sea in the background
could be a reference to the fate of
those who devote themselves solely
to material pleasures.

Opposite below
The Parable of the Blind
Leading the Blind, 1568
Tempera on canvas, 86 x 154 cm
Museo Nazionale
di Capodimonte, Naples
Bruegel has based this picture on
Christ's comparison of actual blind-
ness with blindness in matters of
faith (Matthew 15:14). The group
seen here is being led by a blind
man, a situation which will surely
lead to disaster. Bruegel has depicted
the helplessness of the men with
frightening precision.

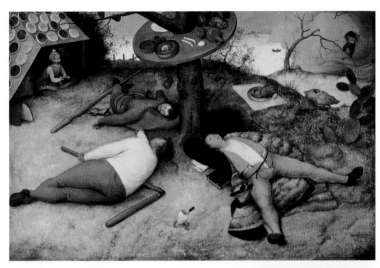

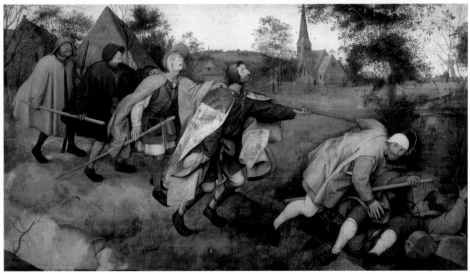

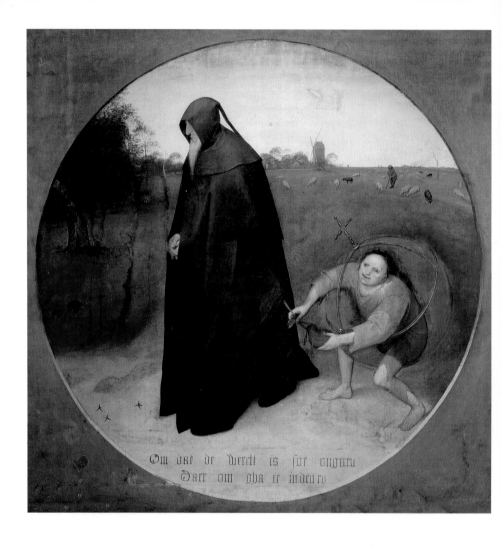

Om dat de werelt is soe ongetru
Dar om gha ic in den ru

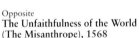

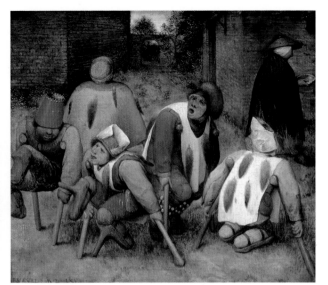

Opposite
The Unfaithfulness of the World (The Misanthrope), 1568
Tempera on canvas, 86 x 85 cm
Museo Nazionale
di Capodimonte, Naples
This work belongs to Bruegel's late paintings containing large figures. A vagabond or beggar enclosed in a glass globe is stealing a purse from an old man dressed in a habit. Underneath is written: "I walk in sadness because the world is so unfaithful." It is not certain who is cheating whom—the wealthy man the world, or the world him. In the background, a contented shepherd looks after his sheep.

Head of an Old Peasant Woman, after 1564
Oil on panel, 22 x 18 cm
Alte Pinakothek, Munich
Bruegel is not known to have painted portraits as such, but he did paint an entire series of head studies, including this late work. Despite his acute powers of observation, he was not interested in rendering individual traits. Rather, he tried to find the universal expression of a certain emotion: in the case of this picture, astonishment. The facial features of the old peasant woman seem both uncouth and true-to-life.

The Beggars, 1568
Oil on panel, 16.5 x 21.5 cm
Musée du Louvre, Paris
In this work Bruegel gives us an unusually close-up view of the group of crippled beggars, and dispassionately shows the imperfection of humanity. Their head coverings probably show the social class from which they came: helmet—soldier, crown—nobility, cap—peasant, fur hat—citizen, and miter—clergyman. There is a Netherlandish proverb that says "lies travel like a cripple on crutches;" according to this picture, all people are liars.

Bruyn, Barthel

Barthel Bruyn (1493 Wesel?–1555 Cologne), also called Bartholomeus the Elder Bruyn, was an outstanding painter whose style lies between that of the late Gothic and the Renaissance. He was related to the painter Jan Joest Kalkar, and studied with him around 1506. From 1512 he is documented as having been in Cologne, where he first worked in the workshop of the late Gothic master St. Severin before starting off on his own in 1515. He became highly respected, and was elected into the city council. In 1522 he worked at the court of Duchess Maria in Düsseldorf. Bruyn painted altarpieces that show the influence of Dutch and Italian art. He was also inspired by the painter Joos van Cleve, who was a friend of his. From the 1520s he received commissions from Cologne nobility. His works include *Altarpieces*, c. 1523, Stiftskirche, Essen; *Altarpieces*, c. 1531, St. Victor, Xanten; and *Portrait of Mayor Peter von Heimbach*, 1545, Wallraf-Richartz Museum, Cologne.

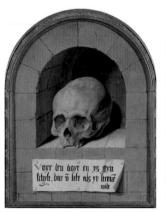

Skull in a Niche
Oil on panel, transferred to canvas, 37 x 30 cm
The Hermitage, St. Petersburg
Vanitas motifs like this one are often to be found on the back of Bruyn's portraits. It is therefore probable that this picture was also painted on the back of another, or that it was the second wing of a portrait diptych. The inscription "No shield can protect you from death: Live until you die" makes the point of such paintings clear—they point out the transitory nature of human life and at the same time act as a warning.

Portrait of a Lady, 1542
Oil on panel, 68 x 49 cm
Galleria Sabauda, Turin
Bruyn's portraits are characterized by the reserved, often somewhat mannered, dignified poses of the sitters as well as by a penetrating observation of their individual personalities. He founded the tradition of the patrician portrait in Cologne and the Lower Rhine area based on this concept. This portrait depicts an unknown woman who, according to the inscription at the top, is 54 years of age. Her eyes and gaze are very expressive and focused on the viewer.

Burgkmair, Hans, the Elder

Hans Burgkmair the Elder (1473 Augsburg–1531 Augsburg) was the leading painter of his time in his home city. He received his first training at the hands of his father, Thomas Burgkmair, a painter in the late Gothic style, and then studied with Martin Schongauer in Colmar. He spent several years travelling about, probably spending some time in northern Italy, where he returned between 1501 and 1508. In 1498 he settled in his native city, joined the Guild of St. Luke, and took over his father's workshop. Burgkmair progressed beyond the late Gothic style of his early works to develop a vivid, powerful and opulent style of his own. Under the influence of Italian art, he adopted the monumental manner of the High Renaissance, and began using richer colors. Among the artist's works are *Pictures for the Basilica*, State Gallery in the Palais Schaezler, Augsburg; *Mary in a Rose Bower*, 1509, Germanisches Nationalmuseum, Nuremberg; and *Esther before Ahasuerus*, 1528, Alte Pinakothek, Munich.

Altar of St. John, 1518
Oil on panel,
Central panel: 153 x 124.7 cm;
Side panels: approximately 146 x 46 cm each
Alte Pinakothek, Munich
The center panel shows St. John the Evangelist on the Aegean island of Patmos where, according to legend, he wrote down his visions of the Apocalypse, here sent to him by an angel. The drama of the scene is reflected in the strong movement of the painting. The romantic depiction of the landscape points to the influence of the Danube school. The wings of the altar show St. Erasmus and St. Nicholas.

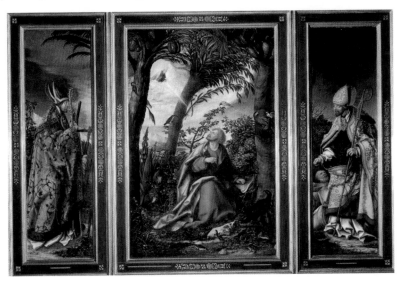

LE VITE

DE PIV ECCEL-
LENTI ARCHITET-
TI, PITTORI, ET SCVL-
TORI ITALIANI, DA CIMABVE
INSINO A' TEMPI NOSTRI: DESCRIT-
te in lingua Toſcana, da GIORGIO VASARI
Pittore Aretino. Con vna ſua vtile
& neceſſaria introduzzione
a le arti loro.

IN FIRENZE
M D L.

Giorgio Vasari: "The Father of Art History"

Giorgio Vasari's (1511–1574) lasting fame and his significance for the history of art are based above all on his authorship of an extensive collection of artists' biographies entitled *Le vite de'più excellenti pittori, scultori e architetti* ("Lives of Famous Artists, Sculptors and Architects"; often abbreviated simply "Lives"). This important work is a compilation of material collected by Vasari from many sources and contains, in chronological order, the biographies of numerous Italian artists dating from the Middle Ages up to the 16th century. The *Lives* begin with Cimabue (c. 1240–c. 1302), and the first two-volume edition, published in 1550, ends with Michelangelo (1475–1564). Only in the second edition, which appeared in 1568 and added an additional volume, did Vasari include contemporary artists. This later edition was also enlivened with wood-cut portraits of some of the artists placed at the beginning of each section.

Vasari's *Lives* still offer a nearly inexhaustible and unique source of information for contemporary art historians and enthusiasts, even if later research has shown that there are many mistakes and inaccuracies in the texts. The many anecdotes, which are sometimes humorous and even border on the grotesque, give a mostly out-dated picture of each artist. The *Lives* are full of invented material and literary allusions, but nonetheless give us vivid descriptions of the leading Italian artists not to be found elsewhere.

Antonio Pazzi: Giorgio Vasari, 1752
Copperplate
From 1752–1762, the Abbot Pier Antonio Pazzi created a series of copperplate engravings based on artists' self-portraits hanging in the Uffizi in Florence, including this portrait of Vasari originally done in 1566.

Opposite
Title Page of the First Edition of Giorgio Vasari's
Le Vite, Florence, 1550
The words *in lingua Toscana* are not on the title page of the 1568 2nd edition because the Tuscan dialect had by then become the accepted literary language.

Vasari tells us, for example, that Cimabue was the first artist to paint pictures on panels, and that Masaccio was a "modest, friendly, peaceable, thoughtful man to whom clothes, food and other

Giorgio Vasari: Michelangelo Buonarroti
2nd Edition of Vasari's Le Vite, *Florence, 1568*
The importance Vasari attributes to Michelangelo is reinforced by the costly brocade coat worn by the artist, who had died only a few years earlier.

worldly goods were a matter of indifference." We can read something similar in his account of the life of Donatello, who refused to accept a costly piece of clothing from the Medici because he found his old and familiar garments more comfortable. Fra Angelico, the "angel-like brother," is said never to have taken up his paint-brush without first saying a prayer. According to Vasari, it was impossible for the sensitive monk to paint a crucifixion scene without tears coming to his eyes. On the other hand, Vasari describes Pontormo as a loner who had completely turned his back on society, and claims that this was the reason that he only painted works that were considered incomprehensible.

Vasari uses a structure in writing his life histories that can be traced back to the tripartite scheme commonly employed in antiquity: a golden age, a decline and a revival. In Vasari's understanding of the progression of the world, the golden age was antiquity, the Middle Ages were the decline, and the revival was the art of the Renaissance, which had its beginnings in the 14th century. He also divides this period of revival into three periods: the "childhood" of the 14th century, the "youth" of the 15th century, and the "maturity" of the 16th century.

For the first time in art history, Vasari subjects the works of different masters to a scholarly analysis of their style. His evaluative criteria are *inventione* (invention, or originality) and *disegno* (drawing and line)—two elements that he sees as being the "mother" and "father" of all the arts. Vasari considers his con-temporary, Michelangelo, to have reached the highest level of perfection, writing that

Michelangelo was sent personally by God to Florence. According to Vasari, the "Divine" Michelangelo marked the grand and final stage of artistic development. He alone could be singled out for not only having imitated the works of antiquity almost to perfection, but even for having surpassed them in terms of beauty, elegance and imagination.

Giorgio Vasari was not only notable as a writer on the theory of art, but also a painter, draftsman and architect in his own right. His

Jan van der Straat, called Stradanus: Riding Display on the Piazza San Croce in Florence
Sala di Gualdrada, Palazzo Vecchio, Florence
This picture is part of a frieze depicting different public squares in Florence. Stradanus (1523–1605) was one of Vasari's assistants, and from 1555 on was commissioned by Cosimo I to work on the decorations in the Palazzo Vecchio.

designs include the Uffizi in Florence—the *palazzo* (palace), now a museum, that still houses the most important masterpieces by the very artists described by Vasari in his treatise.

Campin, Robert

Robert Campin (c. 1375 Tournai–1444 Tournai), who was probably the painter known as the Master of Flémalle, is documented as having lived in Tournai from 1406. Because of his unconventional way of life and his having committed perjury, he was sent on a pilgrimage to St. Gilles in Provence from 1429–1430. Campin's works, which at the start of his career resembled French manuscript illuminations, display extremely exact powers of observation in their depiction of the smallest details. They are also characterized by the plasticity of the figures and the way in which Campin renders a realistic, if mathematically imprecise, illusion of depth in his paintings. These innovative elements make Campin one of the founders of the old Netherlandish painting style. His best-known student was Rogier van der Weyden, who in turn had a noticeable influence on the pictures of his master. Major works by the artist include *The Nativity*, c. 1425, Musée des Beaux-Arts, Dijon; *Mérode Altarpiece*, c. 1425, The Metropolitan Museum of Art, New York; and *The Thief of Gesina*, c. 1430, Städelsches Kunstinstitut, Frankfurt am Main.

Virgin and Child before a Fireplace, c. 1423
Oil on panel, 34 x 24.5 cm
The Hermitage, St. Petersburg
This domestic scene is very realistically portrayed, and shows the Virgin looking after her Child. Inspired by the works of Rogier van der Weyden and Jan van Eyck, Campin renders the details with slightly less precision and depicts movement somewhat more stiffly than these painters, but the composition and characterization seem more carefully planned. This panel is the left wing of a diptych; the other side shows the Trinity.

The Marriage of
the Virgin, c. 1429
Oil on panel, 76.5 x 88 cm
Museo del Prado, Madrid

In this painting, Mary and Joseph are being married by a priest in front of a temple that displays elements of both Roman and Jewish architecture. For many centuries it was customary for couples to marry outside churches (since marriage was considered to be a matter of natural, rather than theological, law) but come to ask the church's blessing. Inside the building, a clergyman is praying together with Mary's unsuccessful suitors. The panel is characterized by clear colors, the expressive faces and gestures of the figures, and the realistic rendering of the plants and architecture.

Opposite left
Heinrich von Werl and John the Baptist
(The Werl Altarpiece), 1438
Oil on panel, 101 x 47 cm
Museo del Prado, Madrid
This work forms the left wing of the *Werl Altarpiece*,
named after its donor, a Franciscan theologian from
Cologne. He has had himself portrayed praying before
the saint. Campin's intuitive depiction of the well-lit
interior is oriented toward the center panel, which has
unfortunately been lost. The mirror hung on the panel-
ing reflects the front half of the room.

Opposite right
St. Barbara in front of the Fireplace
(The Werl Altarpiece), 1438
Oil on panel, 101 x 47 cm
Museo del Prado, Madrid
The right wing of the altarpiece shows the princess
Barbara sitting and reading in front of a fireplace, while
her martyrdom can be seen through the open window.
Campin places religious scenes in a bourgeois setting like
this one without missing any of their symbolic content.
He takes special care with details such as the tracery and
the lettering that can be seen in the segment above.

Canaletto

Canaletto (1697 Venice–1768 Venice), whose real name was Giovanni Antonio Canal, first studied the art of theatrical scenery painting, and around 1719 took an educational trip to Rome. He was also influenced by Giovanni Paolo Pannini and above all the painter Luca Carlevarijs, who specialized in painting *vedute*. Canaletto's works are based on a skillful use of perspective and the precise observation of nature. In his topographical city views he captured the beauty of architecture with great sensitivity. Nuances of atmosphere are created by the interplay of light and shade, as well as by the differentiated coloring of the sky. He also often included genre-like scenes to add some life to his pictures. Canaletto, who worked primarily in England from 1746 to 1753, made Venetian *vedute* famous far beyond the borders of Italy itself. Major works by him include *The Marble Workshop in San Vidal*, c. 1727, The National Gallery, London; *The Fountain of St. Mark*, c. 1739, Museum of the Fine Arts, Boston; and *The Eton Chapel*, 1747, The National Gallery, London.

The Grand Canal, from Palazzo Balbi, c. 1724
Oil on canvas, 144 x 207 cm
Ca'Rezzonico, Venice
In this early work of Canaletto's he shows the longest possible stretch of the Grand Canal, with the Rialto Bridge and the dome of Santa Maria della Salute in the distance. The frame formed by the buildings and the way the use of light varies from the foreground to the background is reminiscent of scene painting. The cloudy sky seems lively in comparison with the peacefully flowing waters with few gondolas.

The Reception of the Emperor's Ambassador in the Doge's Palace, 1729
Oil on canvas, 184 x 265 cm
Private collection, Milan
Canaletto was probably commissioned by the ambassador Count Giuseppe de Bologna to paint the granting of the latter's credentials. He gives us a colorful and detailed depiction of the rituals connected with this state occasion. At the same time, he shows us Venetians of all the different stations in life: Below right, for example, he has painted the nobility and the common citizens separated from one another both by their different clothing as well as by a partition.

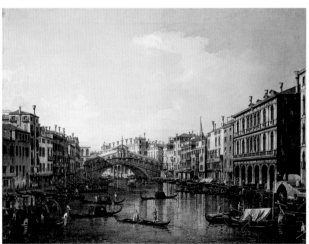

The Rialto Bridge, c. 1737
Oil on canvas, 68.5 x 92 cm
Galleria Nazionale
d'Arte Antica, Rome
In a *veduta* of the Grand Canal, the artist gives us a lovely view of this wooden bridge built in 1591, although the gondolas are the real subject. This part of the canal seems narrow due to the artist's use of shadow, but this impression is reduced by the bright blue sky, which takes up almost the entire top half of the picture and gives the picture a certain festiveness.

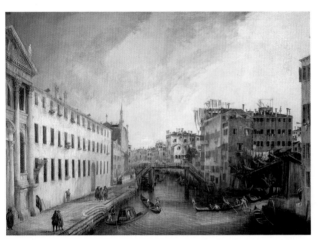

**The Rio dei Mendicanti
(Canal of the Beggars), c. 1723**
*Oil on canvas, 143 x 200 cm
Ca'Rezzonico, Venice*
The Venetian *vedute* painters seldom painted the poorer areas of the city, as they preferred to focus their energies on more beautiful subjects. Therefore, it is surprising that Canaletto has given us such an accurate and detailed view of this shabby area. The undramatic contrast between light and shadow adds to the realism of the picture. This view has an intimate, mysterious atmosphere.

**The Campo San Rocco,
after 1730**
*Oil on canvas, 47 x 80 cm
Woburn Abbey Art
Gallery, Woburn*
In this painting, Canaletto makes deliberate use of a light-filled atmosphere and structural perspective to make this square containing the Scuola di San Rocco appear larger than it really is. He drew sketches of the square from various angles, then combined them in this picture to create a natural, harmonious impression. This synthetic procedure was Canaletto's special trademark, and brought him great recognition throughout Europe.

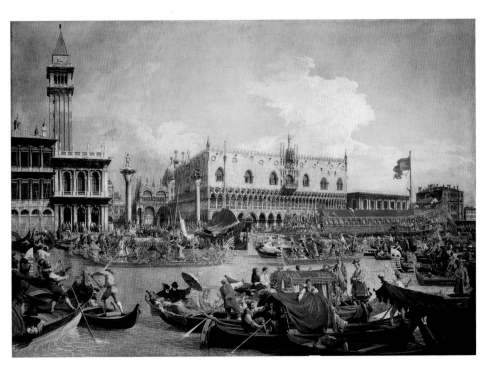

The Bucintoro at the Molo on Ascension Day, 1729
Oil on canvas, 182 x 259 cm
Private collection, Milan
This painting shows an ancient Venetian custom traditionally performed on Ascension Day. The doge, or head of the city, travels out to the open sea on his ceremonial galley, called the *bucintoro*, to throw a ring that represents Venice's symbolic marriage with the sea into the water. Canaletto painted several versions of this festive event. He gives these paintings a narrative character by including many moving figures and the splendid decorations. The shadowy foreground directs our attention to the central image of the doge's galley, also making the scene more spacious.

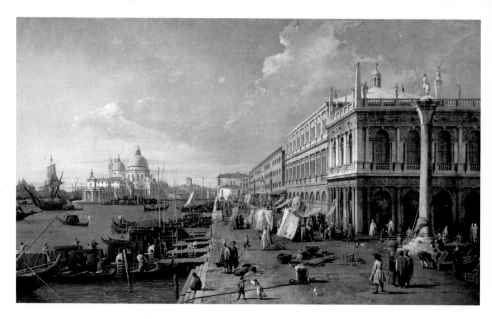

The Molo Against the Zecca, before 1740
Oil on canvas, 110.5 x 185.5 cm
Private collection, Rome
This view of the Molo, the promenade in front of the Doge's Palace, is characterized by the clear division between water and land. The vanishing point of the perspective, which lies almost in the center of the painting, marks the place where the Grand Canal enters the harbor of San Marco. The Santa Maria della Salute church is also visible. The figures enlivening the promenade give this painting the character of a genre picture.

Opposite
The Molo Against the Zecca (detail)
This segment shows some of the bustling activity taking place on the promenade. Some of the people are deep in conversation, while others are busy with cages in which live animals are being offered for sale. Canaletto devotes the same precise attention to detail in his observation of contemporary fashion and the effects of movement as he does in his depiction of the architectural facades. The effect of light is also explored, visible both in the way it glows on the stone column and in the rendering of the long shadows on the ground.

Capriccio with Colonnade, 1765
Oil on canvas, 131 x 95 cm
Galleria dell'Accademia, Venice
Two years after having been accepted as a member of the Academy of Arts in Venice, Canaletto submitted this work as his "Academy piece." It shows an imaginary colonnade that opens onto the court and the first floor of a palace. As in painting scenery for a theater, the vanishing point is in a corner of the building so that the painting has a diagonal construction with a strong feeling of depth. This effect is intensified by the parallel horizontal lines and the extreme foreshortening of the vertical elements. The figures fulfill more than just a decorative function; they also serve to make the perspective more obvious.

Caravaggio, Michelangelo Merisi da

Caravaggio (1571 Milan?–1610 Porto Ercole), born Michelangelo Merisi, studied with Simone Peterzano in Milan from 1584 to 1588 before working in the town of Caravaggio near Bergamo. Around 1592 he went to Rome, where he was employed in several workshops, and soon found patrons at the papal court. He was arrested several times because of his unconventional lifestyle, and spent the last years of his life on the run. In contrast to his contemporary Annibale Caracci, Caravaggio tried to breathe new life into art by portraying people and objects in a more naturalistic way. An extremely realistic depiction of figures as well as strong contrast between light and shadow are characteristics of his works. Although he was shunned by many of his contemporaries, Caravaggio had a great influence on artists of the following generations throughout Europe. His major works include *Christ in the House of Emmaus*, c. 1597, The National Gallery, London; *The Incredulity of Thomas*, c. 1600, Sanssouci Castel, Potsdam; and *David and Goliath*, c. 1609, Museo del Prado, Madrid.

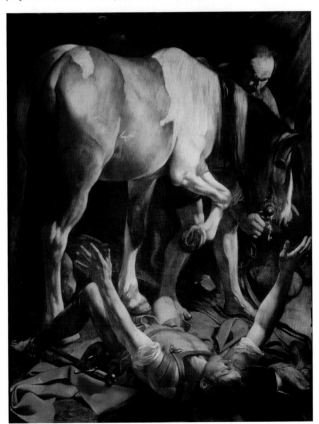

The Conversion of Saul (Conversion on the Way to Damascus), 1601
Oil on canvas, 230 x 175 cm
S. Maria del Popolo, Rome
Here Caravaggio adhered closely to the chain of events related in the Bible. Saul, an army commander, is deeply moved by the appearance of Christ, who calls him to become the apostle Paul. As a result, Saul falls from his horse in shock. In the painting, only the ray of light shining on the prone body indicates the Christ's presence. An old man, sole companion of Saul and sole witness of the event, leads the horse away; it steps carefully over its rider.

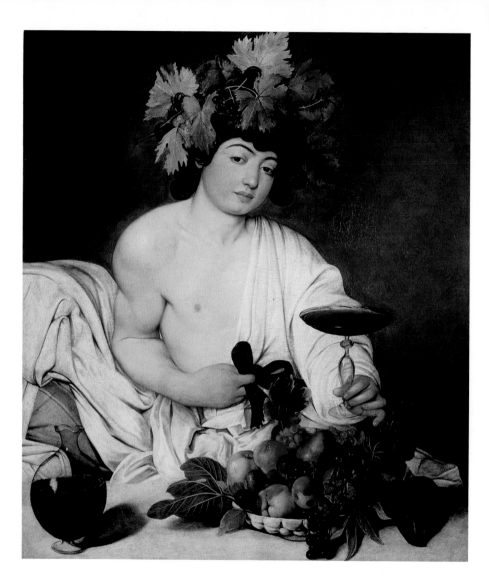

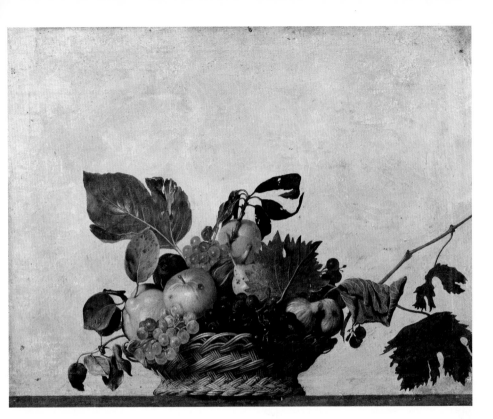

Opposite
Bacchus, c. 1595
Oil on canvas, 95 x 85 cm
Galleria degli Uffizi, Florence
Caravaggio's manner of treating traditional subjects was
revolutionary. In this painting, for example, the wine
god of antiquity is not portrayed as an Olympian deity,
but rather as a somewhat common youth. The mattress
peeping out from under the cloth also indicates an
everyday setting. The sensual poetry of Caravaggio's
painting prevents this profane treatment from becoming
too much like a caricature. This work was probably
painted for Cardinal del Monte.

Basket of Fruit, c. 1594
Oil on canvas, 31 x 47 cm
Biblioteca Ambrosiana, Milan
In this powerful still life Caravaggio created what is un-
doubtedly the earliest masterpiece in the genre. The ap-
parently arbitrary arrangement of fruit and leaves is
skillfully made to stand out against the monochrome
yellow background. This painting entrances the viewer
not only because of the *trompe l'œil* effect and the
"golden section" compositional principles employed in
it (according to which the basket rests slightly to the
left), but also through its abstract character.

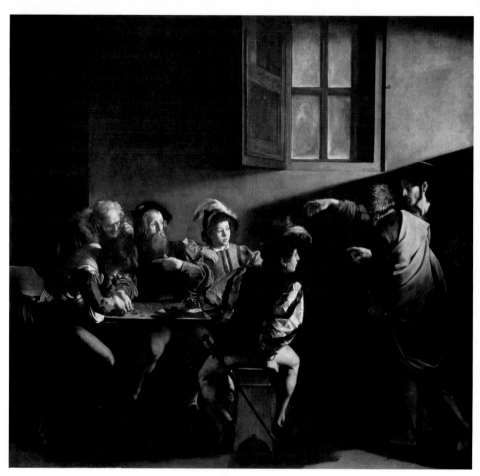

**The Calling of
St. Matthew, c. 1600**
Oil on canvas, 322 x 340 cm
San Luigi dei Francesi, Rome
In this painting, Caravaggio has
combined a Christian subject with
a genre depiction for the first time
in a large-scale painting. Christ—on
the right , behind Peter—appears in
an exchange office and calls upon
Levi, the tax-collector, to become
the apostle Matthew. Although the
main figure, the bearded man wear-
ing a beret, is to the left, the viewer's
attention is nevertheless drawn to
him by the two men pointing at him
as well as by the intensity of the
light shining on him.

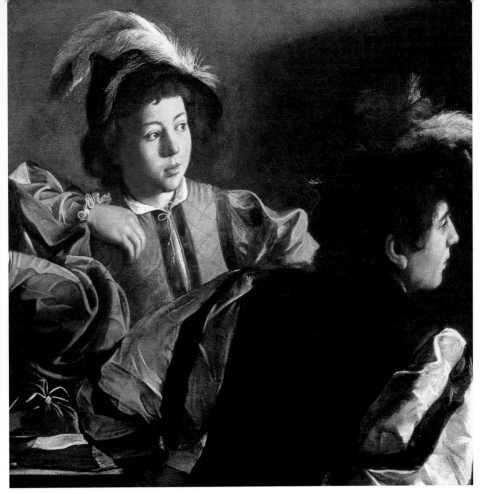

**The Calling of
St. Matthew (detail)**
The ray of light illuminating their
faces draws attention to the two
youths, who appear rather lost in
this group of older men. While one
of them draws back in aprehension
and looks to his older neighbor for
protection, the other has turned
toward the entering figure. Through
the visual contrast between their
reactions, Caravaggio displays psy-
chological insight into two possible
patterns of human behavior in the
same situation.

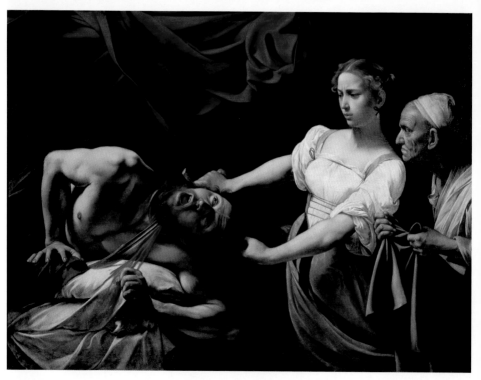

Judith and Holofernes, c. 1600
Oil on canvas, 145 x 195 cm
Galleria Nazionale
d'Arte Antica, Rome

This dramatic painting shows Judith carrying out the terrible deed that liberated her people from its tormentors. According to the Apocryphal story, she was invited into Holofernes' tent and encouraged him to become drunk during a meal. Then she cut off his head using his own sword and took it with her back to the city. In Caravaggio's version, Judith appears unexpectedly from the right along with her maid and beheads the enemy; the lighting emphasizes the macabre details. The splendid red curtain hanging above the scene symbolizes both the bloody nature of the deed and the heroine's triumph. The figures of both Judith and the old maid seem to have been drawn from life. Judith's face and hands have been browned by work in the sun, while the skin of her powerful, active body is pale. The features and workworn hands of the old woman are equally striking.

The Fortune Teller, c. 1597
Oil on canvas, 99 x 131 cm
Musée du Louvre, Paris
With this work, Caravaggio introduced genre painting, which previously had been known only in the Netherlands, into Italian art. In genre painting, an everyday scene carries a hidden meaning. Here, for example, the cunning clairvoyant reads the palm of a well-dressed and armed young man, who is oblivious to the fact that she is pulling the ring from his finger.

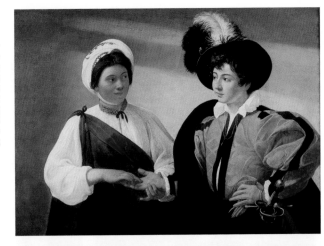

The Lute Player, 1595
Oil on canvas, 94 x 119 cm
The Hermitage, St. Petersburg
The still life in the foreground and the greatly foreshortened lute are painted in a masterly fashion. The music book lying open on the table is the Roman edition of the *Libro Primo* ("First Book") by Jacques Arcadelt, a collection of works by various musicians. The first words of the two madrigals shown indicate the message of the music being played by the androgynous youth: on the right, "Who can say what a delight I feel?" and on the left, "You know that I love you."

The Palafrenieri Madonna
Oil on canvas, 292 x 211 cm
Galleria Borghese, Rome
Here, Caravaggio depicts the first promise of the Redeemer. According to the Bible, after the snake seduced Eve, God cursed it, saying "I will put enmity between you and the woman, and between your seed and her seed; he shall bruise you on the head and you shall bruise him on the heel." (Genesis 3:15.) During the Reformation it was debated whether it was Mary or Jesus who killed the snake; according to papal edict, they did it together.

The Burial of Christ, c. 1603
Oil on canvas, 300 x 203 cm
Pinacoteca Apostolica Vaticana, Vatican
In this altarpiece, originally intended for the church of Santa Maria in Vallicella, Caravaggio concentrates on the sacred event of Christ's burial with exacting attention to detail. The intense grief and bewilderment of the characters is portrayed through their expressive gestures. The figures and objects, particularly the naked body of Christ and the slab of stone protruding into the picture, seem to be shaped by the light, creating the illusion of reality.

St. Jerome, c. 1606
Oil on canvas, 112 x 157 cm
Galleria Borghese, Rome
Caravaggio combines the artistic traditions of both northern and southern Europe in this painting of the Church Father. North of the Alps, this saint was generally shown as a life-size half-length portrait in an interior, while further to the south, he normally appeared as a penitent in the wilderness in the guise of a small, half-naked figure. Caravaggio has removed this latter version from its customary surroundings, enlarged it, and placed it in an indoor setting. The saint's books are lying on a simple wooden table, but there are no details to suggest to the viewer what sort of a room it is. The most important features in the picture are emphasized by lighting effects. Caravaggio has again using a model, but has chosen not to portray the activities usually associated with St. Jerome, and instead has shown him reading with great concentration.

Caron, Antoine

Antoine Caron (c. 1521 Beauvais–1599 Paris) was an important representative of the School of Fontainebleau. He moved to Fontainebleau from his native city and worked there from 1540 to 1550. He developed his typical Mannerist painting style under the tutelage of Niccolò del'Abbate and Francesco Primaticcio. In 1561 Caterina de'Medici (1519–1589) appointed him court painter; in the following years, his duties also included providing the decorations for her large and lavish ceremonies in Paris. Typical of his decorative style of painting are groups of figures in large settings and elongated bodies in affected poses. Striking lighting effects are also characteristic of his work. Important works by the artist include *The Massacre under the Triumvirate*, 1562, Musée des Beaux-Arts, Dijon; *Abraham and Melchisedek*, c. 1590, private collection, Paris; and *Riders with Elephants*, c. 1590, Musée du Louvre, Paris.

Augustus and the Tiburtine Sibyl, c. 1580
Oil on canvas, 125 x 170 cm
Musée du Louvre, Paris
In his works Caron often combines allegorical subjects with contemporary events. Here he has depicted the meeting of Augustus and the Tiburtine Sibyl in front of an impressive architectural background. The Sibyl is predicting the future triumph of the true faith and redemption through Christ. The structure and composition of the picture recall the splendid events and ceremonies that took place at court while Caron was there, and obviously inspired him.

Caroto, Giovanni Francesco

Giovanni Francesco Caroto (c. 1480 Verona—1546 Verona) was the older brother of the painter and art theoretician Giovanni Caroto. He first studied painting in the workshop of Liberale da Verona, then in Mantua with Andrea Mantegna. In 1502 he settled in his native city, but also lived for an extended period in Lombardy. Caroto's early works were mainly influenced by Bernardino, Leonardo da Vinci and Giampietrino. In the 1520s he incorporated new inspiration from Raphael, Giulio Romano and Correggio into his artwork. Caroto's mature style is both Mannerist and eclectic in character. His landscapes are extremely lyrical, and demonstrate the influence of Flemish art. Caroto's most significant works include *Annunciation*, 1508, San Gerolamo, Verona; *Virgin and Child with St. Anne and Saints*, 1528, San Fermo Maggiore, Verona; and *The Temptation of Christ*, 1531, Museo del Castelvecchio, Verona.

Boy with a Drawing, c. 1523
Oil on panel, 37 x 29 cm
Museo del Castelvecchio, Verona
This unusual picture of an unidentified child, which has no symbolic, allegorical or religious message, seems to have been drawn from a very prosaic situation and is probably a portrait. The small boy is showing his work to the viewer with a cheerful, somewhat mischievous expression on his face, and would seem to be competing with the painter. This is a humorous depiction of the boy's naive joy at having produced an artwork.

Carpaccio, Vittore

Vittore Carpaccio (c. 1465 Venice–1525/26 Venice) was an important representative of the Venetian Renaissance. He worked as an assistant in Gentile Bellini's workshop, and was with great likelihood his pupil, as well. Together with Giovanni Bellini, he decorated the Doge's Palace. In addition to these artists, he was also influenced by Antonello da Messina. In his works Carpaccio combines the depiction of real and legendary subjects with motifs of his own invention. Although this "additive" narrative method still displays the influence of the style typical of the early Renaissance, the light-filled atmosphere and the perfectly constructed perspective of his pictures are innovative. Carpaccio painted several series of pictures for the Venetian *scuole*, or confraternities, as well as some religious panels. In these extensive picture sequences the artist relates the lives of saints, transferring them to Venetian surroundings. Other major works of Carpaccio's include *The Miracle of the Relic of the Holy Cross*, 1494/95, Galleria dell'Accademia, Venice; *The Burial of Christ*, 1510, Gemäldegalerie, SMPK, Berlin; and *Portrait of a Young Knight*, 1510, Museo Thyssen-Bornemisza, Madrid.

The Pilgrims Meet the Pope, c. 1491
Tempera on canvas,
281 x 307 cm
Galleria dell'Accademia, Venice
This picture is part of a nine-part series depicting scenes from the life of St. Ursula painted for the Scuola di Santa Orsola. The sequence begins with Ursula, a Christian king's daughter, being courted by a heathen prince, and ends with the martyrdom of the saint at the hands of the Huns in Cologne. The voyage of the large entourage is the main subject depicted, as here in the pope's greeting of the engaged couple in front of the Castel Sant' Angelo in Rome. St. Ursula's retinue appears on the left, while numerous church dignitaries can be seen in the middle and on the right.

Two Venetian Ladies, 1495
Oil on panel, 94 x 63.8 cm
Museo Correr, Venice
The composition of Carpaccio's works is often simple. As can be seen in this painting, figures and objects are placed in juxtaposition to one another without any special finesse. This feature, as well as the mystery attached to the objects depicted, is what makes the picture so interesting. It is still unknown whether these women are bored courtesans sitting on a balcony and waiting, since the hints given by the various symbolic allusions have not yet been deciphered. The painting is an unusually pure genre picture for this epoch.

Opposite
The Birth of the Virgin, c. 1504
Oil on canvas, 126 x 129 cm
Accademia Carrara, Bergamo
This is the opening scene in a six-part series dealing with the life of the Virgin that Carpaccio painted for the Scuola degli Albanesi. In this picture, Carpaccio shows us the living room of a Venetian house of his time, demonstrating that he is also able to depict scenes from private life. St. Anne, the woman who has just given birth, is lying in bed receiving a visitor, while one woman gives her something to eat and another is already preparing a bath for the newborn Mary.

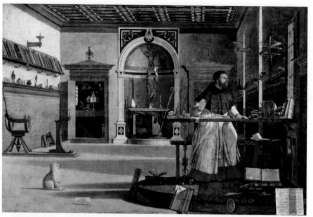

**The Vision of
St. Augustine, c. 1503**
*Oil on canvas, 144 x 208 cm
Scuola di San Giorgio degli
Schiavoni, Venice*
Carpaccio painted a series of pictures with events from the lives of the patron saints of the Scuola di S. Giorgio degli Schiavoni: George, Tryphon and Jerome. St. Jerome appears in this painting as a ray of light entering St. Augustine's study through the window. The soft light endows everything with magical animation. The saint and his dog are both so deeply moved by this mystical vision that they freeze into immobility.

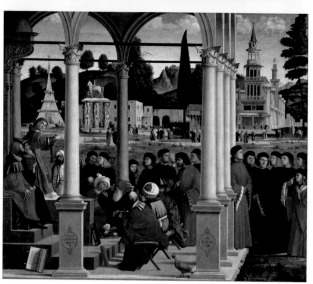

**The Disputation of
St. Stephen, 1514**
*Oil on canvas, 147 x 172 cm
Pinacoteca di Brera, Milan*
The last works produced by this artist are the four paintings of St. Stephen done for the Scuola di San Stephano in Venice. He worked on these pictures from 1511 to 1520 with the help of assistants, who were responsible for the peripheral elements. This painting is the best of the series, outstanding in its clear, all-pervasive lighting and the wonderfully-drawn imaginary buildings.

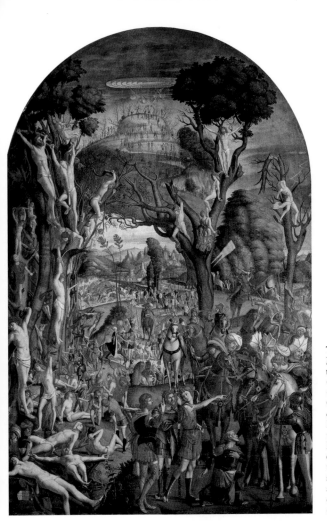

**The Apparition of the
Martyrs of Mt. Ararat in
the Church of St. Anthony, 1515**
*Oil on panel, 307 x 205 cm
Galleria dell'Accademia, Venice*
Carpaccio tends to use light to
convey atmosphere, giving even
large and complex pictures a certain
unity. This tendency, together with
his minutely detailed portrayal of
events, gives his paintings their
unique character. This work, one of
several religious paintings, seems
almost surreal in its unusual
depiction of the landscape and use
of symbolic language.

Carracci, Agostino

Agostino Carracci (1557 Bologna–1602 Parma), the elder brother of Annibale Carracci, was especially important as an art theoretician. He studied with his cousin Ludovico Carracci among others, and subsequently he primarily worked in Ludovico's studio. He was also very involved in the influential Accademia dei Desiderosi in Bologna, which turned its back on late Mannerist tendencies and became the foundation for Baroque painting. In the 1580s he travelled to Parma and Venice with his brother. Around 1597 he followed his brother to Rome, moving to Parma about 1600. In addition to wall and ceiling frescos, Carracci produced numerous pictures and important copperplate engravings. Major works by the artist include *The Assumption of the Virgin*,c. 1592, Pinacoteca Nazionale, Bologna; *Arrigo the Hairy, Pietro the Fool and Amon the Dwarf*, c. 1596, Museo Nazionale di Capodimonte, Naples; and *Portrait of Giovanna Guicciardini*, 1598, Gemäldegalerie, SMPK, Berlin.

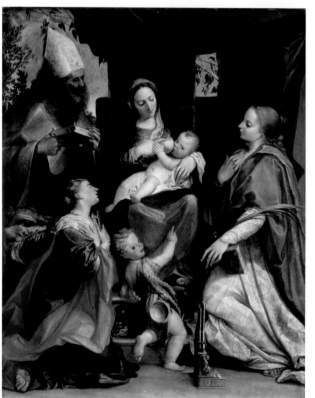

Virgin and Child with Saints, 1586
Oil on canvas, 153 x 120 cm
Galleria Nazionale, Parma
This altarpiece from S. Paolo in Parma shows the Virgin Mary nursing her baby surrounded by St. Benedict, St. Cecilia, St. Margaret and the young St. John. Inspired by Correggio and the opulent palette used by the Venetian painters, Agostino began placing greater emphasis on coloration. Of all the Carracci, Agostino came the closest to the Venetian tradition in his style without ever becoming eclectic.

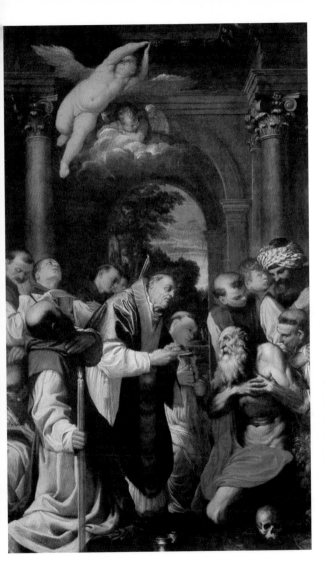

**The Last Communion
of St. Jerome, c. 1592**
*Oil on canvas, 376 x 224 cm
Pinacoteca Nazionale, Bologna*
Around 1590, a noticable change
took place in Carracci's works. The
powerful and carefully planned
style of this painting shows how he
has turned away from the Venetian
manner of painting. Only in a few
areas of the picture does the paint
surface show any complexity.
Carracci has also given the com-
position a static quality, so that the
various figures have a peaceful,
harmonious feeling.

Carracci, Annibale

Annibale Carracci (1560 Bologna–1609 Rome) was born into a family of artists. At first he worked together with his brother in the workshop of their cousin, Ludovico Carracci, who was probably also his teacher. Around 1585 he helped found the Accademia dei Desiderosi in Bologna and later, the Accademia degli Incamminati in Rome, where he settled in 1594. During trips to Parma and Venice he was inspired by the works of Correggio, Titian, Raphael and Michelangelo. He combined these new ideas with an intense study of nature, and developed a clear, harmonious and direct style that idealizes beauty. A rival of Caravaggio, Carracci was the leading painter in Rome. His painting reflects the impact of the art of antiquity and the High Renaissance, and thus manages to free itself from the influence of Mannerism. Important works by the artist include *Venus and Adonis*, 1590, Kunsthistorisches Museum, Vienna; *The Lamentation of Christ*, 1606, The National Gallery, London; *The Assumption of the Virgin*, c. 1600, Santa Maria del Popolo, Rome.

Fishing, 1587/88
Oil on canvas, 136 x 253 cm
Musée du Louvre, Paris
Carracci was a leading influence even when painting idealized landscapes. As this early work already intimates, he took up the development of realistic landscape painting again after it had been interrupted by Mannerism. In his clear, harmonious pictures, segments of real landscapes are combined to form a strict composition. The view into the distance and the foreground, painted in the style of a stage set, are both characteristic of Carracci's style.

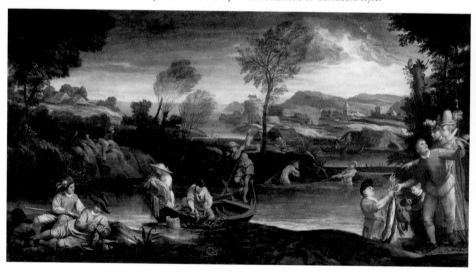

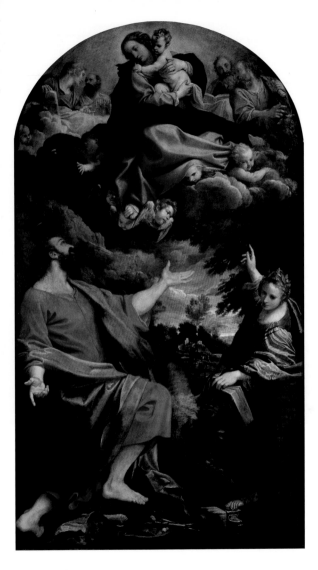

**Virgin and Child
with Saints, 1592**
*Oil on canvas, 401 x 226 cm
Musée du Louvre, Paris*
In this painting, the Virgin Mary,
descending from heaven on a cloud,
appears to the Saints Luke and
Catherine. Carracci's works often
have an expressive and solemn
character, and employ soft lighting
effects; today they seem somewhat
over-sentimental. The powerful
bodies of the figures in this altar-
piece already hint at the idealized,
heroic portrayals in his later works,
which can be characterized as
belonging to the academic style of
Italian Baroque painting.

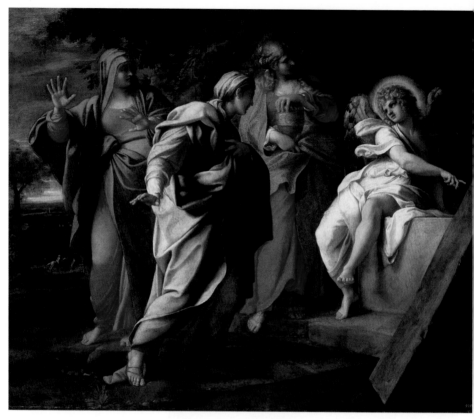

The Three Marys at Christ's Tomb, c. 1600
Oil on canvas, 121 x 145 cm
The Hermitage, St. Petersburg
Carracci has depicted this dramatic scene with great solemnity. An angel announces the resurrection of Christ to the women arriving at His empty tomb. The figures react with dramatic movements that make the weight of their bodies apparent. This work, painted in Rome, is outstanding for its monumental forms and the eloquent treatment of the subject.

Opposite below
Triumphal Procession of Bacchus and Ariadne, c. 1595–1605
Fresco
Palazzo Farnese, Rome
This ceiling painting forms the center of a large series of pictures having as their subject the power of love as exemplified by the Olympian deities. Carracci, who was entrusted with overseeing the project, has returned to the idealized ease that became the new aesthetic concept dominating Baroque fresco painting.

The Bean Eater, c. 1580–1590
Oil on canvas, 57 x 68 cm
Galleria Colonna, Rome
The artists of northern Italy were always quite open to the realistic tendencies of genre pictures from northern Europe. Carracci often depicted the everyday life of common people, adapting his style to fit the coarseness of his subject. Here, for example, he has chosen a simple compositional structure and has applied the earthy tones with crude, simple brush strokes. This "artlessness" enables him to breathe new life into this genre.

Carracci, Ludovico

Ludovico Carracci (c. 1555 Bologna–1619 Bologna) studied with the Mannerist painter Prospero Fontana in Bologna and later with Domenico Passignano in Florence, and worked primarily in his native city. From 1678 on, he was a member of the painters' guild there. Although his works are overshadowed by those of his cousin and pupil Annibale Carracci, he was the first in the artistic family to free himself from the influence of late Mannerism. Through his intense observation of nature he developed a new style by combining impulses from Correggio, Titian and Tintoretto. His workshop was the basis for the founding of the Accademia dei Desiderosi, which he led after the departure of the younger Carracci brothers. His works include *The Bargollini Madonna*, c. 1590, Pinacoteca Nazionale, Bologna; *Scenes from the Life of St. Benedict and St. Cecilia*, 1604/05, S. Michele, Bosco, near Bologna; and *Adoration of the Magi*, c. 1616, Pinacoteca di Brera, Milan.

Opposite

The Annunciation, 1585
Oil on canvas, 210 x 230 cm
Pinacoteca Nazionale, Bologna
Gentle gestures, restrained glances
and above all a fluid, eloquent and
poetic narrative style are typical of
Carracci's simple compositions. The
small number of figures and the use
of predominantly brown tones
distinguish the style of this painting
from the complicated interweave of
figures characteristic of Mannerism.

**The Martyrdom of
St. Margaret, 1616**
Oil on canvas, 340 x 200 cm
S. Maurizio, Mantua
This late masterpiece is outstanding
due to the perfect balance between
all its compositional elements, as
well as for its simplicity and per-
suasive power. St. Margaret is about
to be beheaded for her refusal to
give up her faith and marry the
prefect of Antioch.

**The Martyrdom of
St. Angelus, c. 1609**
Oil on canvas, 218 x 149 cm
Pinacoteca Nazionale, Bologna
In this work from the sacristy of S.
Martino Maggiore, Carracci con-
centrates on the dominating figure
of the saint. Through its refined,
differentiated movement and direct
expression, he gives this figure a
new significance and monumental
power within the composition.

Carriera, Rosalba Giovanna

Rosalba Giovanna Carriera (1675 Venice–1757 Venice) was held in particularly high esteem as a portrait painter by her contemporaries. She received her training from Giuseppe Diamantini and Antonio Balestra, but was also inspired by her brother-in-law, Giovanni Antonio Pellegrini. At first she painted miniature portraits, then turned to larger formats, concentrating on painting with pastels. She was the first to perfect the new technique of chalk painting, which made it possible to work quickly and spontaneously. She was very successful with this method and received many commisions from European courts. In 1705, she was accepted into the Accademia di San Luca in Rome, and became a member of the Academie Royale de la Peinture et Sculpture during her stay in Paris in 1720. She had a lasting effect on French pastel painting and was a genius in bringing out the character traits of her sitters in her portraits. Her pupils included the Carriera sisters and Marianna Carlevaris. Among her significant works are *Portrait of a Young Girl*, c. 1708, Musée du Louvre, Paris; *Portrait of The Dancer Barberina Campanini*, c. 1739, Gemäldegalerie Alte Meister, Dresden; and *Allegory of Air*, 1746, Gemäldegalerie Alte Meister, Dresden.

Self-Portrait, c. 1746
Pastel on paper, 31 x 29 cm
Galleria dell'Accademia, Venice
In this late work, the artist has portrayed herself simply as an elderly woman with her hair brushed back, thin lips and an introverted gaze. The emotional power of the picture is made more intense by the effective gradation of dark tones around the face and throat. The pale skin color and the laurel wreath put one in mind of statues of ancient leaders; in this way, the painter presents herself to the viewer as at once self-confident and vulnerable.

Opposite
Self-Portrait with Portrait of My Sister Noveta, 1709
Pastel on paper, 71 x 57 cm
Galleria degli Uffizi, Florence
Carriera's elegant and lively portraits range from simple studies of heads to carefully planned half-length figures that display the complete lack of any pompous detail and the artist's acute powers of characterization. The transparent, velvety, mother-of-pearl-like colors in this self-portrait, as well as the gentle transitions for which the artist is famous, are achieved by blurring the chalk tones into one another.

Ceruti, Giacomo

Giacomo Ceruti (1698 Milan–1767 Milan) was one of the most interesting Lombard painters of his time. He worked mostly in Brescia, but was also active in Venice and the Veneto around 1736, and in Padua up until 1740. In addition to religious works and portraits, he is especially known for his depictions of the common folk. He shows the plight of this class of society with extraordinary conviction, giving us an unsettling view of humanity unknown until that time. With these pictures, which brought him the nickname of *il Pitochetto* ("little beggar"), he founded a new style of genre painting. Major works by Ceruti include *Women Doing Their Domestic Tasks*, c. 1735, Collezione Conti Salvadego, Padernello, near Brescia; *Laundrywoman*, c. 1736, Pinacoteca Civica, Brescia; and *Still Life with Hen, Onion and Terracotta Vessel*, 1750–1760, private collection.

Boy Carrying a Basket, c. 1735
Oil on canvas, 130 x 95 cm
Pinacoteca di Brera, Milan
Ceruti shows the influence of the local style in his realistic depiction and the use of predominantly brown and white tones. His interest in the common people has nothing to do with his championing their cause, but relates only to their picturesque appearance. Nonetheless, these so-called "beggar pictures" give a sober and at the same time touching insight into the misery of social outcasts.

Opposite
Still Life with Crabs
Oil on canvas, 43 x 59 cm
Pinacoteca di Brera, Milan
Ceruti's very fine still lifes are unjustly hardly known. Here he has placed a small number of everyday objects, vegetables and food in a formal arrangement on a simple wooden table. The crabs suggest a lavish, opulent meal. Despite their simplicity, his still lifes, like his genre pictures, are infused with a poetic truthfulness.

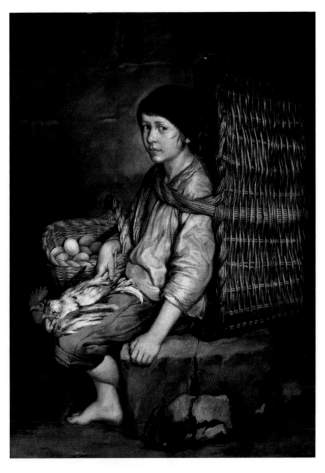

Champaigne, Philippe de

The last teacher of Philippe de Champaigne (1602 Brussels–1674 Paris) was Jacques Fouquières, Rubens' assistant, in Brussels. At first de Champaigne concentrated on landscape painting. In 1621 he went to Paris, where he worked under the Lorrainese painter Georg Lallemant and met Nicolas Poussin. He entered the service of the Queen Mother Maria de'Medici (1638–1683) in 1628. De Champaigne worked in the Palais du Luxembourg, decorated churches and soon received a portrait commission from King Louis XIII (1601–1643) and Cardinal Richelieu (1585–1642). In the 1640s he began to paint religious subjects frequently, and was associated with the Jansenist abbey in Port-Royal de Champs. His great significance in French painting is due to his introduction of Flemish artistic forms. Works by the artist include *The Oath of Louis XIII*, 1638, Musée des Beaux-Arts, Caen; *The Council of Paris*, 1648, Musée du Louvre, Paris; and *Elijah's Dream*, 1655, Musée de Tessé, Le Mans.

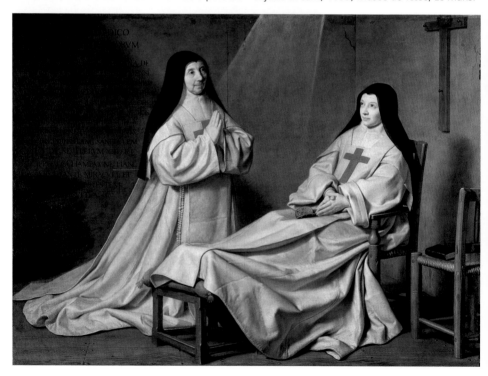

**Portrait of
Cardinal Richelieu, 1635**
Oil on canvas, 222 x 155 cm
Musée du Louvre, Paris
Following Anthony van Dyck's
example, de Champaigne here
shows the cardinal in a full-length
portrait. In this demanding picture,
he combines status consciousness
and individuality to form an artistic
whole despite the exactness of the
detail. The classicizing restrained
elegance and the economical style of
expression were of great importance
to artists of later generations.

Opposite
**Ex voto (Abbess Catherine-Agnès
Arnauld and Sister Catherine
de Sainte-Suzanne), 1662**
Oil on canvas, 165 x 229 cm
Musée du Louvre, Paris
De Champaigne's deep piety was
expressed more and more strongly
in his art after he suffered several
misfortunes in his personal life.
This work was produced after the
miraculous recovery of his daughter,
a nun in the abbey of Port-Royal,
who is seen on the right. She lay
crippled and ill for a long time, but
was suddenly healed after the
abbess had prayed for nine days. It
is typical of this artist that he does
not show the moment when she
recovered, but instead the two nuns
praying trustingly.

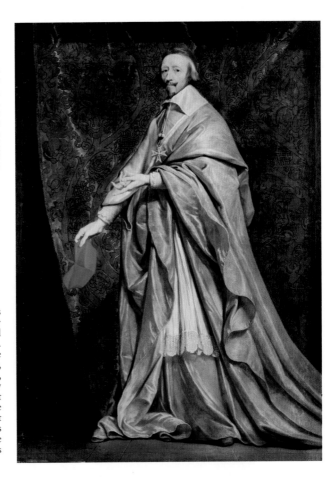

Chardin, Jean-Baptiste-Siméon

From 1720 Jean-Baptiste-Siméon Chardin (1699 Paris–1779 Paris) was the pupil of Noël Nicolas Coypel and Pieter Jacques Cazes, both painters of historical scenes. He then studied in Fontainebleau with Jean-Baptiste van Loo. In 1724 he became a member of the Guild of St. Luke and in 1728 was accepted into the Royal Academy, where he held important positions until 1774. Chardin depicts quiet scenes with poetic intensity, but without any surprise effects or symbolic meaning. His use of restrained, carefully graded color tones, the apparently arbitrary arrangement of the objects in his pictures, and the lack of any emphasis through lighting represent a combination of Dutch models with French tradition. He succeeded in making the still life and the genre painting, both of which were held in low regard at that time, extremely important elements of French art. Major works by the artist include *Child with a Top*, 1738, Musée du Louvre, Paris; *Woman Cleaning Turnips*, c. 1738, National Gallery of Art, Washington; and *Girl with Shuttlecock*, c. 1740, Galleria degli Uffizi, Florence.

The Skate, 1727/28
Oil on canvas, 114 x 146 cm
Musée du Louvre, Paris
This kitchen piece led to Chardin's acceptance into the Academy as a "painter of animals and fruit." Although it is very much in the Dutch tradition, one can see the emerging individual characteristics of its painter. For example, the painting shows his sense for the texture and form of objects, and gives them an aesthetic life of their own quite apart from their realistic depiction. Chardin also achieves a sense of distance from the viewer through the balanced composition.

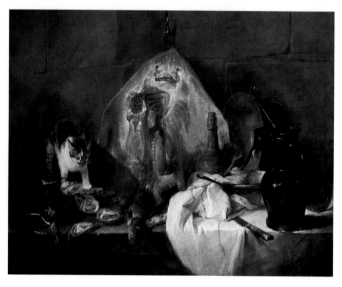

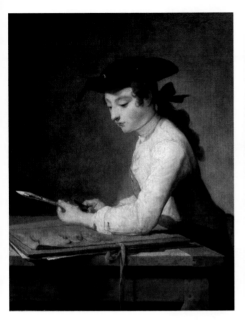

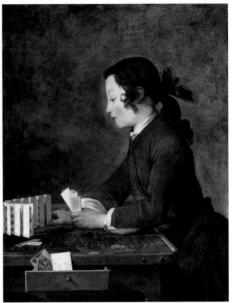

The Young Draftsman, 1737
Oil on canvas, 81 x 64 cm
Musée du Louvre, Paris
Inspired by the Dutch painters of the 17th century, Chardin created a tranquil, relaxed pictorial space in his portraits of children, of which he did several versions. This young artist, while completely absorbed in what he is doing, also seems composed and introspective. Chardin has captured this moment in the manner of his still lifes, depicting simple beauty without including any distracting or overly decorative details.

Boy Playing Cards, c. 1740
Oil on canvas, 82 x 66 cm
Galleria degli Uffizi, Florence
In his genre paintings Chardin merges the portrait elements into a scene of quiet poetry, thus giving them the appearance of timelessness. Despite the sense of enclosure brought about by the narrowness of the picture, the boy remains out of reach for the viewer. He has been portrayed in profile, pensive and involved in his game. The quiet pose, the cards and the half-open drawer show the similarity of genre pictures to still lifes.

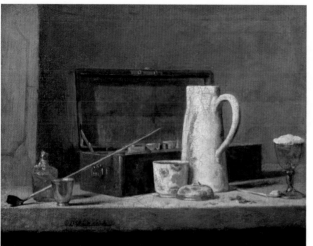

**Still Life with Pipes
and Pitchers, c. 1762**
Oil on canvas, 32 x 42 cm
Musée du Louvre, Paris
This late work clearly shows the
transformation that has occurred in
Chardin's painting style. The seem-
ingly arbitrarily arranged objects
are rendered using dull colors
and are bathed in a mild, subdued
light. Chardin emphasizes the dif-
ferent textures through the way
they are juxtaposed, an effect that is
intensified by the contrast between
vertical and horizontal elements.
The composition thus has an overall
sense of peace and inner warmth.

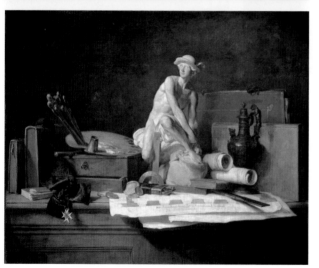

The Attributes of the Arts, 1765
Oil on canvas, 112 x 140.5 cm
Musée du Louvre, Paris
In this work, Chardin reveals his
view of the essence of art. In the
center stands Mercury, the mes-
senger of the gods and conveyor of
artistic inspiration, surrounded by
the attributes of the various artistic
disciplines: palette and brush for
painting, statue and calipers for
sculpture, and protractor for archi-
tecture. The reward for disciplined
work is public recognition; this is
represented by the sash with a
medal. Chardin has made use of
emphatic lighting, an element which
is unusual for him. The detail on the
opposite page shows the strong
contrast between light and shadow
caused by the light falling upon
Mercury at an angle. The god is
shown tying the laces of his sandals.

Christus, Petrus

Petrus Christus (c. 1415 Baerle, near Antwerp– 1472/73 Bruges) is considered one of the most important successors of Jan van Eyck, and was a leading representative of the Bruges School. Upon van Eyck's death, Christus took over his workshop in 1441 after having been his assistant, and completed several works that van Eyck had left unfinished. He was also greatly influenced in the 1440s by the art of Robert Campin and Rogier van der Weyden. Christus further developed the use of perspective by empirically discovering the law of linear perspective and applying it to his painting. He was the first artist to paint portraits of sitters in front of an interior. Recent research, in particular, tends to evaluate him increasingly as an independent artist rather than as a mere imitator of the great masters. His landscapes are also of signifi-

cance: In these, he applied the basic rules of perspective in a manner that broke new ground for his successors. Among his major works are *The Carthusian Monk*, 1446, The Metropolitan Museum of Art, New York; *St. Eligius as a Goldsmith Gives a Ring to the Bridal Couple*, c. 1449, The Metropolitan Museum of Art, New York; and *The Nativity*, 1452, Gemäldegalerie, SMPK, Berlin.

Pietà, c. 1455
Oil on panel, 101 x 192 cm
Musées Royaux des Beaux-Arts, Brussels
This early work already shows Christus' individual style. By simplifying and clarifying van Eyck's compositional method and using block-like, isolated figures that are no longer connected by complex symbolic associations, he achieved a new, sober pictorial concept.

**Portrait of a Young
Woman, c. 1470**
*Oil on panel, 28 x 21 cm
Gemäldegalerie, SMPK, Berlin*
This carefully planned composition
marks a new stage of development
in Dutch portrait painting. The
picture does not show this young
woman, hardly more than a child,
against an undefined background,
but in an interior suggested by the
paneling on the wall. The unknown
sitter emanates courtly elegance,
and seems both fascinating and
unapproachable. The fashionable
and exquisite clothing perhaps
points to the young woman as
being of French extraction.

Cima da Conegliano

Cima da Conegliano (c. 1459 Conegliano–1517/18 Conegliano), whose given name was Giovanni Battista Cima, probably studied painting with Bartolomeo Montagna in Vicenza as well as with Alvise Vivarini. He was also notably influenced by the works of Antonello da Messina, and later by Titian and Giorgione. In 1492 he went to Venice, where he worked until 1516. Cima developed an independent style early on, although his works remain thematically and artistically close to those of Giovanni Bellini. His compositions, which tend to display a calm balance, are characterized by their emotional content; a gentle, peaceful atmosphere; and precise observation of nature. Cima da Conegliano painted mostly religious motifs, chiefly Virgin and Child compositions, but also dealt with some secular subjects. Major works by the artist include *Virgin and Child with Saints*, 1489, Galleria dell'Accademia, Venice; *The Baptism of Christ*, 1494, San Giovanni in Bragora, Venice; and *The Healing of Annanias*, c. 1498, Gemäldegalerie, SMPK, Berlin.

The Incredulity of Thomas,
with St. Magnus, c. 1497–1504
Oil on panel, 215 x 151 cm
Galleria dell'Accademia, Venice
This scene from the Bible is presented in a simplified form with a reduced number of figures; instead of all the disciples, only St. Magnus is depicted. The work is filled with deep inner warmth, especially seen in the gesture with which Christ directs the doubter's hand. The skillful proportioning of the bodies; the precise, careful drawing; and the lively, fresh coloring in this panel are all remarkable. The figures stand under a gateway that closes off the composition from the outside.

Opposite
Virgin and Child with St. John the Baptist
and Mary Magdalene, c. 1513
Oil on panel, 167 x 110 cm
Musée du Louvre, Paris
This late altarpiece from the church of S. Domenico in Parma is also highly expressive. The Virgin Mary, John the Baptist and Mary Magdalene all have turned devotedly to the Baby Jesus. The peacefulness of the scene is reflected in the broad landscape in the background. The clear composition of the meadows and hills and the soft, transparent light give the picture a certain grace. Mary is sitting on a throne backed by a splendidly decorated baldachin.

Cimabue

Cimabue (c. 1240–1302?), whose real name was Cenno di Peppo, probably received his training in the mosaic workshop of the Baptistery in Florence, leaving it sometime around 1260. There is documentary evidence placing him in Rome in 1272 and in Pisa in 1301/02. Cimabue was still very much influenced by Byzantine art, but began to move beyond it by the suggestion of plasticity, three-dimensionality and movement apparent in his works. He also increasingly turned away from the tendency to distort figures prevalant in the medieval tradition of western Europe. He was able to create pictures that were monumental and intense without being stylized. This new style made him one of the pioneers of new Italian painting. The poet Dante Alighieri (1265–1321) was already describing him as the best artist prior to Giotto. Significant works by the artist include *Crucifix*, c. 1260–1270, San Domenico, Arezzo; *Frescoes*, c. 1277, Basilica Superiore di San Francesco, Assisi; and *Virgin and Child Enthroned with St. Francis*, c. 1277, Basilica Inferiore di San Francesco, Assisi.

Maestà, c. 1270
Tempera on panel, 427 x 280 cm
Musée du Louvre, Paris
Cimabue painted several versions of the Virgin and Child enthroned. In this panel from Pisa, his desire for plasticity is apparent in the realistically depicted backrest of the throne, which the angels seem to be holding. Although the faces are not differentiated, they do display lively, if restrained, emotions. The monumentality of the picture is emphasized by the balanced, symmetrical structure of the composition.

Opposite
Santa Trinita Madonna, c. 1280
Tempera on panel, 385 x 223 cm
Galleria degli Uffizi, Florence
For Santa Trinità in Florence, Cimabue painted this altarpiece showing the Christ Child holding up his hand in blessing with eight angels around the throne. Christ's forebears, Abraham and David, can be seen at the bottom center, with the prophets Jeremiah and Isaiah to either side. This interpretation of the subject is without precedent in its monumentality and complexity. The composition and the placement of the angels are again strictly symmetrical.

Claesz., Pieter

Pieter Claesz. (c. 1597 Westphalia–1660/61 Haarlem) is documented as having been in Haarlem from 1617 onward; little is known with certainty about his early life. At first he painted still lifes with different collections of extravagent household items. Together with Willem Claesz. Heda, he then developed the genre of the *monochromen banketje*, a variation of the breakfast still life. In these pictures he avoids the opulence of Flemish models and selects a few objects that he arranges as if by chance on white tablecloths. Characteristic of his style is an earthy palette consisting of tones of brown, ochre, gray and white with little highlighting. With this style, Claesz. gave Dutch still-life painting its classical stamp. Major works by the artist include

Breakfast with Pewter Jug, 1643, Musées Royaux des Beaux-Arts, Brussels; *Breakfast with Ham*, 1647, The Hermitage, St. Petersburg; and *Still Life with Fruit*, 1649, The National Gallery, London.

Still Life with Musical Instruments, 1623
Oil on canvas, 69 x 127 cm
Musée du Louvre, Paris

Dutch still lifes frequently contain a contrast. On the one hand, their well-ordered compositions show picturesque objects whose beauty is made yet more intense by the manner in which their texture and form are rendered, while on the other hand, these same objects remind the viewer of the transitory nature of all earthly things. Objects such as the watch or the mirror in the detail shown opposite symbolize the concept of *vanitas*, the vanity and ephemeral nature of humankind.

Still Life with Candleholder, 1627
Oil on panel, 26.1 x 37.3 cm
Mauritshuis, The Hague
The concept of *vanitas* is also apparent in this painting. The almost burned-out candle symbolizes the finite nature of human existence. Man's earthly life is represented by the books resting on the table. In the center of the composition is a goblet filled with wine. This symbol for redemption also promises a paradise on earth. Still lifes of this type reached their zenith in 17th-century Dutch painting.

**Still Life with Pipes
and Brazier, 1636**
Oil on panel, 49 x 63.5 cm
The Hermitage, St. Petersburg
The contrast between light and shadow created by the strong light coming in at an angle—a contrast that is heightened by the black tablecloth—and the light's reflections make the objects in this picture seem three-dimensional. In addition, the empty space surrounding them gives them a special aura. Claesz.'s still lifes are usually simple in style. They are characterized by a great variety both in the selection of the objects depicted and in the composition. Claesz. often places objects on the very edge of a table to reduce any sense of distance from the viewer.

Breakfast with Fish, 1653
Oil on canvas, 80.5 x 67 cm
The Hermitage, St. Petersburg
This depiction of the pleasures of the table is a reminder of the "real" life after death—represented by the gathered-up tablecloth and the drinking vessels that have fallen over—and thus also of the emptiness of earthly things, as suggested by the costly plates and the pipe. At the same time, redemption through Christ is intimated by the fish, wine and bread. The essence of the picture's message is contained in the half-peeled lemon: The appearance of external beauty often masks sourness inside.

Cleve, Joos van, the Elder

Joos van Cleve the Elder (1485? Cleve or Antwerp–1540/41 Antwerp), also called Josse van Cleef or Joos van der Beke, was almost certainly the artist known as the "Master of the Death of the Virgin," and it is likely that he visited Milan and Paris at some point in his career. In 1511 he entered the Guild of St. Luke in Antwerp. Cleve's art, which shows traits of both the late Gothic style and of Mannerism, was also influenced by the work of Quentin Massys, Jan Gossaert and Leonardo da Vinci. It is thanks to Cleve that Dutch painting was given new energy through contact with Italian art. Typical of his paintings are a fine sense for the weight of each color, the avoidance of dramatic excesses, a slightly cluttered use of figures, and a masterly rendering of various textures and forms. The influence of Italian painting on his works is especially apparent in the clear, expressive nature of his portraits. Among the artist's works are *The Death of the Virgin*, before 1523, Alte Pinakothek, Munich; and *The Adoration of the Magi*, c. 1527, Gemäldegalerie Alte Meister, Dresden.

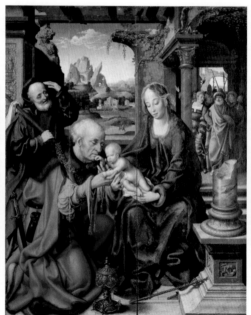

**Portrait of an
Unknown Man, 1520**
Oil on panel, 57 x 42 cm
Galleria degli Uffizi, Florence
Van Cleve looked not only to
Flemish models for inspiration for
his portraits. The peaceful colors
used in the backgrounds and the
careful tonal gradations put one in
mind of the poetical, lyrical atmos-
phere of Leonardo da Vinci's *Mona
Lisa*. The "talking" hands, often
considered an artistic weakness,
are possibly a deliberate substitute
for the background scenes, full of
symbolic allusions, that were a fea-
ture in earlier Dutch works.

Opposite
The Adoration of the Magi
Oil on panel
Central panel: 117 x 95 cm
Side panels: 117 x 43 cm each
Museo Nazionale
di Capodimonte, Naples
The subject of this picture is de-
picted unconventionally. Two of
the Wise Men appear as monu-
mental figures on the altar wings,
separated from the main group.
This scene with its elegant figures,
some of them gesticulating vehe-
mently, has as its background a
broad, light-filled landscape. As
in other altarpieces, Joos van Cleve
has united late Gothic and Man-
nerist elements in this work.

Clouet, François

François Clouet (c. 1520 Tours?–1572 Paris), also called François Janet, was probably the pupil of his father, Jean Clouet, with whom he worked in Tours and then at the royal court in Paris. After his father's death, he worked for Francis I (1494–1547) and for the rulers that succeeded him. His portraits and mythological paintings show the influence both of the realistic, naturalistic style of northern Europe and of German courtly painting. Clouet also adopted elements of Florentine Mannerism. Major works by the artist include *A Lady at her Bath*, 1550–1560, The National Gallery of Art, Washington D.C.; and *Portrait of Charles IX*, 1563, Kunsthistorisches Museum, Vienna.

Portrait of the Apothecary Pierre Quthe, 1562
Oil on panel, 91 x 70 cm
Musée du Louvre, Paris
This picture clearly shows Clouet's interest in Lombard art after the influence of Leonardo da Vinci. He had possibly also come in contact with artists belonging to the school of Fontainebleau. Clouet's use of color and manner of composition serve not only to emphasize the composure and illustriousness of his aristocratic sitters, as in this picture: The artist also demonstrates a very fine touch in his rendering of clothing, jewelry, the curtain and other details.

Portrait of Francis I of France on Horseback, c. 1540
Oil on panel, 27.5 x 22.5 cm
Galleria degli Uffizi, Florence
It is still a matter of contention who painted this small official portrait, considered to be either an early work of François Clouet or a late work of his father, Jean Clouet. The king is sitting proudly on his horse, and his armor and trappings have been depicted in splendid detail. Although this impressive figure lacks any inner vitality, the cunning expression alerts us to the fact that we are dealing with the clever rival of Charles V (1500–1556) of Spain.

Clouet, Jean

Jean Clouet (c. 1480 Brussels or Tours–c. 1540/41, Paris), also called Jean Janet, worked at first in Tours, where he was in the service of Francis I from 1516. In the 1520s he worked at the king's court in Paris, becoming first painter to the king in 1533. In his artworks, which are influenced by Dutch art, he combines elements of the Gothic and early Renaissance styles. He was equally inspired by both the School of Fontainebleau and the Italian Mannerists. Although no work can be definitely credited to him even now, some paintings have been ascribed to his name on the basis of existing portrait drawings. There are no religious works documented as being from his hand. Works most likely by the artist include *The Man with the Book by Petrarch*, 1530, Royal Collection, Hampton Court Palace; and *Portrait of Guillaume Budé*, 1535, The Metropolitan Museum of Art, New York.

King Francis I, c. 1525
Oil on panel, 96 x 74 cm
Musée du Louvre, Paris
Clouet's pictures, which are painted using powerful, cool colors, display objective powers of observation, a feeling for elegance and a mastery of the art of painting. In this picture, he has employed great care in the execution of details and sets off this portrait of the king against a background bearing the royal insignia by the use of rich red and gold colors. The personality of the sitter seems cool and remote.

Constable, John

John Constable (1776 East Bergholt–1837 London) was at first self-taught as an artist. From 1795 he worked as a painter of topographical pictures in London. In 1799, he attended courses at the Royal Academy, of which he became a member in 1829. He was particularly inspired by the old masters as well as by Thomas Gritin and Claude Lorrain. At first he painted portraits and religious pictures, but later turned to landscapes after an influential trip to Italy in 1819. The main feature of his works is a vital observation of nature based on precise studies. He sought above all to accurately capture the precise look of the vegetation and the sky in different weather and lighting conditions. Along with J.M.W. Turner and Richard Parkes Bonington, Constable developed a style of landscape painting that influenced artists throughout Europe, especially the School of Barbizon and later the Impressionists. Among the artist's works are *The White Horse*, 1819, The Frick Collection, New York; *The Haywain*, 1821, The National Gallery, London; and *The Valley Farm*, 1835, Tate Gallery, London.

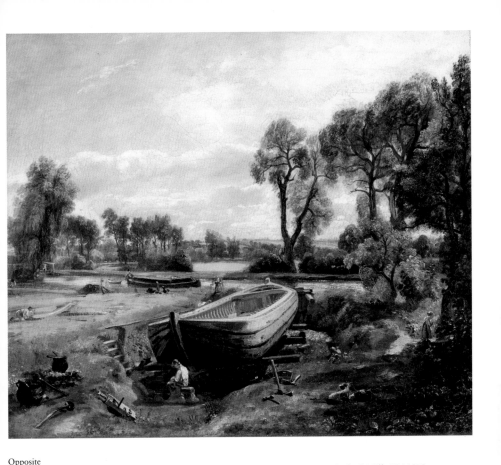

Opposite
Dedham Mill, 1820
Oil on canvas, 51 x 77 cm
Victoria and Albert Museum, London
Constable liked to paint the landscape of the area where
he was born, as in this picture of his father's mill: simple,
objective depictions of farming life in different weather
conditions and seasons or at various times of day. From
1818–1820 he painted three versions of this view, while
his relationship to nature grew ever closer.

Boat Building near Flatford Mill, 1814/15
Oil on canvas, 50.8 x 61.9 cm
Victoria and Albert Museum, London
Constable was the first artist to preserve his impressions
of nature directly in the form of sketches. In this work
showing the dry dock at Flatford, he went one step
further by painting this small picture on the spot. It is
the only painting he did completely in open air, and thus
has a special place in the painter's œuvre.

View of Salisbury Cathedral, 1823
Oil on canvas, 87.6 x 111.8 cm
Victoria and Albert Museum, London
Constable painted this scene several times. The version shown above was intended for the Bishop of Salisbury, who can be seen standing on the far left with his wife. The skillfully arranged composition expresses the harmony between natural and human influences. The tower of the cathedral, which stands radiant in the sunshine, suggests that this harmony is God-given.

Opposite below
Brighton Beach with Colliers, 1824
Oil on paper, 14.9 x 24.8 cm
Victoria and Albert Museum, London
Constable's rejection of traditional principles of composition and coloring, his glowing colors, and a sketch-like style achieved through spontaneous, laconic brush strokes allow viewers to experience the landscape quite directly. These innovations caused quite a sensation and were adopted enthusiastically by artists including Eugène Delacroix and Théodore Géricault.

Old Sarum, 1829
Oil on cardboard, 14.3 x 21 cm
Victoria and Albert
Museum, London

During his visits in Salisbury, Constable made many sketches of this nearby hill, originally the bishop's residence. He may have created these drawings out-of-doors, and then added the figures at a later date. The abstract depiction of the natural phenomena—the stormy sky, the strange light of dusk and seemingly festive color effects—relay his fascination with this out-of-the-way place in a penetrating manner.

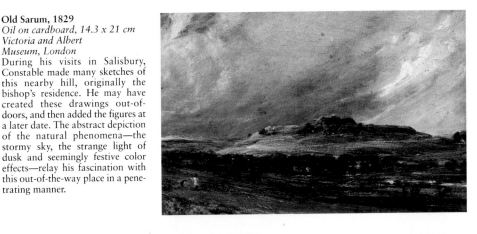

Cornelis van Haarlem

Cornelis van Haarlem (1562 Haarlem–1638 Haarlem) was one of the leading representatives of Dutch Mannerism. He was a pupil first of Pieter Pietersz. and then of Gillis Cogniet in Antwerp. In 1583 he returned to his native city, where he worked as a painter and architect and helped found the local academy. Under the artistic influence of Jan van Hemessens and Bartholomäus Sprangers, Cornelis's painting focused mostly on religious and mythological subjects, but also portraits and some hunting pieces. Typical of his style are representations of nude, muscular bodies and a strict observance of the laws of perspective. His early works often contain many figures, but later he reduced the number to only a few, allowing the background landscape to become more important. His significant works include *Haarlem Hunters' Dinner*, 1583, Frans Hals Museum, Haarlem; *The Slaughter of the Children in Bethlehem*, 1591, Frans Hals Museum, Haarlem; and *The Marriage of Peleus and Thetis*, 1593, Frans Hals Museum, Haarlem.

The Baptism of Christ
Oil on canvas, 170 x 206 cm
Musée du Louvre, Paris
The baptism itself, which confirmed Jesus as the Messiah, has been placed by Cornelisz. somewhat in the background. John the Baptist pours water from the Jordan River over Christ's head, while the Holy Ghost hovers above them in the guise of a dove. Several figures have been added to the scene, including a completely nude Adam and Eve. Depicted in this manner, they form a reference to redemption through God's Son as well as to the Paradise to come.

Corot, Jean-Baptiste Camille

Jean-Baptiste Camille Corot (1796 Paris–1875 Paris) was apprenticed to a cloth merchant before he began to study with the classical landscape painter Victor Bertin in the early 1820s, among others. Although he was formally trained in the style of Nicolas Poussin, he also copied works by Charles Vernet and the 17th-century Dutch masters as well as working from nature. Corot's long stays in Rome had a strong influence on his art. His landscapes are noted for their strict, clear composition, precision of detail and the spontaneous way they capture changing light conditions and moods. By the end of the 1840s, inspired by painters from the Barbizon School, he had developed a diffuse, sketchy representation of forms that was secondary to the mood they expressed. His atmospheric landscapes had a great influence on the Impressionists. Works by the artist include *The Colosseum in Rome as Seen from the Farnese Gardens*, 1826, Musée du Louvre, Paris; *A Remembrance of Morte-Fontaine*, 1864, Musée du Louvre, Paris; and *The Studio (Young Woman with Mandolin)*, 1866, Musée du Louvre, Paris.

Chartres Cathedral, 1830
Oil on canvas, 62 x 50 cm
Musée du Louvre, Paris
Corot painted this view and others of the cathedral while he was staying in Chartres during the July Revolution. The light blue and ochre tones recall his Italian landscapes, but in this case the painting is suffused with the lighter gray color that was becoming typical of his works. He added the seated man and worked over the figure of the standing woman after selling the picture in 1872.

The Stone Quarry at Fontainebleau, c. 1833
Oil on paper, mounted on canvas, 33.6 x 58.8 cm
Museum voor Schone Kunsten, Ghent
This study is one of the best of several works created by the artist in the forest of Fontainebleau. The way objects are shaped by the light falling upon them—the same technique used by Constable—and the inclusion of figures both entrance the viewer. It seems as if Corot has painted these figures directly from nature, not later in his studio, as was the case in earlier works.

Woman in Blue, 1874
Oil on canvas, 80 x 51 cm
Musée du Louvre, Paris
Corot's figure paintings, which
belong to his late period, became
known only after his death. He
obviously considered them to be his
private artistic arena, and used
them as experiments. This work is
very progressive with its clever use
of a few densely applied tones.
Uncharacteristically for Corot, the
young woman appears as a full-
length figure in elegant, fashionable
clothing, which suggests that this is
a portrait of a woman he knew well.

Opposite below
The Bridge at Narni, 1826
Oil on paper, mounted on
canvas, 34 x 48 cm
Musée du Louvre, Paris
Corot was one of the first artists to
make this type of oil sketch out-
doors, a method also favored by the
Impressionists. The work shows
his feeling for a harmonious use of
color employing fine tonal grada-
tions and subordinated to the
natural coloring of the landscape.
His use of his command of color to
create a sense of perspective and the
way he has captured the mood of
the scene are also remarkable. Later
artists were especially enthusiastic
about the lighting effects and the
bright overall impression made by
this landscape. The Impressionists,
in particular, can be considered
Corot's successors.

Correggio

Correggio (c. 1489 Correggio, near Modena–1534 Correggio), born Antonio Allegri, was one of the most important painters of the High Renaissance in Italy. He worked in Rome, Parma and in his native city. He was probably the pupil of Francesco Bianchi Ferrari, but was deeply influenced by the work of Andrea Mantegna and Leonardo da Vinci, and later also by Raphael and Michelangelo. Correggio became a pioneering master of illusionistic painting by trying to achieve the best possible expression of lightness and grace. He employed tone and color to counterbalance his forms, thereby developing innovative effects of light and shadow. He created superb three-dimensionality by means of foreshortening and overlapping; and used lighting along with the aligning diagonals to create a depth of field that he incorporated into the events depicted. His works include *The Vision of St. John the Evangelist*, 1522, San Giovanni Evangelista, Parma; *Adoration of the Shepherds*, 1528, Gemäldegalerie Alte Meister, Dresden; and *Jupiter and Io*, c. 1531, Kunsthistorisches Museum, Vienna.

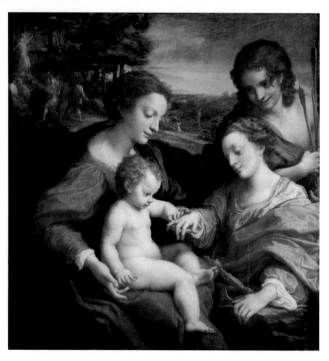

**Virgin and Child with
Sts Jerome, Mary Magdalen and
John (The Day), 1523**
Oil on panel, 205 x 141 cm
Galleria Nazionale, Parma
This altarpiece depicting the Ma-
donna surrounded by St. Jerome,
Mary Magdalene and the young St.
John is one of the artist's best-
known works. Correggio had a
great influence on the development
of religious painting in the Renais-
sance with his vivid depiction of
emotions such as tenderness and
devotion, as well as with his com-
positional style. His soft, tranquil
coloring also anticipates developing
trends in Baroque art.

Opposite
**The Mystic Marriage of
St. Catherine, c. 1517**
Oil on panel, 105 x 102 cm
Musée du Louvre, Paris
The saint is seen receiving a wed-
ding ring from the hand of the
Christ Child, with St. Sebastian
appearing behind her as a witness.
The martyrdom of the two saints is
depicted in the lovely landscape in
the background. This picture radi-
ates grace and a sublime mood. As
in other works from this period, the
artist has rejected the usual hierar-
chical structure in favor of a vital
asymmetry, which is nonetheless
brought into balance by the delicate
colors and the light that transforms
everything in the picture.

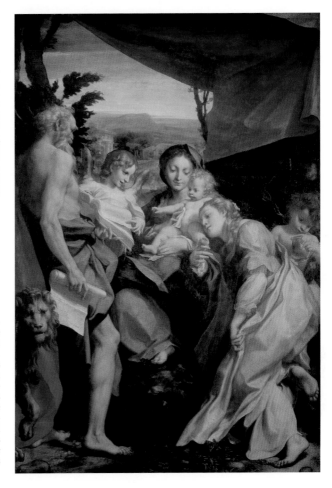

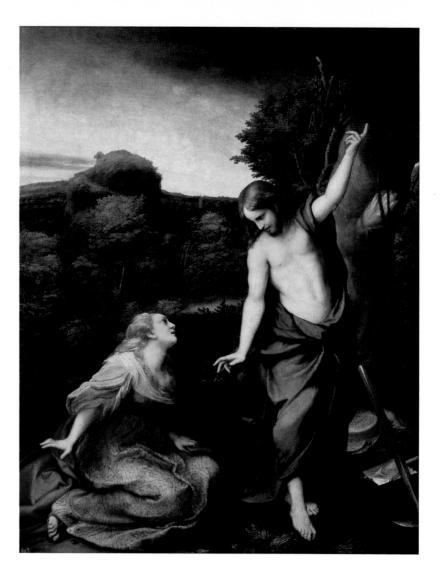

Opposite
Noli Me Tangere, c. 1523
Oil on canvas, 130 x 103 cm
Museo del Prado, Madrid
Here Correggio has captured Mary
Magdalene's powerful emotions up-
on seeing the resurrected Christ on
Easter Monday, without reference
to earlier models. Christ is depicted
in full-length glory. Mary Magda-
lene's reaction to his command
"Do not touch me!" is to back
away in astonishment, though she
maintains an expression of deep
affection. With his raised arm Christ
indicates the Ascension to come.

Jupiter and Antiope, c. 1524
Oil on canvas, 188 x 125 cm
Musée du Louvre, Paris
Jupiter approaches the Theban
princess in the guise of a lascivious
satyr in order to better seduce her:
This intention is indicated by the
sleeping figure of Cupid. The silken
skin of the dreaming woman ema-
nates an inner radiance unknown in
painting before that time. The sweet
grace with which Correggio depic-
ted feminine beauty was also new,
and was admired by painters as late
as the 18th century.

The Adoration of the Child, 1524
Oil on canvas, 81 x 67 cm
Galleria degli Uffizi, Florence
This painting may refer to Correg-
gio's best-known work, *The Nativi-
ty*, which was painted in 1530 and
now hangs in the Gemäldegalerie
Alte Meister in Dresden. In this
work, the Christ Child is depicted in
a milder form as a "miracle of
light" that illuminates the sur-
roundings along with the natural
lighting. The devoted expression
of the Mother of God is also
characteristic of Correggio's works.

Lamentation, c. 1525
Oil on canvas,
157 x 182 cm
Galleria Nazionale, Parma
Correggio painted this altarpiece for
the Cappella del Bono in the church
of San Giovanni Evangelista in
Parma. The subject gave him the
opportunity to express the different

forms of grief experienced by the
women present. In so doing, he goes
beyond the classical depictions of
deep emotion. The muscular body
of Christ, whose wounds are only
subtly shown, forms a counterpoint
to this emotional display. Only the
expression on his face suggests the
torments he has undergone.

Danaë, 1531/32
Oil on canvas, 161 x 193 cm
Galleria Borghese, Rome

According to Greek mythology, the amorous Zeus made his way into the tower where Danaë was imprisoned disguised as a shower of gold, here depicted as a cloud hovering over her bed. Cupid is at the foot of her bed, pulling on her covering to allow her to better receive the god. This picture displays a mysterious contrast of light and shade with soft tonal transitions and lighting effects. Correggio has endowed Danaë's realistically-depicted body with a graceful beauty. The picture was originally a gift from the Duke of Mantua to Charles I of Spain (1500–1556).

The Assumption of the Virgin, 1524–1530
Fresco, 19 x 28 meters
Duomo, Parma

Correggio created a masterpiece with this daring fresco composition painted on the underside of the dome in the cathedral in Parma, one which provided a model for later Baroque illusionism. The apostles stand on the encircling balustrade, while in the center of the scene the Virgin Mary, surrounded by layers of clouds peopled by angels, saints and patriarchs, ascends into the radiant light of heaven. The extreme foreshortening of the bodies and the clear, deliberate lighting create a feeling of complete weightlessness and boundlessness that is accentuated even more by the enormous effect of depth.

Cossa, Francesco del

Francesco del Cossa (c. 1436 Ferrara–c. 1477 Bologna) is one of the primary representatives of the Ferrarese School of painting, along with Cosmè Tura and Ercole de'Roberti; together with the latter, he also founded the School of Bologna. Del Cossa came from an aristocratic family, and is documented as having worked as an artist in his native city from 1456. After a dispute with the Duke of Ferrara over payment for executing allegorical pictures of the months of the year, Cossa left and moved to Bologna in 1470. Piero della Francesca, Andrea Mantegna and the sculptor Donatello (1386–1466) were the main influences on Cossa, whose works include *The Griffoni Altarpiece* (center panel), 1473, The National Gallery, London; and *Allegory of Autumn*, 1475, Gemäldegalerie, SMPK, Berlin.

**Allegory of the Month of April:
The Triumph of Venus,
(detail) 1469/70**
Fresco, 450 x 400 cm
Palazzo Schifanoia, Ferrara
Shown to the right is a section of the
upper part of the *Allegory of the
Month of April*. The reigning mon-
arch of this month is Venus, the
goddess of Spring and of love. In
keeping with this theme the musi-
cians in the picture have given
themselves over to sensual pursuits.
In the background appear the three
Graces, who are Venus' compan-
ions, as are the rabbits. A vital use
of color and a naive narrative style
characterize the entire series of alle-
gorical compositions.

Opposite
**Allegory of the Month
of March: The Triumph of
Minerva, 1469/70**
Fresco, 450 x 400 cm
Palazzo Schifanoia, Ferrara
The apex of Cossa's art was reached
in the embellishment of the Sala dei
Mesi, the large hall in the Palazzo
Schifanoia in Ferrara. This room is
decorated with a series of pictures
depicting the months with their
astrological symbols. The upper
section of this picture shows the
triumph of Minerva, the patron
goddess of weavers and judges.
Underneath her can be seen the
signs of the zodiac and the char-
acters of the constellations. As de-
manded by the overall concept, the
courtly activities appropriate to the
month in question appear in the
bottom third of the fresco.

Virgin and Child with Saints (Pala dei Mercanti), 1474
Oil on canvas, 227 x 266 cm
Pinacoteca Nazionale, Bologna
This large altarpiece from the Palazzo Mercanzia is one of Cossa's last works. Its characteristics are a powerful, plastic and monumental depiction of the figures and a skillful use of perspective. The Mother of God on her throne is flanked by St. John the Evangelist holding a book on one side and St. Petronius of Bologna, here shown in his role as bishop and holding a model of the city. Behind him and quite a bit smaller kneels the figure of Alberto de Cattanei, the donor of the painting; Cossa has placed him in an unusual position, facing sideways.

Courbet, Gustave

Gustave Courbet (1819 Ornans, near Besançon–1877 La-Tour-de-Peilz, near Vevey, Switzerland) started teaching himself to paint in 1840 by copying works by Diego Velázquez, Frans Hals and Rembrandt as well as painting from nature. During this period he developed a characteristic style involving a rough manner of applying his paint. Influenced by his socialist friend Pierre-Joseph Proudhon, Courbet tried to achieve a realistic manner of painting that at the same time reflected the practical spirit of his time. It is for this reason that he commonly painted scenes depicting the everyday life of farmers and workers in an objective and unsentimental way. These subjects had not been acceptable before then, so in choosing them he went against the Academy and the "official" style of painting historical pictures, while at the same time becoming the founder of Realism. Despite much criticism he began to have some success after 1850, as his repeated participation in the Paris Salons showed. He also achieved great recognition in Germany, which he visited several times. In 1871 he became a member of the Paris Commune, was arrested upon its defeat, and fled to Switzerland in 1873. Courbet's painting had a great influence on other artists, particularly the Impressionists. His oeuvre includes still lifes, landscapes, portraits, nudes and animal pictures. The artist's works include *The Winnowers*, 1853, Musée des Beaux-Arts, Nantes; *Hello or Goodbye, M. Courbet*, 1854, Musée Fabre, Montpellier; and *The Young Women of the Seine*, 1856, Musée du Petit Palais, Paris.

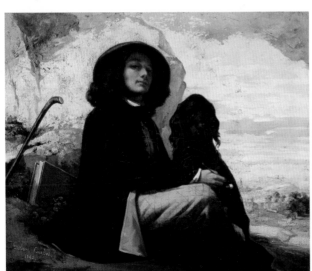

Self-Portrait, 1842
Oil on canvas, 46 x 56 cm
Musée du Petit Palais, Paris
In this painting, the first in which Courbet's individual style is apparent, one can see his great skill of precise observation and his enthusiasm for detail. The powerful expression of the work and the three-dimensionality of the figures are also much in evidence. Although the jury of the Paris Salon, the Academy's official exhibition, recognized these qualities and accepted the picture in 1844, it was not until 1849 that the artist received the next opportunity to present his work in public.

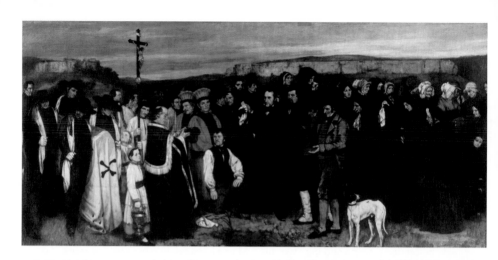

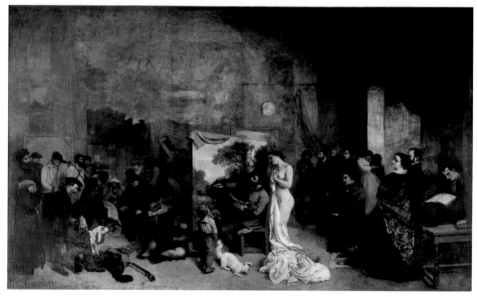

Opposite above
A Burial at Ornans, 1849
Oil on canvas, 315 x 668 cm
Musée d'Orsay, Paris
In this painting, one of Courbet's "Realist" works, the artist depicted a burial taking place in his native village. He used the traditional form of the historical narrative composition for this genre scene, making the figures life-sized. The portraits of the mourners are full of character and in no way idealized, as can be seen in the detail above. The monumental and sober representation of country people together with the choice of subject was considered scandalous by many contemporaries.

Opposite below
The Artist's Studio (A Real Allegory of a Seven-Year Phase in my Artistic and Moral Life), 1855
Oil on canvas, 359 x 598 cm
Musée d'Orsay, Paris
This painting shows Courbet at the height of his creative powers. He divides society into those who are involved in the world of art—his friends and patrons, depicted on the right—and those who remain indifferent to it. Courbet himself stands in the middle. For him, the child and the female nude are symbols for the unaffected and sensuous concept of Truth, and are thus seen as the ideal art aficionadoes.

Sleep, 1866
Oil on canvas, 135 x 200 cm
Musée du Petit Palais, Paris
Courbet also consciously broke with cultural taboos in this captivating work. His novel manner of representation introduced the "disreputable" subject of lesbian love, which was at the time a popular motif in prints and illustrations, into so-called "high art." The two nude women seem completely natural and not at all vulgar. Their bodies and the emotions they convey are celebrated here as an unaffected gift.

The Cliffs of Etretat after a Storm, 1869/70
Oil on canvas, 133 x 162 cm
Musée d'Orsay, Paris
This view of the Porte d'Aval, a rocky promontory jutting into the sea, shows Courbet's deep reverence for nature. He applies the paint roughly to depict the forms and textures of the objects such that they become almost tangible, a technique he primarily employed when he was painting outdoors. One can visibly appreciate the peace that comes after a storm: The fishing boats are safely docked and two washerwomen have begun their work once more. Everything is filled with the warmth radiated by the luminous skies. This subject would later often be painted by other artists, notably Claude Monet (1840–1926).

Pierre-Joseph Proudhon and his Children, 1865
Oil on canvas, 147 x 198 cm
Musée des Beaux-Arts, Besançon
Courbet has depicted his mentor, the philosopher Proudhon (1809–1865), not as an academic or a bohemian but rather as an ordinary father sitting in his garden. The simple shirt and hat characterize Proudhon as a worker, while the books, writing implements and his pensive gaze symbolize his intellectual pursuits. Next to him, his daughters are playing with objects that will occupy them in the years to come: The alphabet and the crockery are symbols of their future duties. The sewing box and the pile of linen on the chair suggest the absent mother. Courbet depicted the family as they were in 1853, probably choosing the date for this very intimate and personal retrospective portrait for two reasons: An important book by Proudhon was published in this year, and at the time the family's happiness was still complete—the younger daughter died shortly afterwards. This painting was completed not long before Proudhon's own death, and was accepted into the Paris Salon in the same year.

Cranach, Lucas, the Elder

Lucas Cranach the Elder (1472 Kronach–1553 Weimar) was probably trained by his father, Hans Cranach. From 1500 to 1504 he worked in Vienna and had contact with humanist circles. From 1505 he worked at the Saxon court in Wittenberg, where he had a large workshop and from 1519 was often a member of the city council, eventually becoming mayor. Influenced by painting in the alpine region and by the works of Albrecht Dürer, Cranach soon developed an individualized painting style that combined landscape and narrative scenes to form a romantic whole. This concept was important for the development of southern German painting and led him to be considered founder of the Danube School. He was again inspired by Dutch and Italian paintings he saw on a trip to Holland in 1508. The artist's works include *Portrait of Dr. Johannes Cuspinian*, 1502/03, Oskar Reinhart Collection, Winterthur; *Cardinal Albert von Brandenburg before the Cross*, c. 1520–1530, Alte Pinakothek, Munich; and *Hercules and Omphale*, 1537, Herzog Anton Ulrich Museum, Brunswick.

Crucifixion (Schleissheim Crucifixion), 1503
Oil on panel, 138 x 99 cm
Alte Pinakothek, Munich
Cranach has depicted this scene from the Passion very impressively and with great attention to detail. He conveys the pervading sense of agitation even in the way Christ's loincloth has been caught by the wind. The novel and unusual placement of the crosses, and the angle of vision which results from it, also contribute to an increase in the dramatic effect.

Opposite
The Rest on the Flight into Egypt, 1504
Oil and tempera on panel, 60 x 51 cm
Gemäldegalerie, SMPK, Berlin
This work, the earliest of his to be signed and dated, is characterized by its clear yet relaxed composition. Cranach organizes the figures in an unrestrained manner against a broad background landscape of low hills that are reminiscent of the terrain in southern Germany. He depicts nature in order to convey a mood and intensifies its emotional content by his use of color. This almost Romantic depiction is without precedent in German painting.

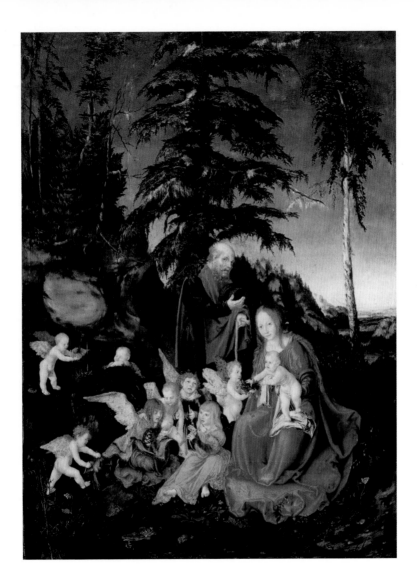

Portrait of a Lady, 1526
Oil on panel, 88.5 x 58.6 cm
The Hermitage,
St. Petersburg
This young woman is portrayed as intelligent and demure, and her opulent clothes and jewelry have been rendered with care. The portrait combines elements of southern and northern art: For example, the emphasis on the well-proportioned facial features shows Cranach's great interest in Lombard painting, while the Gothic and Mannerist aspects are a concession to the contemporary courtly tastes.

Adam and Eve, 1528
Oil on panel, left: 172 x 63 cm;
right: 167 x 61 cm
Galleria degli Uffizi, Florence
It is certain that Cranach imitated Dürer's painting of the same name in his own portrayal of the first human couple. He took the biblical subject as an opportunity to emphasize the beauty of the human body. In the extended forms of the figures he has combined late Gothic and Mannerist elements, making them seem somewhat two-dimensional; but precisely this unconventionality gives them a certain charisma.

Venus, 1529
Oil on panel, 38 x 22 cm
Musée du Louvre, Paris

Cranach's many depictions of Venus, with their gentle, flowing lines, show his predilection for the Italian style. Cranach's works played an important role in causing German artists to adopt subjects from antiquity and mythology as well as to paint figures in the nude. He always emphasized the erotic element inherent in his chosen themes; for example, the transparent veil—a sample of the artist's capacity to render the finest detailed work—tends to draw attention to the goddess's genital area rather than to hide it.

Virgin and Child under the Apple Tree, c. 1530
Oil on panel, transferred to canvas, 87 x 59 cm
The Hermitage, St. Petersburg

In this version of the Madonna theme, Cranach emphasizes the theme of Christ's self-sacrifice from the time of his childhood and depicts him as a new Adam. The apple here symbolizes the Fall of Humanity, but also the overcoming of, and redemption from, sin through the Messiah. The fruit that the child holds in his hand is repeated in the apple tree behind Mary, which closes off the composition towards the horizon.

Above
Portrait of Martin Luther, 1543
Oil on panel, 21 x 16 cm
Galleria degli Uffizi, Florence
Cranach was a close friend of the
monk Martin Luther (1483–1546),
and painted several portraits of
him. An enthusiastic supporter of
the Reformation, he became its
representative painter, attempting to
express the new Christian teaching
in the form of art. For example, he
illustrated the *Luther Bible*, which
appeared in 1522, with a well-
known series of woodcuts. How-
ever, he was careful to adhere to
traditional iconography with his
Catholic clients.

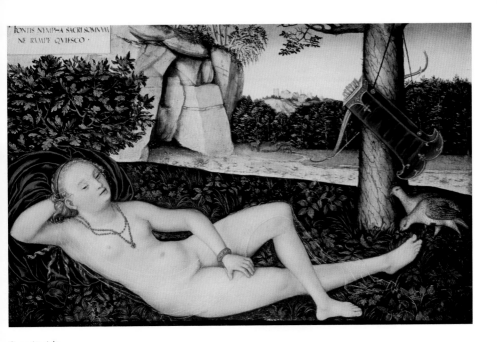

FONTIS NYMPHA SACRI SOMNVM
NE RVMPE QVIESCO ·

Opposite right
Portrait of Doctor Johann Schöner, 1529
Oil on panel, 51.5 x 35 cm
Musées Royaux des Beaux-Arts, Brussels
From early in his career, Cranach showed himself to be
an outstanding master of the bourgeois portrait. He was
able to bring out the personality of his sitters to the full
through his powerful manner of depiction and his deep
insight into the sitters' characters. The influence of
Italian portrait painting can be clearly seen here.

Reclining Nymph, c. 1537
Oil on panel, 48 x 73 cm
Musée des Beaux-Arts, Besançon
Cranach often painted several versions of his famous
nudes that feature figures of women from classical
mythology. Giorgione's *Venus Resting* seems to have
inspired him in his paintings of nymphs. He often used
inscriptions to change the picture into a moral allegory,
as here: "Do not disturb the sleep of the nymph of the
holy spring." There are three known versions of this
painting; this one has also been attributed to Lucas
Cranach the Younger.

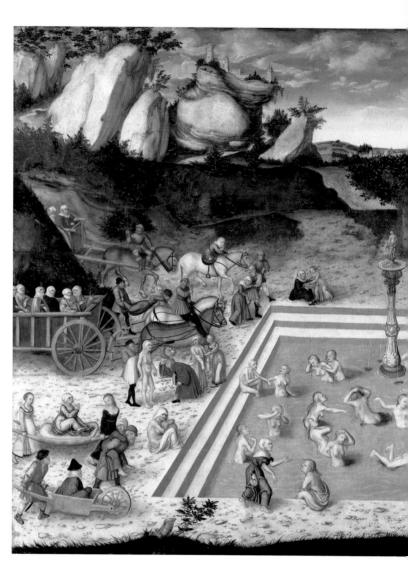

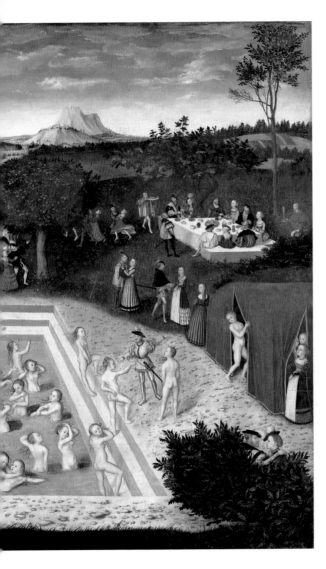

The Fountain of Youth, 1546
Oil on panel, 122.5 x 186.5 cm
Gemäldegalerie, SMPK, Berlin
This painting combines the subject
of immortality with that of eternal
youth, and comes from the mystical
belief in the cleansing and rejuve-
nating effects of water. Only old
women are allowed to undergo
the transformation it effects, as
is shown here. They are brought
to the fountain, which is reigned
over by Venus and Cupid, and
come out of it young and beautiful.
Then they enjoy themselves with
feasting, dancing and pursuits of
love. Men, it was said, became
young again by associating with
young women. In accordance with
contemporary courtly taste, the
artist has reduced this subject to its
purely secular aspects.

Crespi, Giuseppe Maria

Giuseppe Maria Crespi (1665 Bologna–1747 Bologna) was principally active in his home town. A student of Domenico Maria Cantui and Carlo Cignani, he was also inspired by the artwork of Correggio and the Carracci. After he rejected this academic manner of painting, he was able to develop his own personal style. Bold light effects and the freedom in his active, forceful figures characterize his work. Crespi painted mythological and genre scenes in addition to religious themes. His individualistic and intense observation of nature in the former painting types foreshadow the work of minor painters of the following century. He had great influence on many younger artists, including Giovanni Battista Piazzetta and Pietro Longhi, who adopted his *chiaroscuro* effects and integrated them into their own modes of expression. Among the artist's works are *Twilight of the Gods*, 1691, Museo di Palazzo Popoli Campogrande, Bologna; *The Kitchen Maid*, c. 1713, Galleria degli Uffizi, Florence; and *The Seven Sacraments*, c. 1713, Gemäldegalerie Alte Meister, Dresden.

Bookshelves with Music Books, c. 1725
Oil on canvas
Left panel: 165.5 x 78 cm
Right panel: 165.5 x 75.5 cm
Civico Museo Bibliografico Musicale, Bologna
Crespi was probably commissioned to paint this still life by the Bolognese monk and music scholar Giovanni Battista Martin, one of the most highly respected music critics in Europe. Because of its precisely detailed representation of the dust-covered books, scores, and writing instruments, the painting is known as a masterpiece of its genre in the 18th century in Italy.

The Flea Seeker, c. 1730
Oil on canvas, 55 x 41 cm
Musée du Louvre, Paris

Crespi portrays reality down to the smallest detail, simply and directly, in this genre piece. The painting is convincing because of his rejection of allegorical development and because he has a humorous lightness that does not degenerate into satire and caricature. The painting is also a study of the domestic environment, which is observed and represented here with great detail. Crespi, who repeatedly made variations on this theme, completed several versions of this painting.

St. John Nepomuceno Taking the Confession of the Queen of Bohemia, c. 1740
Oil on canvas , 155 x 120 cm
Galleria Sabauda, Turin

Due to its its soft light, this elegant yet sober painting appears to be a relaxed meditation about a simple and ordinary occurrence that can be found even today in any Catholic church. According to the legend, the patron saint of Bohemia was martyred because he refused to breach his bond of confidentiality in order to inform King Wenceslas IV (1361–1419) what the queen had confided to him in the confessional.

Crivelli, Carlo

Carlo Crivelli (c. 1433 Venice–c. 1495 Ascoli ?), also known as Donatino Creti, and brother of the Renaissance painter Vittorio Crivelli, was active in his hometown, from which he was exiled for criminal activity. He went to Zara in Dalmatia, and then moved to Massa Fermana and finally settled in Ascoli in 1469. His artistic development was influenced by artists in the circle of Francesco Squarcione in Padua and by the early works of Adrea Mantegna, as well as later by the School of Ferrara and above all Cosmè Tura. With his conservative approach he remained an exponent of the Venetian tradition. Typical of Crivelli's painting is a penchant for ornamentation and ostentation, as well as a tendency toward precision. Works by the artist include *Polyptych*, 1473, Duomo, Ascoli; *Virgin and Child with Saints*, 1482, Pinacoteca di Brera, Milan; and *The Annunciation*, 1486, The National Gallery, London.

Madonna of the Candles
(Madonna della candeleta), c. 1490
Oil on panel, 218 x 75 cm
Pinacoteca di Brera, Milan
The representational style of the center panel of this polyptych is typical of Crivelli's later style. The sharp-edged forms of the figures wear stiff brocaded clothing with rich gold embroidery and precious jewelry, and are surrounded by architectural details and garlands of fruit. This decorative tendency results in enchanting still-life elements, as seen in the foreground of this piece.

**Enthroned Madonna
with Saints, 1482**
Oil on panel
Center panel: 190 x 78 cm
Side panels: 170 x 60 cm each
Pinacoteca di Brera, Milan
This altarpiece was originally
intended for the Cathedral of
Camerino, but it was acquired in

1799 by the Dominican church of
the city. The center panel depicts the
Virgin with the infant Jesus, who
holds a finch—a symbol of His
future suffering and resurrection—
in his hands. The left panel depicts
Sts. Peter and Dominic, while Sts.
Peter the Martyr and Venatius are
shown on the right wing.

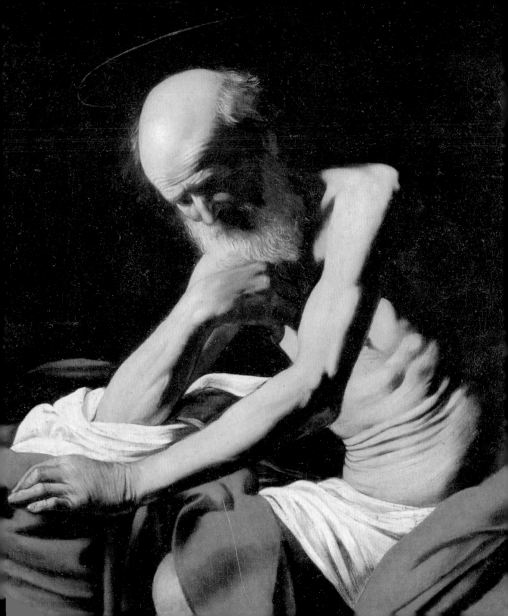

Caravaggio's Earthly Saints

Michelangelo Merisi (1571–1610), better known as Caravaggio, was just as radical and revolutionary in his own life as he was in his artwork. Notoriously argumentative and prone to violence, he was vehemently opposed to the prevailing tastes of his time. Having been forced to flee the authorities in Rome, the center of Italian Baroque painting, he ended up at various points in time in Naples, Malta and Sicily. His extraordinary still lifes of flowers and fruit; his half-length depictions of graceful youths, clairvoyants and lute players done as private commissions; and his large-scale altarpieces depicting stories from the lives of Christ, the Virgin Mary and the saints: None of them follows conventional formulas or adheres to academic ideals of beauty. They express an understanding or interpretation of reality that was unknown until then.

Caravaggio no longer respected the strict division between "high art" and "genre" themes that had maintained a rather strict separation between religious and popular art since the Renaissance. Whether the subject was a religious story or a portrait, Caravaggio showed outstanding ingenuity as a close observer of people and everyday objects. His figures are as beautiful or ugly as average people normally encountered on the street. However, the viewer is not truly confronted with scenes of daily life in Italy in these pictures, but rather with a highly individualized view of life

Caravaggio: John the Baptist (detail), 1600
Oil on canvas, 94 x 131 cm
Galleria Nazionale d'Arte Antica, Rome
The nudity of the model with flabby stomach muscles is emphasized in an almost vulgar manner; there is no sign of the dignity or holiness one would expect in a painting of a saint.

Caravaggio: St. Jerome Meditating (detail), c. 1608
Oil on canvas, 118 x 81 cm
Monastery, Montserrat
Caravaggio has depicted not only the wrinkles on the saint's gaunt body, but also the tanned skin on his hands and face.

and an artificial world that has been arranged in the artist's studio. This latter aspect is emphasized through the extreme constrasts in lighting that are typical of Caravaggio's entire oeuvre. Brightly lit, smooth areas of color form a harsh contrast to dark shadows in a way that had never been seen before, and distinct and earthy tones predominate. Caravaggio's naturalism was something

new, and poorly understood by the vast majority of his contemporaries.

He made numerous enemies, but continued to receive many commissions in Rome, despite his penchant for allowing himself dangerous liberties with their chosen subject matter. The so-called "picture edict" of the Council of Trent had forbidden, on pain of harsh punishment, giving

Caravaggio: Madonna di Loreto (detail), c. 1605
Oil on canvas, 260 x 150 cm
Sant'Agostino, Rome
The Virgin must hold her vigorous Child with both hands as he stubbornly tries to extricate himself from her arms. Only the thin haloes provide a clue as to the identity of the figures depicted.

Guido Reni: Madonna della Neve (detail), c. 1623
Oil on canvas, 280 x 176 cm
Galleria degli Uffizi, Florence
The heavenly nature of this tender scene is emphasized by the heads of the angels that form a halo around this lovely Madonna and Child, surrounded by golden light.

figures in Christian artworks the features of living people. But Caravaggio was not content to simply give his saints the appearance of the models he picked up off the street: It was even rumored that he gave an image of the Virgin the face of one of his mistresses! Such worldliness troubled the pious churchgoers of the time—they were used to seeing Madonnas of unearthly beauty. The realistic style of Caravaggio's religious paintings amounted to a scandal in the opinion of the Catholic Church, which suspected the artist of using sacred art to his own egoistic ends, thus robbing it of its dignity.

Caravaggio: The Sacrifice of Isaac (detail), c. 1600
Oil on canvas, 104 x 135 cm
Galleria degli Uffizi, Florence
Isaac is seen here being held down on the altar by the strong hand of his father, which shows the very worldly traces of age, work and dirt.

But Caravaggio's realism was neither the blasphemous whim of a genius nor a senseless and provocative gesture. The realistic nature of his work demonstrates the down-to-earth piety espoused by St. Philip Neri (1515–1595). In the final analysis, this unconventional master's realism is a product of his religious imagination.

David, Gerard

By the year 1500, Gerard David (c. 1460 Oudewater near Gouda–1523 Bruges) had succeeded Hans Memling as the leading painter in Bruges, where he had been registered with the painter's guild since 1484. He probably completed his training in Holland, as is suggested by his illustrative, faithfully realistic compositions with their differentiated depictions of figures and space. It is possible that David travelled to Italy in 1513, because in his later works he developed a comprehensive pictorial structure that is comparable to the Italian High Renaissance style. The rather stiff gestures of his figures and the cool color palette he preferred recall a Mannerist display. In 1515 David was accepted into the St. Luke's Guild in Antwerp, where he extended his influence on Flemish painting and beyond through his students Joos van Cleve and Joachim Patenier. Works by the artist include *The Judgement of Cambyses*, 1498, Groeningemuseum, Stedelijke Musea, Bruges; *The Mystic Marriage of St. Catherine*, c. 1508, The National Gallery, London; and *Virgin and Child Enthroned with Angels and Saints*, 1509, Musée des Beaux-Arts, Rouen.

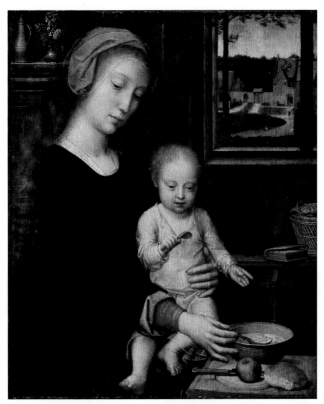

The Baptism of Christ (Triptych of Jean des Triomphes), c. 1502
Oil on panel, central panel: 132 x 96.6 cm
Side panels: 132 x 42.2 cm
Groeningemuseum, Stedelijke Musea, Bruges
The charm of this triptych lies in the wide, detailed landscape containing scenes from the life of John the Baptist. The strict, harmonious construction is determined by the central axis: God the Father, the Holy Spirit in the form of a dove, and Christ. The side panels show the patron, Jean des Triomphes, treasurer of the city of Bruges, his family and their patron saints.

Madonna of the Milk Soup, c. 1513
Oil on panel, 35 x 29 cm
Musées Royaux des Beaux-Arts, Brussels
This iconographic type, which combines the Virgin's motherly care for the infant Jesus with both a still life and a landscape, is probably David's own invention. The new type may be the result of the contemporary custom in Brussels of giving special reverence to Mary's milk. The milk is a symbol of her grace, while bread symbolizes the Last Supper and the apple signifies the transcendence of sin.

David, Jacques-Louis

Jacques-Louis David (1748 Paris–1825 Brussels) is the best-known painter of the neoclassical period in France. In 1766, at the suggestion of his friend François Boucher, he became a student of Joseph-Marie Vien. He was strongly motivated by his first stay in Italy from 1775 to 1780, where he was inspired by the Baroque painting of Caravaggio as well as by Roman antiquities. While he was there he was also introduced to the artistic theories of Anton Raphael Mengs and the art scholar Johann Joachim Winckelmann (1717–1768). In 1784 he became a member of the Paris Academy. As an active Jacobin, he was the leading painter during the French Revolution. He later pledged allegiance to Napoleon I (1769–1821), who named him "First Painter" in 1804. In 1816, after the fall of the emperor, he was exiled to Belgium. David consciously used his art as an instrument of his political convictions. Works by the artist include *Andromache by the Body of Hector*, 1783, Musée du Louvre, Paris; *Joseph Bara or Viala*, 1794, Musée Calvet, Avignon; and *Napoleon in his Study*, 1820, National Gallery of Art, Washington DC.

The Oath of the Horatii, 1784
Oil on canvas, 330 x 425 cm
Musée du Louvre, Paris
This painting depicts an episode from Rome's early history in which the war against the city of Alba Longa was decided by a battle between the Horatii and Curatii families. Two Horatian brothers fell, but the third killed all his opponents and ensured the dominance of Rome. With this representation of the heroic oath to fight to the death, David is referring allegorically to the French revolutionaries' zeal.

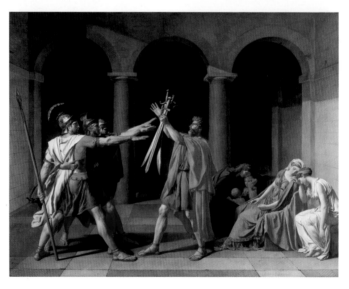

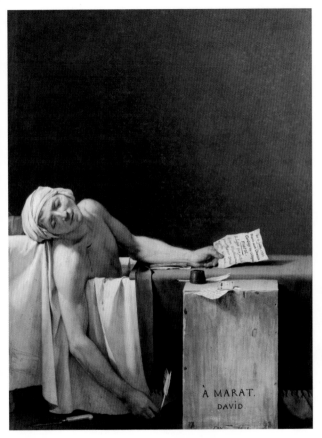

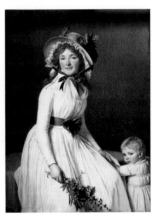

**Madame Sériziat
and her Son, 1795**
Oil on panel, 131 x 96 cm
Musée du Louvre, Paris
David's portraits are distinguished
by the harmony of form and expres-
sion that are seen in this painting. In
his construction he deviates from
previous portrait painting in that his
subjects are pushed into the viewer's
field of vision through their poses,
and he depicts the bourgeoisie of
his time with a more natural and
relaxed bearing than in previous
eras. He is able to produce great
differentiation of materials as well
as solidity of his forms with very
few colors.

The Death of Marat, 1793
Oil on canvas, 165 x 128 cm
Musées Royaux des
Beaux-Arts, Brussels
Here David depicts the death of
Jean Paul Marat (1744–1793), his
friend and a member of the Nation-
al Convention, in the position he
held at their last meeting: sitting in
the bathtub composing letters. Only
the knife left by the murderess,
Charlotte Corday, reminds one of
the act. The severe composition
and the position of the body in the
style of a Deposition from the Cross
scene let the painting serve as a
memorial that idealizes the political
hero as a martyr of the Revolution.

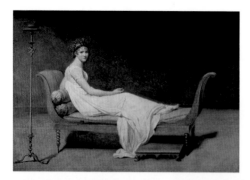

Madame Récamier, 1800
Oil on canvas, 173 x 243 cm
Musée du Louvre, Paris

Although the 23-year-old society woman with her anti-Napoleonic convictions was not in agreement with David's political views, he nonetheless portrays her as a heroine of the Republic. In a classical pose she lies on the divan which has, ever since this painting was first exhibited, been named for her. Nothing in the starkly furnished room distracts the viewer's attention from Madame Récamier. Her stylishly simple clothing and hairstyle, as well as her bare feet, are symbols of revolutionary conviction.

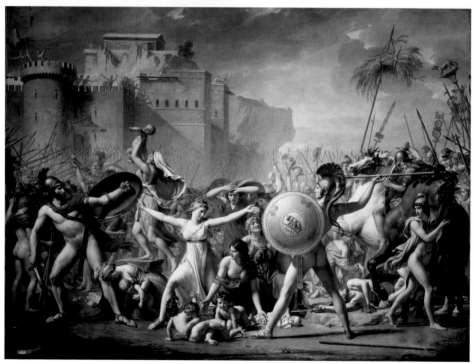

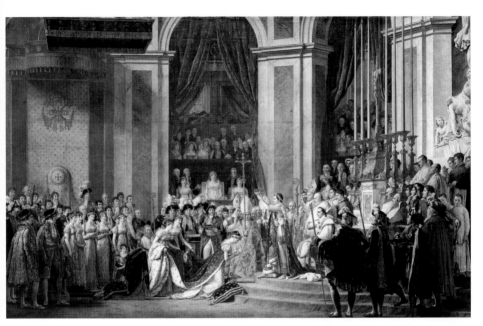

Opposite below
The Rape of the Sabine Women, 1799
Oil on canvas, 385 x 522 cm
Musée du Louvre, Paris
David uses this theme from classical antiquity to give expression to his vision of the reconciliation between the various civil factions involved in the French Revolution. The battle between Romulus, the founder of Rome, and the Sabine leader Tatius is represented in this paining. Tatius' daughter, Hersilia, symbolically clothed in white, intervenes in the fight while other women throw themselves between the warring opponents.

**The Consecration of Napoleon I and
the Coronation of the Empress Josephine,
December 2, 1804; 1806/07**
Oil on canvas, 610 x 931 cm
Musée du Louvre, Paris
Of a planned four-part cycle of scenes of the imperial ceremonies, David was only able to complete this painting and one of the coronation of Napoleon, which illustrate how Napoleon I (1769–1821) crowned himself and his first wife in the presence of the pope in the Cathedral of Notre Dame in Paris in December of 1804. David combines naturalism with neo-Baroque pageantry in this work.

Delacroix, Eugène

Eugène Delacroix (1798 St-Maurice-Charenton near Paris–1863 Paris) is perhaps the most influential artist of the 19th century. In 1815 he began to visit the studio of Pierre Guérin in Paris as well as the École des Beaux-Arts. He was particularly inspired by the work of Francisco Goya, Peter Paul Rubens and Paolo Veronese. Later he admired the light, fresh palette of John Constable, which moti- vated him to visit London in 1825. A second influential trip took him to North Africa and southern Spain in 1832. A member of the Royal Academy since 1857, Delacroix paved the way for French Romantic painting. With images developed solely out of glowing colors, he deviated from "official" neoclassicism. His recognition that color must primarily be representational of light, and that shadow is light's colored reflection, was of special importance to the Impressionists. Among the artist's major works are *Dante and Virgil in Limbo*, 1822, Musée du Louvre, Paris; *Jacob's Battle with the Angel*, c. 1858, St-Sulpice, Paris; and *The Lion Hunt*, 1861, The Art Institue of Chicago, Chicago.

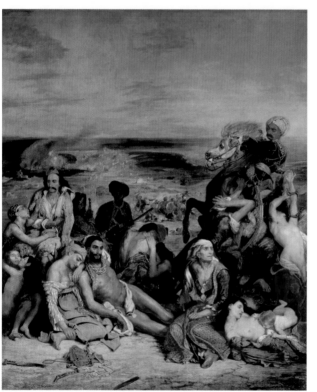

The Massacre at Chios, 1824
Oil on canvas, 417 x 354 cm
Musée du Louvre, Paris
The slaughter of the Turks in the 1822 Greek War of Independence, in which many thousands of the islanders were killed, is depicted in this painting. Three pyramids of dying bodies are artfully positioned in the atmospheric space, which has been developed through the use of light and color. Delacroix revised the work, which had been created for the Academy's annual exhibition and mercilessly denounced by the critics, with light colors and lively brushstrokes after seeing pictures by Constable.

Seated Nude, c. 1822
Oil on canvas, 81 x 65 cm
Musée du Louvre, Paris
This study of one of his favorite models reflects Delacroix's partiality to classical art, which strongly influenced his early work and continued to leave visible traces in several of his mature pieces, as well. The strict mode of representation and the three-dimensional form of the nude woman, as well as her coloration, are reminiscent of compositions by Jacques-Louis David, an artist to whom his student, Guérin, introduced Delacroix.

Below
The Death of Sardanapalus, 1827
Oil on canvas, 395 x 495 cm
Musée du Louvre, Paris
According to legend, the last Assyrian king burned himself with his wives and his treasure when the city of Nineveh was attacked in 883 B.C. This painting, in which Delacroix uses a diagonal structure for the first time, was probably inspired by the poem written about the tragedy of Sardanapalus by the English poet George Byron (1788–1824). The treatment of color in this work was influenced by Delacroix's study of English watercolors.

Portrait of Frédéric Chopin, 1838
Oil on canvas, 45 x 38 cm
Musée du Louvre, Paris
This likeness of the Polish pianist and composer Chopin (1810–1849) is among the best-known of Delacroix's portraits. It was originally conceived as a double portrait of Chopin and his companion, George Sand (1804–1876), but the painting was divided in 1873 and the other half is now located in Copenhagen. Delacroix produced many preliminary studies for this painting, which document a step-by-step approach to the character traits of his musician friend.

Self-Portrait, c. 1852
Oil on canvas, 66 x 54 cm
Galleria degli Uffizi, Florence
Although Delacroix has depicted himself with a confident bearing in this self-portrait, his expression betrays an inner struggle with his ego and the spirit of his painting. When the artist mentioned this picture in his will, he described it as totally incomplete; however, the nervous brushstrokes are not merely attributable to the unfinished status of the painting. They are very characteristic of his work at the time and also express the spiritual excitement of the painter. The date of the self-portrait has long been a matter of contention. Because of the style of the brushwork it is thought to date from 1852, although the painter, who was 54 years old at the time, seems to have depicted himself as quite a few years younger.

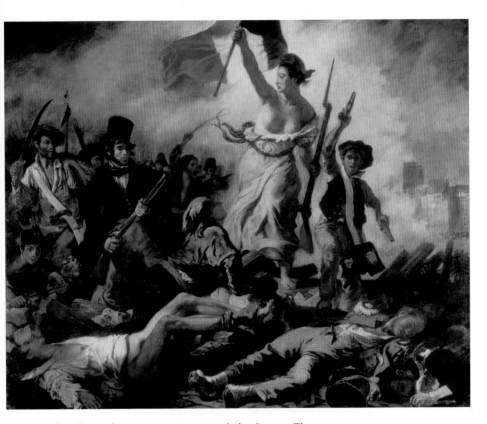

Liberty Leading the People, July 28, 1830; 1830
Oil on canvas, 260 x 325 cm
Musée du Louvre, Paris

In this painting Delacroix renders the dramatic and bloody events of the July Revolution of 1830, which led to the overthrow of King Charles X (1757–1836), with passionate drama. In doing so he combines strict classical construction with the highly animated movements of the figures. The figure of Liberty stands in the center of the picture holding the tricolored flag of France and leading the victory procession. In this painting, which is perhaps the artist's most famous, the powerfully-built female figure represents the strength, power and determination of the French revolutionaries.

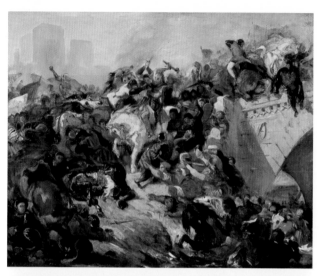

The Battle of Taillebourg, 1834/35

Oil on canvas, 53 x 66.5 cm
Musée du Louvre, Paris

This picture is a study for the painting completed in 1837 for the newly conceived Historical Museum at Versailles; the paintings exhibited there were to glorify the most important moments in the history of France. With great expression and feeling, Delacroix illustrates the victorious battle of King Ludwig IX (1226–1270) at the bridge of Taillebourg in 1246, emphasizing the defense of the threatened king by his loyal soldiers.

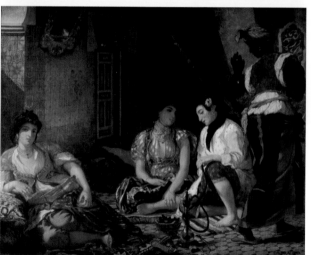

Algerian Women in their Chamber, 1834

Oil on canvas, 180 x 229 cm
Musée du Louvre, Paris

Delacroix was inspired by the exoticism and the light of North Africa. He produced countless studies there, and used them as models time and again. This great painting is one of the few with a peaceful motif. The balance he achieved between naturalistic color and the requirements of decorative harmony distinguish this glimpse into the private sphere of Muslim women. These new impressions are realized in many forms: Delacroix was fascinated by the intimacy of the women and the exotic detail of their bearing and clothing, which are centrally placed in the detail on the opposite page.

Domenichino

Domenichino (1581 Bologna–1641 Naples), whose actual name was Domenico Zampieri, is among the most important successors of the Carracci. He studied at the workshop of Ludovico Carracci, among others, and then began working with Annibale Carracci in Rome in 1602. Influenced by these two artists as well as by Correggio, Raphael and Caravaggio, he developed an independent style that was typical of classical painting's clarity and monumental expressive form. Particularly after the death of Annibale Carracci, Domenichino became the leading master of Bolognese landscape painting. He was active in Rome until 1630 except between 1617 and 1620, when he worked in his native city. He then moved to Naples, his primary locus of activity until his death. Domenichino's frescoes and altarpieces deal with religious and mythological themes. Among his works are *Girl with Unicorn*, 1602, Galleria Borghese, Rome; *Christ in Glory*, c. 1718, Pinacoteca Apostolica Vaticana, Vatican City; and *The Labors of Hercules*, c. 1623, Musée du Louvre, Paris.

Susanna and the Elders, 1603
Oil on panel, 56.8 x 86.1 cm
Galleria Doria Pamphilj, Rome
This biblical motif was very popular during the 16th and 17th centuries because it permitted the depiction of a female nude in a picturesque, idyllic garden. Here Domenichino chooses not to present the traditional version, in which the true theme is reversed and a passive Susanna lies in an erotically suggestive pose. Instead, he shows the young woman's helpless attempts to resist the advances of the aggressive Elders.

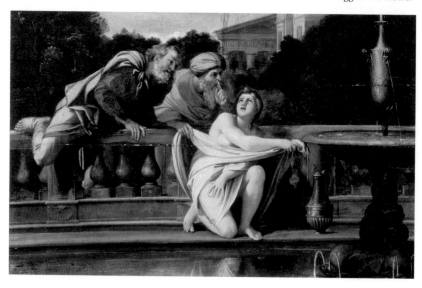

Portrait of a Man, 1603
Oil on canvas, 69 x 56 cm
Hessisches Landesmuseum,
Darmstadt

In contrast to Domenichino's religious works, this early portrait is distinguished by its sincere naturalism. Nonetheless, it contains elements that characterize all of the artist's portraits—the Raphaelesque style, the very gentle form and soft contours, as well as the reduced color palette and fine execution. Also noteworthy are the atmospheric effects, which enliven the sober presentation of the portrait.

Below
The Ford, c. 1604
Oil on canvas, 47 x 59.5 cm
Galleria Doria Pamphilj, Rome
Domenichino painted landscapes combined with genre scenes such as this one for just a short while; his later landscapes, without exception, consist of religious or mythological themes. This enchanting and graceful work showcases the ability of the artist. The structure of the painting's representation of nature and the sketch-like rendering of the figures are impressive evidence of the influence of Annibale Carracci and his circle on Domenichino's style.

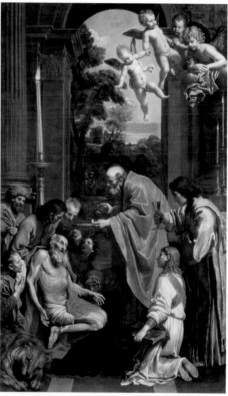

St. Cecilia, c. 1620
Oil on canvas, 159 x 117 cm
Musée du Louvre, Paris

Following the example of Raphael, Domenichino has here depicted the Roman martyr with an idealized beauty. The perfectionistic treatment of every detail is also characteristic of the artist's work. As can often be found in 16th-century and Baroque paintings, he presents St. Cecilia—the patron saint of music—playing an instrument and gazing rapturously at the sky.

The Communion of St. Jerome, 1614
Oil on canvas, 419 x 256 cm
Pinacoteca Apostolica Vaticana, Vatican

Domenichino created this significant altarpiece for St. Peter's Basilica in Rome in imitation of Annibale Carracci's work by the same title in Bologna. The picture is distinguished by its clear structure and its consistency, as well as its strict maintenance of architectural borders. The scene is enlivened by the naturalistic landscape in the background, the burning candle, and the host of angels hovering above the other figures.

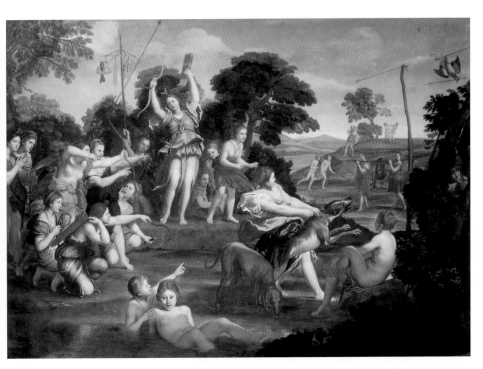

The Shooting Match of Diana, c. 1617
Oil on canvas, 225 x 320 cm
Galleria Borghese, Rome

This work, which was completed at the behest of Cardinal Aldobrandini and is clearly influenced by Titian's *Bacchanal* as well as by Correggio, must be counted among the most harmonious mythological compositions of the *Seicento*. In illustration of a passage from Virgil's *Aeneid*, the nymphs are seen in the midst of a dove-shooting contest. While the first has shot her arrow into the stake, the second has pierced the sling and the third has hit the head of the dove. Diana, who is clothed in an aproned robe, stands in the center of the oval and has raised her arms triumphantly holding the first prize, a golden ring. The other prizes are presented by a handmaiden on a ring around a rod. The harmony, atmospheric closeness and idealized monumentalism, as well as the greenish-gray coloration of the historicized landscape, were to become important compositional principles for future artists, who also borrowed the positions of the individual figures from this painting.

Domenico Veneziano

It is assumed that Domenico Veneziano (ca. 1410 Venice–1451 Florence), born Domenico di Bartolomeo da Venezia, was trained in the late Gothic tradition of northern Italy. By the 1430s, he was at work in Perugia, but settled in Florence around 1440 after successfully applying for commissions from Piero de'Medici (1416–1469). Although Domenico Veneziano was inspired by the techniques of spatial and figural representation developed by Masaccio, Paolo Uccello and Andrea del Castagno, his greatest interest lay in the expressive value of color, and he enriched early Florentine Renaissance painting with the transparency of his paints, becoming the first artist to reproduce atmospheric light. He created glowing and delicate gradations of color by increasing the amount of the oil used as a vehicle. Among his most famous students was Piero della Francesca, who worked together with the master in his studio. Major works by the artist include *The Adoration of the Magi*, c. 1433, Gemäldegalerie, SMPK, Berlin; *Frescoes of the Virgin*, c. 1440, San Egidio, Florence; and *The Annunciation*, c. 1442–1448, The Fitzwilliam Museum, Cambridge.

Virgin with Child and Saints, c. 1445
Tempera on panel, 209 x 213 cm
Galleria degli Uffizi, Florence
This *sacra conversazione*, from the altar of Santa Lucia dei Magnoli, presents the Mother of God on her throne in the company of Saints Francis, John the Baptist, Zenobius and Lucy. In this painting, the artist for the first time broke away from the traditional polyptych format, in which figures appear on separate panels, divided by frames. Also innovative is the representation of sunlight, which had previously been suggested by gold tones.

Dossi, Dosso

Dosso Dossi (c. 1489 Mantua?–1542 Ferrara), born Giovanni de Lutero, is the chief exponent of the of the School of Ferrara in the 16th century. He is first mentioned in 1512 in Mantua, but two years later he entered the service of the dukes Alfonso and Ercole d'Este and settled in Ferrara. On his various travels, he visited Trento, Pesaro and possibly Venice; around 1520, he was active in Rome, where he may have associated with the circle surrounding Raphael. In addition to frescoes, Dossi also painted panels depicting Christian, mythological and allegorical themes in which he combined the lively style of Ferrara with the new forms of expression developed by Titian and Giorgione. Among the artist's works are *Bacchanal*, c. 1518, The National Gallery, London; *Jupiter, Mercury and Virtue*, c. 1530, Kunsthistorisches Museum, Vienna; and *Virgin and Child with Saints*, c. 1521, Cathedral, Modena.

Melissa (Circe), c. 1518
Oil on canvas, 176 x 174 cm
Galleria Borghese, Rome
Dossi's crowning achievement is the combination of human figures with mysterious landscapes that shimmer with atmosphere. These traits, as well as Dossi's harmonious and lyrical composition, are noticeable in this fantastic and iconigraphically unusual portrayal of the ancient sorceress Circe.

The Virgin Appearing to John the Baptist and John the Evangelist, 1520–1530
Oil on panel, transferred to canvas, 153 x 114 cm
Galleria degli Uffizi, Florence
This altarpiece from the Cathedral of Codigoro is one of Dossi's most successful works. It is distinguished not only by its composition and its careful execution, but also through the expert combination and modulation of color. The light appearing against the cool glowing sky, as well as the passionate gestures of the powerful figures of the saints in the foreground of the painting, are highly expressive.

Allegory of Hercules (Witchcraft), c. 1535
Oil on canvas, 143 x 144 cm
Galleria degli Uffizi, Florence
This work presents a scene from the slavery of the legendary hero to Omphale, the queen of Lydia. To please her, he wears women's clothing, plays music and learns to spin.

Dossi was apparently inspired by northern genre painting to create this *bambocciata*, or bluntly realistic portrayal of everyday life: In doing so he also masterfully parodied the coarse, uncivilized courtly amusements of his own culture. The color scheme and pictorial structure reinforce the mythological theme.

Dou, Gerrit

Gerrit Dou (1613 Leiden–1675 Leiden) is the most important miniaturist to originate in Leiden. He was an apprentice under his father, a glass painter, then under the copper engraver Bartholomeus Dolendo, and finally under Rembrandt from 1628 to 1631. As an independent artist, he co-founded the St. Luke's Guild in his hometown in 1648. Dou was a well-known genre and portrait painter even during his own lifetime, but he also produced still lifes and religious paintings. He is outstanding in his ability to combine traditional Netherlandish miniature painting with the Dutch predilection for *trompe-l'oeil* work. He adopted Rembrandt's *chiaroscuro* effects, composition of room scenes, and the motif of the *petit-bourgeois* milieu. Among his students was Frans van Mieris, the Elder. The artist's most significant works include *Tobit and Anna Awaiting the Return of Tobias*, c. 1630, National Gallery, London; *Young Mother*, 1658, Maurits-huis, The Hague; and *The Night School*, c. 1663, Rijksmuseum, Amsterdam.

The Dropsical Woman, c. 1663
Oil on panel, 86 x 67 cm
Musée du Louvre, Paris
Dou is well-known for his extremely detailed rendering of objects and of light reflected on surfaces. To accomplish this, he often worked with a magnifying glass and the finest of brushes. Also characteristic is the representation of things in the foreground of the painting that could belong to the observers' field of vision, as in this case the podium and the gathered curtain.

Young Mother, c. 1660
Oil on panel, 49.1 x 36.5 cm
Gemäldegalerie, SMPK, Berlin
This painting is an outstanding example of Dou's mature work. Not only does the painting sympa-thetically render an intimate domestic scene, but it exemplifies the general understanding of nature at that time. While the mother calming the baby embodies nature in its active form, the doctor's consulta-tion taking place in the background points to the transiency of life and is representative of a more passive view of nature. The warm color tones emphasize the bond between mother and child.

Duccio di Buoninsegna

Duccio di Buoninsegna (c. 1255 Siena–1318/19 Siena), generally known simply as Duccio, originally worked as a casket- and furniture-maker and as a manuscript illustrator. His artistic accomplishments can be traced from the year 1278 in the city of his birth. In addition to his work in Siena, he also worked in Florence, and probably on the frescoes in the Basilica of San Francesco in Assisi. He was inspired by the Sienese School and by the work of Cimabue. Although Duccio was very strongly tied to Byzantine art, he did embrace the new developments of Gothic art and thereby established a new painting style. In addition to their fine lines and bright color schemes, his works are distinguished by a picturesque three-dimensional structure and a rhythm of the figures as well as the entire pictorial surface. Duccio's work is considered to be ground-breaking for the further development of Sienese art in the 14th century. Works by the artist include *Madonna Crevole*, c. 1280, Museo dell'Opera Metropolitana, Siena; *Madonna of the Franciscans*, c. 1295, Pinacoteca Nazionale, Siena; and *The Flight into Egypt*, c. 1310. Museo dell' Opera Metropolitana, Siena.

Madonna Rucellai, 1285
Tempera on panel, 450 x 292 cm
Galleria degli Uffizi, Florence
This panel, which was commissioned in 1285, is generally recognized as an early work by Duccio. It was originally ordered by the Compagnia dei Laudesi for the high altar of S. Maria Novella, and is considered to be one of the largest and most powerful altarpieces of its time. Duccio renders the clothing materials and the spatial relationships in great detail. The discernable bodies beneath the figures' robes and the animated lines of Mary's cloak are evidence of the influence of Gothic sculpture on the artist. The strong ties to the work of Cimabue, which Duccio was able to overcome several years later, is also clearly recognizable.

Maestà, c. 1308–1311
Tempera on panel, 211 x 425 cm
Museo dell'Opera
Metropolitana, Siena

This work, which consists of several parts and is painted on both sides, was intended for the high altar of the Cathedral of Siena. The contract, which is still in existence, is dated 1308; the altarpiece was completed three years later and was installed with great festivities. The central front panel depicted here was the only one constructed as a single composition. The predella, as well as the front and back sides, depict scenes from the life of the Virgin and the life of Christ. Here, the Virgin is surrounded by a host of angels. The patron saints of the city kneel at her feet, while the apostles Paul and John as well as Sts Catherine, John the Baptist and Agnes stand at her right hand. The other apostles appear in the small pictures along the upper rim. In his mature style, Duccio developed a unique integration of Byzantine composition, Gothic figures and Florentine color schemes.

Maestà (detail, The Burial of the Virgin), c. 1308–1311
Tempera on panel, 40.8 x 54 cm
Museo dell'Opera
Metropolitana, Siena

This side of the *Maestà* is completely devoted to honoring the Mother of God. The predella and upper panels depict the events in her life. This picture, which recalls the iconography of the burial of Christ, was probably located on the upper right panel. The illusionistic representation of the landscape and the attending apostles, their involvement and their strickenness, facilitate the impression that the viewer is actually observing the event. The apostles have arranged themselves in a semicircle around the sarcophagus and are lifting the Virgin, who lies on a shroud, into it. Their active participation is both impressive and ahead of its time. The relief-like construction of the landscape and vegetation exhibit definite parallels to contemporary book illustrations, with which Duccio had occupied himself at the beginning of his career.

Maestà (detail, The Entry Into Jerusalem), c. 1308–1311
Tempera on panel,
100.6 x 56 cm
Museo dell'Opera
Metropolitana, Siena

This panel is the initial scene of the 26-part central field on the back side of the *Maestà*, which shows the Passion and the Resurrection of Christ. Duccio illustrates the events with many figures and in rich colors. He brings the picture to life and accents the subject matter with his new rendering of spatial dimension and his precise description of the locale, as well as through his arrangement of the characters and objects portrayed. The scene takes place on Palm Sunday: Christ is seen approaching from the left with his companions, who compose a closed group. The inhabitants of the city come toward him from the right, led by a boy who spreads a cloak before Christ's feet. The lively style of rendering events also applies to the figure of the toll-keeper Zaccheus who, since he is small in stature, climbs a mulberry tree in order to get a better look. The carefully rendered architecture should be understood as an idealized rather than a realistic view of Jerusalem.

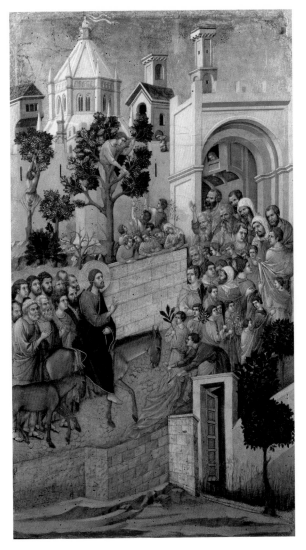

Dürer, Albrecht

Albrecht Dürer (1471 Nuremberg–1528 Nuremberg) learned goldsmithing from his father. In 1486 he began studying under Michael Wolgemut, who introduced him to Dutch art and the paintings of Martin Schongauer. He received definitive inspiration from his journeys to Italy in 1494 and 1506, as well from a trip to Holland in 1520. He studied the southern approach to interpreting space and body forms, as well as its color composition, in which he was particularly influenced by Andrea Mantegna and the Bellinis. He thus became the most important intermediary between the art of southern and northern Europe, and was simultaneously able to construct a basis for the German High Renaissance. The detailed topographical rendering of his landscapes also served as models for the painters who succeeded him. Dürer, who maintained contact with humanist circles in Nuremberg, also wrote essays in art theory. The artist's major works include *The Adoration of the Magi*, 1504, Galleria degli Uffizi, Florence; *All Saints Picture*, 1511, Kunsthistorisches Museum, Vienna; and *Portrait of Maximilian I*, 1519, Germanisches Nationalmuseum, Nuremberg.

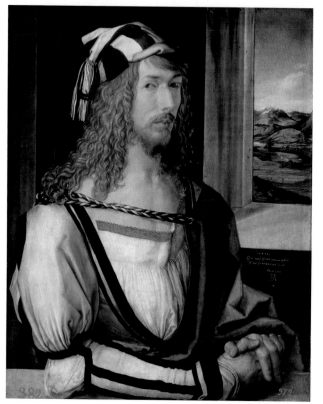

Self-Portrait, 1498
Oil on panel, 52 x 41 cm
Museo del Prado, Madrid
Dürer is among the first western artists to repeatedly paint portraits of themselves. His series of self-portraits are not only evidence of his own personal development, but also document the general transformation taking place in contemporary painting from skilled craft to fine art, a distinction which Dürer helped to introduce in Germany. Here he has depicted himself at the age of 26 as an elegant and stylishly-dressed nobleman.

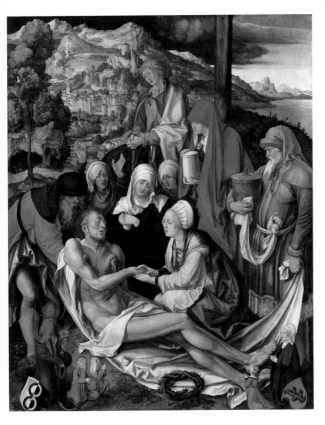

Self-Portrait in a Fur Coat, 1500
Oil on panel, 67 x 48.7 cm
Alte Pinakothek, Munich
Dürer intensifies the expression of his ample self-confidence in this bust portrait. He borrows the symmetrical, strictly frontal view from the ancient Christian *acheiropoieta*—pictures of Christ "not made by human hands"—and from medieval representations of Christ. He thereby acknowledges his own god-like creative powers as an artist, an idea in keeping with the Renaissance conception of human beings.

The Lamentation of Christ, 1500
Oil on panel, 151 x 121 cm
Alte Pinakothek, Munich
In this panel painting Dürer portrays nature no longer as a mere backdrop for the events that comprise the real subject matter of the painting; rather, the dark, ominous clouds and the nearly magical lighting expressively heighten the depressed mood of the hopeless and despairing group of people surrounding the crucified Christ. The family of the goldsmith Albrecht Glim, who commissioned the painting, appears on a smaller scale in front of the monumental group of figures.

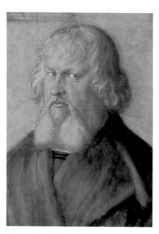

Portrait of Hieronymous Holzschuher, 1526
Oil on panel, 48 x 36 cm
Gemäldegalerie, SMPK, Berlin
This portrait, which is among the most important examples of Dürer's later work, depicts one of the most influential men in Nuremberg at the age of 57, according to its inscription. In this true-to-life rendering Dürer tries to capture not only the external appearance, but also the inner nature of his friend, who gazes outward with a friendly and somewhat skeptical expression. In doing so Dürer over-elevates this particular individual to a more generalized character type.

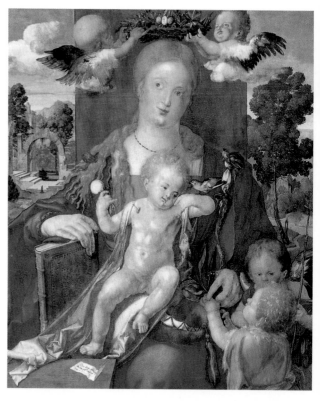

Virgin and Child with a Siskin, the Infant John the Baptist and Angels, 1506
Oil on panel, 91 x 76 cm
Gemäldegalerie, SMPK, Berlin
Dürer incorporated many iconographic references into this work. For example, the crown of roses symbolizes Mary's heavenly joy, while the red and white blossoms represent her suffering and her happiness during her lifetime on earth. The lilies of the valley proclaim not only new life, but also the arrival of Christ, to whom the book with the holy script also refers. The ruin in the background stands for the palace of King David, and unites the contrasting old and new forms of covenant with God.

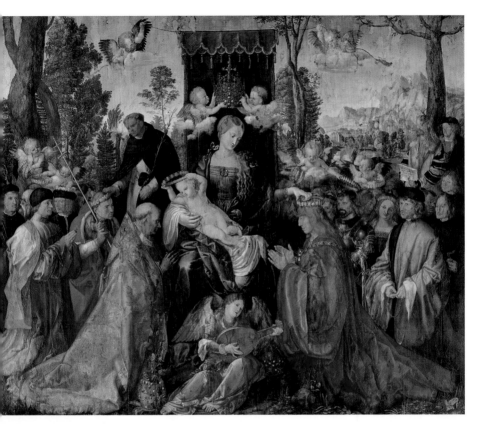

**The Rose Garland Festival
(Altarpiece of the
Rose Garlands), 1506**
*Oil on panel, 162 x 194 cm
Národní Galerie, Prague*
Dürer painted this picture for a
German merchant settlement in
Venice during his second stay in that
city. It depicts the Virgin as Queen
of the Rose Garlands, surrounded
by Pope Julius II (1503–1513) and
Emperor Maximilian I (1459–
1519), as well as by representatives
of the merchant colony, who are
seen wearing period clothing and
exhibiting very personalized, indi-
vidual characteristics. The picture is
of particularly intriguing political
significance. Maximilian, who is
here shown kneeling together with
the pope in adoration of the Child,
is represented as the emperor, al-
though he did not actually accede to
that position until two years later.
The man leaning against the tree
bears facial features similar to those
of the artist.

Right
Christ Among the Doctors, 1506
Oil on panel, 65 x 80 cm
Museo Thyssen-Bornemisza, Madrid
In this painting Dürer combines various inspirations derived from Italian art with his own language of form. The seven heads of the figures fill the surface of the picture almost completely. In its center appear the expressively gesticulating hands of Christ and the old man standing next to him. This work is notable for its eloquent communication and the strong expressivness of the almost caricature-like heads.

The Four Apostles, 1526
Oil on panel, 215 x 76 cm each
Alte Pinakothek, Munich
Dürer donated this late masterpiece, which depicts Sts John and Peter on the left and Mark and Paul on the right, to his native city. A quote from the *Luther Bible* in the inscription exhorts one to follow the pure commandments of God. In this work Dürer combines Italian influences with northern traditions, recognizable in the varied facial expressions and the precision of detail.

Opposite below
The Paumgartner Altarpiece, c. 1498
Oil on panel
Central panel: 155 x 126 cm
Side panels: 157 x 61 cm each
Alte Pinakothek, Munich
In the center panel of this altarpiece, which once belonged to the patrician Paumgartner family of Nuremberg and Augsburg, Dürer still unites traditional figures, landscapes and achitecture. In doing so he maintains the practice of ordering individuals by size according to their importance by depicting the figure of the patron on a smaller scale than those of the saints. He later gave up this practice in favor of a unified composition. The painting brings the monumental figures of Sts George and Eustace on the two side panels into relief with rich contrasts.

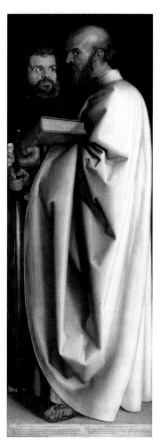

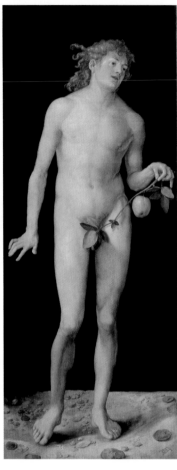
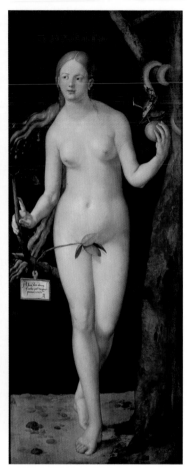

Adam and Eve, 1507
Oil on panel, 209 x 81 cm each
Museo del Prado, Madrid
A central theme throughout Dürer's oeuvre is the human body. At first he tried to use the rules of pro-portion to measure and represent it anatomically, while at the same time he exhibited an ability to render natural, lifelike represen-tations of the body and its pro-portions. If the linearity of his early representations makes them appear somewhat like lifeless ancient statues, the unity of composition in this rendering of the first human couple demonstrates a new under-standing of beauty.

Dyck, Sir Anthony van

Anthony van Dyck (1599 Antwerp–1641 London) is, along with Peter Paul Rubens, the most important Flemish painter. At the age of 11 he began his studies under Hendrik van Balen, and founded his own studio already in 1615. From 1617 to 1620 he was active in the workshop of Rubens, who considered Dyck to be his best student. Immediately thereafter he travelled to London and then through Italy from 1621 to 1627. There he admired especially the work of Titian, Giorgione and the Bolognese School. Upon his return he became the court painter to the Archduchess Isabella, governor of the Netherlands. In 1632 he went into the service of Charles I of England (1600–1649). Under Italian influence Dyck developed a representational style of portraiture of the nobility which served as a model for western portrait painting, especially in England. The style of his portraits changed in England, where he worked primarily as a portrait painter. Major works by the artist include *Susanna in the Bath*, c. 1621, Alte Pinakothek, Munich; *Lamentation*, 1630, Alte Pinakothek, Munich; and *Self-Portrait with Sir Endymion Porter*, c. 1635, Museo del Prado, Madrid.

Crowning with Thorns, c. 1618
Oil on canvas, 233 x 196 cm
Museo del Prado, Madrid
Already in his early work, van Dyck exhibited the sense of balance and reserved emotions that distinguish his religious paintings from the more pompous, massive figures of the Baroque era. Thus, the tormentors here scarcely exhibit any anger or hatred as they carry out their gruesome acts, and Christ seems to patiently endure his torture. Only the figure of the barking dog is somewhat aggressively portrayed.

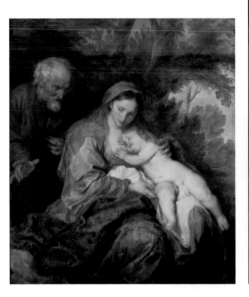

**Rest on the Flight
into Egypt, c. 1629**
Oil on canvas, 135 x 115 cm
Alte Pinakothek, Munich
Van Dyck portrays the protagonists
as ordinary people in this rendering
of the popular pictorial theme. No
otherwordly appearance or won-
derous occurrence points to the
fact that these are the figures of
Christ and the Holy Family. The
color scheme and the painting style
of this harmonious composition are
evidence of the influence of Titian,
as well as of van Dyck's inspiring
stay in Italy.

**St. Sebastian with
the Angel, c. 1630**
Oil on canvas, 160 x 155 cm
Galleria Sabauda, Turin
Van Dyck painted the legend of St.
Sebastian several times without por-
traying the actual martyrdom. He
depicted several versions of the
preparation for it, but here shows
the moment after the torments have
been suffered: Two angels liberate
the collapsing saint from his fetters
and arrows. A sense of nervous
agitation results from the distribu-
tion of light and shadow, as well as
the warm and cool color tones.

Opposite
**Madonna and Child
with Donors, c. 1631**
Oil on canvas, 250 x 185 cm
Musée du Louvre, Paris
This picture is especially distin-
guished by its clear two-part divi-
sion. The conception and form of
the holy figures exhibit strong
Italian influence; in contrast, the
representation of the patrons is
carried out in the simple and real-
istic style, typically Flemish, that
characterized van Dyck's work at
that time. It is possible that the
patrons are Gertruide de Jode and
her husband, Jan de Wael.

Opposite
Portrait of a Family (Detail)
The extent to which van Dyck occupied himself with the surface details and specific characteristics of his subjects becomes especially clear in this detail. The facial characteristics, the eyes and the light coloration of the woman's cheeks are all quite individualistic. He renders textiles with the same care, whether it be the fine and complicated lace of the stylish neck ruff or the net that holds back the young mother's hair.

Portrait of a Family, 1621
Oil on canvas, 113 x 93 cm
The Hermitage, St. Petersburg
Van Dyck has rendered this young bourgeois couple and their child with a sharp eye for detail. As in other portraits of his stemming from the same time period, it radiates a sense of compassion that can no longer be found in his later works. The artist painted this portrait immediately before his brief, but glowingly creative, period in Genoa and his stay in England.

Viola de Gamba Player
Oil on canvas, 114 x 96 cm
Alte Pinakothek, Munich
This work, made during van Dyck's second stay in England, is not only a portrait but also an allegorical composition. The bass-viol, or viola da gamba (an older form of the cello) held by the young woman symbolizes the harmony that one readily sees elsewhere in 17th-century Flemish painting. It also serves as a symbol of *vanitas*, telling of the transience of human life.

Charles I at the Hunt, c. 1635
Oil on canvas, 266 x 207 cm
Musée du Louvre, Paris
In his capacity as court painter, van Dyck made many portraits of the king. He renders the king's figure in full length in this painting, in keeping with the traditional courtly compositional format. The commanding pose, his free-standing silhouette, and the coloration of his clothing lift the figure of Charles I (1600–1649) apart from his surroundings. At the same time, the painting's representational character is softened by the landscape.

Portrait of Cardinal Guido Bentivoglio, 1624
Oil on canvas, 195 x 147 cm
Galleria Palatina,
Palazzo Pitti, Florenz
Van Dyck's artistic abilities are particularly evident in his full-length portraits. A portrait that displays more than just the upper body allowed him to show the social standing of the subject through his or her pose, costly clothing and rich accessories. This is particularly evident in this portrait of his patron, who is shown sitting with an upright and dignified bearing.

Portrait of Maria Ruthven, 1639
Oil on canvas, 104 x 81 cm
Museo del Prado, Madrid
This portrait, made in the year of their marriage, is the only surviving picture of van Dyck's wife, niece of the Earl of Gowrie. She is not rendered with the same degree of flattery with which Dyck painted other English nobles, but the picture is still forthright and discrete. Perhaps he intended to depict his wife simply the way he saw her, without the symbolism that overwhelmingly characterizes the other works he produced at this time.

The Hierarchy of Pictures

In 1678, Samuel van Hoogstraten (1627–1678), a pupil of Rembrandt, wrote a theoretical treatise entitled *Inleyding tot de Hooge Schoole der Schilderkonst*, or "An Introduction to the High School of Painting." In this text he teaches that the status of a painting's subject is dependent on the demands it makes upon the artist's imagination. According to this theory, the highest position is awarded to historical paintings dealing with religious or historical motifs, paintings that "present for humanity's viewing the most noble deeds and ... the wisest creatures." These are followed by "cabinet painting of every sort," followed by still lifes, which take up the lowest position.

Hoogstaten's contemporary, André Félibien (1619–1675), presents a similar viewpoint in the introduction to his *Conférences de l'Academie Royale de Peinture et de Sculpture* ("Proceedings of the Royal Academy of Painting and

Richard Earlom after Johann Zoffany:
The Nude Drawing Room of
the Royal Academy in London, 1773
Mezzotint
Victoria and Albert Museum, London
Zoffany painted this group portrait showing members of London's Royal Academy in 1771. Today, it belongs to the Royal Collection. The picture shows the first director, Sir Joshua Reynolds, as well as other personages. Angelika Kauffmann and Mary Moser, who as female academy members were not permitted to attend nude drawing classes, are represented solely by their portraits on the wall on the right side of the picture.

Willem van Haecht:
The Studio of Apelles (detail), 1628
Oil on panel, 105 x 149.5 cm
Mauritshuis, the Hague
Apelles, court painter to Alexander the Great, was
considered the most important painter of antiquity.
Van Haecht portrays him sitting in front of Alexander and
working on a picture of the beautiful Campaspe. In light
of the fact that Rubens was celebrated as a "new
Apelles" in the 17th century, this painting can be inter-
preted as a pictorial theory of art.

Sculpture"), which was published in Paris in 1669.
Félibien also considers still lifes depicting fruit,
flowers, shells and other inanimate objects to be
the lowest form of art. He assigns paintings of
living animals or idealistic landscapes, for
example, a higher value. An artist reached the
highest level with human portraits, humans being
considered a perfect creation of God.

Both of these art treatises appeared at a time
when the formal art academies were enjoying
their heyday in Europe. The Académie Royale de
Peinture et Sculpture was founded under Louis
XIV (1638–1715) in 1648, and was further
extended in 1666 with the establishment of a
branch in Rome. The Royal Academy was a public
institution financed with public monies, and it
influenced official art politics for a long time. By
1720 there were 19 academies operating
throughout Europe. Their tradition reached
back to the Italian Renaissance: As early as 1494
Leonardo da Vinci created the first school of
painting, in which the pupils learned not only
artistic techniques, but also received scientific

training (including anatomy and perspective, for example). This concept was taken up once more two generations later, as evidenced in the curriculum of the Accademia del Disegno, founded in 1563 in Florence at the instigation of Giorgio Vasari, and also in that of the Accademia di San Luca, founded in 1577 in Rome and still in existence today.

The two concepts of *imitatio* (imitation) and *inventio* (invention) appeared early on in art theory. A lasting debate in the academies on the value of form and color emerged from contradictory ideas about the mere imitation of nature and the creative imagination of the artist. The academies decided on a doctrine in favor of form; that is, of drawing, contour and composition. Students partaking in the classical training at an academy were thus introduced to art with these principles in mind. The first step involved copying earlier masterpieces and making plaster casts of classical sculptures. The study and drawing of the human body from life followed; however, until the end of the 18th century only male models were available. Free drawing and composition were taught only in the final stages of training.

Artists and critics were always rebelling against the dominance of the academies and their rigid rules. For many artists, success and failure depended on acceptance or refusal by these powerful institutions. The opposition to the academies reached its climax in the late 19th century, at the same time as the Impressionists were preparing the way for the developments of modern painting with their concept of art. As late as 1922, the painter Max Liebermann (1847–1935), also president of the Berlin Akademie der Bildenden Künste from 1920, reflected on the problem of evaluating the various genres of artwork. His statement, considered provocative at the time, that a well-painted turnip is preferable to a badly painted Madonna has since become an accepted tenet of modern aesthetics.

Rogier van der Weyden:
St. Luke Painting the Madonna, c. 1450
Oil on panel, 138 x 110 cm
Alte Pinakothek, Munich
This famous painting, of which four versions are known to exist, depicts the evangelist Luke who, according to legend, created an authentic portrait of the Virgin Mary, Mother of God. The patron saint of painters' guilds is dressed as a scholar and, like Apelles, symbolizes the apex of European painting.

El Greco

The actual name of El Greco (1541 Phodele, Crete–1614 Toledo), "the Greek," was Domenikos Theotokópoulos. Today he is known as the main representative of Spanish Mannerism. Trained initially as an icon painter, he emigrated to Venice in 1567, where he studied under Titian and received inspiration from Tintoretto. In 1570 he went to Rome, where he stayed for approximately two years. He then travelled to Madrid for a short time before settling permanently in Toledo. El Greco was able to combine the austere Byzantine style with Italian Renaissance painting, as well as the religious fervor of medieval Spain, in a unique fashion. His paintings achieve their characteristic mystical and spiritual quality through techniques including elongated figures and exaggerated color schemes. Among the artist's important works are *Toledo in the Snow*, c. 1604–1614, The Metropolitan Museum of Art, New York; *Frey Hortensio Félix Paravicino*, c. 1609, Museum of Fine Arts, Boston; and *Laocoon*, c. 1610, The National Gallery of Art, Washington.

The Adoration of the Name of Christ, 1579
Oil on canvas, 140 x 110
Monastero, El Escorial (Madrid)
This piece, which is also titled *The Dream of Philip II*, is one of the few allegorical paintings in the artist's oeuvre. Depicted is the adoration of Christ by the leaders of the "Holy Legion," who broke the Turkish domination of the Mediterranean Sea in the naval battle at Lepanto in 1571. In the background an endless mass of people stretches over one half of the painting, while the artist's terrible vision of hell can be seen on the opposite side.

The Burial of
Count Orgaz, c. 1586
Oil on canvas, 480 x 360 cm
S. Tomé, Toledo

According to legend, Sts Stephen and Augustine came down from Heaven during the 1323 burial of the pious Count Orgaz in order to put his body to rest. El Greco's rejection of realistic spatial arrangements allows him to depict Heaven and Earth as simultaneously separate and intertwined. In the opening of the Heavens, the Virgin and John the Baptist appear as intercessors for Christ, the Judge of the World. This picture, which signified El Greco's transition to maturity as an artist and contains portraits of his contemporaries, led him to obtain further major commissions.

Sts. Andrew and Francis, c. 1593
Oil on canvas, 167 x 113 cm
Museo del Prado, Madrid
The depiction of two saints in one painting is completely in keeping with Spanish tradition. What is unusual here is the joining of two different epochs, as well as two different religious attitudes. St. Andrew represents early Christianity, while St. Francis stands for the era of the medieval orders. Andrew's X-shaped cross also serves as an attribute of St. Francis and acts as a unifying compositional element.

The Disrobing of Christ, 1585–1600
Oil on canvas, 165 x 99 cm
Alte Pinakothek, Munich
This representation of the theme of the Disrobing is totally unique. Christ stands in a red robe surrounded by soldiers, the two robbers and some Jews, one of whom rents His clothes while another bores a hole into a plank to build the Cross. The Virgin and Mary Magdalene can be seen in the foreground. El Greco copied this third draft of the painting from the original, which he created for the sacristy of the cathedral in Toledo.

The Adoration of the Shepherds, c. 1613
Oil on canvas, 319 x 180 cm
Museo del Prado, Madrid

In order to vehemently emphasize the expressiveness of his paintings, El Greco increasingly pulled away from a literal rendering of reality during the course of his artistic career. In his later works he distorts human figures, who lose their bodily shape underneath their expansive robes; disregards standard color schemes and logical spatial arrangements; and dissolves the rigidity of his paintings. This picture belongs to his last productive phase and was intended by the artist for his own burial chapel. As a reference to Italian models, he depicts the newborn Christ Child as a source of light and reflects this reddish glow onto the figures surrounding it.

Opposite

Mary's Ascension, c. 1607–1613
Oil on canvas, 347 x 174 cm
Museo de S. Cruz, Toledo
This painting presents not only Mary's Ascension into Heaven, but also El Greco's idea of a divine world whose richness consists of endless self-transformation: All beings and objects participate in a spiral movement toward heaven. Color, light, volume and line are united by painterly technique into a single substance in which the figures and their surroundings are fused together and each of the two realities transforms itself into the other.

Jorge Manuel Theotokópoulos, c. 1603
Oil on canvas, 81 x 56 cm
Museo de Bellas Artes, Seville
Here the painter's son and colleague is depicted in a sober and severe manner. He is wearing a contemporary black robe with a white lace ruff and cuffs that hardly emerge from the dark background. El Greco was a master of a particularly penetrating style of portrayal. As is true of all his figures, the subjects of his portraits often turn away from the world in deep faith, as they peer into the world beyond.

Boy Lighting a Candle (Breath), c. 1573
Oil on canvas, 59 x 51 cm
Museo Nazionale di Capodimonte, Naples
This painting, which the artist based on a now-lost masterpiece by Antiphilos of Alexandria (ca. 330 B.C.), depicts a boy blowing on a flame within a room. Here El Greco has selected a drastically reduced detail of the original, and heightened the visual impact of the sole source of light through dramatic *chiaroscuro* effects.

Elsheimer, Adam

Adam Elsheimer (1578 Frankfurt am Main–1610 Rome) is one of the most important German painters of the early Baroque. He first studied his trade with Philipp Uffenbach, but later joined the studio of the Netherlandish landscapist Gillis van Coninxloo, who introduced him to the approach of the so-called Danube School. Around 1598 Elsheimer went to Venice, where he worked with Hans Rottenhammer and learned the techniques of Venetian painting. He finally settled in Rome, where he was influenced by Paul Bril, who in turn picked up techniques from the German artist. In addition, Elsheimer admired the figural style of Caravaggio and the ideal landscapes of Annibale Caracci, which he then united into an independent style very much his own. In the process he discovered a new relationship between figure and space derived from complete informality and great presence. Elsheimer preferred to execute small format pictures, and usually painted on copper. His tiny but lively figures are remarkable. His atmospheric and idyllic art influenced Peter Paul Rubens and Roman landscape painting, particularly that of Claude Lorrain. Elsheimer's most significant works include *The Flood*, after 1600, Städelsches Kunstinstitut, Frankfurt am Main; *The Stoning of St. Stephen*, c. 1603, The National Gallery of Scotland, Edinburgh; and *Judith Felling Holofernes*, c. 1608, The Wellington Museum, London.

Opposite

The Veneration of the Cross, c. 1607
Oil on copper, 48.5 x 35 cm
Städelsches Kunstinstitut, Frankfurt am Main

This painting is the center panel of a private altar depicting the Legend of the Holy Cross. Accordingly, the Cross stands in the center, surrounded by angels holding the instruments of Christ's Passion. Above them are the Apostles and Evangelists. To the right, Christ's ancestors are depicted along with Jonas on the fish; to the left are St. Catherine and Mary Magdalene. The foreground contains vivid portrayals of St. Sebastian, Pope Gregory, St. Hieronymus and the first martyrs of the Church.

Flight into Egypt, 1609
Oil on copper, 31 x 41 cm
Alte Pinakothek, Munich

Elsheimer became famous with this lyrical night painting. His treatment of light and balanced composition influenced northern European landscape painting throughout the 17th century and beyond. In this work, four sources of light illuminate fragments of the landscape and emphasize the human figures. At the same time, nature is by no means antagonistic, but is in harmony with humanity, and thus offers the fleeing Holy Family protection and a sense of security.

Eyck, Jan van

Jan van Eyck (c. 1390 Maaseyck near Maastricht–1441 Bruges) was the court painter for Prince Johann of Bavaria, the Count of Holland, in 1422 and in 1425 entered the service of Philip the Good of Burgundy (1396–1467) in Lille. He traveled to Spain and Portugal several times, and in 1430 he settled in Brussels. Van Eyck's innovative conception of the pictorial representation of reality had an enormous influence on European art. He showed the human figure as a body existing in a full space, rendered nature with exacting detail, and distinguished himself through his new style of surface realism. With the development of oil paints, he was able to achieve a powerful, unprecedented use of light and depth of color. Major works by the artist include *Cardinal Nicola Albergati*, c. 1432, Kunsthistorisches Museum, Vienna; *Man with a Red Turban*, 1433, The National Gallery, London; and *Madonna of Canon Georg van der Paele*, 1436, Groeningemuseum, Stedelijke Musea, Bruges.

Ghent Altarpiece, 1425–1432
Oil on panel
Central panel: 350 x 206 cm
Side panels: 350 x 122 cm each
Sint Baafskathedraal, Ghent

This altarpiece consisting of 24 scenes is one of the most significant works of Netherlandish art. The van Eyck brothers created it together, though Hubert was probably primarily responsible for the design and the first draft of the inner sides. After his death, Jan completed the work alone. When the altar is opened, the left wing depicts Adam and singing angels, and above that Abraham's sacrifice of Isaac. God the Father with the Virgin and John the Baptist, who act as intercessors for humankind on Judgement Day, cover the center panel. Eve and angels with musical instruments are depicted on the right wing, under the image of Cain murdering his brother Abel. In the lower section the righteous judges and the warriors of Christ adore the Lamb.

Opposite above

**Ghent Altarpiece (detail,
The Adoration of the Lamb)**

In this grand composition of the Eternal Liturgy, those blessed by the Sermon on the Mount appear in the Heavenly Jerusalem in strict symmetry: the poor in spirit (Apostles), the meek (Angels), those who seek justice (the Prophets), the merciful (the Patriarchs), the peacemakers (those who have recognized the True Faith), the pure of heart (the holy women), and those who have been persecuted on account of their faith (the Martyrs). The Lamb stands in the center of the altar as a blood sacrifice, encircled by angels bearing the instruments used to torture Christ during the Passion. The Fountain of Life is seen in the center foreground. The picture is characterized above all by its liveliness and the painter's love of detail. With its extraordinarily complex and encompassing iconographic program, it is among the most fascinating works of Netherlandish painting.

Opposite below

The Adoration of the Lamb (details)

The representation of figures and nature seen here is evidence of van Eyck's exacting powers of observation. He minutely renders clothing, jewelry, plants and buildings to make them look extremely true-to-life. In his use of light and shadow he forms figures in such a way that they look pliable and alive. Van Eyck advanced the development of the northern painting tradition with his unique conceptions, and also perfected the International Gothic style of painting.

Ghent Altarpiece (detail, Adam and Eve)

This first human couple, after whom the altarpiece was named for a long time, illustrate the transformational quality and the progressiveness of van Eyck's work. For the first time in northern European art, these nude human figures are depicted in a way that is true to nature, even if the organic function of the limbs is not yet fully understood. Van Eyck has also taken note of the details of light and perspective. As a result, Adam's foot is represented from below and severely foreshortened as required by the location in which the panel was to be placed.

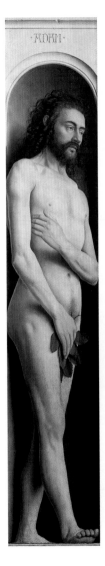
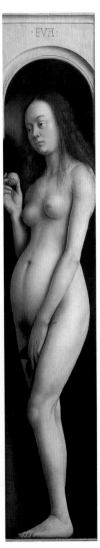

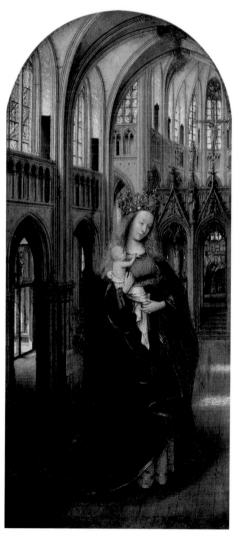

Madonna in the Church, c. 1426
Oil on panel, 31 x 14 cm
Gemäldegalerie, SMPK, Berlin

This panel of a diptych is the most significant early Netherlandish painting of an interior and of the effects of light. The rich contrast between the room and the figure in it lies in the relationship of every detail to the concept of the Madonna. For example, the Church itself refers to the Virgin as the "Temple of God," in whose body Christ incarnate "lives;" the light-flooded windows represent her virginity, and the crown identifies her as the "Queen of Heaven."

Madonna at the Fountain, 1439
Oil on panel, 19 x 12.2 cm
Koninklijk Museum voor
Schone Kunsten, Antwerp

This small devotional painting is the artist's last known dated work. The Virgin, in a flowing blue robe, stands with the Child on a richly ornamented brocade rug held aloft by angels in a garden that can scarcely be seen beyond the window. Before her is the flowing water of the fountain of life. The hedge of the garden is a symbol of her chastity, while the red roses refer to the martyrdom of Christ.

The Virgin of the Chancellor Nicolas Rolin, c. 1435
Oil on panel, 66 x 62 cm
Musée du Louvre, Paris

The powerful court official who commissioned this panel for the cathedral of Autun kneels before the unapproachable and seemingly monumental Virgin Mary with the Child, whose arm is raised in blessing. While the relief sculptures above the chancellor illustrate humankind's sinfulness, the reliefs above Mary depict acts of righteousness. Through the arches of the heavenly temple one can see the Garden of Eden and a terraced landscape, precisely detailed all the way to the horizon.

A Bride, A Groom and Two Witnesses

This double portrait is one of the most imaginative paintings done during the late Middle Ages. It was painted in 1434, two years after Jan van Eyck (c. 1390–1441) had completed his important Ghent altarpiece. By 1516 this panel was in the possession of Margaret of Austria (1480–1530), the regent of the Netherlands.

An old inventory identifies the elegantly dressed couple as being "Arnoul le Fin" with his wife, which has led art historians ever since the middle of the 19th century to usually identify the pair as Giovanni Arnolfini and Giovanna Cenami. Both came from respected merchant families based in Lucca. They lived in Bruges for many years, with Giovanni Arnolfini being chosen as advisor to Philip the Good (1396–1467) in 1461. Their marriage remained without issue; Giovanni died in 1472, Giovanna in 1480.

There are few doubts as to the content of this picture. The man has raised his right hand to swear an oath, just as a groom would today: He is promising to be a faithful husband. It is not by chance that he stands before an open window, through which can be seen a hedge in bloom; a man traditionally represents the connection between the couple and the outside world. He is still wearing his hat and cape, but has taken off his street shoes upon entering the domestic sphere. This gesture, as well as the dog seen at the bottom of the painting, are considered signs of fidelity. The woman, whose shadow falls on the bed behind her, symbolizes domesticity. The wooden statue standing on the headboard represents St. Margaret, the patron saint of women in childbirth. The crystal rosary beads, in those days a traditional present to a bride, along with the whisk broom are references to the Christian virtues of *ora et labora* ("prayer and work"). There are several oranges lying near the window: In Christian iconography, these are the fruits of the Garden of Eden. In the context of this portrait of the Arnolfini, however, they are perhaps also an expression of the couple's wealth, as only the rich upper classes would have been able to afford such exotic imported fruits at the international markets in Bruges. The single candle burning in the seven-branched candelabra that hangs from the ceiling is deserving of special note. On the one hand, it represents the bridal candle presented by the groom during the Christian ceremony; on the other hand, it also stands for the omnipresent light of God.

Jan van Eyck: The Arnolfini Wedding (Giovanni Arnolfini and his Wife Giovanna Cenami),1434
Oil on panel, 81.8 x 59.7 cm
The National Gallery, London
All the details in this painting, even the apparently insignificant ones, can be interpreted on another, symbolic level. This is even more astonishing for the modern viewer in light of the fact that both the couples' clothing and the furnishings in the room correspond to the fashion and style of the late Middle Ages.

The Arnolfini Wedding (detail)
According to medieval tradition, the mirror surrounded by scenes of the Passion can also be interpreted as a symbol of the Virgin Mary. As a *speculum sine macula* ("a mirror without flaw"), it refers to her everlasting virginity and purity.

The convex mirror on the back wall of the room provides a key to understanding the picture. It is surrounded by medallions showing scenes from Christ's Passion. Carefully looking into the mirror, it is possible to see the entire interior scene, including the bridal pair from behind and two other figures that are obviously present as witnesses to the marriage ceremony. It is in this context that the inscription above the mirror takes on a special significance: The words *Johannes de eyck fuit hic* ("Jan van Eyck was here") testify to the painter's presence as a witness to the wedding.

This picture is without doubt one of the few paintings remaining from the Middle Ages to go far beyond a mere depiction of physiognomy. Van Eyck's work is a masterpiece, showing particular skill in the rendering of surface textures. This can be seen in the wood of the shoes and the floor, as well as the fine down of the mink trimming on the man's coat and the peculiar reflections on the convex mirror. Despite the numerous details suggesting an exact study of real objects, it is fairly improbable that this interior is the actual bedroom of the newlywed couple; it

The Arnolfini Wedding (detail)
The wooden sandals that seem to have been thoughtlessly placed in the lower left corner of the painting could be an allusion to a text in the book of Exodus (3:5) that suggests the sanctification of the room in which and the time at which the marriage took place.

The Arnolfini Wedding (detail)
St. Margaret of Antioch is one of the Fourteen Holy Helpers, and is invoked during childbirth. This sculpture on the headboard of the bed thus leaves no doubt as to the desirability of future children in Giovanni Cenami's new marriage.

seems, rather, to be an idealized view, a product of the artist's imagination.

Recent research has called the identity of this bridal couple into question. The doubts are caused by the observation that the woman is standing to the man's left: This could suggest a morganatic marriage, i.e. a marriage between two people of differing rank. However, Giovanni

Arnolfini and Giovanna Cenami came from families of equal station. Perhaps, therefore, it is a painting of Giovanni's brother, Michele Arnolfini, about whose wife nothing is known. Although this picture can conclusively be shown to be a masterly wedding portrait, the mystery surrounding the bridal couple cannot, for the time being, be solved.

Feti, Domenico

Domenico Feti (1589 Rome–1623 Venice) is among the founders of north Italian Baroque painting. He studied under and worked with Ludovico Cigoli from 1604 to 1613, when he became the court painter of Duke Ferdinand II Gonzaga in Mantua. In Mantua he produced monumental frescoes for the cathedral and the Palazzo Ducale. About 1620 he traveled around Tuscany and to Venice. Feti's painting was influenced by the work of Adam Elsheimer, Carlo Saraceni and the Caravaggists, and he was later inspired by the work of Peter Paul Rubens and Venetian artists. In his paintings, Feti achieved a painterly, deep-toned con-straint as well as an expressive color scheme. Aside from mural paintings and large-figured pictures, his early work includes paintings of Christian parables in which he illustrated biblical images in genre fashion. He is considered to be the founder of this particular painting style because of his ability to combine sharp observation with poetic sensibilities. Important works by the artist include *The Feeding of the Five Thousand*, Museo del Palazzo Ducale, Mantua; *The Flight Into Egypt*, c. 1610, Kunsthistorisches Museum, Vienna; and *Portrait of the Workers in the Vineyard*, c. 1618, Gemäldegalerie Alte Meister, Dresden.

Allegory of Melancholy, c. 1621
Oil on canvas, 168 x 128 cm
Musée du Louvre, Paris
Of the four moods of the ancient doctrine of the temperaments, melancholy, which can lead either to brilliant accomplishment or depressive inactivity, is the one most often represented pictorially. Traditionally the more passive aspect is emphasized; here, too, the allegorical figure is depicted as sitting with his head in his hands, brooding over a skull. However, props such as the book and the tools refer to the multifaceted nature of this temperament.

Opposite left
The Parable of the Lost Piece of Silver, c. 1617
Oil on panel, 75 x 44 cm
Galleria Palatina, Palazzo Pitti, Florence
This work, which was probably painted by Feti, is a slightly different version of the painting currently hanging in the Gemäldegalerie in Dresden that illustrates a parable told in the Gospel of Luke 15:8–10. The great joy of the woman over having found the lost coin (she is shown here lighting a lamp in order to look for it) is equal to the great joy of Heaven over the return of one lost soul to the Christian community.

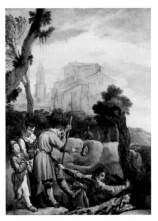

The Parable of the Blind Leading the Blind
Oil on panel, 60.7 x 44.2 cm
Barber Institute of
Fine Arts, Birmingham
As opposed to the situation in Dutch painting, there are only a few Italian works that depict the motif of the blind leading the blind. Feti has modelled this painting on Bruegel's composition *The Parable of the Blind Leading the Blind*, though he has borrowed elements from the art of Veronese in the design of the landscape. This is also a self-made replica of a version in the Gemäldegalerie in Dresden, but with many alterations, not the least of which is its vertical format.

Flegel, Georg

Georg Flegel (1566 Olmütz–1638 Frankfurt a.M.) was the first German artist to focus solely on still-life painting. From as early as 1594 he was active in Frankfurt; he is known to have worked along with the Flemish artist Lucas van Valckenborsch, who introduced him to the art of his homeland. Around 1600 Flegel began working independently as a miniaturist; thus, his early work is distinguished by its fragmented composition and its aggregated, representational style. His later pictures of meal and flower still lifes begin to exhibit a more dense, centered composition, in which sensitively painted objects are composed in an original and well thought-out manner. Works by the artist include *Still Life with Flowers and Fruit*, c. 1610, Národní Galerie, Prague; *The Great Feast*, Alte Pinakothek, Munich; and *Still Life with Candle*, 1636, Wallraf-Richartz-Museum, Cologne.

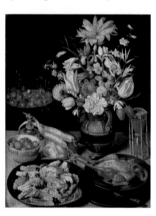

Still Life with Flowers
Oil on panel, 52.5 x 41 cm
The Hermitage, St. Petersburg
The painting shown above illustrates Flegel's outstanding ability to render the surfaces and qualities of a wide range of materials. The hourglass is somewhat unusual for this carefully thought-out arrangement, as it is most commonly used as a symbol of the transience of human life, and is generally found in *vanitas*-type still-life paintings.

Still Life with Parrot and Snack
Oil on canvas, 30.5 x 38 cm
Germanisches Nationalmuseum, Nuremberg
In this painting the costly delicacies arranged on serving platters are shown from a slightly elevated perspective. The flatbreads, pastries, sugar sticks, nuts, fresh and dried fruits as well as the rare bird are all meant to represent the prosperity of the patron. Here Flegel does not use the aggregate-style arrangement of his earlier works, but instead creates a dynamically rhythmic composition. The painting is also distinguished by its mood-setting application of light and color.

Fontainebleau, School of

The School of Fontainebleau had its home base in a hunting lodge by the same name, which had been expanded gradually after 1528 under François I (1494–1547), in a forest on the outskirts of Paris. In 1530, Rosso Fiorentino was the first Italian Mannerist painter to come to Fontainebleau, where along with several compatriots as well as with Flemish and French artists, he worked on the decoration of the palace. In 1532 Francesco Primaticcio was called to the court, and in 1552 Niccolò dell'Abbate followed. The painters Jean Cousin and Antoine Caron were among the French members of the School. Various anonymous artists created outstanding works alongside these better-known figures. The School of Fontainebleau stood at the center of French courtly art from about 1530, and experienced a second flowering around 1600 with the contributions of Toussaint Dubreuil and Martin Fréminet. Other works created by the Fontainebleau School include *Diana and Acteon*, c. 1545, Musée du Louvre, Paris; *Young Lady at her Toilette*, c. 1560, Musée des Beaux-Arts, Dijon; and *Sabina Poppea*, c. 1560, Musée d'Art et d'Histoire, Geneva.

Landscape with Corn Threshers, c. 1560
Oil on canvas, 85 x 112 cm
Musée National du Château, Fontainebleau
This painting, which was formerly attributed to Niccolò dell'Abbate and is now attributed to an unknown member of the School of Fontainebleau, is distinguished by its high artistic quality. Courtly elegance is combined in a highly unusual way with characteristics borrowed from contemporary Flemish landscape painting in the tradition of Pieter Bruegel the Elder.

Diana as a Huntress, c. 1550
*Oil on panel, transferred
to canvas, 191 x 122 cm
Musée du Louvre, Paris*
Diana, the Roman goddess of the
hunt, is depicted striding through
the forest and accompanied by a
dog. Her nude body is protected
only by a yellow cloak casually
hanging from her right shoulder and
a thin veil covering her genitals. The
format of this famous painting,
which has served as a model for
countless later representations of
Diana, suggests that it originally
may have been used to decorate
a fireplace.

Caritas, c. 1565
Oil on panel, transferred to canvas
150 x 100 cm
Musée du Louvre, Paris
The personification of Charity with her five children is
depicted in an artfully arranged pose that radiates grace
and elegance. While the standing female figure is
clearly inspired by the ancient sculpture of the famous
Farnese Flora, the more active putti have been executed
to some extent in the style of Michelangelo.

**Gabrielle d'Estrées and One of her Sisters
in the Bath, c. 1594**
Oil on panel, 96 x 125 cm
Musée du Louvre, Paris
The two half-nude women in the foreground of the
painting present the viewer not only with a valuable
ring, but also with their well-proportioned bodies. These
types of suggestive pictures, distinguished by their refined
eroticism, are characteristic of the Mannerist paintings
of the School of Fontainebleau.

Foppa, Vincenzo

Vincenzo Foppa (c. 1428 Brescia?–c. 1515 Brescia) is considered to be the most important early Renaissance painter in Lombardy and the founder of the Lombardy School. He worked primarily in his native city, in Pavia and in Milan. Early on he developed his own style, in which tone and atmosphere are more heavily accentuated than design and structure. In so doing, Foppa strove above all to reproduce the appearance of natural light. With his restrained, graceful and realistic representations he was able to promote the breakthrough of figurative painting in Lombardy. Works by the artist include *Scenes from the Life of Saint Peter the Martyr*, c. 1567, San Eustorigio, Milan; *The della Rovere Polyptych*, 1490, Santa Maria di Castello, Savona; and *The Adoration of the Magi*, c. 1500, National Gallery, London.

Virgin and Child (Madonna with the Book), 1464–1468
Tempera on panel, 37 x 29 cm
Castello Sforzesco, Milan
Foppa's use of perspective, and in particular the three-dimensionality of his figures, was probably influenced by the work of Andrea Mantegna; thus in this painting the Mother of God appears with the Child within a structured architectural frame. In rendering a calm sense of everyday reality, the figures display restrained feelings and gestures, although the *chiaroscuro* of their faces lends them a melancholy, introspective air.

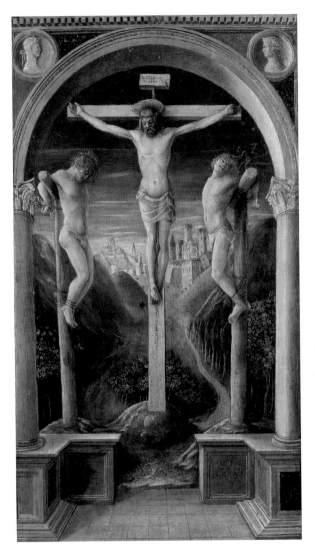

Crucifixion, 1456
Tempera on panel, 68 x 38 cm
Accademia Carrara, Bergamo
This unusual composition, an early work of the painter, highlights his uniqueness within the northern Italian artistic scene. The architectonic frame and the landscape view place emphasis on the cross of Christ, located in the central axis of the picture. The reserved color scheme allows the glistening light to shape the subjects depicted and makes them glow. The entire surface of the picture is filled with a flickering light that is barely diminished by the formal construction, the perspective or the contour lines.

Fouquet, Jean

Jean Fouquet (c. 1417 Tours?–c. 1480 Tours) was one of the best-known painters of his time. His art is influenced both by Flemish painting and by the Limburg brothers, as well as by French monumental sculpture; he became acquainted with the work of Masaccio and Andrea del Castagno during his travels though Italy in around 1448, which also had an impact on his style. Back in Tours he founded a large workshop and, in 1475, he became the court painter to Louis XI (1423–1483). Fouquet produced book illustrations as well as panel and glass paintings and enamel work for Étienne Chevalie, the king's treasurer. In a highly independent manner he combined elements of northern and southern European art, and developed a realistic style of Renaissance painting. His style, which is characterized by a certain distance and abstractly austere construction, served as a guide for future artists. Works by the artist include *Miniatures of the Prayerbook of Étienne Chevalier*, c. 1453, Musée Condé, Chantilly; and *Miniatures of Hebrew Antiquities*, 1455–1476, Bibliothèque Nationale, Paris.

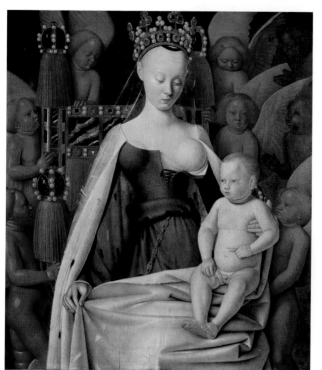

Virgin and Child, c. 1455
Oil on panel, 92 x 84 cm
Koninklijk Museum voor
Schone Kunsten, Antwerp
In contrast to the wing belonging to the *Melun Diptych* pictured at right, this panel displays a certain Gothic character. Typical of Fouquet's painting is the stylization, clarity and formative power. During his time it was quite common to depict holy figures in such a worldly fashion: It is the king's mistress, Agnés Sorel, who is thought to be portrayed in this picture. The bare breast is not a thematic requirement here, but rather an erotic element of the painting.

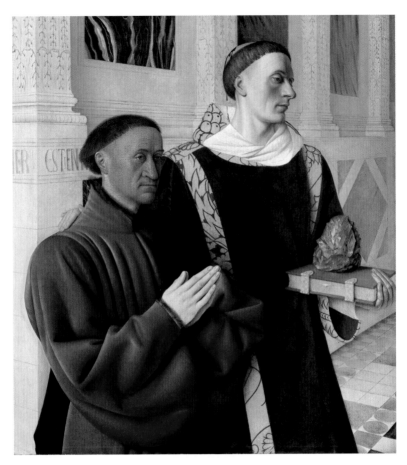

**Étienne Chevalier with
St. Stephen, c. 1455**
*Oil on panel, 93 x 85 cm
Gemäldegalerie, SMPK, Berlin*
This panel shows the left half of the
Melun Diptych, which was intended
for Chevalier's tomb in the Church
of Notre-Dame in Melun. The
patron, who died in 1474, was the
son of a secretary of Charles VII
(1403–1461) and won a great deal
of influence in the course of a
successful career as a court official.
While Chevalier's portrait follows
the painting tradition of Flanders,
the Renaissance architecture and
the idealized rendering of the saint
are represented in an Italian manner.
St. Stephen holds a book in his hand
with a sharp-edged stone on it to
symbolize his martyrdom.

**Guillaume Juvénal
des Ursins, c. 1460**
*Oil on panel, 92 x 74 cm
Musée du Louvre, Paris*
Fouquet renders a serious and physiognomically accurate likeness in this dignified portrait of Charles VII's chancellor. The rich detail and three-quarter view of the figure illustrate Fouquet's connection with French and Dutch painting. In contrast, the depiction of books and the ornamentation on the walls are evidence of his familiarity with Italian art.

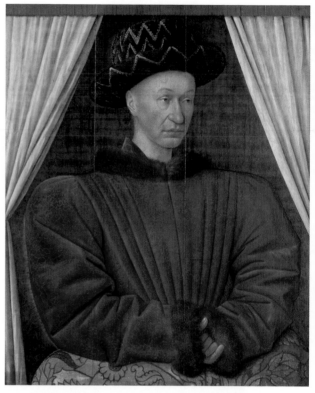

**Charles VII of France,
c. 1445–1450**
*Oil on panel, 86 x 71 cm
Musée du Louvre, Paris*
This portrait of the king of France bears witness to Fouquet's intense preoccupation with Flemish portraiture, particularly in the precise rendering of the various types of cloth. In contrast, he is less interested in the representation of space. The sharply juxtaposed colors and the rigid composition of the geometrical forms give the king a cool presence. The pointedly sedate light effects bring out the king's face, highlight elements of his head covering, and emphasize the gathered curtains, which resemble a window around the painting.

Fra Angelico

Fra Angelico (c. 1395 Vicchio di Muguello near Florence–1455 Rome), also called Beato Angelico, is one of the significant painters of the period between the late Gothic and the early Renaissance. He entered the Dominican monastery at the age of 20, already a trained artist. In 1436 he and the other members of the monastery moved to San Marco in Florence, which had been donated to the Order by Cosimo de'Medici (1389–1464). In 1447/48 and then from 1452 onward he worked for the papal court in Rome while working simultaneously in Orvieto. In his frescoes and panel paintings Fra Angelico embraced the new Renaissance forms while developing his own style, which is especially evident in the closed nature of his figures. Significant works by the artist include *Virgin and Child with Saints (The Annalena Panel)*, c. 1437–1440, Museo di San Marco, Florence; *Scenes from the Lives of Sts Stephen and Lawrence*, c. 1448, Cappella Niccolina, Vatican; and *Scenes from the Life of Christ*, c. 1450, Museo di San Marco, Florence.

Madonna with Child and Saints, 1424–1430
Tempera on panel, 212 x 237 cm
San Domenico, Fiesole
This work illustrates the historically significant change from the traditional polyptych format to that of the *sacra conversazione*. Instead of the carved architectural frame surrounding most altarpieces, the structure of this piece is achieved from within the painting by the extended achitecture of the throne. The arches of the throne frame the Madonna and Sts Thomas, Barnaby, Dominic and Peter the Martyr. The typical gold background is replaced here by a wide landscape.

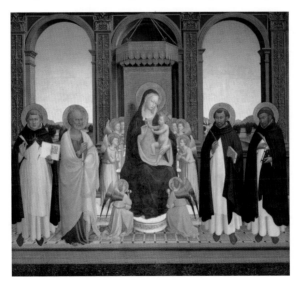

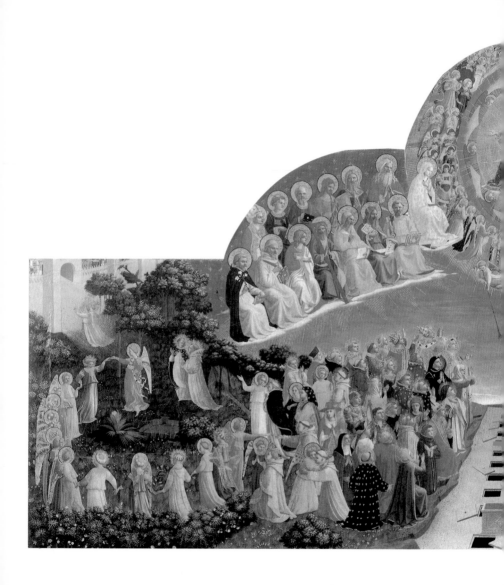

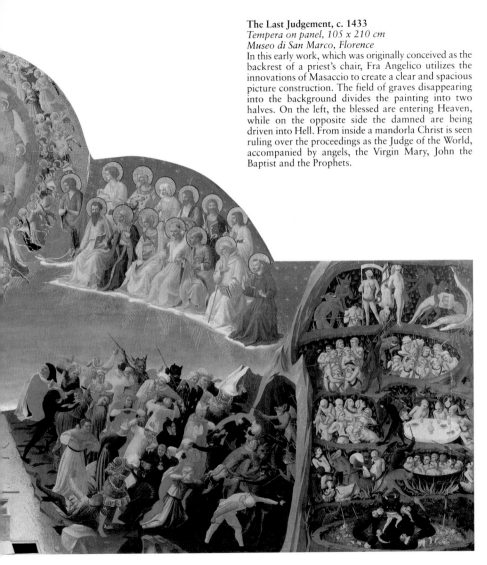

The Last Judgement, c. 1433
Tempera on panel, 105 x 210 cm
Museo di San Marco, Florence
In this early work, which was originally conceived as the
backrest of a priest's chair, Fra Angelico utilizes the
innovations of Masaccio to create a clear and spacious
picture construction. The field of graves disappearing
into the background divides the painting into two
halves. On the left, the blessed are entering Heaven,
while on the opposite side the damned are being
driven into Hell. From inside a mandorla Christ is seen
ruling over the proceedings as the Judge of the World,
accompanied by angels, the Virgin Mary, John the
Baptist and the Prophets.

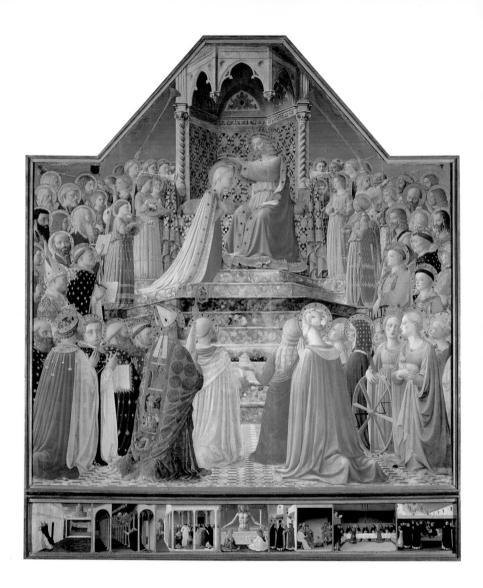

**The Coronation
of the Virgin, c. 1433**
*Tempera on panel, 209 x 206 cm
Musée du Louvre, Paris*
This theme is often found in the
center panels of altarpieces from the
14th to the 16th centuries. As in this
painting, the Virgin is generally
shown kneeling before Christ, so
that the panels also include a prayer
motif along with her glorification.
This work is one of the first in
which the viewer's participation in
the events of the picture is estab-
lished through the turned backs of
the figures in the foreground.

The Linaiuoli Triptych, 1433
*Tempera on panel, 233 x 133 cm
Museo di San Marco, Florence*
Fra Angelico produced this work,
which is installed in a marble ta-
bernacle made by Lorenzo Ghiberti
(c. 1380–1455), for the flax traders'
guild. The gold base of the center
panel is suggestive of the heavenly
light eminating from the Virgin and
the Christ Child. An innovation
for the time is the generous mass of
the curtain, which apparently refers
to scripture in that it shields the
Holy of Holies. The Sts Mark and
John can be seen on the two wings
of the altarpiece.

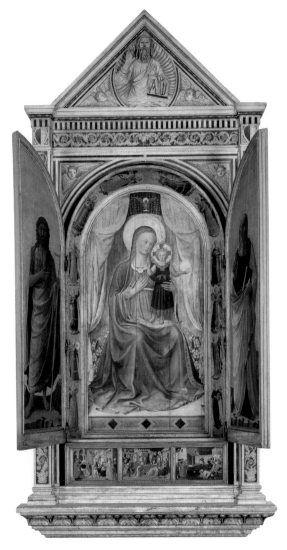

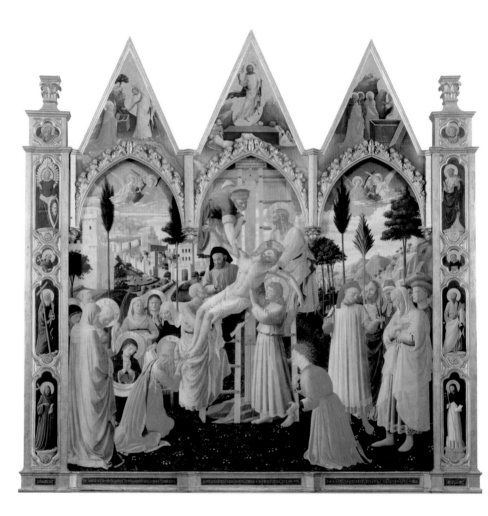

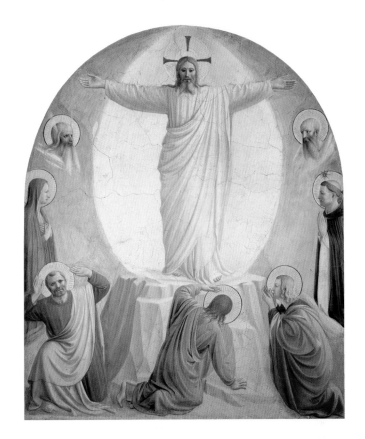

Opposite

Deposition from the Cross, c. 1430–1440
Tempera on panel, 185 x 176 cm
Museo di San Marco, Florence
This work was commissioned by the Strozzi family for
S. Trinità in Florence. It was begun by Lorenzo Monaco,
who painted the gable fields, and completed by Fra
Angelico. The composition of the background identifies
him as one of the great landscape painters of the 15th
century. The panel is also a key work of early Renais-
sance painting because of its realistic spatial construction
and simplified architectural forms.

The Glorification of Christ, c. 1441
Fresco, 181 x 152 cm
San Marco Monastery, Florence
This fresco in a monastery cloister cell testifies to Fra
Angelico's spirituality as well as to the lightness of his
painting style. Christ appears in a mandorla of light,
along with the prophets Moses and Elijah, to the
frightened apostles. Their animated gestures lend a
certain liveliness to the painting's strict composition.
The biblical theme has been expanded here with the
addition of the two saints.

**Madonna and Child with Angels and Saints
(Pala di San Marco), c. 1440**
Tempera on panel, 220 x 227 cm
Museo di San Marco, Florence
The scheme of this panel for the high altar of San Marco
takes into account the desires of the patron, Cosimo
de'Medici (1389–1464), as well as those of the
Dominican monks to whom the church belonged. For
example, while all the depicted saints are patrons of the
Medici, the opened book held by St. Mark refers to the
prayer and poverty vows of the Order. Innovative is the
square format, which relieves the four-part structure of
the altar as well as the applied central perpective.

Opposite below
Annunciation, c. 1450
Fresco, 230 x 297 cm
San Marco, Florence
This work, part of a cycle of frescoes, evokes quiet reverence for the life of Christ through its simplicity. The Virgin sits humbly on a stool and submits herself to the prophesy of the angel. The enclosed garden in which the Annunciation takes place symbolizes the impending immaculate conception. The graceful figures and the light-filled space without strong color contrasts make the painting appear full of poetry and weightlessness.

Entombment, c. 1440
Tempera on panel, 38 x 46 cm
Alte Pinakothek, Munich
This predella panel was once located beneath the painting of the Crucifixion in the Pala di S. Marco. It refers to the Eucharist, since Christ's grave as depicted here is very similar in character to the containers in which the Host was traditionally stored. Despite its strict composition the scene seems alive and full of emotion due to its slight asymmetry and the devout bearing of the Virgin and St. John.

Fra Bartolommeo

Fra Bartolommeo (1472 Soffignano near Florence–1517 Pian' di Mugnone near Florence), actually named Bartolommeo Pagholo del Fattorino, was also called Bartolommeo or Baccio della Porta. In 1484 he began studying under Rossellini, and declared himself independent and went into partnership with Mariotto Albertinelli in 1490. He was a follower of Girolamo Savonarola (1452–1498), and two years after Savonarola's death he joined the Dominican Order of Prato, later based at San Marco in Florence. He then gave up painting until 1504. Fra Bartolommeo, who was inspired by Flemish painting as well as by the art of Giovanni Bellini and Leonardo, is among the most significant representatives of the High Renaissance. Simple compositions and calm, meaningful gestures through which he achieves a festive air characterize his work. Many artists, including Pontormo and Raphael, were inspired by his art. Major works by the artist include *Annunciation*, c. 1500, Galleria degli Uffizi, Florence; *Madonna in Glory between Saints and the Patron Jean Carandolet*, 1511/12, St.-Jean, Besançon; and *Madonna della Misericordia*, c. 1516, Pinacoteca Nazionale, Lucca.

The Vision of St. Bernard, 1506
Oil on panel, 220 x 213 cm
Galleria dell'Accademia, Florence
This impressive painting showcases Fra Bartolommeo's great artistic ability. Surrounded by a host of angels, the Virgin and the Christ Child float down to the kneeling St. Bernard, behind whom stand Sts John and Benedict. A small panel depicting the Crucifixion can be seen in the foreground. The execution of this mystical and ascetic representation prefigures Mannerist and Baroque art.

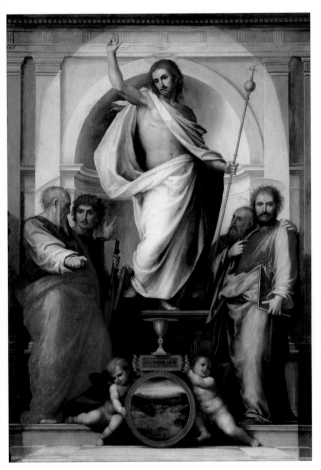

Fra Girolamo Savonarola, c. 1498
Oil on panel, 53 x 47 cm
Museo di San Marco, Florence
This Dominican monk (1452–1498) originally from Ferrara, had great influence on the culture and politics of Venice. He condemned the ostentatious lifestyle of the nobility, advocated the necessity of doing penance and swore that he had apocalyptic visions of the coming turn of the century. After he attacked the papal court as well, he was excommunicated and eventually burned. The portrait's incription indicates that he was thought to be a prophet. Here the ascetic is depicted with a stern and decisive bearing.

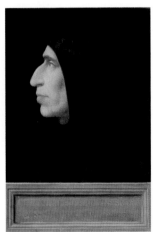

**Christ and the Four Evangelists
(Salvator Mundi), 1516**
Oil on panel, 282 x 204 cm
Galleria Palatina,
Palazzo Pitti, Florence
This panel from the Chuch of San Annunziata in Florence shows Christ as Savior of the World, as indicated by the inscription above the earthly landscape. Following the traditional representation of this theme, Matthew, Mark, Luke and John are gathered around Him. The evangelist on the left points out of the picture toward the Host and the goblet held by the priest during Mass, referring to the Eucharist, a popular theme at the time.

Isaiah and Job, 1516
Oil on panel
169 x 108 cm each
Galleria dell'Accademia,
Florence

These two works constituted the
side panels of the *Salvator Mundi*
altarpiece until the beginning of
the 17th century. Here both Old
Testament prophets sit in simply
constructed architectural niches.
On Isaiah's writing tablet one can
read the inscription "Behold! God is
my Redeemer," while Job's banner
reads, "He Himself is my Redeem-
er." Toward the end of Bartolom-
meo's creative period, his forms
become noticeably more monumen-
tal and stern. At the same time, the
influence of Michelangelo, whose
work Fra Bartolommeo studied
during his stay in Rome in 1514, is
evident in these paintings.

Fragonard, Jean-Honoré

Jean-Honoré Fragonard (1732 Grasse, Provence–1806 Paris) began his training with Jean-Baptiste Siméon Chardin, later studying under François Boucher, whose work impressed him very deeply. In 1752 he won the Prix de Rome and joined the class taught by Carle van Loos. He received a scholarship to study at the Académie de France in Rome from 1756 to 1761, and after his return he became a member of the Paris Academy. He travelled to Italy once again in 1773, then immediately thereafter to Vienna and Germany. Along with Antoine Watteau and François Boucher, Fragonard is among the greatest genre painters at the end of the Age of Absolutism in France. As a Rococo painter, he did not embrace the revolutionary neoclassical aesthetic. Works by the artist include *The Crowning of the Lover*, c. 1772, The Frick Collection, New York; *Festival in St. Cloud*, 1775, Banque de France, Paris; and *The Fountain of Love*, c. 1780, The Wallace Collection, London.

Cart in the Mud, 1760
Oil on canvas, 73 x 97 cm
Musée du Louvre, Paris
Fragonard renders the mood of this rural tragedy with great expression. The simple yet bold composition is dominated by two streams of movement: that of the fully loaded wagon mired in mud, which is being pulled by an ox and pushed by two boys; and that of the herd of sheep being steered away from them by a shepherd and his sheepdog.

Louis de La Bretèche, 1769
Oil on canvas, 80 x 65 cm
Musée du Louvre, Paris
Fragonard painted this fantasy picture, which depicts the older brother of his friend and patron Abbé de Saint-Non, in just one hour. He has outlined the face, colored the flesh, defined the costume and rendered the moving figure in the light of a ray of sun all with just a few lines of chalk and vigorous brush strokes. By doing so, the sketch-like nature of the portrait appears to have a timeless existence.

Portrait of the Dancer Marie-Madeleine Guimard, c. 1767
Oil on canvas, 82 x 65 cm
Musée du Louvre, Paris
Fragonard achieved the lively and magical effects unique to his portraits through deviation from an exact rendering of his subjects and their gestures. He often utilized various elements of historical costume to create this impression. The tension between artistic and natural representation is exactly that which makes this fantasy portrait so charming.

Opposite
The Swing, 1767
Oil on canvas, 81 x 65 cm
The Wallace Collection, London
Pictures of this type enjoyed great popularity in most time periods, and often hung in *boudoirs*, the most intimate rooms of the house. A baron originally commissioned this work to express his admiration for his beloved, and the lusty interplay between voyeurism and exhibitionism is quite obviously represented. The potential explosiveness of the situation is relieved by the gallant's presumably accidental stumbling.

The Blouse Removed, c. 1770
Oil on canvas, 110 x 120 cm
Musée du Louvre, Paris
Through his sketchlike painting and rich coloration, Fragonard created cheerful, graceful and even daring scenes whose indecent content was often shrouded in ambiguity. Thus the observer of this painting is made into a voyeur of a very intimate moment in which the beauty, thinking herself unnoticed, gives in to her imagination. The action is simultaneously mimicked by the putti, an attribute of Venus, goddess of love.

The Stolen Kiss, c. 1787
Oil on canvas, 45 x 55 cm
The Hermitage, St. Petersburg
Inspired by the ideas of the French philosopher and writer Jean-Jacque Rousseau (1712–1778), Fragonard found his way to a romanticized expression in which sensitivity plays a primary role. Thus in this painting, the filmy veil of the young woman may be a symbol of her feelings. The lightness of Fragonard's early works has by this point in his career given way to an emphasis on the monumental.

Friedrich, Caspar David

Caspar David Friedrich (1774 Greifswald–1840 Dresden) studied at the Academy in Copenhagen from 1794 to 1798 under Jens Juel, among others. He then went to Dresden as a painter of theatrical scenery. From 1800 on he met many of the important artists of the German Romantic movement in Dresden, including the poets Novalis (1772–1801) and Heinrich von Kleist (1777–1811), as well as the painters Georg Friedrich Kersting and Carl Gustav Carus. It was not until 1807 that he turned to canvas painting. In 1810 he became a member of the Berlin Academy, and in 1816 joined the Dresden Academy. Friedrich did not strive to create an objective representation of nature in his landscapes. Inspired by Philipp Otto Runge, he instead sought to translate personally experienced metaphysical thoughts and perceptions into his paintings. In doing so he brings out the sorrowful longing of the human spirit to become one with God's universe. Besides his paintings, Friedrich also produced extensive written work. His paintings include *The Cross in the Mountains (The Tetschen Altarpiece)*, 1808, Gemäldegalerie Neue Meister, Dresden; *Monastery in the Oak Forest*, 1809/10, Nationalgalerie, SMPK, Berlin; and *Wanderers over the Sea of Fog*, c. 1818, Kunsthalle, Hamburg.

Tree with Crows, c. 1822
Oil on canvas, 59 x 74 cm
Musée du Louvre, Paris
Friedrich aesthetically strengthens the harmonious interplay of natural and human works with his representations of ancient Nordic barrow graves. As seen in this scene of the Baltic coast, his composition consists of various individual studies. In place of the stones of which the graves originally were made, there appear only trees: In this way a choir-like sacred area is created out of various natural elements.

**A Couple Gazing
at the Moon, 1824**
Oil on canvas, 34 x 44 cm
Nationalgalerie, SMPK, Berlin
Friedrich repeatedly painted figures facing a valley or a distant view with their backs turned to the viewer. They are not mere accessories, but heighten the expression of the vast distance depicted in the painting. Through them, the artist guides the viewer into the role of the reverant observer; this shared experience is emphasized by the representation of a couple.

Opposite
Monk by the Sea, 1808–1810
Oil on canvas, 110 x 171.5 cm
*Galerie der Romantik, Staatliche
Schlösser und Gärten, Berlin*
The coast is one of Friedrich's favorite subjects through which he expresses his love of nature. He conceived of nature as possessing an overwhelming greatness and power, whose eternity and sublimity are experienced by human beings with a kind of religious reverence. The tiny figure of the monk heightens this contrast between boundless nature and human existence.

Gegenüber
Chalk Cliffs near Rügen, c. 1818
Oil on canvas, 90 x 70 cm
Stiftung Oskar Reinhart,
Winterthur
This picture is an example of the discovery of unusual landscapes and perspectives. These steeply rising cliffs expose a view into a deep abyss and the wide expanse of the sea. The foreground offers the hikers very little space, and yet an uneasy serenity results from this extreme situation.

The Polar Sea, c. 1823
Oil on canvas, 97 x 127 cm
Kunsthalle, Hamburg
This picture was originally titled *Wrecked Hope*, after a previous version which depicted a wrecked ship bearing the name "Hope." It is not merely an expression of the uselessness of human striving to penetrate the farthest reaches of the world and of God's mysteries, but also reflects Friedrich's demolished patriotic hope at the beginning of the Restoration Period.

Landscape at Riesengebirge, after 1830
Oil on canvas, 45 x 58.3 cm
Pushkin Museum of
Graphic Art, Moscow
Friedrich utilized two principle motifs—the appearance of mist and the high mountains—in order to aestheticize his religious ideals in paintings of this type. The mountains in the sub-alpine landscape rise up mightily, while the fog enveloping the forms appears as if it was a messenger from heaven, lending their silhouettes a solemn and secretive character.

Froment, Nicolas

Nicolas Froment (c. 1427 Uzès in Languedoc–1483 Avignon) was one of the most important painters in southern France during the second half of the 15th century. He probably lived in Usèz from 1461 to 1467. He then moved to Avignon and went into the service of King René d'Anjou (1409–1480). It is likely that he had already visited Italy before 1465. Aside from altar and mural paintings, he also painted miniatures and theatrical scenery. In his early work, Froment's realistic depictions exhibit his connection to the Dutch tradition. However, at the same time the influence of contemporary Spanish painting is evidenced by his hard and grotesque representational style, as well as his expressive forms and color schemes. He later was able to

produce looser monumental compositions and softer forms. Another important work by the artist is the *Altarpiece of the Burning Bush*, 1475/76, Cathédrale St-Sauveur, Aix-en-Provence.

**The Lazarus Triptych
(The Raising of Lazarus), 1461**
Oil on panel, 175 x 266 cm
Galleria degli Uffizi, Florence
This triptych, which was originally completed for the Minorite monastery in Mugello, is Froment's earliest known work. The center panel shows the raising of Lazarus, one of the miracles worked by Christ (John 11:1–45). Mary and Martha, the sisters of the resurrected man, stand before the open grave. They appear separately with Christ and at the scene of the washing of His feet on the inner sides of the altarpiece's wings.

John Henry Fuseli (Füssli, Johann Heinrich)

John Henry Fuseli (1741 Zurich–1825 Putney Hill by London), son of the painter Johann Caspar Fuseli, aligned himself from the start of his career with the Enlightenment and great literature. He first pursued a career in theology, but was forced to leave Zurich in 1763 for political reasons and settled in England in the following year. He was active as a writer until 1768, but was then introduced to painting by Sir Joshua Reynolds and studied in Italy from 1770 to 1778. In 1799 he became a member, and in 1804 an inspector, of the Royal Academy. His romantic neoclassicism was particularly influenced by Michelangelo and the Mannerists, as well as by literary subject matter. Fuseli is known for his striking dramatizations of theatrical fantasy scenes using strongly rhythmic, tension-filled forms and agitated figures. His works include *Lady Macbeth*, 1784, The Tate Gallery, London; *Titania and the Donkey-Headed Bottom*, c. 1780–1790, The Tate Gallery, London; and *Sin Pursued by Death*, c. 1795, Kunsthaus, Zurich.

Lady MacBeth
Sleepwalking, 1784
Oil on canvas, 221 x 160 cm
Musée du Louvre, Paris
At the beginning of his artistic career, the plays of Shakespeare (1564–1616) were Fuseli's most important source of inspiration. Represented here is a scene from the fourth act of the drama *MacBeth*; the composition is still strongly modeled on a theatrical production. Füssli repeatedly painted such ghostly and frightening visions, making an impressive attempt to represent the human subconscious in tangible form.

Titania Caresses the Donkey-Headed Bottom, 1793/94
*Oil on canvas, 169 x 135 cm
Kunsthaus, Zurich*

Fuseli produced numerous sequences from Shakespeare's confusing mythological/courtly play *A Midsummer Night's Dream*. In this picture the painter has taken as his subject the revenge inflicted by Oberon, the Elf King, on his wife, Titania, with whom he has had an argument. Using a magic potion, he forces her to fall in love with the first being she sees. The victim, a garrulous weaver, has had a donkey's head placed on him to make the love situation as ridiculous as possible. Fuseli enhances on canvas the theatrically constructed, totally absurd situation by combining various fantasy figures with the realistic rendering of Titania, the main character. The detail on the opposite page concentrates on the interplay between the blind love which Titania bestows upon the creature and the rather grotesque and indifferent appearance of the weaver. The parable of the effect of the magic potion is made particularly clear through this contradiction.

Ave Maria, Gratia Plena Dominus Tecum...

"Hail Mary, full of grace, the Lord is with you..." The Annunciation has been one of the central themes throughout the history of Christian art. The Gospel of Luke (1:26–28) relates that an angel appeared to Mary, saying "Hail, thou that are greatly favored among women, the Lord is with thee." The angel prophesies to the terrified Virgin that she shall bear a son, whom she shall call Jesus. "The Lord God shall give unto him the throne of his father David: And he shall reign over the house of Jacob for ever; and of his kingdom there shall be no end." Mary accepts this message humbly, replying before the angel departs "Behold the handmaid of the Lord; be it unto me according to thy word."

Artistic representations of this event concentrate primarily on the two main figures. Sometimes God the Father is also integrated into the scene, having sent the angel to the Virgin who is to bear his Son. Despite the strict canon applying to representations of this scene, the subject has been interpreted in a seemingly endless variety of ways. While in Italian painting the scene is often portrayed in a palatial setting, northern artists tended to choose sacred buildings or luxurious domestic interiors. The angel commonly carries a scepter, a lily, an olive branch or a banner, all of which can symbolize her or his function as a messenger.

The Annunciation scene depicted on the Columba Altarpiece in Munich by Rogier van der Weyden (c. 1399–1464), like many other paintings of this subject, includes a bunch of white lilies displayed prominently as a symbol of Mary's purity and virginity. A pile of books refers to the Virgin's wisdom, and the bedroom in the background symbolizes the mystery of the wedding night that forms one of the themes of the Old Testament's Song of Solomon.

But not only the setting—which is influenced both by local tradition and the individual painter's powers of imagination—is subject to modification. Different elements and aspects of the biblical text are emphasized in the myriad paintings of the Annunciation. In the picture by Rogier van der Weyden shown on page 359, for example, the Virgin turns from the book she is reading toward the angel, who seems to have floated into the room through the closed door. Mary replies to his salutation by raising her hand.

In Botticelli's (1445–1510) painting, on the other hand, shown opposite, both Mary and the Angel of the Annunciation are depicted with crossed hands, a gesture that can be understood

Sandro Botticelli: The Annunciation, c. 1489
Tempera on panel, 150 x 156 cm
Galleria degli Uffizi, Florence
In the so-called "Annunciation of Cestello" Botticelli adheres to tradition in the way he associates the angel with the exterior space by placing him before a landscape, while Mary, kneeling at her *prie-dieu* (kneeling bench), remains in the interior.

as a sign of their compliance with the heavenly message. It is no coincidence that the expulsion of Adam and Eve from the Garden of Eden is depicted in the garden scene at the left edge of the picture. The Fall from Grace is also an aspect of the subject treated by Rogier van der Weyden; a depiction of it in relief decorates the Virgin's *prie-dieu*, or kneeling bench, shown at the bottom right of the painting. When these scenes of the Garden of Eden are shown in conjunction with the Annunciation, it is meant as an allusion to the redemption of the original sin through Christ's crucifixion. Thus, the paintings by Fra Angelico and van der Weyden, coming from quite different cultural backgrounds, both emphasize Mary's significance as the personification of a "new Eve," bringing the promise of redemption.

Opposite
**Fra Angelico: The Annunciation,
c. 1430–1432**
*Tempera on panel, 154 x 194 cm
Museo del Prado, Madrid*
The relationship between Mary and
God the Father is made obvious
by a ray of light connecting the two.
In Fra Angelico's painting, as in
many others on this subject, he has
depiczed a white dove symbolizing
the Holy Ghost.

**Rogier van der Weyden:
The Annunciation (left wing of
the Columba Altarpiece), c. 1455**
*Tempera on panel, 138 x 70 cm
Alte Pinakothek, Munich*
It is not by chance that the words in
front of the angel's mouth intersect
with the scepter held in his left
hand. The cross formed in this way
is a reference to Christ's death and
thus also to redemption.

Gaddi, Taddeo

Taddeo Gaddi (c. 1300? Florence–1366 Florence) was Giotto's most important student and also his longterm collaborator. Gaddi was also inspired by the work of Lorenzetti and the sculptor Tino di Camaino (c. 1285–1337). He deviated from these models, however, in that he used a freer construction of space, which he achieved through a diagonal depth perspective and multi-figured compositions. Gaddi's frescoes and panel paintings are also characterized by a richly detailed and less monumental conception, although his later works seem more picturesque. His workshop was continued after his death by his student and son,

Agnolo Gaddi. Agnolo had assisted his father with countless frescoes while he was still living, so the boundary between the two artists is somewhat blurred; nonetheless, the son never achieved the same level of success as his father. Among the artist's works are *The Story of Job*, after 1340, Camposanto, Pisa; *Virgin and Child Enthroned with Four Saints*, c. 1345–1350, The Metropolitan Museum of Art, New York; and *Virgin and Child with Angels*, 1355, Galleria degli Uffizi, Florence.

The Presentation of the Virgin in the Temple, c. 1330–1338
Fresco
San Croce, Florence
This scene belongs to the cycle of the Life of the Virgin in the Baroncelli Chapel of San Croce. It exemplifies Gaddi's continuation of the painting style of his teacher, Giotto. However, he creates a more complex spatial construction, uses more unusual light effects and achieves a stronger narrative moment.

Opposite
Crucifixion, c. 1360–1366
Fresco
San Croce, Florence
Rigid compositions and stiff figures with stern faces and reserved gestures characterize Gaddi's later creative phase. In this mural painting in the Sacristy of San Croce, the figures of Mary Magdalene, the Virgin Mary and John the Evangelist, as well as St. Francis, St. Henry and St. Louis of Toulouse, appear beneath the cross.

Gainsborough, Thomas

Thomas Gainsborough (1727 Sudbury, Suffolk–1788 London) is one of the most significant 18th-century English painters. He studied under Hubert Gravelot in London from 1740, and later with Francis Hayman. Gainsborough lived in Sudbury and Ipswich from 1746 to 1759, then in Bath, and from 1774 on he resided in London, where he was a member of the Academy. He was inspired by French Rococo, as well as Dutch landscape painting and Anthonis van Dyck. Later he was influenced by Bartolomé Estéban Murillo and the new light effects of the theatrical painter Philippe Jacques Louterbourg. At first he painted idyllic pastoral scenes and landscapes, then increasingly turned to portrait painting and eventually developed the new genre of the landscape portrait. Works by the artist include *Robert Andrews and his Wife Frances*, c. 1750, and *The Watering Hole*, 1777, both in The National Gallery, London; and *Queen Charlotte*, 1781, Royal Collection, Windsor Castle.

Portrait of a Lady in Blue (The Duchess of Beaufort), c. 1777
Oil on canvas, 76 x 64 cm
The Hermitage, St. Petersburg
Elegant portraits of women play a special role in the creations of this painter. In them, he rejects the predominating pretentious artificiality, in keeping with the contemporary conception that beauty and grace can not be separated from nature and naturalness. Thus the handsome woman portrayed here is not squeezed into a tight bodice, and her smile seems neither affected nor coquettish.

Above
Conversation in a Park, c. 1746
Oil on canvas, 73 x 86 cm
Musée du Louvre, Paris
Here Gainsborough depicts a young couple calmly enjoying one another's company in a park landscape, showing his interest in rendering not the unusual, but the beauty of everyday life. Simplicity is simultaneously affirmed and clarified in this idyllic pastoral setting. With this combination of a full-figure portrait and the representation of nature the artist creates a new representational style, called the arcadian view, which characterized subsequent English painting tradition.

Lady Alston, c. 1760
Oil on canvas, 226 x 166 cm
Musée du Louvre, Paris
This portrait of the wife of Sir Robert Alston is a charming example of the painter's mature creations in Bath. The influence of van Dyck's aristocratic, elegant style is unmistakable in the brilliant rendering of the clothing material, the elegant pose and the somewhat melancholy gaze. The shimmering sparkle of the silk matches the sparkling forest landscape, so that a poetic harmony naturally results.

The Morning Walk
(Mr. and Mrs. Hallett), c. 1785
Oil on canvas, 236 x 179 cm
The National Gallery, London
This picture of William Hallet and his wife extends beyond traditional portrait painting. Gainsborough has captured the mood of an easy and intimate moment. In addition, he has not depicted the couple in an artificially constructed, oppulent Baroque garden, but rather in a modern, undisturbed natural landscape park.

Gentile da Fabriano

Gentile da Fabriano (c. 1370 Fabriano–1427 Rome), whose real name was Gentile di Niccolò di Giovanni Massi, is one of the leading masters of the Italian late Gothic. Evidence of him exists only after 1408 in Venice. Between 1414 and 1419 he was in the service of Pandolfo Malatesta in Brescia. He then settled in Florence and became a member of St. Luke's Guild in 1421, and joined the physicians' and apothecaries' guild one year later. He travelled in 1425 to Siena and Orvieto, and to Rome in 1427. Gentile was influenced by the Milanese artistic circle, and apparently by French and Dutch miniature painting as well. His extremely elegant style is characterized by beautiful gilding as well as by extremely varied color effects and surface treatments. Among his students are Pisanello and Domenico Veneziano. The artist's major works include *Virgin and Child with Sts Nicholas and Catherine*, c. 1395, Gemäldegalerie, SMPK, Berlin; *The Coronation of the Virgin*, c. 1416, Collection Heugel, Paris; and *Virgin and Child*, c. 1426, Duomo, Orvieto.

Golden Alms of St. Nicholas
(The Quartesi Polyptych), 1425
Tempera on panel, 36 x 62 cm
Pinacoteca Apostolica Vaticana, Vatican
The predella panels of the *Quartesi Polyptych* in particular show Gentile's turn to Renaissance painting, expressed through an increasingly spacious conception of the pictorial structure as well as the corporeality, complex gestures and foreshortening of his figures. Below, the saint throws three golden balls in a window to save the impoverished girls from being forced to turn to prostitution.

Opposite left

The Stigmatization of St. Francis, c. 1420
Tempera on panel, 87 x 64 cm
Collezione Carminati, Crenna

According to legend, St. Francis of Assisi reached the pinnacle of his devout life in 1224 when he was marked with the stigmata, a visible sign of his worthiness as a successor of Christ. In this painting the Son of God, surrounded by angel's wings, appears to the saint and transmits the stigmata to him via shafts of light. The work belongs to a processional panel, the other side of which depicts the Coronation of the Virgin.

The Adoration of the Magi, 1423
Tempera on panel, 303 x 282 cm
Galleria degli Uffizi, Florence

Gentile painted this altarpiece for the Strozzi Chapel in S. Trinità in Florence. While the worship scene is restricted to the left side, the right side depicts the travelling entourages of the three wise kings in all their courtly splendor. The predella panels show the Nativity, the Flight into Egypt and the Presentation in the Temple. The latter is a copy, the original of which can be found in the Musée du Louvre in Paris.

Gentileschi, Artemisia

Artemisia Gentileschi (1593 Rome–after 1651 Naples) was one of the most famous female artists of her time. She studied first under her father, Orazio Gentileschi, who introduced her to the art of Caravaggio, and then under Agostino Tasso. In 1640 she went to Florence, where she was closely associated with the Academy and where she achieved great success. In 1620 she returned to Rome, but finally settled in Naples in 1628. At the end of the 1630s she was active in the English court for a short while. Gentileschi painted powerful and passionate scenes in which psychological elements are expressively translated into dramatic representations. In Naples she produced almost exclusively conventional church paintings under the influence of the solemn piety predominating there. The artist's most important works include *Susanna and the Elders*, c. 1610, Graf von Schönbornische Kunstsammlungen, Pommersfelden; *Portrait of a Condottiere*, 1622, Collezioni Comunali d'Arte, Bologna; and *Judith with the Head of Holofernes*, c. 1625, Galleria Palatina, Palazzo Pitti, Florence.

The Repentant Magdalene, c. 1618
Oil on canvas, 146 x 109 cm
Galleria Palatina,
Palazzo Pitti, Florence
Unlike her male contemporaries, Gentileschi does not present her female figures from a voyeuristic point of view; thus the unpretentious pose and the tear-streaked face of this woman express the inner struggle of the sinner. The artist achieves the dramatic expressiveness of her esteemed paintings through strong *chiaroscuro* contrasts and flickering light effects.

Annunciation, 1630
Oil on canvas, 257 x 179 cm
Museo Nazionale di
Capodimonte, Neapel
This earliest known work from
Gentileschi's period in Naples de-
picts the annunciating angel stand-
ing with imperious solemnity before
the Virgin. The sweeping gestures
and robes evoke the impression of
great power. In contrast, Mary ap-
pears fragile, almost helpless. Illumi-
nated by a ray of light (with the
Holy Ghost as a dove), her hand
and face express her humble accep-
tance of the heavenly assignment.

Virgin and Child
(Madonna Lactans), 1610–1620
Oil on canvas, 118 x 86 cm
Galleria degli Uffizi, Florence
This early work already exhibits the
painter's independence. As with all
of her female figures, the vivacious
form of the Mother of God appears
feminine and emotional. Typical of
Gentileschi's work is the close
observation of detail, which is
evident in the careful rendering of
the various types of cloth as well as
the realistic formation of the bodies,
in which even Mary's light pink
nipple is precisely rendered.

Following page
Judith and Holofernes, c. 1620
Oil on canvas, 170 x 136 cm
Galleria degli Uffizi, Florence
Gentileschi illustrates this Old
Testament theme in numerous
works, though she does not always
depict the actual murder. Here she
shows the beheading of the military
captain with unflinching accuracy.
In order not to undermine Judith's
credibility, the painter does not
render the heroine as idealistically
beautiful or with negative associa-
tions. The gruesome event is not
symbolically exaggerated, but is
rather very realistically portrayed.

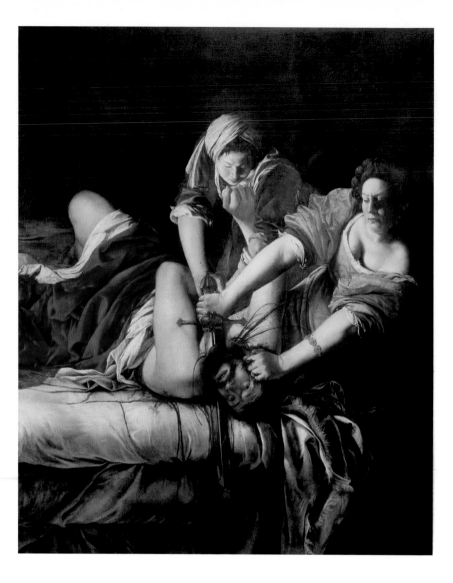

Gentileschi, Orazio

Orazio Gentileschi (c. 1563 Pisa–c. 1639 London), whose real name was Orazio Gentileschi Lomi, was one of the most significant Caravaggisti of his time. Born into a family of artists, he was trained in the Florentine Mannerist style of Agnolo Bronzino and Jacopo Pontormo. At the beginning of the 1580s he went to Rome, where he worked as a fresco painter in the Vatican. Around 1600 he worked as a panel painter in the artistic circle of Caravaggio. In the early 1620s he was active in Genoa and Paris, and from 1626 began working at the English court of Charles I (1600–1649). In his artwork Gentileschi combines Tuscan tradition with Caravaggism and develops a fine expressive style. His later works are distinguished by their balanced color schemes and composition, as well as by their brilliant technique. Other works by the artist include *The Birth of Christ*, Santa Maria della Pace, Rome; *St. Cecilia*, c. 1610, Galleria Nazionale d'Arte Antica, Rome; and *The Lute Player*, c. 1626, The National Gallery of Art, Washington D.C.

Virgin and Child with St. Francesca and an Angel, c. 1617
Oil on canvas, 270 x 157 cm
Palazzo Ducale, Urbino
Gentileschi imbues the subjects of his altarpieces with a quiet and noble dignity, which he achieves not only through the delicate and modest figures. The flawless rendering, in which refined elegance is emphasized, is characteristic of his paintings, in which the influence of Caravaggio remains unmistakeable. The saints, who are shown here glowing with light, are in stark contrast to the dark clouds in the background.

The Finding of Moses, c. 1633
Oil on canvas, 242 x 281 cm
Museo del Prado, Madrid
Gentileschi's style changed during his service as a court painter to Charles I of England (1600–1649). He turned away from Caravaggism and increasingly incorporated his courtly surroundings; thus, he depicts here a staid group of genteel ladies with glowing silk dresses in an idealized landscape. Through this type of picture he reclaims motifs from the Old Testament, interpreted according to his understanding of Anglican Protestantism.

Géricault, Théodore

Théodore Géricault (1791 Rouen–1824 Paris) is an important representative of early Romanticism in France. Beginning in 1808 he studied under Carle Vernet and from 1810 under Pierre Guérin, although he was more strongly inspired by the artists of antiquity and the masters of the 16th and 17th centuries, as well as by Antoine-Jean Gros. He studied the work of Michelangelo and Raphael during a journey through Italy in 1816. Later he was also inspired by John Constable and Richard Parkes Bonington. Géricault did not choose canonical motifs, but preferred current issues with contemporary appeal. In addition to equestrian paintings, he was particularly interested in the human physiognomy and existentially extreme situations. He thereby renders active and realistic representations with passionate feeling instead of abstract ideal forms. Eugène Delacroix, who worked with Géricault, continued this stylistic development. Works by the artist include *Officer of the Guard on Horseback*, 1812, Musée du Louvre, Paris; *Chalk Burning*, c. 1821, Musée du Louvre, Paris; and *Kleptomaniac (The Insane)*, c. 1822, Museum voor Schone Kunsten, Ghent.

Wounded Cuirassier, 1814
Oil on canvas, 292 x 227 cm
Musée du Louvre, Paris
In his early work Géricault painted primarily highly dramatic military pictures in which the French wars are neither glorified nor criticized. Rather, they are a subjective testimony to the experiences and behavior of people during that embattled period. This grandiose work, in which everything is synchronized to the movement of the horse and rider so as to express their violent temperaments, confirms Géricault's strong empathic sensibility.

The Madwoman (Woman with Gambling Mania), c. 1822
Oil on canvas, 77 x 64,5 cm
Musée du Louvre, Paris
This work is one of ten portraits Géricault painted for the psychiatrist Dr. Georget. He does not portray the patients of the Paris insane asylum as creatures possessed by the devil or as grotesque buffoons; rather, he tries to comprehend and objectively represent his subjects' lot in life, thus conforming with the ideas of the physician, who thought insanity was a modern phenomenon brought on by social advancements.

Below
The Raft of the "Medusa" 1818/19
Oil on canvas, 491 x 716 cm
Musée du Louvre, Paris
After the "Medusa" shipwrecked off the coast of West Africa in 1816, its raft floated in the sea for 12 days; only ten of the 149 passengers were rescued. The captain, who was favored by the Bourbon regime, was primarily responsible for the tragedy. This work caused a furor both because it depicted ordinary people in the grandiose style of history painting, and because it critiqued the government.

The Epsom Derby, 1821
Oil on canvas, 92 x 123 cm
Musée du Louvre, Paris

Géricault, a horse-lover and passionate equestrian, produced many works in this theme which are unsurpassed in their liveliness and realism. He painted this picture during a stay in England. With a light, clayish hue it captures the nervous atmosphere of a tension-filled moment in the race. The horses are presented as exaggeratedly extended, which serves to suggest the increased tempo with which they seem to flee the encroaching thunder clouds. The riders are forcing the horses into this unnatural motion. The stormy atmosphere is effectively reflected by the *chiaroscuro* effects. Géricault paved the way for the coming generation of Impressionists with this kind of painting.

Ghirlandaio, Domenico

Along with his competitor Sandro Botticelli, Domenico Ghirlandaio (1449 Florence–1494 Florence), whose actual name was Domenico di Tommaso Bigordi, was the leading fresco painter of the early Renaissance in his home city. After serving an apprenticeship to a goldsmith he was trained by the painter Alessio Baldovinetti. Ghirlandaio was influenced by Dutch and ancient art, and especially by the work of Andrea del Castagno, Fra Lippi and Andrea del Verrocchio. Ghirlandaio's style is characterized by strong three-dimensionality and defined contours. His figure-rich scenes are masterfully arranged, wherein he emphasized the secular by portraying important Florentine personalities as actors in biblical scenes. Genre painting, which became popular after his lifetime, adopted this style of representation. Michelangelo was trained in Ghirlandaio's studio. Works by the artist include *The Summoning of the First Apostles*, 1481/82, Sistine Chapel, Vatican City; *The Visitation*, 1491, Musée du Louvre, Paris; and *Virgin and Child in Glory with Saints (Pala Tornabuoni)*, c. 1492, Alte Pinakothek, Munich.

St. Jerome in his Study, 1480
Fresco, 184 x 119 cm
Ognissanti, Florence
Here the patriarch is represented as a scholar in his study, looking good-naturedly out of the pictorial space as he writes. This painting displays more noticeably than most the influence of northern European art on Ghirlandaio. This is evidenced by details commonly found in still-life paintings, as well as by the tapestry on the writing desk. This mural is the counterpiece to a painting of St. Augustine done slightly earlier by Botticelli.

The Funeral of St. Fina, c. 1474
Fresco
Collegiata, San Gimignano
In the frescoes in the burial chapel of St. Fina—a second one depicts the death of the local saint—the painter develops his own style and simultaneously reaches a high point in his artwork. The miraculous events that took place during the requiem of St. Fina are rendered here: The service was presided over by the bishop and was attended by the patrons of the chapel; the lame wet-nurse in the center of the picture and the blind boy touching the feet of the corpse were healed of their afflictions. The angels floating in the background left evoke the bells of San Gimignano, which mysteriously tolled at the hour of St. Fina's death.

Ghirlandaio, Domenico 375

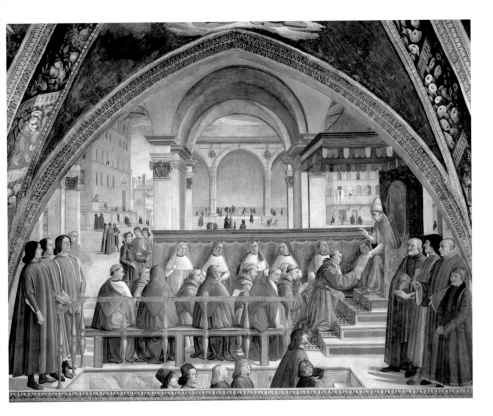

Opposite
The Adoration of the Shepherds, 1485
Tempera on panel, 167 x 167 cm
Cappella Sassetti, S. Trinità, Florence
In this often-copied altarpiece the painter grandiosely combines references to antiquity with the revolutionary realism of the Netherlands. The inscription on the Roman sarcophagus, which serves as a cradle for the Child, refers to Flavius' prophesy: "The urn in which my body lies will bring forth a god." In his representation of the shepherds—the first is thought to be a self-portrait of the artist—Ghirlandaio makes strong reference to the *Portinari Altarpiece* by Hugo van der Goes.

The Confirmation of the Rule of the Franciscan Order, c. 1485
Fresco, 370 cm wide
Cappella Sassetti, S. Trinità, Florence
This mural depicts one of six scenes from the life of St. Francis of Assisi. The Confirmation of the Rule has been transposed to the contemporary Piazza della Signoria in Florence, with the government palace (the Uffizi) visible on the left. Ghirlandaio portrayed important contemporaries in this painting, including the art patron Francesco Sassetti (right foreground) and Lorenzo de'Medici (1449–1492), who stands behind Sassetti.

Ghirlandaio, Domenico 377

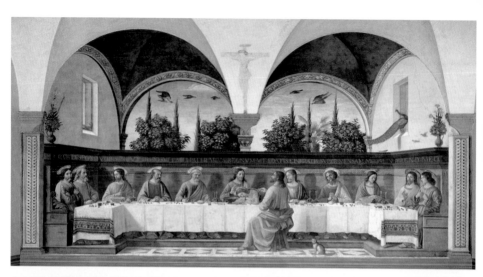

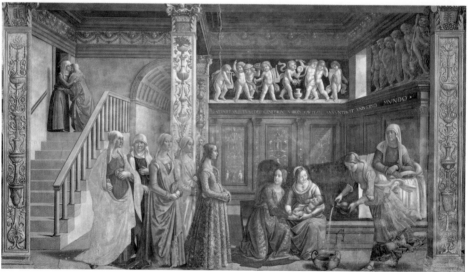

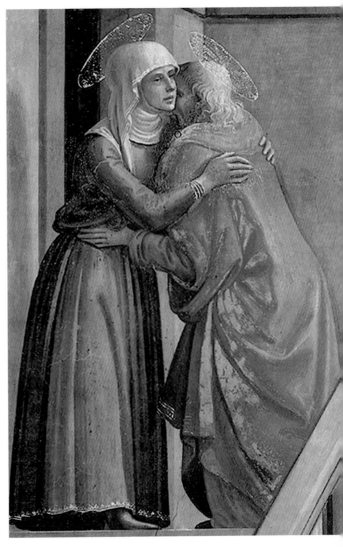

Opposite above
The Last Supper, c. 1486
Fresco, Small Refectory
San Marco, Florence
This fresco is a slightly altered version of the work created in 1480 for the Ognissanti Monastery in Florence. The actual space of the dining hall in the monastery is expanded by Ghirlandaio's illusionistic painting technique. His sensitive observational ability is evident not only in the way he portrays the reactions of apostles to the events occuring, but also in the representation of the food and drinks as well as the treetops and birds in the background.

Opposite below
The Birth of the Virgin, c. 1488
Fresco
Santa Maria Novella, Florence
The room depicted in this fresco of the Tornabuoni Chapel is so cleverly constructed that the painted window seems like an extension of the church window, making the fall of light appear natural. The wet nurses are rendered in a very lifelike manner, while the strongly animated figure in the foreground creates a genre-like impression. A second, chronologically earlier scene takes place at the top of the stairs and in the detail to the right: The meeting of the Virgin's parents. The kiss at the golden gate, through which St. Anne became pregnant through the will of God, is referred to here. St. Anne's expectant expression is patently obvious. Both parents, who are shown in a trusting embrace, are identified by a halo and thereby made clearly recognizable for the viewer.

An Old Man with his Grandson, c. 1490
Tempera on panel, 62 x 46 cm
Musée du Louvre, Paris
Here Ghirlandaio utilizes the Dutch portrait type, which was gaining significance in Italy at the time, showing this man realistically and in three-quarter profile. The artist captures his striking physiognomy and the growths on his nose with total accuracy. Decisive, however, is the old man's loving expression and his obvious devotion to the child on his lap, which make clear the trusting relationship between them.

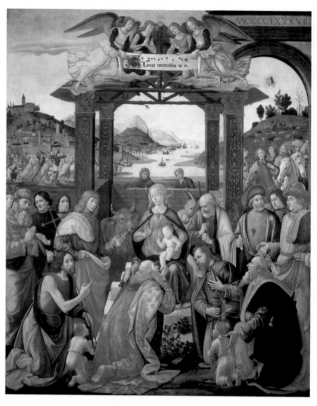

The Adoration of the Magi, 1488
Tempera on panel, 285 x 243 cm
Ospedale degli Innocenti, Florence
Ghirlandaio painted this panel for the high altar of the "Foundling Hospital" and imbued it with a wonderful color scheme. The kings are hardly distinguishable from the other saints. John the Baptist kneels on the left, behind him stands the painter himself, and to his right the patron, Francesco di Giovanni Tesori, in a black robe. In place of the orphans of the foundling house, two boys killed in Bethlehem's Massacre of the Innocents appear in the foreground.

→ *Giambellino, see Bellini, Giovanni*

Giordano, Luca

Luca Giordano (1634 Naples–1705 Naples) was a successful Italian Baroque painter. Because of his prolific production, he was also called Luca *fa presto* ("Luke make-it-fast"), or because of his artistic flexibility, *Proteo della pittura* ("the Proteus of painting"). His work was at first strongly influenced by Jusepe Ribera, and he was inspired by a variety of artists during his stay in Rome and Venice in 1653, in particular Pietro da Cortona. He took a second journey to Venice and Florence in 1666, and his distinctive style became a reference point for late Baroque Italian painting. From 1692 to 1702 he served the Spanish court. In his oil and mural paintings he presents many subjects with great virtuosity and imagination. Important works

by the artist include *Virgin and Child in a Rose Garland*, 1657, Museo Nazionale di Capodimonte, Naples; *Dome Fresco*, c. 1680, Santa Brigida, Naples; and *Dome Fresco*, 1704, Certosa di San Martino, Naples.

Marriage at Cana, c. 1663
Oil on canvas, 80.5 x 100 cm
Museo Nazionale di Capodimonte, Naples
Giordano painted this picture while deeply influenced by Venetian art, above all the magnificent color schemes of Veronese. He thus depicted this biblical theme as a genre scene, into which the observer is drawn by the two figures whose backs are turned. Only Christ's golden halo distinguishes his figure from the members of the courtly society. The composition is also remarkable for its graduated tones of brown and silver.

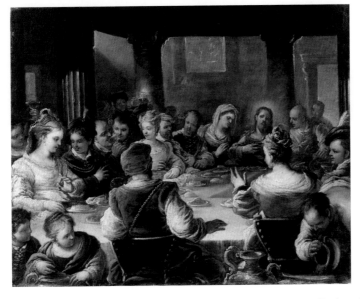

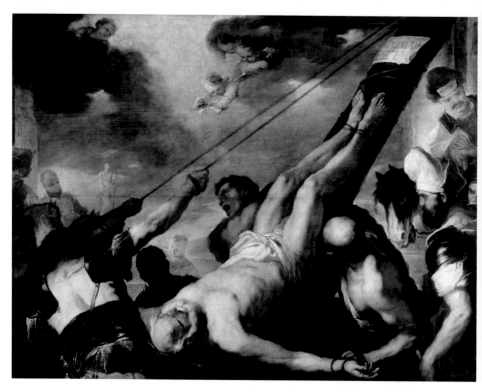

Crucifixion of St. Peter, 1692
Oil on canvas, 196 x 258 cm
Museo Nazionale di Capodimonte, Naples
Giordano's later works, including this painting which
he made before his service to the Spanish court, testify
to the painter's highly unique interpretation of standard
motifs. It was not only Italian Rococo painters who
later oriented themselves on his style: The refined color
scheme and the relaxed rhythm of the forms in this
picture exhibit much of the lightness and elegance of late
18th-century art.

Opposite
**Allegory of Human Life and
the Medici Dynasty (detail), 1682/83**
Fresco
Palazzo Medici-Riccardi, Florence
Giordano produced this grandiose work according to
the directions of Alessandro Segni, secretary of the
Accademia della Crusca. This allegory is rendered in the
dignified form of a mythological narrative. The figures
of the gods symbolize the living power of the four
elements; thus, for instance, Neptune and Aphrodite
represent the power of the sea.

Giorgione

Giorgione (c. 1477 Castelfranco, Veneto–1510 Venice), born Giorgio da Castelfranco and also known as Giorgio Barbarelli, was an important painter of the Venetian High Renaissance. He was probably trained along with his younger friend Titian in the workshop of Giovanni Bellini. There Giorgione developed his own influential style in the painting tradition of Vittorio Carpaccio, Antonello da Messina, and Leonardo da Vinci, as well as of the Dutch painters. He increasingly rejected the use of contour lines to regulate color transitions, thereby emphasizing the true appearance of things. This allowed him to represent figures freely moving in space, as well as the atmospheric effects of landscapes. Among the artist's major works are *The Judgement of Solomon*, c. 1500, Galleria degli Uffizi, Florence; *The Three Philosophers*, c. 1505, Kunsthistorisches Museum, Vienna; and *Portrait of a Woman (Laura)*, 1506, Kunsthistorisches Museum, Vienna.

The Fire Test of Moses, c. 1500
Oil on panel, 89 x 72 cm
Galleria degli Uffizi, Florence
This seldom-painted scene, which was created as a counterpiece to *The Judgement of Solomon*, depicts an episode from the life of Moses. A prophet told the Pharaoh that the boy would later, as a grown man, strive to usurp the Pharaoh's power and wealth. In order to test this prediction, he let the boy decide between a bowl of coal and one of gold. When Moses reached for the glowing coals, the Pharaoh disregarded the prophesy.

**The Old One
(La Vecchia), c. 1504**
Oil on canvas, 69 x 60 cm
Galleria dell'Accademia, Venice
The woman depicted here may be the artist's mother. The text of the inscription on her sleeve, *col tempo* ("with time"), points to another level of interpretation: the *vanitas* theme. It is not rare that an old and toothless woman is used to represent the transience of everything earthly; however, this woman also posesses something demonic about her. One can barely tear oneself away from the expressive power that underlies this picture.

Virgin and Child with Saints Francis and Liberal, 1505
Oil on panel, 200 x 152 cm
S. Liberale, Castelfranco, Veneto
Giorgione created a new type of picture with this altarpiece in that he developed the motif of the *sacra*

conversazione out of the landscape itself. Only the baldachined throne is reminiscent of more traditional representations. It is covered with a brocade rug here, on which the Virgin has seated herself. He has also reduced the group of figures to

three people, and shows the Virgin wearing a green, rather than the more typical blue, robe. She is enthroned amidst a soothing landscape that complements her calm expression.

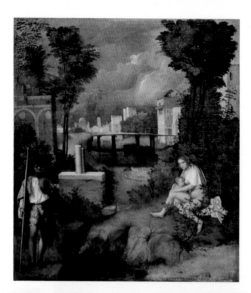

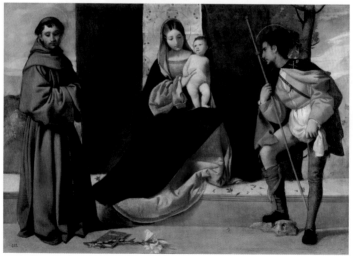

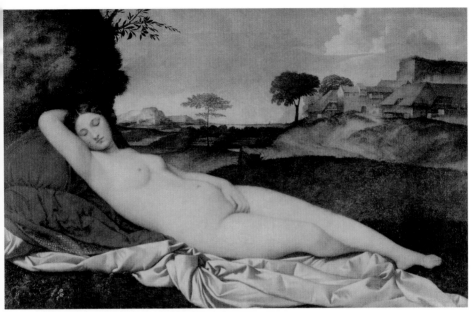

Opposite above
The Tempest, c. 1506
Oil on canvas, 82 x 73 cm
Galleria dell'Accademia, Venice
Like other works by Giorgione, this piece remains puzzling even today. Originally a female nude stood in place of the male figure, leading some to the conclusion that it is not a historical painting, but an atmospheric representation of life in nature and the force of its elements. The landscape no longer serves merely as decoration, but exists in natural unity with the figures, who become part of the poetically conceived landscape.

Opposite below
Virgin and Child with Sts Anthony of Padua and Roch, c. 1510
Oil on canvas, 92 x 133 cm
Museo del Prado, Madrid
This work is not unequivocally attributable to Giorgione; his studio colleague Titian, in particular, has also been postulated as the creator of this piece. However, the similarities to Giorgione's earlier altarpiece in Castelfranco, evident in the wide color surfaces, the spacious expanses and in several details, make a strong case for the current attribution.

Reclining Venus, c. 1518
Oil on canvas, 108 x 175 cm
Gemäldegalerie Alte Meister, Dresden
This famous painting is one of the most important of the Renaissance. For the first time in the new art form, an almost life-sized nude fills the entire pictorial frame. It combines the traditional styles of representing Venus and a sleeping spring nymph. The landscape is also more than just a scenic by-product; through its balanced composition it establishes a mood that, with the figure, creates a harmonious unity.

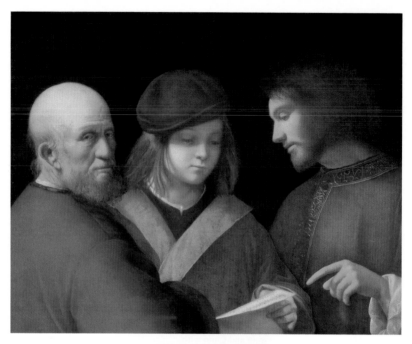

Above
The Three Ages of Man, c. 1510
Oil on panel, 62 x 77 cm
Galleria Palatina,
Palazzo Pitti, Florence
Depicted here are not only the
stages in the life of a man, but also
the initiation of a young boy into
the mysteries of music. Thus, the
picture symbolizes the harmony of
multi-pitched singing—a central
theme of the Renaissance. In such
song, the various voices repeatedly
break free of one another, only to
find their way back together again.
The sacred character of this com-
position highlights the expression of
this harmony.

**Portrait of a Warrior with his
Squire (Gattamelata), c. 1509**
Oil on canvas, 90 x 73 cm
Galleria degli Uffizi, Florence
With his armour and weapons—a
two-handed sword and a mace—the
knight is presented here as both
powerful and determined. No Ital-
ian artist had previously placed
such value on the functional signi-
ficance of heavy armaments; models
for this can be found more readily
in northern European art. Although
the painting is lacking in roughness,
it nevertheless represents latent,
simmering violence, which is not
glorified, but rather serves to illus-
trate the pictorial narrative.

Giotto di Bondone

Giotto di Bondone (c. 1267? Colle di Vespignano, near Florence–1337 Florence) was one of the most important pioneers of western art. This talented painter and architect was certainly in contact with Cimabue, and may have been his student. After 1292 he worked in Assisi, and then in Rome, Padua, Naples, Milan and finally in Florence. There he was appointed master-builder of the cathedral in 1334. Giotto deviated completely from the Byzantine tradition, primarily as a result of the important stimulus he received from French Gothic sculpture. He rediscovered corporeal plasticity and the monumental mode of viewing the human figure, and invented a new formal language of representing sacred events. His robed figures are depicted acting in landscapes and in rooms, so that the story is presented as contemporary reality. His work set in motion the entire stylistic tendencies of the 14th century, and continued to exert lasting influence over further developments within Italian art. Major works by the artist include *Crucifix*, c. 1300, S. Maria Novella, Florence; *The Allegories of the Order*, c. 1317, Basilica Inferiore di San Francesco, Assisi; and *St. Stephen*, 1320–1329, Museo Horne, Florence.

Madonna di Ognissanti, c. 1308
Tempera on panel, 325 x 204 cm
Galleria degli Uffizi, Florence
This altarpiece for the Church of Ognissanti in Florence exhibits a turning away from the traditional forms of representing the *Maestà*. The throne is depicted as an architecturally-structured unit, whose steps elevate the Virgin as if it was a pedestal. Her robe is no longer a token of her holiness; she also seems more human in her dignity and beauty. Her exaggerated scale, however, still characterizes her as a ruling power.

Opposite
Lamentation, c. 1305
Fresco, 185 x 200 cm
Cappella degli Scrovegni, Padua
A soft flow of movement is
characteristic of Giotto's narratives.
In this picture he employs this
approach to express various levels
of feeling, ranging from the women
in the foreground who have with-
drawn into themselves, to the ex-
treme emotion of St. John. Even the
landscape, with its dead tree, is
subordinated to the feelings of
sorrow. The spatial arrangement
of the figures reaches its full de-
velopment through their appor-
tionment on three levels.

The Kiss of Judas, c. 1305
Fresco, 185 x 200 cm
Cappella degli Scrovegni, Padua
All elements of this fresco are
concentrated on a single event: The
gestures and glances of the soldiers
are directed toward a rather un-
gainly Judas and the refined figure
of Christ. The space is not construc-
ted through perspective here, but
through the corporality of the fig-
ures. Giotto achieves this by com-
posing the scene from within and
then setting it in relation to the
frame, thus creating an interior
organization of the pictorial compo-
sition previously unknown.

**The Apparition of St. Francis
in Arles, before 1300**
Fresco, 270 x 230 cm
*Basilica superiore di
San Francesco, Assisi*
The 18th painting in the Legend of
St. Francis cycle depicts his sudden
appearance while St. Anthony of
Padua was preaching in Arles. As of-
ten in Giotto's narratives, the figures
in the painting offer a comment on
the occurrence: The preacher and the
brothers appear surprised, while the
others listen attentively. The figures
depicted from behind are also true-to-
life. Their corporality is apparent
through the blocklike contours.

Joachim's Dream, c. 1305
Fresco, 185 x 200 cm
Cappella degli Scrovegni, Padua
This fresco belongs to the cycle illustrating the lives of Anne and Joachim, the parents of the Virgin. An angel appears to the childless Joachim in his sleep and proclaims to him his imminent fatherhood. A connection between the two figures is established through the color of their robes, while their diagonally opposing positions creates an enormous tension between them. The introspective shepherds give the impression of being guardians of the exalted moment.

Opposite
The Last Judgement, c. 1305
Fresco, 1000 x 840 cm
Cappella degli Scrovegni, Padua
This painting is divided into cohesive segments in the traditional manner. The references made by the various spheres, levels and religious beliefs testify to Giotto's inventive talent. The glowing gold background behind the Judge of the World is like an opening in the sky. Above the host of angels, which seems to disappear behind the actual church windows, the guardians of heaven roll out the firmament from both sides in order to permit a glimpse of the new Jerusalem.

Following pages
The Last Judgement (detail)
The bottom left section of the monumental fresco depicts those who have already been resurrected praying before the Judge of the World. Above them, angels accompany the blessed into the kingdom of heaven. The transfixed men and women prepare themselves for the highest goal of Christian life. Giotto depicts the nobleman Enrico Scrovegni, who was still living at the time the fresco was completed, at the right kneeling before the three Marys and presenting them with a model of the church he had commissioned.

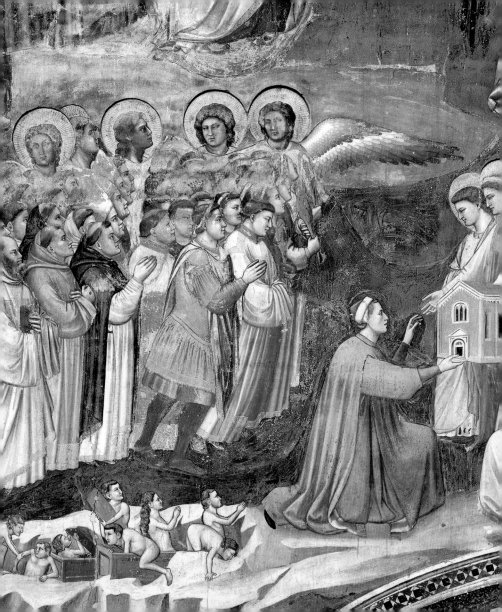

**The Expulsion of the Demons
from Arezzo, before 1300**
Fresco, 270 x 230 cm
Basilica superiore di San Francesco, Assisi
This fresco also belongs to the 28-part Legend of St.
Francis cycle. During the civil war in Arezzo, the saint
saw demons over the city and asked his fellow order
member, Sylvester, to drive them out. Sylvester is
granted the power to do this through his devoted prayer.
The expressive rendering of emotion and the precise
representation of the geograpical locale are distin-
guishing traits in Giotto's art.

The Miracle of the Spring, before 1300
Fresco, 270 x 200
Basilica superiore di San Francesco, Assisi
This scene from the Francis legend depicts another of
the miracles worked by the saint. Solely through the
power of fervent prayer, he causes water to bubble up
from a rock, and the farmer, who has almost died of
thirst and is shown offering Francis his donkey to ride,
can quench his thirst. Giotto concieves of the landscape
as a setting for the events. It serves not only to
construct the space and articulate the events, but also
corresponds to the figures.

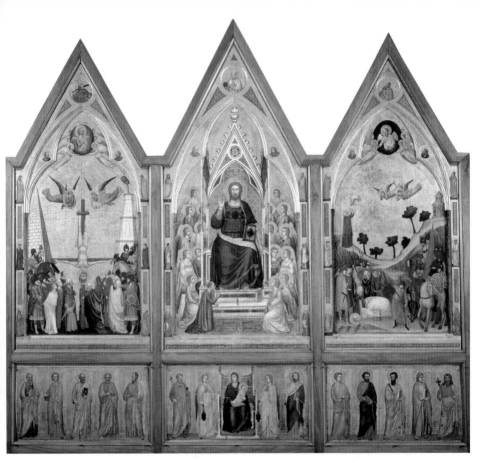

The Stephaneschi Triptych, 1313
Tempera on panel, 220 x 245 cm
Pinacoteca Apostolica
Vaticana, Vatican
Cardinal Jacopo Stefaneschi commissioned this large altarpiece, which is painted on both sides, for St. Peter's Basilica. In the center panel the blessed Son of God is seen sitting on a grand throne surrounded by angels. The martyrdoms of St. Paul (left) and St. Peter (right) are effectively brought to life on the two side panels. The Virgin and Child appear on the predella as the central figures, along with the Apostles. The altar achieves particular splendor through the very finely executed painting on the gold background and through the robust and carefully coordinated colors.

Giovanni da Maiano

Giovanni da Maiano (born in Caversago near Milan), born was Giovanni di Jacopo di Guido da Caversago, can be traced historically from 1346 to 1369. He worked primarily in Florence and was summoned to Rome by the pope in 1348. He apparently received his artistic training in Lombardy, and his work was also influenced by Tuscan and Florentine art. As one of the few painters in Florence, he further developed the innovations made by Giotto. Significant works by the artist include *Altarpiece*, c. 1363, Museo Comunale, Prato;

Pietà, 1365, Galleria dell'Accademia, Florence; and *Scenes from the Lives of the Virgin and Mary Magdalene*, 1365, San Croce, Florence.

The Birth of the Virgin, c. 1365
Fresco, 215 x 270 cm
San Croce, Florence

This scene is part of a cycle in the Rinuccini Chapel that was completed by an unknown artist. The strongly idealized facial characteristics of the figures in this serene and joyful narrative appear festive, yet calm. This work exhibits an ambivalence between idealistically beautiful and naturally realistic representations that is typical of art in later periods.

Goes, Hugo van der

Hugo van der Goes (c. 1443 Ghent–1482 Roode Clooster, near Brussels) was one of the most significant Dutch painters of his time. In 1467 he received the title of master in Ghent. One year later he began working for Karl the Brave (1433–1477) in Bruges. Although he became deacon of the Painters' Guild in Ghent, he joined the Roode Clooster as a lay-brother, possibly because of a health condition. In 1481 he made a trip to Cologne. He furthered the innovations of the old masters by developing greater differentiation in physiognomy and gestures, which enhanced the expressiveness of his figures. His radiant color schemes lend his paintings an otherwordly glow. Through his *Portinari Altarpiece*, completed in Florence in 1483, he exerted lasting influence on Italian artists, including Domenico Ghirlandaio and Leonardo da Vinci. This panel painting evidently served to transmit the technique of oil painting, as well as Dutch compositional elements, to the other side of the Alps. Other works by the artist include *The Fall of Man*, before 1470, Kunsthistorisches Museum, Vienna; *Portrait of a Man*, c. 1480, The Walters Art Gallery, Baltimore; and *The Death of the Virgin*, c. 1482, Groeningemuseum, Stedelijke Museum, Bruges.

Previous page
The Adoration of the Magi, c. 1470
Oil on panel, 147 x 242 cm
Gemäldegalerie, SMPK, Berlin

Hugo van der Goes created this altarpiece for the Spanish monastery of Monforte. On the side panels, which are missing, were depicted the birth and circumcision of Christ. The center panel is the earliest example of the painter's mature style. The figures have gained volume and are strongly individualized. The spatial conception also seems freer, and the composition is stabilized. The altarpiece depicts not only major characters like the Holy Family and the three kings, but is expanded by the presence of other observers. They regard with great curiosity the golden urn that has been brought as a gift. The landscape scenery effortlessly fills the empty spaces and captures the viewer's gaze, as do the richly decorated robes of the three kings. The irises and columbines are thought to be symbols of the Virgin as well as representations of the Passion of Christ. Countless copies testify to the widespread influence of this monumental altarpiece, which probably did not reach Spain until the 16th century.

The Portinari Altarpiece, c. 1475
Oil on panel
Central panel: 253 x 304 cm
Side panels: 253 x 141 cm
Galleria degli Uffizi, Florence

This impressive altarpiece with its representation of the worship of the Christ Child on the center panel was commissioned by the business agent of the Medici family in Bruges for the Church of Santa Maria Nuova in his hometown of Florence. The patron is depicted on the left wing, along with his sons and his patron saints, Thomas and Anthony. His wife and daughter are shown on the right side along with the Saints Margaret and Mary Magdalene. The artist did not organize the figures around a centralized focal point, but rather made the decision, unique for that time, to organize the

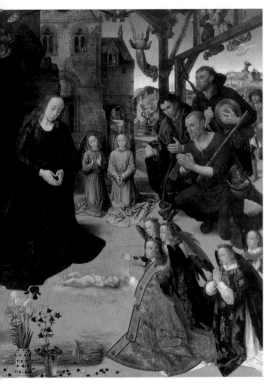

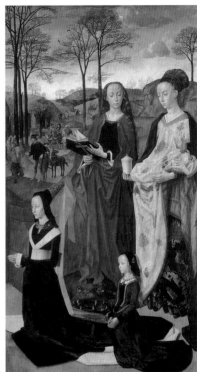

action according to a diagonal scheme. The tension thus achieved is heightened by the *chiaroscuro* effects and the expressive movements of the figures. Van der Goes was the first painter to portray peasant types, who in their earnestness and "ugliness" stand level with the saints in a demonstration of their equality before God. Even the figures of the angels are not given otherworldly facial expressions. Additional scenes are embedded in the background landscape in order to extend the main events depicted. Thus, on the left wing can be seen the Flight into Egypt and on the right, the journey of the three kings from the Orient.

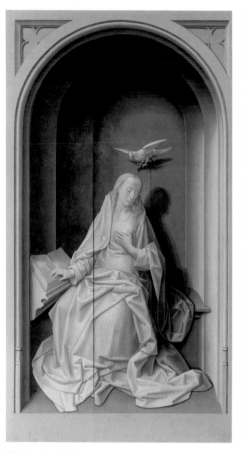
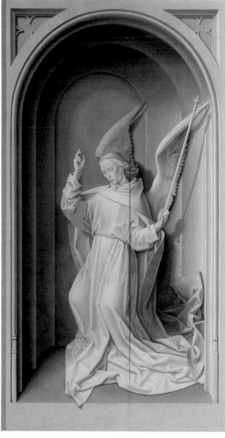

**The Portinari Altarpiece
(outer panels), c. 1475**
*Oil on panel, 253 x 141 cm each
Galleria degli Uffizi, Florence*
The two outer panels, entirely in
grisaille technique, depict the An-
nunciation. The two figures are
deceivingly rendered to resemble
stone sculptures that have been
installed into niches in the wall, an
effect that was heretofore unknown
to the Florentine public. Through
the interplay of light and shadow
the artist suggests deep wall niches
bordered by arches. Stark shadows
cast by the figures onto the back
wall and the overlapping robes of
the angel intensify this effect.

Gossaert, Jan

Jan Gossaert (c. 1478 or 1488 Maubeuge–c. 1534 Breda?), called Mabuse, was one of the first Dutch Romanists and established important standards for painting in that region in the 17th century. Before 1503 he was active in Bruges; he then moved on to Antwerp. He served several noble patrons and in 1508 travelled to Italy as a companion of Philip of Burgundy, where he was able to study antique architecture and sculpture. After his return to the Netherlands, however, he continued to work primarily in the painting tradition of his homeland. Not until 1515 and later did significant new influences appear in his work. Besides small Madonna pictures, Gossaert also painted portraits and mythological themes. The artist's works include *Neptune and Amphitrite*, 1516, Gemäldegalerie, SMPK, Berlin; *Hermaphrodite and Samalcis*, c. 1516, Museum Boijmans van Beuningen, Rotterdam; and *Henry III of Nassau*, Colecciòn Conde de Renilla Gigedo, Madrid.

The Malvagna Triptych, 1511
Oil on panel
Central panel: 45.5 x 35 cm
Side panels: 45.5 x 17.5 cm each
Galleria Regionale
della Sicilia, Palermo

This significant altarpiece was created after Gossaert's journey to Italy, although it still strongly demonstrates connection to 15th-century Dutch painting. This is evident in the minutely detailed rendering of the Gothic architectural elements, the precious coloration as well as the persistence of traditional picture forms. The saints Catherine of Alexandria and Barbara appear on the two side panels.

Deposition from the Cross, 1521
Oil on panel, transferred to canvas, 141 x 106.5 cm
The Hermitage, St. Petersburg
Gossaert's coming to terms with Italian influences is clearly recognizable in this work. In his construction of the figures, which are finely woven into an animated unity, he patterns himself after prototypes by Raphael and Michelangelo, and with the Deposition itself, examples by Mantegna. He combines the expressiveness of southern European art and the subtlety of northern European art into a convincing harmony.

Virgin and Child, c. 1527
Oil on panel, 63 x 50 cm
Museo del Prado, Madrid
This late work, one of Gossaert's best, demonstrates why he was so greatly appreciated at the European courts. Despite his adoption of elements of the Italian Renaissance style, his northern heritage is clearly evident here. The precisely characterized details are beautifully rendered, including the folds of the fine cloth of Mary's robe and the Child's shimmering gold hair. The use of light and line, as well as the play of shadow on the Baby Jesus, are highly expressive.

Opposite
Danae, 1525
Oil on panel, 114 x 95 cm
Alte Pinakothek, Munich
Gossaert incorporated new influences into his art not only in his rendering of three-dimensional figures, but also in his representation of architecture. In this mythological scene, Zeus appears to Danae, with whom he has fallen in love, in the form of a golden rain. Gossaert does not follow the Italian archaeological exactness and conception of the whole, but places individual elements additively together. The clear design and cool painting style are also typical of his work.

Goya, Francisco de

Francisco de Goya (1746 Fuendetodos in Aragón–1828 Bordeaux) was one of the greatest artists of his time. Around 1760 he studied under José Luzán in Saragossa and then transferred to the studio of Francisco Bayeu in Madrid. After a trip through Italy in 1770/71 he worked for the royal tapestry factory. In 1780 he began his career at the Academy as well as at the Spanish court, where he was named "First Painter" in 1799. Under the influence of the French Revolution and his increasing deafness he began a pioneering transformation of style in 1790. In 1824 political persecution forced him to move to Bordeaux, where Goya incorporated French and Italian elements and patterned himself in particular on the works of Tiepolo and Velázquez. With previously unknown realism and passion he achieved a highly expressive alienation from the subjects represented in his work. Goya was the first to occupy himself with a fascination for the uncanny and the horrifying. Works by the artist include *Marquesa de la Solana*, 1794/95, Musée du Louvre, Paris; *Maya Clothed*, c. 1797, Museo del Prado, Madrid; and *Maya on the Balcony*, c. 1811, The Metropolitan Museum of Art, New York.

The Parasol, 1777
Oil on canvas, 104 x 152 cm
Museo del Prado, Madrid
This early work belongs to a series of tapestry designs that Goya produced for the royal factory. The wall tapestry, which is unfortunately now lost, was intended to be hung over the dining room door in the palace of El Escorial. Goya's interaction with various influences is evident here; however, he has developed his own particular style through his individualization of the figures and his characteristic compression of the moment.

Blind Man's Bluff, 1791
Oil on canvas, 269 x 350 cm
Museo del Prado, Madrid
These folkloric cartoon scenes testify to a totally new iconography through which a new and realistic world of endless variety was opened up to artistic portrayal. The charm of this particular design, which was intended for a wall hanging in the royal study in the palace of El Escorial, lies especially in the happy expressions of the players and in the naturalness of their movements. Also typical for Goya is the combination of the free rendering of the figures and the soft, watercolor-like coloration.

Scene of the Inquisition, c. 1800
Oil on panel, 45 x 72 cm
Academia de S. Fernando, Madrid
Goya often addressed the theme of the Inquisition. In this work he emphasizes the tragic fate of the victims, rather than the greusome aspects of the ceremony. He presents the scene, in which the priests and monks seem to be amusing themselves, with expressive light effects and vigorous brush strokes. Their faces appear like masks or skulls, while their bodies blend together to form an amorphous mass.

Opposite below
Maya Nude, c. 1797
Oil on canvas, 97 x 190 cm
Museo del Prado, Madrid
Goya has not created a traditional Venus portrait; rather, sensuality is emphasized and takes the place of subtlety. The painting has a provocative life-like quality due to the obvious "decorative girl" pose of the common people. The identity of the woman portrayed here is the subject of much speculation. The Duchess Alba, who until her death owned this work as well as the closely related *Maya Clothed*, may have been the model.

Charles IV and his Family, 1800
Oil on canvas, 280 x 336 cm
Museo del Prado, Madrid
While Goya has followed the traditional organization of courtly representational paintings in this work, his rejection of idealization does represent a departure from it. Without scenic props the members of the royal family appear almost homely—they command respect only because of their status. The portraits are very realistic; thus, the sharp facial characteristics of Queen Louise in the center make her seem severe, and the expression of Charles IV (1748–1819) makes him look stalwart.

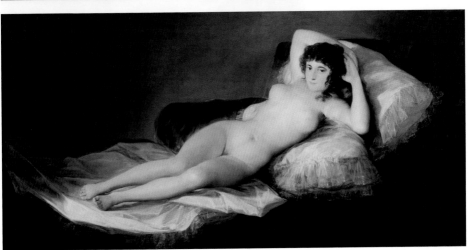

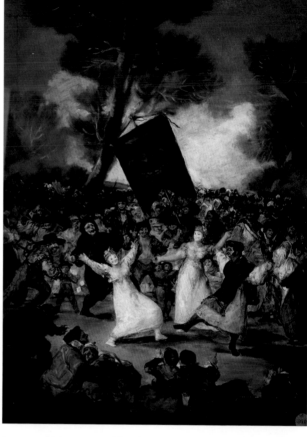

Francisco Bayeu, 1795
Oil on canvas, 112 x 84 cm
Museo del Prado, Madrid
Starting in 1794, Goya painted a series of convincing and psychologically penetrating portraits that are distinguished by the delicacy of their technique. He rendered this likeness of the court painter, also his brother-in-law (1734–1795), shortly before his death. The tired and somewhat irritated facial expression is mirrored by the shoddily fastened frock-coat. The subject nonetheless maintains a dignified bearing by means of his stiff pose.

The Burial of the Sardine, c. 1808–1814
Oil on panel, 82.5 x 52 cm
Academia de
San Fernando, Madrid
In this painting the artist transforms the Spanish folk celebration of Carneval (the pre-Lenten festival) into something gruesome. After the Inquisition he altered the original version of the picture by replacing the inscription *mortus* ("dead") with a caricature, and painted unruly women and soldiers in place of the mask-bearing monks. Their dark boisterousness and twisted gaiety serves as a grotesque allegory of the upheaval that was taking place in Spanish society at the time. With this pictorial interpretation, Goya tries to bring attention to and condemn the abuses brought on by the Inquisition and the problems of his time.

The Giant, c. 1810
Oil on canvas, 116 x 105 cm
Museo del Prado, Madrid
This painting is an impressive representation of Goya's apocalyptic vision of the Spanish War of Independence against Napoleon I (1769–1821). People and animals flee before the awesome and mysterious creature. An innovative aspect of this allegory is that Goya does not refer to well-known traditional symbols, but rather chooses to incorporate contemporary political events and themes.

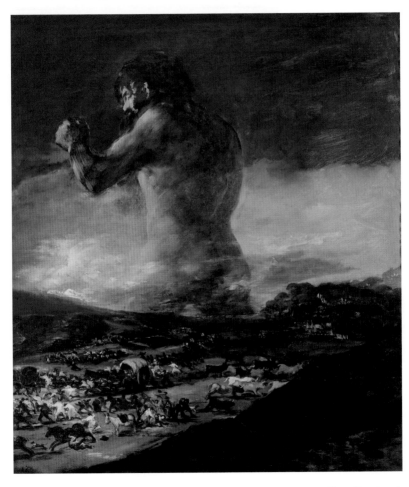

The Third of May, 1808 in Madrid: The Executions on the Príncipe Pío Hill, 1814
Oil on canvas, 266 x 345 cm
Museo del Prado, Madrid

In many cases patriots were executed after the revolt of Madrid against the French. In order to glorify the Spanish resistance, Goya has here rendered the shooting of 43 freedom fighters on the mountain of Príncipe Pío. He was one of the first painters to establish himself as a dissenter through this depiction of the slaughter. The execution of the painting is noteworthy: The forms are rendered with free contours, and the effectively chosen colors are applied to the canvas with unusual thickness.

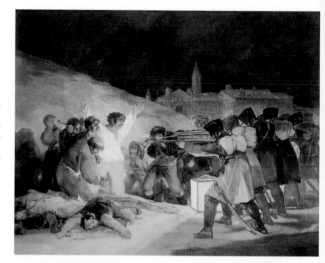

The Witches' Sabbath (The Great Billy Goat), c. 1821
Oil on canvas, 140 x 438 cm
Museo del Prado, Madrid

This monumental picture belongs to the series of "black paintings" that Goya created for his country home. A billy goat stands in the center of the scene: According to an old superstition, he holds mass with 13 witches three times a year. The fantastic and monstrous nature of the event are especially eloquently expressed in the distortion of the human figures. The artist's painting technique, in which paint has been applied very freely and in some cases with the aid of a palette knife (this can be clearly recognized in the detail on the right), is revolutionary. Through this choice of tools and his application of color, Goya achieved an impressionistic effect and was thereby far in advance of his time.

Goyen, Jan van

Jan van Goyen (1596 Leiden–1656 the Hague) was one of the most significant landscape painters of the Baroque period, and a leading representative of Haarlem ceramic painting. He was educated in Haarlem by a variety of painters. After a study trip through France in 1615, he worked in Haarlem with the landscape painter Esaias van de Velde. After reaching the status of master, he was accepted into the St. Luke's Guild in Leiden in 1618. After 1631 he worked in the Hague. Probably because of the various careers he pursued, he travelled extensively throughout Holland. At the beginning of his artistic career, van Goyen painted mainly landscapes with folk scenes using quickly and thickly applied robust local colors. He later returned to the more abstract and reduced his palette to gray, green and brown tones. He eventually strengthened the contrast of color, although his pictures remained largely monochromatic. Important works by the artist include *Dune Landscape*, c. 1633, Kunsthistorisches Museum, Vienna; *Farmstead on a River*, 1636, Alte Pinakothek, Munich; and *View of Leiden*, 1643, Alte Pinakothek, Munich.

Shore with Windmill and Tin-Plated Castle Tower, 1644
Oil on canvas, 98 x 134 cm
Musée du Louvre, Paris
In this painting, typically, the true colors of the objects are reduced and subordinated to a homogeneous overall tone. Through the glaze-like application of color, the transparent ochre-colored background binds the light and dark surfaces in such a way that the objects seem to dissolve. The unchanging atmosphere of the flat, wet land is as clearly expressed as the harmonious coexistence of man and nature.

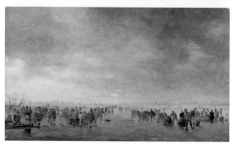

Traffic on the Frozen River, 1641
Oil on panel, 32 x 55 cm
The Hermitage, St. Petersburg
Van Goyen renders the broad river scene as if it is seen through a hazy veil. The theme of the picture—as in the above work—is neither humanity and its activity nor the objects depicted, but rather the atmosphere of the flickering light carried by their forms. The painter manages this through the clayish-toned color scheme and the nervous brush strokes. The red coat of the man in the foreground lends the painting an effective enlivening accent.

Gozzoli, Benozzo

Benozzo Gozzoli (1420 Florence–1497 Pistoia) was originally named Benozzo di Lese. He is credited with combining the painting styles of Tuscany and Umbria, and thereby facilitating the transition between the Gothic and the Renaissance styles. Around 1444 he collaborated with the sculptor Lorenzo Ghiberti (c. 1380–1455) in Florence, and about 1448 he collaborated with Fra Angelico in the Vatican City. He then began working as an independent master in Montefalco, San Gimignano, Florence and Pisa. In addition to fresco cycles, he also produced panel paintings. A lively narrative style of successive episodal scenes, as well as a fresh color palette, are characteristic of his work. Among the artist's works are *Virgin and Child Enthroned with Angels and Saints*, 1461, The National Gallery, London; *The Dance of Salome and the Beheading of John the Baptist*, 1461, National Gallery of Art, Washington D.C.; and *Crucifixion*, 1491, Museo Horne, Florence.

The Bath of the Newborn Francis,
the Annunciation through a Pilgrim and
the Adoration of a Poor Man, c. 1451
Fresco, 220 x 304 cm
San Francesco, Montefalco
Gozzoli's first independent commission was a cycle of scenes from the life of St. Francis for the choir of the Franciscan monastery in Montefalco. In this picture, the first in the series, the three episodes are not chronologically ordered. The scene of the bath with the ass and the ox, symbols of heathenry and Judaism, are reminiscent of the birth of Christ who, in the form of a pilgrim, announces the arrival of the founder of the Order.

**The Vision of Pope Innocent III
and the Ratification of the
Precepts of the Order, c. 1451**
Fresco, 220 x 304 cm
San Francesco, Montefalco
This fresco can be seen above the
introductory mural of the legend of

St. Francis. The left side depicts the
vision of the Pope, in which the
saint appears to him as supporting
the collapsing Laterans Basilica (in
Rome) and with it the fall of the
entire Catholic Church. On the
right side, the highest leader of the

Church, because of his vision, is
seen ratifying the precepts of the
Franciscan Order, the members of
which have dedicated themselves to
a life of prayer and poverty.

The School of Thagaste, c. 1465
Fresco, 220 x 230 cm
San Agostino, San Gimignano
Gozzoli was commissioned to depict episodes from the life of the Church Father Augustine in the 17 scenes that decorate the choir wall in the church dedicated to him in San Gimignano, including this one showing his education as a young boy. Augustine's intelligence and passion for learning are represented in genre-like fashion on the right side of the painting. St. Monica, who is his mother and is identified by a halo, is shown on the left. The city view with early Renaissance buildings is typical of the entire fresco cycle, which posesses a colorful diversity of architectural details and figures.

The Procession of the Magi (detail), c. 1460
Fresco, width approx. 750 cm
East wall, Palazzo Medici-Riccardi, Florence
Stretching over three walls of the chapel is the processional of the three wise kings, the goal of which is the altar painting *Virgin Adoring the Christ Child (The Nativity)*, painted by Filippo Lippi in 1459. King Balthasar, shown here, is said to portray Lorenzo de'Medici (1449–1492), but this cannot be true given the age of the latter at the time the work was created. However, several members of the Medici family can be recognized in the train, including Piero (1416–1469) and his father Cosimo (1389–1464), who lead the group.

Opposite
The Procession of the Magi (detail)
The detail of the processional on the opposite page clearly shows how realistically Gozzoli has represented the figures in this work. Persons who actually existed, for example members of the Medici family, can be easily recognized. The rendering of the faces brings out their characteristic traits in an impressive manner. Their gazes are not all directed in the direction of the march, rather, some of them seem to be steeped in contemplation of the landscape or to gaze into the distance lost in their own thoughts. Gozzoli depicted himself in close proximity to his patron—he is the figure wearing the red cap bearing his signature.

Opposite

The Procession of the Magi
(detail), c. 1460
Fresco, width approx. 750 cm
West wall, Palazzo Medici-
Riccardi, Florence

Depicted closest to the altarpiece is
King Caspar with a large group of
pilgrims. Traditionally this cycle
has been presumed to include
images of important figures of the
age, such as Patriarch Joseph of
Constantinople, who probably
functions as a reminder of the
Florentine Council of 1439. The
effect of the richly detailed painting,
which extends all the way to the
ceiling, is unique: Its depiction of
exotic animals and fashionable
clothing seems to give the picture a
secular cast wholly in keeping with
the multiple functions of the chapel,
which also served as an imposing
reception chamber.

**The Procession
of the Magi (detail)**

Every section of the procession,
with its busy figures, reflects the
lively sense of fantasy that Gozzoli
routinely employed in his work. In
the process, the artist devotes as
much attention to the exotic ani-
mals and rare materials and clothing
as he does to the widely varied
facial features of the attendants. At
the center of the picture, directly
facing the observer, is a man wear-
ing a bright blue turban: This figure
is likely a self-portrait of the artist.

Angel Choir (detail), c. 1460
Fresco
Palazzo Medici Riccardi, Florence
Deviating from the traditional
conception of the Christmas story,
Gozzoli does not depict the arrival
of the procession of the Magi, but
rather the progressive stages of
their journey. In doing so he also
depicts the heavenly realm as
physically separated from the
worldly train on the side walls of
the choir. In this detail, a host of
angels are paying homage to the
Baby Jesus. The rendering of the
tranquil celestial landscape illus-
trates Gozzoli's fondness for natur-
alistic detail, which is even reflected
in the realistic representation of
birds, flowers and trees.

Greuze, Jean-Baptiste

Jean-Baptist Greuze (1725 Tournus, Saône-et-Loire–1805 Paris) is a major representative of *peinture morale* (moralizing genre painting) and a pioneer of neoclassicism. After a three-year apprenticeship under Charles Gardon in Lyon, he moved to Paris in 1747, where he studied at the Academy in 1755. He received lasting inspiration from 17th-century Dutch genre painting through contact with the engravers Philippe Le Bas and Pierre Étienne Moitte. In comparison, a trip to Italy in 1756 was less influential. After his return he soon achieved great fame, in large part due to the contributions of the critic Denis Diderot (1713–1784). Greuze was accepted into the Academy in 1769. He developed the themes of his pictures from the life of the bourgeoisie and presented them in a way that incorporated the pathos of contemporary historical painting. The artist's works include *The Book Dealer François Babuti*, c. 1759, Collection David-Will, Paris; *The Ungrateful Son*, 1777, Musée du Louvre, Paris; and *The First Furrow*, 1801, Pushkin Museum of Graphic Art, Moscow.

The Village Bride (Village Wedding), 1761
Oil on canvas, 90 x 118 cm
Musée du Louvre, Paris

Greuze achieved his first major success with this painting. Following the elite Arcadian and erotic pastoral prototype, which was represented by painters such as François Boucher, he formulated something new with this piece. Earnestness, modesty and shyness are idealized in this elegant and sentimental family scene.

The Paralytic, 1763
Oil on canvas, 116 x 146 cm
The Hermitage, St. Petersburg
In his paintings, Greuze repeatedly addressed the theme of security and simple joy within the family unit. This is shown here through the childlike affection and attachment with which the family members care for their crippled father. The well-organized, almost academic composition lends the scene a stage-like quality.

The Wicked Son Punished, 1778
Oil on canvas, 130 x 163 cm
Musée du Louvre, Paris
Greuze broke from the tradition of genre painting and lent it new character. The color, which no longer has a sensual or decorative value, as well as the details, the facial expressions and gestures of the figures, serves only to illustrate the moral story. The straight-forward reading of these works thus results from the intellect rather than from mere observation, which was totally in keeping with contemporary taste.

Opposite
The Broken Pitcher, 1785
Oil on canvas, 108 x 86 cm
Musée du Louvre, Paris
Greuze's works depicting individual figures, which he painted along with portraits, also have allegorical and moral meaning. Thus the lion fountain, the loosened bodice, the roses in the apron and the broken pitcher hanging from the girl's arm are all symbols of her lost virginity. Although a depiction of the accusatory "finger-wagging" aspect of the bourgeoisie can be recognized here, the painter does seem to feel sympathy for the model.

→ *Grien, see Baldung Grien, Hans*

Gros, Antoine-Jean

Antoine-Jean Gros (1771 Paris–1835 Bas-Meudon, near Paris) was a pioneer of the French Romantic period. Trained by his father in miniature painting, he became a student of Jacques-Louis David in 1785. In 1793 he fled to Italy for political reasons. In 1796 he met Napoleon I (1769–1821) in Milan and accompanied him on his Italian campaign, then returned to Paris in 1799. Inspired by the work of Peter Paul Rubens, Gros developed more active compositions and a more intense coloration. While the freshness and radiance of his work inspired the Romantics, particularly Eugène Delacroix, he nonetheless remained closely bound to the neo-classical academic painting style. Along with realistic war pictures he also painted portraits of nobles. Other works by the artist include *Christine Boyer*, 1800, Musée du Louvre, Paris; *Bonaparte and the Plague-Stricken*, 1804, Musée du Louvre, Paris; and *The Battle of Abukir*, 1806, Musée National du Château de Versailles et de Trianon, Versailles.

Bonaparte at the Bridge of Arcole on 17 November 1796; 1796
Oil on canvas, 73 x 59 cm
Musée du Louvre, Paris
This was the first piece Napoleon commissioned from Gros. A second version, made in 1797, shows the general storming the bridge that had been besieged by the Austrians. In addition to depicting a battle scene, this is also a standard portrait of the future emperor. With total determination and an almost magical effectiveness he urges his troops forward. His dynamic expression is heightened by the agitated brush strokes.

Napoleon on the Battlefield of Eylau on 9 February 1807; 1808
Oil on canvas, 533 x 800 cm
Musée du Louvre, Paris
Napoleon's military achievements inspired Gros to produce glorifying and colossal historical pictures. He won accolades for this representation of the morning after the victory over the Russian army at the Prussian town of Eylau. The emperor rides over the battlefield, strewn with many wounded and dead soldiers. Stricken, he looks up at the heavens and graciously allows the wounded enemies to seek help.

Grünewald, Mathis

Mathis Grünewald (c. 1475 Wurzburg?–1528 Halle an der Saale), who is probably the same individual as the painter Mathis Gothart Nithart; along with Albrecht Dürer, he is the most outstanding artist of his age. Around 1509 he became the court painter for Archbishop Uriel von Gemmingen in Aschaffenburg, and directed the renovation of the palace there. In 1516 he went into the service of Cardinal Albrecht von Brandenburg (1490–1545), from whom he separated in the 1520s because of his own Lutheran convictions. He then went to Frankfurt and in 1527 he settled in Halle as a *Wasserkunstmacher* ("fountain artist"). Although Grünewald was aware of the innovations taking place in Italian and Dutch art, he nonetheless remained bound to medieval traditions. His artworks are passionate sermons in which, through glowing colors and daring light effects, he grants a heretofore unknown and extremely intense expressiveness. Many of his works are lost, including three altarpieces he completed for the Mainz Cathedral. Other important works by the artist include *Virgin and Child*, c. 1518, Parish Church, Stuppach near Würzburg; *The Miracle of the Snow at the Founding of Santa Maria Maggiore in Rome*, 1519, Augustinermuseum, Freiburg im Breisgau; and *Christ Carrying the Cross*, c. 1523, Staatliche Kunsthalle, Karlsruhe.

The Mocking of Christ, c. 1503
Oil on panel, 109 x 73.5 cm
Alte Pinakothek, Munich
This scene shows one of the episodes from the Passion story as told by Luke (22:63). The guard commanders blindfold Christ, mistreat him, and then demand that he use his powers to tell who has hit him. The events are accompanied by the drum-beating and flute-playing of musicians. The viewer is drawn into the event depicted in the painting through the figure with his back turned in the foreground.

**Isenheim Altarpiece
(outer side), c. 1514**
Oil on panel, 336 x 459 cm
Musée d'Unterlinden, Colmar

This altar painting, Grünewald's masterpiece, was commissioned by the preceptor Guido Guersi for the main altar of the Antonite Monastery in Isenheim, in Alsace. The bulky portable altar, which was originally crowned by a high braced frame, has two double wings that are painted on both sides. The complex program of the picture deals with the Birth, Death and Resurrection of Christ. The outer side shows a penetratingly rendered crucifixion scene accompanied by Sts Sebastian and Anthony Abbas, the two patron saints of the order. The cross-bearing lamb, whose blood flows into a goblet, symbolizes the union between the Old and New Testaments as well as the redemption of humankind. The predella, which is also portable, depicts the Lamentation of Christ. Scenes of the Annunciation, the adoration of the Christ Child and the Ascension appear with the first opening of the wings. The inner shrine containing the carved figures of Saints Anthony, Jerome and Augustine was only exposed during special occasions and for the festivals of the patron saints. The painted wings consist of scenes from the lives of the patron saints, the Temptation and the Visit of Paul the Eremite. Carved figures of the apostles in the opened predella complete the program.

**Isenheim Altarpiece
(inner side), c. 1514**
Oil on panel
Central panel: 265 x 304 cm
Side panels: 269 x 143 cm each
Musée d'Unterlinden, Colmar
This inner side of the altar, which
was only exhibited on special occa-
sions, depicts the Birth and Resur-
rection of Christ. On the left panel
the Annunciation is seen taking
place in a Gothic chapel, in the
stone arabesques of which St.
Jeremiah can be seen referring to his
prophesy. The center panel depicts
the Adoration of the Christ Child
and concentrates solely on the
intimacy between Mother and
Child. Above the landscape, God
the Father appears surrounded by
golden light and a host of angels;
while the annunciation to the shep-
herds is just barely suggested on the
hill. The blooming rosebush with-

out thorns that grows on the right edge of the picture is an attribute of the Virgin; the enclosed garden, the glass and the basin are further symbols of the virginity and purity of the Mother of God. The left half of the central panel, which is structurally set apart from the rest by the bulky architecture of the baldachin, harbors a choir of angels playing musical instruments, and depicts Mary with a golden halo as the Queen of Heaven. On the right wing, Christ is shown ascending into Heaven, floating upwards in a circle of light as if carried by super- natural powers. The unusual power of this complex work arises in part from its daring and intense color- ation, and partly from Grünewald's visionary interpretation of the events it depicts. These factors make the altarpiece one of the most signi- ficant works of its time.

Lamentation, c. 1523
Oil on panel, 36 x 136 cm
Stiftskirche, Aschaffenburg
The effect of this singular, strongly foreshortened *pietà* scene is overwhelming. The body of Christ lies between the seals of Cardinal Albert von Braunschweig and Dietrich von Erbach, the Bishop of Mainz. Although Christ's body is overcome by rigor mortis, his face bears the expression of one who is sleeping. Mary's folded hands express helpless sorrow, while the figure of Mary Magdalene, in contrast, appears to be full of pain.

The Disputation of Sts Erasmus and Mauritius, c. 1522
Oil on panel, 226 x 176 cm
Alte Pinakothek, Munich
This panel belongs to the *Mauritius Altarpiece* in the Collegiate Church of St. Moritz and St. Mary Magdalene in Halle an der Saale. The confrontation between the two saints is represented very empathetically. On the left stands St. Erasmus, the Bishop of Antioch. In his hand he holds the windlass that was used to tear out his bowels. St. Mauritius, who led the Theban legion, is depicted as dark-skinned and with armor.

Guardi, Francesco

Francesco Guardi (1712 Venice–1793 Venice) was one of the main representatives of Venetian *veduta* painting. He was trained by his brother, Giovanni Antonio, and worked in his studio until 1747, when he became an independent painter. In 1784 he was accepted into the Painting Academy. At the beginning of his career Guardi devoted himself primarily to altarpieces. He then concentrated on painting atmospheric city scenes, which were influenced by Canaletto and Michele Marieschi. He also produced paintings full of figures that illustrate the splendid festivities that take place in Venice. Important works by the artist include *Capriccio*, c. 1745, Collezione Crespi, Milan; *Ascension Day on the Piazza San Marco*, c. 1775, Museo Calouste Gulbenkian, Lisbon; and *The Burning of the Oil Stock of San Marcoula*, 1789, Galleria dell'Accademia, Venice.

The Doge on the Bucintoro before the Church of San Niccolò del Lido, c. 1768
Oil on canvas, 67 x 100 cm
Musée du Louvre, Paris

Guardi intuitively siezed upon significant moments of Venetian festivities, such as in this case the important folk festival on Ascension Day. On this day, the Doge would sail out to sea in his magnificent gold-plated galley—which can be seen in the background of the painting—in order to throw a sacred ring, the symbol of the union between Venice and the sea, into the water.

Opposite above
The Piazza S. Marco, 1760–1770
Oil on canvas, 47 x 67 cm
Private collection, Milan
In contrast to the precise compositional style of Canaletto, Guardi was not greatly interested in perspectival accuracy or the clear continuity of the individual elements of a picture. Rather, he tried to grasp and render the overall atmosphere and the interplay of light and shadow in a scene. In this way, his agitated brush strokes create the impression that this view of the Piazza S. Marco is gently vibrating.

Opposite below
The Gray Lagoon, c. 1790
Oil on canvas, 25 x 38 cm
Museo Poldi Pezzoli, Milan
In his scenes of coasts and lagoons the artist achieved his own rhythm of color and light that foreshadowed the painting of the 19th century including, for example, the work of J.M.W. Turner. The diffuse light of Guardi's later landscape paintings lends them a soft sense of melancholy. In this painting, his style causes the gondola, the sea and the sky to melt into a surreal distance and emptiness.

The Venetian Gala Concert, 1782
Oil on canvas, 67.7 x 90.5 cm
Alte Pinakothek, Munich
In 1782 Guardi was commissioned to paint a five-part cycle for the state ceremony on the occasion of the visit of the Russian Prince Paul Petrovitch, later Czar Paul I (1754–1801). The lightness and elegance typical of his style are also evident here in this illustration of a concert in the Philharmonic Hall of the Old Procurators, the seat of the city's highest officials at the Piazza San Marco.

Guercino, Il

Il Guercino (1591 Cento, near Bologna–1666 Bologna), whose actual name was Giovanni Francesco Barbieri, was a leading master of the Bolognese School. At the age of 16 he was apprenticed to a local painter, and in 1618 he travelled to Venice and Florence to study. Around 1622, he went into the service of Pope Gregory XV (pope from 1621–1623) in Rome. He then returned to his hometown to work. In 1642, he took over the direction of the Bologna Academy as the successor of Guido Reni. Guercino's major influences were Ludovico Carracci and Bartolomeo Schedoni. Early in his career he produced fresh, dynamic compositions, which were marked by tense light-dark contrasts. He later used cooler colors to achieve an expressive, idealized neo-classicism. Works by the artist include *The Return of the Prodigal Son*, 1619, Kunsthistorisches Museum, Vienna; *The Resurrection of Lazarus*, 1619, Musée du Louvre, Paris; and *Aurora*, c. 1622, Casino dell'Aurora, Rome.

Et in Arcadia Ego, 1618
Oil on canvas, 82 x 91 cm
Galleria Nazionale d'Arte Antica, Rom
The two shepherds thoughtfully contemplate the skull sitting on a rocky ledge in the wall. Below it, the inscription to which the title of the picture refers, "Even I am in Arcadia," can be read. The message is intended to be understood as a declaration of Death, and therefore as a warning of the mortality of man. This motif is of unknown origin and was first found in the work of Guercino, later to be adopted by other artists.

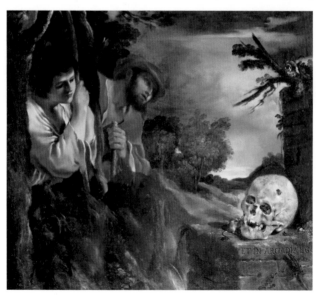

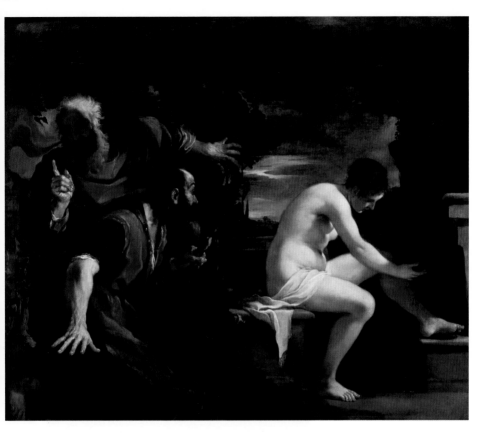

Susanna and the Elders, 1617
Oil on canvas, 175 x 207 cm
Museo del Prado, Madrid
Guercino's direct approach to understanding nature can be readily recognized in this mature early work. It is particularly evident in the play of light and shadow on Susanna's face, as well as on the heads of the elders and in the rendering of the landscape. He skillfully establishes the contrast between the graceful, almost glowing female body and the perspectivally-shortened gestures of the uncouth male figures.

Venus, Mars and Cupid, 1633
Oil on canvas, 139 x 161 cm
Galleria Estense, Modena
This work, which was painted for the Duke of Modena, is unique in Guercino's oeuvre. Depicted here are the war god Mars with his wife Venus, the goddess of love, to whom Cupid is teaching archery. Cupid is aiming at the viewer and in particular the commissioner of the painting, whose seal with an eagle appears on the boiler.

William of Aquitaine Receives the Cowl of St. Bishop Felix, 1620
Oil on canvas, 345 x 231 cm
Pinacoteca Nazionale, Bologna
Guercino produced this altarpiece for San Gregorio in Bologna before his journey to Rome. The soft, fluid execution and the warm clayish-toned environment, as well as the form-dissolving light effects, are characteristic of the painter's early style. With his uniformity and his painterly fusion of figure and space, he developed a new formulation that contrasted with the plastic isolation of the early Baroque style.

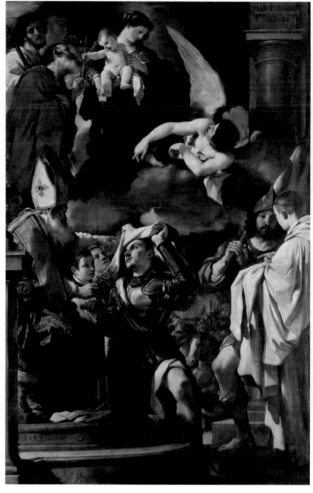

The Doubting of Thomas, 1621
Oil on canvas, 115 x 142 cm
Pinacoteca Apostolica
Vaticana, Vatican
This work is a replica of the original painting, which is now located in the National Gallery in London. It depicts the episode in which the resurrected Christ invites the non-believer to touch his wounds (John 20:27). Guercino has masterfully captured this fleeting moment, expressed particularly in the hand movements of the apostle. The event is condensed into an intense scene through the painter's use of light.

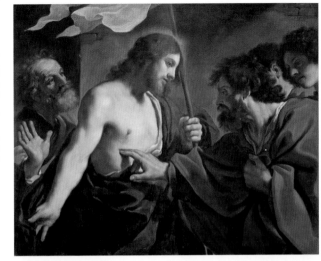

St. Peter Freed by the Angel, c. 1622
Oil on canvas, 105 x 136 cm
Museo del Prado, Madrid
Guercino expressively renders this critical event in the life of the saint. An angel appeared to the apostle Peter, who had been captured by the soldiers of King Herod, and told him to get dressed and follow him. In this composition Guercino develops a freer deployment of intense color accents. The solid forms are therefore set off by the powerful lighting. In his representation of the scene, Guercino rejects all decorative props in order to achieve greater dramatic intensity.

Many Roads Lead to Rome

From the time of the Renaissance, Rome has acted as a magnet, drawing streams of pilgrims, merchants, artists and cultural travelers from the lands north of the Alps to the Eternal City in order to broaden their education. In Rome, they could study first hand the remains of the ancient classical world whose art was adopted as the normative model for the Renaissance. Rome also offered the chance to admire the works of Raphael, Bramante, Michelangelo and many other artists. Beginning in the 17th century, the visitor also came face to face with the impressive art of the Roman Baroque, and the Roman *campagna*, or countryside, became a favorite motif of numerous northern landscape painters as well. In short, Rome became fashionable, offering a colorful array of exchanges among artists, collectors and agents.

One of the first Netherlandish artists to find his way to Rome was Jan van Scorel (1495–1562). Leaving Utrecht in 1518, he traveled first to Palestine, then arrived in Rome in 1521. Two years later he received the honor of the appointment as Raphael's successor as Conservator of the Vatican Art Collection. After his return to the Netherlands in 1524, Scorel played a decisive role in bringing Italian influences into the painting tradition of his native land. We can thank other artists, such as the Haarlem painter Maarten van Heemskerck (1498–1574), who lived in Rome between 1532 and 1536, for a wealth of sketches of ancient buildings and sculptures. Both of his sketchbooks

The Belvedere Torso, 1532–1536
1st Roman Sketchbook, 79 D2, Folio 73 r
Quill drawing on paper, 19 x 13.2 cm
Kupferstichkabinett, SMPK, Berlin
Van Heemskerck sketched ancient works of art with a direct, scientific exactitude.

(now in the possession of the Berlin Kupferstichkabinett) have great historical and topographical interest in addition to their significance to art history.

By the 17th century a stay in Rome had become more or less mandatory in the education of an aspiring young artist. Artist colonies were formed there, such as the Schildersbent, founded by Netherlandish painters around 1624. The Bentveughels, or "flock of birds," as the members called themselves, became infamous for their dissolute life style and initiation rites. When the Haarlem-born Pieter van Laer (1599–1642) arrived in Rome around 1625, he was nicknamed

Maarten van Heemskerck
Forum Romanum, Viewed from
the Palatine Hill, 1532–1536
1st Roman Sketchbook, 79 D2, Folio 6 r
Quill drawing on paper, 19 x 26 cm
Kupferstichkabinett, SMPK, Berlin
Van Heemskerck's cityscapes document the condition and appearance of the remains of ancient Rome before it underwent what were sometimes drastic changes in the following eras.

"Bamboccio" ("Shorty," or "deformed doll") because of his misshapen torso. While in Rome, van Laer developed a new type of genre painting which portrayed the activity of the simple Roman populace. The representatives of the official papal

441

Accademia di San Luca were horrified by the seemingly "low" subjects that appeared in Laer's paintings—but they nonetheless possessed a high market demand. In the end, Pieter van Laer's nickname came to be applied to all the other artists painting similar pictures: the Bamboccianti.

For many French artists of the 17th century Rome was the great metropolis where they felt obligated to spend at least a certain period studying or working. The most important French artist of his time, Nicolas Poussin (1594–1665), settled in Rome at the age of 30 and remained there for the rest of his life except for one period in Paris between 1640 and 1642. In spite of spending the majority of his life in Italy, he always felt himself to be a stranger there, and complained in his letters about the standoffish attitude of the Romans toward foreigners. Nevertheless, a stay in Rome remained of primary importance for French artists. The significance of the Italian capital for the French is clearly indicated by the founding in 1666 of a branch of the Paris Académie Royale de Peinture et de Sculpture in the Eternal City, and by the establishment of a competition among young artists, the winner of which was awarded the coveted "Prix de Rome"—a four-year scholarship to study in the city.

Pieter van Laer
Carnival Party at an Inn
Oil on canvas, remounted onto panel, 54 x 82 cm
Bayerische Staatsgemaldesammlungen, Munich
The drawing and lettering on the wall in the right foreground indicate that the painting depicts the relaxed and festive members of the Schildersbent in the midst of one of their casual, stress-free get togethers.

Haecht, Willem van

Willem van Haecht (1593 Antwerp–1637 Antwerp) was born into a family whose members had been active in Antwerp as painters, art dealers, and panel makers for several generations. Between 1615 and 1619 the young man worked in Paris, then moved on to Italy. He returned to Antwerp in 1625 and was quickly accepted into the Guild of St. Luke as a master painter. In the same year, he assumed the office of administrator of the important art collection of the Antwerp merchant Cornelis van der Geest, who was a friend and patron of Peter Paul Rubens. Willem van Haecht held this post until his early death in 1637. He left behind a small oeuvre in which his paintings of art galleries deserve special mention. Aditional important works by

the artist include *The Workshop of Apollo*, 1628, Mauritshuis, The Hague; and *Salon of the Archduchess Isabella*, private collection, Hawkhurst.

Art Chamber of Cornelis van der Geest, 1628
Oil on panel, 100 x 130 cm
Rubenshuis, Antwerp
In this painting, the self-assured art collector and patron, Cornelis van der Geest, shows his extensive art collection to the archducal couple Albrecht and Isabella Clara Eugenia in the midst of a group of artists (including Rubens, Anthonis van Dyck, as well as other painters and influential citizens of the city of Antwerp). Taken as a whole, the complex content of the painting must be interpreted as a homage to van der Geest himself and to the Antwerp School of painting.

Hals, Frans

Frans Hals (c. 1583 Antwerp?–1666 Haarlem) spent most of his working life in Haarlem. Around 1602 he studied with the painter and writer Karel van Mander (1548–1606), and in 1610 he became a member of the Guild of St. Luke, over which he presided in 1644. In his painting, Hals concentrated on the human image, becoming an incorruptible portrayer of the Dutch bourgeoisie. Initially he confined himself to the Dutch painting tradition of the 16th century, but later, with his sharp eye for observation and lively power of expression, he developed a realistic manner of portrayal free of Italian elements. His work constitutes the first high point of Dutch painting, and at the same time represents the beginning of an independent national style. His works include *Banquet of the Officers of St. George Rifle Club*, 1616, Frans Hals Museum, Haarlem; *The Prodigal Son*, 1623, The Metropolitan Museum of Art, New York; and *Man with Soft Hat*, c. 1664, Hessisches Landes Museum, Kassel.

Catharina Hooft with her Nurse, c. 1619
Oil on canvas, 91.8 x 68.3 cm
Gemäldegalerie, SMPK, Berlin
In keeping with the new aim of presenting the personality of the subject, Hals here softens the class distinction between the daughter of a wealthy jurist and her nurse. Although the clothing and the poses of the figures make the distinction clear, the eyes of the nurse follow the glance of the child, who gazes directly at the viewers, rather than peering downward at them, as was typical in portraits of nobility. In the directness of their portrayal, both figures achieve individuality.

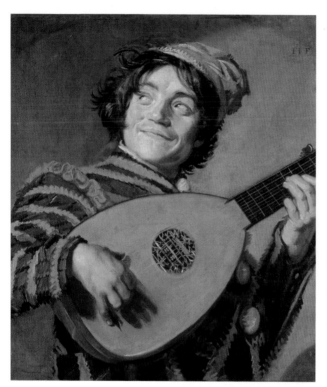

Below
Gypsy Girl (Prostitute), c. 1629
Oil on panel, 58 x 52 cm
Musée du Louvre, Paris
Hals unites genre painting and portraiture in this depiction of a girl with an impudent expression and titillating clothing. Contrary to contemporary practice, he raised the "raw" nature of social outsiders through his portrayal of individual physiognomy. During this period the motif of cheerful, unburdened, and rough figures also served as an allegory of the five senses: The Gypsy girl therefore embodies the sense of touch or feeling.

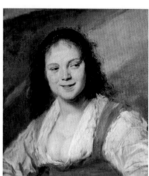

Fool Playing a Lute, c. 1623
Oil on panel, 71 x 62 cm
Musée du Louvre, Paris
Hals worked through the contemporary trends, adopting them only temporarily. In the 1620s he took up the lighting and modeling of the followers of Caravaggio in Utrecht, and arrived at an exaggerated style of portrayal with an emphasis on exceedingly large heads and hands. He created his especially active half-length figures, often people encountered in taverns and stage life, using strong colors and flat forms. The facial expression of this man and the lute move this work into the area of genre painting.

Opposite
Gypsy Woman, c. 1634
Oil on canvas, 78.5 x 66.2 cm
Gemäldegalerie, SMPK, Berlin
Hals has infused this portrait of a crazy woman with moral meaning. The owl, as a nocturnal bird, symbolizes erroneous human behavior, in this case alcoholism (signified by the large beer stein held in her hand). Through the hierarchical organization of motifs and the diagonal turning of the woman's body, the force of the portrayal is heightened. But her expression indicates that she has gained the artist's sympathy: The thick smile derives not only from alcohol abuse, but also stupidity and foolishness.

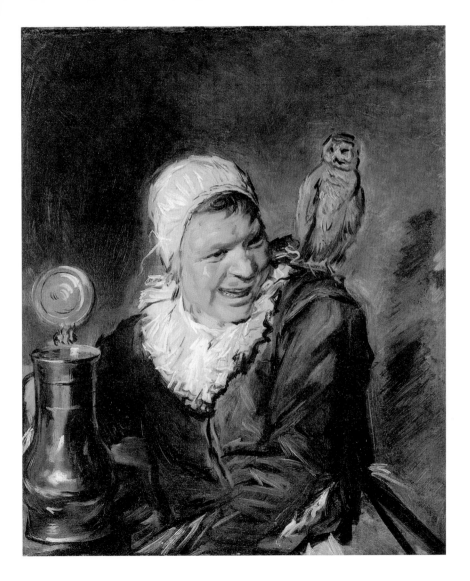

**Portrait of a Young Man
Holding a Glove, c. 1650**
*Oil on canvas, 80 x 66.5 cm
Hermitage, St. Petersburg*
Hals strove to capture a moment in
his paintings, and in the process
developed a spontaneous style by
applying layers of color wet on
wet, directly onto the canvas.
Through unified color values and
his rhythmic stripe-like method of
painting he casts the main impact of
the picture in the subjective per-
ception of fleeting movement—in
this case in the abrupt turning of the
young man's head.

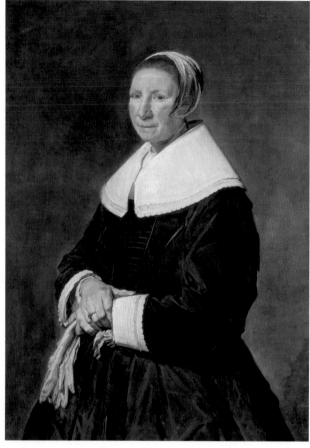

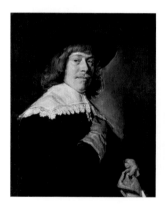

**Woman Standing with
Gloves in her Hands,
Turned to the Left, c. 1648**
*Oil on canvas, 108 x 80 cm
Musée du Louvre, Paris*
After 1630, Hals turned away from
the dynamic disposition of figures to
a more monumental picture type.
He also he reduced his palette to a
few colors and placed less emphasis
on the personal characteristics of his
subject than on a restrained expres-
sion determined by the total effect
of the painting.

Portrait of Willem van Heythuyzenn, c. 1638
Oil on panel, 47 x 37 cm
Musée Royaux des Beaux-Arts, Brussels

In this, the second Hals portrait of the wealthy Haarlem citizen, he depicts him in an unusual manner, placing a full figure in an interior. The fine presentation of gesture and posture achieves an impression of indolence, yet at the same time emphasizes aspects that reach beyond the mere individual. Here Hals draws from the popular genre of the "cheerful company" by including the mood of the surroundings in the composition.

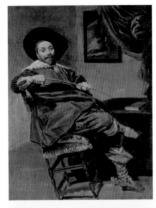

Below
The Dame Regents of the Haarlem Old Men's Almshouse, c. 1664
Oil on canvas, 170.5 x 249.5 cm
Frans Halsmuseum, Haarlem

In Hals' later works, an increased tendency to create an atmospheric mood is noticable. In dignified but isolating postures, the resolute female directors sit in a barren room. The fleeting brush strokes and silhouettes dissolving into the background lend this picture an unsurpassable simplicity. Such psychological depth and frank directness was previously unknown in Dutch painting.

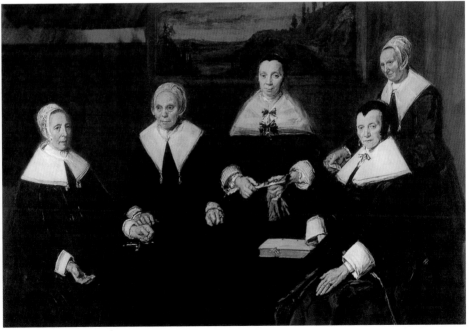

Heda, Willem Claesz.

Among Dutch still-life painters, Willem Claesz. Heda (1594 Haarlem–c. 1681 Haarlem) is—together with Pieter Claesz.—one of the outstanding exponents of the monochrome *banketje*. These still lifes of breakfast and dessert are characterized by a color palette reduced to grays and tones of gray, and the concentration on a few familiarly represented foods and drinks served on fine tableware. Nothing is known of the artist's education, but it is presumed that Heda spent his entire life in Haarlem. His name appears for the first time in 1631 in the documents of the St. Luke's Guild in Haarlem, of which he served several times as dean beginning in 1637. He maintained a large studio that supported numerous pupils and co-artists, whose works are not always clearly distinguishable from each other. Among the artist's works are *Still Life with Herring*, 1629, Mauritshuis, The Hague; *Breakfast Table with a Blackberry Tart*, 1631, Gemäldegalerie Alte Meister, Dresden; and *Still Life with a Nautilus Trophy*, 1654, Magyar Nemzeti Múseum, Budapest.

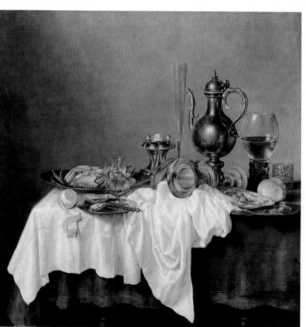

Breakfast of Crab, 1648
Oil on canvas, 118 x 118 cm
The Hermitage, St. Petersburg
The decorative still lifes dating from around the mid-17th century in Flanders by Frans Snyders and others are opulent in both form and color. In contrast, the work treating the same subjects painted by contemporary artists in the northern Netherlands, including Heda, are comparatively restrained and simple, although the vessels and foods are no less precious. It is not splendor, but reference to the Eucharist, that form the centerpoint of these works.

Still Life with Herring, 1629
Oil on panel, 46.2 x 69 cm
Mauritshuis, The Hague
Consisting of fish, bread and wine, this banquet presents a Lenten meal whose content is to be seen as representative of a modest and God-fearing way of life. Since the Middle Ages fish has served as a symbol of Christ; similarly, the nut stands for the cross, and the bread and wine for the Eucharist. The reflection of the cross in the glass is a further reminder. In addition, the clock on the left in the picture is a symbol of the transience of mortal life.

Breakfast Still Life, 1637
Oil on panel, 44 x 56 cm
Musée du Louvre, Paris
The diagonal structure of this picture, the easily comprehensible, scarcely overlapping depiction of the tableware and food, as well as the olive-gray coloration of the painting are characteristics of Heda's work during the 1630s. The plate with the opened pastry, along with the other objects in the painting, also belong to the painter's familiar repertoire.

Heem, Jan Davidsz. de

Jan Davidsz. de Heem (1606 Utrecht–1683/84 Antwerp) was an important bridge between Dutch and Flemish painting. He concentrated on still lifes with flowers and books, and especially decorative still lifes. His paintings, whose subjects are usually arranged in front of columns, draperies, or natural landscapes, mark the high point of the Netherlandish still life. In 1625 the de Heem family moved from Utrecht to Leiden, where Jan Davidsz. married the following year. He moved in 1635/36 to Antwerp, became a member of the St. Luke's Guild, and was granted citizenship in 1637. After

the death of his wife, he married a second time in 1644. In 1667 the family returned to Utrecht, where de Heem again appears as a member of St. Luke's Guild in 1669. Three years later, the painter fled from advancing French troops to Antwerp, where he took up residence. His major works include *Decorative Still Life with Lobster*, c. 1648, Museum Boijmans van Beuningen, Rotterdam; *Decorative Still Life with Golden Pitcher*, c. 1650, Gemäldegalerie, SMPK, Berlin; and *Fruit and Vegetable Still Life with Pitcher in a Landscape*, 1658, Städelsches Kunstinstitut, Frankfurt am Main.

Still Life with Books, 1628
Oil on panel, 36 x 46 cm
Mauritshuis, The Hague
This painting numbers among the artist's early works completed in Leiden, an old university city which especially honored the tradition of the still life with books. Because music is the most transient of all the arts, the violin lying in the background may be understood as a symbol of vanity. The worn volumes can also be seen as a reference to the transitoriness of life.

Fruit and a Vase of Flowers, 1655
Oil on canvas, 95 x 124.5 cm
The Hermitage, St. Petersburg
The development and spread through northern Europe of the particular type of still life set within a landscape can be definitely attri-buted to de Heem, who in turn received important influences from Flemish market scenes and allegories of the seasons. The warm color tones in the painting shown above are characteristic of de Heem's work within this genre.

Decorative Still Life in front of Architecture (A Dessert), 1640
Oil on canvas, 149 x 203 cm
Musée du Louvre, Paris

This wide, large-format painting with its realistically detailed, richly decorated table and bright coloration clearly indicates the extent to which de Heem allowed himself to be influenced by the grandiose Flemish style of still-life painting after his move to Antwerp. Works by Frans Snyders, Adriaen van Utrecht and Daniel Seghers, in particular, seem to have determined his artistic direction. De Heem devoted himself to the subjects of his pictures with extraordinary precision and attention to depicting surfaces. The contrast between light and dark emphasizes the foods, the tablecloth, and the precious vessels, while the musical instruments and architectural framework recede into the background.

Heemskerck, Maerten van

According to Karel van Mander (1548–1606), Maerten van Heemskerk (1498 Heemskerck–1574 Haarlem) studied with Cormelis Willemsz. in Haarlem and Jan Lucasz. in Delft. From 1527 to 1529 he worked with Jan van Scorel in Haarlem, and then embarked on a sojourn to Italy between 1532 and 1536. Upon his return, he again settled in Haarlem, where he became dean of the Guild of St. Luke in 1540. Except for a short period in Amsterdam in 1572/73, Heemskerck remained in Haarlem for the rest of his life, concentrating on religious and mythological history pictures as well as portraits. He also excelled in drawing patterns for woodcuts and engravings, and is one of the most important intermediaries between Italian and Netherlandish art of the 16th century. His works include *St. Lucas Painting the Madonna*, 1532, Frans Halsmuseum, Haarlem; *Venus and Cupid in the Smithy of Vulcan*, 1536, Národni Galerie, Prague; and *Mt. Calvary*, 1543, Museum voor Schone Kunsten, Ghent.

Portrait of Pieter Jan Foppesz. and his Family, c. 1530
Oil on panel, 119 x 140.5 cm
Gemäldegalerie Alte Meister, Kassel
Originally ascribed to Jan van Scorel, this family portrait has since been recognized as an early work of van Heemskerck's. The wealthy Haarlem burger Pieter Jan Foppesz. and his family are known to have been friends of the painter.

Hemessen, Jan Sanders van

Jan Sanders van Hemessen (c. 1504 Hemiksen bei Antwerp–after 1556 Haarlem) appears in official documentation in 1519 as a pupil of Hendrick van Cleve in Antwerp. He was accepted into Antwerp's Guild of St. Luke as a master painter in 1524, becoming its dean in 1548. Although there is no documentary proof that he travelled to Italy, his stylistic development certainly attests to a stay south of the Alps. In 1550 van Hemessen moved to Haarlem. He painted history and genre pictures, and is considered one of the more important representatives of the Roman style in Netherlandish painting in the second quarter of the 16th century. His daughter, Catharina van Hemessen (1528–1587), also became a noteworthy painter. Among the artist's works are *The Last Judgement*, 1537, Sint Jacobskerk, Antwerp; and *The Mocking of Christ*, 1544, Alte Pinakothek, Munich.

The Surgeon, c. 1550
Oil on canvas, 100 x 141 cm
Museo del Prado, Madrid
This depiction of an operation on a patient's head to remove a "stone of insanity," which takes place out-of-doors, is both detailed and dramatic. Indeed, the realism is carried almost to the point of caricature. The half-length figures in the immediate foreground derive from Italian painting and are characteristic of van Hemessen's work.

Hey, Jean

Little is known with certainty about Jean Hey (active between c. 1480 and after 1504 in France); for many years he was designated by art historians simply as the Master of Moulins. He was probably born in the Netherlands, where, based on stylistic similarities, Hugo van der Goes can be reasonably presumed to have been his teacher. From 1483 on he worked in Moulins at the influential Bourbon court. In the naturalistic elements of his paintings, Jean Hey was obviously influenced by early Netherlandish painting, but several motifs and stylistic elements derive from Italian models, the art of Bourges, and the works of Jean Fouquet in particular. Hey's elegant, courtly style clearly identifies him as a French painter, who was already influenced by the Renaissance. His major works include *The Birth of Christ*, c. 1480, Musée Rolin, Autun; and *Ecce Homo*, 1494, Musées Royaux des Beaux Arts, Brussels.

Virgin and Child in Glory, Surrounded by Angels, c. 1500
Tempera on panel, 157 x 133 cm
Notre Dame, Moulins
This painting—Hey's masterpiece—is the center panel of a triptych painted for the Cathedral of Moulins. Whereas Hey follows early Netherlandish style in his depiction of the two patrons, Peter II of Bourbon and his wife Anna, on the side panels of the altar, the center panel is clearly influenced by French–Italian models. In particular, the graceful figure of the Virgin resembles contemporary Madonnas by Benedetto Ghirlandaio.

Charles II of Bourbon, 1482/1483
Oil on panel, 34 x 25 cm
Alte Pinakothek, Munich
This severed panel originally belonged to a diptych that contained an image of the Virgin, as indicated by the leftward-turning figure of the praying man. The coat of arms with the three Bourbon lilies on a strip of brocade to the right and on the carved wood to the left in the picture identify him as Cardinal Charles II of Bourbon, who became archbishop of Lyon in 1447 and cardinal in 1476.

Charles Orlant, Dauphin of France, c. 1492–1495
Tempera on panel, 29 x 24 cm
Musée du Louvre, Paris
Hey completed this portrait of the young successor to the French throne, a child with a serious gaze holding a rosary in his hands, at the same time that he was painting the portrait of the young Suzanne de Bourbon at prayer. Both pictures are today held in the collection of the Louvre. With these impressive paintings—which also serve as important historical documents—the painter proves himself to be an excellent portraitist. This portrait belongs to the group of Hey's largely independent, French-influenced paintings.

Heyden, Jan van der

Jan van der Heyden (1637 Gorinchem–1712 Amsterdam) lived in Amsterdam after 1650. Until 1660, he was engaged in various study tours that certainly led him to explore the southern Netherlands and the Lower Rhine region of Germany, but probably also as far abroad as Italy and the Mediterranean. Van der Heyden was not only a painter, but also an inventor to whom Amsterdam owed its street lighting, introduced around 1670, and the development of a new kind of fire hydrant. In painting it was he, along with the Berckheyde brothers, who developed the background theme of the cityscape into an independent painting subject. Van der Heyden painted the streets and plazas of Amsterdam, Antwerp, Delft, Brussels, and other cities with a wealth of detail, although not always with topographical exactitude. His oeuvre also included landscapes and still lifes. His major works include *View of the Herengracht in Amsterdam*, c. 1680, Musée du Louvre, Paris; *View of the Westerkerk of Amsterdam*, c. 1680, The Wallace Collection, London; and *Corner of a Room with Rare Objects*, 1712, Magyaar Nemzeti Múzeum, Budapest.

The Dam with the New Town Hall in Amsterdam, 1667
Oil on canvas, 83 x 91 cm
Uffizi Gallery, Florence
Van der Heyden painted the Dam of Amsterdam with its city hall and the Groote Kerk a number of times from the mid 1660s, in paintings that can scarcely be differentiated from one another. The sunbeams falling almost horizontally from the right bathe the largest of Amsterdam's plazas in a warm morning light and give special emphasis to the bell tower and the facade of the city hall with its rich decoration of pilasters and sculptures.

The Church of Veere
Oil on canvas, 31.5 x 36 cm
Mauritshuis, The Hague

Veere is a small town situated on the island of Valcheren in the Dutch province of Zeeland, whose flourishing trade relations with Scotland resulted in a golden age during the 15th and 16th centuries. This period also saw the building of its Groote Kerk ("great church"). Characteristic for van der Heyden's cityscapes are the many human figures scattered across the wide plaza, which were often completed by the Amsterdam landscape and figure painter Adriaen van de Velde. Van der Heyden painted this subject again in 1678; however, in the second version the church is set in imaginary surroundings that include a Baroque palace. The later version now resides in the Gemäldegalerie in Dresden.

Hobbema, Meindert

Meindert Hobbema (1638 Amsterdam–1709 Amsterdam) spent his entire life in his native city. From approximately 1657 he studied in the workshop of the landscape painter Jacob van Ruisdael, and in 1668 he assumed the office of Barrelmaster for Wine and Oil, a position he held until the end of his life. He also married in 1668; after this point he painted only a very few pictures, which are nevertheless distinguished by their extraordinarily fine execution. Hobbema drew and painted forest landscapes in particular, often in compositions including water mills, ponds, or broad paths. His work shows a close stylistic relationship to that of van Ruisdael. Around the mid-1660s Hobbema's paintings became noticably brighter, more atmospheric, and more brilliant in color, while his painting style became more fluid. Among Hobbema's works are *Farmstead Under Trees*, 1662, Musée du Louvre, Paris; *Forest Landscape with Farmhouses*, 1663, The Wallace Collection, London; and *Landscape with Water Mill*, c. 1665, The National Gallery, London.

Water Mill, c. 1665
Oil on canvas, 80 x 66 cm
Musée du Louvre, Paris
Hobbema completed more than 30 paintings, drawings, and other images of water mills in wooded landscapes. The artist seems to have been encouraged to approach this subject by his teacher, Jacob van Ruisdael. The painting shown here depicts the water mill of the family seat of the Herrenhouses of Singraven, in the province of Overijssel.

Avenue at Middelharnis, 1689
Oil on canvas, 103 x 141 cm
The National Gallery, London
This light-flooded masterpiece depicts a view of the village of Middelharnis in the province of South Holland. The signature, which reveals a late production date, was long regarded as doubtful by art historians. However, the dating is correct, for this particular lane was laid in 1664, and the light tower rising in the background was not constructed until 1682.

Hogarth, William

William Hogarth (1697 London–1764 London) was one of the first English artists to work independently of the Continental tradition. In addition, his development of a non-moralistic social criticism made him a pioneer of modern caricature. He began learning silversmithing in 1712, and around 1720 was active as a copper engraver. Eight years later he turned to painting, and studied under the court painter James Thornhill, among others. Hogarth's style reveals certain French and Italian Baroque influences, and in the 1740s he also picked up inspiration from the French Rococo. He achieved fame particularly through his moralizing paintings of manners, and through the engravings he made based on his own paintings. He also exerted a great influence and gained much respect with his anti-academic tract *The Analysis of Beauty*, published in 1753. Significant works of his include *The Rake's Progress*, c. 1733, Sir John Sloane's Museum, London; *Marriage á la Mode*, c. 1743, The National Gallery, London; and *Hogarth's Servanthood*, 1760, The Tate Gallery, London.

The Dance, c. 1745
Oil on canvas, 68.5 x 90 cm
Tate Gallery, London
This sketch-like scene belongs to the *Happy Marriage* cycle, and was published as an engraving in Hogarth's book *The Analysis of Beauty*. Hogarth saw his moral pieces as history paintings, but the historicism is meant to be seen ironically. Both the design and the expressiveness of his pictures make them easily understandable illustrations of a story. Hogarth's new method of depicting characters made this kind of genre painting into the most popular type of picture in the 18th century.

Portrait of a Young Lady, c. 1740
Oil on canvas, 76.5 x 63.5 cm
Museum voor Schone Kunsten, Ghent
Realistic portraiture is central in Hogarth's oeuvre. In his portraits, with their paste-like application of color and free brushwork, he drew spontaneously and directly from the works of Hals, Rembrandt, and Chardin, and in the process provided important new impulses to English portrait painting.

Recitation of "The Empress of the Indies", 1732
Oil on canvas,
131 x 146.5 cm
Collection Galway, Dorset

Hogarth drew a great deal from the English stage in his early work. This painting portrays a scene from a drama of the same name by John Dryden (1631–1700) on the occasion of a private performance in honor of the royal children. The figures in the painting form a spirited public, and the guests of honor react in a spontaneous and relaxed fashion. The painting is also a proclamation of the superiority of the noble genius, as is demonstrated by the bust of Isaac Newton (1643–1727). On the mantel below the bust are the symbols of Newton's scientific and administrative achievements.

Holbein, Hans, the Elder

The art of Hans Holbein the Elder (c. 1465 Augsburg–1524 Isenheim?), the German painter and graphic artist, stands at the junction between the Gothic and the Renaissance. He was active in his native city as well as in Ulm, Frankfurt, and Alsace. It is possible that he moved to Basel with his son, Hans Holbein the Younger, in 1516. The father's altarpieces, panel paintings, and portraits bear the stamp of the Augsburg and Ulm Schools, but he was also influenced by Netherlandish painting. Though he remained committed to late Gothic themes, he seems to have accepted Renaissance stylistic developments. His balanced compositions unite realistic observations and clear depictions with charming portrayals and an elegant beauty. His portraits stand out for their masterly characterization and became the model for the genre in Germany. His works include *The Weingartener Altarpiece*, c. 1485, Cathedral, Augsburg; *The Hohenburger Altarpiece*, 1509, Národni Galerie, Prague; and *The Katharinen Altarpiece*, 1512, Staatsgalerie in the Schaezler Palais, Augsburg.

The Martyrdom of St. Sebastian, c. 1516
Oil on panel, 153 x 107 cm
Alte Pinakothek, Munich
The middle panel of the Sebastian Altarpiece depicts the saint in an elegant pose, tied to a tree trunk, and pierced with the arrows of his tormentors. However, he seems to feel no pain; his posture and clear gaze lend him a lofty dignity. Holbein's late Gothic works reveal a change of form: The figures acquire more corporeality and their arrangement energizes the previously symmetrical structure of the paintings.

Following page
Scenes from the Passion of Christ (The Kaisheim Alter), 1502
Oil on panel
Exterior panels 142 x 85 cm each;
Interior panels 179 x 82 cm each.
Alte Pinakothek, Munich
These panels form the external wings of the altarpiece from St. Mariä Ascenscion in Kaisheim near Donauwörth. They depict Christ on Mount Olive, the Capture, Christ before Pilate, the Scourging, the Crowning with Thorns, *Ecce Homo*, the Carrying of the Cross, and the Resurrection. In this series, Holbein arranged his figures freely for the first time, although the placement of the figure of Christ in the center of the picture still emphasizes his importance.

The Fountain of Life, 1519
Oil on panel, 193 x 137 cm
Museu Nacional de
Arte Antiga, Lisbon
This painting unites the atmosphere of earlier Gothic Garden-of-Para- dise pictures with the Venetian form of *sacra conversazione*. The Virgin and Child are shown in a rose trellis surrounded by her parents, St. Joachim and St. Anne, as well as by holy virgins and angels playing mu- sic. The fountain of life symbolizes the soul coming to life through baptism (water) and the Redemp- tion (the blood of the Eucharist). In no other painting did Holbein create so deep and broad a pictorial space.

Holbein, Hans, the Younger

Hans Holbein the Younger (c. 1497 Augsburg–1543 London) was one of the most important portrait painters of his time. He studied first with his father, Hans Holbein the Elder, and afterward went to Basel, where he was accepted into the painters' guild in 1519. There he received contracts for wall and altar paintings, portraits, and book illustrations. Around 1527 he travelled to London for the first time, and settled there in 1532. From 1536 on he turned completely to portraiture, especially of the nobles of the royal court and the merchants of the Hanseatic League. Holbein's early paintings reveal a strong Gothic influence, but contact with Italian art led to a gradual change in favor of clear and simple depictions. Both his portraits and his other pictures are characterized by a cool distance and detailed precision. Among his works are *Christ in the Tomb*, 1521/1522, Kunstmuseum, Basel; *The Slolthurner Madonna*, 1522, Museum der Stadt, Slolthurn; and *The Ambassadors (Jean de Dinteville and George de Selve)*, 1533, National Gallery, London.

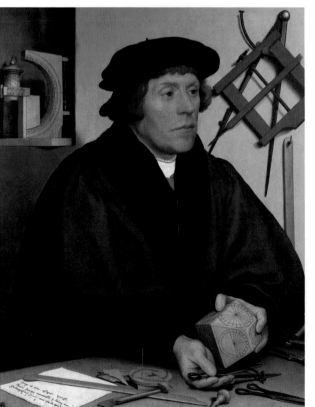

The Astronomer
Nikolaus Kratzer, 1528
Tempera on panel, 83 x 67 cm
Musée du Louvre, Paris
This painting of an interior portrays the famous German mathematician and designer of scientific instruments. Everything is depicted down to the finest detail, and is arranged as if in a still life. The character of the astronomer is portrayed with equally fine feeling. Through his amazing historicity and unprejudiced analytical powers, Holbein developed portraiture into his own unique art form.

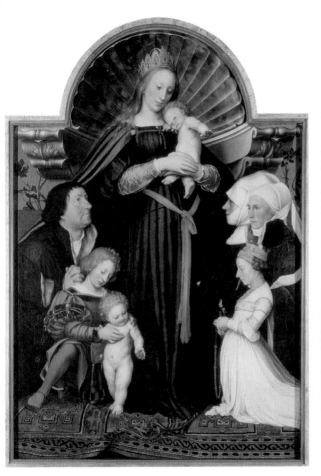

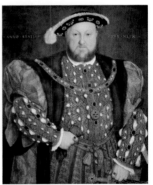

Henry VIII, 1540
Oil on canvas, 89.5 x 75 cm
Galleria Nazionale d'Arte
Antica, Rome
In his late portraits Holbein avoided the portrayal of surrounding detail and objects that serve to characterize the figure. Nothing in this picture detracts from the 49-year-old king, as he is designated in the inscription. The personality of the figure is reflected in his steady gaze and sovereign pose, and well as the imposing stature which almost springs out of the frame.

Virgin and Child with the Family of Burgomaster Mayer, c. 1526
Tempera on panel, 146 x 102 cm
Schloßmuseum, Darmstadt
This famous altarpiece testifies to the firm Catholic faith of its patron, who led the opposition to the Reformation. He appears at the left with his deceased son. To the right, his daughter, his second wife, and his deceased first wife are seen kneeling. The harmony of the composition is reminiscent of Italian painting, and the painting unites characteristics of the patron-sponsored picture, the family portrait, the devotional picture, and the *sacra conversazione*. A copy of this picture in the Dresden Gemäldegalerie was regarded as the original until 1871.

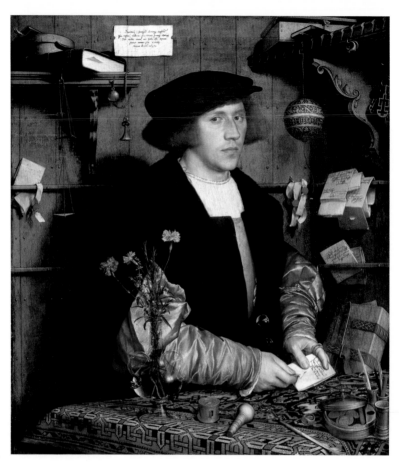

The Merchant Georg Gisze, 1532
Oil on panel, 96 x 86 cm
Gemäldegalerie, SMPK, Berlin
With this painting, Holbein not only achieved a high point of his own artistic development; he also created one of the most important pieces in German portrait painting. His balanced composition leaves nothing to chance. For this reason, the portrait seems to be natural and uncontrived. Holbein here combined the Italian manner of monumental form with the northern European style of detailed representation. As is clear in the detail shown to the right, he has masterfully rendered the different materials and varied reflection of light on glass, metal, clothing, and the objects on the table.

Far left
Erasmus of Rotterdam at his Desk, 1523
Tempera on panel, 42 x 32 cm
Musée du Louvre, Paris
For this portrait of the great humanist (c. 1468–1536) Holbein chose an unusual, almost intimate, perspective. Looking over the shoulder of his subject, the viewer can participate in the scholar's concentrated absorption. In no other rendering of his friend and benefactor did Holbein achieve a comparable measure of intensity.

Above right
Self-Portrait, c. 1542
Colored chalk and quill on paper, 23 x 18 cm
Galleria degli Uffizi, Florenz
Aside from a miniature based on one of Holbein's works, this is the only authentic self-portrait of the painter. He completed this small-format painting at age 45, shortly before his sudden death of the plague. The characteristic elements of his style are clearly evident: Holbein presents himself, sober and distanced, with a searching and unwavering gaze.

Robert Cheseman, 1533
Tempera on panel, 59 x 62.5 cm
Mauritshuis, The Hague
With no other symbols of his status but a falcon, which signified his expensive leisure pursuits, the country squire Robert Cheseman had himself portrayed at the age of 48. Even in this unpretentious piece, Holbein achieves a wonderful balance between his exceptional rendition of the exterior of the figure and a penetrating insight into the psychological interior.

Honthorst, Gerard (Gerrit) van

Gerard (Gerrit) van Honthorst (1590 Utrecht–1656 Utrecht), also known as Gherardo della Notte because of his preference for night scenes, trained with Abraham Bloemaert and worked chiefly in Rome between 1610 and 1622. There he was particularly influenced by naturalism and the work of Caravaggio, whose *chiaroscuro* effects he further developed through painstaking surface preparation and the introduction of a more diffuse source of light. Upon his return to Utrecht, Honthorst gradually took up mythological and Arcadian subjects in the neoclassical style. Between 1637 and approximately 1650, he worked for the Dutch viceroy in the Hague, as well as for other ranking houses of Europe. Honthorst was one of the principle adherents of the Caravaggio School in Utrecht, and he exerted a lasting influence on many of the artists who succeeded him. Among the major works by the artist are *Doubting Thomas*, c. 1620, Museo del Prado, Madrid; *The Birth of Christ*, c. 1620, Galleria degli Uffizi, Florence; and *Adoration of the Shepherds*, 1622, Wallraf-Richartz-Museum, Cologne.

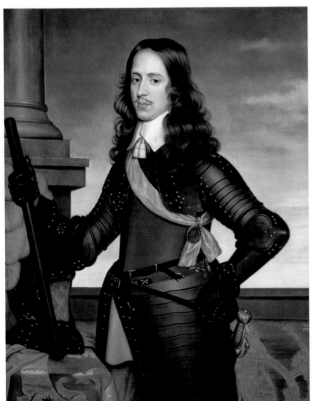

William II, Prince of Orange
c. 1647
Oil on canvas, 117 x 93 cm
Mauritshuis, The Hague
Honthorst's position as court painter under Prince Frederick Henry of Orange, Viceroy of the Netherlands, continued under William II (1626–1650), who succeeded his father in 1647 at the age of 21. In 1650, William II subdued the rebellious city of Amsterdam with his troops, once again affirming the power of the House of Orange and exerting a decisive influence on the course of history in the Netherlands.

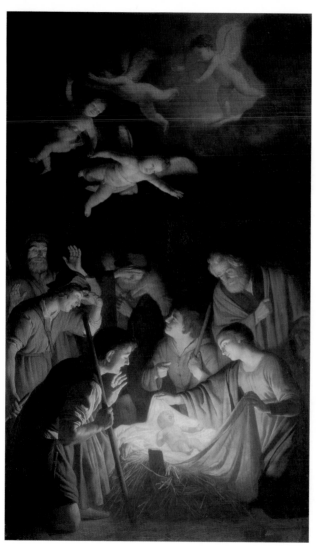

The Adoration of the Shepherds, 1617
Oil on canvas, 338.5 x 198.5 cm
Galleria degli Uffizi, Florence
This work is an impressive example of Honthorst's night paintings. The intimate scene's lighting seems to emanate miraculously from the Christ Child. All the warmth of the world has united here in the form of a new, divine love. This love is the basis of the considerable celebration and joyful mood of the painting.

Opposite above
Susanna and the Elders, 1655
Oil on canvas, 157 x 213 cm
Galleria Borghese, Rome
Honthorst returned to a neutral lighting in his later works. This composition has no parallel in the representations of contemporary Italian artists. In placing emphasis on Susanna's emotions, the painter thematizes the conflict between spiritual and corporeal purity, for in this story the conflict seems to be irresolvable.

Opposite below
The Supper Party, c. 1617
Oil on canvas, 144 x 212 cm
Galleria degli Uffizi, Florence
In Honthurst's traditional, rustic genre paintings the artificial lighting heightens the social atmosphere of the painting. Characteristic for these close-range vignettes are half-length figures grouped around a hidden light source, usually a candle or a torch. In creating this kind of composition, the artist is especially interested in a purposeful balance of light and dark zones.

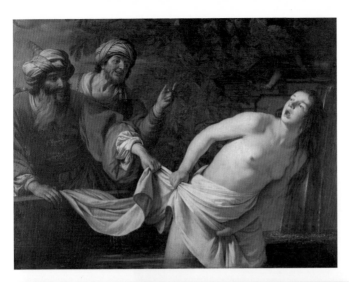

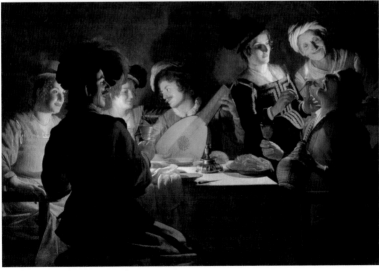

Hooch, Pieter de

Peter de Hooch (1629 Rotterdam–after 1684 Amsterdam) is one of the most important Dutch painters of interior scenes. Around 1647 he was a student of the landscape painter Nicolaes Berchem in Haarlem, and in the 1650s he worked as a painter and servant for a cloth merchant and art collector in Leiden, The Hague, and Delft. At first De Hooch concentrated on scenes depicting inns and guardrooms. Inspired by Carel Fabrizius and Jan Vermeer, however, de Hooch then turned to his famous interior and courtyard scenes in which he depicted everyday bourgeois life in arrangements that resemble still-life pantings. After he moved to Amsterdam around 1661 his style underwent a fundamental change. Influenced by French courtly art, he began to portray elegant social groups in splendid rooms and halls. Among the artist's works are *At the Cellar Door*, c. 1658, Rijksmuseum, Amsterdam; *Maid with Child in a Courtyard*, 1658, National Gallery, London; and *The Cardplayers*, c. 1664, Musée du Louvre, Paris.

Woman Drinking with Soldiers, 1658
Oil on canvas, 69 x 60 cm
Musée du Louvre, Paris
De Hooch's stationary figures are never in command of their space. Instead, they appear to be mere objects in deep, sparsely furnished rooms with open windows and doors. Hooch's characteristically varied lighting effects, ranging from soft, evenly dispersed daylight to starkly contrasting shadows, lend vitality to his scenes and cause his strong colors to emerge with extraordinary brilliance.

A Dutch Courtyard, c. 1619
Oil on canvas, 78 x 65 cm
Mauritshuis, The Hague
In their depiction of natural and dignified humanity, Netherlandish genre painters had been interested in striking a balance between showing obvious vices and imparting moral lessons ever since the 16th century. De Hooch's works reveal, in a contemplative mood, the peace and order of the daily life of the private citizen. The views are not limited to the house, but also include the courtyard, garden and alleys.

A Mistress and her Maid, c. 1663
Oil on canvas, 53 x 42 cm
Hermitage, St. Petersburg
Even this precisely depicted moment seems to be timeless. The particularized facial features of the seated woman may indicate a portrait. In no other period of history did a wealthy woman allow herself to be portrayed in such close contact with a servant. Their shared responsibility for an exemplary household brings them into a silent unity in this idyllic scene.

**Mother Lacing her Bodice
Beside a Cradle, c. 1662**
*Oil on canvas, 95.2 x 102.5 cm
Gemäldegalerie, SMPK, Berlin*
De Hooch's painting style always
has an expressive value of its own.

Here, the harmony of color and
light create a cozy atmosphere that
both corresponds to and accen-
tuates the intimacy of the scene. The
painting portrays the virtuous
mother whose care for her children

includes nursing them—a practice
that was not a matter of course in
higher social circles, and invited
vigorous criticism.

Hoogstraten, Samuel van

Samuel van Hoogstraten (1627 Dordrecht–1678 Dordrecht) was taught first by his father, Dirck van Hoogstraten, and from about 1642 to 1648 by Rembrandt in Amsterdam. In 1651 he relocated to Vienna, where he worked for Emperor Ferdinand III (1608–1657). In 1653 he travelled to Rome, then to London from 1662 to 1666, after which he stettled in Holland and became a member of the Pictura painters' guild in The Hague. After 1670, he worked in his native city. He took up many themes in his painting, initially in the style of Rembrandt, but he turned eventually to a more detailed style. Hoogstraten also pursued graphic work, experimented with optical equipment, constructed peep-hole pictures, and wrote important treatises on art. His major works include *Self-Portrait*, 1645, Museum Bredius, The Hague; *Man at the Window*, 1653, Kunsthistorisches Museum, Vienna; and *Mattheus van den Broucke*, 1670, Rijksmuseum, Amsterdam.

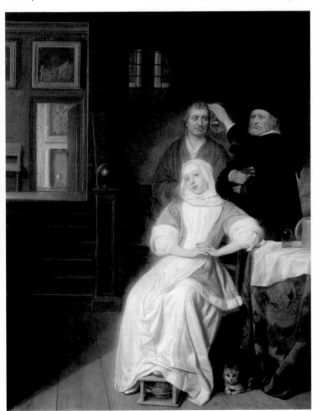

**The Anemic Lady
(The Doctor's Visit) c. 1660**
Oil on canvas, 69.5 x 55 cm
Rijksmuseum, Amsterdam
This interior demonstrates Hoogstraten's accomplished style. Human passion is displayed, but hidden within a farcical scene. The doctor checks the urine of the patient for pregnancy; while her husband stares uncomfortably at the glass, she knowingly regards the viewer. The erotic component is alluded to by the picture of the cat, the picture of Venus, and *putti* above the door of the adjoining room.

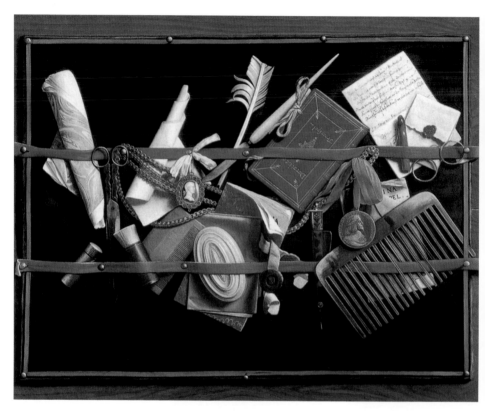

Still Life, c. 1667
Oil on canvas, 63 x 79 cm
Staatliche Kunsthalle, Karlsruhe
Characteristic of Hoogstraten's
works is an illusionistic *trompe-
l'oeil* technique, which he achieves
in a masterly fashion through the
use of precise details and exacting
observation of shadows within
objects as well as the shadows that
they cast. The still life pictured here
provides a typical example of this
type of painting. The deceptive
effect is heightened by the painted
wooden frame, which in turn acts as
the picture's frame. The seemingly
arbitrary selection of objects—
a beloved theme from the second
half of the 17th century onward—
characteristically refers to the tran-
sitoriness of human endeavor.

Huber, Wolf

Wolf Huber (c. 1485 Feldkirch–1553 Passau) is among the most important representatives of the Danube School, along with Lucas Cranach and Albrecht Altdorfer. He was probably the son or nephew of the master painter Hans Huber in Feldkirch, with whom he studied. Around 1500, he embarked on a long tour which took him to Innsbruck, Salzburg, and Augsburg. In 1513 he continued down the Danube, stopping in Linz, Vienna and Wachau. Huber settled in Passau in 1515 at the latest, where he and his wife Anna became citizens. He was probably active in the court of the Passau bishop after 1517. His name is mentioned in 1541 as the city's building master, and a year later he was recognized by Wolfgang, Prince-Bishop of Salm, as his court painter, an office which he held for the rest of his life. Huber painted altarpieces and portraits, and also worked as a graphic artist. Among his major works are *The Annan Altarpiece*, 1520/21, Sammlung Bührle, now on loan to the Landesmuseum Bregenz; *The Raising of the Cross*, c. 1525, Kunsthistorisches Museum, Vienna; and *Portrait of the Humanist Jakob Ziegler*, c. 1544–1549, Kunsthistorisches Museum, Vienna.

The Lamentation of Christ, 1524
Oil on wood, 105 x 87 cm
Musée du Louvre, Paris
Unusual in Huber's *Lamentation* is, on the one hand, the absence of the cross, and on the other, the figure of St. Mary Magdalene anointing the wounds on Christ's left hand with a feather while St. Nicodemus stands holding a pot of salve at the right edge of the picture. Because this figure possesses strikingly individualistic features, it is speculated that it could well portray the patron of the altar, Count Nicolas II of Salm.

Huguet, Jaime

Jaime Huguet (c. 1415 Valls–1492 Barcelona) is not only one of the outstanding Spanish artists of the waning Middle Ages, but is also considered, along with Bernardo Martonell, the most important painter in Catalonia in the second half of the 15th century. He studied with his uncle, the painter Pedro Huguet, who lived in Barcelona, around 1434. The first official reference to Jaime Huguet dates from 1448 in Barcelona, where he was a life-long resident except for stays in Tarragon and Saragossa in the 1440s. Through the efforts of the painter Luis Dalmaus Huguet became acquainted with the naturalistic painting of Jan van Eyck, whose influence is evident throughout the Spanish painter's work. Huguet contributed to large altar projects and left behind a comprehensive oeuvre with assistance from his large workshop. His major works include *The Scourging of Christ*, c. 1455, Musée du Louvre, Paris; *Altar with the Holy Absón and Senén*, 1459–1461, Santa Maria Tarrasa; and *Epiphany Altar*, 1464/65, Real-Capella de San Águeda, Barcelona.

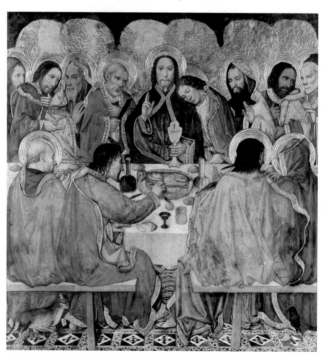

**The Martyrdom of
St. Vincent, 1450–1456**
Tempera on panel, 166 x 93 cm
Museo de Arte
Cataluña, Barcelona
The panel belongs to the main altar
of the St. Vincente Church in Sarriá
near Barcelona, dismantled in the
17th century. Originally it consisted
of a shrine with a statue of Vincent
of Saragossa surrounded by painted
scenes from the life of the saint. The
painting, with its numerous figures,
including angels that are pouring
water on the fire, impressively in-
dicates Huguet's innovation and
sheer joy in storytelling.

Opposite
The Last Supper, after 1450
Tempera on panel, 162 x 170 cm
Museo de Arte
Cataluña, Barcelona
The symmetrically constructed
composition is characterized by the
spatial effect of the presentation and
the naturalistic depiction of the
twelve apostles. The stippled gold
background is typical of Huguet's
work after 1450. Such backgrounds
pleased the conservative tastes of his
patrons, whom the craftsmen's
guilds of Barcelona served almost
without exception.

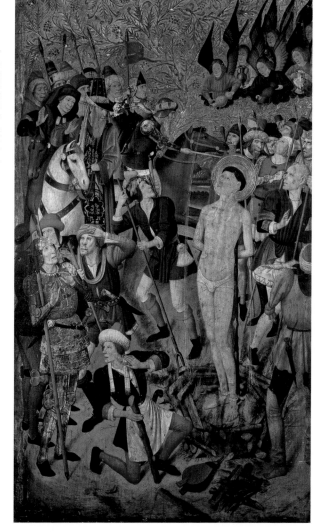

The Moral Hidden in the Paintings

In the picture above, two young men and a young woman are playing music together before a table laden with fruit, wine, and baked goods. While the cavalier in the foreground plays the cello, the youth on the right side of the picture is singing together with the young woman from a single songbook: She places her hand on his neck in a significant gesture.

At first glance, it would seem that this painting by the Utrecht painter Gerrit van Honthorst (1590–1656) depicts cheerful comradeship. But the first impression is deceptive. Closer observation reveals that the ugly old woman, who is giving the cellist a conspiratorial sign with the index finger of her raised right hand, is at the same moment reaching for the money pocket on the belt of one of the distracted singers. What at first seems like harmless pleasure is thus exposed as a con game: The old woman, the musician and the flirtatious young woman are accomplices, preying upon their unsuspecting young victim.

As a message for the observer, Gerrit van Honthorst's *The Concert* contains a moralistic warning against letting oneself fall into dubious company. One should let reason and care prevail rather than placing oneself at the mercy of the dangers emanating from sensual pleasure. Moral content like this, often presented in the form of hidden clues or symbolic references, was familiar to the contemporary viewer, and forms the basis of a great many Netherlandish genre paintings of the 16th and 17th centuries. The roots of this type of picture lie in the medieval illustration of proverbs, and span in time from Pieter Bruegel the Elder (c. 1527–1569) into the 17th century. So-called emblem books—collections of a great number of proverbs and sayings combined with illustrations and an explanatory text—such as the *Sinnepoppen* by Roemer Vischer dating from 1614, have particular significance in this tradition. In this way, elements that at first almost escape

Gerrit van Honthorst: The Concert, c. 1625
Oil on canvas, 168 x 202 cm
Galleria Borghese, Rome
The picture shows a traditional Caravagian theme, namely a young man—who can be identified as the Prodigal Son whose story is related in the Gospel of Luke (15: 11–32)—finding himself in a brothel, where he is robbed both of his money and his innocence.

the viewer's notice can become the key to a second, moralizing interpretation.

Unfortunately, today it is not always possible to find out beyond a doubt whether such a meaning can actually be attached to a particular picture. Moralizing references in genre pictures increasingly lost their importance as the 17th century ran its course. For example, a bird is frequently used as a symbol for love in the emblem books and in the older pictorial tradition. When kept in a cage, a bird can stand for the "happy slavery" of someone in love. It can, however, also refer to lust and sexual intercourse between man and woman (in Dutch, *vogel* means "bird"; and *vogelen* is a vernacular expression for "to have sexual relations"). If a birdcage is depicted as part of a neat, bourgeois interior, as for example, in the mid-17th century paintings of Pieter de Hooch (1629–after 1684) or Jan Vermeer (1632–1675), the knowledgeable viewer may still consider a slight element of eroticism, but no longer any moralizing warning about a dissipated lifestyle.

Jan Steen:
Couple Flirting Outdoors
Oil on canvas, 65.5 x 80 cm
Stedelijk Musea 'De Lakenhal', Leiden
The erotic desire that has taken hold of this servant and maid while they are returning from the market is emphasized by the symbols of the birdcage, the radish with its phallic form, and the rabbit.

485

Ingres, Jean–Auguste–Dominique

Jean–Auguste–Dominique Ingres (1780 Montauban–1867 Paris) studied at the academy in Toulouse between 1791 and 1796, and afterward in Paris with Jacques–Louis David. From 1806 to 1824 he lived in Florence and Rome before returning to Paris. He accepted an appointment to the Academy in Rome in 1835, and taught there until 1841. Strongly influenced at first by David's style, Ingres increasingly turned towards the Renaissance, taking the work of Raphael, Holbein and Titian as his models. Harmony, brilliant composition and fine treatment of surfaces (especially of the human body) distinguish Ingres' work. As a representative of late Classicism he is the counterpoint to Eugene Delacroix, who set himself violently against the "official" academic tradition. His major works include *Napoleon I on the Emperor's Throne*, c. 1806, Musée de l' Armée, Paris; *Madame Devaçay*, 1807, Musée Condé, Chantilly; and *Raphael and La Fornarina*, 1814, Fogg Art Museum, Cambridge.

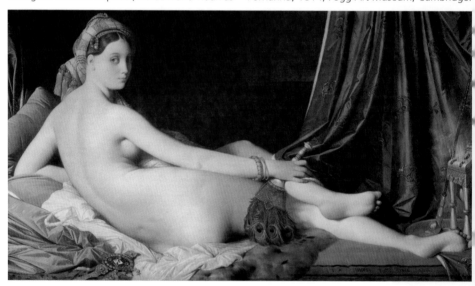

Large Odalisque, 1814
Oil on canvas, 91 x 162 cm
Musée du Louvre, Paris
The harem slave depicted in this painting only seems to be a charming character. She remains sunken in passivity, dissolving into her own body. Ingres' distortions of body and space, as well as his focus on technique, interfere with a sense of real presence and touchability of the painted figure. The content of the picture is therefore insignificant; the painting provides only the pleasure of regarding beauty. This approach makes Ingres a leading representative of 19th-century art, in which he exerted a strong influence that extended into the 20th century.

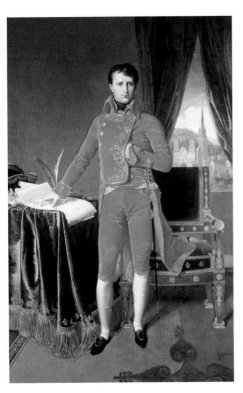

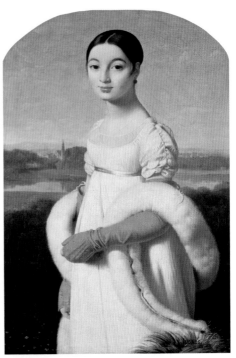

Bonaparte as First Consul, 1804
Oil on canvas, 227 x 147 cm
Musée des Beaux-Arts, Lüttich
Ingres was commissioned in 1802 to create this portrait, which recalls the generous support that Napoleon (1769–1823) gave to the rebuilding of the Flemish city of Lüttich. Ingres looked to the older art of both northern and southern Europe for the naturalism and ideal form of the painting. Behind the minute treatment of details stands the influence of Jan van Eyck; in contrast, the dignified posture of the Consul derives from ancient models.

Mademoiselle Caroline Rivière, 1805
Oil on canvas, 100 x 70 cm
Musée du Louvre, Paris
In this early work, with its soft yet strong form, Ingres reveals a highly sympathetic treatment of the insecure 15-year-old daughter of a respected Paris bourgeois family. The young woman's stiff posture, dreamy gaze and the slight smile are girl-like attributes; they are in contrast to her self-assured and graceful body language. The mood of the painting is also reflected in the misty landscape that provides the background for this beautiful portrait.

The Valpençon Bather, 1808
Oil on canvas, 146 x 96 cm
Musée du Louvre, Paris

The subject of the female nude occurs throughout Ingres' oeuvre. Beginning in his early years he had defined his own economical method of design by using simple lines and forms to express both ideal beauty and strength. He defined bodies and contours clearly and concisely, modeling their forms with a soft play of light. He concentrated on rendering surfaces, painting them with masterly skill and creating the illusion that nothing substantial existed behind them.

The Apotheosis of Homer, 1826/27
Oil on canvas, 386 x 512 cm
Musée du Louvre, Paris

This painting is a manifesto of classical cultural inheritance. In the middle, Homer is crowned by "Fame." At his feet sit his works: the *Iliad* with a sword and the *Odyssey* with a rudder. The epic poets Virgil and Dante stand in the lower left of the picture, and behind them, the contemporary authors Shakespeare and Cervantes. On the opposite side are the French Baroque dramatists Corneille, Molière, and Racine. Raphael and Poussin also are present as the founders of modern painting.

Madame de Senonnes, 1814
Oil on canvas, 106 x 84 cm
Musée des Beaux-Arts, Nantes
This portrait displays Ingres' masterly techniques of composition and drawing, and his fine use of color. The figure is set in a free yet clearly defined relation to the pictorial area, so that the flowing line of the shoulders is continued in the mirror image and the pillow. Contour plays an important role throughout the painting: The curved motif repeats itself in several variations. The gleaming fold and red tones are harmoniously related to each other.

Above right
Louis-François Bertin, 1832
Oil on canvas, 193 x 116 cm
Musée du Louvre, Paris
This picture also reveals Ingres' innovative ability as a portraitist. The figure is that of the founder of the *Journal des Débats*, an influential leader of public opinion during the constitutional monarchy and a model representative of the bourgeoisie. He peers peacefully at the viewer, but his facial features reveal his attentiveness and vitality. The power of his figure is increased by resting his weight on his hands.

Opposite
The Turkish Bath, 1863
Oil on canvas, diam. 108 cm
Musée du Louvre, Paris
Ingres designed this work based on verbal descriptions of the Orient. The painting, a visual synthesis of all his nudes, once again honors the beauty of the female body. The postures and expressive forms of the sensually intertwined nudes convey charm, pride, desire, and surrender. With their full forms and plasticity, a new concept of the figure emerges in the soft, rhythmic arabesque formed by their bodies.

→ *Janet, François and Jean, see Clouet*

Jordaens, Jacob

Jacob Jordaens (1593 Antwerp–1678 Antwerp) was an important painter of the Flemish Baroque. Between 1607 and 1615 he studied with Adam van Noort, who also taught Peter Paul Rubens. He entered the painters' guild as a "water painter"—he probably decorated wall hangings with water colors—and in 1621 became dean of the guild. He was also active for a short time in Rubens' workshop (1618/19), and under his direction he carried out the festive decorations for the Cardinal-Infanta Ferdinand in Antwerp around 1634, and paintings for Philipp IV (1605–1665) in Antwerp in 1637/38. Jordaens also received numerous foreign and domestic commissions. His style is similar to that of Caravaggio, yet also draws from the realistic tendencies of Dutch painting. Although he was a devout Calvinist, strong, solid, sensually lively characters are typical of his multi-thematic oeuvre. His works include *Pan with a Syrinx*, c. 1625, Musées Royaux des Beaux-Arts, Brussels; *Hunter with his Dogs*, 1635, Musée des Beaux-Art, Lille; and *The Twelve-Year-Old Jesus Among the Priests*, 1663, Landesmuseum, Mainz.

The Four Evangelists, c. 1625
Oil on canvas, 143 x 118 cm
Musée du Louvre, Paris
Jordaens arranges this subject differently than the Netherlandish painters who preceded him. He does not present the Evangelists with their traditional attributes at work reading or writing, but sunken in a shared contemplation or meditation of a large book. In addition, he depicts them in the form of the strong and vital figures of his native land, as can be seen in the wrinkled and suntanned faces of the three older Evangelists.

Portrait of the Artist's Family in a Garden, c. 1621
Oil on canvas, 181 x 187 cm
Museo del Prado, Madrid
This painting is the final in a series of three in which Jordaens depicts himself in the circle of his own family—here with his wife, Katharina van Noort, and his daughter as well as with a servant. The painter portrays himself in a triumphant pose within this elegant family scene, while the composition conveys a sense of integration and security.

The King Drinks, 1640
Oil on canvas, 156 x 210 cm
Musées Royaux des Beaux-Arts, Brussels
Here Flemish citizens joyfully celebrate the Feast of the Three Kings on Epiphany (Jan. 6). Traditionally the king is chosen by lot. In Jordaens' version of the scene, the festivities have come to a climax: While some of the party appear relaxed, others have lost control. Each brush stroke recapitulates the mood of the scene and effortlessly reflects the expression of the figures.

A Glance in the Mirror

By definition, still-life paintings take as their primary subjects lifeless, or at least motionless, things: objects that are present for their own sake and seldom have any active relationship to one another. In them we find flowers, fruit, animals and all sorts of objects used in daily life, ranging from the simplest to the most valuable, in many different combinations. Although such motifs were commonly used even in ancient art—such as in wall paintings found in Pompeii, for example—and although they occurred more and more frequently in paintings of the 15th and 16th centuries owing to the rise of a new approach to

looking at reality, the concept of the still life as a genre first came into favor in the late 17th century. The still life became the favorite genre of many painters, particularly in the Netherlands. Some Dutch painters even began to specialize in the portrayal of certain subjects, which meant that some still lifes depicted only fruit, flowers, books, musical instruments, birds or game, while others showed tables spread with frugal breakfasts and snacks, or contained opulent representations of valuable objects.

A large body of *vanitas* still lifes arose in the late 16th and the 17th century as a reaction to

Unknown French artist:
Vanitas **Still Life, 1630–1640**
Oil on canvas, 72 x 90 cm
Musée du Louvre, Paris
All the strange objects collected on the table in this painting—the skull reflected in a mirror, the purse, the lute with a broken string, the books and the flowers—are meant as *memento mori*. Each one of them symbolizes the motto, "Remember that you will die."

Unknown French artist:
Vanitas **Still Life (detail)**
The themes of human vanity, death and the transitory nature of life have seldom been so evocatively symbolized in European art as they are in this image of a skull looking at its own reflection.

the many works of art depicting earthly splendor and riches. Their predominant theme was human vanity, the ephemeral nature of life and the contemplation of true Christian values. This genre became extremely popular, particularly in the Netherlands. However, artists from other European countries also painted works on this theme, as is shown by the unusual *vanitas* still life by an unknown French artist on the preceding pages, which is today located in the Louvre Museum in Paris.

Art historians have tried again and again to explain the meaning of the various elements in this mysterious and strangely peaceful painting. For example, the orange cut in half could be seen as an allusion to the Fall of Humankind, which, according to Protestant doctrine, caused human beings to cease to be made in the image of God, and thus led to the complete corruption of human nature. The chess board, dice and playing cards are probably moralizing references to idleness, while the purse can be understood as a warning against prostitution.

The way the skull seems to be "looking" in the mirror, almost as though it were searching for the picture's viewer, is most remarkable. Looking at oneself in a mirror is an old motif symbolizing *vanitas* that has been used since the Middle Ages. Nothing could express the egotism and transitory nature of life better than this skull and its reflection. In searching for contact with the viewer of the painting with its deep, dark eye sockets, it signifies not only its own evanescence, but also that of all of humankind and all human pursuits.

Vanitas is the true theme of this still life: The flowers will wilt, the fruit will rot, and even the

worthless game and the purse full of money cannot deceive us as to the inevitability of our eventual demise. Even the accomplishments of literature and science, represented by the books and inkpot with a pen, have no lasting existence; neither does music, the most transitory of all art forms, whose finite nature is symbolized in this painting by the lute with a broken string; nor do heroic deeds and fame won by the sword.

The strange, parchment-like coloring used by the artist can only be understood in the context of the heterogeneous content of this picture. Everything looks dusty and faded; even the color of the tulips is dull. The way the mirror, dagger and lute are insecurely placed, neither properly standing up nor lying down, also gives the impression of instability; the objects seem about to plunge into the dark depths in which the table appears to be floating.

Seen against the background of French painting of the 17th century, in which the genre of the still life certainly played a subordinate role, this *vanitas* still life is made all the more exceptional by its subtle style and complex content. Although the manner of painting follows very much in the traditions of French art and Caravaggism, the painter has obviously been influenced by Dutch models in his or her choice of motifs, as similar symbolic elements are not uncommonly found in the works of the Delft painter Harmen Steenwijk (1612–after 1655) and many other still-life specialists from that region. Well-educated and artistically-minded contemporaries of the artist would have had no difficulties interpreting these pictorial elements, although they are combined and presented in

extremely divergent ways by various artists. The moralizing aspect of still-life paintings began to lose its significance from the 18th century on. Artists like Jean-Baptiste-Siméon Chardin (1699–1779), and, in the late 19th century, the Impressionists, were attracted to the genre chiefly by the coloring problems it posed. The popularity of the still life has hardly decreased even into the 20th century.

Harmen Steenwijk: *Vanitas* Still Life
c. 1640–1650
Oil on panel, 58.9 x 74 cm
Stedelijk Museum 'De Lakenhal', Leiden
The skull, the books and the worm-eaten fruit identify this picture as an allegorical representation of the terminal nature of all existence. Behind the skull stands a wooden beam joined to a cross-beam that is partially hidden by the upper edge of the frame; this can be seen as a reference to the Cross.

Kalf, Willem

Willem Kalf (1619 Rotterdam–1693 Amsterdam) lived in France from 1640 to 1646. Upon his return he settled in Rotterdam, and after 1652 he lived in Amsterdam. Around 1680 Kalf gave up painting and was active as an art dealer for the rest of his life. In addition to individual landscapes and interiors with peasants, he painted almost exclusively still lifes. His early pictures drew from the work of François Ryckhals, who has also been suggested as Kalf's teacher, although no documentary evidence of this exists. In the 1650s Kalf began painting precious and decorative still lifes, which established his fame as one of the outstanding Dutch still-life artists. His early works seem rather stiff at times, but he developed a more variable style as time went on and expanded his repertoire of objects to incorporate valuable Chinese porcelain, silver tableware, Venetian glass, mother-of-pearl vessels, selected fruits and Oriental patterns into his pictures. His still lifes present harmonious arrangements without becoming mannered. Some of his works are *Still Life with Pilgrim's Bottle and Two Golden Pitchers*, 1643, Wallraf-Richartz-Museum, Cologne; *Banquet with Nautilus Cup and Chinese Sugar Bowl*, 1660, Museo Thyssen-Bornemisza, Madrid; and *Banquet with Silver "Holbein Bowl"*, 1678, Statens Museum for Kunst, Copenhagen.

Still Life with Porcelain Bowl, c. 1653/54
Oil on canvas, 105 x 87.5 cm
The Hermitage, St. Petersburg
The prosperity that had been achieved by the northern Netherlands by the middle of the 17th century through international trade is clearly reflected in the still lifes of Willem Kalf. Splendor and prosperity are demonstrated not only by the silver goblet, but also by the oranges, pomegranates and peaches, all of which had to be imported from southern lands.

Opposite
Still Life with Chinese Porcelain Jar, 1662
Oil on canvas, 64 x 53 cm
Gemäldegalerie, SMPK, Berlin
In the pyramidal composition of this picture Kalf displays various objects of value and splendor carefully arranged on a marble table surface draped with a richly ornamental Persian rug. In the center stands the precious Chinese sugar bowl from the Wan-Ti period (1593–1620) that appears in other works painted by Kalf during his time in Amsterdam.

Kauffmann, Angelika

Angelika Kauffmann (1741 Chur–1807 Rome) was taught by her father, the painter Johann Joseph Kauffmann. She traveled to Italy for the first time in 1754, then again in 1758, and remained there between 1762 and 1765 before travelling by way of Paris to London in 1766, where she lived until 1781. In England she found a patron and mentor in Sir Joshua Reynolds. In 1781, while still in London, she married the Venetian architectural landscape painter Antonio Zucchi and returned with him again to Italy. The artwork of Angelika Kauffmann is located between Rococo and neolassicism. Her primary works were portraits and mythological narratives, in which she drew inspiration from Anton Raphael Mengs and Ponpeo Girolamo Batoni, as well as from various contemporary English portraitists. Her home in Rome became a social and cultural gathering ground for artists and scholars. Her works include *Johann Wolfgang von Goethe*, 1787, Goethe-National-Museum, Weimar; *Self-Portrait on the Cusp of Music and Painting*, 1792, Pushkin Museum of Fine Arts, Moscow; and *Ludwig I of Bavaria as Crown Prince*, 1807, Neue Pinakothek, Munich.

Opposite
Self–Portrait, 1787
Oil on canvas, 128 x 93.5 cm
Galleria degli Uffizi, Florence
In this impressive work created for the collection of
artist portraits of the Queen of Naples and the Duke of
Tuscany, a brother of Emperor Joseph II (1741–1790),
the artist has depicted herself with drawing pencil and
artists' folder in front of a landscape. The painting
marks the high point of Kauffmann's more than 20
surviving self-portraits. Even the uncommissioned self-
portraits are of a sweet delicacy, emphasized by her own
style of fine color application.

Portrait of the Family of Ferdinand IV, 1784
Oil on canvas, 310 x 426 cm
Museo Nazionale di Capodimonte, Naples
The painting shows King Ferdinand IV (1751–1825)
and Queen Maria Caroline with their six children in a
private familial setting before a vast Campagnan land-
scape. At the same time, the portrait makes conscious
use of all available insignias of power as well as formu-
las of pathos. Various sketches and a model in the
collection of the Prince of Liechtenstein in Vaduz
illuminate the development of this famous painting and
demonstrate the artist's devotion to her commission.

Kersting, Georg Friedrich

Beginning in 1805, Georg Friedrich Kersting (1785 Güstrow–1847 Meissen) attended the art academies of Copenhagen and Dresden, and in 1810 he accompanied Caspar David Friedrich on a walking tour through the Riesengebirge in eastern Germany. In 1812/13 the patriotic young artist applied for military service and entered the Lützow Corps as a volunteer. Starting in 1616 he worked in Warsaw, and was the drawing teacher of Princess Sophia. Two years later he went to Meissen, where he took over the position of director of the painting department in the porcelain factory there. Aside from short journeys to Berlin (1822, 1844), Weimar (1824), Nuremburg and Dresden, he remained in Meissen for the rest of his life. Kersting's paintings, primarily small-format portraits set in genre-like domestic surroundings, were highly praised by Goethe. His surviving works include drawings and watercolors, and include *Man at a Secretary*, 1811, Schloßmuseum, Weimar; and *The Violinist Nicolo Paganini*, c. 1830, Gemäldegalerie Neue Meister, Dresden.

Before the Mirror, 1827
Oil on canvas, 46 x 35 cm
Kunsthalle, Kiel
The simple and familiar became preferred subjects for paintings in the first half of the 19th century. Throughout Europe, peaceful paintings limited to domestic themes arose in what can be interpreted as a reaction to the heroic paintings of the Napolonic era. The largely small-format pictures are in the tradition of 17th-century Dutch genre painting.

Koch, Josef Anton

Josef Anton Koch (1768 Oberfibeln/Tirol–1839 Rome) first studied with the sculptor Martin Ignaz Ingerl in Augsburg, and after 1785 with Philip Friedrich Hetsch and Friedrich Harper at the Karlsschule in Stuttgart. From 1791 on he spent time in Strassbourg, Basel, Bern, Biel, and Neuchatel before moving to Italy in 1794. He travelled first to Naples, then settled in Rome. Except for a period in Vienna between 1812 and 1815, the artist remained in Rome and assumed a central position among the German artists there until his death. It was not until 1803 that he turned to oil painting in the style of Nicolas Poussin and Claude Lorrain. He spent his summers in the mountains near Civitella and Olevano. In addition to his paintings with individual figures, Koch concentrated in particular on heroic classical landscapes from the Roman mountains and the Bern Oberland, themes that were also highly valued by his contemporaries. Among his works are *Heroic Landscape with Rainbow*, 1805, Staatliche Kunsthalle, Karlsruhe; *Italian Landscape with Scouts from the Promised Land*, 1816, Wallraf-Richartz-Museum, Cologne; and *Four Wall Frescoes in the Dante Room*, 1826–1828, Casino Massimo, Rome.

The Schmadribach Waterfall, 1821/22
Oil on canvas, 131.8 x 110 cm
Neue Pinakothek, Munich
Mountain landscapes with waterfalls, such as this impressive view of the Schmadribach Falls in the Bern Oberland (Highlands), intrigued Koch throughout his career as a painter. The motif of flowing, falling water symbolized human existence: In comparison to all-powerful Nature, the tiny, purely decorative figure of a hunter indicates the insignificance of a human being.

Heroic Landscape with Rainbow, 1815
Oil on canvas, 188 x 171.2 cm
Neue Pinakothek, Munich

In 1804 Koch started this large-format picture and another of the same subject (finished in 1805 and now in Karlsruhe). However, this painting was not completed until 1815. His source was a drawing Koch made on the Gulf of Salerno in 1795 of the region around Vietri that he varied for use in his oil paintings. This is one of his works in the tradition of the heroic landscapes of Nicolas Poussin and other 17th-century artists.

Opposite
Heroic Landscape with Rainbow (detail)
The theatrical gestures of the human figures inserted by Koch into his heroic landscapes are reminiscent of the figures he painted in his pre-oil period. They are not shallow figures, but fully modeled; his female figures are well-formed and full-figured under their clothing, without aiming for erotic excitement. The people are secondary to the meaning of the work, and in comparison to the dramatic design of the landscapes, recede into the background.

Kulmbach, Hans Suess von

Hans Suess von Kulmbach (c. 1482 Kulmbach–1522 Nuremberg) is among the most outstanding German German artists of the Renaissance. Starting around 1500 he studied with Albrecht Dürer in Nuremberg, but he was also influenced during this period by Jacopo d'Barbari, who worked in the same city between 1500 and 1503. Although Kulmback became a citizen of Nuremberg in 1511, he worked in Cracow in that year, as well as later (from 1514 to 1516), as he had received various commissions from patrons in the Polish city, which maintained close trade relations with Nuremberg. Hans Suess von Kulmbach was one of the most sensitive colorists of the Dürer School, and his altarpieces and portraits, as well as his woodcuts and sketches for stained glass, reflect both Italian painting and the tradition of the Danube School. After 1511 the master signed his works with the monogram "HK" and finished his panels in brilliant, light-filled colors. His major works include *Adoration of the Magi*, 1511, Gemäldegalerie, SMPK, Berlin; *Markgrave Casimir of Brandenburg*, 1511, Alte Pinakothek, Munich; and *The Tucher Altarpiece*, 1513, St. Sebald Parish Church, Nuremberg.

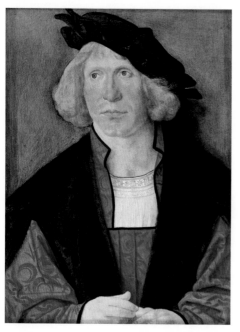

Portrait of a Young Man, c. 1520
Oil on canvas, 35.6 x 26.6 cm
Germanisches Nationalmuseum, Nuremberg
This half-length portrait portrays an unidentified young man in front of a monochromatic green background that forms a luminous contrast to his doublet of red silk damask. The black stole, with its black fur collar draped over the doublet, and the beret complete the masterly color scheme. There was probably once an inscription on the upper edge of the picture, but it has been lost.

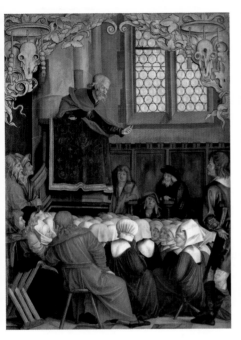

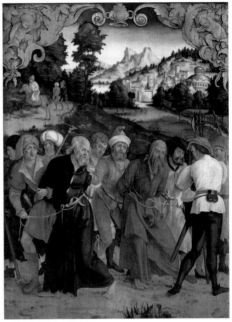

The Sermon of St. Peter, c. 1510
Oil on canvas, 117 x 93 cm
Galleria degli Uffizi, Florence
This and the following image present two of the eight scenes from the lives of Saints Peter and Paul that originally decorated the exterior wings of the famous altar of the two apostles. The inside of the shrine was embellished with free-standing sculptures, and the interior of the wings opened to reveal sculpted reliefs. The altar was in all probability the first that the Kulmbach workshop executed for Cracow patrons.

The Arrest of Saints Peter and Paul, c. 1510
Oil on canvas, 117 x 93 cm
Galleria degli Uffizi, Florence
Kulmbach designed the images of the Peter and Paul Altar with great objectivity and impressive simplicity. Whereas the figures in the arrest scene seem to form a closed group in front of a landscape, the strength of the *Sermon of St. Peter,* with its convincing depiction of an interior space, lies in its unusual composition. Up to this time, the Nuremburg tradition had offered no comparable interior scene.

Angelika Kauffmann: The Cicerone of Rome

On November 7, 1807, people in Rome witnessed a unique spectacle: a funeral designed by the sculptor Antonio Canova (1757–1822). A huge crowd of common citizens, 50 priests, 50 Capuchin monks, prelates in heavy ceremonial robes, and others accompanied the painter Angelika Kauffmann (1741–1807) on her final journey. Girls wearing classical-style costumes walked alongside the catafalque, looking as if they had just sprung from one of the deceased artist's pictures. Directly behind them marched the president of the Academy of Art and others from the art world. Two of Kauffmann's paintings were carried in the funeral procession, as was Canova's sculpture of the artist's right hand, on a velvet cushion with her working utensils surrounded by a bay wreath.

Along with the French portrait painter Elisabeth Vigée-Lebrun (1755–1842) and the Italian artist Rosalba Carriera (1675–1757), Angelika Kauffmann was one of the most important woman painters of the 18th century. She was born on October 30, 1741 in Chur, Switzerland, but spent most of her life in London and Rome. As a child she mastered Italian, English and French in addition to German, her native language. In 1768 the young artist was accepted into the Royal Academy in London, founded by Sir Joshua Reynolds (1723–1792), an admirer of her work.

Kauffmann first visited Rome in 1758 and found a worthy mentor in the German academic and archaeologist Johann Joachim Winckelmann (1717–1768). He was one of the leading figures in the neoclassic artistic movement, a reaction to the exaggerations of Baroque and the over-ornamentation of Rococo; it is characterized by a return to the clear, simple beauty of the Renaissance. Winckelmann encouraged Kauffmann to paint historical and classical mythological scenes, a demanding genre regarded by the academies as the highest form of art.

An unprecedentedly successful career followed, with numerous commissions and official honors accruing to her. Kauffmann married her second husband, the Venetian painter Antonio Lucchi, in 1781. A year later the couple moved into the Casa de'Stefanoni in the Via Gregoriana in Rome, in which Anton Raphael Mengs (1728–1779) had lived and worked as successor to Pierre Subleyras.

Angelika Kauffmann: Self-Portrait, 1784
Oil on canvas, 64.8 x 50.7 cm.
Neue Pinakotek, Munich
The artist painted this self-portrait for the portrait gallery in Leopoldskron Castle. It was commissioned by Count Karl Josef Firmian from Salzburg, one of her first patrons. Kauffmann, then 43 years old, painted a half-length portrait of herself dressed in the fashion of the Italian Renaissance as represented in works by Raphael and other artists.

This elegantly appointed house soon became one of the centers of the city's active social life. Artists and friends, most of them foreigners, met here, surrounded by the artist's collection of oil paintings, sculptures, plaster casts and books.

She was an eloquent tour guide—the cicerone of Rome—and made it her personal responsibility to show prominent political, scientific and cultural figures around "the Rome of the ancients." With them she would visit famous sites from classical antiquity as

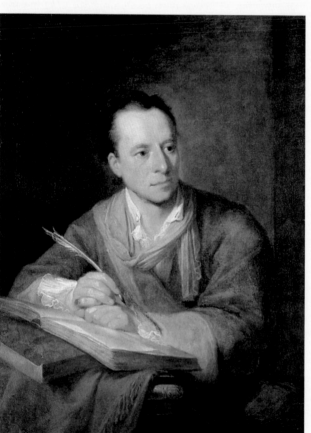

Angelika Kauffmann:
Portrait of Johann Joachim
Winckelmann, 1764
Oil on canvas, 97.2 x 71 cm.
Kunsthaus, Zurich
This painting was praised even during the sitter's lifetime as being a faithful portrait of Johann Joseph Winckelmann, known as the founder of the modern art historical method. He is sitting with a pen in his right hand in front of an open book, which is meant to be a symbol of learning. He is probably reflecting on the ancient relief showing the Three Graces that lies beneath it.

Opposite
Angelika Kauffmann:
Julia, the Wife of Pompey,
Fainting, 1785
Oil on canvas, 100.4 x 128 cm.
Staatliche Kunstsammlungen,
Weimar
This emotional scene is described by Plutarch in his *Life of Pompey* (53,3): When a servant appears carrying the bloodied clothing of her husband, Julia faints, believing that Pompey has been killed. The young man has, however, only been sent to change his master's clothes.

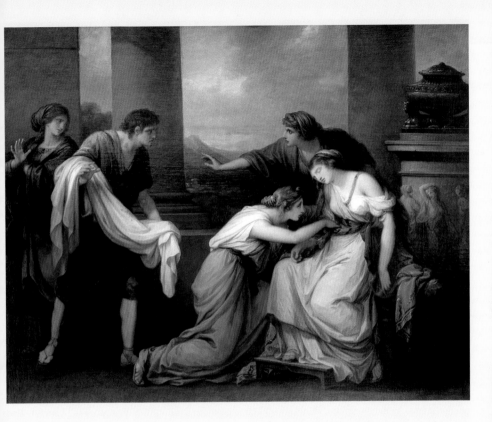

well as the city's splendid collections of pictures and sculptures. The Sunday art excursions with Johann Wolfgang von Goethe (1749–1832) during his sojourn in Rome from 1786 to 1788 have entered the annals of history.

Praise and recognition were poured on Kauffmann even during her lifetime. The German philosopher Johann Gottfried Herder (1744–1803) called her "perhaps the most culti-vated woman in Europe." Goethe, who was close to the artist, described her in his *Travels in Italy,* started in 1787, as a woman "very sensi-tive to everything beautiful, true and tender, as well as unbelievably modest," and praised her as a "woman of truly enormous talent." In *Roman Carnival* (1789) he gave her the hon-orable title of *la prima pittrice del secolo*: "the foremost woman painter of the century."

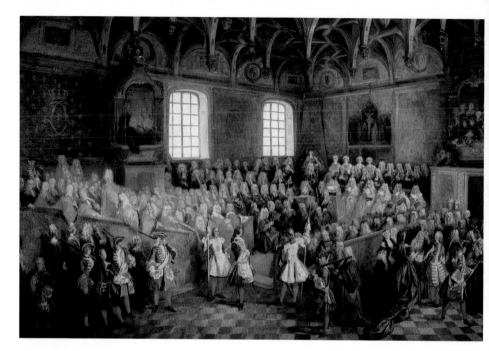

Lancret, Nicolas

Nicolas Lancret (1690 Paris–1743 Paris) spent his entire life as a respected and extremely productive painter in Paris, where he studied from about 1710 in the workshop of the history painter Pierre Dulin. After 1712 he studied with Claude Gillot, in whose studio he fell under the influence of an older co-pupil, Antoine Watteau. In 1719 Lancret was admitted to the Académie Royale de Peinture et Sculpture. After the deaths of Watteau in 1721 and Gillot in 1722, Lancret, along with Jean-Baptiste Pater, became the leading master of the style of painting known as *fêtes galantes*. This new genre of pleasant landscapes and festive social gatherings represented a particular branch of French landscape painting during the Rococo era. Lancret also became known for his theater scenes, likewise painted in the manner of Watteau, which he executed with a great deal of charm without neglecting the realities of the stage. His works include *Elegant Society in the Open Air*, c. 1719, The Wallace Collection, London; *Dance Amusement in the Castle Garden*, c. 1735, Gemäldegallerie Alte Meister, Dresden; and *Fastening Ice Skates*, c. 1740, Nationalmuseum, Stockholm.

Opposite

Session of Parliament
February 2, 1723; 1723
Oil on canvas, 56 x 81.5 cm
Musée du Louvre, Paris
Carried out in a light and sketchy style of painting, this picture shows the session of the French Parliament that declared the 13-year-old Louis (1715–1774) to be of age and officially recognized him as king, an office which had already been conveyed upon him in 1715. The young king sits in a slightly raised position among the numerous dignitaries in the precisely detailed hall of the Palace of Justice.

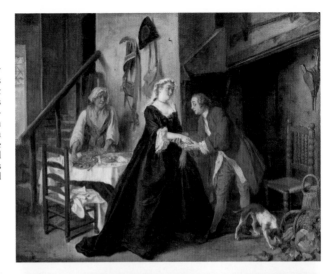

The Meeting
Oil on copper, 28 x 30 cm
Galleria Nazionale
d'Arte Antica, Rome
The tradition of Netherlandish genre and landscape painting experienced a revival in the works of Gillot, Watteau, and Lancret. The way for motifs such as the maid at work, the elegant couple in conversation with each other, and simple interior scenes enriched with still-life elements had already been prepared a century earlier.

The Swing, c. 1735
Oil on canvas, 99 x 132 cm
The Hermitage, St. Petersburg
Lancret's paintings present the convivial, courtly/aristocratic life, with its music, dancing, and pleasures of the table, in endless variation. The motif of the swing, on which a young woman is being pushed into the air by a gallant, is symbolic of amorous play and gives the otherwise innocent painting a tantalizing erotic edge.

Largillière, Nicolas de

As a child, Nicolas de Largillière (1656 Paris–1746 Paris) moved with his parents to Antwerp, where he became a pupil of the still life and genre painter Antoine Goubau at the tender age of 12. In Antwerp, Largillière also studied the paintings of Peter Paul Rubens, Anthonis van Dyck, and other Flemish artists of the 17th century. In 1672 he entered the Antwerp St. Luke's Guild, and from 1674 to 1682 lived in London, where he worked with Sir Pieter Lely. Upon his return from England he moved to Paris, and in the same year was accepted into the *Académie Royale de Peinture et Sculpture* for his portrait of Charles Le Brun. Largillière produced individual still lifes and history paintings as well as large group portraits commissioned by the Paris magistrates and numerous single portraits. Along with Hyacinthe Rigaud, he stands as one of the most respected French portraitists of his time. His works include *Charles Le Brun*, c. 1682, Musée du Louvre, Paris; *A Beauty of Strassbourg*, 1703, Musée des Beaux-Arts, Strassbourg; and *Self-Portrait with Wife and Daughter*, c. 1715, Musée du Louvre, Paris.

Opposite
The Children of James II of England, c. 1695
Oil on canvas, 194 x 144 cm
Galleria degli Uffizi, Florence
Largillière made various portraits of King James II
(1633–1701) and his family during his stay in London.
This double portrait depicting the Prince of Wales, James
Edward Stuart (1688–1766), next to his sister, Louise-
Marie (1792–1712), in the park of the castle at St.
Germain was removed to the Palazzo Pitti in Florence
in 1696. A second version of the painting is in the
National Portrait Gallery in London.

**The Provost and Municipal Magistrates of Paris
Discussing the Celebration of Louis XIV's Dinner at
the Hotel de Ville After His Recovery in 1687; 1689**
Oil on canvas, 68 x 101 cm
The Hermitage, St. Petersburg
In a style known as picture-in-picture, the debate of
eight worthy officials over the granting of a commission
for the creation of a statue is conducted before a
backdrop of a large painting of a banquet in honor of
Louis XIV. The model that the magistrates have decided
upon can be seen on the left edge of the painting.
Largillière's knowledge of 17th-century Netherlandish
painting is evident in this group portrait.

La Tour, Georges de

The name of Georges de La Tour (1593 Vic-sur-Seille–1652 Lunéville) first appears in 1618 on the occasion of his marriage in the city of Lunéville in Lorraine. He worked for the Duke of Lorraine and the French king Louis XIV (1638–1715), under whom he advanced to the position of official court painter. La Tour's style of painting suggests that he probably had travelled to the Netherlands and Italy. His surviving oeuvre numbers less than 20 religious, historical and genre "night" paintings that were only rediscovered at the beginning of the 20th century. His compositions consist of a few large figures placed in the immediate foreground and defined by strongly contrasted light and shadow, a style which reflects the influence of Caravaggio and the Utrecht Caravaggisti. His works include *The Organ Grinder*, c. 1625, Musée des Beaux-Arts, Nantes; *St. Jerome*, c. 1630, Nationalmuseum, Stockholm; and *The Tears of St. Peter*, 1645, Museum of Art, Cleveland.

St. Irene with the Wounded St. Sebastian, c. 1640
Oil on canvas, 167 x 130 cm
Musée du Louvre, Paris
Portrayals of Saint Irene of Rome tending to the wounds of Saint Sebastian are a popular theme in 17th-century painting. However, the patron saint of the sick is usually depicted as an older woman or as a young nun rather than as a young woman in contemporary clothing, as seen in this Parisian painting. A second, nearly identical version of this picture exists in the Gemälde-galerie in Berlin.

The Fraudulent Player, c. 1635
Oil on canvas, 106 x 146 cm
Musée du Louvre, Paris
The model for the card players shown in half-length figures and wearing elaborate costumes is the biblical story of the prodigal son that was quite a popular subject among the Utrecht Caravaggisti at that time. The young cavalier seated at the right is not only being cheated by the two women, who are exchanging meaningful glances with each other, but also by the young man on the left side of the picture, who is pulling an ace from his belt behind his back. La Tour understood how to skillfully draw the observer into the action: Knowledge of the betrayal makes the viewer almost into an accomplice to the crime. In addition, both the viewer and the sole source of light stand together outside the pictorial space.

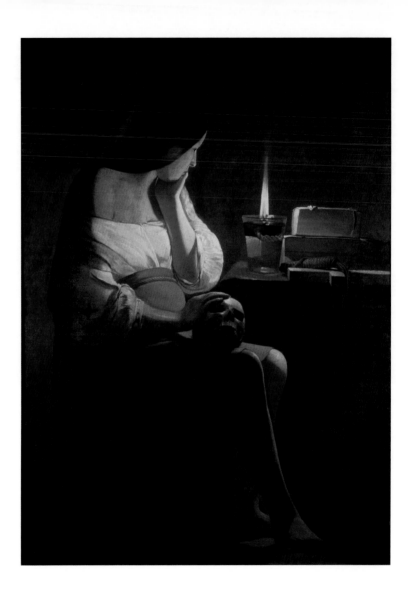

Opposite

The Magdalen of the Candle, c. 1644
Oil on canvas, 128 x 94 cm
Musée du Louvre, Paris

This painting belonged to the Paris collector Camille Terff before it was bought for the Louvre in 1949. It reveals Georges de La Tour not only as a sensitive painter of the human figure, but also as a skilled specialist in still lifes. The skull, the books, and the flame of the simple oil lamp are symbolic references to the transitoriness of mortal life. The cross stands for the hope of redemption in the afterlife.

Young Christ with St. Joseph in the Carpenter's Shop, c. 1642
Oil on canvas, 137 x 101 cm
Musée du Louvre, Paris

In the history of painting, St. Joseph and the Christ Child have appeared together only rarely without the Virgin Mary. La Tour's famous night painting stands out for its masterly use of color and light, and represents a mixture of religious, historical and genre painting. The artist has done away with halos in favor of a purely "worldly" depiction of the work in a humble carpentry workshop.

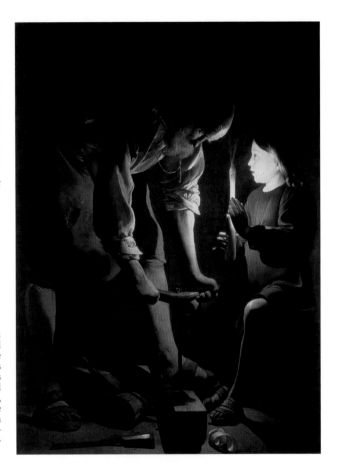

Le Brun, Charles

Charles Le Brun (1619 Paris–1690 Paris), the son of a sculptor, became one of the the most influential painters of his age. At age 13 he was already studying with Francois Perrier, and around 1635 was a pupil of the court painter Simon Vouet. Between 1642 and 1646 he journied with Nicolas Poussin to Rome, where he received stirring inspiration. In 1648 he was a founding member of the *Académie Royale de Peinture et Sculpture* in Paris, which under his direction became the leading art school in France. In the 1660s his court work brought him numerous commissions and offices, including nomination to First Court Painter and directorship of the royal Gobelins tapestry and furniture workshop. Through his various activities Le Brun exerted decisive influence on the development of the pompous and decorative *Louis-Quatorze* style. His works include *Christ on the Cross*, 1637, Pushkin Museum of the Fine Arts, Moscow; *The Martyrdom of St. John Before the Latin Gate*, c. 1641, St.-Nicolas du Cardonnet, Paris; and *The Entry of Alexander the Great into Babylon*, c. 1664, Musée du Louvre, Paris

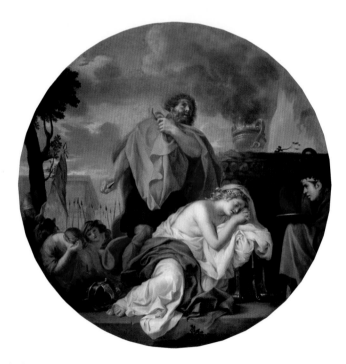

**The Chancellor Séguier
at the Entry of Louis XIV
into Paris, c. 1636**
Oil on canvas, 295 x 357 cm
Musée du Louvre, Paris
Le Brun depicted his first important
patron in a splendidly detailed scene
with typically strong and regimen-
ted classicism. The representation of
the dignified chancellor, mounted
high on his horse, follows the
tradition of the non-individualized
official portrait. At the same time,
the scene is an imaginary rendition
of a festive state event, and is thus
also a history painting.

**The Adoration
of the Shepherds, 1689**
Oil on canvas, 151 x 213 cm
Musée du Louvre, Paris
Le Brun completed this peaceful,
cheerful scene shortly before his
death. As so often in his work,
multiple episodes are portrayed:
Angels surrounded by the glory of
God announce the birth of Christ to
the shepherds, as the shepherds
worship at the stall. New are Le
Brun's exciting light effects, as well
as an inscribed ribbon adopted
from the old masters.

Opposite
The Sacrifice of Lephte, c. 1656
Oil on canvas, diam. 132 cm
Galleria degli Uffizi, Florence
Le Brun depicts this Old Testament
episode (Judges 11) with great in-
tensity. In order to save the Israelites
from the enemy, Lephte swore to
sacrifice whoever left his house first
after he returned home. He did not
realize that the first to leave would
be his own daughter. Stricken, he
throws his gaze to the heavens.
The spirituality of the gesture is
made sublime by the sense of peace
that reigns thoughout the picture.

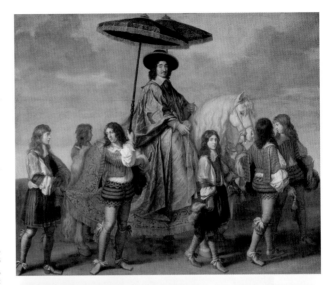

Le Nain, Louis

Nothing is known about the education of Louis Le Nain (1593 Laon–1648 Paris), but he arrived in Paris around 1630 with his two brothers, Antoine (1588–1648) and Mathieu (1607–1677), where the three opened a workshop together. It is difficult to distinguish the brothers' paintings from each other because they often worked on the same canvas as a collaborative team. As the most talented of the brothers, Louis Le Nain was soon designated "the Roman" in reference to a probable, but undocumented, period in Rome. In 1648 he was accepted into the Académie Royale de Peinture et Sculpture. In addition to a few history paintings, the brothers concentrated mainly on scenes of simple peasant life, which present the opposite pole to the courtly painting of the time. Other works of theirs include *St. Michael Dedicating his Weapons to the Virgin*, c. 1633–1640, St. Pierre, Nevers; *Return from the Hay Harvest*, 1641, Musée du Louvre, Paris; and *Venus in the Smithy of Vulcan*, 1641, Musée St-Denis, Reims.

Peasant Family, c. 1642
Oil on canvas, 113 x 159 cm
Musée du Louvre, Paris
The relatively large works of Louis Le Nain are distinguished by their dignified formality and depth from the cheerful, even debauched, representations found in Netherlandish and Italianate ("Bamboccianti") genre pictures. The brown-toned coloration and contrasting lighting underscore the touching mood of these scenes of French peasant life.

Peasant Meal, 1642
Oil on canvas, 97 x 159 cm
Musée du Louvre, Paris
Characteristic of Louis Le Nain is the seriousness and dignity with which he depicts the humiliating living conditions of the country folk during the Age of Absolutism. The shattering poverty of these peasants, who have gathered for a sparse, inadequate meal around a low table, is obvious: Their clothing is partially torn, and not all of them seem to have shoes.

The Guardroom, 1643
Oil on canvas, 117 x 137 cm
Musée du Louvre, Paris
This painting of six cavaliers grouped around a table with a burning candle standing in the center of it is usually associated with the brothers Louis and Antoine Le Nain. One of the men has fallen asleep at the table, and the others, shown in various postures, apparently have nothing to do with the dubious heroic deeds and dissolute pleasures of military life familiar from many comparable depictions of guardroom scenes by Netherlandish painters.

Leonardo da Vinci

Leonardo da Vinci (1452 Vinci near Empoli–1519 Cloux near Amboise) is one of the best-known and most important figures in western art. Beginning around 1468 he studied with Andrea del Verocchio, and continued in his workshop until 1477 although he had already become a member of the guild of Florentine painters in 1472. Leonardo spent the period from 1482/83 to 1499 in the service of Ludovico il Moro (1452–1508) in Milan, where he returned in 1506 after stays in Mantua, Venice, and Florence. In 1513 he moved to Rome, and eventually answered the call to the court of Francis I (1494–1547). Leonardo was not only a painter, sculptor, architect, and engineer, but also wrote scholarly treatises on anatomy and other subjects. He thus embodied the Renaissance ideal of the universally-educated artist, active in all forms of art. Leonardo had great influence of the history of painting through his mastery of pictorial composition and introduction of new ways of painting. His works include *The Baptism of Christ*, c. 1474, Galleria degli Uffizi, Florence; *The Adoration of the Magi*, c. 1481, Galleria degli Uffizi, Florence; and *The Madonna of the Rocks*, c. 1506, The National Gallery, London.

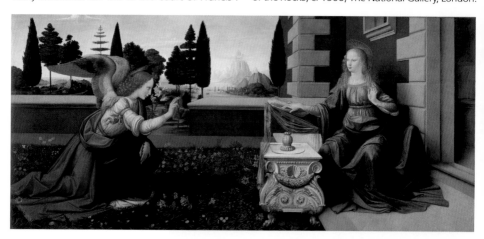

The Annunciation, c. 1472–1475
Oil and tempera on panel,
98 x 217 cm
Galleria degli Uffizi, Florence
This early work of Leonardo's clearly indicates that he still relied on the Florentine painting style, at the time dominated by Botticelli, particularly in its drawing methods.

The presentation of perspective and figures is still rather unskilled: The Virgin's right arm is unnaturally lengthened in order to make her seated position in the corner of the stall plausible. However, the treatment of nature in this painting suggests Leonardo's later understanding of light and atmosphere.

The dignity of the Angel of the Annunciation bowing before the Virgin is clear in the detail to the right. Above the angel's raised hand, an opening in the wall reveals a vast landscape. The figure of the angel is more richly clothed than in later pictures, emphasizing Leonardo's efforts at anatomic exactness.

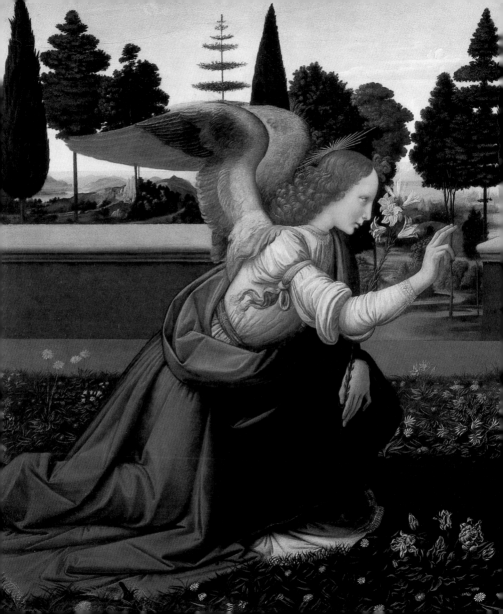

The Virgin of the Rocks, c. 1484
*Oil on panel, transferred to
canvas, 199 x 122 cm*
Musée du Louvre, Paris

This is the earlier of two versions of
the same composition, and it marks
both a high point in Leonardo's
painting and the end of his use of
Florentine style. Spatial and surface
values are balanced within the
pyramidal structure of the group.
Typical for this phase of Leonardo's
artwork are the *sfumato* effect (a
soft treatment of light and shad-
ows), the raised perspective, the
idealized facial features of the
figures, and the precise depiction of
the strange rocky landscape. The
saints are sitting on the stony earth
of a rock grotto. In the finely bal-
anced composition Leonardo unites
the images of water and rock with
the Holy Virgin and the dogma of
the Immaculate Conception.

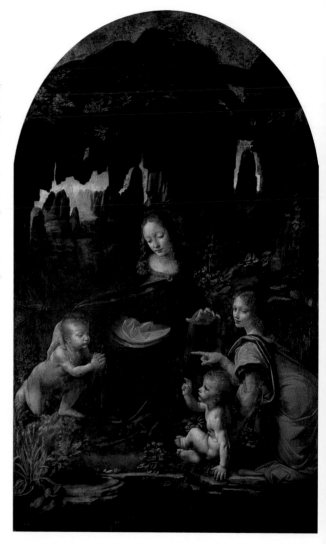

**Virgin and Child
(The Benois Madonna), c. 1479**
*Oil on canvas, 48 x 31 cm
The Hermitage, St. Petersburg*
A clearer structure and a more
robust corporeality of the figures
characterize this picture. No other
contemporary artist depicted the
Virgin and the Child Jesus, wholly
involved in their play, in such a
lively fashion as did Leonardo. The
freedom of their movements and
expressions, as well as their pro-
portions, are based on direct study
of living models—an unusual ap-
proach to this theme at the time.

The Last Supper, c. 1496
*Mixed media, 460 x 880 cm
Refectory, Santa Maria
della Grazia, Milan*
This picture, located in the refectory
of a monastery, remains the most
important pictorial treatment of
this theme. Leonardo transcends
the traditional motif in both content
and form, depicting the moment
when Christ speaks the words:
"One of you will betray me." The
horror and confusion of the dis-
ciples is legible in their gestures
and in the dynamic groups of three.
Judas is among them and yet
isolated: Leaning slightly forward,
his figure remains in the shadows.

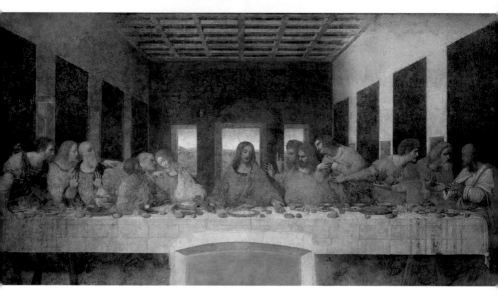

Portrait of a Musician, c. 1485
Oil on panel, 43 x 31 cm
Pinacoteca Ambrosiana,
Mailand
The probable subject of this painting is Franchino Gaffurio, music theorist and music director of the Milan Cathedral. His lifelike face and carefully painted curls arise from the dark background. The portrait is evidence of Leonardo's feel for what is important, for the closed lips seem about to speak. Like many of his works, this one is unfinished: The cap and clothing were completed by one of the master's students.

Portrait of a Lady with an Ermine (Portrait of Cecelia Gallarani), c. 1490
Oil on panel, 54 x 40 cm
Muzeum Czartoryski, Cracow
This work, painted in Milan, is proof that Leonardo was active as a court portraitist. The charming young woman has been identified as the lover of Ludovico il Moro, whose armorial animal she holds in her arms. She has turned herself from the shadows toward the light, while the ermine twists its head, as if she had frightened it. The figure stands out from the dark background as if it was sculpted.

Opposite
Portrait of a Woman (La Belle Ferronière), c. 1494
Oil on panel, 63 x 45 cm
Musée du Louvre, Paris
In this portrait as well as in the previous one, Leonardo reflects not only the outward form of his subjects; he also projects a portion of their psyches. This unknown beauty appears shy and retiring with her slightly lowered head and upward gazing eyes, with which she avoids looking at the viewer. This impression is strengthened by the wooden barrier in the foreground, which creates a spatial distance between her and her potential admirers.

Opposite
Virgin and Child
with St. Anne, c. 1508
Oil on panel, 168 x 130 cm
Musée du Louvre, Paris
Leonardo intertwines the figures of
St. Anne, the Virgin (her daughter),
and the Christ Child in an extremely
complex manner. Their expansive
gestures and postures have been
worked into the dominant geo-
metrical structure of the picture, and
at the same time the contour lines
and inner forms have been shaped
through color. The painting effec-
tively expresses a sense of both
peace and movement.

Mona Lisa, c. 1513
Oil on panel, 77 x 53 cm
Musée du Louvre, Paris
It is neither the mystery of her
identity—for she was probably the
wife of the Marquis Francesco del
Giocondo—nor that of her smile
that has made this late painting of
Leonardo's so famous. He impres-
sively employs the artistic methods
he had developed to create a psy-
chological dynamic. The figure and
the landscape, inner peace and pan-
theism, all unite into a single cosmic
image through the artist's impressive
use of the *sfumato* technique.

St. John the Baptist, c. 1513
Oil on panel, 69 x 57 cm
Musée du Louvre, Paris
The figure of the saint—whose
identity is suggested by the cross just
visible behind him as well as his
gesture and his gaze—is impres-
sively portrayed. He establishes
contact with the observer with his
right eye, a communication that is
reinforced by the position of his left
hand. At the same time, his
upwardly directed left eye and right
arm signify that he is a prophet,
announcing the impending arrival
of the Redeemer.

Leyden, Lucas van

Lucas van Leyden (1494 Leiden–1533 Leiden) first studied his trade with his father, the painter Hugo Jacobsz., and after 1508 with Cornelis Engelbrechtsz. in Leiden (also spelled Leyden). In June 1521 he went to Antwerp, where he met Albrecht Dürer, who drew a portrait of him. Six years later, Lucas van Leyden travelled to Zeeland, Flanders, and Brabant. In Middelburg he met Jan Gossaert. Although there is no documentary evidence that he travelled to Italy, he did spread Italian, as well as Netherlandish and German, influence through his pictures. Van Leyden numbers among the most widely influential artists of his time, having created a few large altarpieces, many small-format devotional pictures, portraits and genre scenes, as well as a comprehensive graphic oeuvre.

Major works by the artist include *Virgin and Child with Mary Magdalene and a Patron*, 1422, Alte Pinakothek, Munich; *The Last Judgement*, c. 1526, Stedelijk Museum "De Lakenhal," Leiden; and *Moses Striking Water out of the Rock*, 1527, Museum of Fine Arts, Boston.

The Card–Reader, c. 1508
Oil on panel, 24 x 30.5 cm
Musée du Louvre, Paris
This painting of a card-reader is one of the artist's earliest works. The small-format painting surface is filled to the uppermost edge with figures of various ages and social classes. While the young female soothsayer hands a flower to the nobleman to the left of the picture, a second woman standing to the right behind her gives a fool a glass of wine. The moral of the picture is that no one is safe from foolishness and flattery.

The Engagement, after 1527
Oil on panel, 30 x 32 cm
Koninklijk Museum voor Schone
Kunsten, Antwerp
An older man slides a valuable ring onto a young woman's left forefinger. Contrary to the traditional interpretation, the painting probably does not depict an engagement to be married: the ages and social classes of the two figures vary too widely. Rather, the scene is reminiscent of the theme of the unequal pair, in this case with the man paying the object of his worship for services rendered. The work is probably a copy made by Leyden's workshop of an original painted around 1527, which now hangs in the Musée des Beaux-Arts in Strassbourg.

**The Healing of the
Blind Man of Jericho, 1531**
*Oil on panel,
transferred to canvas
Central panel: 115.5 x 150.5 cm;
Side panels: 89 x 33.5 cm each
The Hermitage, St. Petersburg*
This altarpiece is one of the artist's few dated works, and represents one of the high points of his final period of creativity. Van Leyden painted the partially-surviving winged altar for the Leiden couple Jacob Florisz. van Montroort and his wife, Dirckje Boelensdr. van Lindenburgh. The artfully shaped figures depict the family's crest and originally were the exterior panels; they have now replaced the altarpiece's interior panels, which have been missing since the 19th century. The central panel depicts the oft-painted miracle of the healing of the blind man of Jericho described in the Gospels of Mark (10:46–51) and Luke (18:35–43). Christ is portrayed with the blind man and his companions in the center of the picture, surrounded by the 12 apostles and numerous observers.

Limburg, Paul, Jan and Herman von

The brothers Paul, Jan, and Herman von Limburg (c. 1387 Nimwegen?–1416 Bourges?) were active as book illustrators and panel-painters. The sons of a wood carver, they were probably first trained in Dijon by their uncle, Jean Malouel, who was a painter at the court of Burgundy. He arranged for Paul and Jan to enter an apprenticeship in a Paris goldsmithy in 1399. In 1402, Paul and Jan found themselves in the service of Philip II of Burgundy (1342–1404), and after his death, the three brothers worked for the Duke of Berry (1340–1416) in Paris and Bourges. The duke commissioned a series of costly handwritten prayerbooks. Paul, probably the most talented of the brothers, may have travelled to Italy in 1410 and studied the art of Florence and Milan. The stimulation he received was combined by the brothers with French traditions. Through their realistic depiction of the social hierarchy of their time, the brothers not only transcended the traditional boundaries of book illumination, but also gave an important impulse to Netherlandish panel painting. Their works include miniatures from the *Duke of Berry's Beautiful Book of Hours*, 1405–1413, The Metropolitan Museum of Art, New York.

The Month of May, c. 1415
Opaque color on parchment, 29 x 21 cm
Musée Condé, Chantilly (Ms. 65, folio 6 v.)
The miniatures from the calendar called the "Very Rich Hours of the Duke of Berry" consist of 71 paintings by the Limburg brothers. This picture shows the magnificent May procession of an elegant courtly group before the city of Riom, capital of the dukedom of Auvergne. The picture precisely indicates a joyful secular observation of nature; however, it can be inferred that life's joy does not arise from this world alone, as the beauty and value of the princely court is also a reflection of heavenly power.

Opposite
The Month of June, c. 1415
Opaque color on parchment, 29 x 21 cm
Musée Condé, Chantilly (Ms. 65/1284, folio 5 v.)
Social differences are consciously portrayed for the first time in the monthly illustrations of the "Very Rich Hours." Peasants are depicted at work in front of the gates of Paris (the Palais de la Cité is to the left, St. Chapelle to the right). The Limburg brothers included both a precise topographic depiction and objectively presented scenes together in a single unity of perspective and atmosphere.

Liotard, Jean-Étienne

Jean-Étienne Liotard (1702 Geneva–1789 Geneva) studied first with Daniel Bardelle in Geneva, and after 1723 with Jean-Baptiste Massé in Paris. In 1736 Liotard travelled to Florence and Rome, where he worked for Pope Clement XII (1730–1740) and other influential patrons. In 1738 he journeyed from Naples to Constantinople, where he remained for five years and acquired the nickname "*le peintre turc.*" He visited Vienna on his way back, and painted portraits of the Empress Maria Theresa (1717–1780) and others in courtly society. Afterward he undertook travels to Italy, Germany, France, England, and the Netherlands before settling in his native city in 1758, where he resided until his death. Shorter trips in the 1760s and 1770s, however, led him again to Vienna, Paris, and London. Liotard was primarily a portraitist and was one of the most important pastel artists of his time. His works include *Count Francesco Algarotti*, c. 1745, Rijksmuseum, Amsterdam; *Madame d' Épinay*, c. 1758, Musée Rath, Geneva; and *Empress Maria Theresa*, 1762, Rijksmuseum, Amsterdam.

Opposite
The Chocolate Girl, c. 1744
*Pastel on parchment,
82.5 x 52.5 cm
Gemäldegalerie Alte
Meister, Dresden*
This well-known picture was painted while Liotard was in Vienna in late 1744 or early 1745. It was purchased immediately after its completion, on February 3, 1745, by Count Algarotti for the princely house of Saxony. The figure of the servant girl offers fresh, frothy hot chocolate in cups of Meissen porcelain on a lacquered Japanese tray. Water in a glass, here of Bohemian crystal, traditionally accompanied the rich chocolate beverage.

**Marie Adelaide of France
in Turkish Dress, 1753**
*Oil on canvas, 50 x 56 cm
Galleria degli Uffizi, Florence*
The dating of this picture and the identity of the woman portrayed have still not been definitively determined. The Oriental aspects of the picture followed a fashion of the period that came about in Paris after a 1746 visit by the ambassadors of Muhammed Said to the city. Liotard himself exemplified this fascination with all things Oriental by sporting a large beard and wearing exotic clothing, and he portrayed such fashions in many variations in his artwork.

Lippi, Fra Filippo

Fra Filippo Lippi (c. 1406 Florence–1469 Spoleto) entered the Carmelite order in 1421 and lived in the monastery of Santa Maria del Carmine in Florence until 1432. There he could intensely observe Masolino and Massaccio engaged in painting the frescoes in the Brancacci Chapel, works which had a decisive influence on the young Lippi. In 1434 he was ordained in Padua. He worked until 1437 in Venice, and afterward in Florence, where he received numerous commissions from the Medici family. After 1452 Lippo lived in Prato, where he worked on the large wall frescoes in the main chancel of the cathedral. After 1467 he began painting the frescoes in the cathedral in Spoleto, which were finished after his death by members of his workshop. Fra Filippo Lippi's students included his son, Filippino Lippi, and Sandro Botticelli. Other works by the artist include *The Annunciation*, c. 1450, Alte Pinakothek, Munich; *Adoration of the Baby Jesus*, c. 1459, Gemäldegalerie, SMPK, Berlin; and *Virgin and Child with two Angels*, c. 1465, Galleria degli Uffizi, Florence.

**Virgin and Child with Scenes from
the Life of St. Anna, 1452**
Oil on panel, diam. 135 cm
Galleria Palatina, Palazzo Pitti, Florence
The so-called *Bartolini Tondo* belongs to a group of
Lippi's Madonna paintings which captivate us through
their verisimilitude. In the background to the right is the
meeting of Saints Joachim and Anna; to the left, in a
contemporary bourgeois domestic chamber, is the birth
of the Virgin. The often-discussed phenomenon of the
realism of the *Quattrocento* is impressively demonstrated
in this picture.

**Virgin and Child with Angels
and Saints Augustine and Fredianus, c. 1437**
Tempera on panel, 217 x 244 cm
Musée du Louvre, Paris
This magificent altarpiece is from the Chapel of
Gherardo Barbadori in Florence's Church of San
Spiritu. Under the center arch of the symmetrically con-
structed picture stands an almost life-size Virgin,
linked in a triangular composition to the two saints
kneeling before her. This pictorial structure has served
as an influential model for numerous artists of
succeeding generations.

Adoration of the Child with St. Bernard, c. 1463

Tempera on panel, 140 x 130 cm
Galleria degli Uffizi, Florence

Toward the end of his career Lippi painted numerous scenes of worship which possess a unique fairytale quality. This painting resulted from a commission by the Medici for the Camaldoli Cloister in Casentino. The revered Christ Child lies in the middle of a precious flowered carpet in front of an imaginary landscape. Above him is the Holy Spirit in the form of a dove, and the hands of God appear in the upper edge of the painting.

The Annunciation, c. 1442

Tempera on panel,
175 x 183 cm
Cappella degli Operai,
San Lorenzo, Florence

This painting is characteristic of Lippi's style during the early 1440s. The figures show a tendency toward more and more elaborate postures. The design of the folds in their clothing becomes increasingly restless, and almost seems to move. A new element that intensifies the spatial effect of the painting is the seemingly overlapping arched architectural elements in the front plane of the pictorial space. The Angel of the Annunciation, accompanied by two other angels, holds a stem of lilies and kneels before Mary in the first moment of their meeting. The Virgin's response to the news brought by the angel is one of shock and agitation.

The Coronation of the Virgin, 1441–1447
Tempera on panel, 200 x 287 cm
Galleria degli Uffizi, Florence

This panel with the coronation of the Virgin in the presence of the heavenly host is from the high altar of San Ambrogio in Florence. The patron, Francesco Maringhi—spiritual counselor to the nuns of S. Ambrogio—is portrayed to the right, next to John the Baptist. As patron saint of Florence he is portrayed extra-proportionally large, as is St. Ambrogio, patron of the cloister, on the left edge of the painting. The composition and modeling reveal hallmarks of Fra Angelico's style, an influence which increased in subsequent paintings.

Following pages
**The Feast of Herod with
the Dance of Salome, c. 1462**
Fresco, width c. 880 cm
Cappella Maggiore, Duomo, Prato

This scene, whose composition recalls familiar representations of the Last Supper, depicts the feast of Herod. His stepdaughter, Salome, dances before the king to the left; at right she presents her mother with the head of John the Baptist. The fresco is one of the most comprehensive and impressive painting cycles with scenes from the life of John the Baptist. Between 1452 and 1462 Lippi brought them together with a series on the life of St. Stephen in the main chancel of the cathedral in Prato.

Lippi, Filippino

Filippino Lippi (c. 1457 Prato–1504 Florence) was the son and pupil of Fra Filippo Lippi. After his father's death he studied with Sandro Botticelli in Florence. He derived much stimulation for his early paintings from both Botticelli and Rogier van der Weyden, whose works were well known south of the Alps. Along with Botticelli, Lippi was one of the most important Florentine painters on the threshhold between the early and High Renaissance periods. Although Lippi produced large altar paintings, allegories, and portraits, he is primarily known as a fresco painter. Between 1487 and 1502 he completed the famed fresco cycle in the Cappella Strozzi in Santa Maria Novella in Florence, and between 1489 and 1492, another in the Cappella Caraffa in Santa Maria sopra Minerva in Rome. A great number of his drawings have also survived. His other works include *Virgin and Child with St.s Jerome and Dominic in a Landscape*, c. 1485, The National Gallery, London; *Vision of St. Bernard*, c. 1486, Badia Florentina, Florence; and *Virgin and Child with St.s Martin and Catherine*, c. 1490, San Spiritu, Florence.

The Death of St. Lucretia, 1475–1480
Tempera on panel, 43 x 123 cm
Galleria Palatina, Palazzo Pitti, Florence
The mourning of the Roman virgin Lucretia forms a link between the peaceful paintings of Lippi's early creative period, influenced by Botticelli, and his rhythmically active style that he began to develop around 1480. Characteristic for Lippi is the symmetrical organization of the composition with an emphasis on the central axis, in this case consisting of the arches with their high pillars, the heathen idol, and the figures gathered beneath it.

Opposite
Virgin and Child with Saints (Madonna of the Otto), c. 1485
Tempera on wood, 355 x 225.5 cm
Galleria degli Uffizi, Florence
The altar panel from the *Sala degli Otto di Pratica* ("Council Chamber of the Eight"), in the Palazzo della Signoria in Florence, is mentioned in several documents. The Virgin and Child are enthroned before a magnificent architectural niche in a symmetrically structured composition reminicent of Botticelli. The lively design of the saints, however, distinguishes Lippi's style from that of his teacher.

The Adoration of the Magi, 1496
Tempera on panel, 258 x 243 cm
Galleria degli Uffizi, Florence
This panel is dated March 29, 1496 on the reverse side
and comes from San Donato a Scopeto near Florence.
It stands out for its magnificent compositional develop-
ment and its wealth of figures. In the strong, curving
postures and the sense of movement in the folds of the
clothing, gestures and hair of the figures, the large altar
painting reveals Lippi's characteristic style during the
1490s, a decade in which he was very productive.

Opposite
The Adoration of the Magi (detail)
In the detail shown to the right, the noble youth in his
costly fur-lined red coat approaches the Christ Child and
presents an ornate golden goblet, while a companion
removes the crown from his head. The older kings from
the Orient have also laid aside their crowns, which
signify their worldly power, before kneeling in front of
the Child. Fra Filippino Lippi received the commission
for this panel after the monastery had waited in vain for
15 years for Leonardo da Vinci to complete the work
that he had started.

Liss, Johann

Johann Liss (c. 1597 Oldenburg in Holstein–c. 1630 Venice) was a pupil in the workshop of his parents, both of whom were painters. Beginning in 1614 he spent his journeyman's years in Haarlem, Amsterdam, Antwerp, Paris, and Venice, settling in Rome in 1622. Toward the end of the 1620s he returned to Venice, where he died of plague at the approximate age of 33. In his short life, reliably documented by Joachim von Sandrart (1605–1688), Liss underwent an amazing artistic development. He began painting in the Haarlem style, then turned toward Peter Paul Rubens and Jakob Jordaens, and finally, influenced by Caravaggio and Domenico Fetti, developed a style of his own that was to revitalize the Venetian Baroque. In addition to his drawings and paintings, typified by an outstanding composition of figures, Liss also produced graphic works. Works by the artist include *Judith*, c. 1625, The National Gallery, London; *Hercules at the Fork*, c. 1625, Gemäldegalerie Alte Meister, Dresden; and *The Inspiration of St. Jerome*, c. 1627, San Niccolò da Tolentino, Venice.

The Sacrifice of Abraham, c. 1627
Oil on canvas, 88 x 70 cm
Galleria degli Uffizi, Florence
This painting depicts the dramatic scene from the book of Genesis (22:1–13) in which an angel descending from heaven prevents Abraham from sacrificing his son, Isaac, at the last minute. In this famous painting from the collection of Cardinal Leopoldo de'Medici (1617–1675), Liss proves himself an outstanding figure painter in the tradition of Titian and Rubens.

The Prodigal Son, c. 1622
Oil on canvas, 161 x 240 cm
Germanisches Nationalmuseum, Nuremberg
This work, also referred to as *The Soldiers' Camp*, is one of the most important examples of German Baroque painting. The large format as well as the numerous, active, life-size figures and gleaming colors are unusual. A second version of the painting in the Gemäldegalerie of Schloss Eilhelmshöhe in Kassel, as well as various other copies, indicate that the picture, executed in the style of Caravaggio, was highly valued by Liss's contemporaries.

Lochner, Stephan

Stephan Lochner (c. 1410 Meersburg on Lake Constance?–1451 Cologne) can be placed from 1442 onward in Cologne, where he was a major representative of the School of Cologne. Starting in Constance he moved down the Rhine, possibly spending some time in the Netherlands. In 1447 he became a city councilman in Cologne, where he had a large workshop. Lochner developed a highly independent, soft style based on the paintings of his contemporary Jan van Eyck as well as on previous works in the Cologne tradition. Spatial and plastic images and realistic details are characteristic of his lyrically sensitive paintings. Lochner united the realistic tendencies of southern German art with the idealism of the late Gothic in Cologne in a unique fashion. His works include *The Last Judgement*, c. 1435, Wallraf-Richartz-Museum, Cologne; *The Trinity Altarpiece*, c. 1442, Cologne Cathedral; and *Bringing Gifts to the Temple*, 1447, Hessisches Landesmuseum, Darmstadt.

Crucifixion
Oil on panel, 107 x 190 cm
Germanisches Nationalmuseum, Nuremberg
This panel is among Lochner's early works. It was commissioned by the Cologne families Dallem and Struss zum Campe, whose coats of arms can be seen lying at the foot of the cross. From left to right stand St. Ursula, Mary Magdalene (holding a vessel of salve), The Virgin Mary, John the Evangelist, St. Dorothy (with a bowl of roses), and St. Christopher carrying the Christ Child on his shoulders. In spite of the Netherlandish influences evident in his work, Lochner remained resolutely true to the traditional gold background that is a hallmark of Cologne painting.

Nativity, 1445
Oil on panel, 37.5 x 23.6 cm
Alte Pinakothek, Munich
The execution of this panel, half of a diptych, reveals Lochner as one of the great painters of his time. He worked primarily with oils applied in very thin layers, thus attaining a unique luminosity and transparence of color. Characteristic of his delicate style are the soft transitions within the shadows, a mother-of-pearl-like shimmer, and strongly emphasized reflections of light.

Madonna of the Rose Bush, c. 1450
Oil on panel, 51 x 40 cm
Wallraf-Richartz-Museum, Cologne
Softly curving lines and perspectively-developed space define this carefully thought out composition. Although the devotional image is richly detailed, nothing in the picture detracts from the Virgin and Child. The flowers are a reference to Mary's virtues, and the unicorn brooch to her virginity. The apple held by the Child symbolizes redemption from sin.

Longhi, Pietro

Pietro Longhi (1702 Venice–1785 Venice) was a genre and portrait painter of the Venetian Rococo. The son of a goldsmith, Longhi received his early training from Antonio Balestra. In 1719 he went to Bologna in order to work with Giuseppe Maria Crespi, who inspired him to an intensive study of nature and genre themes. In 1730 Longhi returned to Venice, where he became a member of the Academy in 1756. Longhi is known for his small-format paintings of manners, along with portraits, religious images and history paintings. Under the influence of Antoine Watteau and his followers, Longhi depicted scenes from the private and public lives of the Venetian nobility. His gentle manner of portrayal and fine, sharp humor conceal the melancholy of the "city on the lagoon," conscious of its decline. Some of the artist's works include *The Tooth-Puller*, c. 1746–1752, Pinacoteca di Brera, Milan; *The Concert*, 1741, Galleria dell' Accademia, Venice; and *Portrait of Francesco Guardi*, 1764, Ca' Rezzonico, Venice.

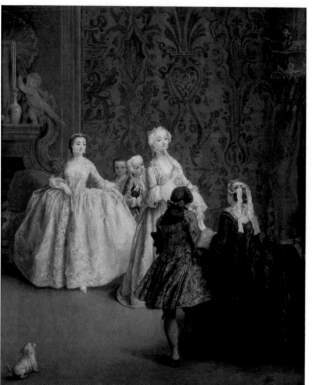

The Introduction, 1740
Oil on canvas, 64 x 53 cm
Musée du Louvre, Paris
This painting is one of a group treating the upper bourgeois or noble class, and for the first time reveals Longhi's personal style and unusual but effective sense of color. He gives deliberate accents to the simple composition, for example, by repeating the form of the group of figures in the curvings of the fireplace, and creating balance between the isolated dog in the foreground and the valuable vase on the mantle.

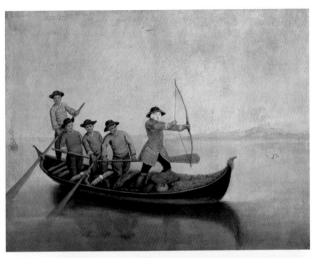

Duck Hunt on the Lagoon, c. 1760

Oil on canvas, 57 x 74 cm
Fondazione Querini
Stampalia, Venice

This picture presents a favorite pastime of Venetian gentlemen. The nobleman has just shot an arrow with the greatest of concentration; whether it was shot at a duck or at one of the clay balls from the pile lying in the basket at his feet is unclear. The rowers observe the events with excited amusement. The diffuse lighting and distant horizon, which are not typical of Longhi, lend the scene an intense economy of form.

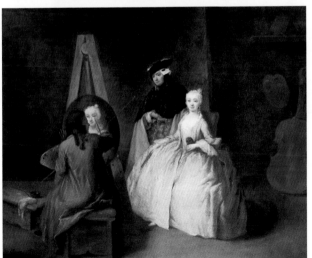

The Painter's Studio, c. 1743

Oil on canvas, 44 x 53 cm
Ca'Rezzonico, Venice

Here Longhi depicts himself at work, although the direction of the light casts his profile strongly into shadow. The painter's intensive gaze is directed toward the beautiful woman: That gaze and the short distance between his head and her painted image indicate a silent but heartfelt dialogue between painter and model. We can see that the concern of the cavalier who has accompanied the beauty to the sitting is completely understandable and justified.

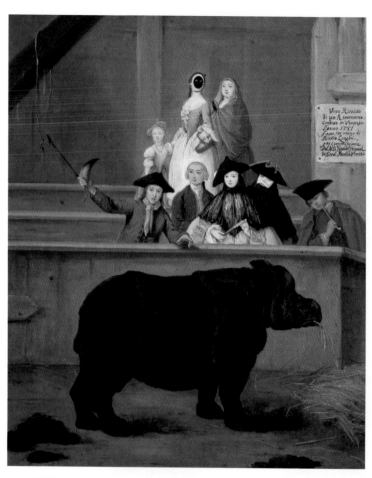

The Rhinoceros, c. 1751
Oil on canvas, 62 x 50 cm
Ca'Rezzonico, Venice
The written notice visible on the right side of the picture announces "a true portrait" of the seemingly monstrous animal that had already been displayed in other European cities. The audience shows no amazement at the sensational sight, but remains involved with its usual concerns. The use of masks, a popular means of changing one's identity during this period, refers to the emptiness of the familiar daily world. Only the exotic animal actually corresponds to reality in this picture.

Lorenzetti, Ambrogio

Ambrogio Lorenzetti (c. 1285 Siena–1348? Siena) was one of the most important masters of the Sienese Gothic. Presumably he studied with his brother Pietro, and afterward worked in his native city until around 1324. In 1327 he became a member of the guild of doctors and apothecaries in Florence, but by 1332 at the earliest he was again working in Siena. Lorenzetti's work unites the traditions of Siena with elements of Florentine art. He found his way to a spiritual deepening of the traditional themes and stylistic methods of Giotto and Simone Martini. His early work is characterized by solid, clear forms and a pure, strong coloration, with objects placed outside the pictorial space. His late works show a comprehensible concept of space that approaches a consciously perspectival representation. In addition, the figures are only slightly reduced to types. Lorenzetti also painted frescoes, seen in the Sala dei Nove, the Loggia, and the Sala del Mappamundo in the Palazzo Pubblico in Siena. His major works include *Nursing Madonna*, c. 1320–1330, Pontificio Seminario Regionale, Siena; *The Annunciation*, 1344, Pinacoteca Nazionale, Siena; and *Madonna Rapalono*, Pinacoteca Nazionale, Siena.

Madonna Enthroned with Angels and Saints, c. 1340
Tempera on panel, 50.2 x 34.5 cm
Pinacoteca Nazionale, Siena
This small panel, executed with a wealth of detail and delicate fine painting, probably served as a devotional picture. The bold structure includes vertical rows of angels and saints grouped in a mandorla form around the Virgin. At her feet kneel Popes Clement I and Gregory the Great and two bishop-saints; Saints Dorothy and Catherine stand beside the throne.

**The Presentation
in the Temple, 1342**
Tempera on panel, 257 x 168 cm
Galleria degli Uffizi, Florence
This late Presentation illustrates the
increasing importance of perspective
in Lorenzetti's work. Within a richly
decorated, ornamental architectural
frame, disappearing into the depth
under the middle arch, the Virgin
and St. Joseph bring their first born
son to the temple as required by
Jewish law. To the right stands the
aged and blind priestess Hanna,
who was the first to recognize the
Redeemer. Both the exterior and
interior views of the sacred space
are presented in a cut-away view.

Opposite
**The Effects of Good Government,
(detail) c. 1338**
Fresco
Palazzo Pubblico, Siena
Lorenzetti's cycle of The Effects of
Good and Bad Government, the
single such example with a secular
theme, represents a high point in
Italian painting. The glorification of
Good Government reaches around
three walls of the *Sala della Pace*
the council chamber of the nine
highest officials. The virtues of bra-
very and intelligence are presented
in a lively and realistic manner
along with an allegory of Peace.

The Effects of Good Government (detail), c. 1338
Fresco
Palazzo Pubblico, Siena
Here Lorenzetti delivers an impressive look into the civic life of Siena by depicting the results of good government. The artist intentionally chose the most strongly illuminated wall of the room to enhance his theme. Peaceful daily life reigns in the city; at the center is trade, the organization of work, and household duties. At the same time, sociability and leisure time are also depicted as praiseworthy results of the well-run government. The artist achieves spatial depth by creating a series of layers arranged in steps above one another, and the shifting points of view allow us to see as

much as possible of the town. The size relationship between the figures and the architecture is unparalleled up to this point in time. The figures are painted in the style of the most gentle and softly-executed figures in Lorenzetti's alterpieces. The spatial-ly rhythmic figures of the dancers who form the centerpoint of the painting, in particular, demonstrate Lorenzetti's great abilities.

Lorenzetti, Pietro

Pietro Lorenzetti (c. 1280 Siena–1348? Siena), who according to documentary evidence lived in Siena from 1320 to about 1344, was one of the most important artists of the early 14th-century Sienese School. Patterning his work on that of Duccio and Giotto, he incorporated the innovations of Simone Martini and the expressive power of the sculptor Giovanni Pisano (c. 1250–after 1314). In contrast to his brother Ambrogio, Pietro created austere and symmetrical scenes into which he effectively incorporated three-dimensional figures. His painting is distinguished by attentive observation of reality and the changes of light according to the time of day and the season. By the end of his career he had fully developed his talent for narrative. Among his works are *The Crucifixion*, 1331, San Francesco, Siena; *Virgin and Child*, 1340, Galleria degli Uffizi, Florence; and *Polyptych of St. Humilitas*, 1341, center panel and single scenes, Galleria degli Uffizi, Florence.

Descent from the Cross, c. 1320–1330
Fresco
Basilica inferiore di S. Francesco, Assisi
This scene from the Passion, located in the transept of the lower church, depicts the event in a natural time sequence, seen in the inclination of the corpse and the bowed postures of the saints. The sculpted figures lend a sense of three-dimensionality to the picture. The noticeable tendency of the fresco series toward flowing and expressive curves finds its high point here.

**The Entry of Jesus
into Jerusalem, 1320–1330**
*Fresco, 244 x 310 cm
Basilica inferiore di
San Francesco, Assisi*
Of all the Sienese painters, Pietro

Lorenzetti was the most intensively
involved with the work of Giotto, as
can be seen in his fresco cycle on the
Passion of Christ. This significant
work is characterized by strict and
elegant principles and an effective

organization of groups of figures in
three-dimensional space. The figures
seen here, for example, are located
within an ambitious and complex
architectural background.

Polyptych, c. 1332
Tempera on panel, 298 x 309 cm
Pieve di S. Maria, Arezzo
This work, painted for Bishop
Guido Tarlati, provides an excellent
example of a multi-winged altar
painting from the *Trecento*. In the
center stands the Virgin holding
the Christ Child in the lower row of
the central panel. The area above
them contains a picture of the
Annunciation. The other fields de-
pict various saints, including St.
Donatus in the lower left. Lorenzetti
usually depicted saints in the tra-
ditional manner; here, however,
their natural appearance allows
them to stand out from the back-
ground of the painting.

The Birth of The Virgin, 1342
Tempera on panel, 188 x 183 cm
Museo dell'Opera
Metropolitana, Siena
The composition of this painting disregards the actual divisions of the panels. This, along with the precise-ly detailed depiction of the scene and the interior space, are examples of Pietro Lorenzetti's innovations in the Sienese tradition. Because the altar is installed in such a way that it can only be approached from the right, the artist took the remarkable step of relating the narrative from that vantage point. The unusually deep view into the room shown in the left panel was also a result of the specific viewing conditions.

Lorenzo di Credi

Lorenzo di Credi (c. 1459 Florence–1537 Florence) first studied in the goldsmith workshop of his father, Andrea di Credi. It is documented that he was a pupil of the painter Andrea del Verrocchio from 1480 to 1488, in whose studio he apparently also made statues and was influenced by his fellow student, the young Leonardo da Vinci. Lorenzo di Credi chiefly painted religious history pictures and portraits. His works are difficult to organize chronologically; they are characterized by their careful and unchanging technical perfection of design, and coloration that is influenced by Netherlandish painting. Di Credi's faces and figures are often repetitions of the same conventional types, painted in light colors. The artist's works include *The Annunciation*, c. 1485, Galleria degli Uffizi, Florence; *Self-Portrait*, 1488, National Gallery of Art, Washington DC; and *Virgin and Child with St. Sebastian and John the Evangelist*, c. 1516, Gemäldegalerie Alte Meister, Dresden.

Portrait of a Young Woman, c. 1480
Oil on panel, 75 x 54 cm
Pinacoteca Civica, Forli
Research has established the identity of the sitter for this portrait as Caterina Sforza. It is one of a number of portraits whose strong characterization indicate di Credi's remarkable strength as a portraitist. He often introduced everyday objects into his pictures, such as the realistic bouquet in a vase in this case, which is evidence of the beginning of still-life painting.

Opposite
The Adoration of the Shepherds, c. 1500
Oil on panel, 224 x 196 cm
Galleria degli Uffizi, Florence
This picture, first mentioned in 1510 and praised by Giorgio Vasari in 1550, was painted by di Credi for the monastery of S. Chiara in Florence, where it hung until 1808. Still in excellent condition, the large-format panel stands out for its artistic quality, luminous coloration, and realistic presentation of the figures. Nature, too, is realistically rendered.

Lorenzo Monaco

Lorenzo Monaco (c. 1370 Siena?–c. 1425 Florence?), born Piero di Giovanni, is an important representative of the International Gothic style. According to documentary evidence, he was active as a painter and miniaturist in Florence between 1390 and 1422. He entered the Kamaldula Monastery S. Maria degli Angeli in 1391, and became a member of the painters' guild in 1402. Lorenzo Monaco was influenced by the Sienese School, especially Simone Martini and Pietro Lorenzetti, and the Florentine successors of Giotto. Characteristic of his mature, delicate style are strongly curved lines, a great variety of ornament, tender colors and surprising light effects. His works include *Virgin and Child with Two Angels*, 1395, Galleria degli Uffizi, Florence; *The Feast of Herod*, 1408, Musée du Louvre, Paris; and *Fresco with Scenes from the Life of the Virgin*, c. 1422, S. Trinità, Florence.

The Adoration of the Magi, 1421/1422
Tempera on panel, 115 x 170 cm
Galleria degli Uffizi, Florence

Opposite

This version of the popular motif unites several episodes of the story. From right to left, the painting depicts the three Wise Men (magi) searching for a comet in front of a barren landscape; their magnificent, rather exotic procession; and finally their worship of the Child. The figures of the magi also represent the three continents known at that time and the three stages of life. The framing with scenes of the Annunciation painted in the spandrels is an addition from the late 15th century.

The Coronation of the Virgin, 1414
Tempera on panel, 450 x 350 cm,
Galleria degli Uffizi, Florence

This altarpiece from the monastery of Santa Maria degli Angeli follows the traditional Florentine scheme in its portrayal of the Coronation taking place amidst a gathering of saints. However, the elegant costumes, decorative poses, precious materials and rich ornamentation depicted in the painting derive from contemporary court ceremonies. The four predella scenes show episodes from the life of St. Benedict as a model for monastic virtue.

Lorrain, Claude

Claude Lorrain (1600 Chamage, Lorraine–1682 Rome), whose real name was Claude Gellée, was known as "Le Lorrain" after the land of his birth. Around 1613 he moved to Rome and became a student of the architectural painter Agostino Tassi. He continued his studies under the architectural and landscape painter Gottfried Sals during a stay in Naples fron 1619 to 1624, at the end of which he spent two years in France. In 1634 he became a member of the Roman Academy, and soon became its leading landscape painter. He at first

drew from the ideal landscapes of Annibale Carracci and the Netherlandish painters working in Rome, but his style later became closer to that of Nicolas Poussin. In contrast to Poussin's heroic tendencies, however, Lorrain pursued a lyric-romantic approach. Taken together, the creations of the two painters form a high point of the Roman Baroque. Among his works are *The Embarkation of St. Ursula*, 1642, the National Gallery, London; *The Stuffing of the Haga*, 1668, Alte Pinakothek, Munich; and *Mt. Parnassus*, 1680, Museum of Fine Arts, Boston.

Above left
**Campus Vaccino
in Rome, c. 1636**
*Oil on canvas, 56 x 72 cm
Musée du Louvre, Paris*
One of the main categories in Lorrain's oeuvre is the *veduta*, or archi-

tectural landscape, of his adopted city of Rome. This painting presents the Campus Vaccino with a view of the Forum Romanum, with figures of impoverished city dwellers standing between the fallen antique monuments; the Colosseum appears in

the distance. The genre-like figures and grazing cattle give life to the panorama, while the soothing light of the evening sun lends a serene atmosphere. A master of ideal landscapes, Lorrain promoted harmonious unity of mankind and nature.

Village Festival, 1639

Oil on canvas, 103 x 135 cm
Musée du Louvre, Paris

Even as a young artist Lorrain had developed the basic compositional principles that are evident throughout his work. Within the shadowed foreground, figures—often painted by another artist—are active; surrounding them is a landscape view of cosmic breadth. In his ideal landscapes Lorrain achieved an atmospheric unity and illusion of reality previously unknown in painting.

The Disembarkation of Cleopatra at Tarsus, c. 1642

Oil on canvas, 117 x 148 cm
Musée du Louvre, Paris

In the 1640s Lorrain devoted himself increasingly to historical, mythological, and biblical themes which he used simply as an excuse for grand compositions. In his harbor scenes, the view opens broadly onto a deep horizon. Neither the classical style buildings nor the figures at work or in conversation with each other appear to be realistic.

Opposite right
Landscape with Apollo and Mercury, c. 1645

Oil on canvas, 55 x 45 cm
Galleria Doria Pamphilj, Rome

This painting tells the mythological saga of the divine theft of Admetor's cattle. Enchanted by his music, Apollo does not notice the treacherous Mercury leading the animals away. Apollo's ecstatic mood is expressively reflected in the light-flooded landscape. Seldom has the Baroque theory that painters are silent poets been so perfectly illustrated as in this lyrical work.

**Landscape with Tobias
and the Angel (La Sera), 1663**
*Oil on canvas, 116 x 153.5 cm
The Hermitage, St. Petersburg*
This painting bears a title referring
to a biblical story that is now little-
known but was quite popular at the
time: the story of the archangel
Raphel and the pious Tobias. Tobias
is advised by his unknown travelling
companion, Raphel, to retain parts
of a fish, which later allow Tobias
to heal and marry the demon-
plagued Sara and cure his father of
blindness. Only then does the angel
reveal his true identity. These mira-
culous events are suggested by the
captured fish in the painting. The
biblical motif, however, actually
serves Lorrain only as an excuse
to paint the natural phenomenon
of the sunset. Everything is satur-
ated with the golden light that the
drama of nature has produced in
immense fullness. As often seen in
Lorrain's work, monumental trees
provide a dignified front for the
contemplative scenery. The strange
cloud formation in the sky strength-
ens this mood.

Landscape with the Nymph Egeria, 1669
Oil on canvas, 155 x 199 cm
Museo Nazionale di
Capodimonte, Naples
The event depicted in the painting is based on an episode from the *Metamorphoses* (15, 486–492) by the Roman poet Ovid (34 B.C.–18 A.D.). Egeria is mourning her dead husband, the mythical Roman king Numa, in the forest of Lake Nemi. The nymphs of the goddess Diana, whose temple appears to the right, have rushed to comfort her. The unity produced by the gloomy coloration and the dim light provides the sorrowful, mournful tone of the picture, again resulting largely from the mighty trees.

Lotto, Lorenzo

Lorenzo Lotto (c. 1480 Venice–1556 Loreto), who is first mentioned in historical documents in 1503, is an important intermediary between the old Venetian masters and the later Baroque art of northern Italy. His many journeys took him to Trevino, Recanati, Bergamo, Venice, and Ancona. Lotto was one of the most sensitive and self-willed artists of his time period. At first he drew inspiration from the paintings of Giovanni Bellini and Antonello da Messina, and later from works by Giorgione, Titian, and Raphael. In the course of his career he developed his own understanding of the precise depiction of cloth and the way figures move, an unusual coloration, and an exaggerated drama and expressiveness. His works include *Portrait of a Youth before a White Cloth*, c. 1506, Kunsthistorisches Museum, Vienna; *Polyptych with Saint Dominic*, c. 1507, Pinakoteca Comunale, Recanati; and *The Sculptor Andrea Odone*, c. 1527, Hampton Court Palace, London.

Portrait of Bernardo de'Rossi, Bishop of Trevino, 1505
Oil on panel, 54.7 x 41.3 cm
Museo Nazionale di
Capodimonte, Naples
This early work, painted in Recanati, indicates that Lotto was already an outstanding portraitist. His expertise shows in the finely detailed painting technique, as well as his ability to sympathize with his subject, seen in the depth of the facial expression. He attempts a larger statement through the use of symbols or objects from the subject's realm, in this case a scroll at the bottom edge of the picture.

Marsilio and his Wife, 1523
Oil on canvas, 71 x 84 cm
Museo del Prado, Madrid
Lotto painted this wedding picture, a penetrating depiction of marital love, during his Bergamo period between 1517 and 1525. While the groom places the wedding ring on the finger of his bride, Amor, the god of love, appears behind and between them to lay on the yoke of matrimony. The sentimentality achieved by the picture corresponds to the emotional intensity of contemporary religious paintings. In spite of the playful accessories, the seriousness of the responsibility being accepted by the couple remains palpable.

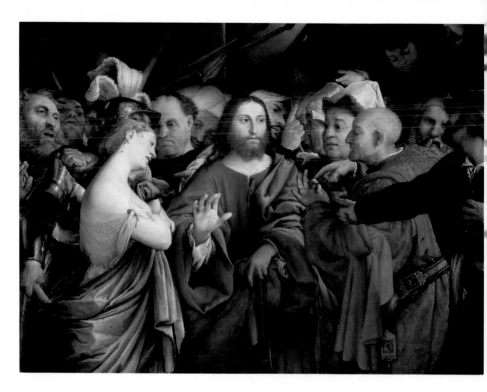

Christ and the Woman Taken in Adultery, c. 1528
Oil on canvas, 124 x 156 cm
Musée du Louvre, Paris
In this scene from the Book of John (8:3–11), the priests lead an adulteress to Christ and demand to know whether she should be stoned according to law. Jesus replies: "Let he among you who is without sin cast the first stone." The drama of the moment is heightened by the strongly contrasting images of Christ and the accusers, and also through the juxtaposition of the woman's white body and the gleaming armor of the soldiers.

Opposite
The Annunciation, c. 1534
Oil on canvas, 166 x 114 cm
Pinacoteca Comunale, Recanati
In this famous work Lotto provides his own version of a traditional motif. The defensiveness and fear of the Virgin before the heavenly apparition is conveyed by the manic cat, who has taken flight, and permeates the entire composition. The contrast between the clear, peaceful arrangement of objects and the powerfully affected figures heightens the shattering effect—like a thunderclap—of the angel's announcement.

Leonardo da Vinci — a Universal Genius

Leonardo da Vinci (1452–1519) was the illegitimate son of Ser Piero di Antonio, a notary, and Catarina, a peasant woman, both from the small town of Vinci near Empoli. Without his father's intervention Leonardo would have become a notary like his ancestors. However, Ser Piero recognized his son's remarkable talents and saw to it that he was trained as a painter, in spite of the fact that art was little regarded as a profession in those days. Leonardo became an apprentice in the workshop of the important Florentine painter Andrea del Verrocchio in 1469. He lived and worked in Verrocchio's house along with Botticelli, Perugino, Lorenzo di Credi and others. The contact with Leonardo had a strong effect on Verrocchio. Vasari relates how Leonardo painted one of the angels in a Baptism of Christ by his master in such a masterly fashion that this angel turned out far more beautiful than Verrocchio's own figures. According to Vasari, Verrocchio was made so angry by the fact that a mere boy was able to surpass him in skill that he never wanted to touch a brush again. Although later paintings by Verrocchio exist or are documented, after 1472 he executed mostly bronze casts or sculptures.

For those familiar with Leonardo's brilliant achievements during the course of his life, his master's embarrassed reaction is easy to understand. While still in the workshop in Florence, known to be a meeting place for intellectuals and scientists, the young Leonardo came into contact with many areas of knowledge besides art. He developed into a remarkable master of many disciplines, becoming an artist, inventor and researcher rolled into one.

Leonardo was the epitome of the Renaissance ideal of the *uomo universale*. His enormous versatility and extraordinary self-confidence are clearly and impressively documented in a letter of application he sent to the tyrannical Duke Ludovico Sforza (1452–1508) of Milan. In it, Leonardo attempts to draw attention to himself chiefly through his military knowledge, inventions and plans. At a time when the city states of Italy were perpetually in conflict with one another, the art of war was of crucial importance, if not essential, to the ruling families and the pope in Rome. In his letter Leonardo describes in great detail various types of military equipment, such as transportable bridges, battering rams, assault ladders, mines, explosives, cannons and guns, sea weapons, attack tunnels, armored attack vehicles, centrifugal accelerators, catapults, and yet more.

Leonardo da Vinci: Letter to Ludovico Sforza
Pen and ink on paper
Codex Atlanticus, fol. 391 a
Biblioteca Ambrosiana, Milan
Although this famous letter of application to the Duke of Milan is not written in Leonardo's own handwriting, its authenticity is not in doubt. In it, the "universal artist" presents himself chiefly as a military engineer and architect, describing various military instruments he has invented.

Havendo S.re mio ill.mo visto et considerato hormai ad sufficientia le prove di tutti quelli che
se reputano maestri et compositori de instrumenti bellici: et che le inventione et operatione di dicti
instrumenti non sono niente aliene dal comune uso: mi exforzaro, non derogando a nessuno alt.o
farmi intendere da v. ex.a: aprendo a quella li secreti mei: et apresso offerendoli ad ogni suo piacimento
i tempi opportuni operare con effecto circa tutte quelle cose che sub brevita saranno qui disotto
notate. Et anchora in molte piu secondo le occurrentie de diversi casi etc.

Ho modi de ponti leggerissimi et forti et acti ad portare facilissimamente: Et cum quelli seguire
et alcuna volta fuggir li inimici: et altri securi et offensibili da foco
et battaglia: facili et comodi da levare et ponere. Et modi de ardere et disfare quelli de l'inimico etc.

So in la obsidione de una terra togliere via l'aqua de fossi: et fare infiniti ponti ghatti et scale
et altri instrumenti pertinenti ad dicta expeditione etc.

Item se per altezza de argine op per fortezza de loco et de sito non si potesse in la obsidione de
una terra usare l'officio de le bombarde: ho modi di ruinare omni forte o altra fortezza
se gia non fusse fondata in su el saxo etc.

Ho anchora modi de bombarde comodissime et facile ad portare: Et cum quelle buttare minuti saxi
ad similitudine quasi di tempesta: Et cum el fumo di quella dando grande spavento al inimico
cum grave suo danno et confusione etc.

Et quando accadesse essere in mare ho modi de molti instrumenti actissimi da offende et defende:
et navili che faranno resistentia al trarre de omni grossissima bombarda: et polvere et fumi

Item ho modi per cave et vie secrete et distorte facte senza alcuno strepito pervenire ad uno
loco designato benchè bisognasse passare sotto fosse o alcuno fiume

Item faro carri coperti securi et inoffensibili quali intrando intra li inimici cum sue artiglierie non è si
grande moltitudine de gente di arme che non rompesseno: Et dietro a questi poteranno seguire fanterie assai illesi et
senza alcuno impedimento

Item occorrendo di bisogno faro bombarde mortari et passavolanti di bellissime et utile forme fora del comune uso

Dove mancasse la operatione de le bombarde componero briccole mangani trabuchi et altri instrumenti di mirabile
efficacia et fora del usato: Et insomma secondo la varieta de casi componero varie et infinite cose da offende et

In tempo di pace credo satisfare benissimo ad paragone de ogni altro in architectura in compositione di edificii et

conducere acqua de uno loco ad uno altro etc.

Item conduro in sculptura di marmore di bronzo et di terra: similiter in pictura cio che si possa fare
ad paragone de omni altro et sia chi vole.

Anchora si potra dare opera al cavallo di bronzo che sara gloria immortale et eterno honore de la
felice memoria del Signor vostro patre et de la inclyta casa Sforzesca

Et se alcuna de le sopradicte cose a alcuno paressino impossibile et infactibile: me offero
paratissimo ad farne experimento in el parco vostro o in qual loco piacera a vostra ex.a alla
quale humilmente quanto piu posso me recommando etc.

After he had elaborated his military technical skills in nine out of ten points, Leonardo finally mentions at the end of his letter, almost as an afterthought, that he is also a painter and sculptor. "In peacetime, I can well compare myself with any in the field of architecture, whether it be the construction and design of public or private buildings or the laying of water lines from one place to another. In addition, in the working of marble, metal, or clay, as well as in painting, I can also offer something that is fit to be seen in comparison with

Leonardo da Vinci: War Wagon, c. 1481
Silverpoint, quill, and ink on paper, 21 x 29.2 cm
Biblioteca Reale, folio 14 r (No. 15583), Turin
Leonardo drew from illustrations in ancient treatises for his models of the construction of sickle wagons. Because the technical solutions and dynamic and narrative design of this extravagantly executed drawing are so thoroughly convincing, one may well suspect that the sheet originally beonged to Leonardo's letter of application to Ludovico Sforza.

the work of any other, whoever he may be. Moreover, it would also be possible for me to work on the bronze horse that will enrich the memory of your lord father to immortal fame and propel the house of Sforza to eternal honor. And if any of the items mentioned above seems impossible or unachievable to anyone, I am entirely prepared for a presentation in Your park, or wherever Your Highness wishes."

One year later, in 1482, Leonardo did indeed enter the service of Ludovico Sforza, who had the reputation of being a generous patron of artists and scholars, and remained at his court in Milan until 1499. There Leonardo undertook a great number of artistic, military, and architectural tasks. In the fruitful intellectual climate of Milan, Leonardo advanced to become a scholar who had broadened his knowledge through the study of books and classical tracts, and he himself wrote a treatise on aethetic theory. Close observation of nature, the growth of plants and involvement with the question about the creation of the earth captured his curiosity, as did the intensive study of human anatomy. Leonardo's tremendous drive for knowledge did not pale before the reality of autopsying corpses, in spite of the strict prohibition of the Church against such activities. Finally, his comprehensive scholarly knowledge also flowed into his paintings, as is impressively evident in the famous *Madonna of the Rocks* in the Musée du Louvre, Paris and his monumental *Last Supper* in the refectory of the monastery of Santa Maria delle Grazie, both of which date from the period Leonardo spent in Milan.

Leonardo da Vinci:
Crossbow, c. 1485
Pen and ink on chalked paper,
20.5 x 27.5 cm
Codex Atlanticus, fol. 149 r-b
(ex 53 v-b)
Biblioteca Ambrosiana, Milan
This huge crossbow is only one of the numerous weapons designed by the artist. There are two additional designs for it in the *Codex Atlanticus* (fol. 52 v-a, 52 v-b), a collection of drawings and notes compiled from every period of Leonardo's artistic activity. The writing tells us that the bowstring is 42 cubits long, and that using this weapon, a man could hurl stones weighing about 100 pounds at his chosen target.

→ *Mabuse, see Gossaert, Jan*

Magnasco, Alessandro

Alessandro Magnasco (1667 Genoa–1749 Genoa) began his studies as a pupil of his father, the painter Stefano Magnasco, and also studied with Valerio Castello. After his father's death he continued his training with Filippo Abbiati in Milan, and beginning in 1703, Magnasco worked in Florence in the service of the Grand Duke Ferdinando de' Medici (1663–1713). In 1709 he worked in Milan for the influential Borromeo and Visconti families, among others, before returning to Genoa in 1735.

Magnasco specialized in landscapes and *capriccio*-like religious genre paintings in which he depicted scenes from the lives of monks, beggars, and vagabonds with imaginative, humorous and critical allusions. The artist's works include *The Interrogation in the Prison*, c. 1705, Kunsthistorisches Museum, Vienna; *The Theft in a Church*, 1731, Palace of the Archbishop, Milan; and *Franciscan Monk Dining in a Refectory*, c. 1735, Museo Civico, Bassano de Grappa.

Opposite
The Golden Raven, c. 1705
Oil on canvas, 47 x 61 cm
Galleria degli Uffizi, Florence
This painting shows a family of vagabonds who have taken up housekeeping beneath a dilapidated archway. The figures have turned their attention to the raven in the center of the picture, whom one of the men is teaching to speak. In the arrangement of the composition and the restless, quickly applied brushstrokes, this grotesque yet interesting scene is typical of Magnasco's work.

Monks at Prayer
Oil on canvas, 53.6 x 43.9 cm
Musée des Beaux-Arts, Ghent
This sketch-like scene, a copy of the painter's *Praying Monks* now in the Rijksmuseum in Amsterdam, is characterized by a high degree of drama and expressiveness not only in the emphatically praying monks, but also in the barren, rocky landscape and the dark clouds lowering in the sky. There are no known paintings by artists contemporary to Magnasco that resemble this picture.

Mantegna, Andrea

Andrea Mantegna (1431 Isola di Cartura, near Padua–1506 Mantua) is one of the most influential artists of the early Renaissance. In 1441 he entered an apprenticeship with Francesco Squaricione, who introduced him to the art of classical antiquity. The sculptures of Donatello (1386–1466), as well as the paintings of Andrea del Castagno and Jacopo Bellini, had a decisive impact on Mantegna. Becoming independent in 1448, he soon became a well-known painter and was called to the Gonzaga court in Mantua in 1460. Mantegna's work is distinguished by the anatomical correctness of the figures, the precise draftsmanship of details, and the virtuosity of his perspective. These innovations in particular influenced his brothers-in-law, Gentile and Giovanni Bellini, and were carried north of the Alps through his highly publicized copper engravings. Some of his works are *The Jacob Cycle*, c. 1457, Cappella Ovetari, Padua; *Christ on Mt. Olive*, c. 1460, The National Gallery, London; and *The Triumph of Julius Caesar*, 1480, Hampton Court Palace, London.

St. Sebastian, 1459
Tempera on canvas, 275 x 142 cm
Musée du Louvre, Paris
This painting clearly reflects Mantegna's humanistic education and his admiration for antiquity, as can be seen in the detailed rendition of the ruins and the muscular anatomy of the saint. Death and mercilessness are expressed not only by the horrific martyrdom of the saint, but also by the antique foot lying next to his bound ankles and the architectural fragments that act as reminders of the inheritance of the ancient world.

Opposite
The Dead Christ, c. 1480–1490
Tempera on canvas, 66 x 81 cm
Pinacoteca di Brera, Milan
This unique and famous work was presumably intended for Mantegna's own tomb in the Chapel of San Andrea in Mantua. No artist before him had ever foreshortened a form so strongly. The presentation of the death of Christ is also new: In the clarity of the wounds, the helpless body with its head tilted to the side, and the color of lividity, this death seems to be a final one.

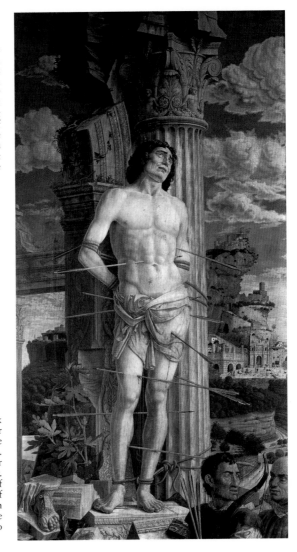

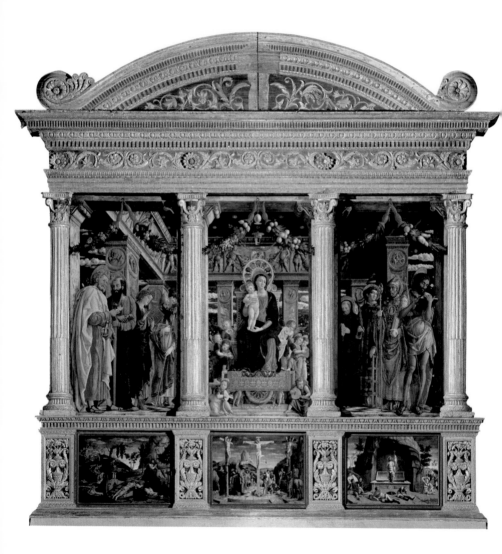

Opposite
San Zeno Altarpiece, c. 1458
Tempera on panel, 480 x 450 cm
San Zeno, Verona
The full reconstruction of this altarpiece demonstrates how Mantegna revised the traditional handling of this compositional form. He maintained the tripartite division of the main panel, but connected the images of the individual panels with each other and reduced the architectural framework to a minimum, thus creating the illusion of a unified space in which the monumental groups of figures are symmetrically arranged.

The Crucifixion, c. 1458
Tempera on panel, 67 x 93 cm
Musée du Louvre, Paris
This work once formed the center predella panel of the San Zeno Altarpiece and was flanked by pictures of Christ on Mt. Olive and the Resurrection, both of which are today in Musée des Beaux-Arts, Tours. Mantegna's typical style is also evident here in the imposing and plastic monumentality of the figures, and in their incorporation into an architectonic perspective that was highly typical of the time.

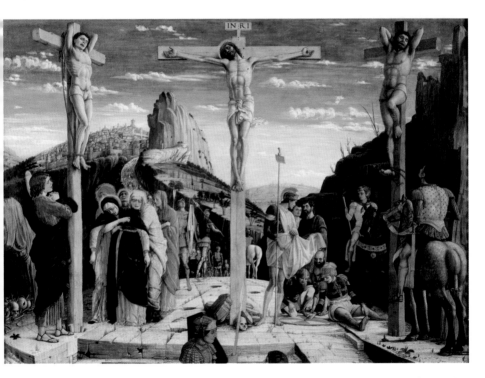

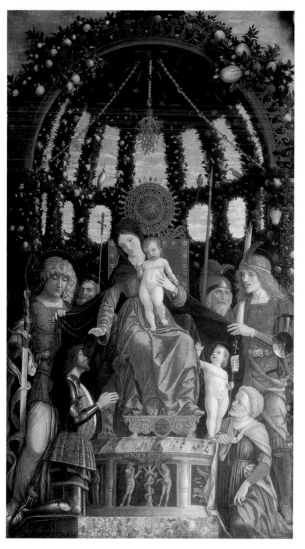

Portrait of a Cardinal
(The Protonary Carlo de'Medici),
1459–1466
Tempera on panel, 41.3 x 29.5 cm
Galleria degli Uffizi, Florence
This is one of Mantegna's most beautiful portraits. The finely executed composition yields a distinct likeness of the subject in the three-quarters profile view typical of northern European art. The figure is generally identified as Carlo de'Medici (c. 1429–1492).

The Madonna of Victory, 1496
Tempera on canvas, 280 x 165 cm
Musée du Louvre, Paris
Francesco II Gonzaga (1466–1519), visible in the left foreground, commissioned Mantegna to paint this work in memory of the battle of Fornovo di Taro in 1495. This significant altarpiece is outstanding in the *trompe-l'oeil* effect of the pergola, the heroic style of the figures, and its warm coloration.

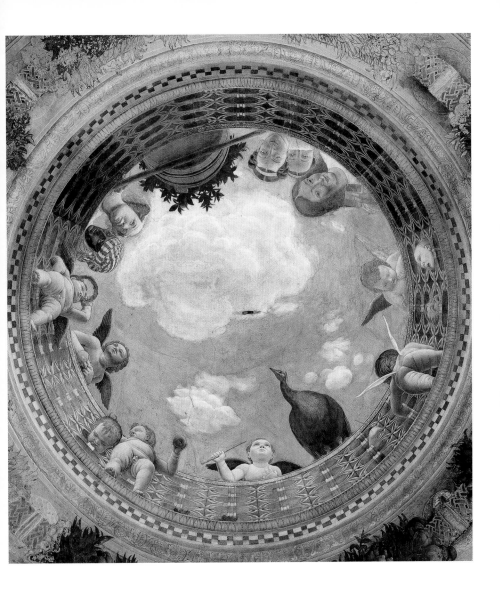

Right
**The Family and Court
of Ludovico III Gonzaga
(detail), c. 1474**
*Fresco, 600 x 807 cm
Castello San Giorgio,
Palazzo Ducale, Mantua*
The frescoes of the *Camera degli
Sposi,* the bedroom of Ludovico III
Gonzaga (1414–1478), are the most
famous example of secular painting
from the Italian Renaissance. In
their broadly laid-out scenes the
artist applies his well-developed
sense of perspective and close ob-
servation of nature to depict the rich
and varied courtly life of the
Margrave, who is portrayed in this
scene in the circle of his family and
closest confidants.

Previous page
**Ceiling Fresco in the Camera degli
Sposi (detail), 1465–1474**
*Fresco, diam. 270 cm
Castello San Giorgio,
Palazzo Ducale, Mantua*
On the vaulted ceiling of this small,
square room, Mantegna created the
illusion of a painted space with an
open view upward into the heavens
for the first time in the history of
western art. The opening is cir-
cumscribed by a railing over which
angels, human figures, and animals
lean and gaze downward. This bold
composition effectively uses fore-
shortening to place the viewer in a
position far below the painting—a
perspective that was borrowed by
later painters, especially during the
Baroque period.

Parnassus, 1497
Tempera on canvas, 60 x 192 cm
Musée du Louvre, Paris

This presentation of the "Mount of the Muses" is the first of a series of paintings created for the *studiolo* (study) of Isabella d'Este (1474–1539), the Countess of Mantua. In the middle, the nine goddesses of the arts are dancing to the music of Apollo; the figure of Vulcan appears over them as the victim of Eros' mockery. On the right, Pegasus and Mercury stand close together. Unusual for this traditional painting motif is the representation of Mars and Venus: The hill on which they are standing has been hollowed out by a tunnel, which allows an unobstructed view into the distance. A castle-like building is also seen rising on the right. The distinct parts of the landscape are depicted in realistic detail, then fancifully reassembled.

**The Triumph of Virtue
over the Vices, 1502**
Tempera on canvas,
160 x 192 cm
Musée du Louvre, Paris
Among the humanistically-inspired
decorations of Isabella d'Este's
studiolo is found this morally
didactic allegory that depicts the
story of how Minerva (the Roman
goddess of war and intelligence,
equipped with spear, shield, and
helmet) drove the Vices from the
Garden of Virtue. This picture,
along with Mantegna's *Parnassus*,
exerted a great influence on the
development of secular art in the
16th century. The garden is enclosed
by a florally decorated arched wall
that allows a view of the sur-
rounding landscape. Other deities
observe the dramatic action in the
Garden of Virtue from their per-
spective in a cloud.

Maratta, Carlo

Carlo Maratta (1625 Camerano–1713 Rome) arrived in Rome at the age of 11 and lived there for the rest of his life. In 1637 he was apprenticed to Andrea Sacchi and worked with him, according to Maratta's friend, the art theoretician Giovanni Pietro Bellori (1613–1696), for the next 19 years. Maratta worked in the tradition of the Carracci, and is an important exponent of the neoclassical tendency within the Roman painting tradition. A highly respected painter, Maratta completed not only portraits and panel paintings with religious and mythological subject matter, but also numerous large altarpieces for Roman churches. His productive workshop provided training for many younger artists, as well. Secular painting in Rome in the first half of the 18th century was decisively stimulated by Maratta's own works and those of his school. Works by the artist include *The Death of St. Francis Xavier*, c. 1676, Il Gesù, Rome; *Apollo and Daphne*, 1681, Musées Royaux des Beaux-Arts, Brussels; The Vision of St. Charles, 1690, San Carlo al Corso, Rome.

Pope Clement IX, 1669
Oil on canvas, 145 x 117 cm
Musei Vaticani, Vatican
Maratta reveals himself to be an outstanding portrait artist with this portrait of Pope Clement IX, who held office from 1667 to 1669. The pope, depicted sitting in a three-quarters pose in a chair, has interrupted his reading of a book to direct his thoughtful gaze toward the viewer. In this masterpiece, Maratta follows upon the Italian tradition initiated by Raphael.

**The Immaculate
Conception, 1686**
*Oil on canvas, 300 x 240 cm
S. Maria del Popolo, Rome*
The rich movement of the garments
and the gestures of the figures, as
well as the upward movement of the
composition as a whole, are charac-
teristics of Roman Baroque paint-
ing. The Virgin appears in the
heavens surrounded by angels,
while in the bottom half of the
painting three Doctors of the
Church discuss the theme of the
picture with the young St. John the
Evangelist, who is identified by the
eagle behind him and to the right.

Martini, Simone

Simone Martini (c. 1284 Siena–1344 Avignon) is one of the most important of the Gothic master painters of Siena, and had won much respect as a painter by 1315. He was active in both his native city and in Naples for King Robert d'Anjou (c. 1275–1343). By 1339 he had gone to the papal court in Avignon, where he became a friend of the Italian scholar and poet Francesco Petrarch (1304–1374). Martini's multifaceted creativity drew inspiration from Duccio, Giotto, and the sculptor Giovanni Pisano (c. 1250–after 1314), as well as from the new directions in French art; and he united these influences with the Sienese tradition. His work is marked by its elegance, sensitivity and tender lyricism. Along with the paintings of Giotto, Martini's work constitutes the most important oeuvre of the 14th century, and his influence extended far beyond Italy. Other works by the artist include *St. Louis of Toulouse Crowning Robert d'Anjou*, 1317, Museo Nazionale di Capodimonte, Naples; *The Dedication of St. Martin as a Knight*, c. 1324?, Basilica Inferiore de San Francesco, Assisi; and *Deposition from the Cross*, after 1333?, Koninklijk Museum voor Schone Kunsten, Antwerp.

Maestà (Virgin and Child with Angels and Saints), 1315
Fresco, 763 x 970 cm
Palazzo Pubblico, Siena
This large wall painting in the *Sala del Mappamondo* (map room) is Martini's earliest known work. Just seven years later the artist had to do restoration work on it because of moisture damage. Although the fresco reveals traces of Byzantine models, Gothic influence predominates in the looser construction and lively grouping of the saints, as well as in the unified size of the figures.

The Annunciation, 1333
Tempera on wood, 184 x 210 cm
Galleria degli Uffizi, Florence
This altar painting created by Martini for the San Ansano Chapel of the Siena Cathedral offers a pure example of the highly developed focus on line in the *Trecento*. Surrounded by the brilliance of the golden decoration, the figures are presented in a non-realistic space. A powerful dynamic is evoked between the gesture of the Angel of the Annunciation and the Virgin's emotional response.

Guidoriccio di Fogliano, c. 1328
Fresco, 340 x 968 cm
Palazzo Pubblico, Siena
This painting, which is also found in the *Sala del Mappamondo* (map room) in Siena, is among the most idiosyncratic of early Renaissance equestrian and ruler portraits. It stands in polar opposition to Martini's already-completed *Maestà* on the opposite wall. The fresco constitutes a memorial to the victory of the Sienese field commander against the rebellious cities of Montemassi and Sassoforte. The rider, mounted upon a war horse that is also wearing richly decorated armor with the ducal armorial bearings, appears to be proud and self-assured. The arms are repeated, along with Siena's city banner, in the fortified camp on the hill as well as in the middle of the painting on the city walls of Montemassi. On the hill at the left stands the fortress of Sassoforte. Martini's painting represents the first historical attempt at the poetic glorification of a contemporary event. The rider clearly stands out in the valley against the dark heavens. The barren panorama of the landscape contains no representation of actual battle scenes; only the fortified camps refer to the events. Only when this work is compared with the ornate *Maestà* on the wall opposite it is the relationship between man and nature fully evident.

Masaccio

Masaccio (1401 San Giovanni Valdarno, Arezzo–1428 Rome), born Tommaso di Ser Giovanni Cassai, is one of the most revolutionary painters of his era and is granted the title of the founder of Renaissance painting. In 1422 he became a member of the Florentine guild of doctors and apothecaries, and two years later he entered the painters' Guild of St. Luke. During this period he worked closely with Masolino, but at the end of 1427 Masaccio went on to Rome, where he died shortly thereafter. The painter was greatly inspired by the sculptor Donatello (1386–1466) and his friend, the master builder Filippo Brunellesci (1376–1446). Masaccio was the first to succeed in uniting emphatically-sculpted figures with a perspectively-constructed space. He also portrayed both architecture and landscape realistically, although in fact they exist only to serve and emphasize the events presented in the pictures. Also characteristic of Masaccio's works is a simple lighting and strict observance of central perspective. Several paintings remained unfinished at his death. The artist's works include *Triptych San Giovenale*, 1422, Pieve di San Pietro, Cascia de Reggello; *Adoration of the Magi*, 1426, Gemäldegalerie, SMPK, Berlin; and *Enthroned Madonna*, 1426/27, The National Gallery, London.

Crucifixion, 1425/26
Tempera on panel, 83 x 63 cm
Museo Nazionale di Capodimonte, Naples
This altarpiece was the crowning panel of the *Pisa Polyptych* for S. Maria del Carmine, which is today divided among several museums. The shapes of the figures are unusually expressive: Christ's head, bent down between his raised shoulders, as well as his body, which has collapsed into itself, make clear the exhaustion caused by the torture he has undergone. Equally expressive is the back view of a desperate Mary Magdalene.

Opposite left
Trinity, c. 1426
Fresco, 667 x 317 cm
S. Maria Novella, Florence
Central to this painting is the motif of the Throne of Grace: God the Father, Christ, and the Holy Spirit are flanked by the Virgin and St. John as well as by the kneeling patrons of the painting, the Gonfaloniere Lenzi and his wife. The significance of the painting is revealed in the inscription on the sockel over the sarcophagus containing a skeleton: "I was what you are; you will be what I now am." Here for the first time, space has been constructed in central perspective that suggests a deep alcove with a coffered wooden ceiling.

The Expulsion from the Garden, c. 1425
Fresco, 208 x 88 cm
Cappella Brancacci,
S. Maria del Carmine, Florence

This wall painting in the Brancacci Chapel presents a typical example of Masaccio's art. It achieves its effect particularly through the precise anatomical representation of the figures, the coloration and the play of light and shadow. Only rarely does one find in Renaissance painting such a simple portrayal of the theme combined with such heavy emotional impact.

Tribute Money, c. 1427/28
Fresco, 255 x 598 cm
Cappella Brancacci,
S. Maria del Carmine, Florence
This wall painting portrays three
episodes in the life of Christ. Christ,
standing among his disciples and
with a tax collector, commands
Peter to catch a fish; a penny is
found lodged in its mouth. At the
right of the picture, the penny is
being transferred to the tax collec-
tor. A warm liveliness emanates
from the monumental, artfully
arranged figures, and the forms of
both the landscape and the architec-
ture are integrated into the events.

Opposite below
**The Raising of the Son of
Theophilus and Peter
in the Cathedral, c. 1425**
Fresco, 230 x 598 cm
Cappella Brancacci,
S. Maria del Carmine, Florence
This fresco in the Brancacci Chapel
depicting the life of St. Peter can be
seen as the cradle of Italian Renais-
sance painting. Their perspective
construction, in particular, marks
the start of a new conception of art.
Masaccio worked on these paintings
with Masolino for a short time in
1425, but when Masaccio left the
city three years later the work was
still unfinished; almost 60 years
passed before the work was finally
completed by Filippo Lippi. The
detail at the right illustrates the
alteration in Masaccio's conception
of figures. The clarity of the spatial
relations is emphasized by the
realistic presentation of the prota-
gonists and their robes.

Masolino da Panicale

Masolino da Panicale (1383 Panicale di Valdarno–1440 Florence), born Tommaso di Cristofano Fini, is documented as being an assistant to the sculptor Lorenzo Ghiberti in Florence between 1403–1407. It was in Florence in 1423 that Masolino entered the guild of the *Medici e Speziali*, the guild to which painters also belonged. A year later he painted the frescoes in San Stefano in Empoli, and also began working with Masaccio. In 1425 the two artists began painting the Brancacci Chapel of the Carmelites in Florence, but Masolino interrupted the work for two years (1425–1427) in answer to a call to serve as court painter in Budapest. Upon his return to Italy he continued his work in the Brancacci Chapel and travelled to Rome with Masaccio in 1428 to execute the wall paintings in San Clemente for Cardinal Branda Castiglione. The final works of Masolino, who numbers among the most important Florentine painters of the early Renaissance, are the frescoes in Castiglione d'Olona near Milan. His works include *Pietà*, 1424, Museo della Collegiata, Empoli; *Virgin and Child with St. Anne*, 1425, Galleria degli Uffizi, Florence; and *Virgin and Child*, c. 1435, Alte Pinakothek, Munich.

The Raising of Tabitha and the Healing of a Cripple, c. 1427/28
Fresco, 255 x 598 cm
Cappella Brancacci,
Santa Maria del Carmine, Florence
This fresco is organized in strips that, along with the Fall from Grace, decorate the central wall area of the Brancacci Chapel. It depicts two episodes from the life of St. Peter (Acts of the Apostles 3:1–8 and 9:36–41). Although the architecture and the sculpture-like forms of some of the figures can be traced back to the influence of Masolino's collaborator Masaccio, the two elegant, delicate youths in the middle of the picture are entirely typical of Masolino's style.

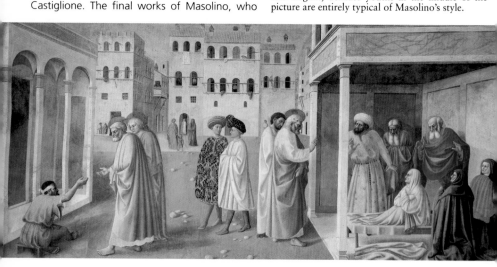

The Fall from Grace, c. 1427
Fresco, 208 x 88 cm
Cappella Brancacci,
Santa Maria del Carmine, Florence
This fresco is one of a cycle based on scenes from the life of St. Peter that the silk merchant Felice Brancacci commissioned Masolino and Masaccio to paint. The Fall from Grace is in the middle of the area of the wall that Masolino worked on immediately before and after his service at the court in Hungary. The influence of Gentile da Fabriano is evident in the soft lighting and the delicate gestures of Adam and Eve.

Herod's Feast, 1435
Fresco, 462 x 375 cm
Battistero, Castiglione d'Olona (near Milan)
Herod's Feast, painted on commission for Cardinal Branda Castiglione, is part of a cycle based on the life of St. John the Baptist that completely covers the walls of the small baptistery. The famous fresco represents the high point of Masolino's fairy-tale-like narrative style, evident in the artist's careful depiction of Renaissance architecture, the contemporary clothing, and the fantastic and unrealistic imaginary mountain landscape of the background.

Massys, Quentin

Quentin Massys (c. 1465 Louvain–1530 Antwerp) probably received his initial training in his native city in Belgium, but later moved to Antwerp, where he was accepted into the Guild of St. Luke as an independent master in 1491. He is known as the founder of the Antwerp School of painting. A contemporary of Albrecht Dürer, Erasmus of Rotterdam (c. 1468–1536), Hans Holbein the Elder, Martin Luther (1483–1546) and Thomas More (1478–1535), Massys was the first Netherlandish painter to portray human figures as freely-acting individuals without reference to traditional Christian iconography. He clearly aligned himself initially with traditional Old Netherlandish models such as Hans Memling, Hugo van der Goes and Dierick Bouts, but his later work bears the imprint of Italian Renaissance painting, especially the work of Leonardo da Vinci. Works by the artist include *The St. John Altarpiece*, 1508–1511, Koninklijk Museum voor Schone Kunsten, Antwerp; *Cosimo de'Medici*, 1513, Musée Jacquemart-André, Paris; and *Virgin and Child*, c. 1524, Gemäldegalerie, SMPK, Berlin.

The Money-Lender and his Wife, 1514
Oil on panel, 70 x 67 cm
Musée du Louvre, Paris
More than 100 years after its creation, this painting appeared in a second version, reproduced as a "picture within a picture" in Willem van Haecht's *The Workshop of Apelles*. Massys' painting leaves open the question of whether the work is meant to be understood as a genre scene, a double portrait, or a religious allegory. In defense of the latter interpretation, Proverbs (16:11) speaks of the righteous scales and the good weight, and Nicolas of Cusa compares God to a banker whose viceroys (priests) act as moneychangers.

**The Kinship of St. Anne
(central panel), c. 1508**
*Oil on panel, 224.5 x 219 cm
Musées Royaux
des Beaux-Arts, Brussels*
The masterfully painted *Kinship of
St. Anne*, also called the *Altarpiece*

of the Holy Kindred, is the first
dated work created by Massys' own
hand, executed for the Chapel of the
Brothers of St. Anne in the Peter's
Church in Louvain. While the side
panels present four scenes from the
life of St. Anne, mother of the

Virgin Mary, the large central panel
portrays the Holy Family. St. Anne
sits to the right of the Virgin holding
a bunch of grapes ready for the
Christ Child, on Mary's lap. The
fruit is to be understood as a symbol
of the Eucharist.

Salvator Mundi, c. 1510
Oil on panel, 38 x 28.5 cm
Koninklijk Museum voor
Schone Kunsten, Antwerp
Christ is portrayed as the Savior of
the World in this almost life-sized
bust portrait: His right hand is
raised in a gesture of blessing, and
in his left is a cross. This picture
forms the right panel of a diptych;
the opposite panel is a depiction of
the Virgin, whose hands, in con-
trast, are folded together in prayer.
In his conception of the diptych
Massys drew from the positioning
of Jan van Eyck's figures in his fa-
mous Ghent Altarpiece.

Erasmus of Rotterdam, c. 1517
Oil on panel, transferred to
canvas, 59 x 46.5 cm
Galleria Nazionale
d'Arte Antica, Rome
Massys painted this portrait and a
matching picture of Pieter Gillis as
a "friendship diptych" for Thomas
More, the English scholar and gov-
ernment official. This valuable por-
trait of Erasmus has generally been
accepted as an original from the
master's hand; however, the books
in the painting are blank although
original sources reporting on this
painting specifically refer to inscrip-
tions. Research has determined that
this is a copy made by Massys him-
self of a lost original. In its masterly
composition, the arrangement of the
books acts as a still life illustrating
the education of the theologian.

→ *Master of Flémalle, see Campin, Robert*

Master of the Darmstadt Passion

The identity of the "Master of the Darmstadt Passion" (active c. 1425–1460 in upper Swabia and the central Rhineland) remains unknown; the painter's name is derived from two panels of a large altarpiece containing scenes from the Passion of Christ that are now located in the Landesmuseum of Hessen in Darmstadt. In the mid-15th century, the anonymous master numbered among the most important painters of upper Swabia and the central reaches of the Rhine. His or her paintings stand out for their sensitive lighting and richly nuanced, tender coloration. Although this great colorist executed pictures with great delicacy and a clear sense of detailed realism, problems of psychology and physiognomy seems to have been of little concern; the simply rendered figures appear on the whole to be oddly removed from reality. Other works attributed to the artist include *The Carrying of the Cross* and *The Crucifixion of Christ*, c. 1435, Hessisches Landesmuseum, Darmstadt.

Previous page left and right
The Adoration of the Magi;
The Transference of the Holy Cross
by Emperor Constantine and
his Mother Helena, c. 1455
Oil on panel, 207 x 109 cm
Gemäldegalerie, SMPK, Berlin
Now shown together, the two panels originally formed the interior of the side panels of a triptych whose center panel contained a Mount Calvary scene with many figures. The central panel, unfortunately, was destroyed in a fire in

St. Martin's Church in Bad Orb in 1983. The exterior of the altar, depicting an enthroned Virgin and Child and a representation of the Trinity, is today in the Berlin Gemäldegalerie along with the side panels. On the left side, the feast-day panel reveals the Adoration of the Magi. The Darmstadt Master followed the contemporary Netherlandish style in the figures and the heads, as can be seen in the detail above. The interior of the right panel depicts the discovery of the

Holy Cross. St. Helena journeyed to Jerusalem in 325 in search of the True Cross. According to legend, she located it on Mount Golgotha, where it had been buried along with the crosses of the two thieves crucified with Christ. To determine which was the True Cross, Helena ordered each of the three to be laid across the corpse of a dead person, who was restored to life at the touch of the True Cross of Christ. Constantine and Helena then made a gift of the Cross to the church.

The Master of St. Veronica

The Master of St. Veronica (active in Cologne c. 1395–1415) was probably not a native of Cologne, but received this appellation from the panel depicting St. Veronica that is now in Munich. The painter probably came into contact with the artistic circle of the French-Burgundian court during his journeyman years. He owes to this encounter the delicate forms of his figures, which are often clad in imaginative, Oriental-looking robes. The Master of St. Veronica set the tone of painting in Cologne in the decades before the appearance of Stefan Lochner, and is still recognized as the most important exponent of the International Gothic style, which is characterized by flowing forms, soft contours and restrained gestures. His pictures also tend to convey an aura of gentleness. Other works that are attributed to the artist include *The Small Mount Calvary*, c. 1400, Wallraf-Richartz-Museum, Cologne; *Mary in Angelic Glory, Surrounded by Saints and Scenes from the Passion of Christ*, triptych, after 1400, The Kister Collection, Kreuzlingen (Switzerland); and *Madonna of the Pea Blossoms*, c. 1410, Germanisches Nationalmuseum, Nuremberg.

St Veronica with the Cloth of Christ, c. 1420
Oil on panel, covered with linen, 78 x 48 cm
Alte Pinakothek, Munich
According to the Boisserée brothers, from whom King Ludwig I of Bavaria (1786–1868) purchased this important panel for the Alte Pinakothek in 1827, the picture came originally from St. Severin's Church in Cologne. It ranks among the leading examples of the School of Cologne during the time of Stefan Lochner. According to legend, Christ is supposed to have left a miraculous print of his face on the cloth that Veronica offered him to wipe the sweat from his face in order to ease his suffering as he carried his cross.

Master of the Aix Annunciation

The Master of the Aix Annunciation (active in Aix-en-Provence c. 1443–1445) is named after the single work known to be by this painter, the *Annunciation Altarpiece* in the Cathedral of Aix-la-Provence. In terms of style, the altarpiece is painted in a masterly fashion and is closely related to works by Robert Campin and Jan van Eyck. The Aix Master took over their realistic design of space and their language of gestures. These elements, combined with the plastic three-dimensionality of the bodies, indicate that the painter had precise knowledge of Burgundian sculpture. The Aix Master, occasionally but not conclusively identified as Barthelemy d'Eyck, materially influenced Provençal painting of the 15th century. Other works attributed to the artist include *Still Life, from the Left Panel of the Annunciation Altar*, c. 1443, Musée du Louvre, Paris; *Isaiah, from the Left Panel of the Annunciation Altar*, c. 1443, Museum Boijmans van Beuningen, Rotterdam; and *Jeremiah, from the Right Panel of the Annunciation Altar*, c. 1443, Museès Royaux des Beaux-Arts, Brussels.

Annunciation, c. 1443
Oil on panel, 155 x 176 cm
St-Marie-Madeleine, Aix-en-Provence
This work forms the center panel of the important *Annunciation Altar* that was originally installed in the Cathedral of the Holy Savior in Aix-la-Provence. The painting was supposedly commissioned by the cloth merchant Pietro Corpici, who lived in the city. The triptych was probably dismantled and sold as early as the 17th century.

Annunciation (detail)
This detail depicts God the Father, with two angels behind Him, leaning over a balustrade to observe the Archangel Gabriel's Annunciation to the Virgin Mary. In His left hand God holds the globe of the world, and with His right, He sends the infinitesimally tiny Christ Child down to Mary on a beam of light. The Child symbolizes the mystery of the incarnation of Christ, while the light serves as a means of connection between God and humans.

Master of the Bartholomew Altarpiece

The Master of the Bartholomew Altarpiece (probably c. 1445 Utrecht–c. 1515 Cologne) is so dubbed after the *St. Bartholomew Altarpiece* now in Munich. The Netherlandish origin of this anonymous panel painter and manuscript illuminator, who took up residence in Cologne around 1480, is undocumented and can only be critically determined from stylistic evidence. By this analysis, the artist's preference for changing colors and the strong plasticity of his or her figures are indicative of the Utrecht style. The Master of the Bartholomew Altarpiece, considered the last significant proponent of Gothic painting in Cologne, is a unique, self-determined artist and unusual colorist. Works attributed to the artist, which reflect the transition from medieval to Renaissance painting, include *Portrait of a Man*, c. 1480, Wallraf-Richartz-Museum, Cologne; *The Baptism of Christ*, c. 1495, National Gallery of Art, Washington DC; and *The Thomas Altar*, c. 1500, Wallraf-Richartz-Museum, Cologne.

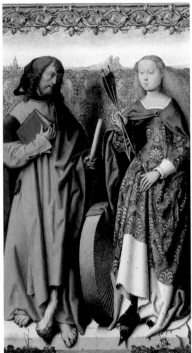

The St. Bartholomew Altarpiece, c. 1505

Oil on panel
Central panel: 129 x 161 cm
Side panels: 129 x 74 cm each
Alte Pinakothek, Munich

St. Bartholomew appears in the center image of the altar panels of the parish church of St. Columba in Cologne, with St. Agnes on the left and St. Cecilia to the right. In front of Bartholomew kneels the donor of the altar, a Carthusian monk whose depiction was first uncovered when the painting was restored in 1950. The row of standing saints is continued on the exterior panels with John the Evangelist and St. Margaret on the left, and James the Less and St. Christina on the right. This arrangement of figures, as well as the wide curtain, follow the Cologne tradition, nor does the painter forego the typical grandiosely conceived landscape panorama in the background. More than any other artists of that time, the Master of the Bartholomew Altar placed high value on minutely detailed replication of the fashionable, almost exaggeratedly elegant clothing of the figures. The attributes of the saints are treated with the same precision: They are notably three-dimensional and presented almost as if they had been painted from life. The imaginative device of the dragon accompanying St. Margaret is treated in a similar manner.

➥ *Master of the Upper Rhine, see Oberrheinischer Meister*

Meléndez, Luis

The full name of Luis Meléndez (1716 Naples–1780 Madrid), born to an Italian mother and Spanish father, is Luis Egidio Meléndez de Rivera Durazo y Santo Padre. In 1717 the entire family emigrated to Spain, where the young Meléndez first trained with his father, Francisco Antonio Meléndez, a painter of royal miniatures, and later with Louis Michel van Loo. Because of bad behavior on the part of his father, the young artist, who had aimed at a career as a painter of historical works and portraits, was excluded from membership of the Academy of San Fernando. Between 1748 and 1752 he lived in Naples and Rome, and upon his return to Madrid he worked as a miniaturist because there was no market for his still life paintings. Only after Meléndez had completed a series of 44 still lifes between 1760 and 1773 for the Castle of Aranjuez did he begin to receive a greater number of commissions. Although Meléndez was one of the most significant 18th-century Spanish still-life painters, he died completely impoverished. The artist's important works include *Self-Portrait*, 1746, Musée du Louvre, Paris; *Still Life with Porgies and Oranges*, 1772, Museo del Prado, Madrid; and *Still Life with Salmon and Lemons*, 1772, Museo del Prado, Madrid.

Opposite
Cucumbers and Tomatoes, 1772
Oil on canvas, 41 x 62 cm
Museo del Prado, Madrid
Characteristic for Meléndez is the simplicity, even
modesty, of the objects he portrays. In this picture are
a clay bowl, an oil pitcher with a vinegar bottle, a salt
shaker, a plate, cucumbers and tomatoes. Through the
articulation of even the smallest details, the painter
achieves an unmistakable verisimilitude that he raises
to a high level of perfection in his unconventional works.

Still Life with Figs and Bread, c. 1773
Oil on canvas, 35.5 x 49 cm
Musée du Louvre, Paris
In his late creative years Meléndez received commissions
for large-format paintings, in which he sometimes
presented arrangements of fruit before a broad land-
scape in the Neapolitan tradition. However, the small,
brilliantly-lighted still lifes of simple foods and daily kit-
chen utensils remain typical of his oeuvre. These paint-
ings also prove him to be an outstanding colorist.

Melozzo da Forlì

Melozzo da Forli (1438 Forlì–1494 Forlì) was probably trained in his native city by the painter Ansuino da Forli, but after 1565 worked in Rome, receiving large commissions from Pope Sixtus IV (1471–1484) and his family starting in 1477. Melozzo left Rome twice—in 1475 and again in 1480—to work on the portraits of scholars and the Allegories of the Liberal Arts in the Palazzo Ducale in Urbino along with Justus van Ghent. In 1484 Melozzo returned to Forli, but left again for Rome

after five years; evidence suggests he was living in Ancona in 1493. Melozzo is recognized as one of the first important Renaissance painters who spent a lengthy period in Rome. As a painter of panels and frescoes, he was a master of architectural perspective, with a preference for bold perspectival foreshortening in his figures—an approach in which he followed the design principles of both Andrea Mantegna and Piero della Francesco. Other works by the artist include *The Peppershaker*, Pinacoteca Comunale, Forli; *Mark the Evangelist*, c. 1470, San Marco, Rome; and *Pope St. Mark*, c. 1470, San Marco, Rome.

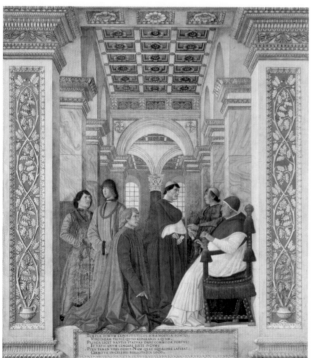

Pope Sixtus IV Appointing Bartolomeo Platina as Prefect of the Vatican Library, c. 1480
Fresco, transferred to canvas, 370 x 315 cm
Pinacoteca Apostolica Vaticana, Vatican
This scene portrays the induction of the humanist Bartolomeo Sacchi, known as Platina (1421–1481), to the prefecture of the Vatican Library by Sixtus IV. Also present are Cardinal Giuliano della Rovere (1443–1513), who later became Pope Julius II, along with other relatives. Platina, who held office starting in 1475, points with his right hand to an inscription referring to the architectural activities of the pope. The spatial construction demonstrates Melozzo's masterly command of perspective.

Memling, Hans

Hans Memling (c. 1433 Seligenstadt am Main–1494 Bruges) stands at the point of transition from the Gothic to the Renaissance. It is possible that he learned his trade in a workshop along the middle Rhine or in Cologne. Evidence suggests that Memling worked in Brussels in 1465, where he may have studied under Rogier van der Weyden, and a year later in Bruges. Expanding upon the tradition of van der Weyden and Dierick Bouts, Memling had developed a style of his own by around 1470. His works reveals rich coloration, graceful figures, and carefully observed details, which he varies in numerous ways, compiling them into a harmoniously organized whole. In his later works he began to come to terms with the early Italian Renaissance. Works by the artist include *Triptych*, before 1479, Museo del Prado, Madrid; *Diptych of Martin van Nieuvenhoven*, 1487, Memling-Museum, Bruges; and *Portrait of a Praying Man*, c. 1483, Museo Thyssen-Bornemisza, Madrid.

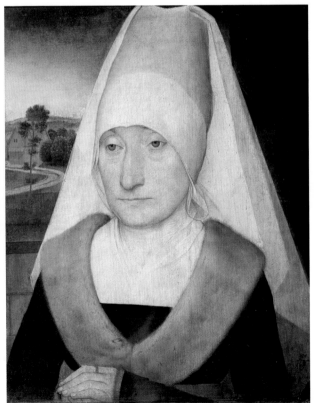

Portrait of an Old Woman, 1470–1475
Oil on panel, 35 x 29 cm
Musée du Louvre, Paris
In this painting, which constitutes one half of a double portrait, the woman is placed far forward within the narrow framework of the picture, robbing spatial considerations of any weight. Instead of perspectival construction and three-dimensional volume, there is a precise observation and rendition of details. Although the portrait is in no way a character study, the personal presence of the figure is clearly evident. In spite of the contrast between the glimpse of landscape and the dark wall on the right, the background scene does not distract from the portrait.

Last Judgment, c. 1471
Oil on panel
Central panel: 223 x 160.5 cm
Side panels: 223 x 72.5 cm each
Muzeum Narodowe, Gdansk

In this early work of Memling's, Christ is portrayed as the *Maestas Domini*, enthroned above a rainbow with his feet resting on the earth. A lily and a sword emerge from his mouth. Surrounding him are the Apostles, the praying figures of Mary and John the Baptist as intercessors for human souls, as well as angels carrying the instruments of the Passion. On earth the Archangel Michael propels the damned into Hell, while the saved ascend into Heaven. Completely naked, they are greeted on a glass staircase by Peter, and are then clothed by angels. A golden light streams behind the Gates of Heaven, which have been reconstructed into a richly decorated archway with a choir of angelic musicians. The background opens onto a view of a richly detailed landscape stretching to the horizon. Memling did not conceive his figures as merely anonymous types, but gave them individual, portrait-like features. Whether or not he was actually painting portraits of his contemporaries is difficult to determine; nonetheless, the soul on the right-hand scale of the Archangel has been identified as a portrait of Tomasso Portinari, a partner of the painting's patron. The altarpiece, which borrows from Rogier van der Weyden's *Last Judgment* panel in Beaune, depicts a lively story. It was commissioned by Jacopo Tani (1415–1492), a native Florentine trade representative living in Bruges, but as the painting was being transported to Florence by ship it was captured by pirates and carried off to Gdansk (see p. 658).

The Virgin of the Rose Garden, c. 1480
Oil on panel, 43.3 x 31 cm
Alte Pinakothek, Munich
This charming work is the interior of the left wing of
a small altarpiece intended for private worship. Despite
the realistic details, the Virgin and the angels are set in
an atmosphere filled with symbolism. Set off from the
world by a hedge of roses, the group is seated in the Gar-
den of Paradise. An angel offers the Christ Child an
apple as a symbol of the fall from grace; the flowers
simultaneously the purity, joys, and sorrows of Mary.

**Triptych of the Mystical Marriage
of St. Catherine, 1479**
Oil on panel
Central panel: 172 x 172 cm
Side panels: 172 x 79 cm each
Memling-Museum, Bruges
The decapitation of John the Baptist depicted on the left
panel reveals a marked depth of field that leads the
viewer's eye to Memling's typically high and upward-
moving horizon. The visions of John the Evangelist on
the island of Patmos on the opposite panel are

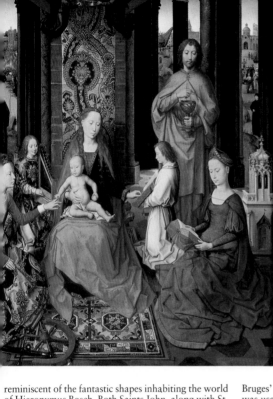

reminiscent of the fantastic shapes inhabiting the world of Hieronymus Bosch. Both Saints John, along with St. Barbara and some angels, are witness to the mystical marriage of St. Catherine, depicted in the center panel. The altarpiece was in all probability intended for the Spital of St. John in Bruges. Here, as in many of his panels, Memling takes advantage of the opportunity to work several extended scenes drawn from the lives of the saints into the landscape. In addition, he draws a connection to contemporary worldly matters: In the center panel above the standing figure of the Evangelist,

Bruges' city building crane can be seen. This implement was used to unload, weigh, and reload wine barrels— a privilege that had belonged to Spital members since the 14th century.

The Seven Joys of Mary, before 1480

Oil on panel, 81 x 189 cm
Alte Pinakothek, Munich

In this painting Memling has taken advantage of an unusually wide format to join together various landscapes in which he has depicted no fewer than 25 episodes from various legends of healing and scenes from the life of the Virgin. These range from the Annunciation inside the building on the upper left edge of the picture, to the Assumption, depicted under the archway to the right. In the center of the picture is the Adoration of the Magi, with reference to the central theme of the composition, the Seven Joys of Mary. Presumably Memling was inspired by contemporary mystery

plays to create a stage-like and thoroughly unique composition, which was originally intended for the Church of St. Mary in Bruges. The patron, the merchant Pieter Bultnyc, appears along with his son in front of the exterior wall of the stall at the nativity scene, in the left corner of the picture next to the heraldic arms.

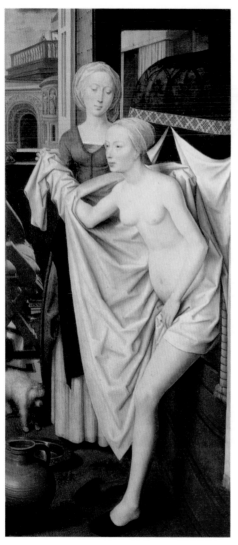

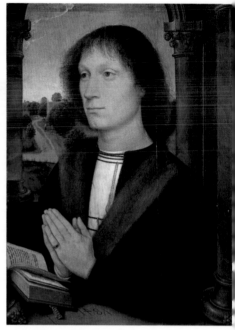

Bathsheba in the Bath, 1485
Oil on panel, 191.5 x 84.5 cm
Staatsgalerie, Stuttgart
The subject of the story of Bathsheba was a very popular theme of Memling's time. Originally the scene was portrayed as taking place in the open air, and depicted how King David spied upon Uriah's wife, surrounded by her servants, whom David himself subsequently married. Memling transfers the action to the bathhouse, making the washing into a ritual bathing of the bride. The simplified forms and the ideal image of the female nude reveal Renaissance tendencies.

Opposite right
Benedetto di Tommaso Portinari, 1487
Oil on canvas, 45 x 34 cm
Galleria degli Uffizi, Florence
This painting depicts the 21-year-old nephew and business partner of the merchant Tommaso Portinari, the former representative of the Medici in Bruges, with sensitivity and fine modeling. His position as a member of the ruling classes is reflected in the colored marble columns. The portrait is the right half of a diptych, whose opposite panel portrays the young man's patron saint, to whom he directs his inward prayer.

The Martyrdom of the Eleven Thousand and The Martyrdom of St. Ursula (The St. Ursula Reliquary), before 1489
Oil on panel, 35 x 25 cm each
Memling-Museum, Bruges
These panels, located on the narrow side of a shrine to St. Ursula, depict the tragic finale of the pilgrimage of the princess and her train to Cologne. Attacked by the besieging Huns, the saint at first succeeds in avoiding massacre, but is nonetheless killed by the commander. In the background appears the city silhouette of Cologne with its then incomplete cathedral.

Mengs, Anton Raphael

Anton Raphael Mengs (1728 Ústí nad Labem, Czech.–1779 Rome) first studied with his father, the Dresden miniaturist Ismael Mengs. He spent 1741 to 1744 in Rome, studying the art of classical antiquity and the Renaissance. Upon his return to Dresden, Mengs became the court painter to August III of Saxony (1696–1763). Except for a second journey to Rome in 1747–1749, Mengs remained in Dresden until 1752, when he again returned to Italy. In 1760, the artist was appointed court painter by King Charles III (1716–1788) in Madrid, where he took up residence two years later and remained until 1777, aside from another period in Rome between 1769 and 1774. Mengs spent the last two years of his life in Rome. He concentrated on portraits and narrative paintings, the earliest of which reveal a Rococo influence; later Mengs devoted himself to an academic neoclassicism. Contemporaries, including Johann Joachim Winckelmann (1717–1768) among others, exuberantly praised his work, and he enjoyed the highest international recognition. Works by the artist include *Assumption of the Virgin*, 1751–1766, Court Church, Dresden; *Johann Joachim Winckelmann*, c. 1760, The Metropolitan Museum of Art, New York; and *Parnassus*, 1760/61, Villa Albani, Rome.

Self-Portrait, c. 1775
Oil on canvas, 102 x 77 cm
Hermitage, St. Petersburg
This painting is in fact a replica by Mengs of a self-portrait dated the previous year and now hanging in the Galleria degli Uffizi in Florence. The portrait depicts Mengs at approximately age 46 with a portfolio and brush in his right hand. The gesture of his left hand, his slightly parted lips and his glance directed toward the right edge of the painting present the painter in the midst of a discussion—a reference to his role as art theoretician and author of *Thoughts on Beauty and Taste in Painting*, published in 1762.

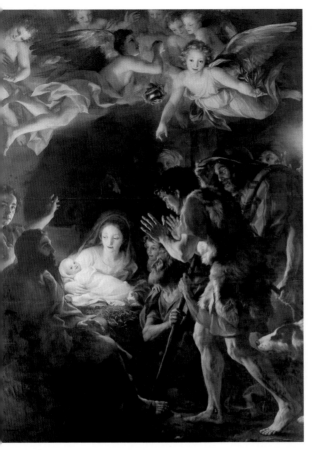

Portrait of Charles III, 1761
Oil on canvas, 154 x 110 cm
Museo del Prado, Madrid
Mengs became acquainted with the Spanish king in 1759, the year of Charles's ascent to the throne of Naples. This impressive formal state portrait, which served as the basis for many subsequent copies, displays Charles III (1716–1788) with all his insignias of power. The king's gaze is directed toward the viewer, but his left hand directs one's attention to the right, toward a portrait of the king's deceased wife, Maria Amalia of Saxony, depicted in pendant format.

The Adoration of the Shepherds, 1770
Oil on panel, 258 x 191 cm
Museo del Prado, Madrid
Mengs painted this picture in 1770, while in Rome, for the collection of the Spanish royal house. His self-portrait is visible behind the figure of St. Joseph on the left side of the painting. This night scene crowded with many figures follows in the tradition of Correggio, whose influence can be seen in the highly dynamic movement of the figures and in the stark contrast between light and shadows.

Menzel, Adolf von

Adolf von Menzel (1815 Wroclaw–1905 Berlin) moved with his family to Berlin in 1830, where the young man took over the lithographic workshop of his deceased father and remained for the rest of his life. Beginning in 1833, he studied at the art academy, and entered the *Jungerer Berliner Kunstverein* ("Younger Berlin Art Union") the following year. In 1855, 1867 and 1868 he lived in Paris, and undertook various tours of southern Germany and Italy as well. In the 1840s Menzel concentrated chiefly on realistic landscapes, and in the following decade, on large historical paintings, at first centered thematically on life at the court of Frederick the Great (1712–1786), and after 1860 on contemporary subjects and events of more recent Prussian history. Menzel also completed smaller-format genre pictures which point toward Impressionism. Throughout his life he remained interested in printmaking techniques, producing lithographs, woodcuts, and etchings as well as paintings. Other works by the artist include *The Balcony Room*, 1845; *Le Theatre du Gymnase*, 1856; and *Steel Mill*, 1875, all located in the Nationalgalerie, SMPK, Berlin.

Emilie at the Parlor Door, 1847
Oil on paper, 46 x 32 cm
Neue Pinakothek, Munich
This work, also known as *The Artist's Sister with a Candle*, must be counted among the high points of early Impressionist painting because of its unusual, even bold use of framing. It is one of a number of pieces inspired by the painter's private life and was never exhibited publicly by Menzel himself. The picture depicts his sister, Emilie, then nineteen years old, who kept his household for him. Menzel often painted her, either alone or together with their brother Richard.

Opposite
Flute Concert of Frederick II in Sanssouci, 1852
Oil on canvas, 142 x 205 cm
Nationalgalerie, SMPK, Berlin
Beginning in 1850 Menzel worked on a cycle of large-format history paintings portraying events from the age of Frederick the Great (1712–1786). The painter was very familiar with the theme, because he had already, in 1839, completed woodcuts for the illustration of Franz Kugler's *History of Frederick the Great*. The diffuse lighting, in this case created by the gigantic chandelier, point towards developments well beyond mid-19th-century painting.

Metsu, Gabriel

According to Arnold Houbraken (1660–1717), Gabriel Metsu (1629 Leiden–1667 Amsterdam) studied under Gerard Dou in Leiden. Metsu's early history paintings, however, reveal rather the influence of the work of the Utrecht painter Nicolaus Knüpfer and his Leiden student Jan Steen. Metsu is documented as being one of the founding members of the Guild of St. Luke in Leiden in 1648, and by the middle of the next decade he had moved to Amsterdam, where he re-enters historical records in 1657. At approximately the same time as his move to Amsterdam, Metsu turned to genre painting, producing cabinet pieces in which he patterned himself on models such as Gerard Dou, Gerard Terborch, Pieter de Hooch, and Jan Vermeer. Metsu's particular sensibility for color, combined with a qualitatively excellent detailed painting style, are the basis of the charm of his many-faceted oeuvre. Works by the artist include *The Usurer*, 1654, Museum of Fine Arts, Boston; *The Music Society*, 1659, Metropolitan Museum of Art, New York; and *The Sick Child*, c. 1660, Rijksmuseum, Amsterdam.

The Hunter's Gift, c. 1660–1665
Oil on panel, 56 x 50 cm
Galleria degli Uffizi, Florence
Around 1660 Metsu repeatedly took up the theme of the returning hunter who presents his wife with game. In Netherlandish genre painting, the courting of a woman with game had been understood as having erotic connotations since the 16th century; the theme was played out not only in earthy market scenes, but also in Metsu's elegant social paintings, which pursued the theme with masterly detail.

Opposite
The Dead Rooster
Oil on panel, 57 x 40 cm
Museo del Prado, Madrid
Pure still lifes hold a special position within the comprehensive works of Metsu. In addition to a monogrammed *ontbijtje* with herring in the Musée du Louvre in Paris, the only other fully signed painting that can be attributed to Metsu is the one shown to the left. The unusual picture is counted among the masterpieces of 17th-century Dutch art because of its outstanding painterly quality.

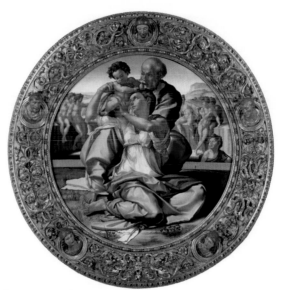

Michelangelo Buonarroti

Michelangelo Buonarroti (1475 Caprese, near S. Sepolcro–1564 Rome) is one of the most important and influential artists in all of western art. After his early training as a painter in Florence under Ghirlandaio, Michelangelo continued his studies around 1490 in the workshop of the sculptor Bertoldo di Giovanni (1449–1492). He was inspired to study classical sculpture and humanistic philosophy by the circle of artists surrounding his patron, Lorenzo de'Medici (1449–1492). During his stay in Rome from 1496 to 1501, he deepened his knowledge of sculpture; then, upon returning to Florence, completed his first paintings. In 1505 he answered the call to the papal court in Rome, where he worked from 1520 to 1534, and was appointed chief architect, sculptor, and painter in 1535.

Michelangelo developed entirely new modes of expression for painting, and created individual, intellectually conceived figures with a three-dimensionality previously unequaled. Works by the artist include *The Crucifixion of Peter*, 1546–1550, Cappella Paolina, Vatican; and *The Deposition* (incomplete), 1500/01; The National Gallery, London.

The Holy Family with St. John
(Tondo Doni), c. 1504–1506
Oil tempera on panel, diam. 120 cm
Galleria degli Uffizi, Florence
This, one of the only completed paintings definitely attributable to the artist, was created for the marriage of Agnolo Doni and Maddalena Strozzi. Michelangelo took up the problem of the corporeality and movement of figures with this complex grouping, using the shape of a pyramid rather than a triangle to inform the group, uniting an ancient spirit with Christian themes in the strong figures.

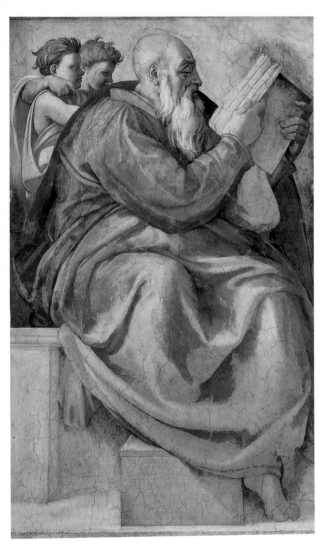

The Prophet Zacharias, 1509
Ceiling fresco, 360 x 390 cm
Sistine Chapel, Vatican
Throughout the design of these
ceiling paintings Michelangelo
alternated seated with standing fig-
ures. He learned the plastic model-
ing of his figures from his work as
a sculptor. Zacharias, the prophet of
the virginal birth of Christ, is proba-
bly the first of the seven pictures of
the prophets painted by Michelan-
gelo. The figure is still completely
enclosed within an architectural
frame, which creates the impression
of a figure in relief. The painting is
located over the entry, a suitable
place for the prophet who foretold
the entry of Christ into Jerusalem,
and thus also alludes to the entry of
the pope on Palm Sunday.

Michelangelo Buonarroti 635

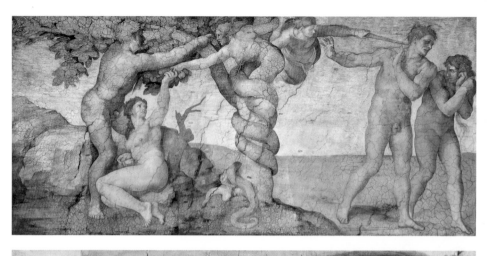

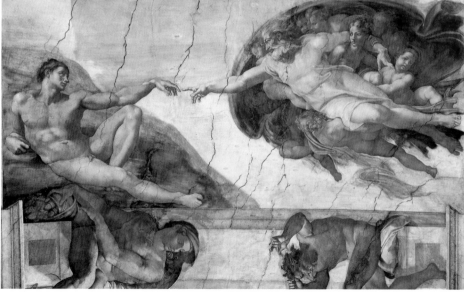

Opposite above

The Fall from Grace and the Expulsion from the Garden (detail), c. 1509/10
Ceiling fresco, 280 x 570 cm
Sistine Chapel, Vatican

The large-scale decoration of the domed ceiling was Michelangelo's first painting assignment, and also marked the beginning of a new era in the history of art. Central to the iconographic scheme is the glorification of Creation; this painting is the third of the central fields. Michelangelo's portrayal of the human figure shows his flawless application of the ancient spirit to biblical themes.

Opposite below

The Creation of Adam (detail), 1510
Ceiling fresco, 280 x 570 cm
Sistine Chapel, Vatican

This famous scene is the first of the central ceiling panels. Adam's athletic figure unites natural and ideal beauty, but Michelangelo's precise anatomic rendition serves only to demonstrate the perfect harmony in human proportions. A mirror image to Adam, the figure of God appears horizontally for the first time in the history of painting. Their fingers meet in front of a neutral background that suggests an electrically charged field.

The Libyan Sibyl (detail), 1511
Ceiling fresco, 395 x 380 cm
Sistine Chapel, Vatican

Five sibyls—wise women who foretold the coming of Christ in antiquity—appear with the biblical prophets in the side panels of the ceiling. Michelangelo's figures form a high point in the treatment of the theme. Here, the generously conceived and freely moving three-dimensional figure breaks out of the painted architectural background.

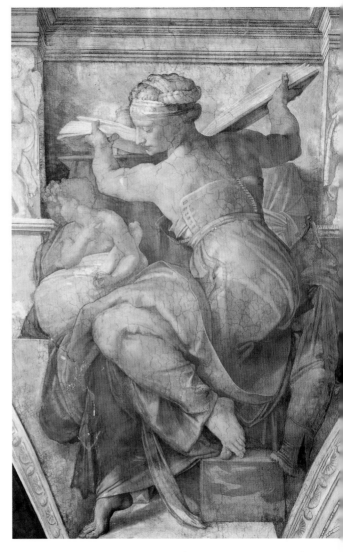

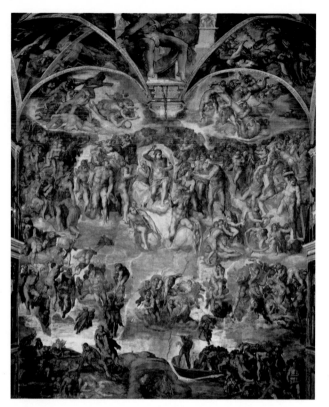

Opposite
Last Judgment
(detail, The Redeemed)
Dazed and uncertain of what is happening, the men and women who are just arising from their graves are lifted up by the whirl-wind of the events portrayed. Still partially wrapped in their shrouds, the redeemed are depicted exerting great effort to help each other. Unusual in this painting is that there is no trace of the angels typically found in scenes of the Last Judgment.

Following pages
Last Judgment
(detail, The Barge of Charon)
Michelangelo's design of the scene in Hell caused a sensation. Charon, the ferryman of the dead in Greek myths, deposits the Damned at the gate of the underworld and, aided by demons, drives them from his boat. Also derived from Greek mythology is the figure of Minos, Judge of the Dead, who receives the miserable souls. His body is en-circled by a snake.

The Last Judgment, 1537–1541
Fresco, 1370 x 1220 cm
Sistine Chapel, Vatican
This painting, on the wall behind the altar, defines a new treatment of the theme. An older and more pessi-mistic Michelangelo painted a dom-inating circular movement of the Just arising from the left and the Damned tumbling down on the right, revolving around the mighty figure of Christ, who is depicted as both an Apollo and a Hercules at once. Christ is not portrayed as Judge, but as the Messiah at the Second Coming. At his side, the Virgin recoils in shock at the course of events. This powerful work drew both favor and criticism. By order of the decree concerning pictures is-sued by the Tridentine Council, Daniele da Volterra, a student of Michelangelo's, painted cloth over the naked bodily parts in 1564.

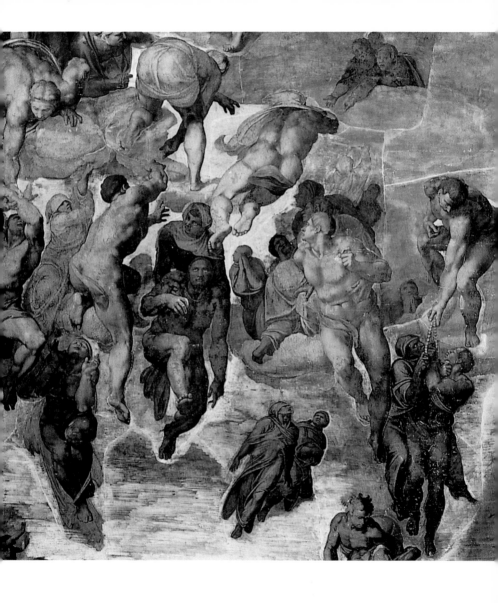

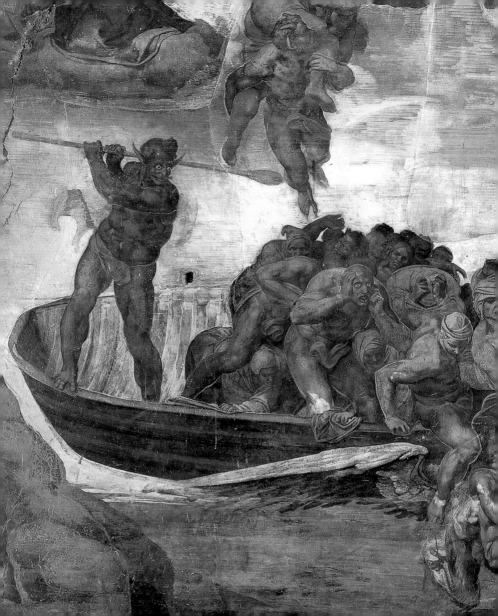

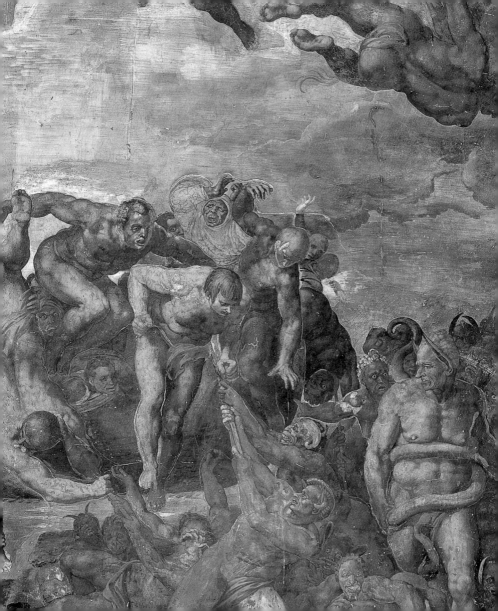

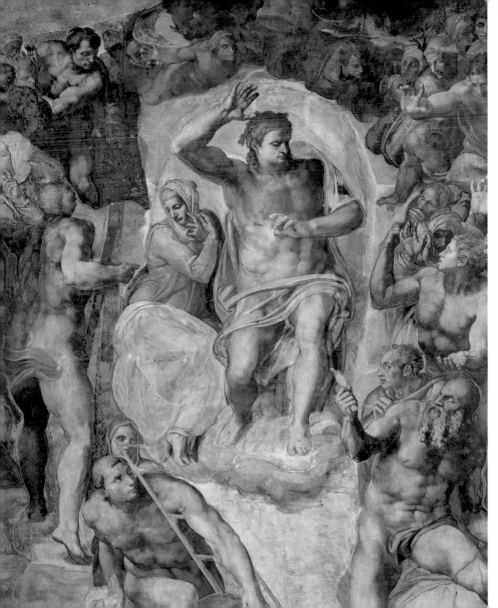

Opposite
Last Judgment (detail, Christ and the Virgin)
At the center of the Last Judgment is the figure of Christ; contrary to tradition, He is unbearded and appears in the prime of youth. The youthful appearance and posture of the Virgin is also unconventional, as are the figures of the Apostles, whose vehement gestures have an impact on the Judge.

The Conversion of Saul, c. 1543
Fresco, 625 x 661 cm
Cappella Paolina, Vatican
Michelangelo wound up his creative work as a painter around 1548 with this fresco and that of the Crucifixion of Peter on the opposite wall. Both compositions contain hints of the coming Baroque period. The conception of Paul and the grouping of his train, all of whom seem to be in the grasp of cosmic forces, made a particularly deep impression on later artists.

Mieris, Frans van

Frans van Mieris (1635 Leiden–1681 Leiden) was a goldsmith's son who studied painting in his native city under Gerard Dou and, for short periods of time, with the glass painter and master draftsman Abraham van Toorenvliet and the history and portrait painter Abraham van den Tempel. In 1658 van Mieris was accepted as a master into the Guild of St. Luke of Leiden, where he was active his whole life, winning some of the richest and most prominent citizens for patrons. Even the Grand Duke Cosimo III de'Medici (1642–1723) and Archduke Leopold Wilhelm (1614–1662) numbered among his customers. Along with his teacher Dou, van Mieris is considered the most important exponent of "Leiden Fine Painting." His oeuvre consists of small-format genre scenes set in interiors, portraits, and a number of historical paintings. Works by the artist include *The Doctor's Visit*, 1657, Kunsthistorisches Museum, Vienna; *The Music Lesson*, 1658, Staatliches Museum, Schwerin; and *Woman with Matchmaker*, 1671, Gemäldegalerie Alte Meister, Dresden.

The Oyster Eaters, 1659
Oil on panel, 44.5 x 34.5 cm
The Hermitage, St. Petersburg
Van Mieris drew the themes of his genre pictures primarily from a bourgeois milieu and treated them moralistically, yet with an ironic distance. His perfect technical execution and the elegance of the presentation stand at cross-purposes with the crude and frivolous content of the pictures; because of this, an erotic reference is surely to be read into the offering of the oysters.

Mignard, Pierre

Pierre Mignard (1612 Troyes–1695 Paris) studied painting first under François Boucher in Bourges, and later with Simon Vouet in Paris. In 1636 he went to Rome, where he remained for 21 years, taking a journey to Bologna, Parma, and Modena in 1654. Mignard, who had won respect in Italy for his portraits and Madonnas, finally returned to Paris in 1671 by way of Avignon. In time he took over the position of his rival, Charles Le Brun, and advanced to the leading portrait painter at the court of Ludwig XIV (1638–1715). He painted portraits of the king and his relatives and, commissioned by the queen mother in 1663, he painted the dome of the Parisian church Val-de-Grâce together with Charles-Alphonse Dufrenoy. As *premier paintre du Roi* ("first painter to the king"), Mignard was also director of the Académie Royale de Peinture et Sculpture and the royal painting cabinet. Among his works are *The Carrying of the Cross*, 1684, Musée du Louvre, Paris, *Self-Portrait*, 1690, Musée du Louvre, Paris; and The *Marquise of Seignelay and her Children,* 1691, National Gallery, London.

Louis XIV on Horseback, 1673
Oil on canvas, 305 x 234 cm
Galleria Sabauda, Turin
This equestrian portrait presents Louis XIV as a successful field general. While the figure of Fama, the personification of Fame, holds a crown of laurel over the king's head, a landscape filled with soldiers and a view of Maastricht stretches out into the background. The Sun King waged the War of Holland between 1672 and 1679 in an attempt to conquer the United Netherlands for reasons of power and politics.

Girl with Soap Bubbles, 1674
Oil on canvas, 132 x 96 cm
Musée National du Château de
Versailles et de Trianon, Versailles
The girl in the picture is probably
Marie-Anne de Bourbon, seen sit-

ting on soft velvet tasseled pillows
in front of a landscape. Her some-
what melancholy gaze is directed to
the viewer and may be understood
as a symbolic reference to her
pastime: Earthly life is as transient

as a soap bubble. The watch lying
on the table is also to be interpreted
as representing vanity.

Momper, Joos de

Joos de Momper (1564 Antwerp–1625 Antwerp) was born into a family of painters and art dealers. As early as 1581 he was inducted as a master into the Guild of St. Luke, of which he became deacon in 1611. Momper spent his entire life in Antwerp. Although there is nothing to document that the artist journeyed to Italy in the 1580s, stylistic evidence makes such a tour seem very probable. Momper devoted himself exclusively to landscapes in the tradition of Pieter Breugel the Elder, but Momper's work illustrates the change from the traditional universal landscape to the flat Netherlandish landscape. Typical of the painter's style are bizarre high mountain ranges and broad landscape views in traditional layered color compositions. He occasionally worked with Jan Breughel and other Antwerp figure painters. Works by the artist include *Fall of Icarus*, c. 1590, Nationalmuseum, Stockholm; *Mountain Landscape with Riders*, c. 1595, Hessisches Landesmuseum, Darmstadt; and *Mountain Landscape with Travelers*, c. 1625, Národni Galerie, Prague.

Landscape with Ice Skaters, c. 1611
Oil on panel, 58 x 84 cm
Museo del Prado, Madrid
Among Flemish painters of the 16th and 17th centuries, Momper stands as the inventor of the winter village landscape. His numerous variations on the theme are quite often matched by pictures of the other seasons; thus, the *Winter Landscape with Ice Skaters* is one of a pair, matched to a spring landscape in the same format, which also hangs in the Museo del Prado in Madrid. The painting of the figures in the spring landscape, however, is attributed to Jan Breughel.

**Market and Washday
in Flanders, c. 1621**
Oil on canvas, 166 x 194 cm
Museo del Prado, Madrid
This large-format painting is a joint
effort by Joos de Momper and Jan
Breughel, and depicts a lively
market scene in a Flemish village to
the left, while to the right one sees

a meadow where women are
spreading out freshly-washed sheets
to dry and bleach in the sun. The
colorful design of the painting with
its brown foreground, green middle
zone, and blue background cor-
responds to the typical coloration of
universal landscapes in the later
16th century.

Mor, Anthonis

Anthonis Mor (c. 1519 Utrecht–1576 Antwerp) studied with the Utrecht artist Jan van Scorel. Documents indicate that Mor was an independent painter and citizen in Utrecht by 1546. After journeying to Italy he settled in Antwerp in 1547, and two years later entered the service of Anton Perrenot de Granvela (1517–1586), Bishop of Arras. This association introduced Mor to the Habsburg courts in the Netherlands and Spain. Between 1550 and 1561 he lived in Lisbon, Spain and Brussels, and in 1554 Emperor Charles V (1500–1558) sent him to England to paint a portrait of Mary Tudor. Afterwards he lived in Utrecht and Antwerp, where he finally settled permanently in 1568. Anthonis Mor specialized in portrait painting, and completed pictures of most of the important rulers of his age.

Among the artist's works are *Portrait of Anton Perrenot de Granvella*, 1549, Kunsthistorisches Museum, Vienna; *Mary Tudor*, 1554, Museo del Prado, Madrid; and *Self-Portrait*, 1558, Galleria degli Uffizi, Florence.

The Utrecht Cathedral Canons Cornelis van Horn and Anthonis Taets van Ameronghen, 1544
Oil on panel, 74 x 96 cm
Gemäldegalerie, SMPK, Berlin
This double portrait, one of the painter's early works, portrays the two canons of the Utrecht cathedral as half-length figures standing behind an inscribed railing. This type of composition derives from the Italian Renaissance painting tradition; in contrast, the narrow framing of the picture and the concentration on the physiognomies of the two men reflect traditional Netherlandish portraiture.

Moroni, Giovanni Battista

Giovanni Battista Moroni (c. 1530 Albino, near Bergamo–1578 Bergamo) probably received his training under the guidance of Alessandro Moretto in Brescia. After his apprentice years he returned to Bergamo, where he remained for the rest of his life without any long interruptions. Moroni, whose painting reflects his grappling with the works of Lorenzo Lotto and Titian, created a series of altarpieces that are still to be found today, parti-cularly in the churches of the northern Italian province of Bergamo. However, the artist's real fame rests on his portraits, which are powerful in their ability to evoke great sympathy with their subjects, sharp detail of observation, and absolute simplicity of setting. In the coloration of Moroni's portraits, restful tones of gray and brown dominate. Some of the artist's significant works include *The Abbess Lucrezia Vertova*, 1557, The Metropolitan Museum of Art, New York; *Isotta Brembati*, c. 1560, Accademia Carrara, Bergamo; and *Gian Girolamo Grumelli (Cavalier in Red)*, c. 1560, Collezione Conti Moroni, Bergamo.

Antonio Navagero, 1565
Oil on canvas, 115 x 96 cm
Pinacoteca di Brera, Milan
The mayor of Bergamo, Antonio Navagero, is wearing a red costume with a stylish codpiece and a heavy fur-lined cape. The folded sheet of paper in his right hand is probably a reference to Navagero's 1565 report to the Venetian senate on the situation in Bergamo. The peaceful picture is a characteristic example of Moroni's preferred use of brown and red tones, also known as *maniera rossa*.

Moser, Lukas

Lukas Moser (active on the upper Rhine in the first half of the 15th century) has been identified from the inscription on the *Magdalen Altarpiece* in Tiefenbronn and from an entry in the files of the parish church of Weil die Stadt, where Moser received 69 gulden for the painting of a famine scene in 1431. The Tiefenbronn altarpiece is the single work that can be authoritatively attributed to Moser, and testifies to the inspiration he received from the Old Netherlandish painting tradition in particular. It cannot be conclusively proven that the Moser who worked in Tiefenbronn near Pforzheim is the same Lukas Moser who was active at approximately the same time in Ulm.

Magdalen Altarpiece, 1432
Mixed media on wood,
300 x 240 cm
St. Maria Magdalena, Tiefenbronn
Executed with exquisite artistry, the exterior panels of this work depict scenes from the life of St. Mary Magdalen. In the gable area is the meal in the house of Simon the Pharisee during which Mary Magdalen washed the feet of Christ with her tears of repentance and dried them with her hair. In the left panel in the middle area of the painting appears the sea journey of the saints in company of Saints Martha, Lazarus, Maximilian and the blind Cedonius. The center panel depicts Magdalen's arrival in Marseilles, and to the right is the last Communion of the saint after her 30-year period of penance in the grotto of St. Baume in southern France. On the predella appears Christ as the Man of Sorrows between the Wise and Foolish Virgins and the coat of arms of the donor. The carved shrine that today decorates the center panel was restored in the 16th century. This work of Moser's is the first in a series of Mary Magdalen altarpieces that were created in Germany in the late 15th and into the 16th centuries.

Multscher, Hans

Hans Multscher (c. 1400 Reichenhofen, near Memmingen–1467 Ulm) is considered one of the most important sculptors and wood carvers of the 15th century in Swabia; in all probability he was also active as a panel painter. In 1427 Multscher became a citizen of the city of Ulm, and in documents he is mentioned as a relief carver and a "sworn workman," a position corresponding to that of an officially recognized expert. Presumably Multscher was trained in the Netherlands, and he eventually came to head a large workshop. In 1433 he completed the stone altar of the family of Konrad Karg in the cathedral at Ulm, of which only fragments remain. Four years later, according to an inscription, he created the so-called *Wurzach*

Altarpiece, one of the major works of Gothic art created in southern Germany. Evidence indicates that Multscher worked on an altarpiece for the *Frauenkirche* ("Lady Church") in Sterzing between 1456 and 1458. Unlike his sculpture, his painting for the side panels of the Wurzach and Sterzing altarpieces has been documented. Other carved panels were executed by assistants from his workshop or by independent painters. The pictures attributed to him mark the beginning of a so-called realistic phase that characterizes the first half of the 15th century of the Swabian late Gothic style. Other works by the artist include the side panels of an altarpiece of the Virgin from 1456–1458 in the Multscher Museum in Sterzing.

Prayer on the Mount of Olives, Carrying of the Cross, Christ before Pilate, and the Resurrection of Christ, 1437
Tempera on panel,
148 x 140 cm each
Gemäldegalerie, SMPK, Berlin
These four panel paintings originally constituted the inner wings of an altar that was presumably commissioned for the city parish church of Landsberg am Lech. From the mid-17th century the panels were in the possession of the Steward of Waldburg in the Wurzach Castle near Memmingen. The corresponding exterior panels, which today are also in the Berlin

museum, present four scenes from the life of the Virgin. The final panel of the large winged altarpiece probably depicted a carved Crucifixion scene. The interior panels, which were arranged vertically in pairs, show the prayer on the Mount of Olives and the Carrying of the Cross, as well as Christ being judged by Pontius Pilate and the Resurrection. Multscher designed his pictures with extremes of emotion and at the same time solidity of form. In the Carrying of the Cross, he depicts the helplessness of Christ, who threatens to break down under the weight of the Cross; Christ's companions are

deeply emotionally involved, as well. Wordlessly and lamenting, the holy women and John follow behind, in contrast to the grimacing facial expressions of the torturers. The spatial representation of the architectural and landscape elements on the panels as well as the three-dimensional forms of the figures reveal Multscher to be an innovative painter. The individual, at times starkly vivid, forms of the figures and the still-life details indicate that the painter had come to terms with the realism emanating from the large art centers in Burgundy and the Netherlands in the early 15th century.

Murillo, Bartolomé Estéban

Bartolomé Estéban Murillo (1617 Seville–1682 Seville) is the chief representative of High Baroque and one of the best-known Spanish painters. In 1627 he began an apprenticeship with Juan del Castillo, but was also heavily influenced early on by the work of Francisco de Zurbarán and Jusepe Ribera. Around 1650 he turned to the works of Anthonis van Dyck, Peter Paul Rubens, and Raphael. Murillo developed a light and filmy style, the *estilo vaporiso*, with soft contours, delicately toned colors, and a golden-to-silver veil of light. He concentrated on religious and genre themes, working mainly in Seville, where he became one of the co-founders of the Art Academy in 1660. His works include *Beggar Boy*, c. 1645, Musée du Louvre, Paris; *The Angelic Kitchen of St. Diego of Alcalá*, 1646, Musée du Louvre, Paris; and *Apparition of the Child Jesus to St. Anthony of Padua*, 1656, Cathedral, Seville.

Grape and Melon Eaters,
c. 1645/46
Oil on canvas, 146 x 104 cm
Alte Pinakothek, Munich
Genre painting was not especially well-known in 17th-century Spain; only in Seville was this type of painting pursued. Murillo's unique depictions of everyday beggar children pretend no claims to moral or allegorical meaning; furthermore, they disavow any feeling of sadness or misery. On the contrary, his paintings convey an unselfconscious merriment and joy of life on the part of the subjects.

Opposite
The Holy Family
with a Bird, c. 1650
Oil on canvas, 144 x 188 cm
Museo del Prado, Madrid
In his religious pictures Murillo often emphasized the distance between the heavenly and the earthly spheres. Here, the Holy Family is presented in a domestic scene. The Virgin is sitting at the spinning wheel, while Joseph watches the Child at play. Typical of Murillo's early work is the side-lighting, which lends the composition unity, and the *chiaroscuro* effect, which gives the figures a relief-like modeling.

The Good Shepherd, c. 1660
Oil on canvas, 123 x 101 cm
Museo del Prado, Madrid
In this picture Murillo depicts Christ's message when he compares Himself with the good shepherd who saves his sheep from danger (John 10:1–16). The soft contours and diffuse lighting that seem to fill the scene with a colored smoke are characteristics of the painter's mature style. In addition, the lyric mood of the painting anticipates the coming Rococo period. The painting was enlarged in 1744.

Virgin and Child, c. 1650–1660
Oil on canvas, 155 x 105 cm
Galleria Palatina, Palazzo Pitti, Florence
This devotional picture achieves its powerful effect not only through the intense gaze of the Mother of God and the young Christ, but also through their realistic, lifelike presentation. Though both seem to be figures familiar from daily life, they are transformed into something special through painterly refinement. The bodies seem to be lighted from within, and the filmy color tones lend them an unreal beauty.

The Immaculate Conception, c. 1678
Oil on canvas, 274 x 190 cm
Museo del Prado, Madrid
In his many variations of the *Madonna Immaculata*,
Murillo created a new type of figure with which he
defined the classical image of this genre of Mary
painting. The Virgin stands, almost hovering, on a
crescent moon. Behind her, the angel-filled and cloud-
laden heavens take on a glorious brightness against
which the figure of Mary emerges clearly. Murillo did
not always reach such an illuminatingly powerful
statement and high level of plasticity as in this painting.

St. Francis in the Portiuncula Chapel, c. 1667
Oil on canvas, 206 x 146 cm
Museo del Prado, Madrid
The defining element of this meditational picture of St.
Francis experiencing a vision is the convincing expression
both of great humanity and of deep religious feeling with
which St. Francis (1183–1226) kneels before Christ and
the Virgin. Murillo has also succeeded here in translating
a supernatural apparition into an earthly event.

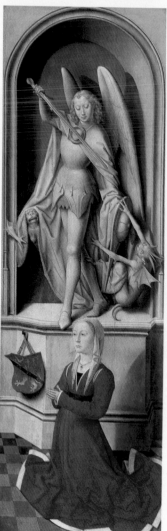

Two Florentine Bankers go Shopping in Flanders

The 15th century witnessed an active exchange of art both north and south of the Alps. Artists travelled from one region to another in order to study; significant works of art were traded; and influential patrons, motivated by prestige, commissioned correspondingly impressive works from distant art centers.

In 1467, Hans Memling (c. 1433–1494), who at the time was living in Bruges, received a commission from the Florentine banker Angelo di Jacopo Tani (1415–1492) to create a monumental altarpiece depicting the Last Judgment with the Archangel Michael as the Weigher of Souls. The painting was probably intended to be mounted in the chapel of St. Michael's Church in Badia Fiesolana in Florence. Tani had worked for the Bruges branch of the Medici bank since 1450, where he had become acquainted with and appreciative of Old Netherlandish art, and by 1455 he was the director of the powerful Medici bank.

Memling's triptych, which measures 223 x 305 cm (without frame) when opened, was a gigantic work for its time, especially since it was intended to be "exported." Six years after Memling received

Hans Memling: Last Judgment
(exterior altar panels), c. 1467–1471
Tempera on panel, 223 x 72.3 cm each
Narodowe Muzeum, Gdansk
The donor, Angelo di Jacopo Tani, is portrayed with his wife, Caterina di Francesco Tanagli (1446–1492), on the exterior of the *Last Judgment* altarpiece.

the commission the altar was completed and ready for transport. *The Last Judgment* left the Bruges harbor on the ship *San Matteo*, filled with cloth, furs, rugs, spices, and other valuable goods. The planned itinerary led first to London, then to Italy.

However, the ship never reached its port of destination. War raged between England and the Hanseatic League, and although the *San Matteo* was sailing under the neutral flag of Burgundy, it was attacked off the coast of England on April 27, 1473, by the caravelle Peter of Danzig. After a bitter struggle the ship was seized and the booty distributed in the north German city of Bremen. The altarpiece was designated for the Church of St. Mary in Danzig (today Gdansk), where it was erected in the George Chapel. Negotiations over the return of the painting or any retribution for the thievery failed in spite of intervention by the Medici, Pope Sixtus IV (1471–1484), and the Duke of Burgundy, whose help had been enlisted by the influential patrons.

Thus, the altar remained for more than 300 years in the premier church of Danzig. In 1807, on order of Napoleon (1769–1821), the painting was removed to the Louvre in Paris, but after his defeat the painting was seized by the victorious powers, who took it upon themselves to restore the art treasures stolen by Napoleon's troops on their march through Europe. In 1815/16 the triptych was displayed in Berlin, where a great effort was made to keep it. The determined

altarpiece from Hugo van der Goes (c. 1443–1482) with a depiction of the birth of Christ on the central panel. As a religious donation the work was supposed to benefit the soul of Portinari and his relatives, but it also served to satisfy the family's desire for an impressive presence while they were still on this earth. In contrast to Memling's altar, the work of Hugo van der Goes reached Italy without harm. It was carried by sea from Bruges to Pisa, and then up the Arno River to Florence, where it arrived on May 28, 1483. Contemporary sources indicate that no fewer than 16 men were required to carry the paneled altarpiece from the harbor to the church of San Egidio in the Hospital of Santa Maria Nuova.

The presence of the work, which had successfully made its way from the distant Netherlands to Florence, was of major significance for the development of Italian art in the late 15th century. The painting's detailed realism was enthusiastically embraced by the emancipated artists and scholars of the Renaissance as part of their interest in the secular world. The altarpiece surpassed anything that had been done in Florence, not only in terms of its grand dimensions and stylistic direction, but particularly in its execution in shimmering, glazed oil paints: It inspired new accomplishments in art south of the Alps.

position of the city authorities resulted in the return of the altarpiece in 1817 to the Church of St. Mary in Danzig. Today, only a copy of the altarpiece can be viewed there: The original has been displayed for all to admire in the city's Narodowe Muzeum since 1960.

In the mid-1470s—that is, only a relatively short time after the creation of Memling's *Last Judgement*—the Florentiner Tomasso Portinari (c. 1428–1501), who like his predecessor Angelo de Jocopo Tani worked as an agent of the Medici in Bruges, commissioned a monumental paneled

Hugo van der Goes: Portinari Altarpiece
(center panel), c. 1475
Oil on panel, 253 x 304 cm
Galleria degli Uffizi, Florence
The realistic figures of the shepherds, their faces clearly aged by the effects of wind and weather, introduced a new and totally unknown element into the Italian painting tradition.

Domenico Ghirlandaio: Adoration
of the Shepherds (detail), 1485
Oil on panel, central panel: 167 x 167 cm
Cappella Sassetti, S. Trinità, Florence
Ghirlandaio was personally familiar with van der Goes' *Portinari Altarpiece,* and was inspired by the work to give individual physiognomies to the group of shepherds in his own rendering of the subject.

661

Nattier, Jean-Marc

Jean-Marc Nattier (1685 Paris–1766 Paris) received his first instruction in painting from his father, the portrait and history painter Marc Nattier. Afterward, young Nattier presumably became the pupil of Jean Jouvenet. Starting in 1710 he and his father worked together to complete etchings based on the paintings of Peter Paul Rubens, Charles Le Brun, and other old masters, and in 1717 the Czar Peter the Great (1682–1725) offered Nattier a position at the court of St. Petersburg; however, the painter turned it down. The following year Nattier was accepted into the Paris Academy as a *peintre d'histoire* ("history painter"), yet his eventual fame did not derive from his history paintings. Instead, his numerous impressive and brilliantly executed portraits of Parisian society reveal him to be one of the leading portraitists of the era of Louis XV (1715–1774). Among Nattier's works are *Joseph and the Wife of Potiphar*, 1711, Hermitage, St. Petersburg; *Battle at Poltava*, 1717, Pushkin Museum of the Fine Arts, Moscow; and *Duchess de Chaulnes as Hebe*, 1744, Musée du Louvre, Paris.

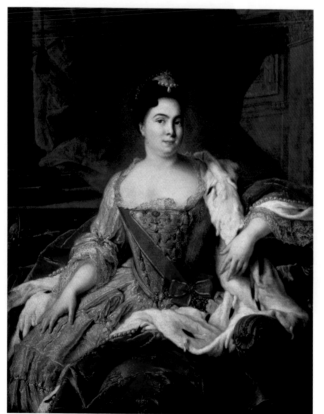

Portrait of Catherine I, 1717
Oil on canvas, 142.5 x 110 cm
The Hermitage, St. Petersburg
Nattier painted this impressive state portrait of Catherine I (1684–1727), the second wife of the Czar Peter the Great, in the Hague in 1717. The Czarina is wearing over her precious gown a splendid ermine-lined cape whose soft folds fill the entire bottom half of the picture. In the same year Nattier also painted a counterpiece to this portrait depicting the armored Czar in front of a battle scene in the background.

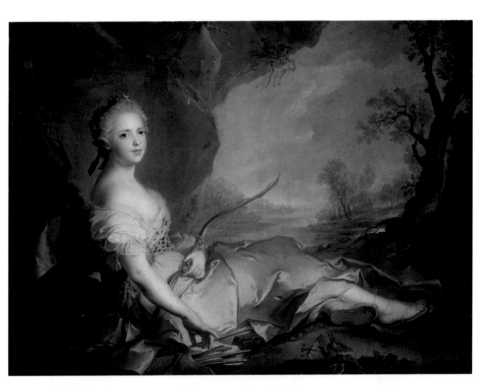

**Marie-Adelaide of France
Represented as Diana, 1745**
*Oil on canvas, 95 x 128 cm
Galleria degli Uffizi, Florence*
This idealized portrait depicts
Marie-Adelaide (1732–1800), the
third daughter of Louis XV, dressed
as the goddess Diana in front of a
broad, wooded river landscape. The
quiver with arrows, the bow, and
the crescent moon in her hair, as
well as the tiger fur decorating her
dress, are all references to the god-
dess of the hunt. This type of
painting, the *portrait historié* that
Nattier often used with multiple
variations in his Rococo portraits,
derived from the tradition of 17th-
century Netherlandish painting.
With artistic finesse he unites the
sitter's delicate facial expression,
the tender bodily form, the charm-
ing pose, and the gleam of the
material into a unified whole.

Oberrheinischer Meister / Master of the Upper Rhine

The Master of the Upper Rhine (active in the first quarter of the 15th century) has been identified only in association with the *Little Garden of Paradise* in Frankfurt. Attempts to attribute two other paintings to the same artist—a Crucifixion from the Musée d'Unterlinden in Colmar dating from c. 1405 and an Annunciation dating from c. 1430, now in the Collection of Oskar Reinhart in Winterthur—have provided little convincing evidence as yet. Because of the lack of sources, arguments can only be based on a critique of style, and the other works do not match the quality of this one.

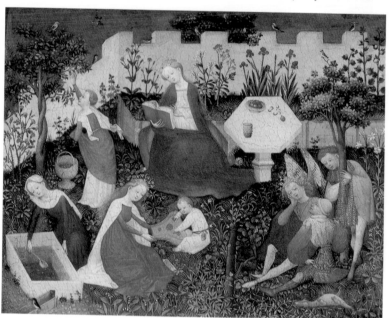

Little Garden of Paradise, c. 1420
Oil and tempera on panel,
24 x 33 cm
Städelsches Kunstinstitut,
Frankfurt am Main
Every detail of this outstandingly executed picture can be interpreted as a medieval symbol. For example, the crown indicates that the Virgin is the queen of heaven, while the walled garden is a reference to the *hortus conclusus* and, together with the lilies, symbolizes Mary's virginity. The May bells serve as a symbol of love, future joy, and the arrival of Christ; whereas violets represent humility. The peaceful *Little Garden*, which expresses the joy of the soul, corresponds to a type of small-format devotional picture which reached its apotheosis around 1450 in Stefan Lochner's *Madonna in the Rose Garden*, now located in the Wallraf-Richartz Museum, Cologne.

Orcagna, Andrea

According to Giorgio Vasari, Andrea Orcagna (1308 Florence–after 1368 Florence), whose actual name was Andrea di Cione Arcagnuolo, was trained as a painter by his older brother Nardo. Orcagna remained in Florence his entire life, busy with commissions for frescoes and altarpieces. The multifaceted master was not only a painter, however, but also a sculptor, architect, and poet. As early as 1347 his name occurs in a document from Pistoia citing him as being among the best Florentine artists, and later both Lorenzo Ghiberti (c. 1380–1435) and Vasari praised him highly. Characteristic of Orcagna's work are large painting formats and monumental design of the statuesque-like figures, all of which reveal a familiarity with Giotto. The lively coloration and rhythmically Gothic flow of lines in the figures' clothing are signs of the new style that would subsequently give a decisive stamp to Florentine art. Works by the artist include *Christ with the Virgin and Saints (Pala Strozzi)*, 1357, Santa Maria Novella, Florence; and *The Triumph of Death*, c. 1360, fresco fragment, San Croce, Florence.

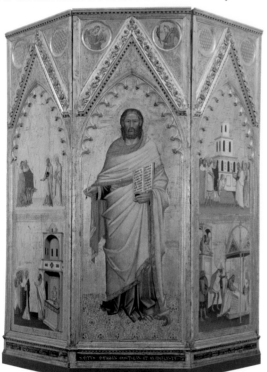

St. Matthew Altarpiece, 1367/68
Tempera on panel, 291 x 265 cm
Galleria degli Uffizi, Florence
This monumental paneled altar was Orcagna's last work, commissioned in 1367 for a pillar in the Florentine church of Or San Michele. After the master's death, his younger brother, Jocopo Orcagna, completed the altar. In the center panel stands the apostle Matthew, author of the first Gospel. The side panels show scenes from his life: In the upper left is his defeat of the dragon that was set against him in Vadaber, and beneath them is Matthew's conversion to Christianity. On the right panel are scenes containing the resurrection of the son of King Egippus in Vadaber and Matthew's death as a martyr by a dagger wound.

Orley, Barent van

Barent van Orley (c. 1488 Brussels–1542 Brussels) was the son and pupil of the painter Valentin van Orley. Later he probably studied under Herman van den Haute in Mechelen, and from 1515 he worked in Brussels for the Archduchess Margarete of Austria (1480–1530), the viceroy of the Netherlands. She appointed him court painter in 1518, an office which he retained under the archduchess' successor, Maria of Hungary (1505–1558), in 1530. There is no documentation that the artist journeyed to Italy, but knowledge of Italian Renaissance painting is clear in Orley's work, a familiarity which he may have gained through sketches of Raphael's paintings that were available for viewing in Brussels as well as his acquaintance with Albrecht Dürer, whom Orley met in 1521. In addition to large altarpieces and portraits, the master also left behind plans for decorative tapestries and painted glass windows. The artist's works include *The Holy Family*, 1522, Museo del Prado, Madrid; *The Last Judgment Altarpiece*, 1525, Koninklijk Museum voor Schone Kunsten, Antwerp; and *Portrait of Jean Carondelet*, c. 1530, Alte Pinakothek, Munich.

Portrait of Joris van Zelle, 1519
Oil on panel, 39 x 32 cm
Musées Royaux des
Beaux-Arts, Brussels
According to the inscription on the tapestry in the background, the portrait depicts Joris van Zelle at age 28. Barent van Orley painted his friend, who is documented to have been the city doctor for Brussels from 1522, in the figure of a humanistic scholar, a portrayal which is iconographically connected with the depiction of St. Jerome in his study. The intertwined hands appearing on the wall hanging are to be read as a symbol of harmony.

Ostade, Adriaen van

Adriaen van Ostade (1610 Haarlem–1685 Haarlem) spent his entire life in the city of Haarlem, near Amsterdam. According to Arnold Houbraken (1660–1719), the artist learned his trade in the workshop of Frans Hals. He is first documented as a painter in 1632, and two years later he entered the Haarlem Guild of St. Luke, of which he became dean in 1662. Ostade painted occasional history paintings and portraits, but devoted himself in particular to peasant genre scenes, a form that was noticably influenced by his work. In the 1630s he preferred small format, multi-figured paintings of tavern scenes and peasant dwellings, but from the 1640s, the rough peasant milieu gave way to scenes of bourgeois and city life. Ostade completed several

hundred paintings and left behind around 400 drawings and watercolors, as well as approximately 50 etchings. Among the artist's works are *School Lesson*, 1634, Landesmuseum, Mainz; *Peasant Family*, 1668, Royal Collection, London; and *Peasant Family in a Courtyard*, 1673, National Gallery of Art, Washington.

Village Feast, c. 1635
Oil on panel, 27 x 30 cm
Museo del Prado, Madrid
The caricature-like crudeness of this group of peasants is typical of Ostade's work in the 1630s. The painter's genre scenes appealed to an artistically educated bourgeois public that enjoyed the stimulation of the strange, comic, and absurd that they found in the banal and instinct-driven activities depicted by Ostade in his peasant scenes.

Family Portrait, 1654
Oil on panel, 70 x 80 cm
Musée du Louvre, Paris
The relatively small format of this family portrait is characteristic of 17th-century Dutch portrait painting. It was around this time that the backgrounds to such paintings, which up until then usually had been monochrome, became increasingly individual. Thus the background of this family portrait, now in Paris, presents the interior of a prosperous middle-class household. The rich decoration of the room, including pictures and pieces of porcelain, indicates the inhabitants' artistic sensibility.

Overbeck, Johann Friedrich

Johann Friedrich Overbeck (1789 Lübeck–1869 Rome) studied first with Jean Peroux and later, from 1806, attended the Academy in Vienna, where he was among the founders of the Guild of St. Luke there. Overbeck moved to Rome in the autumn of 1809, where he resided for the rest of his life with the exception of a stay in Germany in 1831. The artist is valued as the leader of the "Nazarenes," a group of German painters living in Rome who took up residence in the monastery of S. Isidoro in 1810, and produced a nationalistic yet religious art. Overbeck participated in the collective work of the group with the decoration of the Casa Bartholdy in Rome, begun in 1816/17, and the painting of the Villa Massimo between 1817 and 1827. Other works by the artist include *Self-Portrait with Family*, 1823, Sankt Annen Museum, Lübeck; and *The Sale of Joseph and the Seven Lean Years*, 1816/17, Nationalgalerie, SMPK, Berlin.

Italia and Germania, 1811–1828
Oil on canvas, 94 x 104 cm
Neue Pinakothek, Munich
The two young women are personifications of the art of the Italian Renaissance and the Old German painting tradition. Italia, on the left, is reminiscent of the Madonnas of young Raphael and Perugino. The blond Germania, to the right, is wearing a gown from the time of Albrecht Dürer.

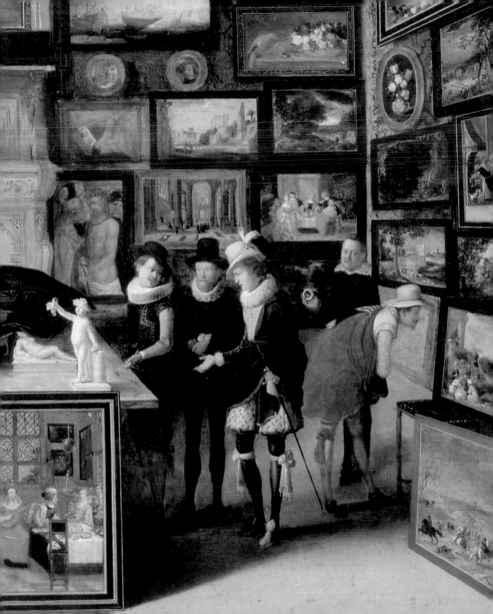

From Market Booths to Art Dealers

As early as the end of the 15th century Flemish painters in Antwerp were beginning to complain about unwanted competition from the surrounding areas. Travelling art dealers arrived from various locales and hawked their pictures in alleys, on bridges, and in the plazas. In Antwerp, as in other cities, the magistrates and the painters' guild attempted to put an end to this uncontrolled sales activity. They drew up an ordinance stating that "from henceforth, anyone, no matter who, from the land of Brabant or beyond, shall be allowed to deal in altar paintings, pictures, carvings, readers desks…and similar items, whether painted or unpainted, from wood or stone, during the annual market only by the church yard of the Church of Our Lady." Scofflaws were subject to punishment.

As a result, the first professional art market in the Netherlands arose in the booths that were erected in 1481 on both sides of the church yard specifically for selling art wares. The dealers who worked there paid a fee for the privilege according to the square footage of their stands. Paintings, sculptures and other wares produced for the open market were still offered for sale throughout the land at the annual and seasonal markets. The booths with paintings, visible among the animal dealers, medicine men, musicians, etc., in the series of illustrations of the annual market by David Vinckeboons (1576–1632), prove that the free sale of art work remained the normal practice into the 17th century.

Hieronymus Francken II: The Art Dealership of Jan Snellinck in Antwerp, 1621
Oil on panel, 94 x 124.7 cm
Musées Royaux des Beaux-Arts, Brussels
Elegant customers throughout Europe came to Jan Snellinck, one of the more important art collectors and dealers in Antwerp, to purchase Netherlandish and Italian paintings and occasionally sculpture.

Around 1540, when the population of Antwerp had reached approximately 60,000 and the city had emerged as one of the most important economic and trading centers of the world, the city located on the Schelde River was equally attractive to scholars, humanists, and artists. At that time the city was home to around 300 masters who produced paintings and printed works of art. This number becomes even more astounding in contrast to the number of bakers

(about 150) and butchers (around 75) at work in the city. If the blossoming of art in an area goes hand in hand with a thriving economy, the same holds for those dealing in art. In an exemplary move, the city of Antwerp set up a permanent salesroom in the uppermost gallery of the newly founded trade market. In 1565, Bartholomaus de Momper (1535–after 1597), son of the painter Joos de Momper, took over the gallery. A general recession occurred along with the violent iconoclastic warfare that began in 1566 and raged throughout the final quarter of the century, causing craftsmen and artists to leave the city in order to avoid judgments and confiscation of their artworks. The *Spaanse Furie* ("Spanish Fury") of November 1576, in which hundreds of citizens died and large portions of Antwerp were plundered by Spanish troops, forced many merchants to abandon the city permanently, thus leading to a serious breakdown of its economic life. By 1595, even Bartholomaus de Momper's gallery consisted of a mere eight booths. Aside from him, only three other painters remained as renters.

Now under the rule of the Spanish Habsburgs, in the following years Antwerp developed into a bulwark of the Counter-Reformation. The altars that had been destroyed during the iconoclastic attacks in churches, cloisters, and chapels had to be restored or, to a large extent, replaced. This task was accomplished chiefly by the well-organized workshop of Peter Paul Rubens (1577–1640), who lived in Antwerp from 1608 on. Most importantly, his works caused a new blossoming of the Antwerp School of painting and an international art trade.

After the mid-16th century, auctions represented another means of acquiring art beyond that offered by the established art traders. These

David Vinckeboons:
Annual Market
Oil on panel, 115 x 141 cm
Herzog-Anton-Ulrich-Museum,
Brunswick
This composition, a copy of a lost work by David Vinckeboons, portrays a kermess festival at the marketplace of a small imaginary town set outside the city gates of Antwerp. In front of the city hall in the center of the picture, in addition to a touring troupe of actors, are booths and stands set up for the sale of paintings and other works of art.

affairs often were held at the *Vrijdagsmarkt* ("Friday market"), which had been established as a free market, held close to the Schelde River, in 1547. Contemporaries soon were complaining about the crafty and all-too-often importunate behavior of the traders, who tried to hawk bad copies or second-class paintings to unsuspecting customers. The regulations that allowed the painters' Guild of St. Luke to sell only finished pictures from artistic remnants by deceased members led to the reworking of numerous unfinished pieces by pupils, workshop assistants, and other painters. These pictures then tended to be offered for sale, largely at the free market.

Toward the middle of the 17th century, Antwerp lost its position of leadership as the chief trade city of Europe when the Schelde, which connected the city to the sea, was blocked and the harbor filled with sand. However, the decline of Antwerp became the particular good fortune of Amsterdam, the capital city of the Netherlands. A new economic center arose there which included numerous artists and an active trade in artworks.

Pacher, Michael

Michael Pacher (c. 1435 Bruneck–1498 Salzburg) probably received his early artistic training in his native city, and is mentioned for the first time in 1467 as a painter and citizen of Bruneck, located in the south Tyrolean Pustertal. In 1484 he moved to Salzburg, where he worked on a high altar in the Franciscan church that remained uncompleted at his death. Pacher's artwork shows the influence of Hans Multscher, and recapitulates Multscher's *Sterzinger Altarpiece* (completed in 1458) as well as the art of northern Italy. In all probability Pacher travelled to Mantua and Padua in the 1450s and again around 1475. Active as a painter and a carver, Pacher numbers among the few outstanding artists north of the Alps whose work clearly illustrates the transition from Gothic to the early Renaissance. In his strongly expressive paintings, the outward movements of the figures are combined with a deep introspection. The artist's significant works also include *High Altar*, 1471–1481, parish church of St. Wolfgang, St. Wolfgang (Salzkammergut).

Prayer of St. Sigisbertus, c. 1480
Oil on panel, 103 x 91 cm
Alte Pinakothek, Munich
This painting, which older scholarship had interpreted as the prayer of St. Wolfgang, comprises one of the four exterior panels containing scenes from the life of St. Ambrose that were removed from the *Altar of the Church Fathers*. The panel shown here depicts the vision of the saint-bishop Sigisbertus of Disentis, to whom an angel appears with the heart of St. Augustine contained in a monstrance.

The Coronation of the Virgin, c. 1475
Oil on panel, 144 x 92 cm
Alte Pinakothek, Munich
The coronation of the Virgin takes place under a baldachin with richly intertwined architectural tracery. The spatial effect created by the painting must be seen as a masterwork of Gothic architectural painting. Even today it is impossible to determine whether this very finely finished—but considerably downsized—work was originally painted as a single piece, or was the central panel of a winged altar.

Following pages
Altar of the Church Fathers, c. 1480
Oil on panel
Central panel: 212 x 200 cm
Side panels: 216 x 91 cm each
Alte Pinakothek, Munich
The feast-day side of the altar presents the larger-than-life figures of the four Latin Church Fathers, from left to right the Sts. Jerome, Augustine, Gregory and Ambrose, enthroned under late-Gothic baldachins. Characteristic of Pacher's work are the deep figures filling the entire space, and accompanied by rich accessories. The writing desk and the four white doves, symbols of the Holy Spirit providing divine inspiration, refer to the Fathers' writings. Pacher finished the altar around 1480 for the Augustinian canons of Neustift near Brixen.

Palma Vecchio

Palma Vecchio (c. 1480 Serina, near Bergamo–1528 Venice), whose given name was Jacopo d'Antonio Negreti, moved to Venice in the late 1490s where he was a pupil of Francesco di Simone da S. Croce. Later he presumably worked in the workshop of Giovanni Bellini, and in 1513 he became a member of the Scuola di S. Marco. Palma, whose painting style owes much to the inspiration of Giorgione and the young Titian, numbers among the most important Venetian painters of the High Renaissance. He chiefly concentrated on mytho-logical and religious history paintings, in addition to impressive altarpieces. Balanced composition, avoidance of dramatic action, and a glowing, enameled coloration with a view to a harmonious effect are characteristic of Palma Vecchio's painting. Other works by the artist include *Venus Resting*, c. 1519, Gemäldegalerie Alte Meister, Dresden; *The St. Barbara Altarpiece*, 1521–1524, Santa Maria Formosa, Venice; and *Diana Discovers the Pregnancy of Callisto*, c. 1525, Kunsthistorisches Museum, Vienna.

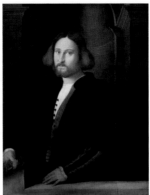

Francesco Querini, 1525–1528
Oil on panel, 86 x 72 cm
Fondazione Querini
Stampalia, Venice
The masterfully-executed coloration and lighting of this relatively simple portrait of a man make it clear why Palma Vecchio's contemporaries respected him so highly. The female counterpiece to this portrait, that of Paola Priuli Querini, likewise belongs to the Collection Querini Stampalia in Venice.

Judith with the Head of Holofernes, c. 1525
Oil on panel, 90 x 71 cm
Galleria degli Uffizi, Florence
In this painting Judith presents the head of Holofernes, whom she had decapitated to save the Israelites, to the viewers. The heroine appears before a dark background in the form of a well-endowed Venetian woman with long blond hair, corresponding to the ideal image of womanhood that is repeatedly found in the works of Palma and his contemporaries.

Opposite
The Adoration of the Shepherds, c. 1526
Oil on canvas, 118 x 168 cm
Museo del Prado, Madrid
This painting, executed with free brush strokes, presents the unity of man and nature in a world full of poetry and harmony. Although the composition of the *Adoration of the Shepherds* corresponds to Palma's presentations of the *sacra conversazione*, this interpretation has repeatedly been questioned.

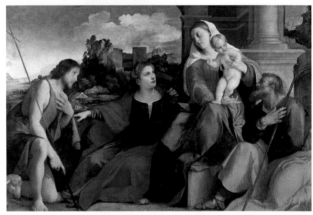

Sacra Conversazione, c. 1527
Oil on canvas, 126 x 195 cm
Galleria dell'Accademia, Venice
Palma Vecchio was concerned with the theme of the "sacred conversation" throughout his entire painting career, generally choosing to depict it in a square format. Here, in a seemingly free and unforced, but

nonetheless restrained manner, Mary Magdalen and John the Baptist have come to honor the Holy Family. The Virgin Mary no longer embodies the supernatural, but is quite fully integrated into the human world.

Pantoja de la Cruz, Juan

Juan Pantoja de la Cruz (1553 Valladolid–1608 Madrid) was initially a pupil of the Spanish painter Alonso Sánchez Coello, and probably remained in the workshop until his master's death in 1588. In the same year, Pantoja de la Cruz was appointed court painter by King Philip II (1527–1598), a position which he also held under Philip III (1598–1621). After 1598 the painter also held the additional title of *Pintor de Cámara* ("Chamber Painter"). Pantoja de la Cruz concentrated chiefly on portraits of the Spanish royal family and aristocracy. Between 1600 and 1607 he completed 66 portraits of 39 different members of the royal family. He also painted religious narratives, which often contain portraits of members of the royal house, and *bodégones*, or simple interior views of inns and kitchens. These, along with his ceiling frescoes, have rarely survived. Works by the artist include *Portrait of the Infanta Isabella Clara Eugenia*, 1599, Alte Pinakothek, Munich; *Anne of Austria*, 1604, Kunsthistorisches Museum, Vienna; and *The Adoration of the Shepherds*, 1605, Museo del Prado, Madrid.

Portrait of Philip III, 1606
Oil on canvas, 204 x 122 cm
Museo del Prado, Madrid
This large-format portrait is one of at least nine that Pantoja de la Cruz painted of the Spanish monarch. The counterpiece to this work, a portrait of Queen Margarete, also hangs in the Prado today. The portrait of Philip III corresponds to the type of the official, full-length portrait of a ruler that had been introduced by Anthonis Mor and Titian in the 16th century.

Parmigianino

Parmigianino (1503 Parma–1540 Casal Maggiore), whose actual name was Girolamo Francesco Maria Mazzola, spent his apprenticeship in Parma, where he was also chiefly active in the ensuing years. He lived in Rome between 1523 and 1527, and afterward moved to Bologna, finally returning to his native city in 1531. The last several years of Parmigianino's short life were spent in Casal Maggiore near Parma. He painted portraits as well as mythological and history paintings, and also carried out many commissions for frescoes and preliminary designs for prints. Parmigianino was influenced by Correggio, Raphael, and Michelangelo. The figures in his paintings are developed with great elegance, and typically show elongated proportions. His coloration varies, sometimes approaching the garish. Other works by the artist include *Self-Portrait In a Convex Mirror*, 1523, Kunsthistorisches Museum, Vienna; *Portrait of a Lady (Antea)*, 1524–1527, Museo Nazionale di Capodimonte, Naples; and *Madonna with a Rose*, c. 1530, Gemäldegalerie Alte Meister, Dresden.

The Turkish Slave, c. 1530/31
Oil on panel, 67 x 53 cm
Galleria Nazionale, Parma
The unknown woman gazing so charmingly at the viewer is wearing a costly dress and an Oriental-looking headdress. Her left hand, with its slim elongated fingers, is characteristically Mannerist. This picture from the collection of Cardinal Leopoldo de'Medici (1617–1673) impressively proves Parmigianino to be not only an innovative history painter, but also a fascinating portraitist.

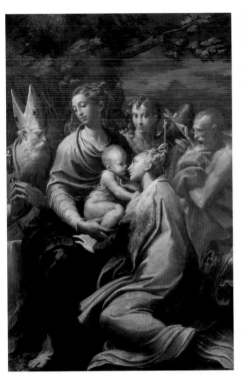

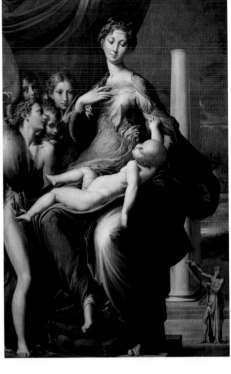

The St. Margaret Madonna, 1528/29
Oil on panel, 204 x 149 cm
Pinacoteca Nazionale, Bologna
The Virgin and Child are depicted in the open air,
surrounded by saints. The figure of Margaret of Antioch,
identified by the dragon in the lower righthand corner
of the picture, takes the boy Jesus from Mary and into
her own arms. The soulful eye contact between the two
testifies to the young woman's depth of faith. She is
supposed to have been beheaded under Emperor
Diocletian (284–305 A.D.), and according to the legend
drove off a dangerous dragon, who nevertheless remains
here to aid in identifying her.

Madonna of the Long Neck, c. 1535
Oil on panel, 216 x 132 cm
Galleria degla Uffizi , Florence
The so-called *Madonna dal Collo Lungo*, which origi-
nally hung in the Severite Church in Parma, is among
the major works of Italian Mannerism. Characteristic
of this style are the rich contrasts in the composition:
The large and small figures stand in opposition to each
other, as do the empty versus the over-filled surfaces.
The artificial formal language is effectively demonstrated
in the figure of the Madonna, here presented as the type
of the *figura serpentinata* which would became a
trademark of Parmigianino's later style.

Patenier, Joachim

Joachim Patenier (c. 1485 Dinant or Bouvignes–1524 Antwerp), also known as Joachim Patinir, was accepted into the St. Luke's Guild of Antwerp as a master in 1515, but the location of his apprenticeship remains unknown. In 1521/22 he initiated contact with Albrecht Dürer, who had great respect for the Antwerp artist. The totality of Patenier's oeuvre consists of around 20 paintings, none of which are dated, and only five are signed—chiefly religious narrative paintings with panoramic landscape views. His generic landscapes, marked by strange rock formations, are important to the development of the independent genre of landscape painting. Significant works by the artist include *The Flight into Egypt*, Koninklijk Museum voor Schone Kunsten, Antwerp; *The Sermon of John the Baptist*, Musées Royaux de Beaux-Arts, Brussels; and *The Temptation of St. Anthony*, Museo del Prado, Madrid.

Journey into the Underworld, c. 1522
Oil on panel, 64 x 103 cm
Museo del Prado, Madrid
This painting with its broad landscape seen from a bird's eye view unites elements of classical mythology and Christian iconography. Charon rows his ferry containing a single dead soul across the River Styx. In the composition, which corresponds to the medieval scheme of the Last Judgement, Heaven is to the left and Hell is seen on the right.

St. Christopher
Oil on panel, 100 x 150 cm
Monastero, El Escorial,
near Madrid

According to legend, St. Christopher carried Christ in the form of a child across a raging river. The giant, who almost collapsed under the Child's weight, was converted to Christianity after the Child revealed himself to be the Creator and Lord of the World. Patenier portrays the action before a broad and lively generic landscape. The painter exerted a lasting influence on Netherlandish landscape painting with this background type.

Rest on the Flight into Egypt
Oil on panel, 121 x 177 cm
Museo del Prado, Madrid

Patenier modeled himself on the older tradition of Lucas van Leiden and Rogier van der Weyden in his paintings of the Virgin, but the artist's broad populated landscapes are convincingly modern—an aspect that is evident in the structure of the composition and in the tripartite scheme of the coloration. The layering of brown, green, and blue remained canonical in Netherlandish landscape painting until around 1600. The imaginary city seen in the detail on the opposite page yields a glimpse of the journey's goal. People in Oriental clothing, some of whom are carrying sacrifices to heathen gods, populate the buildings. Here, also, Patenier's intensive study of Old Netherlandish painting is clear.

Perugino, Pietro

Pietro Perugino (c. 1448 Città della Pieve, near Perugia–1523 Fontignano), born Pietro de Cristoforo Vannucci, stands as one of the major masters of the Umbrian School and a trailblazer of the High Renaissance. His early apprentice years were probably spent in Perugia, and from 1472 he was a member of the painters' guild in Florence, where he may also have been a student of Andrea de Verrocchio and Piero della Francesca. Following their example, Perugino took up issues in the design of bodies in space as well as the balance between pictorial surface and pictorial space. In the process he arrived at balanced and self-contained compositions with a soft, unified coloration. Active in Umbria, Venice, and Tuscany, Perugino often worked in Rome between 1478 and 1492. By the end of his career he was occupied exclusively in Florence. The peak of his creativity was reached around 1500, when the young Raphael entered his workshop as a pupil. Works by the artist include *The Vision of St. Bernard*, 1489, Alte Pinakothek, Munich; *Crucifixion*, c. 1495, S. Maria Maddalena dei Pazzi, Florence; and *Struggle between Chastity and Love*, 1540/45, Musée du Louvre, Paris.

**Healing of a Girl by
St. Bernard, 1473**
*Tempera on panel, 75 x 57 cm
Galleria Nazionale
dell'Umbria, Perugia*
Along with other artists, including
Pinturicchio, Perugino participated
in painting a cycle of scenes from
the life of St. Bernard for the church
of San Francesco al Prato. The
works stand out for their splendid
rendering of architecture and their
delicate landscapes, and they clearly
indicate a knowledge of the painting
of Andrea Mantegna on the part of
the artist. In addition, their clear
colors and their elegant and dainty
figures reflect the art of Ferrara.

Opposite
**Virgin and Child
with Saints, c. 1480–1490**
*Oil on panel, diam. 148 cm
Musée du Louvre, Paris*
The figures in this tondo painting
are in complete harmony with one
another. At the left is St. Rose and,
opposite her, in an area separated
from the world by a wall, stands
St. Catherine. The delicate compo-
sitional style characteristic of
Perugino's painting is also evident in
this work. Even if his paintings are
often lacking in drama, the charm,
elegance and loveliness of his figures
nevertheless have nothing decora-
tive about them. Rather, they arise
from the painter's heartfelt feelings
and quiet sensitivity.

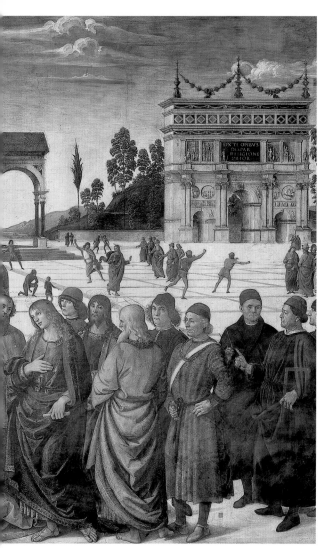

The Charge to St. Peter (The Handing of the Keys), c. 1482

Fresco, 335 x 550 cm
Sistine Chapel, Vatican

This fresco brought Perugino high renown particularly for the depth of its perspective and the artful arrangement of the architecture. The painting depicts the awarding of the highest level of earthly priesthood to Peter, the first of the succession of popes. The transference of the keys—the symbol of ecclesiastic power—is emphasized by the downward vector from Christ to the kneeling apostle Paul. The faces of the witnesses to the scene here are rumored to include portraits of some of Perugino's contemporaries, including the artist's self-portrait.

Francesco delle Opere, 1494
Oil on panel, 52 x 44 cm
Galleria degla Uffizi , Florence
The portraits of the masterful Perugino reveal brilliant psychological understanding, visible here in every facial feature of this rich Florentine merchant. He gazes out at the viewer with self-confidence and somewhat scornfully, even though the words "fear God" are written on the roll of paper in his hand. The high quality of this painting points the way to the portraiture of Raphael.

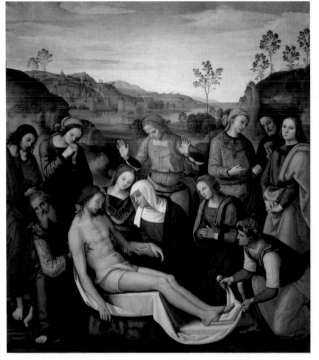

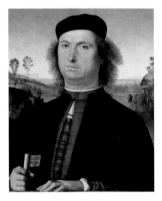

Mourning of the Dead Christ (The Deposition), 1495
Oil on panel, 214 x 195 cm
Galleria Palatina,
Palazzo Pitti, Florence
This altarpiece is among the most significant works of the artist's mature creative years. The new, free design of the painting is outstanding here, as is its delicate coloration as well as the gestures and the facial expressions, all worked out in fine gradations of feeling. The emotions range from the wonder and love expressed by the kneeling Virgin, through the bewildered incomprehension of Mary Magdalen standing behind her, to the deep pain of Nicodemus in the left foreground. Giorgio Vasari later praised the beautiful landscape of this painting, in particular.

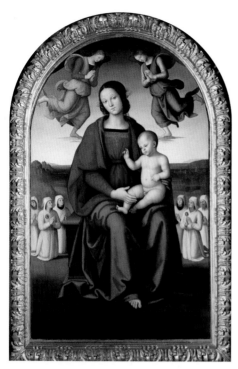

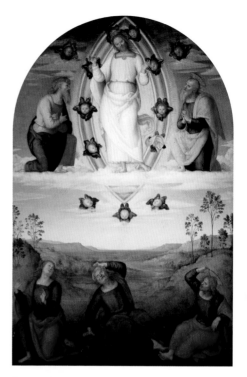

Madonna Consolazione, c. 1497
Tempera on panel, 263 x 176 cm
Galleria Nazionale dell'Umbria, Perugia
Perugino presents the Virgin Mary not only in the role
of comforter but also as the protector of the Brother-
hood of St. Peter the Martyr. The members of the order
appear in the background, smaller but nonetheless finely
characterized. Perugino redefined this type of Madonna
composition by depicting the Christ Child in a sitting
position with his hand raised in blessing. The panel also
stands out for its fine and sophisticated execution.

The Transfiguration of Christ, c. 1518
Tempera on panel, 290 x 185 cm
Galleria Nazionale dell'Umbria, Perugia
This altarpiece is a beautiful example of Perugino's soft,
transparent application of color as well as of his fine
depiction of the distant hill landscapes that serve to
highlight the importance of the figures. Blinded from the
appearance of Christ and the prophets, the apostles fall
back in awe. As in the *Deposition*, the sensitive ex-
pression of the figures is mirrored in their movements,
which have been developed individually.

The Last Supper, c. 1500
Fresco, 435 x 794 cm
Cenacolo de Foligno, Florence
Inspired by Ghirlandaio, Perugino created this fresco for the cloister of nuns at San Onofrio. The artist rejected strong displays of emotion in this particular rendition of the popular theme. Rather, the total effect of the main event, along with the addition of the incident that followed it, gives the painting its unmistakable character. In this way the landscape with Christ on Mount Olive is included, and the chalice in the hands of the angels refers to Christ's prayer that this cup may pass him by.

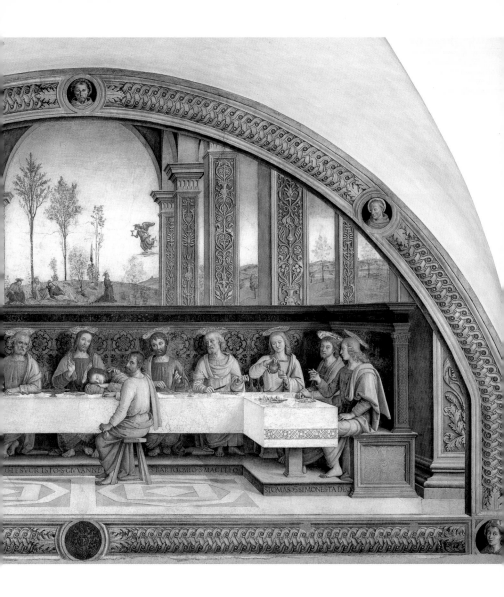

Pesne, Antoine

Antoine Pesne (1683 Paris-1757 Berlin) first studied with his father, the painter Thomas Pesne, and later with Charles de la Fosse in Paris. Between 1705 and 1710 the artist visited Italy, spending time especially in Venice, where he associated with Andrea Celesti, whose painting had a clear influence on Pesne's early work. In 1710 Pesne was appointed by King Frederick I of Prussia to the post of court painter in Berlin, which became his base for short journeys to the courts of Dessau (1715), Dresden (1718), London (1723) and Paris (1724) in the ensuing years. In 1733 he was named director of the Berlin Academy of Art. Pesne stands as one of the important conduits of French art to Brandenburg-Prussia. Primarily active as a portrait painter, he also carried out many wall and ceiling paintings for Frederick the Great (1712–1786) in his royal palaces. Other works by the artist include *The Painter with his Family*, 1718, Neues Palais, Potsdam; *Self-Portrait*, 1728, Gemäldegalerie Alte Meister, Dresden; and *Frederick the Great as Crown Prince*, 1739/40, Gemäldegalerie, SMPK, Berlin.

The Ballerina Barbara Campanini, known as "La Barbarina", c. 1745
Oil on canvas, 221 x 140 cm
Charlottenburg Palace, Berlin
In its light and gracefully moving forms, its seemingly spontaneous painting technique, and its light, pastel colors, this painting is characteristic of the work of Antoine Pesne and the Rococo period as a whole. Frederick the Great (1712–1786) highly valued the famous *plein-air* ("open-air") portrait of his court painter, and allowed it to be hung in a preferred place in his private study in his palace in Berlin.

Piazzetta, Giovanni Battista

Giovanni Battista Piazzetta (1682 Venice–1753 Venice) was the son of the wood carver and sculptor Giocomo Piazzetta. After initial instruction with his father, the young man continued his training in Venice under Antonio Molinari, and after 1703 in Bologna where he was especially influenced by the genre painting of Giuseppe Maria Crespi. After 1711 Piazzetta became a permanent resident of Venice. Piazzetta was the most sought-after ecclesiastical painter of the *Settecento* in Venice besides his younger colleague and rival, Giovanni Battista Tiepolo. He also painted portraits and genre paintings and executed illustrations for books. Among his important patrons were the Prince-Elector Clement-August of Cologne, and Field Marshal Johann Matthias von der Schulenburg. Other works by the artist include *Susanna and the Elders*, c. 1720, Galleria degla Uffizi , Florence ; *St. Francis in Ecstasy*, c. 1732, Museo Civico, Vicenza; and *Rebecca at the Well*, c. 1740, Pinacoteca di Brera, Milan.

The Vision of St. Philip of Neri, 1725
Oil on canvas, 367 x 200 cm
Santa Maria della Fava, Venice
Philip of Neri (1515–1595) was the founder of the Oratorian order, and paintings of his heavenly vision, in which he was visited by the Virgin and Child, were present in almost every one of the many Oratorian churches of the 16th and 17th centuries in Italy. Piazzetta underlined the visionary character of the event through the upward-sweeping design of the monumental composition, the heavy glowing colors, and the strong *chiaroscuro* effect.

**St. James Being Dragged
to Martyrdom, c. 1717**
Oil on canvas, 165 x 138 cm
S. Stae, Venice
The two figures depicted in the
immediate foreground of this paint-
ing are at once vivid, tense and
monumental. As the aged apostle
James is straining to the right, his
young torturer uses his whole
strength to drag the bound figure
off toward the left. According to the
legend, James the Lesser, the author
of the Epistle, was thrown from the
wall of the temple in Jerusalem for
his faith and then clubbed to death.

Piero della Francesca

Piero Della Francesca (c. 1420 Borge San Sepolcro, near Arezzo–1492 Borge San Sepolcro), born Piero de Benedetto dei Franceschi, was one of the most important painters of the early Renaissance and a pioneer of the art of rendering perspective. He lived in Florence between 1439 and 1442, where he worked together with Domenico Veneziano. It is from Veneziano's work, as well as from the innovations in perspective and coloration introduced by the other Florentine painters (in particular Andrea del Castagno), that Piero developed a new and earnest pictorial language. His paintings are characterized by the three-dimensional modeling of his figures and his mathematically precise construction of spatial depth. He also developed an innovative glazing technique that lent his works an atmospheric effect. Piero della Francesca did most of his work in his native city, but also carried out commissions in Ferrara, Arezzo, Rome, Urbino, and elsewhere. Important works by the artist include *St. Jerome with the Patron Girolamo Amadi*, 1440–1450, Galleria dell'Accademia, Venice; *Nativity*, 1470–1485, The National Gallery, London; and *The Adoration of the Magi*, after 1472?, The National Gallery, London.

Virgin and Child (Madonna di Senigallia), c. 1465–1475
Oil on panel, 61 x 53.5 cm
Galleria Nazionale
delle Marche, Urbino
Although this panel shares many similarities with the *Pala Montefeltro*, it creates an entirely different, more intimate effect achieved through the clear contours of the figures, which bring them very close to the viewer. The same effect results from the view into the Virgin's bedroom, referring to the earlier event of the Annunciation. The representation of the various materials is likewise outstanding.

Right

The Scourging of Christ, c. 1470
Mixed media on wood,
58.4 x 81.5 cm
Galleria Nazionale
delle Marche, Urbino

As in the fresco above, this painting
also portrays two separate scenes. In
the right foreground, three ele-
gantly-clothed gentlemen stand in a
sunny square. Diagonally across
from them and in an interior room,
the scourging is taking place before
Pontius Pilate and another observer.
The real theme of the painting is the
light with which the painter skill-
fully shapes the figures and archi-
tecture. In the process he is equally
rational as he is in constructing the
perspective that determines the
effect of the picture as a whole.

Opposite, top

The Adoration of the Holy Wood by the Queen of Sheba and her Meeting with King Solomon, c. 1452–1466

Fresco, 336 x 747 cm
San Francesco, Arezzo

This fresco in the chancel of the church belongs to the Legend of the Holy Cross cycle and depicts two separate scenes. On the left, the queen kneels humbly before a bridge in the knowledge that it is made from the Holy Wood. On the right, seen also in the detail, she tells Solomon about her vision. The clear and strong structure of the fresco creates a certain warmth and an incomparable intensity through the depiction of the expression of emotions. Piero della Francesca created a masterpiece of the early Renaissance in the frescoes of the chancel chapel of Arezzo.

The Adoration of the Holy Wood by the Queen of Sheba and her Meeting with King Solomon (detail)

The Queen of Sheba—who appears in various outfits within the scenes of the cycle but always wears the same headdress—is seen greeting King Solomon with great dignity. Impressed by the wisdom of the king, she confirms his claim to the throne as the will of God and gives him rich gifts of gold and precious jewels. Piero della Francesca worked with various sketches of the scene which were then transferred and copied, as here in the companions of the queen—a method of working which suggests that the artist allowed his assistants to complete the comprehensive project.

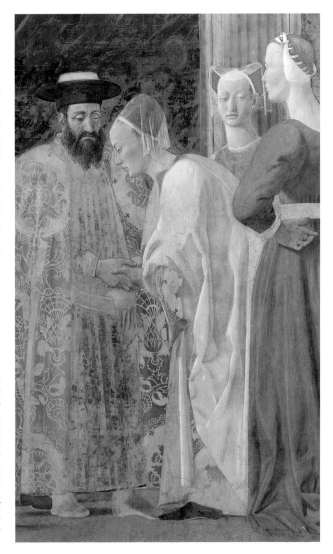

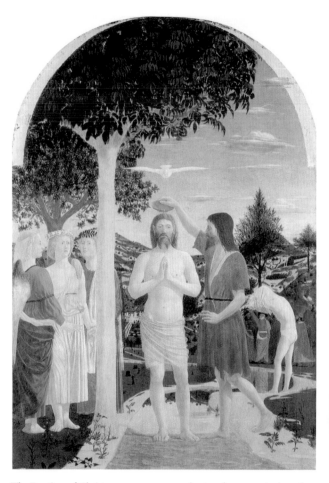

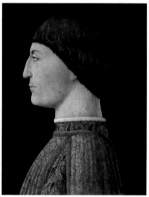

Portrait of Sigismondo Pandolfo Malatesta, c. 1450
Mixed media on panel,
44 x 34 cm
Musée du Louvre, Paris
This impressive portrait depicts the tyrannical Prince of Rimini, who was reputed to be completely amoral in his political affairs. Particularly striking here is the dark background from which the brightly lit profile emerges. This harsh contrast, as well as the absence of decorative props and the statuesque presentation of the figure, lends the portrait the monumental character of a sculptured bust.

The Baptism of Christ,
c. 1440–1450
Tempera on panel, 167 x 116 cm
The National Gallery, London
This painting is significant in its time period for its harmonious synthesis of geometrical surface composition and a spatially deep landscape. The rectangular arrangement of the figures along with the horizontal constellation of Christ, the baptismal bowl, the Dove symbolizing Holy Spirit, and the crown of the tree all preserve the surface of the picture, whereas the smoothly winding Jordan River and its reflections unite the foreground with the background.

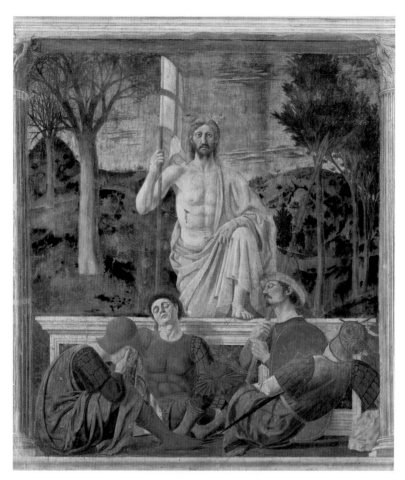

**The Resurrection
of Christ, c. 1460**
*Fresco, 225 x 220 cm
Pinacoteca Comunale,
Sansepolcro*
The artist painted this majestic

scene for the city hall in Sansepolcro
("Holy Grave"). Thematically it
refers to the city's coat of arms, but
the painting also contains a mystical
symbolism. The landscape in the
background seems to be split in two

at the moment of the Resurrection:
To Christ's left it remains bleak
and barren, while to the right it is
brought to life with vegatation and
a village, which acts as the witness
to human existence and creativity.

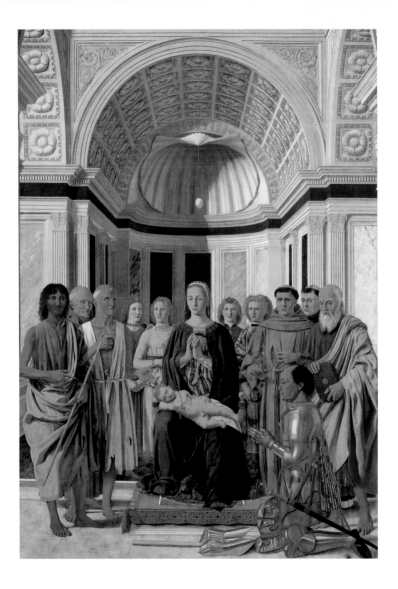

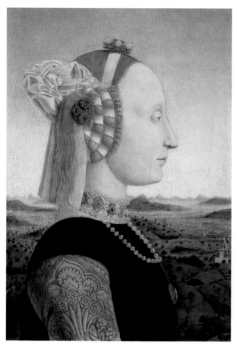 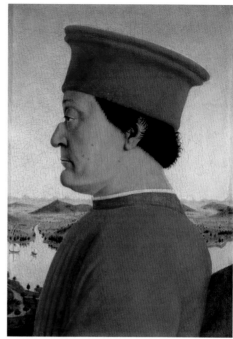

Opposite
Virgin and Child with Saints
(Pala Montefeltro), c. 1473
Oil on panel, 248 x 170 cm
Pinacoteca di Brera, Milan
This altar painting, commissioned by Federigo da
Montefeltro (1444–1484) for S. Bernardino in Urbino,
portrays the patron in gleaming armor in front of the
Virgin, who is enclosed in a semicircle of saints. The
pictorial space extends far into the depths, so that the
group is placed in the transept of the church rather than
in the apse. The suspended egg is at once a symbol of
the birth of Christ and the emblem of the Montefeltros.

Battista Sforza and Federigo
da Montefeltro, c. 1465–1466
Oil on panel, 47 x 33 cm each
Galleria degla Uffizi , Florence
The ducal pair is presented here in geometrically stark
profile—a mode of portrayal that still reflects the
Italian early Renaissance, yet the fine execution of the
details, the distant landscape depicting the ducal
territories, and the exaggeratedly high position of the
subjects on the canvas reveal a Flemish influence. The
reverse side of the diptych depicts the triumphant
procession of the ruler in a classical style.

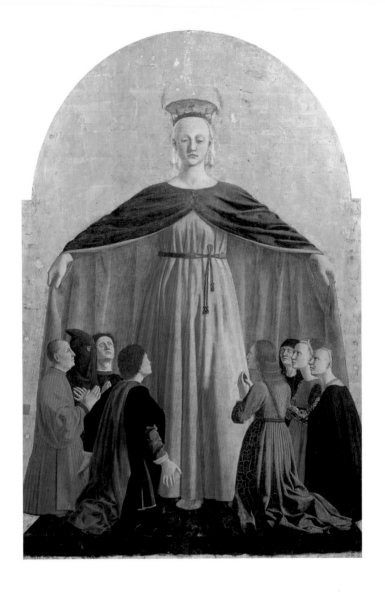

Opposite
Madonna of the Protective Mantle, 1444–1464
Mixed media on wood,
134 x 91 cm
Pinacoteca Comunale,
Sansepolcro
This work forms the main panel of the polyptych of the Misericordia for the Brothers of Mercy in Sansepolcro. The theme derives from the medieval custom of the "protective mantle" that might be extended by socially prominent women who presented themselves as intercessors for the persecuted by granting them asylum under their mantle or veil. The portrait of the artist can be found in the group on the left side next to the figure in the hood.

The Perugia Altarpiece, 1460–1470
Mixed media on wood,
338 x 230 cm
Galleria Nazionale dell'Umbria,
Perugia
The painter impressively combines old and new conceptions of art in this still-traditional altar work with its many fields. Thus the perspectively-constructed architecture in the Annunciation scene gives way to the medieval gold background of the main panel. The presentation of the stigmatization of St. Francis in the center predella panel is also unusual, as it presents one of the few nude scenes in the early Renaissance.

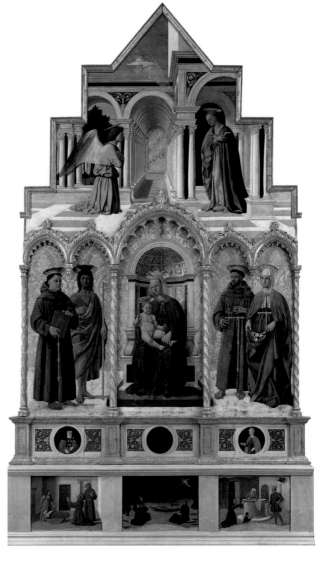

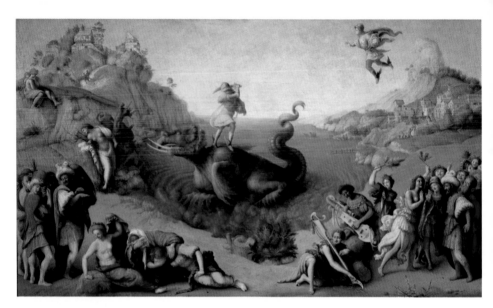

Piero di Cosimo

Piero di Cosimo (1462 Florence-1521 Florence), whose real name was Piero di Lorenzo, studied in Florence under Cosimo Rosselli. In 1481-82 he worked together with Rosselli on the frescoes in the Sistine Chapel in Rome, but subsequently spent most of his creative life in Florence. Not a single signed or dated picture from his own hand has survived, but based on Giorgio Vasari's biography of 1550, several altarpieces, mythological narratives and portraits have been attributed to him. The artist's style shows the influence of Filippino Lippi, Domenico Ghirlandaio, the early work of Leonardo da Vinci and Hugo van der Goes. These various inspirations were combined by di Cosimo into a style that combines lyric and dramatic pictorial elements. Other works by the artist include *Venus and Mars*, c. 1498, Gemäldegalerie, SMPK, Berlin; *Scene from the Legend of Prometheus*, c. 1510–1520, Alte Pinakothek, Munich; *The Discovery of Honey*, Worcester Art Museum, Worcester.

Perseus Rescuing Andromeda, c. 1515
Oil on panel, 71 x 123 cm
Galleria degla Uffizi , Florence
Piero depicts the heroic deed of Perseus with a character-filled scene and with rich imagination. The son of Zeus flies through the air with his sword in order to slay the sea monster to whom the Ethiopians have sacrificed Andromeda, the daughter of King Cepheus, in order to save themselves. While Andromeda's mother lies lamenting on the ground, the populace is already cheering the hero as he rushes by.

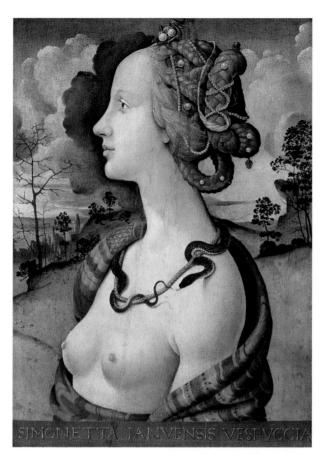

SIMONETTA IANVENSIS VESPVCCIA

Simonetta Vespucci,
c. 1500-1510
Oil on panel, 57 x 42 cm
Musée Condé, Chantilly
Giorgio Vasari, who had viewed this picture in 1568 in the house of Francesco da Sangallo, identified it as the "beautiful head of Cleopatra with a snake wound around her neck." The Vespucci family, who possessed the picture until the early 19th century, probably added the inscription with the name at the bottom of the painting in honor of their famous predecessor, for it is a later addition made at an unknown point in time. Because the depiction of a young woman with an undraped bosom was unthinkable in portraiture around 1500, the picture probably represents an allegory of classical beauty.

Pietro da Cortona

Pietro da Cortona (1596 Cortona–1669 Rome), born Pietro Berrettini, was first a pupil of the Florentine painter Andrea Commodi, and then worked from 1613 in Rome with Baccio Ciarpi. About 1620 his patron, the Marquis Marcello Sacchetti, recommended him to the Barberinis. Between 1634 and 1638, da Cortona was a member of the directing committee of the Accademia de San Luca in Rome. From 1640–1647 he worked in Florence, and afterward again took up residence in Rome.

Da Cortona, who also authored a treatise on art, is equally important as a painter and an architect. His light-flooded and movement-filled frescoes, including those in the Piano Nobile of Florence's Palazzo Pitti, (1640–1647) spurred the development of High Baroque ceiling painting throughout Italy. Other major works include *The Annunciation*, 1665, S. Francesco, Cortona; and *The Pleading Procession of St. Charles Borromeo on the Occasion of the Plague in 1576*, 1667, S. Carlo ai Catinari, Rome.

The Birth of the Virgin, 1643
Oil on canvas, 248 x 164 cm
Pinacoteca Nazionale, Perugia
According to the signature on the reverse side, this altarpiece from the Chiesa Nuova in Perugia was painted while Cortona was in Rome in 1643. The picture proves him to be a sensitive painter of figures and a master of color: St. Anne, who lies in childbed against the dark background to the left, appears again in the foreground of the picture in a glowing red dress as a beaming mother holding the Virgin on her lap.

Opposite
Virgin and Child with Saints
(The Passerini Madonna), 1626–1628
Oil on panel, 285 x 188 cm
Museo Comunale, Cortona
The saints James, John the Baptist, and Francis with Pope Stephen are seen grouped around the raised Virgin who is enthroned under an arch with the Christ Child. The figures are bathed in a pale light and are depicted using warm tones. The painting was commissioned by the patrician Cosimo Passerini for the family chapel in S. Agostino, and was the first—and for a long time the only—work that Pietro carried out in his native city.

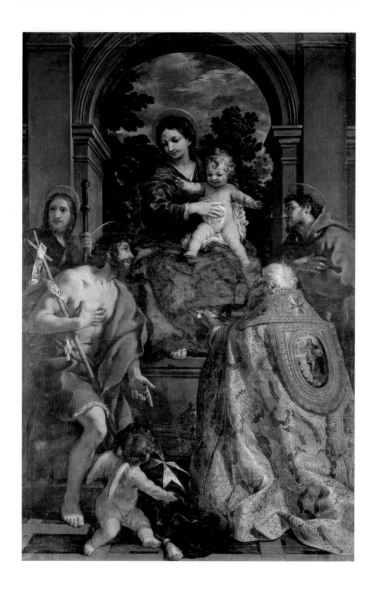

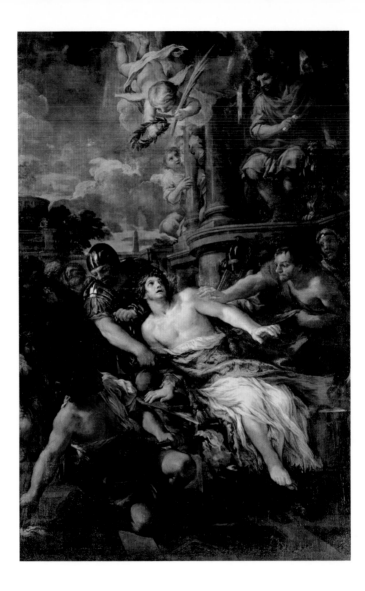

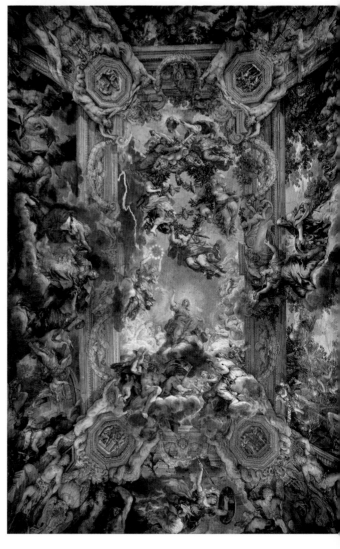

**The Martyrdom of
St. Lawrence, 1653**
*Oil on canvas, 320 x 210 cm
Cappella Franceschi,
SS. Michele e Gaetano, Florence*
Pietro painted this immense work
under commission from the Baron
Filippo Francesci for his family
chapel, where it still decorates the
altar to this day. The chapel, built in
1637, is dedicated to St. Lawrence.
As can be seen through the dynamic
and dramatic movement of the
picture, the saint is chained to the
grate on which he was burned alive
by two torturers under the eyes of
Emperor Valerian. A third holds a
torch to ignite the fire under him.

**Allegory of the Pontificate of
Urban VIII, 1633–1639**
*Fresco, 15 x 25 m
Palazzo Barberini, Rome*
This painting, the largest fresco in
Rome in terms of sheer surface
area, decorates the 15-meter-high (
approx. 49 feet) ceiling of the Gran
Salone in the Palazzo Barberini.
The complex iconographic program
presents a heroic homage to the
Roman Church and the Barberini
family, represented by the bees and
heraldic animals. In the lower third
of the painting, *Divina Providenza*
("Divine Providence") is receiving a
crown of stars from Eternity.

Pinturicchio

Pinturicchio (c. 1454 Perugia–1513 Siena), whose real name was Bernardino di Betto Biago, was first apprenticed in the workshop of Fiorenzo di Lorenzo, but was also strongly influenced by Perugino, for whom he served as assistant from 1481 to 1483 in the painting of the Sistine Chapel in Rome. In addition to Perugia and Rome, the painter was also active in Orvieto, Spoleto, Spello, and Siena, where he took up residence in 1502. Pinturicchio spent his first six years in the city decorating the *Biblioteca Piccolomini* ("little library"). The artist was chiefly interested in frescoes, but also completed religious narrative paintings and portraits. He cultivated a charming, sometimes genre-like narrative style with decorative effects but usually without dramatic elements. His coloration is of great luminosity. Pinturicchio was the first in the Italian Renaissance to introduce grotesque ornamentation derived from antiquity into his work. Other works by the artist include *Portrait of a Boy*, c. 1480, Gemäldegalerie Alte Meister, Dresden; *The Burial of St. Bernard*, c. 1484, Bufalini Chapel, Santa Maria in Aracoeli, Rome; *Pala de Santa Maria dei Fossi*, 1495–1498, Galleria Nazionale, Perugia.

Opposite
**Dispute of St. Catherine of Alexandria
with the Pagan Philosophers before
Emperor Maxentius, 1492–1494**
*Fresco, Sala della Vita dei Santi,
Appartamento Borgia, Vatican*
According to legend, the debate between Catherine, a
king's daughter and Christian convert, and the philoso-
phers who in this picture are seen gathering from vari-
ous directions, ended with the men's capitulation; the
saint was nonetheless martyred. The celebratory and
decorative effect of the scene, created in part through
the use of gold, is characteristic for Pinturicchio. The
fresco, created for Pope Alexander VI (1492–1503), is
in the second room of the Appartamento Borgia.

The Annunciation, 1501
Fresco
Cappella Baglioni,
Santa Maria Maggiore, Spello
In this wonderful fresco, which constitutes a high point
in Renaissance painting in Umbria, Pinturicchio placed
less value on the representation of the relatively small
figures than on the perspective construction of the
imaginary architecture and its decoration by means of
a comprehensive repertoire of classical ornament. As the
pictorial space continues into the distance the view
opens into the bordering garden and the landscape. A
self-portrait of the master is recognizable in the small
picture on the wall on the right.

**The Coronation of Mary,
the Apostles and Saints, 1503**
*Oil on panel, transferred to
canvas, 330 x 200 cm
Pinacoteca Apostolica
Vaticana, Vatican*
The coronation of the Virgin by
Christ occurs in the heavens, while
the twelve apostles, St. Francis, and
other saints observe the occasion
from a delicate Tuscan landscape
in the lower half of the painting.
Pinturicchio carried out this monu-
mental painting along with with
Giovan Battista Caporali for the
church of the Convent of Santa
Maria dei Minor Osservanti in
Umbertide, near Perugia. It has
been in the Vatican since 1826.

Opposite
**The Coronation of
Pope Pius III, 1502–1508**
*Fresco
Biblioteca Piccolomini,
Duomo, Siena*
The coronation of Cardinal Fran-
cesco Todeschini Piccolomini as
Pope Pius III took place on Oct. 8,
1503. In the lower half of the fresco,
numerous people are seen crowding
into St. Peter's Square; in spite of
their portrait-like facial expressions,
however, it is difficult to identify
them. The fresco is the eleventh pic-
ture in a series representing scenes
from the life of Pius II (1458–1464),
the uncle and influential predecessor
of Pius III.

PIVS·III·SENEN·PII·NEPA·AN·
M·D·III·SEPTEMBR·XXI·
APERT·ELECT·VS·SVFFRAG·
VIII·OCTOBR·CORONAT·VS·ESI·

Piombo, Sebastiano del

Sebastiano del Piombo (c. 1485 Venice–1547 Rome), whose given name was Sebastiano Luciani, is also known as Viniziano. According to Giorgio Vasari, he studied first with Giovanni Bellini and afterward in Venice with Giorgione, whose style deeply influenced the young artist. In 1511 Piombo went to Rome at the call of Agostino Chigi to decorate the Villa Farnesina with frescoes. Aside from a period in Venice in 1528/29, Piombo remained until the end of his life in Rome, where he was awarded the honorary office of Keeper of the Seal by the Curia in 1531. Sebastiano del Piombo chiefly pursued large altarpieces for Roman churches, but was also active as a portrait painter. Both Raphael and Michelangelo influenced his style, which is characterized by monumentality and a powerful formal language present in most of his large-format works. Other works by the artist include *Cardinal Carondelet and his Secretary*, c. 1512–1515, Museo Thyssen-Bornemisza, Madrid; *The Resurrection of Lazarus*, 1517–1519, The National Gallery, London; and *The Scourging of Christ*, 1521–1524, Cappella Borgherini, San Pietro in Montorio, Rome.

Opposite
The Death of Adonis, c. 1513
Oil on canvas, 189 x 295 cm
Galleria degla Uffizi , Florence
Here the artist depicts the myth of Venus and Adonis
from Ovid's *Metamorphoses* (X:708–728) in front of
the skyline of Venice. The goddess, who fell passionately
in love with the young hunter, is constantly afraid for
him. One day he is in fact attacked by a boar and killed:
Venus and her entourage had arrived too late to
prevent the tragedy.

The Martyrdom of St Agatha, 1520
Oil on panel, 127 x 178 cm
Galleria Palatina, Palazzo Pitti, Florence
The martyrdom of St. Agatha is portrayed here with
frightening realism. When the Catanian virgin from
Sicily refused to renounce her Christian faith even under
torture, her breasts were cut off. St. Peter healed her in
prison, but she was subsequently put to death by being
thrown naked into a fire of glowing coals, seen here in
the background on the right.

Opposite
The Visitation, 1521
Oil on canvas, 168 x 132 cm
Musée du Louvre, Paris
The foreground of this painting depicts the meeting between the Virgin and St. Elizabeth, the mother of John the Baptist. The two pregnant women are presented almost life-sized in the painting, which illustrates a passage in the Gospel of Luke (1:41–42): "And as Elizabeth listened to Mary's greeting, the babe within her leaped for joy. Then, filled with the Holy Spirit, Elizabeth spoke in a loud voice, 'Blessed are you among women and blessed is the fruit of your womb'."

Pope Clement VII, c. 1526
Oil on canvas, 145 x 100 cm
Museo Nazionale di
Capodimonte, Naples
Clement VII (1532–1534) was one of the most influential patrons who commissioned work from Piombo. He ordered not only this official, masterly-executed portrait, but also the *Resurrection of Lazarus*, which was intended for the Cathedral of Narbonne. He also appears as Cardinal Giulio de'Medici, later to become Pope Clement VII, at the side of Leo X (1513–1521) in the famous Medici family portrait by Raphael that hangs in the Palazzo Pitti in Florence.

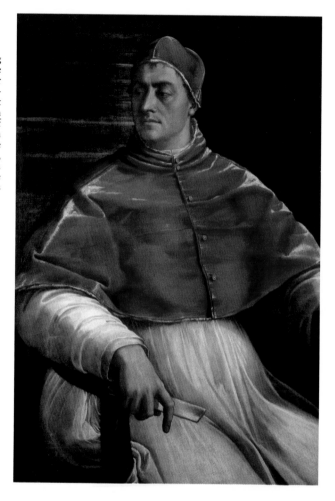

Pisanello

Pisanello (1395 Pisa-1455 probably Rome), whose real name was Antonio di Pucci Pisano, was raised in Verona, the native city of his widowed mother. From 1418 to 1420 he studied in Venice under Gentile da Fabriano, and as his assistant participated in the painting of the Doge's Palace. Around 1423 Pisanello followed his master to Florence, but moved to Rome after his death in 1427. After approximately 1430 Pisano became one of the most sought-after painters of his day, working for the courts in Mantua, Ferrara, and Milan, as well as in Naples for King Alfonse of Aragón (1396–1458). Pisanello, who made a name for himself as a painter of frescoes and panels, as a draftsman, and as a medalist, stands as one of the representatives of the International Gothic style, uniting Gothic delicacy and elegance with joy in narration and a sharp observation of nature. Works by the artist include *The Annunciation*, c. 1426, San Fermo, Verona; *St. George and the King's Daughter*, c. 1435, Santa Anastasia, Verona; and *The Vision of St. Eustachius*, c. 1448, The National Gallery, London.

Lionello d'Este, 1441
Oil on panel, 28 x 19 cm
Accademia Carrara, Bergamo
This portrait of Lionello d'Este grew out of a competition with Jacopo Bellini in Ferrara. Both here and in other flatly conceived profile portraits of Pisanello's, the close relationship to his medallion portraits, which he raised to the level of an independent art, becomes evident. Pisanello completed a total of four medallions from this profile of Lionello d'Este, boldly outlined against the dark background.

Opposite
Portrait of a Young Woman, c. 1436–1438
Tempera on panel, 43 x 30 cm
Musée du Louvre, Paris
The young woman portrayed here is either Margherita Gonzaga of Mantua, who later married Lionello d'Este, or Genevre d'Este, the betrothed of Sigismondo Malatesta. Although the carpet-like columbines, carnations, and butterflies strewn across the dark background testify to Pisanello's connection with the Middle Ages, the individualized facial features of his figures prove the artist to be an outstanding portrait painter of the early Renaissance.

Pollaiuolo, Antonio del

Antonio del Pollaiuolo (1431 Florence–1498 Rome) began his career as a goldsmith. He turned to painting around 1460 along with his brother, Piero Pollaiuolo, who was a member of a communal workshop. From 1484 on Antonio resided in Rome, where he designed the bronze grave markers for Pope Sixtus IV (1471–1484) in the Museo Petriano and Innocent VIII (1484–1492) in St. Peter's, and then advanced to become the most important sculptor of the *Quattrocento*. As a painter, Pollaiuolo concentrated on frescoes and panel paintings. His style is characterized by a strong movement of forms and clear lines. The multi-faceted Pollaiuolo was one of the first Italian artists of the early Renaissance to do copper engravings, among them an anatomical study depicting two nude men struggling with each other completed in 1475. Other major works by the artist include *Wall Fresco with Dancers*, c. 1460, Villa Lanfredini, Arcetri near Florence; *Hercules and the Hydra*, c. 1465, Galleria degla Uffizi , Florence; and *The Martyrdom of St. Sebastian*, 1475, The National Gallery, London.

The Assumption of St. Mary Magdalen, c. 1465
Tempera on panel, 199 x 166 cm
Pieve di Santa Maria, Staggia Senese
This painting was mistakenly interpreted as depicting of the assumption of St. Mary of Egypt. The medieval *Legenda Aurea* ("Golden Legend") tells of an angel sent to the penitent Mary Magdalen to carry her to heaven. In the painting, Pollaiuolo's language of passionately moving forms is especially strong and must be interpreted in the spirit of the late *Quattrocento* as a mirror for the movement of the spirit.

Opposite
Portrait of a Young Woman, c. 1465
Tempera on panel, 52.5 x. 36.5 cm
Gemäldegalerie, SMPK, Berlin
This famous profile portrait numbers among the outstanding products of Florentine portraiture of the early Renaissance in the perfection of its stylistic execution and its glowing dignity. Explosive disagreement has repeatedly erupted since the late 19th century over the identity of the painter of the portrait. In all probability, however, it is a work of Antonio del Pollaiuolo, whose experience as a goldsmith and medallion portraitist explains the precise design of the ornamentation on the clothing.

Tobias and the Angel, c. 1465
Tempera on panel, 187 x 118 cm
Galleria Sabauda, Turin
Pollaiuolo, who as a rule preferred
small format paintings, also under-
stood how to compose a painting
on a large scale. In this panel from
Turin, Tobias and his guiding angel,
Raphael, appear almost life-size in
the foreground of the picture. They
are far removed from the landscape,
which stretches far into the distance,
a combination which is typical for
this painter. The archangel Raphael
is carrying the vessel of salve with
ointment containing fish bile that
will allow the pious Tobias to cure
his father's blindness.

Pontormo

Pontormo (1494 Pontormo, near Empoli–1557 Florence), whose given name was Jacopo Carrucci, moved to Florence in 1508 after the early death of his parents and remained there for the rest of his life, with the exception of short journeys into the nearby countryside. After initial artistic contact with Leonardo da Vinci and Piero di Cosimo, Pontormo was probably first apprenticed to Fra Bartolommeo, and in 1512–1513 to Andrea del Sarto. He studied the works of Albrecht Dürer and modeled himself on Michelangelo. As early as 1520 he developed a new expressive style that transcended the neoclassicism of the High Renaissance. Along with Rosso Fiorentino, Pontormo is the main exponent of the early dramatic and expressive phase of Mannerism. Among the artist's works are *Sacra Conversazione (Pala Pucci)*, 1518, S. Michele Visdomini, Florence; *The Adoration of the Magi*, 1519/ 1520, Galleria Palatina, Palazzo Pitti, Florence; and *Virgin and Child with St. Anne and Saints*, 1529, Musée du Louvre, Paris.

Cosimo de'Medici Il Vecchio, c. 1518/1519
Oil on panel, 86 x 65 cm
Galleria degla Uffizi , Florence
Although Georgio Vasari's biography of the painter stresses his independence from the Medici, some of his best work was done under their patronage. Pontormo painted this dignified portrait of the famous statesman and art patron, Cosimo de'Medici Il Vecchio (1389–1464), for Ottaviano de' Medici based on a medallion dating from the 15th century.

Joseph in Egypt, 1517/1518
Oil on panel, 96.5 x 109.5 cm
The National Gallery, London
Several episodes of the Old Testament story of Joseph are played out here in front of a backdrop of an imaginary landscape and architectural elements. The protagonist, who is found in the group in the left foreground, is standing before the Pharaoh, pointing to his kneeling father, Jacob. Jacob's bed is recognizable in the upper right-hand corner. This picture, which Vasari highly praised in his *Lives*, belongs to the cycle that Pontormo painted for the bedroom in the Borgherini Palace in Florence. The slightly winding stairway in the center of the painting lends tension and drama to the composition.

Portrait of a Musician, 1518/19
Oil on panel, 86 x 67 cm
Galleria degla Uffizi , Florence
This painting, which clearly shows the influence of Andrea del Sarto, proves Pontormo to be an outstanding portraitist. The light falling from the side brightly illuminates the right half of the face, the right wrist, and the book of notes of the young man, whose identity remains unknown to this day. The piercing gaze of the subject directed toward the viewer is one characteristic of Pontormo's portraits.

The Supper at Emmaus, 1525
Oil on canvas, 230 x 173 cm
Galleria degla Uffizi , Florence
Pontormo painted this large-format picture for the Carthusian monastery of Certosa del Galluzzo, south of Florence, where the painter had sought refuge from the plague that was raging through the city. The artist enlarged the scene with narrative details, such as the pouring of the drink and the cats. The story of the visit of the resurrected Christ to the disciples in Emmaus as told in the Gospel of Luke (24:13–33) has been expanded by the figures of five contemporary Carthusian monks whose portrait-like features were admired by Vasari. The eye of God over Christ's head is a later addition.

Opposite

The Carrying to the Grave, c. 1525–1528
Oil on panel, 313 x 192 cm
Cappella Capponi, San Felicità, Florence
This work combines elements of the Deposition from
the Cross, the placing in the grave, and the Pietà in an
idiosyncratic iconography. Christ, the fainting Mary and
other mourning saints are interwoven with each other
in a circular arrangement. The 11th figure from the right
is the painter himself, who executed this masterpiece for
the burial chapel of the Florentine Capponi family.

The Carrying to the Grave (detail)
The colors of this work, which took Pontormo three
years to complete, gleam with a luminosity that arises
both from the contrasts as well as from the application
of the paint. A magical brightness and transparency give
the composition a unique intensity, expressed even in the
smallest details, and especially in the faces that exude
calm suffering, in contrast to the open grief of the Virgin.
The gazes of most of the figures are not directed to the
crucified Christ, but rather toward the viewer.

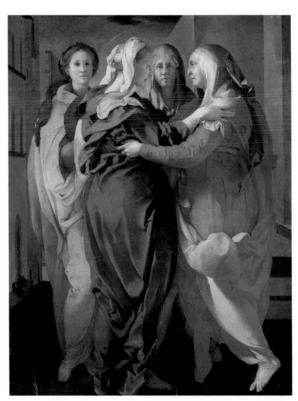

The Visitation, 1528–1530
Oil on panel, 202 x 156 cm
S. Michele, Carmignano

This painting depicts the Visitation between the Virgin and St. Elizabeth as described in the Gospel of Luke (1:41–42). The visionary nature of the scene and the close relationship between the two pregnant women are conveyed through their gestures and the intimate exchange of glances. This work, which still reflects Pontormo's Mannerist phase, was painted for the Villa Pinadori in Carmignano; today it hangs in the parish church of S. Michele.

Opposite below
Venus and Cupid, 1532–1534
Oil on panel, 128 x 197 cm
Galleria dell'Accademia, Florence

Pontormo executed this panel painting for the collection of Alessandro de'Medici (1511–1537) from a sketch by Michelangelo. The nude figures representing love and the poetry of love, as well as the allegorical still life on the left edge of the picture, clearly display Michelangelo's strong formal language. Pontormo, who resembled his great contemporary in his openness to innovation, took up Michelangelo's language in a masterly fashion.

The Martyrdom of the Eleven Thousand, c. 1530
Oil on panel, 65 x 73 cm
Galleria Palatina, Palazzo Pitti, Florence

This composition with its many figures was painted for the nuns of the Florentine Orphanage. It depicts the story, narrated in the *Legenda Aurea*, of the Theban Legion, which had converted to Christianity. The baptism and crucifixion at the upper edge of the picture mark both the beginning and end of this simultaneous narration of the events. In the center stands the Roman viceroy who is seen giving the order for the persecution and torture of the martyrs with a dominating gesture.

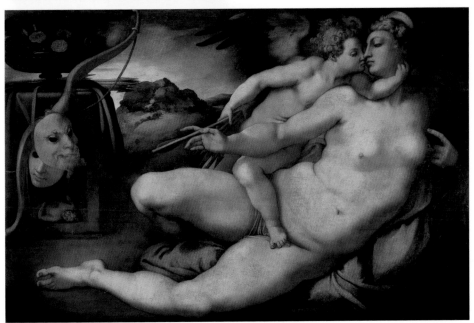

Poussin, Nicolas

Nicolas Poussin (1594 Les Andelys–1665 Rome) arrived in Paris in 1612 to continue the training he presumably had begun in Rouen under Georges Lallement and Ferdinand Elle. After a stay in Venice, Poussin travelled to Rome under the patronage of the poet Cavaliere Marino. There he found favor with Cardinal Francesco Barberini (1597–1679), among others, and aside from a journey to Paris from 1640 to 1642, he remained in the Eternal City until his death. Poussin is considered the founder of French neoclassicism. Based on the art of antiquity and the Italian Renaissance, he concentrated on history paintings, portraits and landscapes, which he always carried out according to strict principles of organization that stove for complete perfection. Important works by the artist include *The Death of Germanicus*, 1627, The Minneapolis Institute of Art, Minneapolis; *The Martyrdom of St. Erasmus*, 1627, Pinacoteca Apostolica Vaticana, Vatican; and *Self-Portrait*, 1650, Musée du Louvre, Paris.

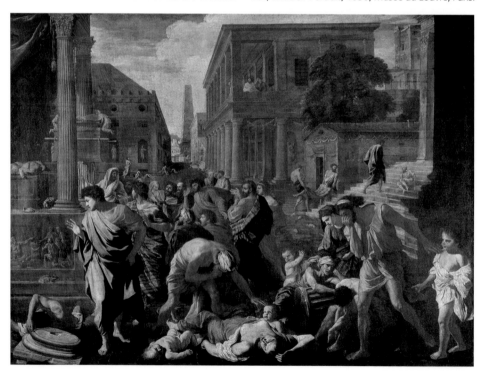

The Plague on Ashdod, 1630
Oil on canvas, 148 x 198 cm
Musée du Louvre, Paris
At the left in the painting is the Temple of Dagon in Ashdod with the broken statue of the god and the Tabernacle, a gilded wooden chest containing the tablets God had inscribed with the laws of Israel and given to Moses. Poussin impressively depicts the horror and fear of the inhabitants of Ashdod as God punishes them with the plague because of their heathen beliefs. It is likely that the painter did not select this theme from Samuel (5:1–6) by accident, since the plague was also raging in Milan in 1630.

Midas and Bacchus, c. 1630
Oil on canvas, 98 x 153 cm
Alte Pinakothek, Munich
In his *Metamorphoses* (XI: 85–145), Ovid relates how King Midas of Phrygia returned the kidnapped Silenus to Bacchus. As his reward, Midas requested that Bacchus grant him the power to turn everything that he touched into gold. When Midas experiences the full extent of his fulfilled wish, that even his food turns into gold, he begs the god to take back his gift, and is in fact saved from his foolish greed by bathing in the River Paktolos. It is still not clear just which moment of the story is depicted in the painting.

**The Rape of the
Sabine Women, c. 1635**
Oil on canvas, 159 x 206 cm
Musée du Louvre, Paris
Because there were disproportionately few women in Rome at the time, Romulus (seen at the left of the picture on a pedestal) ordered the capture of all the Sabine women who were attending festival games as guests. This famous saga from the prehistory of Rome is recounted by Livy, Virgil and Plutarch. Poussin painted this highly dramatic picture for Cardinal Aluigi Omodei, two years after he had finished an earlier version which now hangs in New York. In the version located in Paris, depicted above, the composition is much more compact and creates a higher level of tension in its dramatic movement. Even the architecture is drawn into the dynamism of the picture.

**Landscape with
Polyphemus, 1649**
*Oil on canvas, 150 x 198 cm
The Hermitage, St. Petersburg*
Against the backdrop of a peaceful
landscape Poussin portrays the saga
of the one-eyed giant Polyphemus,
who had fallen in love with the
Nereid Galatea and kills her lover
Actis out of jealousy and rage. The
painting depicts the moment before
the dramatic deed as the giant, still

unobserved by the other figures,
stands behind the mountain that
rises mightily in the middle of the
picture. Actis is resting in a relaxed
posture on a stone in the left fore-
ground as he watches Galatea and
her companions being teased by
satyrs. Poussin painted this work
with its clearly organized compo-
sition for Jean Pointel. The style has
led to speculation that the painting
might have been done in the 1660s.

The Israelites Gathering Manna in the Desert, 1637–1639
Oil on canvas, 149 x 200 cm
Musée du Louvre, Paris
Poussin painted this picture for his friend and patron Paul Fréart de Chantelou (1609–1694). Moses, who is standing upright with a raised hand in the midst of the starving and wailing Israelites, begs God for quail and manna to ease the sufferings of his people. Poussin used the biblical scene with its many figures as an occasion to present variations of dramatic movement inspired by emotion.

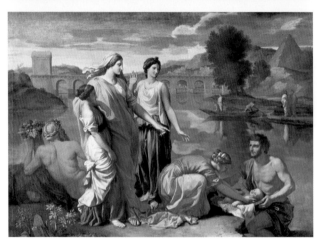

Moses Saved from the Waters, 1638
Oil on canvas, 93.5 x 121 cm
Musée du Louvre, Paris
The balanced design of the composition and its harmoniously gradated coloration designate this painting as a masterpiece among the numerous variations on this theme. Poussin's painting depicts the moment in which Moses is discovered by Thermuthis, daughter of the Egyptian pharaoh, on the banks of the Nile. According to Félibien, the painting was finished in 1638, was part of the collection of the royal gardener André le Nôtre in 1685, and finally came into the possession of Louis XIV (1638–1715) in 1693.

The Boy Moses Tramples the Pharaoh's Crown, 1645
Oil on canvas, 99 x 142 cm
Musée du Louvre, Paris

According to legend, Thermuthis is supposed to have taken the boy Moses, whom she had adopted, to the court of her father and as a joke the pharaoh set his crown on the child's head. Moses, however, threw the crown to the earth and trod upon it with his foot. As the Pharaoh's vizier is about to slay the boy for his disrespect, the princess intercedes and thus saves the child's life a second time. This scene, which has only rarely been a theme in painting, is portrayed by Poussin in a tense, horizontally organized composition that, like the coloration, is carefully balanced.

Et in Arcadia Ego (The Shepherds of Arcadia), 1650–1655
Oil on canvas, 85 x 121 cm
Musée du Louvre, Paris

The shepherds are standing in a classic posture around a tomb marker, deciphering the inscription *Et in Arcadia ego* ("I too am in Arcadia"); i.e., death is also present in this peaceful, harmonious, pastoral idyll. The landscape, which is bathed in the warm light of morning and includes a horizon marked by a massive chain of mountains suggesting permanence, corresponds to Poussin's idea of classical antiquity. As one of the artist's major works, this famous "elegy on the transience of life" had an immense influence on subsequent landscape painting.

Pozzo, Andrea

Andrea Pozzo (1642 Trento–1709 Vienna) entered the Jesuit Order in Milan as a lay brother in 1665. Between 1676 and 1678 he carried out the painting of the Jesuit Church of San Francesco in Mondovi. At the end of 1681 Pozzo was summoned to Rome by the Jesuit General Padre Oliva at the recommendation of Carlo Maratta, and in the 1690s painted the monumental ceiling of the Jesuit Church of San Ignatio there. After 1703 Pozzo was active as an artist in Vienna, where he painted the ceiling of the University Church, and decorated the ceiling of the Lichtenstein garden palace in Rossau with the deeds of Hercules. Pozzo was active as a painter, architect, and art theoretician. His treatise *Prospettiva de pittore e architetti* ("Perspectives on painting and architecture") appeared in 1693 in Rome, and was translated into German in 1706. Other works by the artist include *Self-Portrait*, c. 1685, Galleria degla Uffizi , Florence; *The Jesuit Pietro Pinamonti*, c. 1700, Galleria Palatina, Palazzo Pitti, Florence; and *The Adoration of the Shepherds*, 1701, S. Madonna della Fede, Turin.

**Triumph and Apotheosis
of St. Ignatius of Loyola, 1691–1694**
Ceiling fresco, 17 x 36 m.
Middle aisle, San Ignazio, Rome
In a written tract Pozzo described the comprehensive pictorial program of the 29-meter-high (95 feet) ceiling, which is one of the most outstanding examples of Baroque fresco painting. The work as a whole is to be understood as a glorification of the Jesuit Order. The center depicts a brightly lit heavenly sphere with the Holy Trinity and St. Ignatius of Loyola, on whose breast a beam of light emanating from Christ is streaming. The personifications of the four quarters of the earth in the attic area of the fantastically painted imaginary architecture refer to the worldwide presence and missionary activities of the Jesuit Order.

Primaticcio, Francesco

Francesco Primaticcio (1504 Bologna–1570 Paris) took part in the decoration of the Palazzo del Tè in Mantua, along with Giulio Romano, beginning in 1525. Six years later he was appointed to the court of Francis I (1494–1547), where he remained for the rest of his life aside from two stays in Rome in 1540/41 and 1546. From the early 1530s he worked first with Rosso Fiorentino and, after his death, with Niccolò dell'Abbate and other artists on the decorative painting of the palace at Fontaine-bleau. The excellent appointment of the Salon of the Duchess d'Estampes exerted a clear influence on the work of Parmigianino; equally outstanding is Primaticcio's painting of the large hall of the palace. The artist is among the most important representatives of the School of Fontainebleau, whose refined, academic Mannerism in the Italian tradition had a long-lasting effect on French art. Other significant works by the artist include *Danae*, 1537–1539, Musée National du Château de Fontainebleau, Fontainebleau; *Jean de Dinteville as St. George*, c. 1550, The Wildenstein Gallery, New York; and *Odysseus and Penelope*, Museum of Art, Toledo.

The Holy Family with St. Elizabeth and St. John the Baptist, 1541–1543
Oil on slate, 43.5 x 31 cm
The Hermitage, St. Petersburg
Sketch-like in its execution, this painting has been variously attributed to a number of artists since the 19th century. The names Parmigianino and Pontormo have been suggested because of its Mannerist characteristics. Parallel motifs found in paintings known to be Primaticcio's, as well as the influence of Rosso Fiorentino, have led modern scholars to conclude that Primaticcio is, in fact, the creator of the work.

Quarton, Enguerrand

Enguerrand Quarton (probably c. 1410 Diocese of Laon–after 1466), also known as Charanton, Charton, or Charretier, has been rediscovered only recently. Based on stylistic characteristics that point to a knowledge of the cathedral sculpture of northern France as well as Old Netherlandish painting, scholars suspect that Quarton originated in Laon. Apparently he migrated as a young artist into Provence, where he first appears on record in 1442 as a citizen of Aix-en-Provence. In 1446 he moved to Arles, but after a year was living in Avignon. Quarton and his contemporary Jean Foquet are considered the most important French painters of the 15th century. Quarton's style is characterized by sure lines, a balance of expressive and ornamental effects, and a splitting of forms

into facet-like elements. Among the artist's major works are *Madonna of the Protective Mantle*, 1452, Musée Condè, Chantilly; and *The Coronation of the Virgin*, c. 1454, Musèe de l'Hospice, Villeneuve-lès-Avignon.

The Lamentation of Christ, c. 1460
Tempera on panel, 162 x 217 cm
Musée du Louvre, Paris

The attribution of this work, also known as the *Pietà of Villeneuve-les-Avignon*, has remained controversial over many years because it does not clearly fit into any given style. The figure of John the Baptist removing the crown of thorns from Christ's head is unique in mid-15th-century painting, and is without precedent in paintings preceding that time. The panel comes from the Carthusian monastery of Villeneuve-lès-Avignon, where it probably decorated the grave of Jean de Montagnac, depicted on the left in the picture.

Art and Curiosity Collections

Princes and patrons of the arts, such as the dukes of Berry and of Burgundy, and the Medici in Florence, began to build up splendid collections of art and rarities as early as the Middle Ages and the Renaissance. Passionate collecting and a fascination with encyclopedic knowledge resulted in numerous rooms of art and wonders, especially during the 16th century and mainly north of the Alps, in which exquisite works were to be found along with highly extraordinary and exotic objects. Natural finds, including rare shells, snails and fossils, were very popular because of their beauty and priceless value: They served to form a link between *natura* (nature) and *ars* (art). The largest collections of this kind were in the possession of Archduke Ferdinand of Tyrol (1529–1595) in Castle Ambras and Emperor Rudolf II (1576–1612) in Prague. As time went on, learned people and merchants began to share the princes' delight in these chambers of wonders.

In time, artists themselves began to appreciate the importance of collections of art and rarities.

Frans Francken II: Meal at the Home of Mayor Rockox, c. 1630–1635
Oil on panel, 62.3 x 96.5 cm
Alte Pinakothek, Munich
This painting shows the reception room of the house named *Zum Goldenen Ring* ("the golden ring") in which Nicolas Rockox (1560–1640), the humanist-educated mayor of Antwerp, displayed his extensive collection of works of art.

They collected old as well as contemporary paintings, prints, drawings and sculpture and heightened their reputations with objects from antiquity thought to reflect their erudite learning. Artists such as Andrea Mantegna, Albrecht Dürer, Giorgio Vasari and Jacopo Tintoretto were known to have had such extensive collections.

The art collections of Rembrandt Harmensz. van Rijn (1606–1669) and Peter Paul Rubens (1577–1640) were doubtless the most famous of the 17th century. Besides works of art from classical antiquity, Rembrandt owned excellent graphics by Dürer, Cranach and Holbein as well as many paintings. In addition, specimens of plants and animals, exotic objects from far-away lands, and historically important objects attest to the encyclopedic character of the collection. In 1657 Rembrandt was forced to auction off his possessions along with his house in Amsterdam in order to ameliorate his financial situation. The inventory taken of his house during the bankruptcy proceedings remains a reliable and valuable historical source for us.

Rembrandt's older Antwerp contemporary, Peter Paul Rubens, was in a position to enjoy his treasures for a longer period of time. As court painter to the Archduke Albrecht and Archduchess Isabella, his official duties included advising the court as to the value of a number of ancient statues, gems, coins and paintings from Italian, Dutch and Old German masters as the royal couple built up their considerable inventory. Rubens' collection was nevertheless only one of the many outstanding collections to be found in the rich economic and cultural center of Antwerp. The expansive scope of the collections of Nicolas Rockox, the city's mayor, that of the collector Pieter Stevens, or even that of Cornelis

Rembrandt: The Snail, 1650
Etching, reworked with drypoint and burin, 2nd state,
9.7 x 13.2 cm
Kupferstichcabinett,
SMPK, Berlin
The cone snail, native to East India, was one of the rarities to be found in Rembrandt's collection.

Opposite
David Teniers, the Younger:
The Gallery of Archduke Leopold Wilhelm in Brussels, c. 1651
Oil on copper, 106 x 129 cm
Museo del Prado, Madrid
Views of galleries such as this one by David Teniers the Younger are a specialty of the Antwerp School of painting.

van der Geest compares favorably with the collections amassed by aristocrats of their time.

During the 17th century, the trend moved away from encyclopedic collections toward a concentration on art only, a transformation that can best be traced in the famous Brussels collection of Archduke Leopold Wilhelm (1614–1661) from the House of Hapsburg. Among the most important duties of David Teniers the Younger (1610–1690), court painter to the archduke, was the task of overseeing the princely collection of paintings and expanding it through new acquisitions that increased its renown. Leopold Wilhelm participated in this endeavor by sending out views of his gallery, above all to members of his royal family.

Raphael

Raphael (1483 Urbino–1520 Rome), whose real name was Raffaello Sanzi, received his first training in art from his father, the painter and poet Giovanni Sanzi. Around 1500 Raphael arrived in the atelier of Pietro Perugino in Perugia. In 1504 he went to Florence, where he studied both older and contemporary painting. Pope Julius II (1503–1513) called Raphael to Rome in 1508, where he worked from 1509 on, especially on the frescoes for the papal suites in the Vatican. After Bramante's death he was placed in charge of the construction of the Church of St. Peter in 1514. The following year, he assumed the office of Curator of Roman Antiquities. Raphael is considered the most significant painter of the High Renaissance. His famous altarpieces, sensitive Madonnas and portraits, as well as his enormous wall frescoes with their complex content, are characterized by formal clarity and deeply felt, natural expressive power. His artwork was often emulated by succeeding generations; Giorgio Vasari praised especially the humility and grace of his works. Among the artist's major works are *La Belle Jardinière*, c. 1507, Musée du Louvre, Paris; *The Canigiani Holy Family*, c. 1507, Alte Pinakothek, Munich; and *Julius II*, 1511/12, Galleria degli Uffizi, Florence.

Agnolo Doni, c. 1506
Oil on panel, 65 x 45.7 cm
Galleria Palatina, Palazzo Pitti, Florence
This portrait of the wealthy Florentine cloth merchant Agnolo Doni is the counterpiece to the portrait of Maddalena Doni, a member of the Strozzi family, also preserved in the Palazzo Pitti. The married couple complement each other in their posture: The panel of the man is on the left side, opening out to the right, as does the masterful landscape in the background.

Opposite
**The Engagement of the Virgin
(Lo Sposalizio), 1504**
Oil and tempera on panel, 170 x 117 cm
Pinacoteca di Brera, Milan
This painting was done in Umbria at the end of Raphael's early period, and is an altarpiece for the Albizzini family chapel in the church of St. Francis in Città di Castello. The young artist self-confidently signed his work in large letters on the frieze of the temple, the place where the central lines of perspective meet. The composition was influenced by Perugino.

The School of Athens, 1509
Fresco, 770 cm wide at the base
Stanza della Segnatura, Vatican
Museums, Vatican City

This fresco belongs to the decoration of the *Stanza della Segnatura*, or "signature room," which was to be used by Julius II (1503–1513) as his private library. Plato and Aristotle are seen surrounded by many other scholars in a scene symbolizing the wisdom of classical antiquity. They represent Philosophy, which at that time belonged to the four areas of scientific knowledge along with Theology, Justice and Medicine. They are personified on the ceiling fresco, whereas the opposite wall portrays "Disputa," the battling and triumphant Church.

The Triumph of Galatea, c. 1511
Fresco, 295 x 225cm
Villa Farnesina, Rome
Raphael painted this fresco depicting Galatea on a boat
of shells drawn by dolphins for the villa of the wealthy
Sienese banker Agostino Chigi. Mythological and legen-
dary beings surround her, representing the passionate
lust and emotional uproar of corporeal love. Neverthe-
less, the sea nymph gazes only at Amor (upper left), par-
tially hidden by a cloud, who represents Platonic love.

Madonna della Sedia
(Madonna of the Chair), c. 1512–1514
Oil on panel, diam. 71 cm
Galleria Palatina, Palazzo Pitti, Florence
This *tondo*, the apex of High Renaissance Madonnas,
was probably painted for Pope Leo X (1513–1521).
Mary is formally incorporated into the round format
through the tilt of her head and the curve of her right
arm. Her body language expresses naturalness and
affinity with the peaceful, satisfied Christ Child.

**The Liberation of Peter
(detail), 1514**
*Fresco, 660 cm wide at the base
Stanza di Eliodoro,
Vatican Museums, Vatican City*
From 1511 on Raphael worked on
painting the Stanza di Eliodoro,
which derived its name from the
fresco entitled *The Banning of
Heliodorus from the Temple*. The
detail shown here depicts the
apostle Peter in the center, chained
to two thugs in prison. He is being
liberated by an angel whose hea-
venly origins are revealed by the
circle of gleaming rays of light.
This prison scene is one of the most
renowned figure-against-the-light
paintings in western art.

The Sistine Madonna, c. 1513
*Oil on canvas, 265 x 196 cm
Gemäldegalerie Alte
Meister, Dresden*
Raphael painted this famous picture
on commission for Pope Julius II for
the high altar of the abbey church of
St. Sixtus in Piacenza. Pope Sixtus,
patron saint of the della Rovere
family to which Julius II also be-
longed, mediates between the
heavenly scene with the Madonna
and the secular plane of the viewer
through his gestures and stance.
St. Barbara, whose relics were wor-
shipped in this church, kneels to the
right of the Virgin.

Transfiguration, 1519/20
Oil on panel, 405 x 278 cm
Pinacoteca Apostolica
Vaticana, Vatican
The last work completed solely by
Raphael was commissioned by
Cardinal Giulio de'Medici (1478–
1534), who was later to become
Pope Clement VII (1523–1534),
for the Cathedral of Narbonne. In
order to portray the dual human
and divine nature of Christ, Raphael
depicted the healing of the sleep-
walking boy, seen being possessed
by demons in the lower part of the
picture, and the transfiguration of
the resurrected Christ on Mount
Tabor in the upper part.

Opposite
Transfiguration (detail)
The expressive bodily gestures and
the glazed, open-eyed stare reveal
the illness of the sleepwalking boy.
Raphael's efforts to portray physical
and psychic conditions through
masterful artistic technique is clearly
visible, not only in this one extreme
figure, but perhaps particularly in
his depiction of the emotional
involvement of the boy's parents
and the other bystanders.

Baldassare Castiglione, c. 1515
*Oil on panel, transferred to
canvas, 82 x 67 cm
Musée du Louvre, Paris*
Raphael brought the classical tri-
angular composition to its culmi-
nation in his Madonna portraits;
however, this portrait of Baldassare
Castiglione (1478–1529) is com-
posed of circular forms. The sitter's
face and body are clearly set apart
from the nearly monochrome back-
ground. Baldassare Castiglione was,
as a humanist and writer, one of the
leading figures of the Italian Renais-
sance. In his book *The Courtier* he
describes the court of Urbino, at
which he played an active role as
an ambassador.

**Pope Leo X with
Cardinal Giulio de'Medici and
Luigi de'Rossi, 1513–1518**
*Oil on panel, 155.2 x 118.9 cm
Galleria Palatina,
Palazzo Pitti, Florence*
Pope Leo X (1513–1521) is por-
trayed as a lover of the arts, gazing
at a valuable illuminated manu-
script from the 14th century. The
Pope's enormous presence and
dominance is emphasized by the
fact that the two cardinals are
placed farther into the background.
As a group portrait the painting
celebrates the power of the Medici
family and was sent to Florence in
1518 on the occasion of the wed-
ding of Lorenzo de'Medici (1492–
1519) and Maddalena de la Tour.

Rembrandt Harmensz. van Rijn

Rembrandt Harmensz. van Rijn (1606 Leiden–1669 Amsterdam) was first trained in Leiden by Jacob van Swanenburgh, and later by Pieter Lastman in Amsterdam. After around 1625 he again worked in Leiden as an independent master in a workshop along with Jan Lievens. In about 1631 Rembrandt moved to Amsterdam, where he remained for the rest of his life. In 1633 he married Saskia van Uylenbourgh, who died in 1642, after which he lived with Hendrickje Stoffels. His financial difficulties steadily grew, culminating in bankruptcy in 1656: His house and his extensive art and rarities collection had to be sold in order to pay his bills. Rembrandt was the most significant and most versatile Dutch painter and graphic artist of his day. He tried his hand at all types of art common at the time, but concentrated especially on religious themes and portraits. Among his works are *The Rape of Ganymede*, 1635, Gemäldegalerie Alte Meister, Dresden; *Moses Breaking the Commandment Tablets*, 1659, Gemäldegalerie SMPK, Berlin; and *The Staalmeesters*, 1661, Rijksmuseum, Amsterdam.

Self-Portrait, 1629
Oil on panel, 15.5 x 12.7 cm
Alte Pinakothek, Munich
Throughout his life, Rembrandt was fascinated with the theme of self-portrayal. This small picture in Munich shows the painter at the age of 23. The portrait is given a spontaneous effect through the quick brush strokes, reinforced by the forward positioning of the head, the unkempt hair and the contrasting areas of light and shadow.

The Anatomy Lecture of Dr. Nicolaes Tulp, 1632
Oil on canvas, 170 x 216.5 cm
Mauritshuis, The Hague
This famous group dates from the beginning of Rembrandt's creative period in Amsterdam and is characterized by its forceful naturalism: Dr. Tulp is demonstrating to a group of interested and curious students the function of a muscle, which he has bared to view through the dissection of the corpse lying before him. Dr. Tulp held the office of "Praellector Anatomiae" in the surgical guild of Amsterdam from 1628 to 1653. This painting was hung in the guild, in the Hall of Anatomy, as an example of progressive thought.

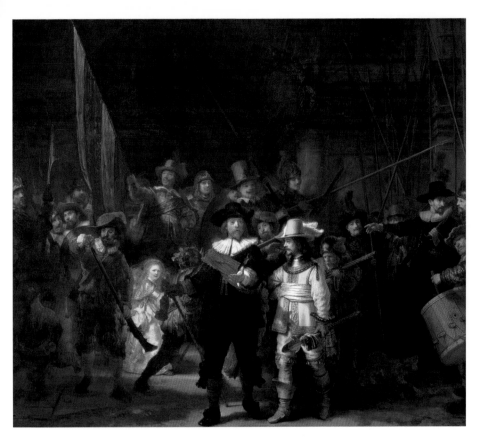

The Company of Captain Frans Banning Cocq and Lieutenant Willem van Ruytenburch (The Nightwatch), 1642
Oil on canvas, 363 x 437 cm
Rijksmuseum, Amsterdam
Rembrandt painted this outstanding masterpiece, one of his best-known works, for the festival hall of the "Cloveniersdoelen," that is, for the rifle guild of Amsterdam. He has chosen to paint the moment at which the company receives the order to march. One of the party is the butler who is responsible for the soldiers' meals. Viewed stylistically, this many-figured night painting is dramatically characterized by its light-dark areas, which are typical of Rembrandt's work.

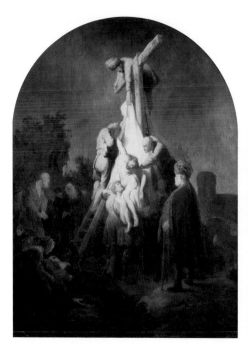

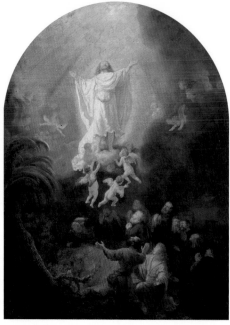

Deposition, c. 1633
Oil on panel, 89.4 x 65.2 cm
Alte Pinakothek, Munich
Here the artist's encounter with Flemish Baroque painting, especially with the altarpieces painted by Peter Paul Rubens around 1610–1611 for the Antwerp Cathedral, is clear. Whereas the Flemish painter emphasized the divine aspect of Christ, Rembrandt portrayed the human element. We are confronted with a crucified body that has succumbed to terrible sufferings; there is no trace of transcendence.

Ascension, 1636
Oil on canvas, 92.7 x 68.3 cm
Alte Pinakothek, Munich
This picture is a one of a series of scenes from the life of Christ executed for Prince Frederik Hendrik of Orange, governor of the northern Netherlands. In the *Ascension*, the last of the cycle, Rembrandt chose a form of representation unusual in western painting: Christ does not rise into heaven; rather, he is carried aloft by angels. His figure is steeped in gleaming light, whereas the human figures remain hidden in the dark.

Opposite
The Sacrifice of Isaac, 1636
Oil on canvas, 195 x 132.3 cm
Alte Pinakothek, Munich
Rembrandt portrayed the central event of Abraham's life, based on the Old Testament book of Genesis (22:1–13), quite dramatically and full of Baroque pathos. God tests the patriarch's faith by commanding him to sacrifice Isaac, his only son. Isaac is willing, but at the last moment an angel prevents the bloody deed. Instead, Abraham is told to sacrifice a sheep (bottom left of picture) in place of his son.

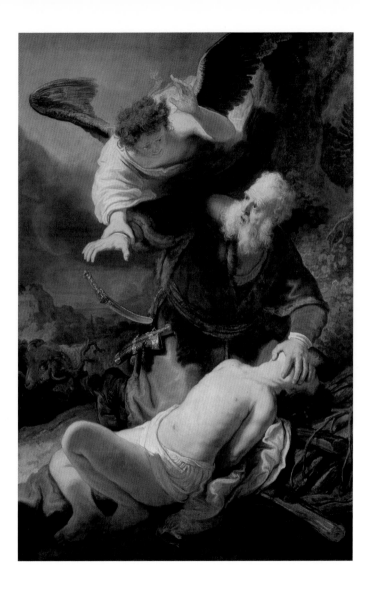

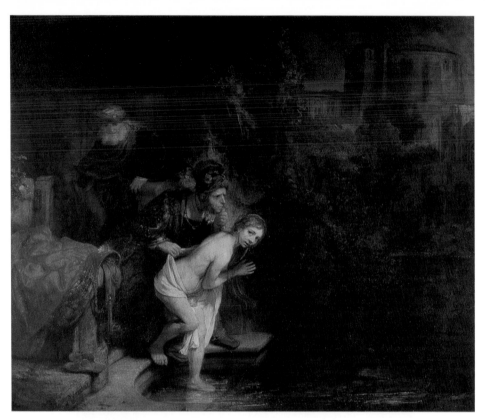

Susanna and the Elders, 1647
Oil on panel, 76.6 x 92.8 cm
Gemäldegalerie, SMPK, Berlin

During the 16th and 17th centuries the story of
Susanna from the Apocryphal Book of Daniel was a
popular subject of paintings, probably because it en-
abled artists to depict the nude female body. Susanna
is observed by two older judges while she is bathing.
When she fends off their inappropriate advances, they
accuse her of adultery. Inspired by God, however, Daniel
recognizes her innocence and condemns the judges.

Bathsheba, 1654
Oil on canvas, 142 x 142 cm
Musée du Louvre, Paris

In the 2nd book of Samuel (11:2–27), David observes
the beautiful Bathsheba, wife of his neighbor Uriah,
from his rooftop as she bathes. David sends for her and
she becomes pregnant. Uriah is sent into heavy fighting
and killed, whereupon David marries Bathsheba. In this
painting Rembrandt captures the moment in which
Bathsheba receives the king's invitation and is wavering
between obedience and fidelity.

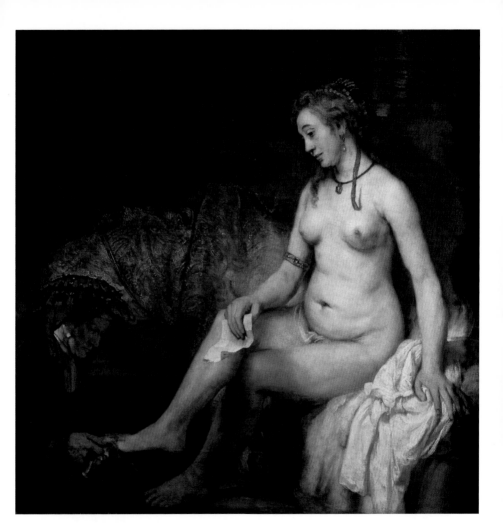

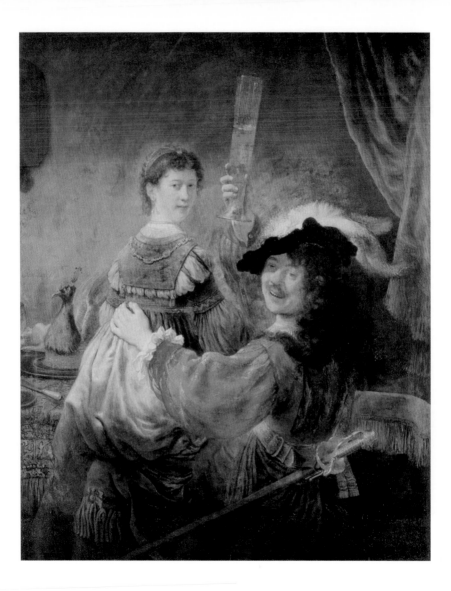

Opposite

Rembrandt and Saskia in the Parable of the Lost Son, 1635/36
Oil on canvas, 161 x 131 cm
Gemäldegalerie Alte
Meister, Dresden

Originally a lute player stood between the figures of Saskia and Rembrandt, but the artist himself painted over this figure. It had served to complete the double portrait, making it an illustration of the parable of the lost son among the prostitutes (Luke 15:11–32). Since a drinking glass symbolizes excess and the peacock represents pride and arrogance, this scene can also be interpreted as a moralizing warning against a licentious life.

The Slaughtered Ox, 1655
Oil on panel, 94 x 67 cm
Musée du Louvre, Paris

A slaughtered ox or pig is a recurrent motif in the paintings of the Netherlands from around the mid-16th century on. Rembrandt painted only a few still lifes in the course of his career. In this monumental work, he drastically and impressively depicts the death and mortality of everything on earth. The panel, located in Paris, contains elements of both the genre and still-life painting styles.

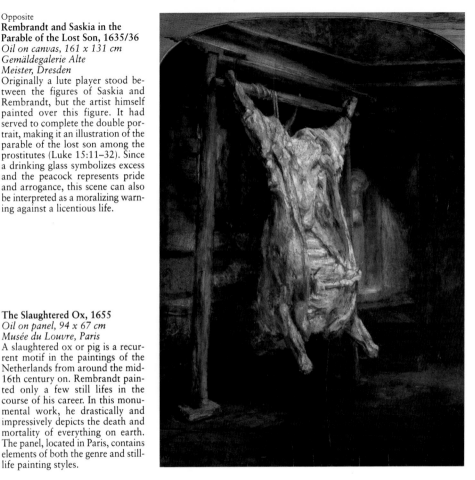

Reni, Guido

Guido Reni (1575 Calvenzano near Bologna–1642 Bologna) studied art with the Dutch painter Denis Calvaert, who lived near Bologna from around 1584 on. Later he worked with Calvaert in the older artist's workshop. Around 1595 he joined the Academy of the Carracci in Bologna. Between1600 and 1614 he visited Rome numerous times. After 1614 Reni lived in Bologna, where he remained for the rest of his life, aside from occasional short sojourns in Ravenna (1620), Naples (1622) and Rome (1627). After the death of Annibale Carraci in 1609, Guido Reni became the uncontested master of Baroque painting in Bologna. His oeuvre includes frescoes, altarpieces and mythological narratives as well as portraits. Significant works by the artist include *The Murdered Children of Bethlehem*, 1611, Pinacoteca Nazionale, Bologna; *The Assumption of the Virgin*, 1617, San Ambrogio, Genoa; and *Portrait of the Artist's Mother*, c. 1620, Pinacoteca Nazionale, Bologna.

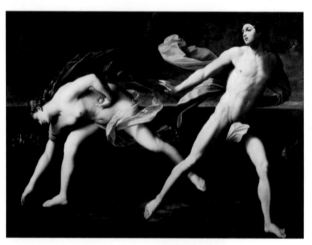

Atalanta and Hippomenes, c. 1615–1620
Oil on canvas, 206 x 297 cm
Museo Nazionale di Capodimonte, Naples
Only rarely chosen as subject matter, the mythological race between Atalanta and Hippomenes is a central work of Reni's early creative period. It is characterized by cool color tones, a smoother style of painting and a more artificial composition. This work is a prominent example of the neoclassical style of art favored in Bolognese painting during the *Seicento*.

Opposite left
David with the Head of Goliath, c. 1605
Oil on canvas, 222 x 147 cm
Galleria degli Uffizi, Florence
This early painting, from the collection of Louis XIV (1643–1719), clearly mirrors Reni's interest in both the art of Caravaggio and that of the ancient world. Caravaggio's influence is evident in the contrasting areas of light and dark; David's statuesque posture between a column and a pedestal is clearly based in classical antiquity in its temperament and form.

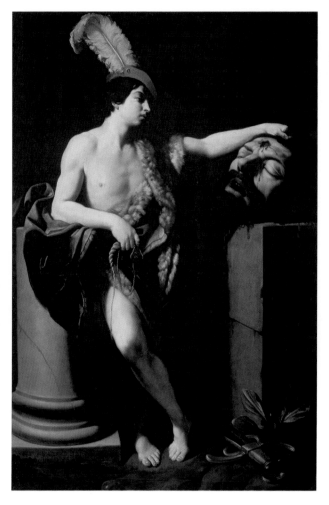

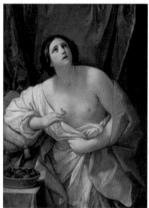

The Suicide of Cleopatra, c. 1639
Oil on canvas, 96 x 122 cm
Galleria Palatina,
Palazzo Pitti, Florence

Reni decisively influenced 17th-century European styles of painting with his depictions of a solitary hero or single historical figure. Representative subjects are the dying Cleopatra, of which the artist painted numerous versions, as well as his depictions of Samson, Hercules, Lucretia and Mary Magdalene. All of these pictures are characterized by a sentimentality that is typical of Reni's style of expression.

Aurora, 1613/14
Ceiling fresco,
280 x 700 cm
Casino Rospigliosi-
Pallavicini, Rome
Commissioned by Cardinal Scipione
Borghese (1576–1633), Reni pain-

ted this famous and highly praised
fresco as a monumental hymn to
light. It portrays Apollo, ancient god
of light, among other things, sur-
rounded by the Horae (goddesses of
the seasons), rushing forward on his
chariot, which is drawn by the

horses of the sun. Aurora, the
goddess of the dawn, floats at the
front of the procession, proclaiming
the coming day and driving away
the vestiges of dark night still
clinging to the land at the bottom
right of the picture. Numerous

sketches of the procession of divinities, whose bodies are full of expressive movement and yet clearly defined, are in existence. The unity of the composition and its dynamic forward impetus are particularly evident in those sketches.

Reynolds, Sir Joshua

Sir Joshua Reynolds (1723 Plympton near Plymouth–1792 London) first studied with the portraitist Thomas Hudson in London from 1740–1743. From 1749 to 1752 he travelled to Italy and studied the art of the ancient world and of the Renaissance in Rome, and the paintings of Titian, Tintoretto and Veronese in Venice. From 1753 on he resided permanently in London. He was appointed the first president of the newly formed Royal Academy in 1768, holding this office until 1790. King George III (1738–1820) knighted him in 1769 and Oxford awarded him an honorary degree. In 1781 and 1785 he visited Holland and Flanders. Reynolds was the most successful and the most productive English portraitist of his time. His important lectures on aesthetics were published as *Discourses* in numerous editions. Other works by the artist include *The Actress Sarah Siddons as the Tragic Muse*, 1774, Gallery of Art, Dulwich; *The Members of the Society of Dilettanti*, 1777–1779, Society of Dilettanti, London; *Lord Heathfield with the Key of Gibraltar*, 1787, The National Gallery, London.

Self-Portrait, 1775
Oil on canvas, 71.5 x 58 cm
Galleria degli Uffizi, Florence
Reynolds painted his own portrait in the style of Rembrandt, whose light-dark paintings he admired. Although he first visited the Netherlands in the 1780s, Reynolds had previously had many opportunities to study the works of Rembrandt, Anthonis van Dyck and other Dutch painters of the 17th century in London. The document in his right hand refers to Michelangelo: Reynolds believed the highest aims of painting were achieved in Michelangelo's style.

Nelly O'Brien, 1760–1762
Oil on canvas, 127 x 100 cm
The Wallace Collection, London
The famous portrait of the courtesan Nelly O'Brien is a fine example of Reynolds' artwork. His sensitive portrayals of women and children are imbued with a high degree of liveliness and immediacy; their effect is natural, enhanced by the landscape in the background, which is characteristic of Reynolds' style. With their richly contrasting colors, Reynolds' portraits are idealized images of English society.

Ribera, Jusepe de

Jusepe de Ribera (1591 Játiva near Valencia–1652 Naples) probably studied with Francisco Ribalta in Valencia. As a young painter he journeyed to Italy, where he was given the nickname *Lo Spagnoletto* ("the little Spaniard") because of his small stature. In Parma he became familiar with the works of Correggio; and in Rome he discovered Caravaggio's art, which continued to have a decisive influence on his own paintings. In 1615 Ribera settled in Naples. Here, the Spanish viceroy of the kingdom of the Two Sicilies, the Duke of Osuna, became his patron; Ribera also painted works for the duke's successor. Ribera is considered one of the most important Spanish painters of the 17th century.

Usually his works are religious in subject; the colors are applied with thick impasto executed through quick strokes of the brush. Luca Giordano was probably the most famous of Ribera's many pupils. Important works by the artist include *Diogenes with a Lantern*, 1637, Gemäldegalerie Alte Meister, Dresden; *St. Agnes*, 1641, Gemäldegalerie Alte Meister, Dresden; and *The Adoration of the Shepherds*, 1650, Musée du Louvre, Paris.

Holy Trinity, c. 1635
Oil on canvas, 226 x 181 cm
Museo del Prado, Madrid
At the center of the painting is the pathetic body of the dead Christ. His arms, resting on the knees of God, are spread in a position reminiscent of his Crucifixion; his body is held by a white cloth. This cloth, as well as the billowing cape of God the Father, emphasize the diagonal structure of the composition. Newly restored, this painting now more clearly reveals Ribera's excellent color technique.

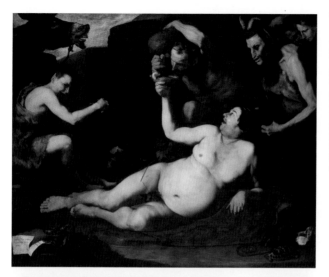

The Drunken Silenus, 1626
Oil on canvas, 185 x 229 cm
Museo Nazionale
di Capodimonte, Naples
This work was probably commissioned by the Antwerp merchant Gaspar Roomer. It is likely that he also chose the subject matter, as Rubens was doing similar themes in Flanders at this time. This iconographically complex painting is foremost a moralizing admonishment to the viewer to desist from excess and gluttony, and to espouse a virtuous way of life.

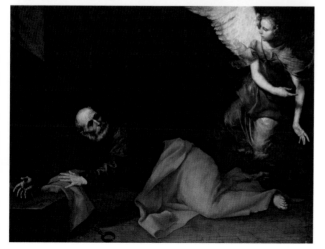

The Freeing of Peter, 1639
Oil on canvas, 177 x 232 cm
Museo del Prado, Madrid
Ribera has captured the moment of the apostle's story in which St. Peter is miraculously freed from prison by an angel. Lying on the floor, the apostle is startled by the sudden infusion of light, cutting through the darkness of night. Elements typical of Ribera's style include the diagonal construction of the composition, a Caravaggio-like use of light, rich in contrasts, and the expressive postures of the figures.

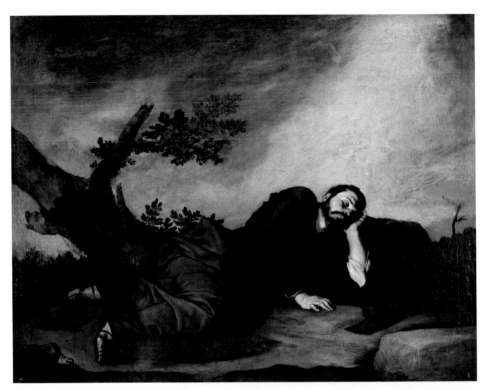

Jacob's Dream, 1639
Oil on canvas, 179 x 233 cm
Museo del Prado, Madrid
Ribera depicted the Old Testament patriarch as a sleeping wanderer. In this painting, Jacob is on his way to Haran to find a wife. His dream is mirrored in his serious, pensive facial expression and in the brightly lit heavens, enlivened with angels.

Jacob is dreaming of a ladder, from which God proclaims that some day the land Jacob is lying on will belong to him and to his numerous descendants, the people of Israel. On the following morning, Jacob takes the stone on which he had pillowed his head, erecting it as a monument, and names this spot *Bet-El* ("House of God"). Ribera

uses this story to concentrate on the portrayal of the solitary man; in this painting, as in all of Ribera's works, forceful realism is united with profound religious piety.

The Club-Footed Boy, 1652
Oil on canvas, 164 x 92 cm
Musée du Louvre, Paris
This wandering beggar child is portrayed from a low perspective in an expansive landscape. Through this "frog's eye" view, his small figure appears monumental in front of the towering sky, structured through clouded areas. The cripple's trustfulness in God is also proclaimed in the inscription on the note in his left hand. It reads DA MIHI ELIMOSINAM PROPTER AMOREM DEI ("Give me alms for the love of God").

Immaculata Conceptio, 1635
Oil on canvas, 504 x 330 cm
Convento de las Agustinas
Recoletas, Salamanca
Painted as an endowment from the
Viceroy Count of Monterey, the
Immaculate Conception portrayed
in this monumental work makes use

of the typical motif of *La Purissima*
and brings it to perfection. Standing
quietly and majestically on a cres-
cent moon, the Virgin Mary is
painted larger than life and sur-
rounded by rays of light. God the
Father and the Holy Spirit, in the
form of a dove, hover above her.

An adoring circle of lively angels
surrounding her and the symbols of
Christianity portrayed attest to the
virginity of the Mother of God.
Visible in the detail above are the
playful movements of the angels,
skillfully intertwined and ending in
the strip of clouds beneath.

Ricci, Sebastiano

Sebastiano Ricci (1659 Belluno–1734 Venice) travelled to Venice as a young man and studied with the artists Sebastiano Mazzoni and Federico Cervelli. From the late 1670s on he worked with Giovanni Giuseppe dal Sole in Bologna. Ricci received numerous commissions in Piacenza and in Rome through his patron, Count Ranuccio II Farnese. In 1694 he went to Florence; from 1696–1698 he was active in Milan, which is likely where he encountered Alessandro Magnasco. After this period, Ricci was again situated primarily in Venice, but he also visited Vienna (1701–1703), Florence (1706/07) and London (1712–1716). The works of this significant Venetian Rococo painter are characterized by agitated, decorative, illusionistic forms and light color tones. Among his works are *Scipio's Magnanimity*, c. 1705, Royal Collection, London; *Marriage of Bacchus and Ariadne*, c. 1711, Graf von Schönborn Art Collection, Pommersfelden; and *Bathsheba Bathing*, c. 1725, Gemäldegalerie SMPK, Berlin.

Pope Paul III Prepares for the Council of Trent, c. 1687/88
Oil on canvas, 120 x 180 cm
Museo Civico, Piacenza
This unusual painting is a part of a series of 12 works depicting scenes from the life of Pope Paul III (1468–1549). Ricci painted them under commission from Ranuccio II Farnese for the palace of this influential family in Piacenza. In this work we see Fides, the personification of Faith, inspiring the Farnese pope to convene the Council of Trent (1545–1563), which was to be of decisive importance for the future of the Church.

Richter, Adrian Ludwig

Adrian Ludwig Richter (1803 Dresden–1884 Loschwitz near Dresden) received his first art lessons from his father Carl August Richter, a copper engraver. In 1820–1821 the young painter travelled through France, and he received a grant to study in Italy from 1823 to 1826, where he had contact with Joseph Anton Koch and Julius Schnorr von Carolsfeld. From 1826 to 1836 Richter worked as a teacher at the school of drawing at the Meissen porcelain factory. Afterward he taught at the Art Academy of Dresden until 1877; in 1841 he was appointed professor. During the mid-1830s Richter distanced himself from Italian motifs and turned to German subjects. He illustrated many popular folk writings, children's books, poems, fairy tales, songs and stories. Richter is considered to be the most popular artist of the German Biedermeier period. Significant works by the artist include *Mount Watzmann*, 1826, Neue Pinakothek, Munich; *Pilgrims' Rest*, 1839, Kunsthalle, Bremen; and *Genevieve in the Solitude of the Forest*, 1841, Kunsthalle, Hamburg.

Crossing the Elbe at the Schreckenstein, 1837
Oil on canvas, 116.5 x 156.5 cm
Gemäldegalerie Alte Meister, Dresden
Richter was inspired to this subject in 1834: He was on a walking tour of the Elbe valley in Bohemia when he observed an old ferryman crossing the river at dusk. Painted three years later, Richter's ferry boat holds people of all ages. It has become a "ship of life"—a motif of Romanticism—in the quietly flowing stream of time. The painting exudes a ceremonial, almost sacred, atmosphere.

Rigaud, Hyacinthe

Hyacinthe Rigaud (1659 Perpignan–1743 Paris) arrived in Montpellier around 1674, where he studied and worked first in the atelier of the painter Pezet and then with Henri Verdier and Antoine Ranc. From 1677 on Rigaud lived in Lyon; after 1681, in Paris. There he became the favorite portraitist of the French aristocracy and the Catholic Church. In 1700 Rigaud was made a member of the Académie Royale de Peinture et Sculpture, and became its director in 1733. In 1709 the influential painter was elevated into the aristocracy, and in 1729 he received the medal of St. Michael. Rigaud's paintings, which were modeled on the elegant portraits of Anthonis van Dyck and on the works of Charles LeBrun, became the standard for court portraits throughout all of Europe during the 18th century, and of course their price rose parallel to their critical acclaim. Among the artist's important works are *Cardinal de Bouillon*, 1708, Musée Hyacinthe Rigaud, Perpignan; *Electoral Prince Friedrich August von Sachsen*, 1715, Gemäldegalerie Alte Meister, Dresden; and *Samuel Bernard*, 1726, Musée National du Château de Versailles et de Trianon, Versailles.

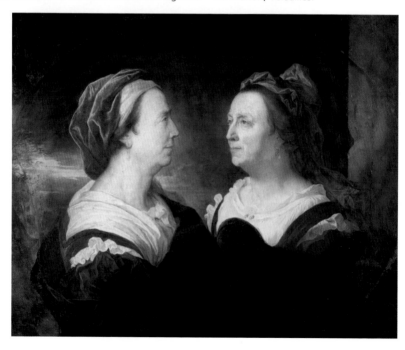

Portrait of Louis XIV, 1701
Oil on canvas, 279 x 190 cm
Musée du Louvre, Paris
With extraordinary elegance Rigaud
allows his viewers to enjoy a display
of official magnificence. This por-
trait of Louis XIV (1638–1715) is
characterized by strong, bright
colors, effective contrasts of light
and dark, and a brilliant modeling
of materials. It is the epitome of
Baroque official portraiture. During
the 18th century Europe grew to
consider this the quintessential
portrait of the absolute monarch.

Opposite
**Portrait of the Artist's
Mother, 1695**
Oil on canvas, 81 x 101 cm
Musée du Louvre, Paris
Throughout his entire artistic career,
in addition to important commis-
sioned portraits of officials, Rigaud
also painted the people in his own
circle of familiars. In this sensitive
study, his mother is portrayed from
two different angles. As in his
official portraits, here too, Rigaud
seems to pattern himself after the
Flemish painter Anthonis van Dyck,
who is known to have executed
similar studies.

Robert, Hubert

Hubert Robert (1733 Paris–1808 Paris) attended the Collège de Navarre and studied drawing in the atelier of the sculptor Michel-Ange Slodtz. In 1754 he left for Rome, where he remained for over ten years. It was there that he received (between 1759 and 1762) the official sponsorship of the Académie de France. In 1760 he travelled to Naples to view excavations of the antique world. Robert's work in Italy was decisively influenced by Giovanni Battista Piranesi and Giovanni Paolo Pannini. In 1765 Robert returned to Paris, where he joined the Académie as an architectural painter in 1766. After a brief imprisonment during the Revolution, he became a member of the commission responsible for remodeling the Louvre into a new national museum. Robert is considered an important precursor of French 19th-century landscape painting. His works include *Demolition of Houses on the Pont au Change*, 1788, Alte Pinakothek, Munich; *The Prisoners of St-Lazare*, 1793, Musée Carnavalet, Paris; and *Avenue in a Park*, 1799, Musées Royaux des Beaux-Arts, Brussels.

Imaginary View of the Grand Gallery of the Louvre, 1796
Oil on canvas, 114.5 x 146 cm
Musée du Louvre, Paris
Hubert Robert depicted numerous versions of the national art museum as a ruin, allowing the impressions he gained in Rome to influence his view. The Louvre's Grand Gallery has the appearance of an ancient ruin, and was intended as an allegory on the transitoriness of human accomplishment. Thematically, this painting is one of many demolition pictures characteristic for Robert, including ruins created by fire, natural disasters or other extraordinary events.

Romano, Giulio

Giulio Romano (c. 1499 Rome–1546 Mantua), whose real name was Giulio Pippi, learned his craft in the atelier of Raphael, becoming his most important pupil and his favorite assistant. Until 1524 this young artist, also influenced by Bramante and Michelangelo, was active in Rome. Afterward he was court painter and architect to the Gonzaga family in Mantua. From 1525 to 1535 Giulio Romano was engaged in constructing a country castle, the Palazzo del Tè, for the Duke Federigo Gonzaga (1500–1540), adorning it with his famous frescoes. In 1537 he was occupied with the decorative ornamentation of various rooms of the Palazzo Ducale in Mantua. Romano was decisive in spreading Raphael's formal principles in northern Italy. Other works by the artist include *The Martyrdom of St. Stephen*, c. 1520–1525, San Stefano, Genoa; *Madonna with the Washbowl* (La Madonna della catina), c. 1525, Gemäldegalerie Alte Meister, Dresden; and *The Rape of Europa*, c. 1530, Royal Palace, Hampton Court.

Virgin and Child, c. 1520–1525
Oil on panel, 105 x 77 cm
Galleria degli Uffizi, Florence
During the early 1520s Giulio Romano painted a number of intimate Madonna scenes whose composition was inspired by the works of Raphael. This Virgin and Child is no exception: Whereas the lively, natural position of the Child is reminiscent of Raphael, the figure of Mary is evidence of the new generation's changed sense of style, which led to the beginnings of Mannerism.

**Wedding of Cupid
and Psyche (detail), c. 1528**
*Ceiling fresco
Sala di Psiche,
Palazzo del Tè, Mantua*
Lying casually on a couch, the
figures of Cupid and Psyche are a
detail of a monumental ceiling
fresco that exudes an atmosphere of
idyllic peace. According to Giorgio
Vasari, it was painted by Giulio
Romano together with his assistants
Benedetto Pagni da Pescia and
Rinaldo Mantovano. Based on the
sketches of his master, Rinaldo
Mantovano also painted the fres-
coes in the *Sala dei Giganti* ("Hall
of Giants") some years later.

Opposite
**The Fall of the Giants (detail)
1532–1534**
*Wall fresco
Sala dei Giganti,
Palazzo del Tè, Mantua*
The subject, the fall of the Giants,
adorns all the walls as well as the
vaulted ceiling of the *Sala dei
Giganti* ("Hall of Giants"). These
scenes display the creative height of
Giulio Romano's artistic career, and
are a milestone in the imaginative
paintings of Mannerism. The
murals are not integrated into the
wall segments by frames. Instead,
the viewer is drawn into the
immediacy of a forceful, whirling
fall of agitated bodies and tumbling
architectural elements. The illusion
is complete and perfect.

Zeus and the Gods of Olympus, 1532–1534
Ceiling fresco
Sala dei Giganti, Palazzo del Tè, Mantua
Zeus, who hurls bolts of lightning against the Giants, seems himself to be tumbling down from the heavens. He completes the illusion of terror begun on the walls: It is especially his expression of fear that for centuries has been admired in the *Sala dei Giganti*. Zeus possibly symbolized the totalitarian rule of the House of Habsburg and the Spanish King Carlos I (1500–1558), who tried to assert his predominance in Italy with massively aggressive tactics in the *sacco di Roma* (sacking of Rome) of 1527–1528.

Zeus and the Gods of Olympus (detail)
With enormous power and force, Zeus, floating on a cloud that has been portrayed as the accumulation of balls of thunder, is trying to evict the Giants from Olympus. Not only is he hurling lightning, but he is also seen trying to tear off the Giants' clothing, leaving them helpless in their nakedness as is seen in a figure in the middle. According to the painting, lightning shoots forth through Zeus' mere touch of the clothes of his opponents, giving the scene a mystically heightened expressive power. The Giants' defense is reduced to a helpless gesture.

Rosa, Salvatore

Salvatore Rosa (1615 Arenella near Naples–1673 Rome) had his first art lessons from his uncle, Domenico Antonio Greco, and afterward studied with his brother-in-law Francesco Fracanzano in Naples. From 1632 to 1635 he worked with Jusepe Ribera and Anjello Falcone. Beginning in 1635, the young painter lived in Rome. He visited Florence from 1641 to 1649, where he was employed by the Medici family. Afterward he returned to Rome, where he remained until the end of his life. Rosa, who was also active as an etcher, a poet and a musician, is considered one of the most versatile Italian artists of the *Seicento*. He painted primarily landscapes and battle scenes, but also left portraits and religious, allegorical and historical figure paintings. Rosa's satires were aimed at society. The 19th century in particular admired his landscapes, which are often imbued with passionate pathos. Significant works by the artist include *Witches and their Spells*, c. 1645, The National Gallery, London; *Allegory of Vanitas*, c. 1651, Fitzwilliam Museum, Cambridge; and *Wooded Landscape with Three Philosophers*, c. 1665, Gemäldegalerie Alte Meister, Dresden.

Battle Scene
Oil on canvas, 180 x 258 cm
Museo Nazionale
di Capodimonte, Naples
Salvatore Rosa's extensive fame is based primarily on his numerous battle scene paintings, which are distinguished by a spirited painting technique that has the effect of looking almost like sketches. The dynamic movement of his style is suited to the turbulent battle turmoil that stretches far into the background. Almost entirely based on shades of brown, the landscape itself is not very clearly defined; it is essentially subsumed into the central battle event.

Rosso, Giovanni Battista

Giovanni Battista Rosso (1494 Florence–1540 Fontainebleau) was trained as an artist in the atelier of Andrea del Sarto. Around 1520 he worked in Volterra for a year, but then returned to Florence. Hoping for commissions from Pope Clement VII (1523–1534), he moved to Rome in 1524, but in 1527 Rosso had to flee from the *sacco di Roma* (sacking of Rome) and spent several years restlessly wandering between Perugia, San Sepolcro, Città di Castello and Arezzo. In 1530, upon the recommendation of his friend Pietro Arretino, Rosso was called to the French court and put in charge of the interior redecorations of the Fontainebleau Castle. Here he created his masterpiece, the decoration of the Gallery of François I with frescoes and ornamental plaster-work. Rosso's style, along with that of his colleague Primaticcio, became known as the School of Fontainebleau. The artist's other major works include *Madonna with Ten Saints*, 1522, Galleria Palatina, Palazzo Pitti, Florence; *The Engagement of the Virgin*, 1523, San Lorenzo, Florence; and *Leda and the Swan*, 1530, The Royal Academy, London.

Virgin and Child Enthroned with Four Saints, 1518
Oil on panel, 172 x 141 cm
Galleria degli Uffizi, Florence
This unusual representation of the Virgin and Child was painted for the church of Santa Maria Nuova in Florence. We see Mary seated on a throne with the Christ child; they are surrounded by John the Baptist and the saints George, Stephen and Anthony Abbas. Only the two cherubs sitting at Mary's feet radiate simple naturalness. The saints seem morbid and unreal, attesting to Rosso's rejection of the normative values of High Renaissance painting.

The Deposition, 1521
Oil on panel, 333 x 195 cm
Pinacoteca Comunale, Volterra
This altarpiece painted for the
Cathedral of Volterra is one of the
most important works of Rosso's
early period. At the same time, it is
a characteristic example of Floren-
tine early Mannerism. Typical of
this style is the disjointed com-
position, lacking any inherent,
logical connection: The figures are
distended and out of proportion;
and the artist has chosen coloring
mainly in cool shades.

Opposite
**Moses Defends the
Daughters of Jethro, 1523**
Oil on canvas, 160 x 117 cm
Galleria degli Uffizi, Florence
With a gesture that seizes control of
his surroundings, Moses, clad
simply in a billowing red cape,
rushes in to protect the daughters of
Jethro from the attack of the
Midianite shepherds. The expressive
form of the powerful, active bodies
depicted here is typical of Man-
nerism. The bodies also prove that
Rosso had already studied the
paintings of Michelangelo inten-
sively before his journey to Rome.

Rubens, Peter Paul

Peter Paul Rubens (1577 Siegen–1640 Antwerp) studied with the painters Tobias Verhaecht, Adam van Noort and Otto van Veen. In 1598 he was asked to join the city's Guild of St. Luke's as a master. From 1600 to 1608 he visited Italy and became court painter to Vincenzo Gonzaga II, Duke of Mantua; he also visited Genoa, Venice, Florence and Rome. In 1608 he settled in Antwerp. The following year he became court painter to Archduke Albrecht and Archduchess Isabella in Brussels, but continued to live in Antwerp. From 1628–1630 he travelled on diplomatic missions to the courts of England and Spain. Rubens is considered the most important Flemish painter of the Baroque era. His extensive oeuvre includes many paintings on religious and mythological subjects, monumental ceiling and picture cycles, portraits and landscapes. Major works by the artist include *The Adoration of the Magi*, 1624, Koninklijk Museum voor Schone Kunsten, Antwerp; *The Assumption of the Virgin*, 1625, Onze-Lieve-Vruowe-Kerk, Antwerp; and *The Judgement of Paris*, c. 1639, Museo del Prado, Madrid.

Self-Portrait with Isabella Brant, 1609/10
Oil on canvas, transferred to panel, 178 x 136.5 cm
Alte Pinakothek, Munich
Here Rubens is seated with his young wife, Isabella Brant (married October 3rd, 1609). The double portrait was perhaps a present to Rubens' in-laws, as the painting is mentioned in 1639 in an inventory of the estate of Jan Brant, the Antwerp patrician. The painting has an allegorical significance since the honeysuckle blossoms in the background are one of the symbols of married love and constancy.

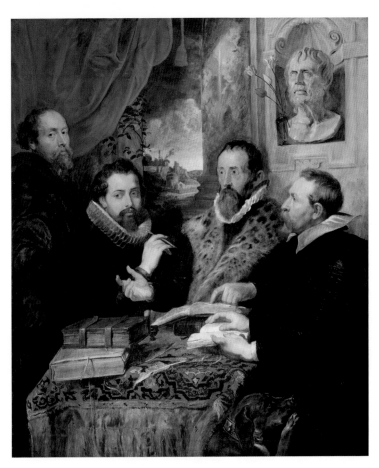

The Four Philosophers,
c. 1611/12
Oil on panel, 164 x 139 cm
Galleria Palatina,
Palazzo Pitti, Florence
This group portrait was probably painted shortly after the death of

Philipp Rubens (1574–1611), and should be viewed as a memorial to the artist's brother. Philipp Rubens and Jan Woverius are discussing the books lying before them at the table with their teacher, the important philosopher Justus Lipsius (1547–

1606). The painter himself appears at the left edge of the picture. Seneca's bust is placed into a niche in the wall over Woverius, whereby Rubens honors the most important source of the neo-Stoic philosophy he himself espoused.

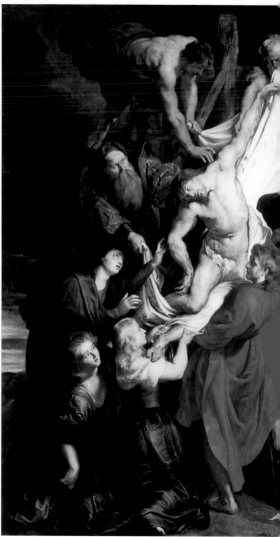

**Descent from the Cross,
1608–1612**
Oil on panel
Central panel: 420 x 310 cm
Side panels: 420 x 150 cm each
Onze-Lieve-Vrouwe-Kerk,
Antwerp

Rubens received the commission for this altarpiece in 1608 from the Archery Guild, whose patron saint is St. Christopher, the "Bearer of Christ." After the Council of Trent (1545–1563), only the figure of Christ or other New Testament figures was allowed in the central panel of altar triptychs. Saint Christopher therefore appears on the outer side of the triptych, since his story is not related in the Bible but was passed down only through numerous legends. The middle panel of the triptych on the festival side shows Christ being taken from the cross, flanked by scenes of the Visitation and the Presentation in the Temple. All of the scenes are iconographically united through the theme of "the bearing of Christ."

**The Doubting of Thomas,
1613–1615**
Oil on panel, 143 x 123 cm
*Museum voor Schone
Kunsten, Antwerp*
This is the middle panel of a
triptych that Rubens painted for
Nicolas Rockox (1560–1640), the
mayor of Antwerp and also an
important art collector. Rubens
portrayed Rockox and his wife,
Adriana Perez, on the inside of the
flanking panels. Not only are the
apostles Thomas and Peter painted
in the middle panel, but also Paul,
who did not actually take part in
this biblical story.

**Helene Fourment
in Bridal Dress, 1630/31**
Oil on panel, 163.5 x 136.9 cm
Alte Pinakothek, Munich
On December 6th, 1630, four years
after the death of his first wife,
Isabella Brant, Rubens married
Helene Fourment, the 16-year-old
daughter of a highly esteemed
Antwerp merchant. Rubens has
here painted his young wife as if
she were a queen, in a luxurious
gown bedecked with rich jewels.
The gown is of costly satin brocade,
and her hair ornament is set with
pearls and jewels, indicating her
status as a bride.

Opposite
**The Rape of the Daughters
of Leucippus, c. 1618**
Oil on canvas, 224 x 210.5 cm
Alte Pinakothek, Munich
Rubens masterfully portrayed
mythological subjects throughout
his entire career. The painting to the
right depicts the legendary moment
when the two daughters of Leucip-
pus, the King of Argos, are being
carried off by the twins Castor and
Pollux. Whereas Castor, the horse
tamer, is seen seizing one of the
women from atop his mount,
Pollux, who can be identified as a
boxer by his naked torso, hoists the
other one up to his brother.

Opposite
Marie de'Medici, Queen of France, Landing in Marseilles on November 3, 1600; 1621–1625
Oil on canvas, 394 x 295 cm
Musée du Louvre, Paris

This painting is part of a cycle of 16 scenes from the life of Maria de'Medici (1573–1642), wife of Henry IV (1553–1610), that Rubens painted for the Palais du Luxembourg in Paris. Their wedding took place in October, 1600. In May, 1610 Maria assumed the regency in Paris, just one day before her husband's violent death. After continuing disputes over power and rule, Rubens was in 1621 commissioned to create the most important cycle of his career; it was completed in June 1625 with the assistance of his workshop. This scene portrays the Queen landing in the harbor of Marseilles after her marriage. She disembarks from an Italian galley and is welcomed by two allegorical figures, Francia and the personification of the harbor city. Over the Queen hovers Fama, goddess of fame. The sea god Neptune and a group of sirens and tritons accompany the pageantry.

The Village Fair, 1635
Oil on panel, 149 x 261 cm
Musée du Louvre, Paris

In his last years Rubens painted a number of masterful landscapes and genre pictures. *The Village Fair*, with its wealth of figures in motion, is surely one of Rubens' most beautiful landscape scenes and proves his affinity with the older Flemish School of painting, especially with the works of Pieter Bruegel the Elder. The happy activity that Rubens painted, that of farmers celebrating outside, was surely based on works by Bruegel. Although it is filled with figures, the composition remains unified. It was painted five years after Rubens' marriage to Helene Fourment, the daughter of a respected Antwerp merchant. In the same year, Rubens bought a country estate near Mecheln. In his later years, he suffered increasingly from gout, which forced him to paint on smaller canvases.

The Village Fair (detail)
Rubens portrayed the individual scenes of a village fair in light, brilliant colors, set off with very little accentuation. The lovers dancing and their physical embraces leave no doubt that the merriment is turning to lust. It is a matter of speculation whether this mood mirrored the artist's own situation. But, through this depiction of the coarse enjoyments of simple people, Rubens created a counterpart to the social events of more refined circles.

800 Rubens, Peter Paul

Virgin and Child in a Garland of Flowers, c. 1620
Oil on panel, 185 x 209.8 cm
Alte Pinakothek, Munich
Rubens painted this picture together with his friend Jan
Brueghel the Elder, who was a specialist in flower
paintings and who executed the depiction of the flower
garland. The Virgin Mary, appearing as a picture
within a picture, has the features of Rubens' first wife,
Isabella Brant. His son Albert, born in 1614, was the
model for the Christ Child.

Opposite
The Three Graces, 1636–1638
Oil on canvas, 221 x 181 cm
Museo del Prado, Madrid
The three Graces, the daughters of Jupiter and
Eurynome, were often portrayed during the Renaissance
by Botticelli, Raphael and others. Rubens, a collector
of ancient art and well-acquainted with his predecessors,
painted this traditional subject in the language of the
Baroque. The figures, imbued with motion and seem-
ingly life-sized, form a kind of hymn to femininity.

50.

Ruisdael, Jacob van

Jacob van Ruisdael (1628/1629 Haarlem–1682 Amsterdam?) was the son of the picture framer and painter Isaack van Ruisdael. He probably received his earliest training in the atelier of his uncle, Salomon van Ruysdael. In 1648 he was accepted as master in the Haarlem St. Luke's Guild; but works were signed and dated by him as early as 1646. During the 1640s and early 1650s he travelled to the region around Egmont aan Zee and to Bentheim and Kleve, near the border between Germany and the Netherlands. Around 1656/57 van Ruisdael moved from Haarlem to Amsterdam, where he established himself as a citizen. In 1676 he received the diploma of Doctor of Medicine in Caen. Jacob van Ruisdael was one of the most important Dutch landscape painters of his generation. Significant works by the artist include *Waterfall with Mountain Castle*, c. 1668, Herzog Anton Ulrich Museum, Braunschweig; *The Mill at Wijk near Duurstede*, c. 1670, Rijksmuseum, Amsterdam; and *The Bleaching Fields near Haarlem*, c. 1670, Kunsthaus, Zurich.

Landscape with Shepherds and Farmers, c. 1665
Oil on canvas, 52 x 60.5 cm
Galleria degli Uffizi, Florence
This landscape painting dates from the period Ruisdael spent in Amsterdam. It is characterized by spiritual profundity and classical clarity of form, united with a sensitivity for effective atmosphere. The pointedly attention-drawing dead branches of the trees suggest the theme of the vanity and temporality of earthly life. The human figures in these paintings are further reminders of the fleeting nature of life.

Haarlem, Seen from the Dunes
in the Northwest, c. 1670–1675
Oil on canvas, 52 x 65 cm
Gemäldegalerie, SMPK, Berlin
Ruisdael's so-called *Haarlempjes*, or views of his home city of Haarlem, form a high point of Dutch landscape painting. The rows of linen lying on the meadows to bleach in the sun document the importance of the cloth business for the city. The whiteness of the linen is suggestive purity and chastity, virtues which the soul should strive to attain.

**The Jewish Cemetery
at Ouderkerk, c. 1670**
*Oil on canvas, 84 x 95 cm
Gemäldegalerie Alte
Meister, Dresden*
The artist has incorporated motifs derived from the Jewish cemetery at Ouderkerk near Amsterdam into this picture, although the painting is not a topographically accurate rendering of the site. Somber and melancholy in overall tone, the painting is instead intended to be an expression of mortality, symbols of which include the rushing brook, the dead tree, the graves and the ruins. The idea of *vanitas* is at the heart of this composition.

Runge, Philipp Otto

Philipp Otto Runge (1777 Wolgast–1810 Hamburg) received his first training in drawing from his elder brother Daniel, who lived near Hamburg, in 1794. From 1799 to 1801 Runge studied at the Academy of Art in Copenhagen; from 1801 on he pursued his studies on his own in Dresden. In 1803 he again settled in Hamburg. He died as a young man, just 33 years old. In spite of this, together with Caspar David Friedrich, Runge is considered one of the most important representatives of northern German Romanticism. He mainly painted portraits of his friends and relatives, but his goal was to bring new expressive power to landscape painting. Works by the artist include *Self-Portrait*, 1802,

Kunsthalle, Hamburg; *The Artist's Parents*, 1806, Kunsthalle, Hamburg; and *Louise Perthes at the Age of Three Years*, 1805, Schlossmuseum, Staatliche Kunstsammlungen, Weimar.

Opposite
The Morning (1st version), 1808
Oil on canvas, 106 x 81 cm
Kunsthalle, Hamburg
In 1803 Runge sketched a four-part cycle on the theme of Time which, based on the divisions of the day and the seasons, included the stages of human life from birth to the grave, the ages of the world, and finally, time and eternity. Of these, *The Morning* is the only design Runge rendered in oil. The program of the picture shows the artist's version of Utopia: In the harmony of light we see the origin of the landscape in conjunction with the young, innocent beginnings of human life.

The Hülsenbeck Children, 1805/06
Oil on canvas, 131 x 141 cm
Kunsthalle, Hamburg
This famous painting of children shows the five-year-old Maria with her younger brothers August and Friedrich in the family garden in the village of Eimsbüttel, adjacent to the gates of Hamburg. In addition to being a group portrait, this picture documents Runge's theory of color, which was based on the polar contrast of light and dark and of translucent and opaque colors. In this way the life of the new day dispels the darkness, which, for example, still lingers on the leaves of the sunflowers.

Ruysdael, Salomon van

Salomon van Ruysdael (c. 1602 Naarden near Amsterdam–1670 Haarlem) travelled to Haarlem in 1616 after the death of his father. He remained there as a wealthy and respected citizen for the rest of his life without any long periods of absence. In 1623 he was accepted by the Haarlem St. Luke's Guild; in 1648 he assumed leadership of the guild as its Deacon. Historical sources dating from 1651 also refer to van Ruysdael as "coopman," as he traded in the blue color used in the Haarlem bleacheries. The artist left to posterity an enormous oeuvre numbering more than 800 paintings. Among them are many variations of quiet river scenes and shorescapes. Less often he painted winter and ship scenes, cavalry battles and still lifes. Dated works of his, known to have been done by his own hand, exist between 1627 and 1669. Works by the artist include *River Landscape with Fishermen*, 1631, The National Gallery, London; *Bringing In the Herd*, 1641, Landesmuseum, Mainz; and *River Landscape with Ferryboat*, 1649, Rijksmuseum, Amsterdam.

Still Life with Fowl, 1661
Oil on canvas, 112 x 85 cm
Musée du Louvre, Paris
Salomon van Ruysdael distinguished himself as an exceptional still-life painter with only a very few works. They were executed between 1659 and 1662, in the later period of his creative life. He mainly portrayed dead game animals and birds that have been gathered into woven baskets, piled up or arranged on stone slabs. Artfully-draped cloths complete the decorative character of these works.

Opposite
River Landscape near Arnheim, 1651
Oil on panel, 89 x 116 cm
The Hermitage, St. Petersburg
Ruysdael's river scenes are often constructed on a compositional plan that he varied only slightly. In the foreground, the river occupies the entire width of the picture, extending on the right side all the way to the horizon. On the left, the height of the trees on the shore lend stability to the composition. They lead the viewer's eye into Ruysdael's landscape, which is always peopled with travelers, fishermen and farmers with their animals.

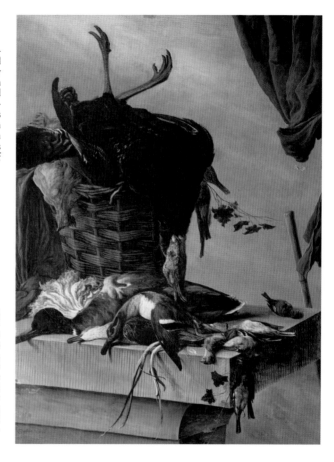

The Charm of the Old

Italian, French and Dutch masterpieces were all the rage in England during the mid-18th century, especially works by Raphael, Michelangelo and Titian, Poussin and Lorrain, Rembrandt and Rubens. It was also deemed necessary for youth to tour the Continent, i.e. to visit Italy by way of Holland and France, in order to be considered well-educated. It was at this time that many important art collections were begun, such as that of Robert Walpole, the first Prime Minister: After his death in 1779, the collection was sold for a spectacularly high price to the Czarina Catherine II of Russia. Sotheby and Company was founded in 1744, and the first auction at Christie's was held in 1766. These two firms, still the most notable dealers of art today, were not the only two that specialized in the art of the past: There were other well-known houses such as Agnew and Sons, and Colnaghi. Towards the middle of the 18th century, London thus joined Paris as the world's leading forum of exchange for works by the old masters.

The contemporary English artists, in particular, suffered from the consequences of this wide-spread conservative taste in art, which also dominated the Royal Academy after it was founded in 1768. William Hogarth (1697–1764), who headed an academy that served as a forerunner of the Royal Academy and was widely feared because of his biting satires and moralizing attacks, continually published pamphlets directed against art dealers with their shady business practices and lack of artistic acumen. He accused them of importing entire shiploads of "old masterpieces," which were in reality copies, forgeries, copies of copies and forgeries of forgeries. On these they "scribbled terribly hard-to-decipher names of a few Italian masters."

Hogarth also vented his scorn on collectors who treated art "like furniture," letting themselves be led astray by sonorous names. In 1744/45 Hogarth drew The Battle of the Paintings as an illustration to help sell tickets to an auction. On the left is the auction house with a steeply ascending stairway, characterized by a hammer on its standard. Portraits, religious paintings and mythological scenes all jumbled together are being offered by the dealer. On the right is Hogarth's atelier with examples of his work. In the middle, the devastating battle of the paintings is taking place: The canvases attack and slice through each other willy-nilly.

Unfortunately, Hogarth's sarcasm did not bring about any decisive change in the art market. As

William Hogarth: The Battle of the Pictures, 1744/45
Etching 17.8 x 19.8 cm
Kupferstichkabinett, SMPK, Berlin
The paintings by the old masters are fighting against those of Hogarth; *The Flaying of Marsyas* and *The Rape of Europa* are in the foreground. A portrait of St. Francis is piercing through Prudery in Hogarth's *The Morning*, and above it *The Penitent Magdalen* is invading a prostitute's room. The art of the old masters has allied itself against Hogarth.

The Bearer hereof is Entitled (if he thinks proper) to be a Bidder for Mr. Hogarth's Pictures, which are to be Sold on the Last day of this Month

a matter of fact, when in the late 19th and early 20th centuries droves of artists and millionaires and a small circle of agents and collectors poured from America to Europe to view and, in part, to eagerly buy old masterpieces, some of them without restraint or scruples, they headed first and foremost for London and Paris. The New York art dealer Joseph Duveen (1869–1939), for example, travelled steadily back and forth between Europe and America after 1886 to discover and acquire new works for his customers. Among these customers were such impressive figures as Andrew Mellon, Samuel H. Kress, P.A.B. Widener and others whose collections would become the bases for the great American museums. They had enormous financial means, but often lacked the necessary judgment and knowledge to critically appraise the works

being offered for sale. Although Duveen made efforts to educate the artistic taste of his customers, other art historians and private collectors of the Old World continued to regard the self-assured, newly rich Americans, who constantly drew attention with their spectacular purchases, with great skepticism.

Like Duveen, Wilhelm von Bode (1845–1929), a museum founder, spent a considerable amount of time in London each year in order to buy works destined for the art museums in Berlin. He described his meeting with John Pierpont Morgan (1837–1913), the powerful American collector whose artworks were later donated to New York's Metropolitan Museum of Art, in his biography, which appeared in 1930. Von Bode viewed Morgan with a mixture of respect and disdain: "Without knowing anything particular about any period of art, without exceptional taste or natural talent, without even so much as a good advisor, this strange man has in very few years put together a collection which can measure itself against those of the great old museums, even surpassing them in some areas. He has done so solely through his own financial means and the liberty with which he expended them, by his cleverness and single-mindedness." Wilhelm von Bode's critique of Morgan's taste in and understanding of art certainly echoes the satires that William Hogarth wrote over 100 years previously.

Salviati, Francesco

Francesco Salviati (1510 Florence–1563 Rome), whose real name was Francesco de'Rossi, learned his craft in Florence, first from Guiliano Bugiardini and Baccio Bandinelli, and then from around 1529 with Andrea del Sarto. From 1531 he worked in Rome for Cardinal Salviati, whose name the painter took on. From 1544 to 1548 he resided in Florence, where he decorated the Sala dell'Odienza in the Palazzo Vecchio, among others, with frescoes. Afterward he returned to Rome and remained there for the rest of his life, aside from one sojourn in France in 1554/55. Salviati was highly esteemed in Rome: He was a member of the Accademia di San Luca and accepted into the Virtuosi al Pantheon, an elite group recognized as experts in ancient artwork. He was one of the important representatives of Florentine-Roman Mannerism. His diverse oeuvre includes frescoes, altarpieces and portraits, as well as designs for carpets, triumphal and stage decorations. Other important works by the artist include *The Visitation*, fresco, c. 1538, Oratorium, San Giovanni Decollato, Rome; and *Scenes from the Life of David*, fresco, 1553/54, Palazzo Sacchetti, Rome.

Caritas, c. 1545
Oil on panel, 156 x 122 cm
Galleria degli Uffizi, Florence
This *Caritas* and a second version of the subject now located in the Alte Pinakothek in Munich were painted during Salviati's stay in Florence. Suitably, Caritas, as the personification of compassion, appears here with three small children, as is customary in the iconographic tradition. The piece displays features typical of Mannerism: The figures radiate artful elegance and movement, while the coloring is iridescent and often exaggerated.

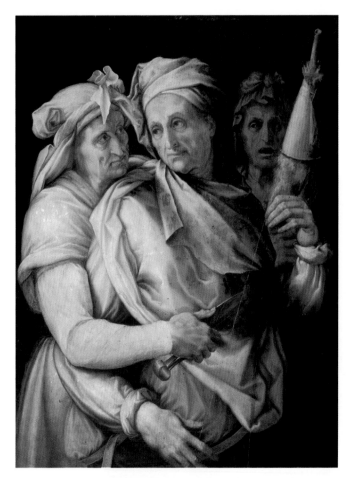

The Three Fates, c. 1545
Oil on canvas, 83 x 61 cm
Galleria Palatina,
Palazzo Pitti, Florence
Although probably painted during
Salviati's stay in Florence, the ex-
ceptional quality of this work has
given rise to speculation that it was
done by someone else, perhaps even
by Michelangelo. According to the
attributes they hold, the three old
women represent the classical god-
desses of fate, the Moirai (Greek) or
Partae (Latin). Clotho spins the
thread of life, Lachesis measures it,
and Atropos, the Inevitable, stands
ready to cut the thread at the
designated end.

Sánchez Coello, Alonso

Alonso Sánchez Coello (c. 1531 Benifairón–1588 Madrid) was trained in Flanders and Lisbon. From 1557 on, he remained at the Spanish court in Valladolid, where he became the favorite court painter of King Phillip II (1527–1598). Sánchez Coello was strongly influenced by the works of Titian and Anthonis Mor, whom he knew personally. In addition to altarpieces, Sánchez Coello concentrated on single and double portraits, as well as paintings of riders. With their rigidly assigned compositions, his pictures were well-suited to the etiquette of the Spanish court; Sánchez Coello usually chose coloring in sensitive and harmoniously shaded warm tones. Works by the artist include *The Infant Don Carlos*, 1564 Kunsthistorisches Museum, Vienna; *The Mystic Marriage of St. Catherine*, 1578, Museo del Prado, Madrid; and *Portrait of Philip II*, c. 1580, Museo del Prado, Madrid.

**The Infanta
Isabella Clara Eugenia, 1579**
*Oil on canvas, 116 x 102 cm
Museo del Prado, Madrid*
This quasi-official portrait shows Isabella Clara Eugenia, the daughter of Philip II (1527–1598) and his third wife, Isabella of Valois, at the age of 13. The Infanta (1566–1633) married Albrecht of Austria in 1599 and, at the behest of her father, took over the regency of the Catholic Netherlands. In this pose she is wearing a magnificent dress whose severe cut was typical for the fashion at the Spanish court. The detail reveals the even, idealized features of the girl's face, framed by costly pearls and jewels.

Sassetta

Sassetta (c. 1392 Siena–1450 Siena), whose given name was Stefano di Giovanni, was probably trained at the atelier of Paolo di Giovanni Fei. The first official mention of his name was in Siena in 1427. Sassetta is considered one of the most important Sienese painters of the *Quattrocento*. His work corresponds stylistically to the transitional period when the International Gothic style gave way to the early Renaissance, and reveals the influence of Masaccio and Masolino. Sassetta preserves in his compositions the elegant contour work and spatial perspective that Simone Martini introduced into Sienese painting about 100 years earlier ,and developed his own, often fairy-tale-like, narrative style. Among the artist's works are *Virgin and Child With Angels and Four Saints*, 1430–1432, Collezione Contini Bonacossi, Palazzo Pitti, Florence; *Mystical Marriage of St. Francis with Chastity, Poverty and Humility*, 1437–1444, Musée Condé, Chantilly; and *The Coronation of the Virgin*, fresco, 1447, Porta Romana, Siena.

**St. Francis in Glory with
the Blessed Rainer of Borgo San Sepolcro
and John the Baptist, 1437–1444**
Tempera on panel, 195 x 217 cm
Collezione B. Berenson, Settignano near Florence
St. Francis appears almost life-size, flanked by Rainer of Borgo San Sepolcro and John the Baptist in this work, which originally adorned the festive side of the famous double-sided polyptych that Sassetta painted for the high altar of the Church of St. Francis in Borgo San Sepolcro. The Blessed Rainer, a Franciscan monk who died in 1304, lies buried there. On the back side of the altar are eight panels depicting various scenes from the life of St. Francis.

Savery, Roelandt

Roelandt Savery (1576 Kortrijk–1639 Utrecht) fled with his family from the political upheavals in the southern Netherlands in 1580 to Haarlem. There he was trained in the atelier of his older brother, Jacob Savery the Elder. From 1604–1614 he was court painter for Emperor Rudolf II (1552–1612) in Prague. According to Joachim von Sandart (1606–1688), Savery travelled to the Tyrol on behest of the emperor from 1606–1608. Aside from visits to Salzburg, Munich, Prague and Amsterdam, he lived in Utrecht from 1619 on, where he joined the St. Luke's Guild as a master. Savery is considered an important intermediary between the painting of the southern and northern Netherlands. In addition to many landscapes, he painted animal pictures, genre paintings and flower still lifes. His works include *Wooded Landscape with Hermit*, 1608, Niedersächsisches Landesmuseum, Hannover; *Tower Ruins at the Bird Pond*, 1618, Gemäldegalerie Alte Meister, Dresden; and *Paradise*, 1628, Kunsthistorisches Museum, Vienna.

Courtyard of a Farmhouse, c. 1610
Oil on panel, 53 x 78 cm
Pushkin Museum of the Fine Arts, Moscow
This painting belongs to the genre of fantastic animal landscapes which, in their great detail, are characteristic of Savery. The barn in the left foreground, connected with the house through a crumbling wooden walkway, is falling into ruin. Opulent nature is growing over transitory human achievements. But nature, too, is subject to temporality, as can be seen in the split tree trunks at the lower edge of the picture. The entire painting leaves the viewer with a fairy-tale-like, enchanted impression typical of Savery's works.

Schönfeld, Johann Heinrich

Johann Heinrich Schönfeld (1609 Biberach-on-the-Riss–1682/83 Augsburg) was the son of a goldsmith and was trained as a painter by one of the Sichelbeins, a family of artists in Memmingen. From 1627–1629 he lived in Stuttgart. His journeyman years led him as far abroad as Basel and in 1633 through France to Rome, where he was especially influenced by the neoclassical-Arcadian movement of the period. From 1638 on he lived in Naples, but in 1651 returned to Germany to work first in Ulm and then in Augsburg from 1652.

Schönfeld painted primarily religious and mythological scenes, influenced by the neoclassical artworks of Nicolas Poussin and contemporary Neapolitan painting. Along with Johann Liss, Schönfeld is considered the most significant German painter of the 17th century. Important works by the artist include *The Triumph of Venus*, c. 1640, Gemäldegalerie, SMPK, Berlin; *The Suicide of Cato*, 1659, Kunsthistorisches Museum, Kremsier; and *Treasure Hunters in Roman Ruins*, 1662, Staatsgalerie, Stuttgart.

The Oath of Hannibal, c. 1660
Oil on canvas, 98 x 184.5 cm
Germanisches National-
museum, Nürnberg
The nine-year-old Hannibal (246–182 B.C.) is here depicted taking an oath, swearing to remain the eternal enemy of Rome, before a statue of Mars, the god of war, in the presence of his father Hamilcar and the inhabitants of Carthage, who surround him in a wide circle. This scene is described by Livy (*Ab urbe condita*, XXI,1). The excitement generated by the placement of the statues, the masses of people, and the highlighting of single figures in the huge, brilliantly lit temple is a masterful accomplishment, revealing Schönberg as an extremely skillful artist.

Schongauer, Martin

Martin Schongauer (c. 1450 Colmar–1491 Colmar?) was the son of the goldsmith Caspar Schongauer. After a brief stint as a student of theology at the University of Leipzig in 1465/66, he was probably trained in the atelier of the Colmar city painter Caspar Isenmann. In the journeyman years that followed, Schongauer seems to have travelled to Cologne, to the Netherlands, to Beaune in Burgundy, and to the northwest of Spain. He again settled in Colmar in 1471. In 1489 he obtained citizen status in Breisach near Colmar in order to paint the frescoes of the *Last Judgement* in its cathedral. Schongauer had a decisive influence on late Gothic painting in Germany through his numerous excellent copper engravings and drawings, as well as through his altarpieces, of which unfortunately only very few have been preserved. Other works by the artist include *The Virgin of the Rose Bower*, 1473, Münster Sankt Martin, Colmar; *Side Panels from an Altar to the Virgin*, c. 1475, Musée d'Unterlinden, Colmar; and *Holy Family*, Kunsthistorisches Museum, Vienna.

Nativity, c. 1475–1480
Tempera on panel, 26 x 17 cm
Alte Pinakothek, Munich
The Virgin is seated on a grassy bench giving the Christ Child chicory, a plant that, since the Middle Ages, was believed to have the power to avert disaster. In the background at the right, Joseph is standing in the stable in Bethlehem seeming to prepare for the flight into Egypt. This is a moment rarely portrayed in paintings. This small devotional panel was probably originally complemented by a second on the left side, showing a portrait of the donor.

Opposite
Noli Me Tangere, c. 1480–1490
Tempera on panel, 114 x 82 cm
Musée d'Unterlinden, Colmar
Mary Magdalene with the resurrected Christ is one of 24 panels in the Colmar Museum which once adorned a monumental winged altarpiece. It was originally painted by Martin Schongauer, along with assistants from his atelier, for the Dominican church of the city. The *Noli Me Tangere* is without a doubt one of the most beautiful paintings of the altarpiece. It is located on the inner side which is composed of 16 scenes depicting the Passion of Christ.

Nativity, c. 1480
Tempera on panel, 37.5 x 28 cm
Gemäldegalerie, SMPK, Berlin
Schongauer has portrayed Mary, Joseph, and the three shepherds of different ages adoring the newborn Christ Child in the stable of Bethlehem in glowing colors in front of a wide, well-populated river landscape. The eyes of all the figures are centered on the Child lying on a simple white cloth on the ground. The white cloth, optically highlighting the Child, draws the viewer's gaze there first.

Scorel, Jan van

Jan van Scorel (1495 Schoorl near Alkmaar–1562 Utrecht) first attended the Latin school in Alkmaar and then learned his craft in the atelier of Cornelis Willemsz. in Haarlem from 1509 to 1512. From 1512 to 1518 he worked with Cornelisz. van Oostsanen in Amsterdam, and from 1519 to 1525 he travelled via Nuremberg, Carinthia and Venice as far as Jerusalem, Rhodes and Rome. There he was appointed by Pope Hadrian VI (1522/23) to be Raphael's successor as curator of the papal collection of ancient art in the Belvedere. In 1524 he returned to Holland and lived in Haarlem and Utrecht. In the following years, he travelled again, this time to Breda and Mecheln (1532/33) and then to France (1540). Jan van Scorel was educated as a humanist: He was an artist who also made a name for himself as an architect and a hydraulic technician. As a painter, he executed mainly altarpieces and portraits. In Italy he was primarily inspired by Raphael and the Venetians. His paintings are characterized by a clear compositional form and rich colors. Around 1540 he turned to Mannerism, which increasingly influenced his style. Other works by the artist include *Triptych of the Holy Family (Frangipani Altar)*, 1519/20, Pfarrkirche, Obervellach in Carinthia; *Baptism of Christ*, 1527, Frans-Hals-Museum, Haarlem; and *Virgin and Child with Wild Roses*, c. 1529, Centraal Museum, Utrecht.

Portrait of Agatha van Schoonhoven, 1529
Oil on panel, 38 x 26 cm
Galleria Doria Pamphilj, Rome
Agatha van Schoonhoven was Jan van Scorel's wife. The date of their wedding is unknown, but by 1537 the couple was known to have four children. This famous picture is characterized by the natural air of the young woman, her lively gaze holding the eyes of the viewer.

The Flood, c. 1530
Oil on panel, 109 x 178 cm
Museo del Prado, Madrid
In Genesis 6:7 God speaks these words: "I will blot out man whom I have created from the face of the earth, man and beast and creeping things and birds of the air, for I am sorry that I have made them." Only Noah found favor in God's eyes, and was allowed to save himself and his family along with a pair of every kind of animal from the ensuing flood. In the foreground of the painting, people and animals struggle against the masses of water. Noah's ark can be distinguished in the middle of the composition, in front of the elevated castle. Some scholars have also attributed *The Flood* to Frans Floris.

Opposite
The Flood (detail)
In this detail it is obvious how the frantic people tried to escape from the approaching waters by climbing the trees and hills, helping each other out of danger. They are not passively submitting to God's fate, but are actively trying to save themselves from the rushing waters. Little attention is being paid to the animals, who are seen fending for themselves. Only Noah thought to ensure the continuation of animal life in the new world. The scene is highly dramatic, a typical example of Scorel's Mannerism.

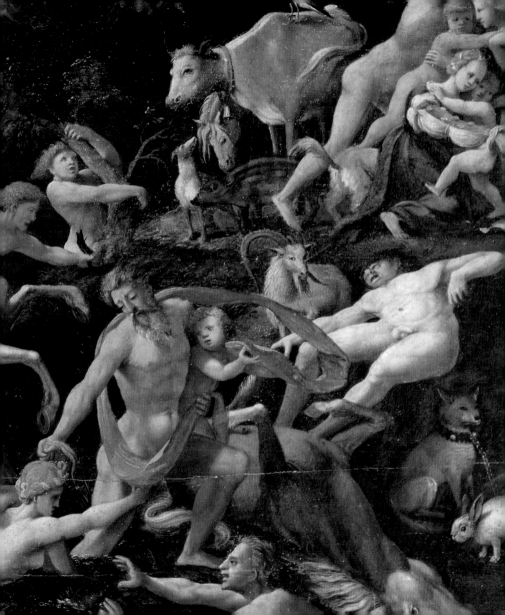

Seghers, Daniel

Daniel Seghers (1590 Antwerp–1661 Antwerp) learned his craft from 1610–1611 in the atelier of Jan Brueghel the Elder in Antwerp. In 1611 he was accepted into that city's St. Luke's Guild as a master painter. He converted to Roman Catholicism and entered the novitiate of the Jesuits in Mechlin in 1614. From 1617 to 1621 he lived in the Jesuit monastery in Antwerp, and afterward he went to Brussels. The Jesuit Order sent him to Rome from 1625–1627, and he remained in Antwerp after his return. Aside from a few land-scapes, Seghers painted mainly flower garlands around coaches and medallions; the figures and religious subjects were then added by Peter Paul Rubens and other Antwerp figural painters. Among the artist's works are *Flowers in a Glass Vase*, 1635, Toledo Museum of Art, Toledo, Ohio; and *Holy Family in Floral Decorations*, 1644, Kunsthalle, Karlsruhe.

Ecce Homo inside a Garland of Flowers
Oil on canvas, 94 x 71 cm
Pinacoteca Apostolica
Vaticana, Vatican
Seghers, a still-life specialist, colla-borated numerous times with the narrative painter Erasmus Quillinus (1607–1678) who did the *Ecce Homo* scene at the center of the work. Jan Brueghel the Elder had introduced the motif of the flower wreath into Antwerp painting in the early 17th century, and his pupil Seghers raised this motif to its apex. His extremely detailed, meticulous flower garlands are the pictorial form of a spiritual, profound view of nature as the ultimate expression of God's artistry.

Seghers, Hercules Pietersz.

Hercules Pietersz. Seghers (c. 1590 Haarlem–before 1639 The Hague) moved in 1596 with his family to Amsterdam where he met the landscape painter Gillis van Coninxloo sometime before 1606. In 1612 Seghers became a member of the Haarlem St.Luke's Guild. In the years 1614 to 1631 he lived in Amsterdam; in 1631 he moved to Utrecht where he worked as an art dealer. Toward the end of 1632 he settled in The Hague. Highly esteemed by his contemporaries, Seghers painted mainly landscapes, among them wild mountainous scenes and views of the expansive Holland lowlands. Of his works, only eleven paintings, two sketches and various graphics (some of them colored) have been preserved; none of his works is dated. Seghers' paintings are stylistically characterized by the use of the color brown. His early works show the influence of Joos de Momper and Roelant Savery. Other works by the artist include *Landscape with a View to the Rhine*, Gemäldegalerie, SMPK, Berlin; and *River Landscape with Houses*, Museum Boijmans van Beuningen, Rotterdam.

Broad Valley Landscape with Rocks, c. 1625
Oil on canvas,
transferred to panel,
55 x 99 cm
Galleria degli Uffizi, Florence

This picture, along with no fewer than seven other expansive landscapes by Hercules Seghers, was a part of Rembrandt's art collection in Amsterdam in 1656. The painting was part of a study series of imaginary valley landscapes framed by bizarre rock formations. The effect of spaciousness in a composition of primarily somber colors is accentuated through the conscious use of some lighter areas.

Signorelli, Luca

Luca Signorelli (c. 1445 Cortona–1523 Cortona) probably learned his craft in the atelier of Piero della Francesca in Arezzo, as Signorelli's early works are stylistically indebted to the older artist's paintings. Under the influence of Antonio del Pollaiuolo and Andrea del Verrocchio, Signorelli developed his own forceful artistic language that was imbued with movement. His works mark the high point of central Italian painting during the late *Quattrocento*. His figures are usually subject to a geometric-stylized posture. About 1482/83, Signorelli painted two frescoes in the Sistine Chapel in the Vatican under the direction of Perugino. He spent the rest of his life in southern Tuscany and in Umbria where he worked in Spoleto, Volterra, Orvieto, Perugia and San Sepolcro among other places. Signorelli also painted frescoes and altarpieces. Other works by the artist include *Cycle of Frescoes with Scenes from the Life of St. Bernard*, 1496–1498, Cloister Abbey, Monteoliveto Maggiore; *Portrait of a Musician*, c. 1500, Gemäldegalerie, SMPK, Berlin; *Crucifixion*, c. 1500, San Crescentino, Morra.

Virgin and Child with St. Onofrius, John the Baptist, St. Lawrence and Bishop Jacopo Vanucci (Pala di Sant'Onofrio), 1485
Oil on panel, 221 x 189 cm
Museo dell'Opera
del Duomo, Perugia
The strikingly individual figures of the four saints flank the throne of the monumental Madonna with the Christ Child. An angel, playing music, sits at her feet. The composition is reminiscent of goldsmithing work in its minutely detailed rendering of forms. The realistic depiction of certain details, for example, the vase of flowers at the lower edge of the panel, is reminiscent of older Dutch paintings that were known in Italy through a few works such as the *Portinari Altarpiece* painted by Hugo van der Goes.

Fall of the Damned
1499–1504
Fresco, total width c. 670 cm
Cappella di San Brizio,
Duomo, Orvieto
Throughout his career as a painter, Signorelli was deeply interested in the depiction of nude figures in motion, and his figures demonstrate an affinity to contemporary sculpture. The depiction of landscapes, on the other hand, was not of great importance to him. In this work, Signorelli portrays spiritual despair and dramatic emotions with extraordinary expressive force using violently moving bodies, energetic gestures, and a well-developed sense of mimicry.

**Procession of the Elect
into Paradise, 1499–1504**
*Fresco, total width c. 670 cm
Cappella di San Brizio,
Duomo, Orvieto*
This wall fresco is part of a compre-
hensive representation of the Last
Judgement which had been begun
in 1447 by Fra Angelico, also the
painter of the chapel's ceiling depict-
ing Christ as Judge of the World.
On the walls beneath, Signorelli
added the depictions of Paradise
and the Fall of the Damned, as well
as two other large scenes. The myri-
ad variations in human anatomy
that can be found in Signorelli's
work are part of a tradition leading
back to Pollaiuolo, but these nudes
go far beyond those of his forerun-
ner in their stylistic severity and
compositional clarity.

Sittow, Michel

Michel Sittow (c. 1469 Reval–1525 Reval) was born in Reval, a city that at the time belonged to the German dominion in Estonia and was a member of the Hanseatic League. Sittow first learned painting from his father, the artist Claus van der Suttow. After Claus' death in 1482, Michael went to the Netherlands, settling in Bruges in 1484, where Hans Memling had a strong influence on him. In 1492 Sittow travelled to Spain. In Toledo he became court painter to Isabella I, The Catholic, of Castile (1451–1504). While in the service of Philip I, The Beautiful (1478–1506), he returned to the Netherlands in 1502; from 1506 on he again worked in Reval. In 1514 he was officially mentioned in Copenhagen at the court of King Christian II (1481–1559). In 1515 he was in Mechlin, working for Margarete of Austria (1480–1530), the city's regent. After a period in Valladolid, Sittow finally returned to Reval in 1518 and settled there permanently. Important works by the artist include *Portrait of a Man*, c. 1510, Maurishuis, The Hague; *Don Diego de Guevara*, c. 1515, National Gallery of Art, Washington D.C.; and *St. Anthony Altarpiece*, c. 1520, Nikolai Church, Reval.

Virgin and Child, c. 1515
Oil on panel, 32 x 24.5 cm
Gemäldegalerie, SMPK, Berlin
This panel is the left wing of a diptych. The right side portrays the donor, Don Diego de Guevara, treasurer to Margarete of Austria. Sittow is strongly influenced by Hans Memling in his rendering of the half-length Madonna and Child, but the very personal portrayal of these two figures and their marked corporeality are Sittow's own.

Snyders, Frans

Frans Snyders (1579 Antwerp–1657 Antwerp) was trained in Antwerp by Pieter Brueghel the Younger and Hendrik van Balen. In 1602 he joined the city's St. Luke's Guild as a master. In 1608/1609, he journeyed to Italy, first to Rome and then to Milan. In July 1609, Snyders was again in Antwerp. There, two years later, he married Margaritha de Vos, the sister of the painters Cornelis and Paul de Vos. In 1619 he became a member of the Romanist Society; in 1628 he headed the society as its deacon. Frans Snyders is considered the most important Flemish still-life painter of the Baroque era. He painted large market and kitchen pieces, fruit, fowl and game still lifes, as well as hunting scenes and animal pictures. All his works are characterized by a very naturalistic rendering of the subject matter. He often worked together with Peter Paul Rubens, Anthonis van Dyck, Cornelis de Vos and other Antwerp figural painters. Among the artist's paintings are *Fowl Still Life*, 1614, Wallraf-Richartz-Museum, Cologne; *Elk Hunt*, c. 1638, Museo del Prado, Madrid; and *Still Life with Game, Fowl, Vegetables and Fruit Basket*, c. 1640, Gemäldegalerie, SMPK, Berlin.

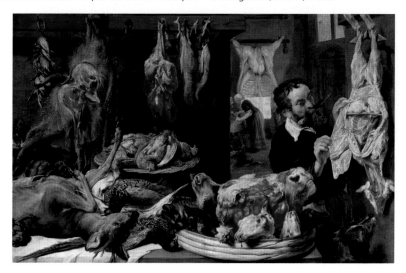

The Butcher, c. 1635
Oil on canvas, 135 x 210 cm
Pushkin Museum of Fine Arts, Moscow
This painting dramatically alludes to the sacrificial death of Christ and the mortality of all earthly life. In the foreground, the butcher, with a knife held in his mouth, is pulling the skin from a lamb. On the table next to him lie a deer, a pheasant, the head of a wild boar and in flat baskets, bull and sheep heads as well as some quail and snipe. Other slaughtered animals are hanging against the wall. In the adjacent room, two women are seen busy with animals' entrails.

The Fruit Basket, c. 1632
Oil on canvas, 153 x 214 cm
Museo del Prado, Madrid
This painting was mentioned as early as 1636 as part of the inventory of Alcázar Palace: It was hanging in the resting and dining room of King Philip IV of Spain (1605–1665). The figs in the bowl that the woman is just taking into her left hand allude symbolically to love and fertility, as does the parrot, the bird of love. Likewise, the carnation (seen here in the bowl of strawberries) was considered a symbol of fertility and marriage during the Middle Ages. Snyders' painting is masterful in its characterization of different materials and textures and in its composition, enlivened by a varied, attention-grabbing rhythm.

Still Life with Swan, c. 1645
Oil on canvas, 162 x 228 cm
Pushkin Museum
of Fine Arts, Moscow
This painting contains all the stylistic features which characterize the apex of Flemish still-life painting around the middle of the 17th century: the large format, the dynamic composition, and the bright color tones that are rich in contrast. The

Antwerp portraitist Cornelis de Vos, who often worked together with Snyders, probably painted the young man on the left, in front of a window with a view to the countryside. The game and fowl on the table are dominated by the white swan at the center of the picture. In the background, the gaping mouth of the wild boar's head retains a hint of its former frightening quality.

Two greyhounds are seen on a leash in front of the table. In this picture we are shown the trophies of the "high" hunt, a privilege accorded only to the nobility. The arrangement of these choice delicacies is enhanced by a bundle of asparagus and by oyster shells.

Sodoma, Il

Il Sodoma (c. 1477 Vercelli–1549 Siena), whose given name was Giovanni Antonio Bazzi, came from a small village in the Piedmont region of Italy. From 1490 to 1497 he trained in the atelier of the local painter Giovanni Martino Spanzotti. In 1500 the young artist went to Siena through the influence of the Spannocchi, a banking family. He was called to Rome in 1508 to help paint the backgrounds of Raphael's Stanza della Segnatura in the Vatican. However, he did not progress beyond these mere beginnings at the Vatican. In 1510, his wedding in Siena is documented. Sodoma was again in Rome in 1512, this time painting the famous *Alexander* fresco for Agostino Chigi (1465–1520) in the Villa Farnesina. In his later creative years he was based in Siena, but also worked in Volterra (1539/40), Pisa (1540–1543), Lucca (1545) and Piombino. His works include *The Wedding of Alexander the Great and Roxane*, fresco, 1512–1515, Villa Farnesina, Rome; *Christ in Purgatory*, fresco, c. 1530–1534, Oratorio di S. Croce, Siena; and *The Sacrifice of Abraham*, 1542, Duomo, Siena.

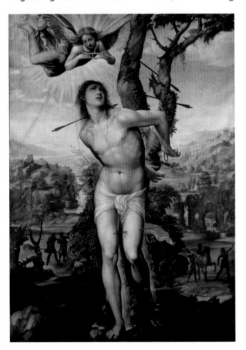

St. Sebastian, 1525
Oil on canvas, 206 x 154 cm
Galleria Palatina, Palazzo Pitti, Florence
In his famous book *Lives...* (see p. 154), Giorgio Vasari praised this work, a canvas painted on both sides with St. Sebastian on the one side and a *sacra conversazione* on the other. It originally served as a processional flag for the Brotherhood of San Sebastian in Camollia near Siena. This work was done by Sodoma in his mature period. The painting is characterized by a detailed narrative style: The figures are three-dimensional and corporeal against a broad background landscape. St. Sebastian's transcendent upward gaze as well as the half-darkness into which the figures are set are elements typical of Sodoma's style.

Solimena, Francesco

Francesco Solimena (1657 Canale di Serino–1747 Barra near Naples) first learned painting from his father, the artist Angelo Solimena. In 1674 he went to Naples where he continued his studies with Francesco di Maria. Here he became acquainted with the paintings of Giovanni Lanfranco, Mattia Preti and Luca Giordano, whose works helped him develop his own style. Aside from short trips to Montecassino (1702) and Rome (1700 and 1707), Solimena remained in Naples. He is considered the most important exponent of Neapolitan painting of the late Baroque. His large murals and ceiling paintings, as well as his panel paintings, are characterized by a wealth of figures, a dramatic impulse toward movement, and dramatic *chiaroscuro* effects. Other works by the artist include *Samson and Delilah*, c. 1690, Herzog Anton Ulrich Museum, Braunschweig; *Virgin and Child with St. Francis of Paula*, c. 1705, Gemäldegalerie Alte Meister, Dresden; and *Expulsion of Heliodorus from the Temple*, c. 1725, Galleria Nazionale d'Arte Antica, Rome.

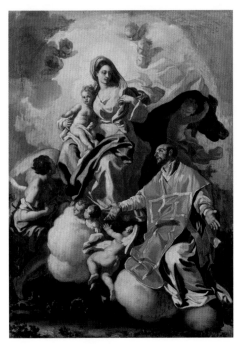

Virgin and Child with
St. Philip of Neri, c. 1725–1730
Oil on canvas, 68.5 x 50 cm
Museo Nazionale di Capodimonte, Naples
In 1533, Philip of Neri (1515–1595) left his native Florence for Rome, where he founded the Order of the Oratorians. Solimena, who had already portrayed the popular saint in a fresco cycle in San Gerolamini in Naples, here depicted Philip of Neri's vision of the Virgin. The heavenly scene is composed on the diagonal, the slanted flow of light emphasizing and illuminating the miraculous experience.

**Massacre of the
Giustiniani Family
on Chios, c. 1715**
*Oil on canvas, 277 x 164 cm
Museo Nazionale di
Capodimonte, Naples*
The large painting is a study for one
of three monumental canvases that
Solimena painted for the senatorial
hall of Genoa in 1715–1717. The
final version has since been lost in a
fire, but his prototype clearly shows
that this historical scene was
rendered with great intensity and
High Baroque pathos, as is seen
especially vividly in the expressive
gestures of the figures. The ver-
tically-structured composition, mov-
ing upward in a zigzag, is a preview
of Rococo art.

Spitzweg, Carl

Carl Spitzweg (1808 Munich–1885 Munich) began as a student of pharmacy at the University of Munich. In 1832 he travelled to Italy and, after an illness the following year, decided to become a painter. Spitzweg was first active mainly as a draftsman and illustrator. He lived in Munich all of his life, but he took many trips to the mountains and jaunts to small Bavarian and Frankish cities. In 1849 he travelled to Prague and in 1850 to Italy with Eduard Schleich. In 1851 he visited the World Expo in Paris; 1856 found him in Berlin for a short time. He was awarded honorary membership in the Kunstakademie (Art Academy) of Munich in 1868. Spitzweg painted mainly landscapes and genre paintings in which he depicted anecdotes from the bourgeois world of the Biedermeier era with kindly humor. Works by the artist include *The Butterfly Catcher*, c. 1840, Städtisches Museum, Wiesbaden (on loan from the state collection); *Englishmen in the Campagna*, c. 1845, Nationalgalerie, SMPK, Berlin; and *The Painter in the Garden*, 1882, Stiftung Oskar Reinhart, Winterthur.

Schoolgirls on a Walk, c. 1860
Oil on canvas, 32.1 x 54.1 cm
Neue Pinakothek, Munich
This small picture shows not only two nuns taking a walk with their charges on a path through the fields, but also a group of farmers taking a rest from their labors and a soldier and his lady love. Spitzweg was well-acquainted with Dutch landscape painting of the 17th century: This is evident in his composition of the wide-angle view into the countryside and the high, unstructured sky.

The Poor Poet, 1839
Oil on canvas, 36.3 x 44.7 cm
Nationalgalerie, SMPK, Berlin

Spitzweg depicts the deprivations of a poor poet in his tiny attic apartment with much humor and irony. In addition to all his other difficulties, the poet has just caught a flea. Nevertheless, he is trying to reach the "peak of Parnassus" (i.e., the height of fame), as the inscription *gradus ad parnassum* on the binding of the book next to his bed discloses. It is possible that the Munich poet Matthias Ettenhuber (1720–1782) served as the artist's inspiration.

Opposite
The Scribe, c. 1850
Oil on paper, 38.1 x 22.4 cm
Neue Pinakothek, Munich

The small copyist stands in front of a very tall window in his oversized office in a somewhat pompous pose. The bright sunlight penetrating the room alludes to the expansive world beyond, a sharp contrast to the narrow confines of the office. Even when the scribe rises to peer out into the world, the indispensable equipment of his trade remains with him: His writing quills are still in his hand and behind his ear, and his sitting pillow is stuck to his pants.

Spranger, Bartholomeus

Bartholomeus Spranger (1546 Antwerp–1611 Prague) learned his trade in Antwerp from Jan Mandijn, Frans Mostaert and Cornelis van Dalem. In 1565 he travelled via Paris and Lyon to Italy. After stops in Milan and Parma he arrived in Rome in 1566, where he stayed for nine years, working for Cardinal Farnese (1520–1589) and Pope Pius V (1566–1572), among others. In 1575 he went to Vienna to work in the court of Emperor Maximilian II (1527–1576). After the emperor's death, Spranger followed his son, Rudolf II (1552–1612), to Prague, where with his late Mannerist mythological and religious subjects he became the leading court painter. In 1584 Sprangern was appointed Chamber Painter, and at the same time became a member of the painters' guild in Prague. In 1602 he travelled to Antwerp, Amster-dam and Haarlem; here he also met his biographer, Karel van Mander. The artist's works include *Epitaph for the Goldsmith Nicolaus Müller*, c. 1592, Národní Galerie, Prague; *Minerva as Victor over Ignorance*, c. 1592; and *Venus in the Smithy with Vulcan*, after 1607, both located in the Kunsthistorisches Museum, Vienna.

Self-Portrait, c. 1600
Oil on canvas, 54 x 42.7 cm
Galleria degli Uffizi, Florence
Spranger portrays himself with dignity as an older, somewhat gray-haired man, without the brush or palette that would indicate his profession. This excellent painting takes on a special significance in the context of his complete oeuvre, as Spranger only rarely turned to portraiture throughout his relatively long creative career.

Venus, Mercury and Cupid, 1597
*Oil on canvas, transferred
to panel, 89 x 69 cm
Germanisches National–
museum, Nürnberg*
Venus, the goddess of love, and
Mercury, the messenger of the gods

depicted with his winged hat and
messenger's staff, are trying to
blindfold the young Cupid, who
struggles against them with all his
might. This painting stems from
Spranger's late Prague period. Char-
acteristic for this time is the imme-

diacy of the figures: They are directly
in the foreground of the picture
and in the viewer's space, cut off
only by the edges of the canvas
with no other framing devices.

Steen, Jan

Jan Steen (c. 1625 Leiden–1679 Leiden) supposedly studied with Nicolaes Knüpfer in Utrecht, with Adriaen van Ostade in Haarlem and with Jan van Goyen in the Hague. In 1649 he became a member of the St. Luke's Guild in Leiden. In the same year he married Margaretha van Goyen, the daughter of his teacher, in the Hague, probably remaining in the city until 1654. Afterward he is known to have taken over breweries in Delft and in Leiden. In 1656 he moved to Warmond near Leiden, and from 1661 to 1670 he lived in Haarlem. He spent the last years of his life in Leiden, where he owned a restaurant from 1672 on and where he remarried in 1673. Jan Steen is considered one of the most important Dutch painters of the 17th century. His extensive and varied oeuvre includes narrative and allegorical works and a few landscapes and portraits, but he concentrated on genre paintings. Among the artist's works are *The Chicken Yard*, 1660, Mauritshuis, The Hague; *The World Upside Down*, 1663, Kunsthistorisches Museum, Vienna; and *Rhetorician at the Window*, c. 1665, Philadelphia Museum of Art, Philadelphia.

The Lovesick Woman, c. 1662
Oil on canvas, 61 x 52.1 cm
Alte Pinakothek, Munich
Jan Steen made about 20 variations on the theme of the doctor's visit in his paintings. In all of them the doctor cuts a somewhat ridiculous figure with his officious manner and old-fashioned clothes, a view also often espoused in contemporary plays. In the left hand of the young patient, a note discloses the true cause of her sufferings: *Daar baat geen medesyn want het is minepyn* ("There is no medicine for love-sickness").

**As the Old Sing, so the Young Tweet (The Artist's Family),
c. 1663–1665**
*Oil on canvas, 134 x 163 cm
Mauritshuis, The Hague*
Playing on the proverb, *zo d'ouden zongen, zo pijpen de jongen* ("as the old sing, so the young tweet"), the

subject of the generation gap was a popular one in both the northern and southern Netherlands during the 17th century. Steen illustrates the proverb in terms of a family celebration, characterized by the older generation's foolish and immoderate consumption of alcohol

and tobacco. It is not by accident that a bagpipe player provides the music: He was at that time considered to be a symbol of laziness and stupidity. Naturally, the young people participate in the festivity, following the unedifying example of their elders.

Card Players Quarreling, c. 1665
Oil on canvas, 90 x 119 cm
Gemäldegalerie, SMPK, Berlin
A cavalier is involved in a violent fight with a group of
farmers in front of an inn. At the root of the argument
lie the vices of alcohol and tobacco, as can be seen from
the playing cards and utensils lying on the ground. The
fighting factions embody Ire, or Anger, one of the Seven
Deadly Sins which were repeatedly depicted in Dutch
painting from the late 16th century on.

Opposite
Card Players Quarreling (detail)
The cavalier has drawn his rapier in order to avenge
himself on the farmers for his losses at the game table.
A woman, probably the innkeeper's wife, throws
herself at him in order to try to calm him down. The
gesture of the little girl, seen from the back, indicates
that she, too, is trying to soothe the cavalier and hinder
him in his intentions. Here, Steen blames not cheating
but uncontrolled anger as the cause of unreflective,
violent deeds.

Strigel, Bernhard

Bernhard Strigel (c. 1460 Memmingen–1528 Memmingen) was probably the son and pupil of the painter Hans Strigel the Younger. Bernhard Strigel is first documented in 1505 in the tax records of Memmingen. When the Parliament of Constance convened in 1507, he painted his first portrait of Emperor Maximilian I (1459–1519). He then worked under commission of the emperor in Vienna in 1515 and 1520. From 1517 on Strigel was mentioned officially as a member of the Memmingen city council. As its envoy, he negotiated on behalf of the city in Innsbruck, Ulm, Augsburg, Ravensburg and Esslingen in 1523 and 1525. Strigel was equally esteemed by his contemporaries as a portraitist and a painter of altarpieces. Together with Albrecht Dürer, Albrecht Altdorfer and Lucas Cranach the Elder, Strigel is one of the leading representatives of old German painting. Important works by the artist include *Mindelheimer Family Altar*, c. 1505, Germanisches Nationalmuseum, Nuremberg; *The Altar of the Virgin*, 1507/08, Markgräflich Badisches Schlossmuseum, Salem; and *Emperor Maximilian and His Family*, 1515, Kunsthistorisches Museum, Vienna.

Portrait of Sibylla von Freyberg, born Gossenbrot, c. 1505
Oil on panel, 61 x 35.8 cm
Alte Pinakothek, Munich
Since the coats of arms on the back of the panel are those of the Freyberg and Gossenbrot families, the woman portrayed here is assumed to be Sibylla von Freyberg. The necklace she wears with the sign of the swan reveals her membership in the Order of the Swan. The rosary in her hands emphasizes the steadfast faith of the young woman, whose goodness is also attested to by the cherries lying on the sill.

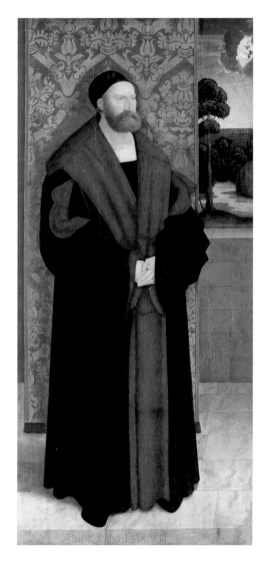

**Portrait of
Konrad Rehlinger, 1517**
*Oil on panel, 209 x 101 cm
Alte Pinakothek, Munich*
This life-sized portrait is the left half
of a diptych, the right panel of
which (also in Munich) shows the
eight children of the Augsburg
patrician Konrad Rehlinger (1470–
1553). Rehlinger's wife, Barbara,
had died in 1515. The inscriptions
on both panels reveal that her
husband and children are praying
for the protection of God and the
Virgin Mary.

Strozzi, Bernardo

Bernardo Strozzi (1581 Genoa–1644 Venice), called *il prete Genovese* ("the Genoese priest"), was first trained in his native city by the painter Pietro Sorri from Siena. In 1598 he entered the Capucin Order, but he left the order in 1610 in order to support his mother and to pursue his artwork more freely. In the following years he was active as a mission-ary, and from 1614 to 1621 worked as a harbor engineer in the Republic of Genoa. Around 1630, Strozzi, who is perhaps the most important Geno-ese painter of the Baroque era, went to Venice, where he was elevated into the aristocracy. He remained in Venice until the end of his life. Here Strozzi studied the works of the older masters: Through the artistic richness of his style, he was able to give new inspiration to Venetian painting of the *Settecento*. Among the artist's major works are *Lamentation of Christ*, c. 1610, Accademia Ligustica, Genoa; *Isaac Blessing Jacob*, c. 1615, Palazzo Bianco, Genoa; and *The Gamba Player*, c. 1640, Gemäldegalerie Alte Meister, Dresden.

The Old Flirt, c. 1625
Oil on canvas, 135 x 109 cm
Pushkin Museum
of Fine Arts, Moscow
The somehow ridiculous old woman seated before her mirror, whose two servants adorn her with jewelry, ribbons and a feather like a young girl, is the personification of Vanity and Transience. This allegory, painted during Strozzi's period in Genoa, has been preserved in several variations. In the past this picture has been attributed by some to the German painter Johann Liss, who was active in Rome and Venice around the same time, but this supposition has proven untenable.

The Cook, c. 1620
Oil on canvas,
177 x 241 cm
Galleria di Palazzo
Rosso, Genoa
Strozzi based this extraordinarily well-executed masterpiece on the important market and kitchen works painted in the second half of the 16th century north of the Alps by artists such as Pieter Aertsen and Joachim Beuckelaer. Strozzi was able to view and admire these works in his native city's famed art collections, which even the likes of Peter Paul Rubens and Anthonis van Dyck are known to have visited, in 1607 and 1621 respectively.

Subleyras, Pierre

Pierre Subleyras (1699 Saint-Gilles-du-Gard–1749 Rome) came from the Languedoc region of France. He took his first art lessons with his father, the painter Mathieu Subleyras, in Uzès and later learned his craft from Antoine Rivalz in Toulouse. From 1726 to 1728 he lived in Paris, where in 1727 he won the Academy's first prize with his painting *The Iron Snake*. The following year he went to Rome and studied at the Académie de France until 1735. Afterward he worked independently for the clergy and for Italian nobility. In 1740 he became a member of the Accademia di San Luca in Rome. Aside from portraits, Subleyras painted mostly monumental altar and narrative works that were strongly influenced by Italian painting of the High Baroque. His works occupy a special place in the French art of this time. Other works by the artist include *Pope Benedict XIV*, 1740/41, Musée Condé, Chantilly; *Emperor Theodosius before St. Ambrose*, c. 1645, Alte Pinakothek, Munich; and *The Mystic Marriage of St. Catherine*, 1746, Galleria Nazionale d'Arte Antica, Rome.

Charon Ferrying the Souls of the Dead into the Underworld, c. 1735
Oil on canvas, 136 x 84 cm
Musée du Louvre, Paris
Charon, the ferryman on the River Styx in classical mythology, was usually portrayed as a lugubrious old man; here, however, he is portrayed as a nude study: We see only the muscular back of a young man. The mysterious, doleful aspect of the legend is represented in the white-shrouded, huddled figures crouching in the boat and in the red-brown color of the background. Since the painting was still in possession of the artist in 1746, it was almost certainly not a commissioned work.

Emperor Valens before Bishop Basilius, 1743
Oil on canvas, 133.5 x 80 cm
The Hermitage, St. Petersburg
This painting is a study for the final, well-known altarpiece that Subleyras was to complete in 1743–1747 for the church of St. Peter's in Rome, on commission for Pope Benedict XIV (1740–1758). Today, however, only a mosaic (done a short time later) of the more than 7-meter-high (approximately 23 ft.) painting remains in St. Peter's. Subleyras' enormous canvas painting hangs in the Roman church of Santa Maria degli Angeli. It depicts the legendary mass of the Greek theologian Basil, in which he was able to convince the East Roman Emperor Valens of the power of his religious faith.

Ridon le carte (The Letters are Shining)

In the tenth song of his *Purgatorio*, Dante Alighieri (1265–1321) writes, "The letters are shining." The illuminated manuscripts of the Middle Ages are, indeed, jewels of the highest order. At first only a small, learned elite of clergy and scholars were involved in their creation. The ornate manuscripts are part of a long tradition reaching back through the early Middle Ages and into late antiquity. The most common from of book today is the *codex*

(Latin for wooden block or writing tablet); the oldest known forms date from the 2nd century A.D. Aside from the papyrus that was used when scrolls were common, writing was first done on parchment (vellum) and then on paper. The parchment codex came into general use from the 4th century A.D. on in conjunction with the spread of Christianity. It was both handier than the scroll and more practical, as both sides of the sheets could be written on. Moreover, parchment is more durable than the old scrolls of antiquity. The skins of sheep or goats supplied the raw material: This was first scraped clean of hair and tissue, then washed in a chalk and water solution, and finally smoothed with pumice. A fine layer of chalk was rubbed into the skins in order to prevent the ink from running. Afterward they were cut into large

The Four Evangelists,
The Treasury New Testament, early 800s
Parchment, 30.5 x 24 cm
Treasury of the Cathedral of Aachen, folio 14v
This miniature depicting the four authors of the Gospels is an outstanding example of the illusionist, artistic quality of Carolingian book illumination.

Opposite
Jean and Paul Limburg: Human Anatomy,
Les Très Riches Heures du Duc de Berry, c. 1416
Parchment, 29 x 21 cm
Musée Condé, Chantilly, Ms. 65, folio 14v
The depiction of the young man is not at all anatomical from a modern point of view. Instead, he represents Man as integrated into the cosmos.

sheets and folded to form the pages of the codices. Since parchment is almost indestructible, many manuscripts from the early and high Middle Ages have survived until the present day despite endless wars, fires, and willful vandalism.

Moreover, the manuscripts contain a surprisingly wide spectrum of colors, which people have been producing from minerals and plants from very early in history. If necessary the pigments could be made to adhere to the parchment with a fish-based glue. Goose quills served as writing utensils, and the fur of weasels and squirrels provided the fine hairs necessary for the tips of paint brushes. When gold leaf was used, the surface of the parchment was first treated with a mixture of chalk, bole (red earth), fish glue, and honey to make sure that the thin sheets of gold would adhere.

Because the raw materials were so costly, it is not surprising that during the early Middle Ages book illumination was carried out exclusively in *scriptoria*, the scribal copying rooms of universities and large monasteries. The *vita contemplativa* was the rule of order in such chambers; i.e. an atmosphere of meditative peace conducive to the endless patience necessary for the painstaking copying and decorating of manuscripts. We do not know whether the artists who produced books, for example at the court of Charlemagne (742–814), splendid works that were models for all the monasteries of the kingdom, were monks. Workshops did not arise in a specific place; instead, they attracted painters and scribes from many different regions. It was possible for Roman-Byzantine painters to work side-by-side with native or Irish artists in

The Healing of the Cripple,
The Golden New Testament of Henry III, c. 1045/46
Parchment, 35 x 50 cm
Library, El Escorial, codex Vitrinas 17, folio 65r
This illumination illustrates a scene from the book of Mark (2:1–12). It is one of almost 120 illustrations of the so-called *Codex Aureus*. Henry III (1039–1056) had it made in the monastery of Echternach for the Salic Imperial Cathedral of Speyer.

Charlemagne's palace school, where secular manuscripts were illustrated as well as the Bible, breviaries, and psalters. Secular works included

Jean and Paul Limburg: Priests, Monks and the Faithful celebrate High Mass,
Les Très Riches Heures du Duc de Berry, c. 1416
Parchment, 29 x 21 cm
Bibliothèque Nationale, Paris, folio. 158
This minutely detailed depiction of the interior of a Gothic church is an artistic challenge to which the brothers Jan and Hubert van Eyck in northern Europe, above all, were equal.

herbals, or works on the healing properties of plants based on ancient models, or treatises on astronomy or the art of warfare.

New and different centers of manuscript illumination arose during the Ottoman period of the late 10th and early 11th centuries. Magnificent codices were produced on the Island of Reichenau, in the cities of Cologne, Regensburg and Salzburg, as well as others in France, England and Spain. These various schools had some contact with each other through the journeys undertaken by the artists. In the late Middle Ages the subject matter of books expanded to include the new, secular literature, again bringing about change in illustrations. French romances of knights as well as the epic poems of German provenance were preserved in book form. Above all, Dante's *Divina Commedia* (1307–1321) provided miniaturists with almost infinite inspiration to create breathtakingly beautiful illustrations.

Illustrated manuscripts reached another high point during the High Gothic period. Miniatures made during this time mirror the glowing colors and finely detailed representation and ornamentation of the great cathedral windows and also of the sculptures and panel paintings characteristic of the age. It is important to remember that manuscript illumination with its at times extremely innovative pictorial elements often served to inspire panel paintings throughout the entire Middle Ages.

After the invention of printing by Johannes Gutenberg (c. 1397–1468) in Mainz around the year 1400, book production rapidly increased. Individual hand-made illustrations became unprofitable after the invention of the technique of illustration through woodcuts and copper engravings, and lost their significance by the end of the Middle Ages.

Teniers, David, the Younger

David Teniers the Younger (1610 Antwerp–1690 Brussels) first studied with his father, David Teniers the Elder. In 1632/33 he became a member of Antwerp's St. Luke's Guild, which he later headed as deacon. In 1637 Teniers married his first wife, Anna Bruegel, daughter of Jan Breughel the Elder; her legal guardian was Peter Paul Rubens, who was also a witness at their wedding. Teniers moved to Brussels after he was appointed court painter to Archbishop Leopold Wilhelm (1614–1662) and curator of his important painting collection. Teniers was a many-faceted painter, draftsman and printmaker. He preferred to paint genre pictures, but also did historical narratives, allegories, portraits, landscapes, still-lifes and views of galleries. Works by the artist include *The Country Wedding*, 1637, Museo del Prado, Madrid; *Kermesse in the Country*, 1648, Staatliche Kunsthalle, Karlsruhe; and *The Art Gallery of Leopold Wilhelm in Brussels*, 1651, Musées Royaux des Beaux-Arts, Brussels.

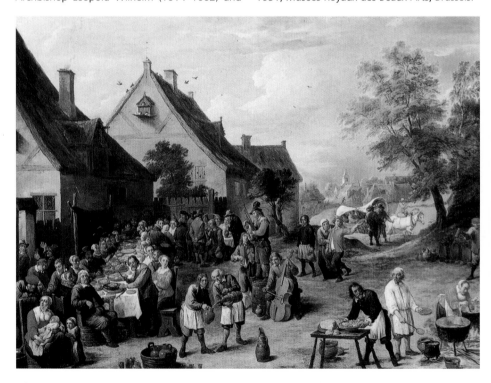

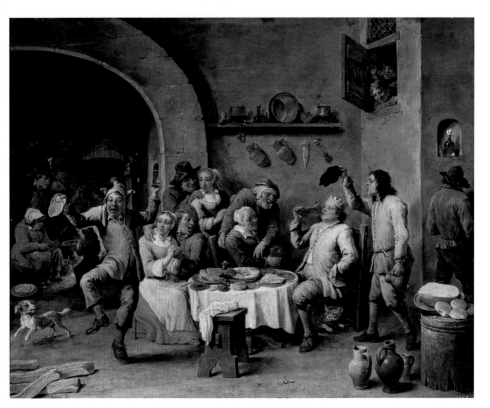

Opposite
Country Wedding, c. 1640–1650
Oil on canvas, 84.5 x 115.5 cm
Galleria Doria Pamphilj, Rome
Teniers depicts with a wealth of detail the numerous
farmers coming together at a long table to celebrate. In
his portrayals of country life with weddings, church fairs
and dancing, Teniers makes use of a tradition in
Flemish painting that had begun in the 16th century. He
gave new impulses to this genre through his light-
hearted view of country life. Even when moralizing
aspects are included, the focus of the picture remains the
convivial gathering itself.

The King Drinks (Twelfth Night), c. 1668
Oil on copper, 58 x 70 cm
Museo del Prado, Madrid
A group of farmers has gathered to celebrate the Feast
of the Magi on the 12th night of Christmas. The
dancing fool on the left, with a full glass and a large
piece of ham, turns to catch the eye of the viewer. He
is moralizing, pointing out the foolish behavior of the
farmers due to gluttony and alcohol. The painting *The
Temptation of St. Anthony* in the Prado also admon-
ishes toward a virtuous life; Teniers painted it as a
counterpiece to this inside view of country life.

The Alchemist, c. 1650
Oil on panel, 26.6 x 37.5 cm
Mauritshuis, The Hague
The workshop of the alchemist was
a favorite subject in Dutch art of the
16th and 17th centuries, beginning
with the work of Pieter Bruegel the
Elder. Teniers took on this motif
numerous times in his long career.
His pictures moralize on the
foolishness and senselessness of the
alchemist's field of study and of
experiments that inevitably lead to
poverty and ruin.

Apes in the Kitchen, c. 1645
Oil on panel, transferred to
canvas, 30 x 50 cm
The Hermitage, St. Petersburg
From the early 1630s on, Teniers
painted monkey scenes as parodies
of human activity and vanity. In the
kitchen shown here, the monkeys
are busy preparing dishes, eating,
drinking, playing cards or idling.
The scene is a metaphor for the
busy-ness of human activity, which
first and foremost centers on cor-
poreal well-being.

Terborch, Gerard

Gerard Terborch (1617 Zwolle–1681 Deventer), also known as Gerard ter Borch, first learned painting with his father and from 1634 on with the landscape painter Pieter Molijn in Haarlem. There he entered the painters' Guild of St. Luke in 1635. During the summer of 1635 he travelled to London, continuing on to Germany, Italy, France and Spain. In 1646 he portrayed the delegates to the peace conference of Spain and the Netherlands in Münster in Westphalia. He settled in Deventer in 1654; in 1655 he received citizens' rights and was elected *Gemeensman* in 1666. Terborch is considered one of the leading Dutch genre painters and portraitists of the 17th century. The artist's works include *The Family of the Stone-Whetter*, c. 1654, Gemäldegalerie, SMPK, Berlin; *Girl Peeling an Apple*, c. 1660, Kunsthistorisches Museum, Vienna; and *The Gallant Soldier*, c. 1662/63, Musée du Louvre, Paris.

Self-Portrait, c. 1668
Oil on canvas, 61 x 42.5 cm
Mauritshuis, The Hague
The occasion for this painting may have been Terborch's election to the city council in 1666, or the occasion on which he was awarded citizen's rights in 1655. The artist did not present himself as a painter with brush and palette, but as an affluent, respectable and self-assured citizen, dressed according to the latest fashion. This picture belongs to a study group of small-format portraits depicting the entire figure of the subject, mostly against a monochrome background.

A Boy Delousing his Dog, c. 1655
Oil on canvas, 34.4 x 27. 1 cm
Alte Pinakothek, Munich
The boy, probably Mozes Terborch, the artist's younger brother, is completely absorbed in his little dog. His writing utensils, meanwhile, lie untouched on the rough table on the left side of the picture. The intended meaning of this famous picture has remained a mystery to the present day: It has been interpreted both as an example of virtue and as an admonishment not to neglect learning.

Terbrugghen, Hendrik

Hendrik Terbrugghen (1588 Deventer–1629 Utrecht), a student of Abraham Bloemaert's, was a prominent member of the Utrecht Caravaggists. In 1604 he travelled to Italy and stayed primarily in Rome and Naples; it is possible that he met Caravaggio personally. After returning to Utrecht, he joined the painter's guild in 1616. Terbrugghen, whose works are only known from those done in the 1620s, painted primarily religious subjects and genre pictures. His portrayal of ordinary people and people from the theatrical world is quite realistic; he does not idealize. In addition, a light, muted range of colors as well as a soft, flowing depiction of light and shadow are characteristic of his art. Among the artist's important works are *Flute Player*, 1621, Staatliche Gemäldegalerie, Kassel; *St. Sebastian Nursed by his Sister St. Irene*, 1625, Allen Memorial Art Museum, Oberlin, Ohio; and *Jacob and Laban*, 1627, National Gallery, London.

Duet, 1628
Oil on canvas, 106 x 82 cm
Musée du Louvre, Paris
This work is one of Terbrugghen's most beautiful because of its harmonious composition and its fine color gradations. He often painted musicians in half-length figures, but they rarely appeared together as in this painting. The fine lighting works to accentuate the sensual charms of the duo, so that the picture seems "loud." The embodiment of hearing is one of the facets of the "five senses," a popular motif in Dutch art.

Tiepolo, Giovanni Battista

Giovanni Battista Tiepolo (1696 Venice–1770 Madrid) was a pupil of Gregorio Lazzarini. By 1717 he had already become an independent painter in Venice, where he received important commissions for decorating churches and the palaces of the aristocracy. From 1750–1753 he worked with his sons, Giovanni Domenico and Lorenzo, on the interior decorations of the Würzburg Residence, and in 1757 on the Villa Valmarana near Vicenza. He was president of the art academy in Venice from 1756 to 1758. Tiepolo's fame spread throughout all of Europe, bringing him commissions from the French, English and Russian courts. From 1762 on he was active in the service of the Spanish court and painted, again along with his sons, frescoes for the Palacio Real in Madrid. Tiepolo's art marks the high point of 18th century Italian painting. Other works by the artist include *The Triumph of Zephyr and Flora*, 1734/35, Ca'Rezzonico, Venice; *Zeus and Danae*, c. 1736, University Museum, Stockholm; and *The Death of Hyacinth*, c. 1752, Museo Thyssen-Bornemisza, Madrid.

The Last Communion of St. Lucy, 1747/48
Oil on canvas, 222 x 101 cm
S. Apostoli, Venice
Tiepolo painted this altarpiece for the Cornaro Chapel of the Church of the Apostles in Venice. St. Lucy, surrounded by secular and religious dignitaries, kneels in front of a wonderful architectural backdrop, while onlookers watch the happenings from their balcony. The heads of two angels and, in the foreground, a knife and two gouged-out eyes lying on a plate remind the viewer of the grisly martyrdom suffered by this saint.

Rachel Hiding Idols from her Father Laban, 1726–1729
Fresco, c. 400 x 500 cm
Palazzo Patriarcale (today the Palace of the Archbishop), Udine
The interior decoration of the Palazzo Patriarcale in Udine is the high point of Tiepolo's early creative period. He decorated the Sala Rossa, originally the seat of the ecclesiastic tribunal, with Old Testament scenes from the life of the Patriarchs. In this story, Laban, old and bent, demands the idols from his daughter Rachel while they are en route to Canaan with Jacob's caravans.

Opposite
The Education of the Virgin, 1732
Oil on canvas, 362 x 200 cm
S. Maria della Consolazione, Venice
This altar painting is characterized by bright, glowing colors and strong light-dark contrasts. It was the first important commission that Tiepolo completed in Venice. Mary is at the center of the composition; she is depicted as a young girl, being taught out of a book by her mother, St. Anne. The angels, with their overly large bodies that are bigger than those of Anne or Mary, as well as Joachim's upward glance, reinforce the visionary quality of the scene.

America (detail), 1752/53
Ceiling fresco, c. 1900 x 3050 cm
Stairwell, Residence, Würzburg
America personified is part of the
imposing ceiling fresco that crowns
the magnificent stairways designed
by the architect Balthasar Neumann
(1687–1753). We see Apollo in the
midst of the four continents known
at the time, Europe, Asia, America
and Africa. With a theatrical
gesture, "America," depicted as an
untamed individual, is riding to the
hunt on the back of a gigantic
crocodile with bow and arrow in
hand. As a contrast to the fantastic
image of untamed energy and lack
of culture, the cornucopia at
America's feet points out the wealth
of this far-away continent.

Tiepolo, Giovanni Battista 869

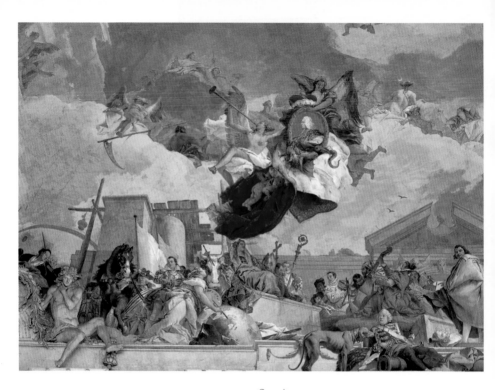

Europe (detail), 1752/53
Ceiling fresco, c. 1900 x 3050 cm
Stairwell, Residence, Würzburg
This magnificent fresco adorns the end wall of the stairwell in the Würzburg Residence. Europe, the central figure, is lying on a stone throne and leaning on a steer. The character of this continent is conveyed mainly in terms of its culture. We see personifications of painting, sculpture and music, in addition to representatives of the Church and of religion. In the foreground are Balthasar Neumann, the architect of the Residence and its stairwell, and at the left edge, a self-portrait of the artist.

Opposite
Europe (detail: The Apotheosis of the Prince-Bishop Carl Philipp von Greiffenclau)
Above the depiction of Europe, the medallion bearing the portrait of Carl Philipp von Greiffenclau, the person responsible for commissioning Tiepolo's frescoes for the Residence, is being carried up to the gods on Mount Olympus. The medallion is carried by Fama, on the left and playing on the long trumpet, while the winged personification of Virtue places a crown on the medallion from above. A griffon, the heraldic animal of the Greiffenclau family, appears holding on to the lower edge of the medallion.

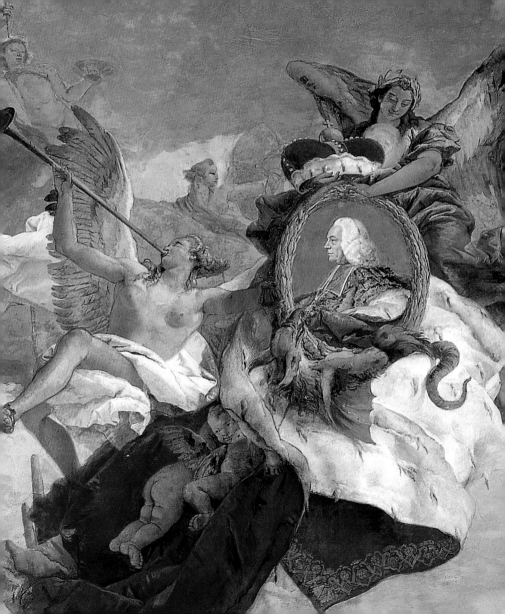

The Adoration of the Magi, 1753
Oil on canvas, 405 x 211 cm
Alte Pinakothek, Munich
Tiepolo painted this work at the end of his three-year stay in Würzburg for the former Abbey Church in Frankish Münster-Schwarzach. This dramatic night scene, rich in movement and figures, is a depiction of the Epiphany, the appearance of Christ among humans. The momentous import of the event is revealed through the bright highlighting of the central group of figures, which have been elevated on a dais.

Tintoretto

Tintoretto (1518 Venice–1594 Venice), who was born Jacopo Robusti, was officially listed as an independent painter in Venice from 1539. We do not know with whom he studied. Titian, Andrea Schiavone and Paris Bordone are often mentioned in this context. His style would indicates that he had been in Rome during the 1540s. Around 1547, the *Last Supper* in the church of S. Marcuola and the *Miracle of St. Mark* in the Galleria dell'Accademia ushered in a period (1574–1588) of secure commissions resulting in a number of works done mainly in Venice. Some of these are especially note-worthy, including the interior of the Scuola di S. Rocco, the works commissioned by the state for the Doge's Palace in Venice, as well as the Gonzaga cycle for the Palazzo Ducale in Mantua. Tintoretto also numbered among the best portraitists of his time, and is considered the most important representative of Venetian Mannerism. Other works by the artist include *Three Camerlenghi Before the Virgin and Saints Sebastian, George and Theodore*, 1566, Galleria dell'Accademia, Venice; *Rise of the Iron Snake*, 1576, Scuola di S. Rocco, Venice; and *Self-Portrait*, c. 1588, Musée du Louvre, Paris.

Leda and the Swan, c. 1552–1558
Oil on canvas, 145 x 145 cm
Palazzo Vecchio, Florence
According to classical mythology, the god Zeus, in the shape of a swan, seduced Leda, the beautiful wife of Tyndareus, King of Sparta. She bore two eggs: from these emerged Helen and the twins Castor and Pollux, known as the *dioscuri* ("sons of Zeus"). This story had already been very popular in Roman times when it was depicted on cameos, murals, mosaics and in sculpture. Because of its erotic content, it has been portrayed numerous times since the Renaissance.

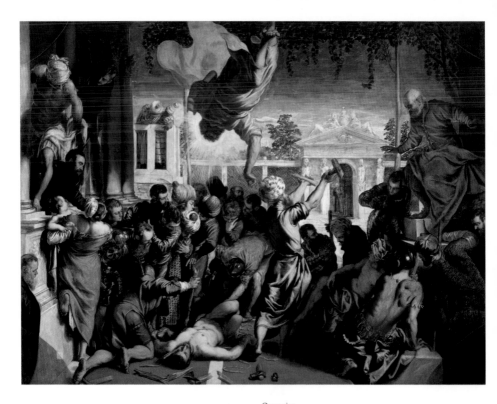

St. Mark Freeing the Slave, 1547/48
Oil on canvas, 415 x 541 cm
Galleria dell'Accademia, Venice
Tintoretto depicts this miracle in a painting filled with drama and movement. St. Mark hurtles down from Heaven in order to free a slave who has been condemned to death. According to legend, the slave was to lose his eyes and hands because he had left his master in order to pray at the coffin of St. Mark. The patron saint of Venice drives asunder the circle of torturers and curious onlookers; the instruments of execution grow blunt and break apart.

Opposite
The Recovery of the Body of St. Mark, c. 1562
Oil on canvas, 398 x 315 cm
Galleria dell'Accademia, Venice
In front of a schematic architectural facade that is more implied than articulated, and that creates a sensation of depth that was previously unknown, the naked and strongly foreshortened body of St. Mark is seen being carried away by three men. According to legend, the body of the evangelist was brought from Alexandria to Venice in the year 829. The restless, flickering light emphasizes the visionary quality of this impressive, moving depiction.

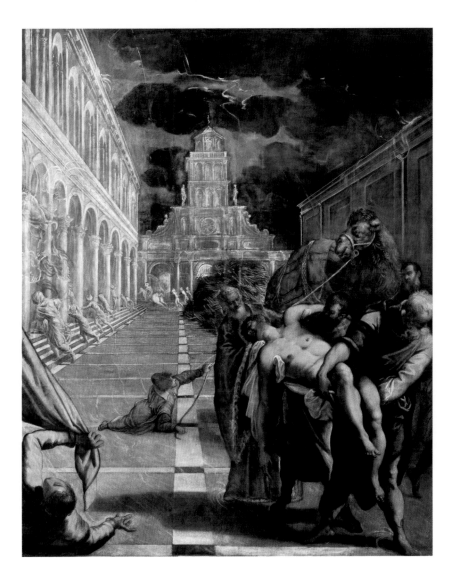

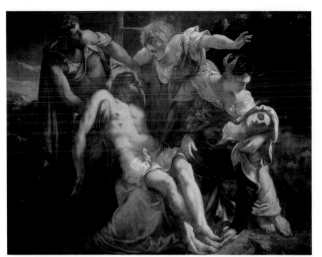

Lamentation, c. 1550–1560
Oil on canvas, 226 x 293 cm
Galleria dell'Accademia, Venice
The body of Christ, held by
Nicodemus, lies diagonally across
the lap of the Virgin who has sunk
down helplessly in a faint. She is
being supported by one of the other
Marys. In the background, Mary
Magdalene compositionally medi-
ates between the two groups of
figures. This scene, characteristic of
a number of Tintoretto's works,
portrays the almost incomprehen-
sible moment when Christ hovers
between his descent from the Cross
and his burial. It was painted for the
Venetian dell'Umiltà Church.

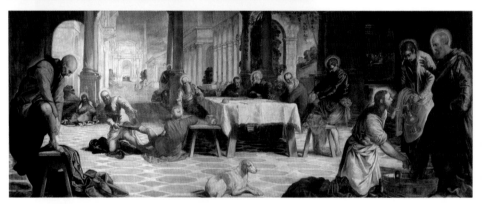

**Christ Washing the Feet
of his Disciples, 1547**
Oil on canvas, 210 x 533 cm
Museo del Prado, Madrid
This painting and its counterpart,
The Last Supper, were originally
part of the interior of San Marcuola

in Venice. Tintoretto deliberately
moved the central event, the wash-
ing of Peter's feet (described in John
13:6–8) to the far right edge of the
canvas. Genre elements such as the
anecdotally portrayed disciples,
casually gathered around the large

table and taking off their things, and
the dog lying in the foreground, take
up the main area of the compo-
sition. The architectural facade is
again impressive, widening the sense
of space and leading the viewer's
gaze far into the background.

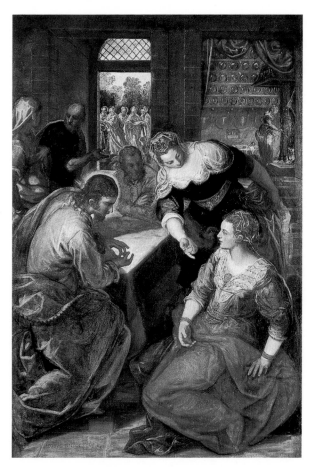

Christ in the House of Mary and Martha, c. 1580
Oil on canvas, 200 x 132 cm
Alte Pinakothek, Munich
This painting is from the Dominican Church in Augsburg and portrays Christ's visit to the house of Martha and Mary, an episode related in the Gospel of Luke (10:38–42). Since the Middle Ages the two sisters have been thought to personify two different forms that a Christian life can take. Whereas Martha, the embodiment of *vita activa*, busies herself with preparing and serving the meal, Mary, symbol of *vita contemplativa*, sits at the feet of Jesus, listening to his words.

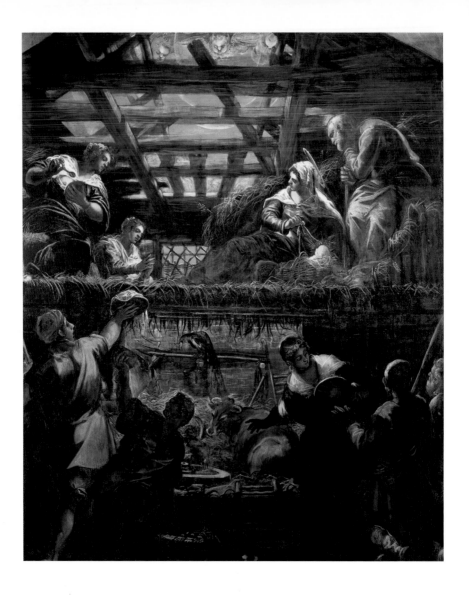

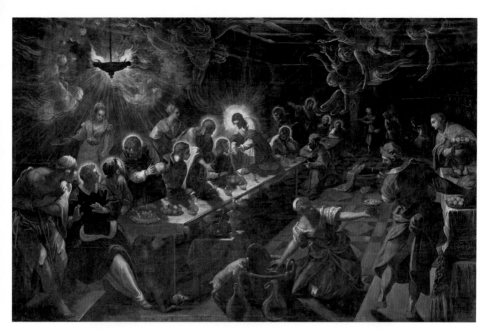

Opposite
The Birth of Christ, c. 1578–1581
Oil on canvas, 542 x 455 cm
Sala Superiore, Scuola di S. Rocco, Venice
The Birth of Christ is one of 66 wall and ceiling paintings that Tintoretto created for the Scuola di San Rocco in Venice, beginning in 1564. This impressive cycle containing scenes from both the Old and New Testaments is unequivocally one of the masterpieces of western art. Tintoretto's depiction is most unusual: Christ is born into a two-story stable. The shepherds and women are seen bringing gifts of food to the Holy Family. The giving of earthly food to the Child moves into the foreground, displacing the actual subject, the shepherds adoring the newborn Christ Child.

The Last Supper, c. 1591–1594
Oil on canvas, 365 x 568 cm
S. Giorgio Maggiore, Venice
This enormous work in the choir of San Giorgio Maggiore in Venice marks the high point of Tintoretto's late period. Tintoretto has depicted this rendition of the *Last Supper* in a large kitchen in which many servants and maids are busy with the preparation of different dishes. Christ is at the moment saying the words, "Take this and eat, this is my body." The fantastic, unreal quality of the crowded scene is supported by the transparent angel figures, filled with heavenly light. They are floating through the room, unnoticed by the many people.

Tischbein, Johann Heinrich Wilhelm

Johann Heinrich Wilhelm Tischbein (1751 Haina–1829 Eutin) first studied art with his uncle, Johann Heinrich Tischbein the Elder, in Kassel and then after 1766 with Johann Jacob Tischbein, another uncle, in Hamburg. After spending time in Holland (1771–1773) and Berlin (1777–1779), the artist lived in Italy for the next 20 years with only minor interruptions. In Rome Tischbein belonged to the circle of artists around Angelika Kaufmann. In 1789 he became the director of the art academy in Naples.

In 1808, as court painter to the Duke of Oldenburg, he was called to Eutin. Tischbein's fame is based on his portraits, but he also painted historical narratives, fruit and flower still lifes, and animal pictures. He also did engravings based on older works of art. The artist's important works include *Family Scene*, 1778, Niedersächsisches Landesmuseum, Hannover; *General Bennigsen and his Corps*, 1816, Kunsthalle, Hamburg; and *The Artist's Daughter Angelika*, 1822, Städelsches Kunstinstitut, Frankfurt.

Goethe in the Campagna, 1787
Oil on canvas, 164 x 206 cm
Städelsches Kunstinstitut,
Frankfurt
This famous portrait of the great German poet was made during Goethe's sojourn in Italy (1786–1788). Goethe (1749–1832) and Tischbein, who were friendly with each other, shared a studio apartment in the Via del Corso in Rome. This painting is distinguished by its monument-like, heroizing composition and its well-thought-out program. Tischbein celebrates Goethe as an admirer and reviver of classical antiquity, referring obliquely to *Iphigenie*, the play Goethe was working on while in Italy.

Titian

Titian (c. 1488 Pieve di Cadore–1576 Venice), born Tiziano Vecellio, is the most important Venetian painter of the *Cinquecento*. His date of birth and details about his early creative period remain speculative. He may have studied with the Venetian mosaicist Sebastiano Zuccato, as well as with Gentile and Giovanni Bellini. In 1508/09 Titian, along with Giorgione, painted the frescoes of the Fondaco dei Tedeschi in Venice and in 1510/11 the frescoes in the Scuola del Santo in Padua. From 1515 he worked for the Gonzaga, Este, Farnese and Rovere families as well as Francis I (1494–1547) of France. In 1533 he became court painter to Emperor Charles V (1500–1558), and was awarded the Order of the Golden Fleece. In 1545 he worked for Pope Paul III (1534–1549) in Rome, and later almost exclusively for Philip II (1527–1598). His major works include *Portrait of a Young Man (Ariost)*, c. 1512, The National Gallery, London; *The Presentation of the Virgin in the Temple*, 1534–1538, Galleria dell'Accademia, Venice; and *The Annunciation*, 1559–1564, San Salvatore, Venice.

Danae and Cupid, 1544–1546
Oil on canvas, 120x 172 cm
Museo Nazionale di
Capodimonte, Naples
Titian exhibited this painting in Rome in 1545/46, where its liberal depiction and its perfect painting technique found great acclaim among his contemporaries. The scene portrays Danae, the daughter of Akrisios, King of Argos, who had been locked in a tower by her father. She was then impregnated by Zeus, who appeared to her in the form of a golden rain. Their son, Perseus, would later kill his grandfather Akrisios, as an oracle had prophesied. Cupid playfully adorns the right side of the picture, observing the golden rain.

The Assumption of the Virgin, 1516–1518
Oil on panel, 690 x 360 cm
Santa Maria Gloriosa
dei Frari, Venice
The *Assumption*, Titian's first important commissioned work in Venice, has adorned the high altar of the Franciscan church since 1518. His contemporaries were immediately fascinated with the upward-striving dynamics, the expressive scenic drama and the marked agitation of the figures. All in all, this painting marks a fundamental break with the tradition of Venetian painting up to then.

Opposite
Virgin and Child with Saints and Members of the Pesaro Family, 1519–1526
Oil on canvas, 385 x 270 cm
Santa Maria Gloriosa
dei Frari, Venice
Painted for the Pesaro family altar, this work was the first ever to place the Virgin and Child outside of the picture's center. By moving Mary into the right half of the picture and the donor, Jacopo Pesaro, to the bottom left, this painting was given a wholly new, diagonal movement that at the same time strives upward. It became a model for many altarpieces done during the following generations.

Portrait of Pietro Aretino, c. 1545
Oil on canvas, 96.7 x 77.6 cm
Galleria Palatina,
Palazzo Pitti, Florence
This portrait impressively demonstrates Titian's uninhibited use of color, seen especially in his paintings from the 1540s on. His contemporaries at first reacted negatively. Pietro Aretino (1492–1556), author and critic, was a friend of Titian's and lived in Venice from 1526. Partly due to his famous letters, he was the social critic whose commentary was both most sought after and most feared.

**Emperor Charles V
at Mühlberg, 1548**
Oil on canvas, 332 x 279 cm
Museo del Prado, Madrid
This famous equestrian portrait depicts Emperor Charles V (1500–1558) as an armed military commander in a self-assured pose and radiating military strength. It is intended as a monument to his vic-tory over the Protestant princes in the Battle of Mühlberg on April 24th, 1547. In the winter of 1547/48, the Emperor called together the leading representatives of the disputing parties to a parliament in Augsburg. This portrait was painted there since Titian, too, had travelled with the court of Charles V to Augsburg.

**The Andrians (The Bacchanal),
1523–1525**
*Oil on canvas, 175 x 193 cm
Museo del Prado, Madrid*
Titian painted *The Andrians* and
two other depictions based on
classical mythology for the *studiolo*
("study") of the Duke of Ferrara,
Alfonso I D'Este (1486–1535). The
picture shown above reveals an
orgiastic feast celebrated by the
followers of Bacchus, the god of
wine, who can be seen sleeping on
a plateau in the upper right corner.
According to Philostratus, wine
flowed in the rivers on the island of
Andros instead of water. Titian
depicts the effects of the wine in a
painting rich in contrasts and with
a wealth of narrative detail. Peter
Paul Rubens painted a copy of this
famous painting in Rome.

**Pope Paul III with
his Grandsons (1545/46)**
*Oil on canvas, 200 x 173 cm
Museo Nazionale di
Capodimonte, Naples*
Titian painted this warm-toned

group portrait for the Farnese
family during his trip to Rome. It
was never completed, but is ne-
vertheless considered a masterpiece
of psychological portraiture. We
see the aged Paul III, born in 1468

as Alessandro Farnese and elected
pope in 1534, together with his two
grandsons, the Cardinals Alessan-
dro and Ottavio (who was married
to Margaret, one of the daughters of
Charles V).

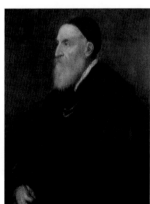

Self-Portrait, c. 1566
Oil on canvas, 86 x 69 cm
Museo del Prado, Madrid
Titian was already about 75 years old when he presented himself as an earnest, modest man in front of a neutral background. With his paint brush in his right hand, he quietly refers to his highly renowned career as an artist. The double-stranded gold chain around his neck is a sign of his knighthood. Titian's masterful command of color and delicately modulated shading are again on display in this late portrait.

The Man with the Blue-Green Eyes (The Young Englishman),
c. 1540–1545
Oil on canvas, 111 x 93 cm
Galleria Palatina,
Palazzo Pitti, Florence
Although the self-assured young man in the portrait above has yet to be identified, his light hair and blue eyes seem to substantiate the title *The Young Englishman*, which, however, is not based on sources but was given to him by earlier scholars. This painting proves Titian to be a master of portraiture and again documents his virtuosity in dealing with color. The tone of the man's eyes harmonizes with the coloring of the background, increasing the intense effect of the picture as a whole. The young man's head is effectively contrasted with the darker background, whereas the color of his clothing is subordinated to the rest of the portrait.

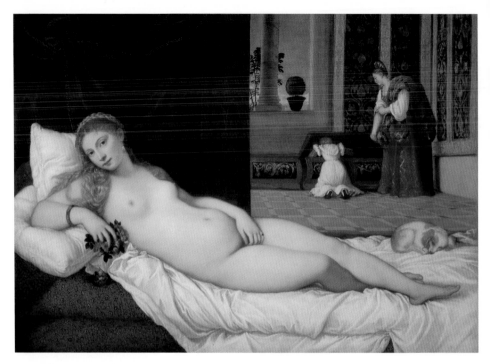

Venus of Urbino, 1538
Oil on canvas, 120 x 165 cm
Galleria degli Uffizi, Florence
Titian painted this picture of a life-sized "naked lady" (as the *Venus of Urbino* was called in a contemporary letter) for Guidobaldo della Rovere (1514–1574), the Duke of Urbino. Venus's erotic sensuality and the portrait-like character of the work caused early scholars to speculate that this was a painting of a courtesan. Today, however, the picture is interpreted as an allegory of married love and fidelity. This theory is based on the sleeping dog and the two servants in the background, busy with the chest.

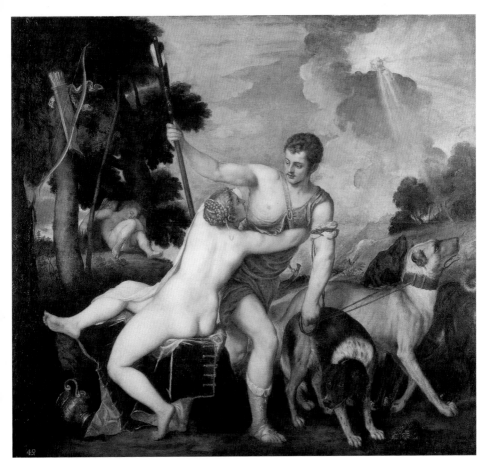

Venus and Adonis, 1553/54
Oil on canvas, 186 x 207 cm
Museo del Prado, Madrid
Titian delivered this painting along
with a new version of the *Danae* to
Philip II (1527–1598), who became
King of Spain in 1556. Titian notes

in a letter that he especially wished
to portray the nude female body
from both sides. In the work above,
Titian has painted a scene from the
Metamorphoses by Ovid (43 B.C.–
18 A.D.) in which Venus, despite all
her pleading, cannot keep her lover

Adonis from joining the hunt. Left
to the mercy of fate, the youth is
gored and killed by a wild boar.

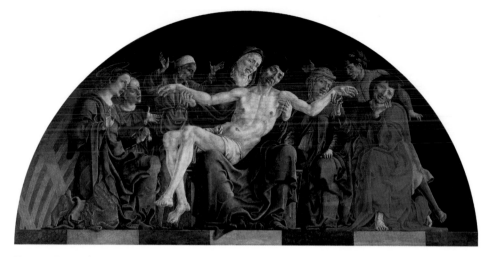

Tura, Cosmè

Cosmè Tura (c. 1430 Ferrara–1495 Ferrara), whose actual name is Cosimo Tura, is considered the master of Renaissance painting in Ferrara. He probably encountered the local Gothic tradition of painting during his apprenticeship, but he also owed much to the avant-garde artists from Padua, where Tura likely spent the years 1452–1456, including Donatello, Francesco Squarcione and the young Andrea Mantegna. Afterward Tura became court painter to the Este family in Ferrara, as is noted in many documents but in only a few surviving paintings. Tura's pictures distinguish themselves through their clarity of line, while his figures are characterized by a hard plasticity and late Gothic restlessness of form. In later works this is intensified into passionate emotion. Important works by the artist include *Portrait of a Young Man of the Este Family*, 1451, Metropolitan Museum of Art, New York; *Virgin and Child With Musician Angels*, 1474, The National Gallery, London; and *The Penitent St. Jerome*, c. 1480, The National Gallery, London.

Pietà, 1474
Oil on panel, 132 x 267 cm
Musée du Louvre, Paris
The lunette with the *Pietà* is part of a winged altarpiece which Tura painted for the Rovere family chapel in San Giorgio in Ferrara. The splendid central panel with the enthroned Madonna is today in London; the side panels are in Rome and San Diego. The expressive gestures of the mourning figures, the rich folds of their garments, and the coloring with its wonderful contrasts are characteristic features of Cosmè Tura's artistry.

Virgin and Child, c. 1484
Oil on panel, 119 x 59 cm
Galleria dell'Accademia, Venice
The Christ Child seen sleeping in the arms of his mother is a motif that also occurs in the depiction on the altarpiece of San Giorgio in Ferrara. What is unusual and different here is that Mary's veil is lying on top of the Child's halo. The siskins pecking at the bunches of grapes at the upper edge of the picture foreshadow Christ's Passion.

Turner, Joseph Mallord William

Joseph Mallord William Turner (1775 London–1851 London) was briefly apprenticed to the architect Thomas Malton, but in 1789, at the age of only 14, he entered the Royal Academy as a student. During his early creative period he painted mainly watercolors, but after 1795 he turned to oils. In 1802 he was made a full member of the Royal Academy; in 1809, he was named a professor of the science of perspective. Turner did topographic sketches of nature on numerous journeys throughout England, Scotland and Wales. In 1802 he travelled to France and Switzerland for the first time. His paintings from the years following this trip reflect Turner's efforts to come to terms with the art of Nicolas Poussin and Claude Lorrain. Turner embarked on journeys to Italy in 1819 and in 1828; the result was a transformation in style from landscape impressions suffused with light to more visionary creations. Important works by the artist include *The Death of Nelson*, 1808, The Tate Gallery, London; *Odysseus Ridiculing Polyphemus*, 1828, The Tate Gallery, London; and *Rain, Steam and Speed*, 1844, The Tate Gallery, London.

**River Landscape
with Viaduct, c. 1813**
Oil on canvas, 76 x 65 cm
The Tate Gallery, London
Turner was inspired to paint this broad southern river landscape on a journey through Devonshire in 1813. In the foreground, two young women are standing at a ford. The compositional form as well as the colors attest to Turner's interest in landscape painting of the 17th century. The works of Nicolas Poussin and Claude Lorrain, in particular, served as Turner's models.

Landscape with a River and a Bay in the Background, c. 1835–1840
Oil on canvas, 93 x 123 cm
Musée du Louvre, Paris
Only at second glance does the viewer perceive the river landscape, rendered only faintly in its outlines. This painting is an unusually excellent example of Turner's effort during the late 1820s to capture the magic of the misty atmosphere of the hidden landscape with its diverse shimmering colors. Turner is considered one of the most important forerunners of Impressionism based on these landscapes painted during his late creative period.

Snowstorm in Val D'Aosta, 1836
Oil on canvas, 91 x 122 cm
The Art Institute of Chicago, Chicago
At the bottom right of this dramatic landscape is a group of small figures, unprotected and at the mercy of the inordinately powerful snowstorm that rages about them. Turner painted this work, along with a number of watercolors on the same subject, in 1836 during a journey to the Piedmont region of Italy. The only color tones used are shades of white, beige and brown. He is not interested in rendering a topographically accurate view of the mountainous valley, but in reproducing the atmosphere and the effect of the masses of snow whirling through the air.

The Development of Oil Painting

Jan van Eyck (1390–1441) is said to have been the inventor of oil painting. At least, this is what Giorgio Vasari (1511–1574) maintains in his *Lives of Famous Painters, Sculptors and Architects* (*Le vite de' piu excellenti pittori, scultori e architetti*), which appeared in 1550. Vasari also reported that the Netherlandish painter had withdrawn to his studio for years in order to experiment on colors with the help of alchemy. In point of fact, the technique of binding color pigments with oil in order to produce paint is far older than van Eyck. In antiquity oil paint was used for ships, flags or signs in order to make them more resistant to weathering. Today we can be certain that Jan van Eyck further developed and perfected the implementation of oil-based paints during the first half of the 15th century.

In oil painting, powdered pigments are ground together with flaxseed, poppyseed or walnut oil. The technique of glazing—that is, the application of extremely thin, single layers of color—achieved an especially brilliant, glowing surface such as that often seen in the works of the old Dutch masters. This technique also made possible the most subtle and fluid transitions between areas of different color. In tempera painting, on the other hand, egg white, egg yolk or gum arabic served as the binder. The paint dried faster, but the surface was duller and somewhat muted compared to that of an oil painting. Paints can be analyzed with the help of modern scientific techniques, and it has been known for some time that painters often used both types of binder in the same artwork, especially during the 15th century. Since different pigments were produced by different means, it is clear that the technique of oil painting was not subject to hard and fast rules; instead, mixing and painting procedures varied from one artistic circle or workshop to another.

The grinding and production of pigments from minerals or organic matter was primarily the responsibility of the apprentices in an artist's studio. In self-portraits depicting artists in their studios, apprentices are often visible in the background making paints, for example in the illustration of the workshop of Adriaen of Ostade (1610–1685), today in the Gemäldegalerie, Dresden; or in the woodcut by Hans Burgkmair (1473–1531) in which the artist is visited by Emperor Maximilian while he is working busily in his studio. In this print, Burgkmair pointedly draws attention to the fact that he held the enviable position of court painter. Not only does the emperor come personally to his studio, but Burgkmair's clothing is clearly elegant and up

Hans Burgkmair: Emperor Maximilian in the Artist's Studio
Woodcut from "The Wise King," 1514–1516
This scene confirms Maximilian's keen interest in art, as well as the friendly relationship between court painter and emperor.

to date; he even sports a dagger at his side. His apprentice, on the other hand, is comparatively humble in his attire.

Making one's own paints became less and less common from the 15th century on. Painters began to buy both their painting surfaces and their materials from paint merchants and panel makers. Pigments remained expensive, even extremely costly: Silver and gold colors were made from the precious metals themselves, and pure blue was made from the rare stone lapis lazuli. It is therefore not surprising that Albrecht Dürer (1471–1528), during his journey through the Netherlands, noted in his diary that he had traded art worth 12 ducats for one ounce of good ultramarine. In addition, contracts between producers of pigments and artists commonly stipulated precisely the amount of pure blue to be used in a pigment, which was billed separately. Guilds had statutes forbidding the use of second-rate blue or of saffron in place of gold leaf, and transgressions were punished.

Oil paintings are unfortunately subject to aging: With time their surface yellows and often develops many fine cracks, so-called *craquelure*. Nevertheless, from the Renaissance onward, the technique of painting with oils became more and more important in art both north and south of the Alps. Its special charm lies in the fact that the quality of the color achieved in

Adriaen van Ostade:
The Painter in his Studio, 1663
Oil on oak panel, 38 x 35.5 cm
Gemäldegalerie Alte Meister,
Dresden
This scene of a typical artist's studio gives a good idea of the methods used by Dutch painters in the 17th century. In addition to an easel with a canvas or wooden panel, paint stick, brushes, colors and different painting utensils, there is also a plaster model and a skeleton to aid in the study of proportions. Sailcloth on the ceiling allows the artist to regulate the level of light coming through the window.

Jan van der Straat, called Stradanus: Color Olivi
(Copper engraving by Philip Galle
according to a sketch by the artist)
Sheet 14 of the folio Nova Reperta, c. 1595
Based on the description in Giorgio Vasari's *Vite*,
Stradanus (1523–1605), an artist from Bruges who was
living in Florence, portrayed his conception of the studio
of the brothers Jan and Hubert van Eyck. One of the
masters is working on a large history painting while
standing on a podium. To the right, oil colors are being
mixed; on the left, a young pupil is drawing a plaster
bust, while at the window a more experienced appren-
tice is painting an elegant woman's portrait. Their
assigned tasks and methods of dress make clear that the
individual men are of different social standing.

each artwork is unique, depending on the artist's
individual mixture of pigments and binders. This
experimentation largely ceased toward the end
of the 19th century when industrially mass-
produced paints became widely available on the
market. Though uniform and lacking some of the
originality of self-mixed paints, these new
colors, conveniently packaged in tubes, made
entirely new methods of working possible for
artists; for example, it became more common to
paint out-of-doors.

Uccello, Paolo

Paolo Uccello (c. 1397 Pratovecchio near Arezzo–1475 Florence) trained from 1407–1412 in the atelier of Lorenzo Ghiberti (c. 1380–1459) in Florence. As his assistant, Uccello was involved in the creation of the great scuptured and gilded bronze doors of the Baptistery of the Duomo in Florence. In 1415 he was accepted into the guild of Medici e Speziali. He is known to have been in Venice from 1425–1431, working with other artists on the mosaics in San Marco. Afterward he settled in Florence, where he painted two large frescoes with scenes from Genesis in the cloister of Santa Maria Novella. Under the influence of Masaccio and Donatello, Uccello became the greatest master of perspective of his generation, and he is one of the most important forerunners of the Florentine Renaissance.

His major works include *The Flood*, 1446, fresco, Chiostro Verde, Santa Maria Novella, Florence; *St. George and the Dragon*, c. 1456, The National Gallery, London; and *The Miracle of the Desecrated Host*, c. 1467, Galleria Nazionale, Urbino.

The Battle of San Romano (center panel), c. 1456
Tempera on panel, 182 x 323 cm
Galleria degli Uffizi, Florence
Uccello depicts the June 1, 1432 Battle of San Romano on three large panels. On the central panel, facing front, he shows the decisive moment in the battle between the Florentine soldiers and the Sienese troops. A lance pierces Bernardino della Carda, commander of the Sienese mercenaries, and he is thrown from his horse. The Sienese are defeated. Uccello probably painted these unusual battle pictures on commission from the Medici family: The paintings are known to have been in the Medici's Florentine city residence in 1492.

Previous page
The Battle of San Romano (detail)
Uccello's most important achievements are the use of elements of perspective and the development of extreme viewpoints. In this detail, for example, the horse, kicking out with its hind legs, is seen from an extremely low angle and is boldly foreshortened. This was a stunning innovation for painting of that period. The artist's daring representation is supported by his choice of a stylized, strongly distancing color palette. All in all, the viewer has the impression that this is more a portrayal of a knightly tournament than of a battle scene.

The Battle of San Romano (right panel), c. 1456
Tempera on panel, 180 x 316 cm
Musée du Louvre, Paris
The right panel of this work shows the condottiere Michelotto da Cotignola with his mercenaries coming to the aid of Niccolò da Tolentino, the renowned Florentine commander. Through the extremely simple depiction of the horses, the positioning of the soldiers' lances, and the structuring of the landscape background into geometric areas, *The Battle of San Romano* as a whole is imbued with a sense of abstraction that is characteristic of Uccello's artistry.

Opposite
Monument to Giovanni Acuto (John Hawkwood), 1436
Fresco, transferred to canvas, 820 x 515 cm
Cathedral, Florence
This enormous equestrian painting honors John Hawkwood, whom the Florentines called Giovanni Acuto, an English condottiere and victorious mercenary commander. He appears as a painted sculpture, high above the viewer on a pedestal supported by three consoles. While the rider is seen strictly in profile, Uccello brilliantly uses perspective to render the pedestal, viewed diagonally and from a low angle, a unique viewpoint at that time.

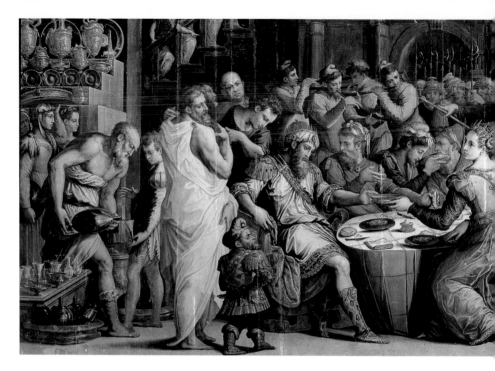

Vasari, Giorgio

Giorgio Vasari (1511 Arezzo–1574 Florence) began his diverse, humanistic education with the glass painter Guillaume de Marcillat in Arezzo. From 1524 on he continued his training with Andrea del Sarto and Baccio Bandinelli in Florence. After 1532 he divided his time between Florence and Rome. In the course of his many journeys, Vasari studied Italian art from antiquity up until his lifetime, and was commissioned as a painter and architect by such influential families as the Medici and the Farnese. His fame, however, rests primarily on his tract entitled *Le vite de' piu eccellenti pittori, scultori e architetti*, or *Lives of the Most Famous Painters, Sculptors, and Architects*. It first appeared in 1550, and a second, expanded edition was published in 1568. Vasari's *Lives* is considered the most important original source for art history. His artistic works include: *Holy Family with St. Francis*, 1541, Los Angeles County Museum of Art, Los Angeles; *The Resurrection of Christ*, 1550, Pinacoteca Nazionale, Siena; and *The Incredulity of Thomas*, c. 1570, San Croce, Florence.

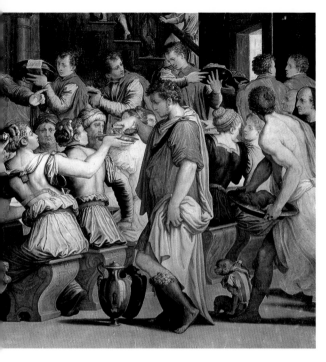

**The Wedding of Esther
and Ahasuerus, c. 1548**
Oil on panel, 289 x 745 cm
*Museo Statale di Arte
Medievale e Moderna, Arezzo*
Vasari painted this panel for the
refectory of the Abbey of St. Flora
and St. Lucilla in Arezzo. The
subject is the Old Testament story of
the wedding of the Persian king
Ahasuerus to the Jewish woman
Esther (Book of Esther 2:15–20),
and the entire court has gathered
together for the celebration. Sty-
listically close to Mannerism and

filled with original, imaginatively
conceived figures, this painting is
characteristic of Vasari's artistic
oeuvre, and his keen interest in the
theater is also evident. He had made
a name for himself through inno-
vations in the creation of theatrical
stage settings; similarly, in this panel
Vasari has positioned a lively group
of people in relief as though they
were on a stage in front of an
architectural backdrop.

Self-Portrait, c. 1567
Oil on panel, 100.5 x 80 cm
Galleria degli Uffizi, Florence
In this self-portrait, Vasari presents
himself at the age of about 56 in the
dignified, restrained pose of a
scholar. At the bottom left edge we
see the drawing tools used in his
profession. As a scholar of aesthetic
theory, Vasari personally owned an
extensive collection of drawings:
For him, *disegno*, or the art of
drawing, was the basis of all the
visual arts.

Veen, Otto van

Otto van Veen (1556 Leiden–1629 Brussels) first learned his craft from the figural painter Isaak Claesz. van Swanenburgh in Leiden. Veen's family fled the Dutch war of independence to Antwerp in 1572, later moving to Aachen. In 1573 Veen went to Lüttich as a page to the court of the Prince-Bishop. After a period in Rome (1575–1580), Veen returned to Flanders via Prague and Munich. Around 1587 he entered the service of Alessandro Farnese (1545–1592), then the governor of the Spanish Netherlands. In approximately 1590 he settled in Amsterdam, where Peter Paul Rubens was his pupil from 1594 to 1598. In 1615 he was called to Brussels to become director of the city's mint.

Otto van Veen painted mainly religious works, but there are also allegories and portraits among his ouevre, which includes *The van Veen Family*, 1584, Musée du Louvre, Paris; *The Engagement of St. Catherine*, 1587, Musées Royaux des Beaux-Arts, Brussels; and *Lamentation*, c. 1590, Augustinermuseum, Freiburg.

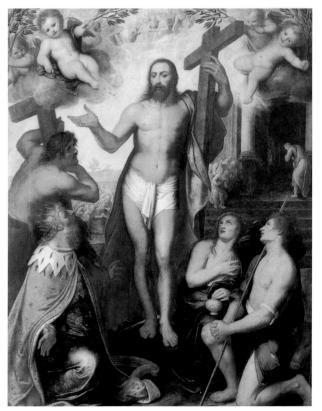

Christ with the Penitent Sinners, c. 1607
Oil on panel, 269 x 214 cm
Landesmuseum, Mainz
In this painting we see the resurrected Christ surrounded by King David, the good thief Dismas, Mary Magdalene, and the Prodigal Son. In keeping with the spirit of the Counter-Reformation, this painting takes the forgiveness of sins as its theme. It is the central panel of a triptych commissioned by the merchants' guild for the Cathedral of Antwerp. In 1794 the winged altarpiece was confiscated by the troops of the French Revolution. This central panel was carried via Paris to Mainz, while the side panels came to reside in the Royal Museum in Antwerp.

Velázquez, Diego

Diego Velázquez (1599 Seville–1660 Madrid) was trained by Francisco Herrera the Elder and, from 1613–1617, by Francisco Pacheco in Seville. In 1622 and 1623 he took his first trips to Madrid with Pacheco. At that time Velázquez gained the attention and favor of King Philip IV (1605–1665), who appointed him court painter. In 1627 his swiftly-rising court career began, culminating in the office of Lord Chamberlain in 1652. In 1628 he became acquainted with Peter Paul Rubens in Madrid. He travelled to Italy from 1629 to 1631 and from 1649 to 1651 to buy Renaissance and neoclassical works of art for the Spanish royal house. In Rome, Velázquez joined the Accademia di San Luca in 1650. Through the intercession of the Spanish king he was made a knight of the Order of Santiago in 1658. Considered the most important 17th-century Spanish painter, Velázquez was involved in all forms of his trade. His works include *Adoration of the Magi*, 1619, Museo del Prado, Madrid; *The Triumph of Bacchus*, c. 1629, Museo del Prado, Madrid; and *Venus Before her Mirror*, 1651, National Gallery, London.

Equestrian Portrait of Baltasar Carlos, c. 1635/36
Oil on canvas, 209 x 173 cm
Museo del Prado, Madrid
Velázquez's fame as one of Europe's most important 17th-century portraitists was founded on the many portraits he made of the royal family and its court. Here we see the six-year-old crown prince in the pose of a military commander, suggestive of the future that awaits him. The portrait hung in the space above the doorway in the throne room of the king's hunting lodge, the Buen Retiro Palace.

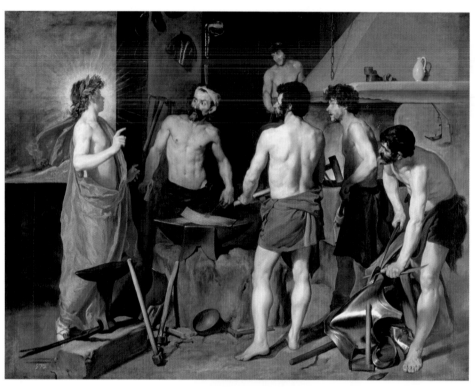

**Apollo in Vulcan's Forge,
c. 1630/31**
*Oil on canvas, 223 x 290 cm
Museo del Prado, Madrid*
It is likely that this painting dates from Velázquez's first trip to Italy. Apollo is visible standing to the left of the scene with his shining halo and laurel wreath announcing to Vulcan, the god of fire, that Venus, goddess of love and beauty, has committed adultery with Mars, the god of war. Vulcan's assistant, the Cyclops, looks up from his work in disbelief. Acquired by King Philip IV in 1634, this picture plainly shows the influence of Tintoretto and Titian in the smooth, casual manner of painting. Velázquez had studied human anatomy and classical sculpture while in Rome: Here he is demonstrating his newly-gained knowledge and ability to render nudes in the different poses of the six bare-torsoed men.

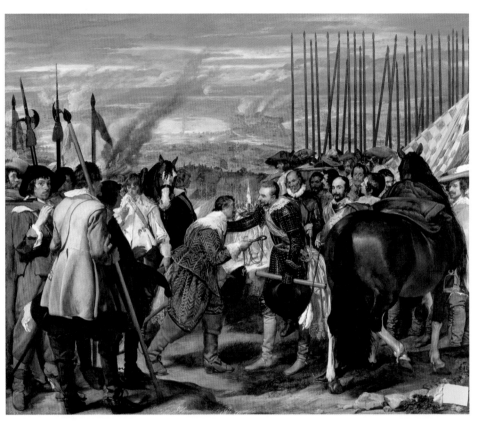

Surrender of Breda
(Las Lanzas) c. 1635
Oil on canvas, 307 x 367 cm
Museo del Prado, Madrid

The keys to the city of Breda were given to the victorious Spanish commander Ambrosio de Spínola by Justinus of Nassau on June 2, 1625. The Duke of Olivares (1587–1645) commissioned Velázquez to paint the scene for the Salón de Reinos, the throne room of the royal palace Buen Retiro. While the actual warfare takes place in the background of the picture, the center foreground shows an act of reconciliation between the two great commanders. Spínola is seen laying a friendly right hand on the shoulder of his opponent. It is interesting to note the positioning of the lances carried by the soldiers in this unusual, monumental work: Whereas the tips of the Spanish soldiers' lances rise proudly and in great numbers toward the heavens on the right side of the picture, those of the Dutch have dipped downward in defeat.

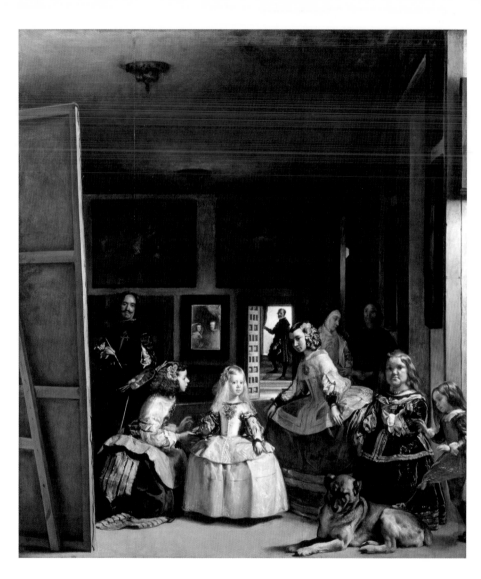

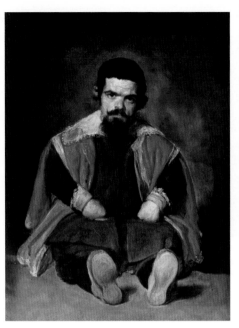

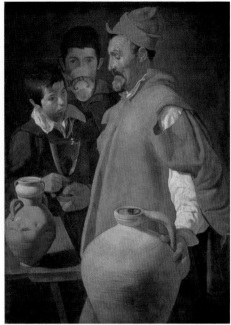

Opposite
**The Family of Philip IV
(Las Meninas/The Maids of
Honor), 1656**
Oil on canvas, 318 x 276 cm
Museo del Prado, Madrid
Although the group portrait of the
5-year-old Infanta Margherita with
the royal household is among the
most important works in all of
Spanish art, the scene has not been
clearly interpreted. To the left stands
Velázquez himself with his painting
tools in front of a huge canvas. He
is thought to be painting the portrait
of the Infanta, or perhaps of the
King and his wife, who are visible in
the mirror behind his head.

**Portrait of a Dwarf at Court (Don
Sebastián de Morra?), c. 1644**
Oil on canvas, 106 x 81 cm
Museo del Prado, Madrid
In the 1630s and 1640s Velázquez
painted a number of the fools,
dwarfs and cripples who served to
amuse the court. Such paintings
gave the artist an opportunity to
paint freely, demonstrating his
talents as a portraitist without
having to take into consideration
the demands of official represen-
tation or courtly etiquette. Sources
are inconclusive as to whether or
not the dwarf shown here is actually
Don Sebastián.

**The Water Seller
of Seville, c. 1621**
Oil on canvas, 103 x 77 cm
*Fondazione Contini
Bonacossi, Florence*
This painting is a variation of one
located in London's Wellington
Museum. It is a typical work from
Velázquez's early creative period in
Seville, with its depiction of an old
man offering his young customer a
glass of water with a fig. Stylis-
tically, these early genre paintings
have warm, earthy colors and their
lighting is rich in contrasts, some-
what reminiscent of the works of
Caravaggio.

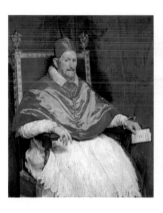

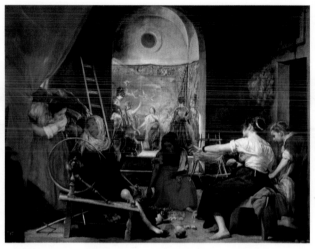

Pope Innocent X, 1650
Oil on canvas, 140 x 120 cm
Galleria Doria Pamphilj, Rome
Velázquez most likely based both
the composition and color scheme
of this splendid painting on papal
portraits executed by Raphael,
Titian and other artists of the Italian
Renaissance whose works he was
able to study while he was in Rome
and Venice. Unusual here is the
exceptionally realistic rendering of
the physiognomy of Pope Innocent
X (1644–1655); Velázquez painted
this portrait during his second
journey to Italy.

The Tapestry Weavers
(Las Hilanderas, also called
The Tale of Arachne), c. 1659
Oil on canvas, 220 x 289 cm
Museo del Prado, Madrid
This late work, characterized by a
spontaneous painting style, shows
five women at work weaving a
tapestry in the foreground. Behind
them, three elegantly dressed
women are gazing at a tapestry
depicting the legend of Arachne, a
scene from Ovid's *Metamorphoses*.
According to the story, Athena
transformed Arachne into a spider
because she dared to compare her

weaving skills to those of the
goddess. Velázquez was alluding
to the situation of Spanish artists,
who were still classified as
craftsmen in the 17th century. The
women in their workshop are quiet
and skillful in their movements.
One of the women is lifting a
curtain, allowing a view into a
stage-like area and emphasizing the
complexity of the scene. Velázquez'
quick brush strokes correspond to
the quick turning of the spinning
wheel in the center foreground; the
individual spokes seem to vanish
with the rapidity of movement.

Vermeer, Jan

Jan Vermeer (1632 Delft–1675 Delft), also called Jan or Johannes Vermeer van Delft, was the son of Reynier Jansz., a Protestant silk weaver, innkeeper and art dealer in Delft. The young painter, who had probably learned his trade with Leonaert Bramer and Carel Fabritius, inherited his father's fortune and business in 1652. In 1653 Vermeer married Catharina Bolnes, a Catholic, and entered the painters' Guild of St. Luke in Delft as a master. In 1662/63 and 1670/71 he held the office of *Hoofdman*, the head of the guild. He was called to The Hague in 1672 as an expert in order to determine the authenticity of works attributed to Holbein, Giorgione and Titian. Despite his reputation, Vermeer continued to live in financial straits until his death. His small oeuvre consists of just 34 paintings, including *A Woman Weighing Pearls or Gold*, c. 1662–1664, National Gallery of Art, Washington; *Allegory of Painting*, c. 1666/67, Kunsthistorisches Museum, Vienna; and *The Love Letter*, c. 1669/70, Rijksmuseum, Amsterdam.

La Dentellière (The Lacemaker), c. 1669/70
Oil on panel, transferred to canvas, 24 x 20.5 cm
Musée du Louvre, Paris
The craft of lace-making is depicted as a domestic virtue in Dutch art and literature. In addition, the small prayer book that lies next to the slightly opened bobbin cushion from which red and white threads flow attests to the virtuous life of the young girl. Vermeer's fascinating painting technique, as well as the clothing and hairstyle of the young woman, seem to date this intimate work at around 1670.

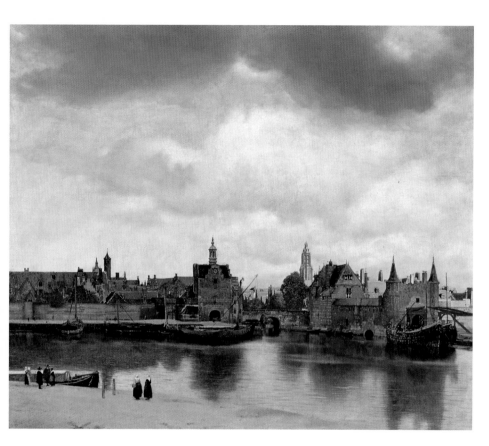

View of Delft, c. 1660/61
Oil on canvas, 96.5 x 115.7 cm
Mauritshuis, The Hague
This is the only large landscape ever painted by Vermeer, who preferred to paint interiors peopled by very few, and primarily female, figures. The topographically exact view of Delft from the south, bathed in the warm light of evening, is a fascinating and extremely effective painting due to its unconventional, enormously detailed and precise rendering. When the painting was restored in 1994 experts found that Vermeer had used large clumps of white lead combined with sand as an undercoating, giving the surface an almost relief-like structure.

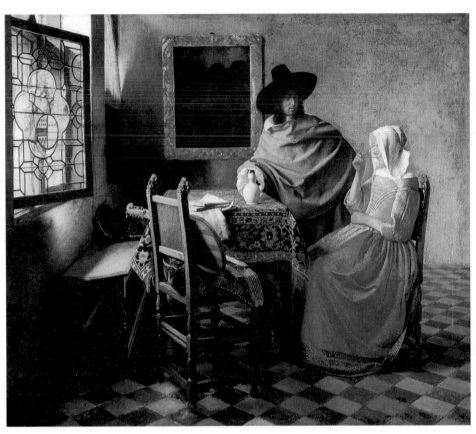

The Glass of Wine, c. 1660/61
Oil on canvas, 65 x 77 cm
Gemäldegalerie, SMPK, Berlin
Each element in this thoroughly thought-out picture, down to the smallest detail, is related to the motto *serva modum* ("preserve the measure"). For example, the woman holding reins in her hand depicted on the pane of glass to the left is to be understood as a personification of *Temperantia*, or moderation.

Opposite
The Glass of Wine (detail)
Among the moral paintings of the 17th century, there is hardly a more unambiguous scene than this one, a woman drinking wine. She is wholly absorbed in her large glass and does not even glance at the young man, who is clearly looking for an erotic adventure. Vermeer's fine style is evident in the nuances of color and in the exact observation and rendering of light, light reflection, and shadow.

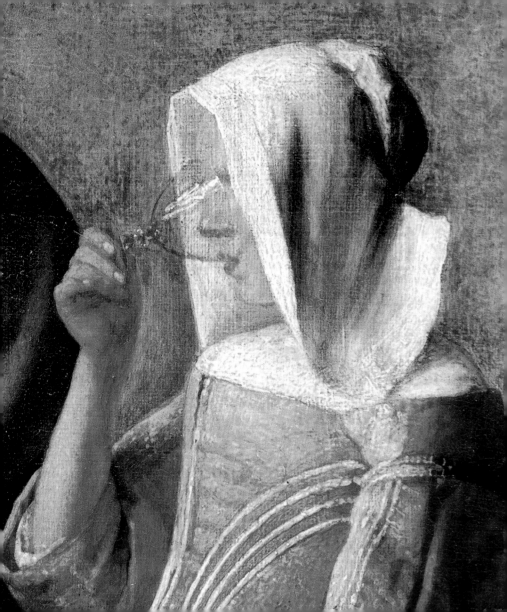

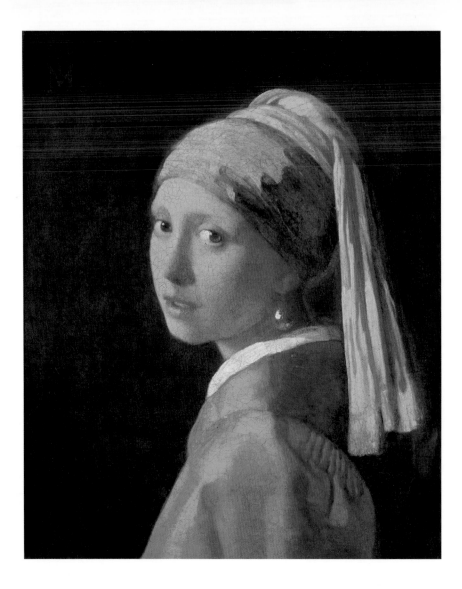

Girl with a Pearl Earring, c. 1665
Oil on canvas, 44.5 x 39 cm
Mauritshuis, The Hague
The viewer is irresistibly drawn into the spell of this mysterious girl wearing an exotic turban through her direct gaze and her slightly parted lips. Her skin is just as flawless and pure as the large pearl worn at her ear. Strangely enough, nothing is known about the history of this picture with its atmosphere of timelessness. It first appeared in 1881 at an auction in The Hague, where it was sold for 2 guilders and 30 cents.

Young Woman with a Pearl Necklace, c. 1662–1665
Oil on canvas, 55 x 45 cm
Gemäldegalerie, SMPK, Berlin
An elegantly dressed young woman is standing at her dressing table, looking critically in the mirror while she dons her pearl necklace. It seems to be the finishing touch in her morning toilette, and is being done in complete leisure. This work is an allegory of *Superbia*, or pride, whose main attribute is the mirror, and can also be interpreted as a warning about the transience of earthly possessions.

The Astronomer, 1668
Oil on canvas, 50 x 45 cm
Musée du Louvre, Paris
In this picture Vermeer shows us an astronomer in his study, wearing a dressing gown. On the table before him and holding his full attention are books and a globe of the heavens. The man is probably Anthonis van Leeuwenhoek (1632–1723), a Delft contemporary of Vermeer's and a famous natural scientist and developer of the microscope. Vermeer depicted the scholar in a second painting called *The Geographer*, which is now located in the Städelschen Kunstinstitut in Frankfurt am Main.

Veronese, Paolo

Paolo Veronese (1528 Verona–1588 Venice), born Paolo Caliari, most likely learned his craft from Antonio Badile in Verona. He went to Venice in 1553, where he spent his life except for a stay in Rome in 1560–1561. From 1553 he worked in the *Sala del Gran Consiglio* (Hall of the Great Council) of the Doge's Palace, and from about 1555 to 1570 on the interior decorations of the church of San Sebastiano. In 1561–1562 he painted the famous frescoes in the Villa Barbaro in Maser near Treviso. The oeuvre of this multifaceted late Renaissance artist includes ceiling frescoes, altarpieces, mythological narratives and portraits. Along with Titian and Tintoretto, Veronese is one of the triad of great Venetian painters of the *Cinquecento*. After his death, his brother Benedetto and his sons Carlo and Gabriel continued his work, signing themselves "Paul's heirs." Among his works are *Madonna with the Cuccina Family*, 1571, Gemäldegalerie Alte Meister, Dresden; *Bathsheba in her Bath*, 1575, Musée des Beaux-Arts, Lyon; and *Four Allegories of Love*, c. 1580, The National Gallery, London.

Christ With the Doctors
in the Temple, c. 1555–1565
Oil on canvas, 236 x 430 cm
Museo del Prado, Madrid
According to the Book of Luke (2:41–51) the 12-year-old Jesus went to the Temple in Jerusalem to speak with the learned men there. Although the painting bears the date "1548" on the open book held by the scholar sitting to the left of the column, it is nevertheless usually thought to be a work from Veronese's more mature period, about 1555–65. The composition of the painting is complex and full of excitement; his rendering, secure.

The Wedding Feast at Cana, 1562/63
Oil on canvas, 666 x 990 cm
Musée du Louvre, Paris
This enormous, magnificent painting came from the refectory of the Benedictine monastery San Giorgio Maggiore in Venice. Like *The Feast in the House of Levi* from 1573, it belongs to a group of works in which Veronese uses religious subject matter in order to express the joy of life and the splendor of Venetian festivities. The political and religious upheavals of his day find no expression in his paintings. Typical for Veronese's works are the wealth of figures and the classical look of the background architecture with its balustrades. From here, spectators look curiously down on the happenings below.

Opposite
The Wedding Feast at Cana (detail)
Great Venetian painting of the *Cinquecento* was characterized by exceptionally bright and glowing colors. In addition, the wealthier citizens of Venice had a special predilection for costly materials and rich clothing, as can clearly be seen in this detail. The artist lavished equal care on rendering the vessels, cups, trophies, urns and dishes. On the other hand, some scholars doubt that the faces of the people shown are accurate in their details. Rather, among the large number of persons shown, the individual features and different characters give the impression of a cross-section of contemporary society.

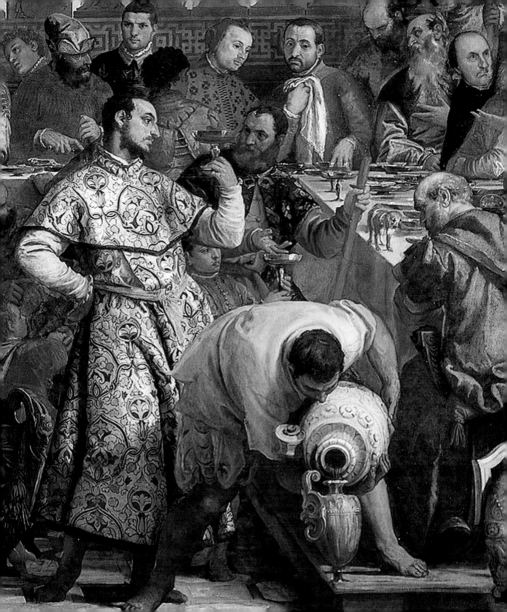

Feast in the House of Levi, 1573
Oil on canvas, 555 x 1280 cm
Galleria dell'Accademia, Venice
Veronese completed this imposing
painting for the refectory of the
Dominican monastery SS. Giovanni
e Paolo in Venice on April 20,
1573. On July 18th, however, the
Inquisition took exception to many
"suspicious" details that seemed to
desecrate the subject of the Last
Supper, and forced Veronese to
change the theme of the painting to
that of the Feast in the House of
Levi (Luke 5:27–32). It was in the
house of Levi, the tax collector,
that Christ spoke the words, "I
have not come to call the righteous,
but sinners to repentance."

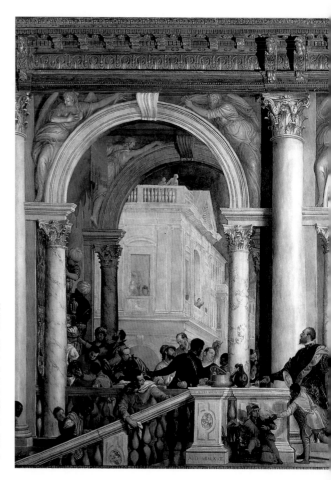

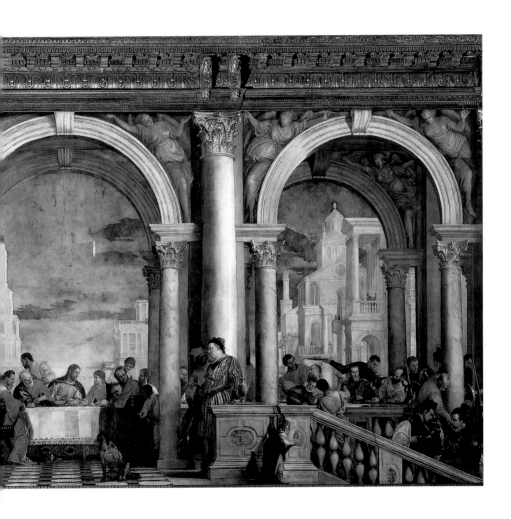

Holy Family with St. Barbara,
c. 1560–1570
Oil on canvas, 86 x 122 cm
Galleria degli Uffizi, Florence
St. Barbara, the Virgin, St. Joseph
and a young John the Baptist are
seen arranged in a circle around the
Christ Child. He is sleeping quietly
in his mother's arms, though young
John is playing with his foot. The
figures in the foreground of the
composition are considerably cut
off by the edge of the canvas, en-
dowing the scene with a sponta-
neous, natural look. This style, as
well as the "heavenly" glowing
coloration, is typical for Veronese.

Portrait of a Nobleman
with a Fur, c. 1550–1570
Oil on canvas, 140 x 107 cm
Galleria Palatina,
Palazzo Pitti, Florence
Whereas the pale, well-lit face and
hands of the unknown gentleman
are very carefully executed, the
costly snow leopard skin of his
long cape was painted with quick,
easy brushstrokes. It is not sur-
prising that this unusual painting
technique especially appealed to
the Impressionists in the late 19th
century. The dating of this Floren-
tine portrait varies among scholars
between 1550 and 1570.

Opposite
Allegory of the Battle of Lepanto,
after 1571
Oil on canvas, 169 x 137 cm
Galleria dell'Accademia, Venice
In the upper half of the painting,
Venezia, the personification of
Venice, clothed in a white robe, is
presented to the Virgin by the Saints
Peter, Roch, Justina and Mark in the
presence of the heavenly host. In the
lower, worldly zone, a glorious
naval battle is being waged, rep-
resenting the defeat of the Turks at
the hands of the Venetian fleet on
October 7, 1571 at Lepanto. This
unusual work is from the church of
S. Pietro Martire in Murano.

691.

Opposite
Discovery of the Young Moses, 1580
Oil on canvas, 50 x 43 cm
Museo del Prado, Madrid
This masterpiece radiates an air of festive cheer; it is a skillfully structured composition with soft, finely nuanced colors. The emotionally moving figures are in harmony with the finely crafted landscape. The two trees mirror the parted stance of the daughters of the Pharaoh and the old servant, who is holding a cloth for the child Moses, who was found unprotected on the bank of the Nile.

The Rape of Europa, c. 1580–1585
Oil on canvas, 240 x 303 cm
Palazzo Ducale, Venice
Veronese probably painted this mythological landscape, located in the Doge's Palace since 1713, on commission for Jacopo Contarini. According to legend, Zeus, in the form of a steer, approached Europa, the daughter of the Phoenician King Agenor. He abducted her and brought her to Crete in order to make her his wife. At the left Europa climbs onto the steer with the help of her servants; on the right we see the path to the sea.

Verrocchio, Andrea del

Andrea del Verrocchio (c. 1435 Florence–1488 Venice), whose given name was Andrea di Michele Cione, learned his craft from the goldsmith Giuliano del Verrocchio and chose to take his name. In the following years he created works in bronze and was active as a goldsmith, sculptor and painter. Along with Donatello (1386–1466), his main rival, he was considered to be the most important Florentine sculptor during the second half of the 15th century. His first major commission was a monument for Piero and Giovanni de'Medici in the church of San Lorenzo in 1472. In 1486 Verrocchio went to Venice, where he executed the demanding equestrian statue of the Condottiere Bartolomeo Colleoni, located on the piazza in front of the church of SS. Giovanni e Paolo. Verrocchio's small

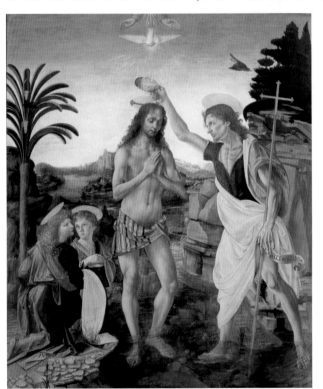

oeuvre of paintings can only be distinguished from those of his pupils—among whom were Leonardo da Vinci, Lorenzo di Credi, Perugino and Luca Signorelli—with great difficulty. The artists' works include *Mary with Child*, c. 1470, Gemäldegalerie, SMPK, Berlin; and *Tobias and the Angel*, c. 1470–1475, The National Gallery, London.

The Baptism of Christ, c. 1475
Tempera on panel,
180 x 152 cm
Galleria degli Uffizi, Florence
This painting from San Salvi in Florence was a collaboration between Verrocchio and his pupil and assistant, Leonardo da Vinci, and was highly praised by the art critic Giorgio Vasari. The two main figures are obviously the work of the sculptor Verrocchio: They are characterized by an informed rendering of human anatomy and a hard, linear drawing style. Leonardo's hand is evident in the soft contours of the landscape and in the finely nuanced coloration.

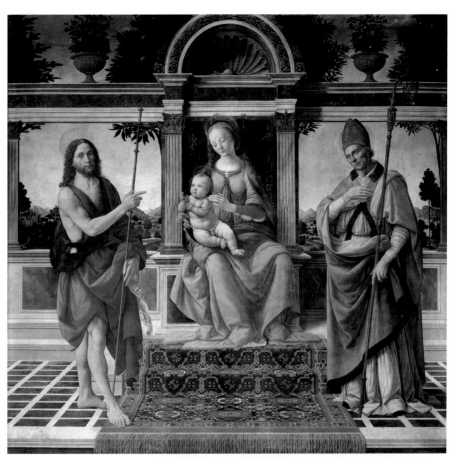

Virgin and Child with St. John the Baptist and St. Donatus,
c. 1475–1479
Tempera on panel, 189 x 191 cm
Cathedral, Pistoia

Verrocchio created this large altarpiece in collaboration with his pupil Lorenzo di Credi. The painting is symmetrically structured around a vertical axis and displays a broad pictorial space. The saints, reminiscent of painted sculptures, are relatively far apart, flanking both sides. There is nevertheless a fine tension between them, linking one to the other. This *sacra conversazione* is considered Verrocchio's most mature work, and stands as one of the most beautiful and important such works in all of Florentine early Renaissance painting.

Vigée-Lebrun, Élisabeth

Marie-Louise-Élisabeth Vigée-Lebrun (1755 Paris–1842 Paris) first learned her craft from her father, the pastel painter Louis Vigée, and then from Gabriel Doyen and Gabriel Briard. She furthered her education by studying the paintings of Peter Paul Rubens, Anthonis van Dyck and Rembrandt in the art collections of Paris. In 1776 Elisabeth Vigée married Lebrun, the wealthy painter and art dealer. In 1779, at the tender age of just 24 years, Queen Marie-Antoinette (1755–1793) appointed her to the role of court painter. In 1783 she was accepted into the Academy of Fine Arts, and from then on she was allowed to exhibit her works each year in the Salon of the Louvre. During the French Revolution she fled first to Rome in 1789, and then on to Berlin, Dresden, St. Petersburg and London. She finally returned to Paris in 1809 as a highly esteemed portraitist of the European aristocracy. Among her major works are *Portrait of Joseph Vernet*, 1778, Musée du Louvre, Paris; *Portrait of Queen Marie-Antoinette*, 1783, Musée National du Château de Versailles et de Trianon, Versailles; and *Portrait of Hubert Robert*, 1788, Musée du Louvre, Paris.

Self-Portrait, 1790
Oil on canvas, 100 x 81 cm
Galleria degli Uffizi, Florence
This portrait was done at the request of the Uffizi while the artist was staying in Rome in 1790. It has been reproduced numerous times in copies and engravings. Élisabeth Vigée-Lebrun portrays herself in front of a large canvas, painting a barely-discernible portrait of her great patroness, the French queen Marie-Antoinette.

Vignon, Claude

Claude Vignon (1593 Tours–1670 Paris) learned his craft in the studio of Jacob Bunel. In 1616 he was accepted into the Parisian painters' guild as a master. Although his biographer, Guillet de Saint-Georges, reported that Vignon went to Rome in 1609, based on stylistic information scholars now believe his Italian journey began somewhat later, probably in 1616. He returned to France by way of Spain in 1624. Vignon's reputation in Paris was great, as can be seen in part by his eight imposing "May pictures," commissioned by the Parisian goldsmiths' guild for the Cathedral of Notre Dame. He was held in equally high regard at the courts of Europe, especially by Ludwig XIII (1601–1643), Cardinal Richelieu (1585–1642) and Maria de' Medici (1573–1642). Vignon himself possessed an extensive art collection: Among his acquisitions were works by Nicolas Poussin, Claude Lorrain, Adriaen Brouwer, Willem Kalf, Peter Paul Rubens and Rembrandt. He was also active as an art dealer and bought paintings for the French queen in Italy and Spain. In 1635 he was appointed a professor at the Académie Royale de Peinture et Sculpture. Significant works by the artist include *Martyrdom of St. Matthew*, 1617, Musée Municipal, Arras; *Esther and Ahasuerus*, 1624, Musée du Louvre, Paris; and *The Washing of the Feet*, 1653, Musée des Beaux-Arts, Nantes.

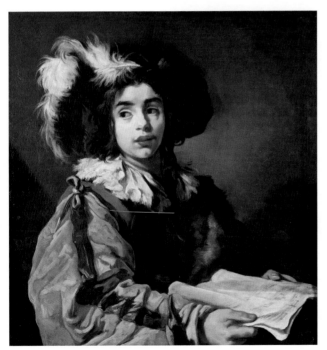

Young Singer, c. 1622/23
Oil on canvas, 95 x 90 cm
Musée du Louvre, Paris
Vignon was drawn under the spell of Caravaggio's works in Italy, as were many of his young contemporaries from all over Europe. This boy singer is painted in front of a neutral background with a feather beret on his head, features characteristic of Vignon's early period. Not only the half-length figure, but also the strongly contrasting areas of light and dark, are stylistic features reminiscent of Caravaggio's painting style.

Vitale da Bologna

Vitale da Bologna (c. 1308/09 Bologna–c. 1360?), also called Vitalis de Equis, Vitale delle Madonne or Mimmo de'Cavalli, was a painter and also a wood sculptor. He is considered the founder and the most important representative of the Bolognese School of painting in the *Trecento*. His name was first mentioned in 1330 in connection with the frescoes in the church of S. Francesco in Bologna, which have since been destroyed. His commissions for the Order of St. Francis continued until 1340. In 1349 he painted the frescoes in the Cathedral of Udine; in 1351, he worked in Pomposa near Ravenna. His works are characterized by a simplification of contours and a richly nuanced color sense consisting of small areas of glowing color. His late paintings, in particular, show Vitale to be an important representative of the International Gothic style that pervaded northern Italian painting around the mid-14th century. His major works include *The Last Supper*, 1340, Fresco, Pinacoteca Nazionale, Bologna; *Madonna dei Denti*, 1345, Collezioni Comunali d'Arte, Bologna; and *The Death of St. Nicholas*, 1349, Duomo, Udine.

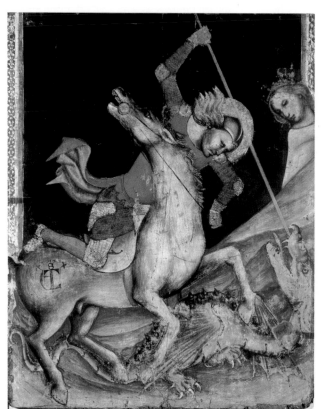

St. George Slaying the Dragon, c. 1350
Tempera on panel, 88 x 70 cm
Pinacoteca Nazionale, Bologna
St. George, a Christian soldier under the Emperor Diocletian, bravely used his lance to save the life of a princess who was to be sacrificed to a dragon. Vitale da Bologna was one of the first artists in western painting to use this subject, which was to be elaborated and varied repeatedly during the following centuries. Vitale created a tension-filled, dramatic scene by emphasizing the different directions of movement taken by horse and rider.

Vivarini, Alvise

Alvise Vivarini (c. 1445 Venice–c. 1504 Venice) was one of a family of artists whose members can be traced in Venice during the 15th and 16th centuries. Alvise was the son of Antonio Vivarini, considered the founder of the so-called School of Murano. He was probably trained in the atelier of his uncle, Bartolomeo Vivarini. Alvise's most important commission, the decoration of the *Sala del Maggiore Consiglio* (Hall of the Greater Council) in the Doge's Palace—which is also considered the masterwork of the School of Murano—was destroyed by fire in 1577. Stylistically, Alvise's early paintings are related to those of his uncle and to the work of Andrea Mantegna. From 1480 on, Alvise's pictures become more delicate, the forms quieter and more balanced. Because of these stylistic tendencies Alvise can be seen as a forerunner of Giorgione. Among the artist's works are *St. Anthony of Padua*, c. 1480, Museo Correr, Venice; *Portrait of a Nobleman*, 1497, The National Gallery, London; and *Madonna with Sleeping Child and Two Angels Making Music*, Chiesa del Redentore, Venice.

Sacra Conversazione, 1480
Tempera on panel, 175 x 196 cm
Galleria dell'Accademia, Venedig
This altarpiece from the church of San Francesco in Treviso shows the saints Louis of Toulouse, Anthony of Padua, Anne, Joachim, Francis and Bernard of Siena flanking the enthroned Virgin and Child. The overly slender, ascetic figures of the saints are characteristic of Alvise, and are in stark contrast to those painted by his uncle, Bartolomeo Vivarini.

Vivarini, Bartolomeo

Bartolomeo Vivarini (c. 1430 Murano–after 1490 Murano) was the younger brother of Antonio Vivarini from Murano as well as the uncle and probable teacher of Alvise Vivarini. From 1450 he worked with his brother in a jointly owned studio. In contrast to Antonio's relatively traditional works, still late Gothic and early Renaissance in style, Bartolomeo's works are distinguished by minute exactness of details, sharp contours and folds in garments, and strong coloring. He also enjoyed reproducing decorative elements, as is especially obvious in his imaginatively arranged and entwined flower and fruit garlands. Bartolomeo Vivarini's paintings represent the transitional period from the early to the High Renaissance in Venice. His works include *Virgin and Child with Four Saints*, 1476, Santa Nicola, Bari; *Virgin and Child with Four Saints*, 1482, Santa Maria Gloriosa dei Frari, Venice; and *St. George Slaying the Dragon*, 1485, Gemäldegalerie, SMPK, Berlin.

Virgin and Child with Saints, 1465
Tempera on panel, 118 x 120 cm
Museo Nazionale di Capodimonte, Naples
This work is the central panel of a Mary-triptych. The Virgin is enthroned with the sleeping Christ Child, and is flanked left and right by the saints Augustine, Roch, Louis of Toulouse and Nicholas of Myra. This splendid *sacra conversazione* bears the inscription "OPUS BARTOLOMEI VIVARINI DE MURANO 1465" on the lower step of the Virgin's throne. The composition of the painting is symmetrical, the architectural elements detailed and relief-like, and the fruit and flower garlands are decoratively entwined; these stylistic elements are all characteristic of Bartolomeo Vivarini's works.

Vouet, Simon

Simon Vouet (1590 Paris–1649 Paris) first learned his craft from his father, the painter Laurent Vouet. By the age of 14 he had already been called to England to do a portrait. In 1611 Vouet travelled to Constantinople, and in 1612 to Venice. Toward the end of 1613 he settled in Rome for approximately 15 years. In 1624, Vouet was appointed rector of the Accademia di San Luca. At the behest of King Louis XIII (1601–1643), he returned to Paris in 1627 to become *Peintre du Roi* ("the king's painter"). This date is usually used to mark the beginning of the period of French painting known as neoclassicism. The multifaceted Vouet, who ran a large workshop, redecorated the interiors of numerous noble residences and castles and designed tapestries in addition to painting altarpieces and portraits for the royal court and the landed gentry. Some of his works are *St. Mary Magdalene*, c. 1630, Museé de Picardie, Amiens; *Lot and His Daughters*, 1633, Musée des Beaux-Arts, Strassburg; and *The Martyrdom of St. Eustace*, c. 1637, St-Eustache, Paris.

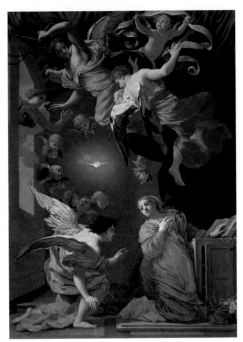

The Annunciation, c. 1620
Oil on canvas, 120.5 x 86 cm
Galleria degli Uffizi, Florence
This picture came into the collection of Ferdinand III (1769–1824), the Grand Duke of Tuscany, in 1793 along with a number of other paintings. We do not know where *The Annunciation* was originally hung. Although some scholars date the painting between 1630–1640, the style is in opposition to the artist's later works: It is extremely conscientious, even hesitant, suggesting an earlier date perhaps during Vouet's creative period in Italy.

Psyche Watching Amor Sleep, 1626
Oil on canvas, 112 x 165 cm
Musée des Beaux-Arts, Lyon
This painting impressively documents Vouet's growing
skill by the end of his stay in Italy. Influenced by the
works of Giovanni Lanfranco, Annibale Carracci and
Guido Reni, Vouet developed an ever-increasing
harmony of form and a subtler use of light. Winged
Amor, shamelessly revealing his boyish body in sleep,
is illuminated by Psyche, who is holding an oil lamp
above him. The red drapery of the bed intensifies the

erotic atmosphere of the scene, which is soon to take
a tragic course. According to the text by Lucius
Apuleius, the goddess Aphrodite grew envious of
Psyche, the king's daughter, because of her extra-
ordinary beauty. Aphrodite then sent her son, Amor, to
avenge her. But Amor, who only appeared to the
princess at night, fell in love with Psyche. Driven by her
curiosity, Psyche tried to find out who her lover was.
Awakened by a drop of falling wax, Amor disappeared
and did not return. Eventually, Zeus' intervention
reunited the two lovers after a long separation.

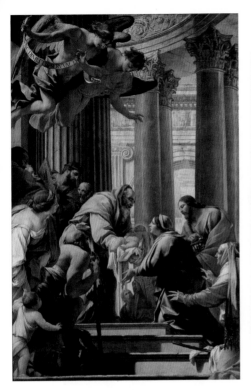

Presentation in the Temple, 1641
Oil on canvas, 393 x 250 cm
Musée du Louvre, Paris
Based on a copper engraving by Michel Dorigny, it is certain that this painting was commissioned by the Cardinal Richelieu (1585–1642) for the Jesuit church St. Louis-des-Jésuites in Paris. As the central panel, it originally decorated the monumental altar retable along with with a depiction of the apotheosis of St. Louis, which is today preserved in the Musée des Beaux-Arts in Rouen. The central panel of the altar unites neoclassical forms with a Baroque rhythm that can be seen in the strong upward movement.

Allegory of Wealth, c. 1633
Oil on canvas, 170 x 124 cm
Musée du Louvre, Paris
A young woman, winged and crowned with a laurel wreath, casts only a passing glance at the putto on her right holding costly jewelry and vessels. True wealth is, after all, the little child in her arms. This picture was first mentioned in 1706 in an inventory of the collection of art in possession of the French royal house. It was probably part of a series of allegorical narratives that Vouet painted in the early 1630s on commission from King Louis XIII (1601–1643) for his newly-built palace, St.-Germain-en-Laye.

The Beginning of Reproductions

The origin of printmaking dates back to the early 15th century. Even before woodcuts came into widespread use, copper engravings had been developed, primarily in the workshops of goldsmiths in southern Germany. At first, only a relatively small number of prints were made. The technique of printmaking was invented at about the same time that Johannes Gutenberg (c. 1397–1468), in Mainz, developed the movable type printing press that so revolutionized the world. Printmaking seems to have grown out of the desire to make illustrated ideas available to a wider public. One impetus was a growing demand for religious pictures for laypeople to use for personal meditation and as talismans and decorations for their homes. Another force during the second half of the century came from the increased production of profane playing cards, calendars and other products pertaining to entertainment and education.

From the late 15th century onward, artistic copper engravings took the form of autonomous single sheets, giving artists an opportunity to experiment and develop even unconventional motifs, free from the demands and desires of patrons, who otherwise had fairly tight control of their purse strings. In addition, prints of important paintings and sculptures could be made available to a relatively large number of people, fairly quickly, and at affordable prices. Prints soon developed into popular objects that were traded or collected.

Copper engravings also had a kind of advertising function, spreading works to other artists and artistic circles, as can be seen in the example on the following page by Martin Schongauer (c. 1450–1491). Through the development of new linear techniques, Schongauer attained a variegated texture that had been previously unknown. He was also able to convey light and shadow through crosshatching, giving his works a corporeal quality similar to that of paintings. Because his works were extremely popular among his contemporaries, they were soon copied, as in the case with the *Birth of Christ* by Wenzel von Olmütz, an artist who worked in Prague during the last quarter of the century. Martin Schongauer's printed works traveled so far that their traces and influence can be seen not only in many German panel paintings, but also in Dutch and Spanish works of art.

Albrecht Dürer (1472–1528), himself a master of copper engraving, became acquainted with Schongauer's works in Nuremberg. During his

Albrecht Dürer: Honorary Portal, 1515
Woodcut, 341 x 292 cm
Germanisches Nationalmuseum, Nuremberg
This enormous woodcut, consisting of 190 separate sheets, was commissioned by Emperor Maximilian I to serve as political propaganda. Its size dwarfs all other prints of its time.

Martin Schongauer: Birth of Christ, c. 1471–1473
Copper engraving, 25.8 x 17 cm
Kupferstichkabinett, SMPK, Berlin
Schongauer uses the foreground to depict the Virgin's adoration of the Christ Child in the midst of a decaying, overgrown architectural structure. On the left in the background, shepherds are seen coming to see the child: This is the adoration of the Child by the ordinary, simple man. Schongauer was influenced in the composition of this engraving by the works of Rogier van der Weyden, especially his *Bladelin Altarpiece* in the Gemäldegalerie in Berlin. Schongauer's engraving, in turn, inspired numerous later masters to create similar works.

journeyman years, probably in early February 1492, he travelled to Colmar but was unable to meet the master himself: Schongauer had died just one year earlier. In 1513/14 Dürer produced three superb engravings: *Knight, Death and the Devil*; *St. Jerome in His Study;* and *Melancolia I*. Of these three, the copperplate engraving of St. Jerome in his study (shown on the opposite page) is clearly Dürer's masterpiece, as it demonstrates the artist's special use of central perspective, an ability he acquired through the study of Italian works. Moreover, the clever structuring of space, the differentiation of textures, and the atmosphere created through the interplay of light and shadow (Dürer left no part of the print's surface untouched), combine to give this work its perfection.

In addition to these free artistic works, Dürer made prints that served as political propaganda. In 1512, Emperor Maximilian I (1493–1519) commissioned him to create woodcuts for the so-called *Honorary Portal*. Borrowed from the triumphal archways of antiquity, this motif was intended to glorify the life and deeds of the emperor and his ancestors. Reminiscent of splendid Renaissance *palazzi* in composition and architecture, classical ideals were united with contemporary forms. Although other artists also contributed to the *Honorary Portal*, the design was Dürer's alone and he remained responsible for its execution through completion of the project, which consists of 190 woodcuts. Joined together, they form an impressive area of almost 10 square meters (30 square feet). This monumental work was intended as a ceremonial decoration, but a large number of copies, 700

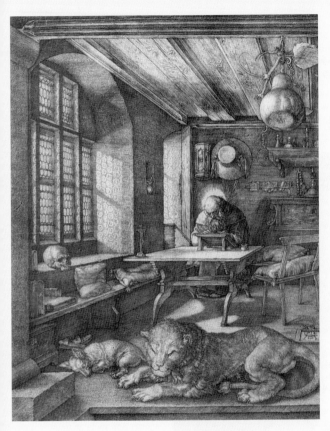

in all, were to be printed in order to ensure that the fame of Emperor Maximilian would be spread to the far corners of his kingdom.

With the flowering of the Renaissance, printmaking developed into a new branch of the fine arts. Because of its nature and origins it inhabits a position between words and pictures, and has therefore been an important medium for the exchange of information since its beginnings. Printmaking has obviously been used to various ends: for the propagation of works of art to a broader audience, to publicize religious works, to convey political information, and to suit the demands of royalty.

Watteau, Jean-Antoine

Jean-Antoine Watteau (1684 Valenciennes–1721 Nogent-sur-Marne) first learned his craft from the painter Jacques-Albert Gérin in Valenciennes. In about 1702 he went to Paris, where he earned his living with difficulty by making copies in the workshops of Notre Dame, and continued his training with Claude Gillot and Claude Audran III. These masters introduced Watteau to motifs pertaining to the world of the *commedia dell'arte* and the free technique of drawing arabesques. In 1709/10 Watteau lived in Valenciennes, returning afterward to Paris. In 1717 he was accepted into the Académie Royale de Peinture et Sculpture as a painter of *fêtes-galantes*. By now highly in demand, Watteau worked in London in 1719/20. Considered one of the most important masters of 18th-century French painting, Watteau's major works include *Savoyarde with Ground Hog*, c. 1707–1709, The Hermitage Museum, St. Petersburg; *The Italian Comedy*, c. 1718, Gemäldegalerie, SMPK, Berlin; and *The Hunting Party*, c. 1720, Wallace Collection, London.

The Holy Family on the Flight Into Egypt, c. 1715–1717
Oil on canvas, 129 x 97.2 cm
The Hermitage, St. Petersburg
This work is unusual for Watteau because of its religious subject matter and its large format. It was known to be in the possession of Nicolas Hénin, a friend of the artist, in 1794. In 1732, this dynamic, emotional composition was repeated as an engraving and widely reproduced. A drawing by Anthonis van Dyck supposedly inspired Watteau to execute this work, painted with quick, fleeting strokes of the brush.

Marriage Contract in a Landscape, c. 1712
Oil on canvas, 47 x 55 cm
Museo del Prado, Madrid
The motif of this painting seems to derive from Flemish art, specifically from the works of David Teniers the Younger. Along with its counterpiece, *Gathering at the Neptune Fountain*, it is among Watteau's most controversial works. To this day experts cannot decide whether these works from the collection of Elisabeth Farnese, wife of the Spanish king Philip V (1683–1746), are originals or whether they are among the numerous imitations and copies made under Watteau's name in the 18th century, in order to subsequently be bought and sold on the open market.

Actresses of the Comédie-Francaise, c. 1712
Oil on panel, 20 x 25 cm
The Hermitage, St. Petersburg
Aside from *fêtes-galantes*, Watteau's special interest was the theater. This small panel in the Hermitage, also known under the titles *Invitation to a Dance*, *Return from a Dance* or *The Masquerade*, differs from Watteau's other theater depictions because of its close-up view. The costumed ladies are probably portraits of contemporary actresses who were known to the artist.

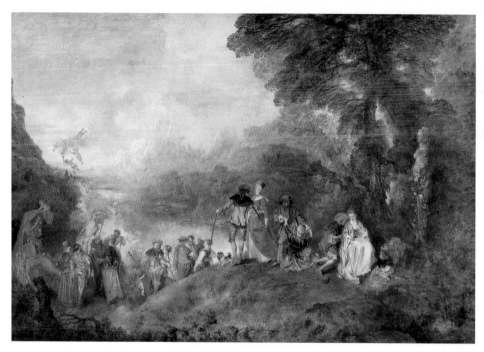

Pilgrimage to the Isle of Cythera, c. 1717
Oil on canvas, 128 x 193 cm
Musée du Louvre, Paris
This picture brought a completely new pictorial genre, the *fête galante*, into being; and with it Watteau was accepted into the Royal Academy in August, 1717. The famous painting shows a pilgrimage of lovers setting out for the legendary shrine of Venus on the Mediterranean island of Cythera. The lovers are positioned in a loose, swinging chain of figures, extending from the statue of Venus, standing at the edge of the woods on the right, to the boat on the left edge of the picture. Imbued with the warm light of evening, the landscape has a cheerful, Arcadian atmosphere. The departure of the pairs of lovers is filled with yearning for their far-off happiness.

Opposite
Gilles (Pierrot), c. 1719
Oil on canvas, 185 x 148 cm
Musée du Louvre, Paris
The large format (for Watteau) of this painting can be explained its purpose. It served as the poster advertising a troupe of actors who were performing *A laver la tête d'un âne on perd sa lessive* ("When washing the head of a donkey, you are wasting the shampoo!"), a play by Th. Simon de Gueullette. The play is about the difficult education of Gilles, a poor fellow who has no luck anywhere and is laughed at by all. Behind the central figure in the lower part of the painting Watteau has placed the other characters in the play: the father, the pair of lovers, and the *maître* who arranges everything and leads the donkey on the leash.

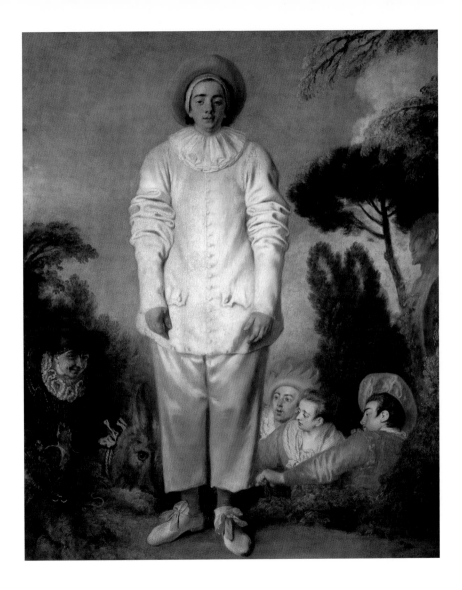

Right
Portrait of a Gentleman, c. 1720
Oil on canvas, 130 x 97 cm
Musée du Louvre, Paris
Watteau painted only a very few portraits during his short artistic career. Purchased in 1973 for the collection of the Louvre, the authenticity of this male portrait has at times been questioned by experts. However, arguments for ascribing it to Watteau include the dreamy facial expression of the unknown model; his elegant hands with their long fingers; and the fleeting, hastily painted landscape background. The result is a memorable study of the anonymous sitter.

Below
The Shop Sign of Gersaint, the Art Dealer, 1720
Oil on canvas, 161 x 308 cm
Schloß Charlottenburg, Berlin
On returning from London Watteau contracted tuberculosis and stayed in the house of the art dealer Gersaint. This painting was the shop sign for his friend, to be placed as a *sopraporte* above the entryway. Looking at the painting, the viewer is already looking into the store. On the left, a mirror and a portrait of Louis XIV (1638–1715), symbols of a by-gone age, are being packed into a crate while on the right, fashionable ladies and gentlemen busy themselves with "modern" art.

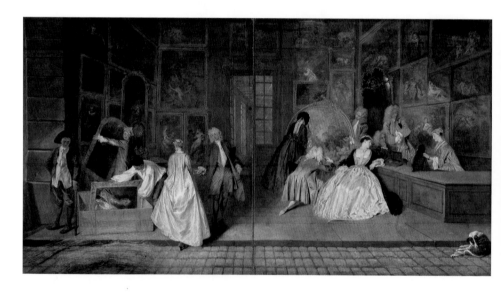

**The Judgement of Paris,
c. 1720/21**
*Oil on panel, 47 x 31 cm
Musée du Louvre, Paris*
One of Watteau's last paintings,
this picture depicts the well-known
myth in an unconventional manner.
Surely Watteau was inspired by
Ruben's *Judgement of Paris*, which
was housed in the art collection of
the French court, since in his
painting Paris' choice between the
three women has already been
made. Venus stands victorious in the
center of the picture, whereas Hera
and armed Athena only appear as
subordinate figures.

Weyden, Rogier van der

Rogier van der Weyden (1399/1400 Tournai–1464 Brussels), also called Rogelet de la Pasture, is considered one of the most important representatives of 15th-century Dutch painting. In 1427 he entered the workshop of Robert Campin, of which he eventually became the head. Shortly after he was granted the status of a free master he moved to Brussels, where he was appointed to the position of city painter in 1435/36. During his pilgrimage to Rome around 1450, he was active in Ferrara and in Florence as well. Influenced by the works of Campin and of Jan van Eyck, van der Weyden developed more slender and elegant figures, and perfected perspective views of interior rooms and landscapes. The balance between space and surface became increasingly important to him in his later years. He also subordinated the precise representation of details to a concern for the composition as a whole. Among his works are *The Bladelin Altarpiece*, before 1450?, Gemäldegalerie, SMPK, Berlin; *Virgin and Child with Saints (The Medici Madonna)*, c. 1450, Städelsches Kunstinstitut, Frankfurt; and *Portrait of Charles the Bold*, c. 1460, Gemäldegalerie, SMPK, Berlin.

Portrait of the Knight of the Golden Fleece (Anton of Burgundy), c. 1460
Oil on panel, 36.8 x 26.9 cm
Musées Royaux des Beaux-Arts, Brussels
Van der Weyden's portraits are among the most important of the genre. Starting from van Eyck's affinity to nature, he could convey strong emotional expression through stylization. The sitter of this portrait is usually identified as Anton of Burgundy (c. 1422–1504), the illegitimate son of Philip the Good (1396–1467). He was an imposing figure at the English and French courts and was awarded the Order of the Golden Fleece, a Burgundian honor, in 1456.

Opposite
Portrait of a Woman with a Winged Turban, c. 1435
Oil on panel, 47 x 32 cm
Gemäldegalerie, SMPK, Berlin
The portrait of this simply dressed unknown woman from the upper-middle class is close to life and far from any strictly realistic representation. Her gaze is unusual for this time period: She does not look meditatively inward, but makes direct eye contact with the viewer. Her gaze expresses understanding and interest. Van Eyck and van der Weyden were the first to introduce this innovation into portraiture.

Descent From the Cross, c. 1435
Oil on panel, 220 x 262 cm
Museo del Prado, Madrid
This impressive composition imitates a carved altar with painted figures. The rounded figures are depicted on a narrow stage with precise detail, and are rhythmically bound to one another with great skill. Despite their radical, emotive movements in space, they are still firmly visually attached to the surface. This panel, originally the central panel of a triptych, was often copied. The side wing panels have been lost.

Opposite
The Lamentation Before the Tomb, c. 1450
Oil on panel, 110 x 96 cm
Galleria degli Uffizi, Florence
This panel comes from the villa of the Medici family in Careggi. It was formally inspired by the strict compositions of Fra Angelico; however, van der Weyden's composition is freer and includes more figures, and the details depicted are more individualized. A lively movement that links the kneeling figure of Mary Magdalene to St. John is reinforced by the angle of the gravestone on which he stands.

The Adoration of the Magi
(The Columba Altarpiece), c. 1455
Tempera on panel, 138 x 153 cm
Alte Pinakothek, Munich

The artist's mature style is evident in this central panel of the Magi Altar originally in St. Columba Church in Cologne. The Virgin and child Jesus are positioned slightly left of center, making the view into the stable slightly asymmetrical. The three wise men balance this displacement, and at the same time create meaning. Characteristic is also the relief-like composition of the figures and the parallel surfaces of the architecture. Exquisite in its details and coloring, this image must have moved van der Weyden's contemporaries, as numerous copies were made and its details were repeated over and over again.

**Annunciation Triptych,
c. 1435–1440**
Oil on panel
Central panel: 86 x 92 cm
Side panels: 86 x 53.5 cm each
Musée du Louvre, Paris
(central panel);
Galleria Sabauda, Turin
(side panels)
This early work proves van der Weyden's artistry and his ability to add brilliance and optical charm to his paintings. The objects and the space surrounding them are persuasively rendered through their coloration, and each detail contributes to the density of the composition's content. Although the artist painted this subject numerous times, he never again portrayed the Virgin as modestly or the vision of the angel as elegantly as here. On the left side of this small altarpiece we see the donor, who remains unidentified; this side has in part been heavily repainted. On the right, we see the Visitation. Van der Weyden has sensitively depicted the encounter between the Virgin Mary and Elizabeth, mother of John the Baptist, before the gates of the city. The older woman humbly embraces Mary and touches her blessed body, while Mary tenderly returns the gesture. A solemn atmosphere emanates from these two figures so simply depicted.

**The Seven Sacraments
Altar, c. 1445**
Oil on panel
Central panel: 200 x 97 cm
Side panels: 119 x 63 cm each
Koninklijk Museum voor Schone
Kunsten, Antwerp

In this alterpiece, the painter developed his lifelike figures and profound pictorial content through design, rhythm and modeling. Because of his attention to the spiritual realm, the natural world plays a comparatively small role. Depicted are the Seven Sacraments with angels in the liturgical colors of the Catholic Church. From left to right they represent Baptism, Confirmation, Confession, Communion, Priesthood, Marriage and Anointing of the Sick. As in Jan van Eyck's work, van der Weyden here depicts the sacred interior area as a symbol for the Church and its community. The people attending the baptism are clothed fashionably, as can be clearly seen in the detail at right. They also have individualized features, and are perhaps contemporaries of van der Weyden's.

Witz, Konrad

Konrad Witz (c. 1400 Rottweil–1445 Basel or Geneva) came from Rottweil on the Neckar. He was first mentioned officially in 1434 when "Master Konrad von Rotwil" was accepted into the painters' guild of Basel, and in 1435 he was granted the rights of citizenship in that city. The inscription on the *Petrus Altar* in Geneva, dated 1444, is the last known official mention of the artist, from whom only a few works have survived. His murals and the greater part of his panel paintings were destroyed by iconoclasts during the Reformation period. Konrad Witz was a contemporary of Masaccio and Jan van Eyck. Like them, he must be counted among the most important forerunners of the "new" art on the basis of his sculptured, corporeal figures, his interest in the problems of perspective, and because of his realistic landscape backgrounds. The artist's works include *St. Christopher*, c. 1435, Kunstmuseum, Basel; *Esther and Ahasuerus*, c. 1435–1437, Kunstmuseum, Basel, and *St. Peter's Miraculous Catch of Fish*, 1444, Musée d'Art et d'Histoire, Geneva.

Annunciation, c. 1440
Tempera on panel, 157 x 120 cm
Germanisches Nationalmuseum, Nuremberg
This Nuremberg panel is part of an altar dedicated to Mary about which no sources exist. In the perspectival depiction of the simple, unfurnished room as well as the realistic rendering of wall area, revealing wooden beam and boards, we can see the impact of the artist's encounter with the paintings of Robert Campin and Jan van Eyck. It is not clear whether Witz travelled to Flanders during his years as a journeyman or at a later date.

Opposite
The Queen of Sheba
with King Solomon, c. 1435–1437
Tempera on panel, 84.5 x 79 cm
Gemäldegalerie, SMPK, Berlin
The Queen of Sheba is seen visiting King Solomon, bringing him a gift. This is one of eight scenes on the inner sides of the wings of the *Heilsspiegel-Altar* from St. Leonard in Basel. These scenes come from the *speculum humanae salvationis*, or the "Mirror of Salvation." The 14th-century inscription reveals that the events of the Old Testament prefigure the New Testament's life of Christ and story of salvation. Thus, the joy of the Queen of Sheba when beholding Solomon's wisdom prefigures the joy of the blessed in heaven in the presence of Christ.

Wouwerman, Philips

Philips Wouwerman (1619 Haarlem–1668 Haarlem) first learned his craft from his father, the painter Paulus Joosten Wouwerman, and afterward in the workshop of Frans Hals. In 1638/39 he lived in Hamburg. 1640 found him again in Haarlem, where he became a member of the painters' Guild of St. Luke. He probably remained there for the rest of his life. Wouwerman is a well-known and highly versatile painter. In his early period he painted landscapes of dunes with small subsidiary figures, following the Haarlem tradition in which he was trained. But his exceptional fame is due to his depictions of horses with riders and battle scenes, all characterized by a remarkable liveliness. The artist also painted genre scenes and mythological narratives. Among Wouwerman's most significant works are *Riders Battling before a Burning Windmill*, c. 1650, Gemäldegalerie Alte Meister, Dresden; *The Assumption of Christ*, c. 1650–1655, Herzog Anton Ulrich-Museum, Braunschweig; and *Rest during the Stag Hunt*, c. 1660–1665, Alte Pinakothek, Munich.

Landscape with Resting Hunters, c. 1640–1650
Oil on panel, 35 x 44 cm
Mauritshuis, The Hague
Characteristic elements of Wouwerman's artistry visible in this picture are a broad landscape view with a low-lying horizon and the relatively large figures. During the 19th century this painting was still attributed to Pieter van Laer, but later examination by experts revealed Wouwerman's signature on the panel. Pieter van Laer returned to Haarlem from Italy in 1638 and energized Dutch painting with the warm color tones of his Mediterranean landscapes.

Wright, Joseph

Joseph Wright (1734 Derby–1797 Derby), called Joseph Wright of Derby, learned his trade from 1751–1753 and 1756/57 in the workshop of the London portraitist Thomas Hudson. He later worked in Derbyshire, and from 1768–1770 in Liverpool. Wright travelled through Italy from 1773 to 1775, and, influenced by Caravaggio's paintings, he developed a style of painting rich in contrast between light and shadow. At the center of his paintings is often an effective depiction of candlelight. After a stay in Bath in 1775/76, he returned to Derby.

Wright painted mainly portraits, narratives and landscapes. Because of his contact with the leading natural scientists and intellectuals of his day he liked to paint contemporary technological subjects: It is on these works, executed with great artistry, that his far-reaching fame is based. His works include *Peter Perez Burdett and His First Wife Hannah*, 1765, Národní Gallery, Prague; *The Smithy*, 1771, Art Gallery, Derby; and *The Young Corinthian or The Origin of Painting*, c. 1782–1785, National Gallery of Art, Washington D.C.

An Experiment on a Bird in an Air Pump, 1768
Oil on canvas, 72 x 96 cm
The National Gallery, London
The creation of a vacuum through technical machinery, and its effect on a bird's breathing, is effectively being demonstrated here. The different facial expressions and gestures of the members of the audience express curiosity, fear and fascination. Wright's depiction of light is extraordinary; it emanates from one point alone, giving the scene a sense of mystification. Stylistically, this painting is classified as classical Realism.

The Air Pump (detail)
Through the creation of a vacuum, the bird—significantly, a white dove—for a moment loses the air it needs to breathe. In this moment, the scientist must decide between life and death, a decision which clasically belongs to God alone. The reactions of those present are varied. Whereas the youngest girl watches the glass bulb with disbelief and curiosity, the older girl turns away in anxiety. Only the father tries to allay her fears through an explanation. The man at the table, the oldest and presumably most experienced of the group, looks meditatively at the light, reflecting on the event and its transcendence of the border between earthly and heavenly powers.

The Frame is Half the Picture

The history of picture frames reaches far back into antiquity, as can be seen in the painted or stone borders that surround wall frescoes and floor mosaics in Pompeii. In the sacred art of the Middle Ages, frames were a part of panel paintings well into the 15th century. Sometimes a frame was formed by indenting the painted area into the surface of a panel, and occasionally plain slats were nailed onto the border of a painted panel in order to keep it from falling over. The form and decoration of these framing slats grew ever more divergent until by the close of the Middle Ages— parallel to the rise of independent panel paintings—the autonomous, individually formed frame emerged.

From the very beginning of its history a frame fulfilled numerous functions. It was not only meant to protect the painting, but also to separate the painted world within the picture from the reality of the wall or room on which or in which it was displayed. This is especially important when works are hung close together, as is often the case in galleries, where frames help to focus the gaze of the viewer on a single picture. Historically, frames were commonly made by the painters themselves or built according to their specifications by professional framecrafters. They can be helpful devices in locating pictures in history because, as a form of decoration, frames mirror the aesthetic taste of changing times or reveal the rank and status of their owner.

For example, in the 17th century, bourgeois Dutch paintings as a rule had frames consisting of relatively simple, straight profiles made from any of the several kinds of wood readily available; but during the same time period in Flanders, Italy and France, curved frames with abundant, sculpted decorations were *en vogue*. In those countries fruit, vines, leaves and shells covered the entire profile, which was usually painted an impressive gold. After the end of the 17th century coats of arms, initials and trophies were also added. The most popular form at this time was the frame in the French *Louis-Quatorze* style, with richly ornamented corners.

The *tondo* was a special round picture form developed during the Italian Renaissance; oval frames first came into fashion in the 17th century and were especially popular in the Rococo period. Neoclassicism favored a more stern, antiquated frame form despite the wealth of different profiles that were available by then. From about 1760 on-

Opposite
Sala di Marte
Palazzo Pitti, Florence
The wall area of the Mars Gallery is framed by a base and an *attica*, or sculpted zone at the top. The ceiling is decorated with a fresco by Pietro da Cortona. The wonderful allegories and portraits displayed here, in a room of the former Medici palace, are works by Rubens, van Dyck, Murillo, Titian, Tintoretto and Veronese, among others. The paintings are hung in two rows and fitted with ornate 17th-century gold frames.

ward, laurel wreaths, pearls, dentils and rosettes served as decorations with increasing frequency. Romanticists like Caspar David Friedrich and Philipp Otto Runge sometimes considered the frame to be an integral part of their painting, and therefore designed their own. During the second half of the 19th century, historical frame styles again came into fashion. Only Art Nouveau developed its own frame forms, aesthetically suiting each frame to the work of art it was intended to surround.

The original frames of old works of art have often been lost. They were exchanged when they no longer suited the taste of a new owner, or the paintings were fitted with standard frames when they were made part of a collection. This can be seen, for example, in the works on display in the Palazzo Pitti in Florence and in the Gemälde-

galerie in Dresden: Without regard to their context or period of creation, most paintings were given Baroque frames for the gallery display. Wilhelm von Bode, the prominent Berlin art historian who wrote the pioneering article "Picture Frames of the Past and the Present" in his periodical *Pan*, argued that uniform frames do not do justice to the individual work of art. When he became the director of the Berlin Gemäldegalerie in 1904 he used the opportunity to remove the so-called *Schinkel-Rahmen* he had so sharply criticized. He began to buy costly frames, originals from the same period as the work itself, or he had copies made that were stylistically more suited to the works. Bode was therefore, at the beginning of the 20th century, the first museum director to propose a practice that has become a matter of course for museums and collectors.

Opposite
Karl Louis Preusser: In the Dresden Gallery, 1881
Oil on canvas, 68 x 87 cm
Gemäldegalerie Alte Meister, Dresden
The standardized gold Rococo frames from the mid-18th century are, even today, unique to the famous Dresden Gemäldegalerie.

Atelier of a Frame Gilder
Encyclopedia of Diderot and d'Alembert,
Paris, 1751–1765
The top third of the image shows the stages of gilding frames, and below are the tools necessary to the centuries-old craft of framing, practiced until the present day.

Zoffany, Johann

Johann Zoffany (1733 Frankfurt am Main–1810 Strand-on-the-Green), also known as Zauffaly, was reared in Regensburg until the age of 13 alongside the son of the Prince von Thurn und Taxis, in whose service his father was employed. Zoffany's artistic training began there in 1747 with the painter Martin Speer. In 1750–1758 he studied in Rome with Masucci and Mengs; afterward, he was ap-pointed court painter to the Viceroy in Trier. In 1760 Zoffany settled in London, where he was able to exhibit works in the "Society of Artists" from 1762 on. He advanced to become the favorite painter of King George III (1738–1820). In 1772 he traveled to Florence at the behest of the Queen. He moved to Vienna in 1776 and was elevated into the hereditary aristocracy by Empress Maria Theresia (1717–1780). Zoffany took his last great journey, to India, in 1783–1789. His oeuvre consists mainly of portraits and society pieces. Major works by the artist include *Self-Portrait*, 1761, Royal Portrait Gallery, London; *The Modeling Class at the Royal Academy*, 1772, Royal Art Collection, Windsor Castle; and *The Tribuna of the Uffizi*, 1772–1778, Royal Art Collection, Windsor Castle.

Street Musicians (Concerto di Svonatori Ambulanti), 1779
Oil on canvas, 117 x 94 cm
Galleria Nazionale, Parma
Zoffany, an expert at the multi-figured yet carefully executed group portrait, was in Parma at the beginning of 1779, where he enjoyed the patronage of the royal family. Parma is also where he painted *Street Musicians*, one of his liveliest and most optimistic works. It reflects his long-standing infatuation with Dutch genre painting of the 17th century.

Zoppo, Marco

Marco Zoppo (1433 Cento–1478 Venice), whose given name was Marco Ruggiero, received his nickname because of a physical handicap: *il zoppo* means "the lame one." In 1453 he was adopted by Francesco Squarcione in Padua and became his pupil and closest colleague. After just two years he left his master over a dispute and went to Venice. From there he moved to Bologna, arriving no earlier than 1462. In 1471 he was again working in Venice, as an inscription on a Madonna painting now in Berlin, but originally from Pesaro, testifies. Zoppo, whose oeuvre stylistically belongs to the early Renaissance, painted both large altarpieces and small devotional paintings and portraits. He also left a sketchbook that was once attributed to Andrea Mantegna. Works by the artist include the *St. Clemente Altarpiece*, c. 1462, Chiesa di San Clemente del Collegio di Spagna, Bologna; *The Pesaro Altarpiece*, 1471, Gemäldegalerie, SMPK, Berlin; and *Two Angels Weeping Over the Dead Christ*, 1471, Museo Civico, Pesaro.

Virgin and Child with Angels Making Music, c. 1455
Tempera on wood, 88 x 72 cm
Musée du Louvre, Paris
On the *trompe-l'oeil* painted note at the lower edge of this painting is the inscription OPERA DEL ZOPPO DI SQUARCIONE ("Work of Zoppo di Squarcione"). Zoppo bore the name of his teacher and adoptive father until their relationship was legally annulled on October 9th, 1455. The Madonna picture in the Louvre, therefore, must have been done before this date. It is probably a work from Zoppo's early period in Padua, as can be seen in the elegant forms and the light, clear colors.

Zucchi, Jacopo

Jacopo Zucchi (c. 1541 Florence–c. 1590 Rome or Florence) first studied with Giorgio Vasari in Florence and in 1563 was accepted into the Florentine Academy. In Rome he acquired the favor of Cardinal Ferdinand de'Medici (1549–1606), for whom he first worked in the Palazzo Firenze in 1574/75. In 1581 Zucchi was accepted into the Accademia di San Luca in Rome. There, on commission from Orazio Rucellai, he painted important mythological frescoes in the Palazzo Rucellai-Ruspoli in 1588/89.

For Ferdinand de'Medici he created the frescoes in the *Sala delle carte geografiche* ("map room") in the Galleria degli Uffizi in Florence. Zucchi's significance in terms of art history is based mainly on his position as the intermediary between Florentine-Roman Mannerism and the Mannerism of the Dutch painters. Major works by the artist include *The Golden Age*, c. 1570, Galleria degli Uffizi, Florence; *Allegory of the Discovery of America (Coral Fishing)*, Galleria Borghese, Rome; and *Paradise*, Galleria Borghese, Rome.

Amor and Psyche, 1589
Oil on canvas, 173 x 130 cm
Galleria Borghese, Rome
The story of Amor and Psyche as related in Apuleius' *Metamorphoseon libri XI* was very popular, especially during the 16th and 17th centuries, because of its erotic element. The artificial poses of the two mythological figures, the contrasting areas of light and dark, and the primarily cold colors are all characteristic features of Zucchi's later creative period.

Zurbarán, Francisco de

Francisco de Zurbarán (1598 Fuente de Cantos–1664 Madrid) studied with Pedro Díaz de Villanueva in Seville from 1614 to 1617. In 1617 he settled in Llerena, but worked primarily for the monasteries in Seville. Zurbarán returned to Seville in 1629 and was awarded the honorary title of city painter. During the 1630s he was at the height of his career, and in 1634 was called by Philip IV (1605–1665) to the court in Madrid. In 1636 he returned to Seville in order to paint the important painting cycles for the Carthusians in Jerez de la Frontera (1636–1639), for the monastery in Guadalupe (1638/39) and for the Carthusians of Seville. Hoping for new commissions, he went to Madrid in 1658. Zubarán is considered one of the most prominent Spanish painters of the 17th century, together with Velázquez, Ribera and Murillo. Works by the artist include *Christ on the Cross*, 1627–1629, Museo Provincial de Bellas Artes, Seville; *The Death of St. Bonaventure*, 1629, Musée du Louvre, Paris; and *St. Lawrence*, 1636, The Hermitage, St. Petersburg.

Still Life with Oranges and Lemons, 1633
Oil on canvas, 60 x 107 cm
Fondazione Contini-Bonacossi, Florence
Among Zubarán's few still lifes, this example in Florence is the only one bearing a date and a signature. In its compositional structure and dark, earthy colors this work falls firmly in the tradition of Spanish still-life painting. Also characteristic is the uncluttered placement of the pictorial elements in an evenly-spaced row without any overlap. Zubarán's contrasting use of light and shadow reveals the substantial influence of Caravaggio's work.

The Immaculate Conception, c. 1630–1635
Oil on canvas, 139 x 104 cm
Museo del Prado, Madrid
Like Murillo, Zubarán painted the subject of the *immaculata conceptio* numerous times throughout his artistic career. Originally from the collection of the Margravine Puebla de Ovando in Seville, this exquisite painting, now in the Prado, depicts a quiet, introverted Virgin standing on a crescent moon. She is surrounded by items from the Loretan symbology, all of which represent her purity and virginity.

Portrait of Friar Hernando de Santiago, 1633
Oil on canvas, 204 x 122 cm
Academia de San Fernando, Madrid
This portrait is one of a group of ten life-sized portraits of monks that Zubarán painted for the library of the Convento de la Merced in Seville. Zubarán had composed a cycle of paintings with scenes from the life of St. Petrus Nolaskus for the same monastery in 1628/29. The monks seem like painted sculptures in their white robes, positioned in front of dark backgrounds. These portraits are typical of Zubarán's work in their realistic expressions and ascetic severity.

**The Defense of Cádiz
against the English, 1634**
Oil on canvas, 302 x 323 cm
Museo del Prado, Madrid
Zubarán painted 12 works for the Duke of Olivares (1587–1645) for the Salón de Reinos, the reception hall of the royal palace Buen Retiro in Madrid, where Velázquez' famous painting *The Surrender of Breda* also hung. In the painting shown below, Zubarán has depicted the landing of Lord Wimbledon with 8,000 English mercenaries near Cádiz in 1625. The city was defended by only 600 men under the leadership of their garrison commander, Fernando Girón y Ponce de León, who had to direct the battle from a chair because of his gout-related symptoms.

Opposite
**Christ on the Cross
with St. Luke, c. 1635–1640**
Oil on canvas, 105 x 84 cm
Museo del Prado, Madrid
Zubarán most likely painted this
work, which is unusual both in
form and content, for himself rather
than for a specific patron. This is the
first time in the history of art that St.
Luke appears at the Crucifixion. He
is the patron saint of painters and,
according to legend, painted a
portrait of Mary with the Christ
Child. Some have maintained that
St. Luke is Zubarán's self-portrait,
but this seems unlikely, as the
features of the saint bear little
resemblance to those of Zubarán.

**St. Elisabeth of Portugal
(St. Casilda of Toledo), c. 1640**
Oil on canvas, 184 x 90 cm
Museo del Prado, Madrid
Nothing definite is known about
either the original purpose of this
picture or its history. It was first
cited in 1814 in an inventory of the
royal palace in Madrid. Because of
the rose in her hands, the woman
was identified as the charitable St.
Casilda of Toledo, who was said to
have transformed food into roses.
The same miracle was, however,
also attributed to St. Elisabeth of
Portugal. Zubarán portrays the
saint as dressed in the costly fashion
that was worn in his day at the
Spanish court.

When Art Became Public ...

In 1750 the citizens of Paris were granted permission to visit the royal art collections, which were in part housed in the Palais du Luxembourg, on two days each week. This was remarkable, since it was customary for the large collections of art at European courts not to be open to the general public: Only invited guests, scholars and some well-connected artists had the privilege of visiting the galleries. Even in France, the situation only changed after the outbreak of the Revolution and the overthrow of the monarch, when the new French government declared the royal art treasures national property.

In 1793, the Louvre, formerly the city palace of the regent, was opened as a museum. With this, France became part of a pan-European movement. In 1739 the Grand Duchess Anna Maria Ludovica (1667–1743), the last regent of the Medici, had given the priceless collection of art accrued by her family over many generations, located in the Uffizi, to her native city of Florence "for the enhancement of the state and for public use." The first museum to be founded by the state

Karl Friedrich Schinkel: Altes Museum (The Old Museum), Berlin, 1823–1830
Photograph of the façade of the Monument to Friedrich Wilhelm III, about 1930
This structure is characterized by its harmonious proportions: Built in the neoclassical style, 18 Ionic columns support the entrance hall.

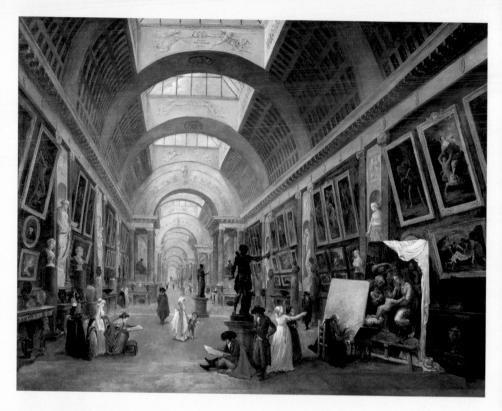

was the British Museum in London in 1753, while the first building to be erected specifically to house an art collection was the Museum Fridericianum in Kassel, Germany in 1779. This separate museum building made it clear that art, as collective property, requires its own suitable identity architecturally. As a result, many neoclassical temples of art arose whose designs were based on the principles of ancient Greek architecture in order to give physical expression to the immortality of the artistic spirit housed within them. This is true of the temple-like structure of the Fridericianum in Kassel as well as of the Altes Museum in Berlin built by Karl Friedrich Schinkel (1781–1841) in 1823–1830, the National Gallery in London, which opened its doors to the public in 1824, as well as numerous other institutions throughout Europe.

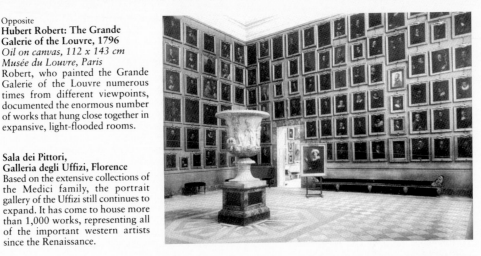

Opposite
Hubert Robert: The Grande Galerie of the Louvre, 1796
Oil on canvas, 112 x 143 cm
Musée du Louvre, Paris
Robert, who painted the Grande Galerie of the Louvre numerous times from different viewpoints, documented the enormous number of works that hung close together in expansive, light-flooded rooms.

Sala dei Pittori,
Galleria degli Uffizi, Florence
Based on the extensive collections of the Medici family, the portrait gallery of the Uffizi still continues to expand. It has come to house more than 1,000 works, representing all of the important western artists since the Renaissance.

At the outset of this movement, museums and art collections were expressly intended to provide the public with an education in artistic traditions, and had a high didactic, even moral, purpose. At the time it was not considered important to have priceless original works of art executed by famous artists. Rather, museums tried to offer visitors an overall view of the history of art through copies of famous paintings. In Paris and Berlin, public collections of copies similar to that of the Schack Galerie in Munich, which was private, were planned. These projects were abandoned in both cities as being too expensive to fully realize. In Paris, the *Musée des Copies* ("Museum of Copies"), initiated by Charles Blanc, founder of the *Gazette des Beaux-Arts*, was not opened to the public until April, 1873.

Many different organizational models for the presentation of pictures existed in the art galleries of the 19th century. In some, the pictures were arranged according to schools or artistic circles, as is customary in most museums today. On the other hand, other collections were arranged thematically. One wall of the entrance hall of the Galleria degli Uffizi in Florence, for example, has been densely filled with portraits since 1753. In some cases paintings were simply organized according to the size of the canvas or hung where space was available when they were acquired by the museum. Today, the sheer quantity of pictures exhibited in many European galleries often seems overwhelming and illogical. In most of the large art galleries of Europe, such as the Galleria degli Uffizi in Florence as well as in The Hermitage in St. Petersburg and the Musée du Louvre in Paris, the paintings were hung in several closely-spaced rows reaching all the way to the ceiling well into the 20th century.

GLOSSARY

Académie Royale des Peintures et Sculpture (French, "Royal Academy of Painting and Sculpture") The primary French academy, founded by King Louis XIV in 1648. It became extremely powerful and exerted great influence on the practice and the aesthetics of art.

Academy (Latin *academia*; Greek *akademia*) An institution or society to further artistic or scientific training and studies. The first important academies arose during the Renaissance in Italy and were modeled on the schools of antiquity. As a consequence of Absolutism, the concept of the academy spread throughout Europe. The term was probably derived from a grove near Athens suitable for gymnastic exercises, consecrated to the Attic hero Akademos. Plato then named the school of philosophy that he founded in 387 B.C. after his favorite place.

Accademia di San Luca The most important Italian academy (see above), founded in Rome in 1593. Members included leading Italian artists as well as influential foreign artists.

Adoration of the Lamb see Apocalyptic Lamb.

Air perspective (Middle Latin *perspectiva (ars)*, "(art) looking through") A method of painting that allows the depicted images to become spatially more imprecise. Its basic principle rests on the observation that with increasing distance, all colors become more blue-green in hue. As seen diffused through the atmosphere, colors become lighter and more colorless towards the horizon, while at the same time objects grow less distinct. The air perspective is a special form of color perspective.

Al fresco (Italian, "on the fresh") see Fresco painting.

Allegory (Greek *allegoria*; allegorize, "to picture differently") An illustration of abstract concepts and ideas by means of a pictorial representation, usually in the form of a person or a well-known story or situation.

All Saints picture, or a depiction of the Adoration of the Lamb. The Lamb, one of the symbols of Christ, is shown being worshipped by ranks of saints, surrounded by the Patriarchs and Prophets as well as by representatives of all the tribes, nations and languages. This pictorial type is based on specific passages from Revelations, the last book of the New Testament, as well as popular images of All Saints' Day (November 1st), which was instituted by Pope Gregory IV (died 844) and Emperor Louis the Pious (778–840) in the 9th century.

Al secco (Italian, "on the dry") see Secco painting.

Altar panel (Latin *altare*, "sacrificial table" and *tabula*, "board") see Altarpiece.

Altarpiece (Latin *altare*, "sacrificial table"), also altar panel. A sculpture, carving or painted artwork that adorned the altar of a church during the Middle Ages. Early altars were primarily adorned with goldwork or sculpted figures, and only later did painted pictures become commonplace. Painted altarpieces may consist of a single picture or numerous panels. They often rise high behind the altar or are mounted onto the back of the altar (altar retable).

Altar retable (French *retable*; Latin *altare*, "sacrificial table" and *retabulum*, "back wall"), also called a retable. A decorated raised shelf, or the rear wall of the altar that is firmly attached to the altar table, and adorned with paintings or sculptures.

Amor see Cupid.

Amorettos (Italian *amoretto*; diminutive of *amore*, "love;" singular *amoretto*) Small, winged boys used as love-gods in worldly scenes, also called putti. The form is patterned on Amor, the Roman god of love.

Anamorphosis (Greek *anamorphosis*, "distortion, new formation") A method of representation used in the 16th century, especially in painting and graphic arts, by which a figure or an object is projected at a certain angle onto the surface to be painted. The resulting optical distortion becomes "normal" when viewed from an angle.

Anatomy (Greek *anatemnein*, "cut open, cut apart") Medically speaking, knowledge of the structure of the human body gained primarily by means of dissection. In art, anatomical depictions are based on exact studies of nature and the nude human figure as well as on a profound understanding of the bodily elements underlying the external form. Renaissance artists developed a great scientific interest in anatomically accurate proportioning of the human body.

Androgyny (Greek *androgynos*, genitive for *aner*, "man" and *gyne*, "woman") A hermaphrodite, or a physical and spiritual conflation of the male and female genders.

Annunciation The moment in which, according to the Gospel of Luke (1:26–38), the Archangel Gabriel announced to Mary that she would bear the Son of God. This was one of the most popular artistic themes during the Middle Ages and the Renaissance.

Antiquity (French *antique*, "old-fashioned;" Latin *antiquus*, "old") This term refers to the Greco-Roman Classical period that served as inspiration for the Renaissance and neoclassicism. It began with early Greek immigrations in the 2nd

century B.C., and ended in the Western Empire in 476 A.D. with the overthrow of the Roman emperor Romulus Augustulus (about 475 A.D.). In the Eastern Empire it ended in 529 A.D., when the Emperor Justinian (482–565 A.D.) closed the Platonic Academy.

Apelles (about 330 B.C.) A Greek painter. Although some of his pictorial compositions were only preserved through literary descriptions, Renaissance painters sometimes attempted to reproduce them.

Aphrodite see Venus.

Apocalypse (Greek *apokalyptein*, "uncover," "reveal") The approaching end of the world and the descriptions of its defining events as found, for example, in Revelation to John, the last book of the New Testament.

Apocalypse of John (Greek *apokalyptein*, "uncover," "reveal") see Revelation to John.

Apocalyptic Lamb (Greek *apokalyptein*, "uncover," "reveal") The Lamb with seven eyes and seven horns in the Revelation to John (5:6), in which the end of the world and the return of Christ are described (see above). The lamb has been a Christian symbol for Jesus since the 2nd century. In visual depictions, the Apocalyptic Lamb rarely has more than two eyes and horns. The Adoration of the Lamb is a common motif of the Apocalypse, but different types of representation arose: The Lamb, appearing in a mandorla, is usually surrounded by the four symbols of the Evangelists and by the 24 Eldest or a large crowd of people. In late medieval scenes, the Lamb usually sits at the feet of an enthroned God or Christ. It is also portrayed among the choirs of the Elect on Mount Zion, from which the four rivers of Paradise flow.

Apocalyptic Rider (Greek *apokalyptein*, "uncover," "reveal") One of the four Riders in the

Revelation to John (6:2–8; see below). The Riders embody the misfortunes bearing down on humanity, including plague, war, starvation and death. Their attributes are the bow, the sword and the scales of judgement. In some images, the First Horseman of the Apocalypse has a halo and is identifiable with Christ. His horse is white, while the horses of the other riders are red, black and brown.

Apocrypha (Greek *apokryphos*, "conceal" or "to push underneath") Additional early Jewish or Christian writings that are not generally accepted as belonging to the canon of either the Old or the New Testament of the Bible; usually they are appended onto the Bible.

Apollo A Greco-Roman god, son of Jupiter and Latona, and twin brother of Diana. He is, among other things, the god of prophecy, music and the arts, as well as the lord of the muses (*Apollo Musagetes*) and of light and the sun (*Phoebus Apollo*). In antiquity he was considered to be the embodiment of Ideal Beauty.

Apostle (Greek *apostolos*, "messenger," "forefighter") One of Jesus' original twelve disciples. They were selected by Jesus out of the large crowd of his followers to continue his work and spread his teachings.

Apotheosis (Greek *apotheoun*, "deify," "transfigure") Deification; the depiction of an earthly being as divine.

Apse (Latin; Greek *hapsis*, "connection, curve, or vault") A niche in a church in which an altar can be placed, built over a semi-circular or polygonal base and vaulted.

Aquarelle painting see Watercolor painting.

Arabesque (French *arabesque*; Italian *arabesco*, "Arabic") Originally a classical ornamental motif of stylized leaves and vines, often including heads, masks or figures, revived during the Italian Renaissance.

Arcadia The shepherds' idyll in Greece. In pastoral poetry Arcadia is usually described with yearning as an idealized, beautiful place in which a natural way of life is possible.

Ars moriendi (Latin, "the art of dying piously") An edifying tract on death written in the late Middle Ages, describing the battle between Heaven and Hell for the soul of the dying person and admonishing Christians on proper conduct in their hour of death.

Artes liberales (Latin) The free or liberal arts. In antiquity this was the sum of knowledge a free man (as opposed to a slave) should possess. Seven liberal arts were enumerated as essential well into the Middle Ages, and the description of the different attributes of their female personifications was a popular subject for artistic representation: Grammar—rod, Rhetoric—slate and pencil, Dialectic—wild hair, scorpion or snake, Arithmetic—abacus, Geometry—pair of compasses, Music—musical instruments, Astrology—astrolabe.

Assistant figure (Latin *assistere*, "to also stand") A subordinate figure in a composition, watching the event but not necessary to its unfolding, usually seen in pictures with religious content.

Attribute (Latin *attributum*, "the added") An object given to a person in order to identify them; a symbol characterizing a person, usually in relation to an important event in their life.

Augustinians see Order of Saint Augustine.

Aureole (Latin *aureolus*, "golden, beautiful, or sweet") A halo or radiating circle of light surrounding an entire person. See also Gloria.

Bacchanal (Latin *Bacchus*, the Roman god of wine) A feast honoring Bacchus. See also Dionysus.

Bacino di San Marco (Italian, "Saint Mark's Harbor") The bay bordering the center of the city of Venice; the Piazzetta with the Doge's Palace is located on the bay, and the Grand Canal flows into it.

Baldachin (Italian *baldacchino*), a roof of cloth over a throne or a bed; also the portable heaven held up by poles and carried in processions. The term is derived from the costly silk cloth, interwoven with gold threads, that came from Baghdad (Italian *Baldacco*).

Bamboccianti (Italian *bamboccio*, "simpleton or clumsy fellow") Term for a group of Dutch painters working in Italy in the 17th century who became famous for their coarsely realistic scenes of everyday life (Italian *bambocciati*; German *Bambocciade*). The label was derived from a derisive nickname for their founder, Pieter van Laer (1599–1642).

Banketje (Dutch, "snack," "brunch" or "in-between meal") also *Ontbijtje* (Dutch "breakfast") Dutch term for the breakfast piece, a special form of still life that was developed in the Netherlands during the 17th century. In such pictures is a table, laid for breakfast, with a small selection of food and dishware.

Baroque (Portuguese *barocco*, "pebble, crooked-round") A European artistic epoch between the end of Mannerism, about 1590, and the beginning of Rococo, about 1725, which is not characterized by a unified style. In painting divergent movements—both a neoclassical-idealistic trend, mainly seen in Italy, and a realistic trend that represented temporal and spiritual areas of life—can be traced. The means of representation varied from absolute artificiality to deceptive perceptions, to exaggerated Naturalism. Characteristic features are idealization, idolization and exhibitionism. Allegories, genre scenes and landscapes were painted during this period, in addition to religious and mythological subjects. The term Baroque originally came from the craft of goldsmithing, in which "barocco" meant an irregular pearl.

Begging order, also mendicants (Latin *mendicare*, "to beg") An ascetic way of life. From the 13th century on these religious orders, whose members renounced all material possessions, gained in influence and counteracted the increasing secularization of the Church. Mendicants were dedicated to providing spiritual guidance, teaching and missionary work. Franciscans, Capuchins, Dominicans, Augustinians and Carmelites are mendicant orders.

Bishop (Greek *episkopos*, "overseer") High spiritual official. In early Christianity the bishop was the head of a community; later, as the earthly successor to the Apostles, he was the head of a bishopric, a diocese or a parish. A bishop's authority includes those of the priesthood, teaching and pastoral duties. Bishops are distinguished by the mitre (bishop's hat), the shepherds' staff and the bishop's ring.

Bohemian (French *bohème*, "artistic world;" Bohemian *Böhme*, "Gypsy") The non-bourgeois world; a nonconventional life led by people relatively free of obligations, for example, artists and students, often perceived by others to be free of constrictions, even irresponsible.

Breve (Latin *brevis*, "short") A short papal decree.

Brotherhood Catholic societies which met for communal prayer in the early Middle Ages. At first they consisted only of monks and other clergy; later laymen were also included. Their goal was to support piety and further love of one's neighbor.

Book illumination, also illuminated manuscripts or miniature painting (Latin *miniatura*; *miniatus* past participle of *miniare*, "to color with red lead"). The depictions of images and other decorations meant to adorn or clarify a written text or book. They are either an integrated part of the text itself, or can appear on a separate page. Miniatures reached their highest development on parchment during the Byzantine and medieval periods in Europe.

Book of Hours, also (French) *Livre d'heures*. A prayer book for laity with texts for each hour of the day. During the Middle Ages and Renaissance, these books were often illuminated with magnificent miniatures. The calendar preceding the texts illustrated typical activities pertaining to the months of the year and the cosmology of the heavens, and was often especially luxurious and beautiful.

Bucintoro The splendid galley of the Venetian Doge, rowed by 200 men. Each year, at the Feast of the Ascension, the Doge rode onto the open ocean in this galley in order to throw a ring into the water, symbolizing the marriage of Venice to the sea.

Bull (Latin *bulla*, "capsule") Originally a special form of a metal seal; today, a Papal letter displaying a lead seal.

Bust (French *buste*, "breast picture") A sculpture resting on a base that shows the upper torso, breast, shoulders, neck and head of a person. The term is also extended to portrait painting.

Byzantine art Art emerging from late antiquity and formed by Orthodox Christianity in the realm of influence of the Byzantine Empire, with its capital in Constantinople (formerly Byzantium, and today Istanbul), from about 330 A.D. to 1453. Characteristic features are a solemn, festive immobility and an other-worldly loftiness of representation resulting from strict adherence to artistic and theological rules and models. Despite the plethora of guidelines, more naturalistic trends eventually emerged in Byzantine artwork, especially in its later manifestations. Because it was so diverse and far-reaching, Byzantine art has continued to provide western art with new impulses and inspiration.

Cabinet picture (French *cabinet*, "cabinet, closet" or "gallery") also showpiece. A painting which was especially suited for display in a private showcase (cabinet) because of its subject matter, its small format, and its handiness. These pictures emerged in the course of the 15th century as a result of the growth of private art collections.

Calvary (Latin *calvaria*, "skull") The hill outside Jerusalem where the bones and skulls of criminals were deposited; the Biblical Golgotha; and in paintings, the depiction of the site of Christ's crucifixion along with many figures.

Camaldolese Benedictines A hermit order founded in 1012 by Saint Romuald of Ravenna (952–1027) in Camoldoli near Arezzo in Tuscany.

Camera obscura (Latin, "dark room") A forerunner of the camera consisting of a portable box with an aperture—in early versions merely a hole—instead of a lens or a mirror. It assisted landscape painters, architectural and veduta painters in drawing their perspective constructions. The rays of light reflected from external objects were channeled through the tiny hole into the dark box, forming a smaller replica of those objects on the opposite side, albeit in mirror image and upside-down.

Campo (Italian, "field") A Venetian term for a square within the city, usually consisting of the courtyard of a church or a small space between palazzi which, as a rule, has an opening onto the canal on one side.

Candelabra (French *canélavre*; Latin *candela*, "candle") An elaborate, branched candlestick or lamp holder, often adorned with many decorative ornaments.

Capriccio (Italian, "mood") Term for all kinds of imaginative depictions which are usually placed together arbitrarily according to subject. The "Caprichos" of Francisco de Goya (1746–1828) are the most important, along with the pictures of Giuseppe Arcimboldo (c. 1527–1593).

Caravaggisti Term for painters who were greatly influenced by the style of Michelangelo da Caravaggio (1571–1610). Characteristic of his work are strong lighting contrasts, in particular that of well-lit figures against dark backgrounds, used for dramatic effect. See also Chiaroscuro.

Cardinal virtues (Late Latin *cardinalis*, "of a hinge") The four basic virtues which Christian ethics adopted from Plato (427–347 B.C.): *Temperantia* (moderation, level-headedness), *Fortitudo* (courage, fortitude), *Prudentia* (cleverness, wisdom), and *Justitia* (justice). Pope Gregory the Great (540–604 A.D.) expanded this list of virtues with the addition of three Godly, or theological, virtues: *Fides* (faith), *Caritas* (love) and *Spes* (hope). In the High Middle Ages there were therefore seven cardinal virtues.

Carmelites (Latin *Ordo Fratrum Beatae Mariae Virgilis de Monte Carmelo*, "Order of Friars of Our Lady of Mount Carmel") A mendicant order founded in 1247 whose members devote themselves to the contemplative life, including scholarship and spiritual guidance. This order emerged from a hermit community at Mount Carmel near Haifa, Israel.

Carthusian Order (Latin *Ordo Cartusiensis*) The Roman Catholic hermit order founded by Bruno of Cologne (1032–1101) in Grande Chartreuse near Grenoble in 1084. The order combines a reclusive life with a communal one. The monks live in individual cells, but gather together in church to worship. During the 14th and 15th centuries, new monasteries were founded that were influenced by late medieval mysticism, the *devotio moderna* (new piety), and by humanism.

Cartoon (French *carton*, "cardboard;" Italian *cartone*, "large paper;" Latin *charta*, "paper") A design drawn with coal, chalk or pencil on a stiff sheet of paper to the actual scale of the mural, mosaic, glass paintings or tapestry to be made according to that design.

Cathedral (German *Dom* from Latin *domus Dei*, "House of God") A bishop's church and official seat of a diocese; sometimes more generally used to refer to a minster, or the most outstanding church in a city.

Catholic Reformation A term from Church history applied to the movement to renew the entire Church structure, something that large circles of clergy felt to be inevitable, in the late Middle Ages. Proposals for reforms such as those made at the Council of Constance (1414–1418), the Council of Basel (1431–1437 and 1448), and the Fifth Lateran Council (1512–1517), did not lead to permanent, sustained results. Finally, the Protestant Reformation forced the Pope and the Roman Curia to take strong measures against corrupt internal practices such as abuse of office, moral laxity, selling indulgences, excesses in the acquisition and worship of relics. Pope Paul III (1534–1549) convened the Council of Trent in 1544 with his bull called the *Laetare Jerusalem*. The council met for three separate periods between 1545 and 1563 in order to focus on internal Church reforms. Whereas the term "Catholic Reform" refers primarily to an internal process of renewal which continued beyond the Reformation into the 17th century, Leopold von Ranke (died 1886) coined the term "Counter-Reformation" to refer to the steps taken by

the Roman Catholic Church to force adherence to Catholicism, done specifically to stop the growing Protestant movement. The Religious Peace of Augsburg (1555) demanded that Catholic rulers enforce the Catholic faith in their districts and justified the measures they undertook, at times drastic, to ensure the Counter-Reformation. This effort was not limited to Germany, of course, but spread especially to France, England and the Spanish Netherlands in the mid-16th century.

Centaur (Greek *kenauros*; plural centaurs) Greek mythological beings which are human from the waist up but have the four-footed body of a horse; a satyr, on the other hand, has the hoofs of a goat or ram.

Centralized composition (Latin *centralis*, "[lying] in the center" and *compositio*, "composition") A painting in which all the pictorial elements direct the viewer's attention to the central event, which is portrayed in the middle of the canvas.

Centralized perspective (Latin *centralis*, "[lying] in the center " and Middle Latin, *perspectiva [ars]*, "[art] looking through") Developed by Filippo Brunelleschi (1376–1446) at the beginning of the 15th century, this is a scientific-mathematical method of depicting perspective. For the viewer, all lines lead into the picture and meet at a central vanishing point. By foreshortening and proportioning all the figures, buildings, objects and the countryside accordingly, a two-dimensional surface can be given the illusion of three-dimensionality.

Chapel (Middle Latin *cap(p)ella*, "small cloak") The name given to a small cult area separated from the main nave of a church. The term is derived from a small prayer room in the royal castle in Paris in which the cloak of Saint Martin of Tours (316/17–397) has been housed since the 7th century A.D.

Charon (Greek) In Greek mythology, Charon is the ferryman who transports the souls of the dead across the river Styx to the underworld.

Cherubim (Hebrew; singular *cherub*) In the hierarchy of angels, cherubim and seraphim are on the highest level and as choirs they belong to God's court, usually surrounding his throne. In the New Testament, they form the honor guard of Christ. In Christian art, two types of cherubim are distinguished. The tetramorph has either two or four heads—human, lion, steer and eagle—as well as four wings set with eyes. The cherubangel, on the other hand, has one human face and four wings with eyes. Both types are often depicted with six wings, however, making them indistinguishable from the seraphim. Cherubim originated in ancient Oriental imaginary as winged animals with human faces.

Chiaroscuro painting (Italian, "light-dark") In this method of depiction, light and dark effects are contrasted often for the sake of drama or to make a scene appear more sculpted and vivid. This technique reached its peak of expression in the paintings of Caravaggio.

Choir (Latin *chorus* and Greek *choros*, "ring dance," "dance and singing group") Usually an elevated, separate area in the interior of a church that is reserved for the choir or for communal prayer of the clergy.

Church Fathers (Latin *patres ecclesiae*) Church teachers and important theologians of the early Christian era whose authority was officially acknowledged by the popes. The four Fathers of the Roman Catholic Church are St. Ambrose (c. 340–397), St. Augustine (c. 354–430), St. Jerome (c. 340/347–420) and Pope Gregory the Great (c. 540–604). Since the 8th century they have been associated with the four Evangelists and their symbols (Matthew—man or angel, Mark—lion, Luke—bull, and John—eagle).

Cinquecento (Italian, "five hundred") Italian term for the 16th century.

Classicism see Neoclassicism.

Collegio dei pittori (Italian, "college of painters") The professional association of painters in Venice, approved by the senate instead of an Academy. The Collegio continued to exist even after the founding of the Academy in 1754. It was disbanded in 1797 by Napoleon's troops.

Color perspective (Middle Latin *perspectiva* [*ars*], "[art] looking through") The optical depth of a painting produced through the use of color. In this technique, more distant objects were painted less intensely in blues and greens, while objects closer to the foreground were red, orange and yellow.

Coloration (Italin *colorito*, "coloring;" Latin, *color*) The choice and use of color for a statue or painting and its atmospheric or emotional effect.

Commedia dell'arte (Italian) Italian comic theater of the 16th to 18th centuries. These comedies had only one written sequence of scenes, which meant that the actors had to improvise to create the action of the play. The main characters embodied comic types, always appearing in the same mask and costume; the most common type was the Harlequin. At the time the term meant "professional theater."

Complementary colors (French *complémentaire*, "completing;" Latin *complementum*, "means of completing, filling") Colors that are opposite or in contrast to each other. On a color wheel (wherein the primary colors of red, yellow and blue are arranged in a circle with their mixtures in between), complementary colors appear across the circle from each other. According to the proportions in which the colors are combined, they become either white or almost black, as for example in red-green, yellow-violet, or blue-orange. The effects obtained by considered use of these color pairs are decisive in determining the tone of paintings.

Concetto (Italian, "concept") The artists's plan for the content of a painting or other work of art.

Condottiere (Italian, "leader") Commander of an army or of mercenaries in Italy during the 14th and 15th centuries.

Contrapposto (Latin *contrapositus*, "placed opposite;" *ponere* "place or put") A bodily posture developed by the classical Greek sculptor Polyclitus (about 460–415 B.C.) that became the principle on which later European sculpture (particularly of the Renaissance) was based. In this posture the weight of the body is supported by one leg while the other leg poses freely: In this way the different directions of movement and centers of balance could be made more aesthetically pleasing.

Conversation piece (Latin *conversatio*, "contact, company"), also known as a society piece. A category of genre painting in which the social and leisure pastimes of the aristocracy and the upper bourgeoisie are depicted, for example, listening to musical performances, attending festivals, or playing games. This type of painting originated in the Netherlands and was especially popular in the 17th century.

Council (Latin *concilium*, "meeting") Assembly of high Church officials, especially of bishops.

Counterfeit (French *contrefait*, "copied;" Latin *contrafacere*, "to copy") see Portrait.

Copper engraving (Late Latin, *cuprum*; Latin *aes cyprium*, "Iron from Cyprus") The oldest method of making prints on a plate by using a burin (sharp drawing tool). The lines cut by the

burin into the copper plate are filled with ink and appear in the print. Originally a term for all prints done by hand.

Courtesan (French *courtisan* and Italian *cortigiano*, "someone at court;" Italian *corte*, "court") Can refer to a lady-in-waiting, the paramour of a nobleman, or an elegant prostitute.

Craquelure (French, "cracking") Term for the network of fine cracks that develop over time in the protective coating (generally a varnish), color and undercoatings of oil paintings due to aging. It is caused by the complete hardening of the coats of paint and varnish, resulting in a loss of elasticity in the different layers. These can then no longer follow the support (the canvas or the wooden panel) as it continues to expand and contract with changes in humidity over the course of decades.

Crucifix (Latin *cruci*, "cross" and *fixus*, "attached"), also crucifixion. In the arts, the term crucifix refers to the motif of an isolated depiction of Christ on the cross without scenic embellishments or sub-figures.

Cupid (Latin) Another name for Amor, the Roman god of love. The son of Venus, the goddess of love (called Aphrodite in Greek mythology), and the war god, Mars, he is depicted as a winged boy with bow and arrow.

Cupids (Greek *eros*, "love, god of love") Playful, usually winged boys who, like the god Cupid, are the companions and sons of Aphrodite, the mythological Greek goddess of love. In Renaissance, Baroque and Rococo art, they are called amoretti, genii, or putti (see below).

Cycle (Late Latin *cyclus* and Greek *kyklos*, "circle") In the fine arts, a closed or completed set of works that belong together because of their form and content.

Dedication picture (Latin *dedicatio*, "consecration" or "dedication") A picture featuring as its main subject the festive presentation of an architectural model, a work of art or a book to one or more donors or patrons.

Deesis (Greek, "plea") A picture type showing Christ enthroned as the ruler and judge of the world, generally placed between the Virgin Mary and John the Baptist, both of whom are interceding on behalf of humankind.

Devotional picture Usually a small image belonging to an individual or a community for the purpose of enriching worship and prayer.

Dionysus, also Bacchus in Latin mythology. The Greek god of wine and of all-creating Nature. He is the son of Zeus and Semele, and the husband of Ariadne.

Diptych (Latin *diptychum*; Greek *diptychos*, "doubly folded") In antiquity, a hinged writing tablet; in the Middle Ages, a two-winged, collapsible altar painting without a central panel to balance the wings.

Doge (Italian; Latin *dux*, "leader") Title given to the city official wielding the highest executive power in Venice (697 A.D.–1797) and Genoa (1339–1797).

Dom see Cathedral.

Donor (Latin, "the giver of a present"), also patron. Someone who commissions a painting for a church or, less often, for another institution. As a sign of their piety, donors often had themselves painted into the work in the form of a portrait.

Dominican Order see Order of Dominic.

Ductus (Latin *ductus*, past participle of *ducere* "to lead") In painting, this is the "handwriting" of

the artist that remains visible in the structure of the painting in the traces left when applying and lifting the brush or palette knife.

Duomo (Italian, "dome") see Cathedral.

Ecce Homo (Latin, "Behold the man!") The words with which Pontius Pilate identified Christ in order to appeal to the compassion of the people (John 19:4–15). In art history this is the usual term for the depiction of Christ bound, beaten and wearing the crown of thorns. The public exhibition of Jesus in this condition was a common subject during the Middle Ages.

École des Beaux-Arts (French, "School of the Fine Arts") An academy of art.

Eclecticism (Greek *eklegin*, "select") In the fine arts and architecture, usually a pejorative term indicating that an artist has adopted forms, motifs or techniques already seen in earlier works. It generally is meant to imply a lack of creativity and imagination on the part of the artist.

Emblem (Greek *emblema*, "inlaid work") A symbol, device or figure that is adopted by an artist and used as an identifying mark.

En face (French, "facing, opposite") In portraiture, a full frontal view of the face or head.

Ensemble (French, "together, community") In the fine arts, this term is applied to an entire group of related works of art that may be of different types and techniques, but nonetheless belong together, for example in the interior of a chapel.

Epigram (Old Greek *epigramma*) The poetic inscription on a work of art, a tombstone or a consecrated offering.

Epiphany (Greek *epiphaneia*, "appearance") In antiquity, a god who has become visible to mortals.

The Christian holiday of Epiphany, or "The Appearance of the Lord," is the Feast of the Magi, celebrated on January 6th.

Epitaph (Greek *epistaphion*) A funerary inscription, the inscription on a commemorative tablet or plaque in a church, or words spoken at a funeral for the deceased.

Este One of the oldest aristocratic families of Italy (972–1803 A.D.) seated in Ferrara, Modena and Reggio. Isabella d'Este (1474–1539) of Naples, who from 1494 on became the Margravine of Mantua, was probably the first large-scale female art collector.

Etching (from Latin *radere*, "scrape, scratch") A type of copper engraving that originated in Augsburg, in the works of Daniel Hopfer. To make an etching, a design is drawn with an etching needle onto a carefully polished copper plate that has been covered with an acid-resistant coating. After the drawing is complete, the plate is put into an acid solution; the acid reacts and removes metal from the untreated surfaces on the copper plate to produce the lines that form the drawing. The etched indentations are inked and a paper is printed. In comparison to the linear, even flow of a copper engraving, etching is freer, allowing for a wider variety of shading and a more paint-like effect.

Eucharist (Greek *eu* "good" and *charis* "thanks") Giving thanks; the sacrament pertaining to the Last Supper, celebrated with bread and wine; and the climax of a Catholic mass.

Europa Daughter of the Phoenician King Agenor and Telephassa in Greek mythology. While playing at the seashore, Europa was abducted by Zeus, who had taken on the form of a white bull, and taken to Crete. This is the origin of the name of the continent (actually unknown in antiquity). According to the antique view, this

continent was bordered to the west by the Atlantic Ocean, to the east by Ephesus, and on the south by the Mediterranean.

Evangelists, symbols of (Greek *euggelistes*; Latin *evangelista*) The winged beings (tetramorphs) attributed to or symbolizing the four authors of the Gospels: Matthew—man or angel, Mark—lion, Luke—bull and John—eagle. These also represent Christ, who embodied the unity of the Gospels in his person. The symbols of the Evangelists derive from the Prophet Ezekiel in the Old Testament (1:4 ff.) and from the book of Revelation (4:6 ff).

Ex voto (Latin, "from an oath") An endowment or gift resulting from an oath or promise.

Faun (Latin *faunus*) Roman god of nature, god of animal and plant fertility, and protector of shepherds. Fauns are often depicted as a group of hoofed, horned, lecherous wood spirits, corresponding to Greek satyrs. In Greek mythology, he is equated with the god Pan.

Fêtes-galantes (French, "courtly feast") A genre of 18th-century French painting that depicts courtly festivities. Jean-Antoine Watteau (1684–1721) was a master of *fêtes-galantes*.

Figura serpentinata (Italian, "winding, serpentine figure") A twisted, involuted figure or group of figures that spiral upwards. The *figura serpentina* allowed Mannerist artists of the 16th century to closely approximate the ideal of a sculpture that provided an equally beautiful view from all sides.

Five senses: seeing, hearing, smelling, tasting, and feeling. These are often represented in Dutch painting at the end of the 16th century and into the middle of the 17th century. At first they appear as personifications, then as exemplary activities in realistic depictions of ordinary life. For example, ladies in front of a mirror denote seeing; farmers smoking, taste; musicians, hearing. Even in still lifes there are frequent references to the senses, for example, abundant bouquets of flowers that allude to the sense of smell.

Folio (Latin *folium*, "leaf") A book produced in a large format.

Fountain of life (Latin *fons vitae*), also fountain of heaven or fountain of grace. In Christian iconography, the fountain is a symbol for the resurrection of the soul in Heaven through baptism (water) and salvation (blood of the Eucharist). In Pentecostal paintings, the flowing fountain of life also represents the Holy Spirit. It is alternatively depicted as a spring, an architecturally structured well, or a vessel from which animals drink.

Franciscans see Order of Saint Francis.

Fresco painting (Italian *fresco*, "fresh;" *al fresco*) A technique of mural painting in which the colors are applied to freshly laid wet plaster. Because plaster dries quickly, only as much of the wall can be coated with plaster as the artist can paint that day. In comparison to paint applied to a dry surface, frescoes are extremely durable under stable climatic conditions.

Fugger A Swabian family of merchants, bankers, art patrons and collectors, seated in Augsburg from 1367 onward. As they were successful in trade and business and wielded far-reaching political power, members of this family were active in commissioning important works of art and architecture.

Genius (Latin; plural, *genii*) In Roman times, the invisible protective spirit of an individual or of a place. Since antiquity, this minor divinity has been personified in works of art as a winged, usually child-like figure.

Genre painting (French, "kind") Painting which depicts typical scenes and events from ordinary daily life, of a certain profession, or of a social class. Such works are also called "paintings of life and customs." Genre painting reached a high point in its development in 16th-century Dutch art, and even more so in the 17th century when new genre subjects developed, for example, the soldier picture or the conversation piece. During the 18th century, courtly genre paintings arose that depicted pastoral idylls, *fêtes-galantes* (see above), and playful country scenes. The addition of satire and sentiment brought about a renewal of genre painting at this time. In the 19th century, paintings of laborers and farmers again widened the meaning and content of genre paintings.

Gilded surface A surface for painting that has been covered beforehand either partly or entirely with gold leaf.

Glaze painting (Middle Latin *lazur(i)um*, "blue-stone, blue color;" Arabic *lazaward*, "glaze stone, glaze color") A style of painting in which the artist applies thin layers of transparent colors so that the bottom layers show through, thereby slightly changing the tone of the newly applied color.

Gloria (Latin "fame, brilliance, heavenly magnificence"), also aureole. A special form of halo that surrounds the entire figure of God the Father, Christ, the Holy Spirit, and the Virgin Mary.

Golden Section (Latin *sectio aurea*) A certain proportional relationship among objects such that a length (A) can be divided into two parts (B, C) so that the smaller part (C) bears the same relationship to the larger part (B) as (B) to the whole: (A:B=B:C). During the Renaissance and later neoclassicism, eras in which the search for absolute form was an important theme, this ancient proportional relationship was felt to be especially harmonious.

Golgotha see Calvary.

Gonfaloniere (Italian, "standard bearer") The highest officials in medieval and early Renaissance Italian city-states.

Gonzaga An Italian aristocratic family that came into power in Mantua in 1328. In 1433, the Gonzagas were awarded the title of margrave, and in 1530, the title of duke. The main branch of the family died out in 1627.

Gothic (Italian *gotico*, "barbaric, not classically civilized") The European medieval style of art that emerged in northern France around 1150. It ended there about 1400, but in other places continued to be influential into the beginning of the 16th century. The term is derived from the Germanic tribe called the Goths. Characteristic Gothic architectural features are the pointed arch (broken at the vertex), the ribbed vault (the right-angle of two barrel vaults of the same size), and the relocation of the buttresses (the elements that absorb the thrust of the vaults and weight of the roof) to the exterior of buildings. The verticality, dissolution and virtual transparency of the walls give the entire building a sense of lightness. Gothic art found its highest expression in the cathedral, or bishop's church. Sculptures were integrated into the architecture, and the long, idealized figures and their drapery strive for similar height and lightness. In other art forms a new range of emotions, namely tenderness and pain, were depicted. Personal participation became important, resulting in new iconographic emphases. Stained glass, manuscript illumination and panel paintings were also important areas of art production.

Graces see Three Graces, The.

Graphic arts (Greek *graphike techne*, "the art of writing or drawing") Artistic production based on drawing. Historically, tools or utensils

have included the pencil, feather, chalk, charcoal or paintbrush. The term also refers to the process of duplication via printmaking.

Grisaille (French *gris*, "gray" and *grisailler*, "to paint gray") Paintings executed in gray on gray tones, in which artists consciously exclude the spectrum of colors except for shades of stone, brown or gray. It is especially suited to representations of sculpture.

Grotesque (Italian *grottesco*, "wild, fantastic") A form of decoration dating back to classical antiquity consisting of fantastic plant and animal ornamental forms. The term was coined in the 16th century from their place of discovery, the subterranean rooms (Italian *grotta*) known today as the thermal springs of Titus or the Golden House of Nero (*domus aureus*), in Rome.

Guild A league of craftsmen or artists who banded together to protect their rights and interests with regard to working conditions, compensation, and training. In almost all important 16th-century European cities, the guild had both judicial and quality control functions, in addition to providing for its members in emergencies.

Guild of Saint Luke An economic union of craftsmen originating in the Middle Ages. This guild was for painters, whose patron is Saint Luke the Evangelist. According to legend, Saint Luke painted a portrait of the Virgin Mary.

Hercules In Greek mythology, the son of Zeus and Alkmene, famous even before his birth as the strongest of all mortal men and sons of Zeus; he was also the Doric national hero. When the growing youth slew his teacher in anger, he was banned by Zeus to the mountains, where he tamed the Nemean lion. At a crossroads, the hero had to choose between comfort and virtue. Hera then punished him with madness, and he killed his own children. Thereafter he was sentenced

to serve Eurystheus and complete twelve labors, which are numbered differently according to local Greek traditions.

Heroic landscape (Greek *heros*, "hero") see Landscape painting.

Icon (Greek *eikon*, "picture, image") Small, portable panel paintings of religious figures, common in the Eastern Orthodox Church, most often with strongly idealized, unnatural forms and colors. The particular cultic veneration of icons is based on the centuries-old tradition of a postulated original image of Jesus, Mary and the saints.

Iconography (Greek *eikon*, "picture, image" and *graphein*, "write, describe") The study of meaning and symbolic language in pictorial images, especially in Christian art. The term originally referred to ancient portraiture.

Iconoclasm Movements opposed to religious pictures and the fervent devotion they can inspire, including the period from 725–842 when the Eastern Orthodox Church banned icons, as well as the heated struggle against placing religious pictures in churches in the age of the Reformation (1517–1648). Martin Luther (1483–1546) tried to be somewhat moderate, as opposed to his contemporaries Karlstadt (c. 1480–1540), Ulrich Zwingli (1481–1531) and John Calvin (1509–1564), all of whom radically opposed devotional images. Iconoclast movements were active in most of western Europe, in Switzerland as well as in France, England, Scotland and especially in the Netherlands.

Illuminated manuscripts see Book illuminations.

Impasto (Italian *pastoso*, "dough- or porridge-like;" Italian and Latin *pasta*, "dough") A method of applying oil paints liberally, resulting in a thick, relief-like surface.

Indulgence (Latin *indulgentia*, "remission") In the Roman Catholic Church, remission of sins. Practices that began as communal repentance in the 10th century, such as granting endowments to the Church or making individual pilgrimages, became less and less important during the High Middle Ages; instead, by the beginning of the 16th century, selling indulgences was an important source of income for the Church. The mercantile nature of repentance caused the schism (from 1517) between Martin Luther (1483–1546) and Archbishop Albrecht of Mainz, and became the main impetus for the Reformation (1517–1648).

International Gothic (Italian *gotico*, "barbaric, not ancient"), also called the "soft style." This is the name given to a unified trend in painting and sculpture in western Europe between approximately 1380 and 1430. Beginning from the gothic language of forms, this phase is characterized by soft, elegant and rhythmic lines as well as slender, elongated proportions. Characteristic for paintings is also the differentiated depiction of precious materials and their generous folds. Another innovation was a deeper pictorial field, so that larger landscapes and interior spaces were shown as illustrative background.

Jeromites A congregation of hermits named after Saint Jerome of Stridon (died 419/20 A.D.). They live according to the Augustinian Rule, with additional precepts derived from the writings of Saint Jerome.

Jesuit Order see Order of Jesuits.

Jupiter see Zeus.

Judgement Day see Last Judgement.

Landscape Painting An independent type of painting developed in the late Middle Ages or in the Renaissance containing the realistic or stylistic depiction of landscapes in combination with minor figures and architectural forms. The depiction of a beautiful, harmonious, usually wooded landscape filled with sunlight is called an idealized landscape (Latin-Greek *idea*). Here, selected parts of actual natural forms are united in a strict compositional structure. Characteristic features are a stage-like foreground with a view into the distant background. This type of landscape painting was developed around 1600 by Italian and northern European painters in Rome. If mythological or historical figures and classical architecture appear, it is called a heroic landscape (Greek *heros*). Another type was developed in the Netherlands in the late 16th century, the world landscape or panorama. With this style of landscape, the viewer looks into a wide countryside from a higher or cosmic elevation, with all elements seen in miniature and of equal value. A further specialialization of this type developed in the 18th and especially during the 19th century, the pure landscape, does not contain any figures whatsoever.

L'art pour l'art (French, "art for art's sake") A principle of art proclaimed in the mid-19th century by certain French authors (such as Victor Cousin, 1792–1867). According to this principle, art should contain no political, social or religious messages; its only task is to be art.

Last Judgement, also Judgement Day or Doomsday. The apocalyptic end of the world, when Christ will descend to judge the living and the dead. Pictorial depictions tend to be a conglomeration of Old and New Testament descriptions of these events. The essential elements are: a depiction of the *Maiestas Domini*, or Christ enthroned in the clouds with a sword and a lily emerging from his mouth; the twelve Apostles sitting beside him; angels sounding trumpets; the dead rising from graves that have opened; scales on which the Archangel Michael weighs the souls of those wakened from the dead; and depictions of

Heaven and Hell. During the long history of the development of this subject, other motifs have been added, such as the Virgin Mary and John the Baptist kneeling in front of Christ's throne, interceding on behalf of the people, depictions of the 24 Eldest added to the group of the twelve Apostles, and the four beings of the Apocalypse: the bull, the lion, the eagle and the angel.

Lavier (French *laver* and Italian-Latin *lavare*, "to wash") A technique in which the colors and the transitional areas of paintings and drawings are deliberately smudged. A wide variety of artistic effects can be achieved by the blurring of thinned colors.

Legenda Aurea (Latin, "Golden Legend") The collection of the legends of the saints compiled by the Dominican friar Jacobus de Voragine (1228/29–1298) in the 13th century. It has been an especially important resource for Christian iconography since the Middle Ages.

Legend of the Holy Cross According to one of the stories contained in the *Legenda Aurea*, Saint Helena (c. 255–c. 330), mother of Constantine the Great (306–337), unearthed three crosses on Golgotha while on a pilgrimage to Jerusalem. In order to find out which one belonged to Christ, she had each of the crosses in turn placed on the body of a dead man, who awakened when the True Cross was placed on his body. The Empress Helena brought a piece of that cross back to Constantinople. The pieces remaining in Jerusalem were stolen in 614 by the Persian King Khosroes II (590–628), but were eventually recovered by Emperor Heraklius (575–641). The depiction of these events is usually combined into a single picture cycle, with the "Raising of the Cross" sometimes appearing as a single painting. From the 12th century onward this subject found widespread popularity, and the depictions done in the High Middle Ages elaborated far beyond the original text.

Life and Customs Painting see genre painting.

Lithography (Greek *lithos*, "stone" and *graphein*, "describe") A print made using a stone, a planographic method based on the phenomenon of water repelling oil. An absorbent, evenly textured limestone is coated with a greasy ink or crayon and then wet with water. When the printing paper is applied, only those parts that were not moistened with water are copied.

Liturgy (Greek *liturgia*, "public service, open work") The worship service (mass) in the Roman Catholic church and in the Eastern Orthodox tradition, which take place according to an established set of rituals in a prescribed order.

Madonna lactans (Latin, "giving milk") Motif of the Virgin Mary nursing the Christ Child.

Madonna misericordia see Protective cloak of the Madonna.

Madonna of the Rose Garden Depiction of the Mother of God, crowned and holding the Christ Child in front of a rose hedge or in a partially fenced-in rose bower. The rose symbolizes the virginity and purity of Mary, who is accompanied by the holy virgins and by angels playing music. Variations of this type are the Madonna on a Rose Bench and the Paradise Garden.

Maestà (Italian, "majesty, enthroned in glory") Term for the strict pictorial motif in which the Virgin Mary is enthroned with the Christ Child in heaven among images of angels and saints. This subject is found primarily in Italian painting of the 13th and 14th centuries.

Mandorla (Italian, "almond") An almond-shaped halo surrounding the entire figure of Christ or Mary, often depicted in the colors of the rainbow or with the colors blue, red, green and yellow. The mandorla is just one of many Christian

symbols of light and alludes to the incarnation of Christ or to the virginity of Mary.

Mannerism (French *manière*, "way and manner;" Latin *manuarius*, "belonging to the hands") A period of art between the Renaissance and the Baroque, approximately 1520/30 to 1620. In Mannerism, the ideals of the Renaissance (harmonious, ideal forms, proportions and compositions) are negated. The scenes depicted become more dynamic and the human body is elongated, taking on anatomically contradictory positions. Compositions are often excessively complex and irrational, lighting is theatrical and there are great departures from traditional concepts of appropriate coloration.

Man of Sorrows Depiction of Christ's sufferings and martyrdom. See also Passion Christi.

Manuscript (Latin *manu scriptus*, "written by hand") A handwritten ancient or medieval book; its pages are often adorned with ornamental borders, colorful capital letters at the beginning of a text or paragraph, and miniature paintings. These books were created mainly on commission, and at first scribes (in the scriptorium of a monastery) copied famous manuscripts and made copies of copies. In the Netherlands and in northern Germany the "Brothers of Communal Life" occupied themselves primarily with manuscript copying from 1383/84 on. Flanders, Burgundy and especially Paris emerged in the 15th century as important centers for the production of breviaries and books of hours.

Martyrdom (Latin; Greek *martyrion*, "witness, proof") Pain and torture suffered because of one's faith or beliefs, generally ending in a sacrificial death.

Mater dolorosa (Latin, "mother full of sorrows") A representational motif depicting Mary in mourning, lamenting Christ's sufferings.

Maecene A patron or person who routinely commissions works or furthers the arts. The term is derived from the name of Gaius Maecenas (died 8 B.C.), who was especially generous to the Roman poets Horace (65–8 B.C.) and Virgil (70–19 B.C.).

Medallion (French *médaillon*, "large medal") A picture or relief (see below) in a round or elliptical frame.

Medici Patrician family that ruled Florence with only brief interruptions between 1434 and 1737. From 1569, the Medici also ruled Tuscany. One of their most influential family members was Lorenzo I, the Magnificent (1469–1492), who was a patron of the arts and sciences and gathered leading humanists at his Platonic Academy in Florence. His son, Giovanni de'Medici (1475–1521) reigned from 1513 to 1521 in Rome as Pope Leo X.

Mendicants see Begging order.

Mezzotint (Italian *mezzatinta*: *mezza*, "middle, half" and *tinta*, "color") Italian term for the technique of creating a special form of planographic print on copper. The copper plate is roughened with a fine-toothed steel knife called a rocker. After the outlines of the image are drawn, the areas within are smoothed with a polished steel scraper to varying degrees according to how much ink the artist wishes to accumulate on the paper. The less ink desired, the smoother the surface must be. This method is used to achieve extremely fine color gradations.

Miniature painting (Latin *miniatura*; *miniatus*, "colored with Mennige" [a lead oxide]) see Book illumination. From the 15th century the term has also been used for the many small pictures produced on parchment, ivory or cord. In the 17th and 18th centuries, miniatures done in an enamelling technique were very popular.

Minorites, Order of see Order of Minorites.

Misericordia (Latin) Compassion, one of the Christian virtues.

Modello (Italian) Art history term for either a study done in oil that serves as a contract with a patron, or for a sketch of a painting that will be completed later. It is distinguishable from the finished picture only by its smaller format and its sketchier character.

Molo (Italian, "harbor dam, pier") The promenade along the shore of the Grand Canal in front of the Doge's Palace in Venice. On the opposite side, it is called Riva degli Sciavoni.

Monochrome (Greek *monos*, "alone" and *chroma*, "color") An image that is made with only one color, as opposed to polychrome (multicolored).

Mosaic (French *mosaique*, Latin *musaicum*, Greek *mousa*: "muse, art, artistic activity") A surface pattern or picture on a wall or floor that has been assembled from small, vari-colored pieces of glass or stone.

Mythology (Greek *mythologia*: *mythos*, "word, speech, tale" and *logos*, "teaching") The accumulated tales of the traditions of a people; in particular their ideas concerning the origins of the world, their gods, demons and heroes.

Naturalism (New Latin, French *naturalisme*) A depiction in fine arts or literature in which reality as perceived through the senses is rendered as accurately as possible, even with scientific precision.

Nazarenes A group of German painters who joined together in Vienna in 1809 to protest against the academy and then worked mainly in Rome. They strove for a renewal of the arts based on religious and patriotic reasoning. The result was the creation of a special branch of German Romanticism that remained active into the early 20th century. Their name derives from their striking hairstyle, reminiscent of that of Christ as passed down in old renderings. They called themselves the *Lukasbrüder*, a reference to the medieval painters' union, the Guild of St. Luke.

Neoclassicism (French *classique* and Latin *classicus*, "of the highest class," "standard") A European style of art based on classical antiquity (5th–4th century B.C.). The term is used to identify the prevalent forms of art between about 1750 and 1840. Characteristic of this period is the desire for naturalness, simplicity and a humanist identity, supported by an ethical-moral body of thought that was mirrored in the mythological-historical subjects most often represented. In comparison, the earlier Rococo leaned more towards frivolous subjects, while the later Romantics rejected strict adherence to aesthetic rules. Formally, neoclassicism can be identified as a style that emphasizes form and line, cool colors, and severe compositional structure that avoids the illusion of spatial depth. Any artistic style is termed "classical" if it is heavily indebted to an artistically or ideologically exemplary period of art.

Nimbus (Middle Latin, "luminous cloud") A halo, which as a rule is golden in color, or a golden-yellow disk or ring placed above the head of sacred persons in religious paintings.

Noli me tangere (Latin, "do not touch me") The words that the resurrected Christ spoke to Mary Magdalene on Easter morning at the open grave. She did not recognize him at first, imagining him to be the gardener (John 20:14–18). In religious art, the earliest depictions of this scene date back to the 4th century.

Nymph (Greek, "young woman, bride;" Latin *nympha*) In Greek mythology, a female natural

spirit. Nymphs were considered goddesses of nature, imagined as living on mountains, in the sea, in springs and in trees.

Oeuvre (French "work, complete works") The complete collected works of an artist.

Offering in the Temple The Virgin Mary's visit to the temple with the young Jesus, related in the Gospel of Luke (2:22–40). According to Jewish custom, a firstborn child was brought to the temple forty days after its birth to be presented to God, whose property he was said to be, and to be redeemed from the temple by offering a sacrifice. During Mary's visit, the aged priest Simeon recognized Jesus as the promised Redeemer. From the 8th/9th century, a specific image developed that combined glorification of the Child with the "offering": Mary passes the child to Simeon across an altar. Joseph and the Prophetess Hannah are often subsidiary figures in these compositions.

Oil painting (Latin *oleum*, Greek *elaion*, "olive oil") A technique in which pigments (powdered colors) are mixed with a dry oil, such as linseed, poppy-seed or walnut oil. These colors do not fade in bright light; the colors can be opaque or, when thinly applied, allow underlayers to show through without the colors mixing or muddying each other. Moreover, fine gradations of color and smooth transitional areas are possible. In order to achieve maximum durability, after the paint layers are completed the painting is covered with a varnish, or transparent protective coat. Although the technique of mixing and painting with oil colors had been known since antiquity, it was reintroduced in Dutch and Italian art during the 15th century. The surfaces used as painting supports were at first wooden panels, but later included canvas, cardboard or thin copper plates. In the 17th century, painting with oils dominated the field and virtually replaced painting with tempera.

Ontbijtje (Dutch, "breakfast") see Banketje.

Open-air painting Also called *plein-air* painting (French). In contrast to painting in a studio, this refers to paintings done outdoors under the open sky. These painters were especially concerned with a realistic depiction of the natural landscape the feeling of the outdoors. First tentative steps towards open-air painting were taken during the Renaissance and in the Dutch landscape paintings of the 16th and 17th centuries, when landscape paintings were begun by sketching outside but then completed in the studio. Following the example of English landscape artists such as John Constable (1776–1837) and Richard Parkes Bonington (1801–1828), French artists (particularly the adherents of the Barbizon School) in the mid-19th century began to complete their paintings entirely out of doors.

Oratorians (Latin *orare*, "pray, speak") Members of the Oratory, a fraternity of world priests founded by St. Philip of Neri (1515–1595) in Rome.

Order of St. Dominic (Latin *Ordo fratrum prae-dicatorium*, "Order of preaching friars") A religious order founded by Saint Dominic (1170–1221) in Toulouse in 1216, committed to spreading and defending the Christian faith through preaching. In 1232 the pope entrusted the Dominicans with the job of implementing the Inquisition, the Church court that investigated and punished those who did not adhere to the "true faith."

Order of Jesuits (Latin *Societas Jesu*, "Society of Jesus") A Roman Catholic order founded in 1534 by Saint Ignatius Loyola (1491–1556) in order to combat heresies. The order endeavored to reaffirm the authority of the Church and to counter the Reformation through missionary work, education, scholarly activity and literature; thus, the Jesuits have exerted their main influence in the sphere of education.

Order of Minorites Another name for the Order of St. Francis; see below.

Order of Saint Augustine An order of mendicant monks living according to the rules of Saint Aurelius Augustinus (354–430), stemming from small groups of hermits living according to the Augustinian Rule since the 6th or 7th century. These groups expanded dramatically in the 14th and 15th centuries. The order is dedicated to educational work, in particular. Under the influence of Renaissance humanism, many members of the Augustine Order joined the Reformation movement, which was initiated by their fellow monk Martin Luther (1483–1546).

Order of Saint Francis (Latin *Ordo fratrum minorum*, "Order of the minor friars") A mendicant order founded by St. Francis of Assisi (1181/82–1226) in 1209. The members adhere to an ascetic lifestyle and do not own personal property. As the most fervent worshipers of the Virgin Mary during the Middle Ages, the Franciscans placed their order under the protection of the Mother of God.

Order of the Poor Clares A women's mendicant order based on the rule of St. Francis, espousing poverty and asceticism. It was founded in 1212 by Clara of Assisi (1194–1253), a close associate of St. Francis of Assisi (1181/82–1226).

Orders of Saint John Various religious orders that developed from a common source, including the Johnite, the Hospitaler, the Rhodes and the Maltese Orders. This was the first order of knights for clergy, emerging in 1060 from a society that cared for the sick.

Orientalism A variant of the general exoticizing trend in European art. The tendency to admire all things Oriental was spurred by scientific and sightseeing tours (spread by means of published travelogues) of the newly-opened Near East and Egypt, and reached its zenith in 19th-century French painting. The spectrum of subjects ranged from moralizing motifs to realistic and imaginary landscapes, to scenes from everyday life.

Ornat (Latin *ornatus*, "jewelry, clothes") The solemn and festive garments worn by the officials of Christian churches.

Ovid (43 B.C.–18 A.D.) A Roman poet, actually Publius Ovidius Naso. He wrote the *Metamorphoses*, containing legends of transformation in Greek and Roman mythology, as well as a work on the world's development from its origins to imperial harmony in the age of Augustinian.

Pala (Italian "panel") An altar decoration in sculpted or painted form; see Altarpiece.

Palazzo (Italian "palace;" plural *palazzi*) A richly adorned and spaciously built home.

Panel painting (Latin *tabula*, "board") Collective term for different techniques of painting, but especially for tempera and oil painting done on flat, firm surfaces. Wood was a good surface for painting, but ivory, cardboard, clay and thin metal plates—especially copper—as well as canvas stretched on a wooden frame were also used. A panel painting is an independent work, not attached to a wall or other fixed place. It can be in various shapes and may be a single image or part of a cycle.

Panorama see Landscape painting.

Pantheon (Latin *pantheum* and Greek *pantheion*, "temple of all the gods") An honorary temple; or also the sum of all the gods worshipped by a people; originally, a classical temple in Rome consecrated to all the Roman gods.

Paradise garden (Greek *paradeisos*, "garden of Eden") A motif in Christian iconography that

elaborates on the Madonna in a Rose Garden theme (see above). It depicts the Virgin reading or playing with the Child while surrounded by saints and angels playing music in a larger, enclosed garden, the *hortus conclusus*. This alludes to the Immaculate Conception of the Mother of God, while the different flowers depicted represent her virtues.

Paragone (Italian, "comparison") The term used to describe the wrangle among the various arts as to their relative worth, a popular subject since the Renaissance. The ongoing debate has resulted in an extensive body of writings on the theory of art.

Parchment (from Greek Pergamum, an ancient city in northwestern Asia Minor, today the Turkish city of Bergama), also called vellum. The skin of a sheep, goat or calf that has been cleaned and treated in a special chalk solution in order to made it into a durable surface for writing and painting. In the 4th century A.D., parchment finally replaced the less durable papyrus that had been used until that time. In the manuscript illuminations of the Middle Ages, parchment was used for codices, documents and manuscripts. Parchment was also used for a long time as a surface for gilding. It has always been somewhat costly, but was occasionally used for drawings (especially by Albrecht Dürer). In the panel paintings of the 12th to 16th centuries, parchment was often used as the material covering the boards before the primer (see below) was applied. With the rise of paper production, parchment quickly lost its importance.

Parnassus (Greek Parnassos, a mountain near Delphi) In ancient Greece, the mountain of the Muses and the realm of poetry. Since the Renaissance, and especially in the Baroque period, the mountain has been depicted with the enthroned god Apollo surrounded by the Muses, the nine goddesses of the arts. Pegasus, the winged horse with magical powers, often flies upward, crowning the scene.

Passion Christi (Church Latin, *passio*) The story of Christ's sufferings. The term generally includes all the events directly or indirectly involved with the crucifixion, for example, Judas's betrayal with a kiss, Christ being taken prisoner, the interrogation, the crowning with thorns, and Christ carrying the cross.

Pastel painting (Italian *pasta*, "batter") A technique of painting and drawing using soft sticks of a single color that consist of compressed color dust and chalk. These are known to have been used in France before 1500, primarily in combination with more durable materials like red chalk, charcoal or silverpoint for sketching. The supporting surface most commonly used for pastels is a soft, toned natural paper. In the 16th and 17th centuries pastel painting was used in Italy, the Netherlands and in France; it reached its developmental peak in 18th-century France.

Pastoral (Latin *pastoralis*, "shepherd-like") Depictions of idyllic shepherd life exist in ancient murals, and the motif was revived during the Renaissance. Pastoral scenes were very popular during the Baroque and Rococo periods.

Pastoral idyll see Arcadia.

Patron see Donor.

Patronage (Latin *patronus*, "patron, protective lord") The honor, office and rank of a patron; or the legally-determined relationship between a donor and the church they wished to endow.

Pendant (French, "hanging") A companion piece or counterpart.

Perspective (Middle Latin *perspectiva (ars)*, "(art) looking through") The depiction of three-

dimensional objects on an flat surface. Objects and figures are rendered according to optical principles that also determine how the viewer sees the depicted reality.

Perspective of importance A widely used means of representation especially in the Middle Ages, in which people and objects do not have the relative size they would in a realistic depiction. Instead, their size depends on their "ideal" rank or level: They are depicted according to their significance. Therefore saints, gods or heroes are larger than other persons, such as patrons. See also Perspective.

Physiognomy (Greek *physis*, "nature" and *gnonai*, "recognize") The external appearance of a person, especially their face.

Pietà (Italian, "pity, compassion;" Latin *pietas*, "piety") A depiction of the Virgin in mourning, holding the dead body of Christ in her arms.

Pigments (Latin *pigmentum*, "color materials") Powdered color that is added to a solution of oil, water or turpentine and mixed with binders such as glue or gum arabic to form paints. With a fresco (a mural painted on moist plaster; see above), the only binder is water.

Plein-air painting see Open-air painting.

Polychrome (Greek *poly*, "many" and *chroma* "color") Multi-colored, in contrast to monochrome (see above).

Polyptych (Greek *polyptychos*, "full of folds") An altarpiece (see entry) with more than two wings. They are especially suitable for depicting a longer story cycle or more extensive content.

Portrait (French; Latin *protrahere*, "to draw forth") or counterfeit (French *contrefait*, "imitated"; Latin, *contrafacere* "to re-make") The depiction of a specific person by recreating her or his individual features. In principle, only a similarity is necessary, and this need not be identical with their external appearance. In a supra-individual portrait the person is recognized through name, rank, attributes, symbols or heraldic signs. The main function of such a painting is to represent the absent one, to call them to mind and honor her or him. This kind of painting is especially important in religious art. Distinctions are drawn among single, double and group portraits.

Predella (Italian "pedestal, footstool") A kind of base or pedestal on winged altarpieces, sometimes used to preserve relics (revered objects or bodily parts of a saint). It is often adorned with pictorial illustrations.

Priming The process of preparing a surface to be painted (canvas, wood, copper, paper, etc.) by applying a primer, the coloring and absorbency of which is dependent on the selected binder (leather, animal-derived, or casein), filler (chalk or plaster) and pigments (zinc, white lead, red earth, or green earth). This base coat determines the surface effect and the durability of the paint layer, and can make it possible to date the work in question.

Profane painting (Latin *profanus*, "lying before the holy estate, unholy") A painting made for worldly, everyday use rather than for a religious purpose; in contrast to sacred paintings.

Prometheus, a Titan. The wise son of Japetos and Clymene, he was responsible for bringing fire from the heavens to the earth and furthered the cultural development of humanity. Various poets (including Hesiod, Aeschylus and Plato) tell different versions of his story.

Proportion (Latin *proportio*, "symmetry, elegantly proportioned") In paintings, sculpture and architecture, the ratio of single parts to each other

and to the whole; also a harmonious relationship among the parts.

Protective cloak of the Madonna A painted depiction of the Virgin in which she holds her cloak protectively around the faithful. This motif originated from a legality in everyday life: Children were legitimized and adopted when their father symbolically took them under his cloak. Persons of high rank, especially women, could shield persecuted persons under their cloaks and ask for leniency or pardon. This right of women to practice the protective cloak was projected onto the Virgin Mary.

Punchwork (Italian *punzonatura*, "the Stanzas" and Latin *pungere*, "to cut in") The ornamentation of leather and metal using steel rods and stamps. This method emerged from the art of goldsmithing, and was sometimes applied in medieval panel paintings.

Putti (Italian, "little boys;" Latin *putus*, "boy;" singular *putto*) A small, nude boy with or without wings. Putti were an innovation of the Italian early Renaissance that were influenced by Gothic child-angels, in turn modeled on *eroti*, the sons and companions of Aphrodite, the goddess of love. See also Cupids.

Quadratura painting (Middle Italian *quadratura*, "the quarter;" Latin *quadrare*, "to make four-cornered") Illusionistic wall and ceiling paintings that break the spatial barriers of a room; also the seeming expansion of a room through painted architectural forms.

Quattrocento (Italian, "four hundred") Italian term for the 15th century.

Realism (Middle Latin *realis*, "factual, essential" and Latin *res*, "thing") In art, the term for a socially critical work resulting from the experience and observation of reality. This term is used especially to describe the artistic trends in France in the 19th century. Artists there were reacting against a severe, academic neoclassicism and against popular narrative painting; however, they never developed a single unified style.

Reformation (Latin *reformatio*, "reorganization, renewal") A movement set into motion by a series of theses promulgated by Martin Luther (1483–1546) in 1517 against the Church practice of selling indulgences, among other things. There were heated disputes in Heidelberg and Leipzig as to a renewal of the Roman Catholic Church, culminating in the end of a unified Church in the west due to the formation of the Protestant denominations. See also Catholic Reformation.

Relief (French; Latin *relevare*, "elevate") An elevated depiction formed by molding or chiseling into a flat surface. A relief is called a flat, half or high relief depending on the degree of depth.

Relic (Latin *reliquiae*, "rest, left behind") Originally the bodily remains of a saint; more broadly any object venerated because of its association with a saint or martyr.

Renaissance (French; Italian *rinascimento*, "rebirth") A progressive cultural epoch of the 15th and 16th centuries that began in Italy, later spreading to the rest of Europe. Its late phase, from 1530 to 1600, is called Mannerism. The term *rinascita*, or "rebirth", was coined in 1550 by Giorgio Vasari (1511–1574); he was referring mainly to the ability of artists to go beyond the art of the Middle Ages. The ideal of the *uomo universale*, or the "Renaissance man" who was knowledgeable and talented in a variety of fields, developed as a result of humanism, the philosophy based on classical knowledge that promulgated the dignity of human beings and their spiritual and corporeal self-realization in the temporal world. As a consequence, the fine arts were raised from the status of a craft to that of the liberal or free arts, whereby the artist

gained a higher social status and enjoyed greater self-esteem. Art and science worked hand in hand, as for example in the mathematic calculations necessary to portray perspective, or in accurate knowledge of anatomy.

Replica (French *réplique*, "answer, imitation") A work almost identical to the original, executed either by the artist her- or himself or by their workshop.

Repoussoir (French *repousser*, "to drive back, to scare away") The term for the figures or objects appearing in the foreground of a picture, such as tree stumps or architectural fragments. They often serve to create the illusion of deep space and may draw attention to the main subject if it has been placed somewhat to the back of the pictorial area.

Retable see Altar retable.

Revelation to John The last Book of the New Testament, also called the Apocalypse of John, in which the Final Judgement (see Last Judgement above) is depicted in terms of three visions: Terrible natural catastrophes will engulf the earth, then the final battle between the powers of evil and good will rage. Finally, the unity of a new heaven and new earth will be established in the Heavenly Jerusalem. The announcement of Christ's return at the end of the world was meant to comfort beleaguered Christians and warn them of horrors to come.

Rococo (French *rocaille*, "pebble, grotto-work, shell-work") A stylistic era in European art between 1720/30 and 1770/80 in which many Baroque elements were brought to maturity and neoclassicism was presaged. Characteristics of Rococo art are a decorative style that is light, playful and consists of small parts; lighter colors used in paintings; more worldly matters than religious subjects being depicted; a more sensual

aesthetic; and erotic subjects rendered in a lyrical, idyllic atmosphere.

Romanesque (Latin *Romanus*, "Romans, Roman") A term initially used in France during the first third of the 19th century for the architecture of the early Middle Ages that was indebted to Roman forms: the round arch, columns, and vaulted ceilings. This period began from about the year 1000 in France and from the mid-11th century in Germany into the mid-13th century. In central France it was replaced by the early Gothic style as early as the mid-12th century, and at this point national characteristics and stylistic elements developed. Romanesque art achieved its highest forms in Burgundy, Normandy, Upper Italy and Tuscany. Its main application was in the building of churches, where architectural form manifested a clear interplay of cylindrical and cubic elements.

Romanism (Latin *Romanus*, "Romans, Roman") An important movement in Dutch art from about 1510 to 1570; its representatives were influenced primarily by classical art and by the Italian Renaissance.

Romanists (Late Latin *Romanistae*, "Romans") The term given to a group of Dutch painters, draftsmen, engravers and pictorial weavers of the 16th century who had lived at times or permanently in Italy (in particular Rome and Venice). Their works reveal a synthesis, at times very individual, between the stylistic elements of late Renaissance Italian paintings and of Mannerism (Raphael, Michelangelo) with influences from antiquity and their own native traditions. This movement began about 1510 with the work of Jan Gossaert, called Mabuse (about 1478–1533), and extended to Frans Floris de Vriendt (c. 1516–1570).

Romanticism (French *romantique*, "Roman-like;" English *romantic*, "poetic, fantastic, emotional")

A philosophy developed around the beginning of the 18th century by philosophers and writers. At first it was a way of viewing art and the role of the artist as an individual which was especially influential for German artists. In a revisitation of earlier traditions, Romanticists called for a renewal of art and religion that would give expression to the new intensity of feeling for life and nature. Painters were not concerned with the depiction of visible reality, but wished to express subjective feelings. They painted their longing for God, for example, for the past, and for exotic lands.

Rose Garden Madonna see Madonna of the Rose Garden.

Sacco di Roma (Italian, "sacking or plundering of Rome") The occupation of Rome by the troops of Emperor Charles V (1500–1558), primarily German and Spanish mercenaries, from May 1527 through February 1528. Many of Rome's churches and artistic treasures were destroyed or stolen during this period.

Sacra conversazione (Italian, "holy conversation") Term for the depiction of a dignified meeting of the Virgin and Child with any number of saints. The term is somewhat misleading, as an actual conversation is not necessarily depicted.

Sacred art Religious paintings whose motifs and subject matter is determined by cultic and liturgical rules and concerns.

Sacraments (Latin and Church Latin, *sacramentum*, "consecration, oath of fidelity, religious secret") Religious actions recalling Christ and eliciting divine grace. In these acts, the mutual bond or covenant between God and humanity is reaffirmed. The seven sacraments of the Roman Catholic church are: Baptism, Confirmation, Repentance, the Eucharist, Priesthood, Marriage and Extreme Unction. Most Protestant denominations recognize two: Baptism and the Eucharist. Sacramental acts and related Biblical events have often been portrayed in paintings.

St. Luke's Guild see Guild of St. Luke

Saints Persons who, because of their pious lives, the miracles they performed during their lifetime, or their martyrdom, have officially been declared as such after their death by the Catholic or Orthodox Churches. They are revered individually by the faithful and are called upon to intercede with God on their behalf.

Salon (French; Italian *salone*, "great hall") Term used in the French language in the 18th and 19th century for any exhibition room as well as for the art exhibition in the *Salon carré* of the Louvre, held annually since 1863.

Satyr (Greek *satyros*) Greek demons of nature, appearing as a four-legged mule with a human head and torso, but with mule ears, a tail and hoofs. Sometimes the satyr has the legs of a goat and is horned. He is an unbridled, lecherous companion of Dionysus (see above), the Greek god of wine and fertility.

Scholasticism (Latin *scholasticus*, "belonging to a school") The philosophy and science of the Middle Ages, based on classical philosophy, the dogmatic exegesis of the Bible and the writings of Church Fathers.

School (Greek *schole*, "rest, peace, institute for learning, lecture;" Latin *schola*, "place for teaching, disciples of a teacher") In the fine arts, this term denotes a group of artists with a common training or schooling or similar points of departure, as for example, a city, a region, or similar stylistic criteria.

Scuola (Italian, "school;" plural *scuole*) Originally medieval penitent and mortification brotherly

orders, the *scuole* developed into guilds, or unions based on craft, profession or even nationality. During the 17th and 18th centuries the *scuole* in Venice, under the patronage of various saints, had their own assembly rooms and devoted themselves to important social and charitable activities, such as providing for the sick and needy.

Secco painting (Italian *secco*, "dry;" *al secco*), a technique of wall painting in which colors of various compositions are applied *al secco* onto dry plaster.

Seraphim (Hebrew, "purifying;" *seraph* "burn;" singular *seraph*) According to the Old Testament, the seraphim and the cherubim are the highest orders in the hierarchy of angels, part of God's court and the guardians of Paradise. In the New Testament they belong to the honor guard of Christ. The seraphim have six wings that are usually decorated with eyes. Of these, two cover their face and their feet and the rest are used for flying. Their animal-like shape was derived from Oriental art. As the cherubim often also have six wings, it is difficult to distinguish them from one other.

Serenissima (Italian; abbreviation of *La Serenissima Repubblica Venezia*, "the most serene Republic of Venice") This formula was used from the Middle Ages to describe the splendor and dignity of the "city on the lagoon" and testifies to the self-confidence of the Venetians.

Sforza Italian aristocratic family, the rulers of Milan from 1450–1535, who controlled the majority of Lombardy.

Sfumato (Italian *sfumare*, "evaporate") A manner of depiction usually associated with Leonardo da Vinci (1452–1519), who painted soft contours that merged into each other, as though seen through the veil of a fine mist.

Sibyl (Greek *sibylla*, "prophetess") In antiquity, a woman who predicted the future. According to legend and ancient Greek writings, she foretold the birth, passion and resurrection of Christ. Originally there was one Sibyl in the ancient world, a Greek prophetess, but later their number was set at ten. Early Christianity held that there were twelve sibyls, analogous to the twelve prophets of the Old Testament.

Sinopia (Italian *sinopia*, "red chalk, iron ochre") The preliminary sketch for a fresco, done in actual size on the wet plaster. The term is derived from the city of Sinope on the Black Sea, where the reddish earth used for drawing was mined.

Soft style see International Gothic.

SMPK (German abbreviation for Staatliche Museen Preussisches Kulturbesitz, "National Museums of Prussian Cultural Heritage") An umbrella organization that includes most of the art museums in Berlin.

Staffage (Old French *estoffer* and French *étoffer*, "filled with material") Decorative additions, additional equipment; in landscape and architectural paintings, the figures and animals that enliven the scene, which are often symbolic. During the Baroque, the staffage enriched the composition, gave an opportunity to add color accents, and intensified the sense of spatial depth (*repoussoir*). From the 16th to the 18th centuries, staffage figures were often added by painters specializing in this area.

Stanza (Italian, "room") Term used to refer to rooms in palaces and other important chambers that were oppulently decorated during the Renaissance with monumental paintings.

Stigmata (Greek *stigma*, "sting, dot, brand") According to the Catholic faith, the miraculous appearance of one or more of the five wounds

suffered by Christ, or wounds of martyrs, on other persons.

Still-life paintings (Dutch *still-leven; still* "still, immobile," *leven*, "model") also *nature morte* or *natura morte* (French and Italian, "dying nature, lifeless creation") A form of painting that reached its peak in 17th-century Dutch art in the realistic portrayal of objects at rest. Different kinds of still lifes are distinguished according to the objects portrayed: For example, there are flower and fruit, hunting, kitchen and market still lifes. This kind of picture was devalued by the academies of the 18th century, which considered it an inferior art form.

Supraporte (Italian *sopraporta*, "above the door"), also *sopraporte*. An area above the frame of a doorway that was adorned with a painting or a relief.

Tabernacle (Latin *tabernaculum*, "small tent, small hut") The shrine where the consecrated wafer (host) used in celebration of the Eucharist is kept.

Tempera painting (Italian; Latin *temperare*, "mix, combine") A type of paint that was increasingly replaced by oils during the 15th century. At the end of the 19th century this technique was revived with colors whose pigments (powdered colors) were mixed with a binder of egg, animal glue or casein, an important protein in milk. Tempera paints dry very quickly once they have been applied, so that painting wet in wet is not possible. Therefore, fine shading and transitions between colors are made with many layers of parallel brush strokes. The color differences between wet and dry tempera paint make it difficult to attain the same shade of color when painting over a section of the composition.

Three Graces, the (Latin *gratia*, "pleasing") The daughters of Zeus and Eurynome: Aglaia (Brilliance), Euphrosyne (Joviality), and Thaleia (Flowering). Like the minor deity Caritas, they dispense modesty, beauty and joy to humanity. In their roles they are akin to the Horae (goddesses of the seasons) and to the nymphs (female spirits of nature) and are, among other things, companions of Venus.

Throne of Grace A way of representing the Holy Trinity. God the Father is depicted either sitting on a throne or standing, holding the Cross with the crucified Son. Between them is the Dove, symbolizing the Holy Spirit.

Tonal painting (Latin *tonus*, "sound, color"), also *valeur* painting (French "value") A way of painting in which the ultimate effect is achieved through a gradual increase of color along a uniform basic tonal scale. The degree of light and darkness is determined by minute gradations of color saturation: This is used to highlight the various bright and shady areas.

Tondo (Italian, "ball, plate;" Latin *rotundus*, "round") A circular painting or relief.

Tools of the Passion (Latin *arma Christi*, "weapons of Christ" or his "trademark"), also known as the symbols of Christ's suffering. These are objects associated with the suffering of Christ and consist of the following: the cross, the crown of thorns, the lance, the staff with a vinegar-soaked sponge, the martyr column, the scourge, the whip, the fetters, three nails, a hammer, a ladder, tongs and three dice. Originally they were viewed as signs of Christ's triumph or majesty and appeared in paintings proclaiming Christ's return, especially in Last Judgement scenes.

Topography (Greek *topos*, "place" and *graphein*, "describe") The rendering of a geographic place with as much specific detail as possible.

Tracery Geometrical Gothic ornamental stone work, measured precisely with a compass, used

to subdivide the tops of the arches of large windows, and later used to structure pediments, gables, walls and other surfaces.

Transfiguration (Latin *transfigurare*, "transform"), the Transfiguration of Christ According to Matthew (17:1–9), Mark (9:2–9) and Luke (9:28–36), Christ went with his disciples Peter, John and James the Elder onto a mountain to pray. As they prayed, Christ's face and clothing began to glow with a supernatural light. In addition, Moses and the prophet Elijah appeared and spoke to him. Christ forbade his distressed disciples to speak about this event that foreshadowed his Resurrection.

Transformable altar An altar shrine with several different wing panels, allowing the pictures to be changed for High Feasts, Sundays and ordinary days, for example.

Trecento (Italian, "three hundred") Italian term for the 14th century.

Trinity (Latin *trinitas*, "threesome") The Christian doctrine of the unity of a tripartite God: God the Father, God the Son and God the Holy Spirit, a basic tenet of the Christian faith.

Triptych (Greek *triptychos*, "three-layered, threefold;" *tri*, "three" and *ptych*, *ptyx* "fold, layer, folded") A three-part panel painting, especially a medieval winged altarpiece, that consists of a self-supporting central section and two movable side wings.

Trompe l'oeil (French, "visual deception") A manner of depiction popular since antiquity which tries to make it impossible for the eye of the beholder to distinguish between a painted and a real object. The *trompe l'oeil* can be a pictorial motif or, since the mid-15th century and particularly in Dutch painting of the 17th century, an independent type of painting.

Typology (Greek, "form, pattern, model" and *logos*, "teaching, lore") The teaching of the correspondence between the Old and New Testaments, based on the view that the New Testament is the culmination or fulfillment of the Old (for example, the prophecies of Jesus's coming).

Uomo universale (Italian, "universal man") The well-rounded, spiritually and physically educated and developed person possessing abilities in a wide range of artistic and scientific fields; the cultural ideal of the Renaissance.

Vanitas (Latin, "vanity, emptiness, transience") The belief in the transience, and therefore the worthlessness, of everything earthly, based on the Old Testament lament, *vanitas vanitatum* ("all is in vain"). The idea of *vanitas* was a popular pictorial subject especially during the Baroque period, in connection with the admonition *memento mori* ("remember that you will die"). Typical symbols of vanity include the skull, the hour-glass and the burning candle.

Varnish (French *vernis*, "veneer, glaze;" Middle Latin, *veronix*) The final, transparent coat applied to paintings and other artistic works to seal and protect them.

Vanishing point see Central perspective.

Vedute painting (Italian *veduta*, "view") A type of landscape painting in which the city or countryside is rendered factually and true-to-life, as opposed to pure landscapes. During the 17th century *vedute* attained a character of its own, and in the 18th century reached the high point of its development in Italian art. A special form was the *vedute ideale* (Italian "ideal view"), which depicted a fantasy landscape or a view of a city with imaginary buildings. See also Landscape painting.

Vellum see Parchment.

Venus (Italian) Roman goddess, originally of spring or of the garden, later the goddess of love, like the Greek goddess Aphrodite. According to some legends, she was born from the foam of the sea. She is the wife of Vulcan, god of fire, the smithy and craftsmen, including artists. Among her entourage is the god of love, Amor, as well as the Three Graces of Modesty, Beauty and Joy and the Horae, goddesses of the seasons.

Verism (Latin *verus*, "true, real genuine") A movement striving for realism in the fine arts, aiming at representing unadulterated reality.

Visitation, Visitation of the Virgin (Latin *Visitatio Mariae*) In the Gospel of Luke (1:39–56), Mary is visited by Elizabeth, the mother of John the Baptist, while both women are with child. Their meeting has been portrayed since the 6th century in individual paintings, in cycles or as the counterpiece to an Annunciation scene, the moment in which the Archangel Gabriel announces to Mary that she will give birth to the Son of God. In the 13th century the Annunciation was depicted as an independent subject. Finally, during the late Middle Ages, it was depicted as the main event of Mary's life among the seven joys ascribed to the Mother of God.

Vita (Italian, "life," plural *vitae*) The biography, or life story, of a person.

Votive picture (Latin *votives*, "praised, consecrated"), see also *Ex voto*. A picture dedicated to a saint or to God in gratitude for having been rescued from danger, to support a plea, or as thanks for a prayer that has been heard.

Watercolor painting (Italian *acquarello*, "watercolors;" Latin *aqua*, "water") The technique of painting with transparent watercolors. The pigments are mixed with a binder (for example, gum arabic, a very sticky vegetable juice made from African acacias) and water so that the colors will remain water soluble even after drying. The main features of watercolor painting are the abandonment of distinct outlines and sketching, and the inclusion of the painted medium (canvas, wood, etc.) as an independent element in the composition.

Winged altarpiece (Latin *altare*, "sacrificial table") A widespread form of altar painting, especially in Germany and the Netherlands during the last third of the 15th and the beginning of the 16th centuries. The middle section, called the altar shrine, is flanked by folding wings on the right and left, on the inner and outer sides of which are carved or painted depictions.

World landscape see Landscape painting.

Zeus (Greek) God of light and the heavens, the highest of the Greek gods who rules the other gods and humankind from Mount Olympus. He was the son of Kronos and Rhea, and husband of Hera. Greek mythology attributes to him a large number of divine and human wives, whom he won over by transforming himself, for example, into a bull for Europa and into a golden rain for Danae. The Romans called him Jupiter.